Alberto Giacometti

Alberto Giacometti

REINHOLD HOHL

Harry N. Abrams, Inc., Publishers, New York

Standard Book Number: 8109-0139-0
Library of Congress Catalogue Card Number: 70-160216
Copyright 1971 in West Germany by Verlag Gerd Hatje, Stuttgart

Printed and bound in Switzerland

Table of Contents

To Ernst Beyeler, Gerd Hatje, and James Lord

Foreword

When the art dealer Pierre Matisse was preparing an exhibition for Alberto Giacometti in New York in December, 1947, he asked the artist for a list of his works. At that time Giacometti was known in New York—and in Paris and London—as a highly gifted sculptor working in a Surrealist vein, even though he had not done work of this kind for years. Rather, he had spent the eleven preceding years on works which one would be right in calling "Nature studies"—although they led to something completely different from the results usually expected from such studies—their deepest meaning coming from a confrontation with reality. In the twelfth year, Giacometti achieved a group of "realizations," a word shared with Cézanne and a concept which means more than a "work of art": they were temporary realizations of a conception which could never be fully carried out. When Giacometti decided to show these works for the first time, he was not satisfied with a simple listing of titles; he sent Pierre Matisse a long letter with sketches: "Here is the list of sculptures I promised you, but I could make the list only by relating the works to each other—with short comments at least—otherwise it would be meaningless." He goes on to give a unique account of a working process which lasted over thirty years in pursuit of a creative goal he never reached.

To fit Giacometti's oeuvre and the separate periods of his life into a whole picture: that is the idea behind this monograph. I am working on the premise that, not only is his oeuvre, taken as a whole, as important as the artistic quality of any individual piece, but also that an insight into Giacometti's entire output will be more rewarding than a study of any one successful single work. Thus, each individual piece—whether it be a bust, a *Standing Woman*, or a portrait—will take on a much greater significance as a representative of the whole, and can therefore be experienced all the more deeply. This book's division into creative periods and the grouping of its illustrations serve as the columns upon which the great arch of Giacometti's life work rests.

My second assumption at the outset is that every step taken in the creation of works of art has its forerunners; every form has its historic basis. Any study of an artist's work must take this into account in order to attain to the insights—though not to an explanation—allowing us to place the oeuvre accurately in the context of its time. I shall not speak of "influences" here; I shall try to name the forms and thought patterns which Giacometti shares with other artists and writers.

David Douglas Duncan, the photographer, has passed on Picasso's remark to the effect that he, Picasso, had only one competitor in terms of fame—Giacometti and his (belated) recognition—and that Giacometti's *reputation* was based on the countless legends which had formed around him during his lifetime, styling him as a picturesque artistic figure like Van Gogh or Modigliani. He has really almost become a legend, Alberto (everybody calls him "Alberto"): the last Bohemian of Montparnasse (100; 161); the millionaire in the lousiest studio in Paris (67); the seeker of the absolute (383)....

There are too many remembered conversations with Giacometti, too many poetic essays, and too many pointed and sometimes controversial remarks from the artist himself for one simply to be able to distill "the truth" from a mixture of them. In the Documentary Biography section of this book, important quotations have been arranged in such a way that in sum—partly due to their very inconsistency—they produce a picture of Giacometti's personality as close to the truth as possible.

Figures in parentheses refer to works listed in the systematic bibliography (pages 311–324). When more than one number is referred to, they are divided by semicolons; figures after a colon refer to page numbers.

PART ONE · BACKGROUND

ORIGIN AND ANCESTRY—TALENT—EARLY EDUCATION

Borgonovo—Stampa—Maloja
Giovanni, Augusto, Alberto Giacometti

Alberto Giacometti was born in the Bergell, an Alpine valley in southeastern Switzerland. The road from the north crosses three passes in the Alps, and the railroad from Chur runs through a series of curving tunnels before it reaches St. Moritz; from there one has to take the mail bus to Lugano, which, after an hour's ride down the valley, arrives in Stampa, the home of the Giacomettis. Simpler—and richer in associations—is the trip from Milan or Como to the Bergell, which opens to the south both topographically and culturally. The styles of northern Italy have determined the architecture of the area's churches; its vegetation and farming methods are Italian. Its people are Protestants, another reflection of the region's historical independence from southern Switzerland. Their language, which today sounds rather like a Lombardic dialect, belongs to the Rhaeto-Romanic group. The Upper Bergell Valley, on the other hand, has a long history of political relations with the northern part of Graubünden (Grisons), through ancient contracts with the Bishop of Chur and due to the large amount of land owned by the people of Stampa, especially in the Engadine Alpine meadows surrounding Maloja; the construction of many peasant and patrician houses in Stampa and Borgonovo reflects this historic connection. The period of prosperity, of which more than one village took advantage to build castles and palazzi, lasted until the Gotthard railroad was built: the Septimer Pass, approached through the Bergell, had for centuries been the easiest trade and travel route through the Alps.

Alberto Giacometti's artistic career, unique as it was, nevertheless followed well-traveled paths.

The inhabitants of the southern Alpine valleys have been remarkable for their artistic creativity over many generations. A handful of villages in southern Switzerland has produced more sculptors and architects in the last four hundred years than the rest of the country put together. Stuccoworkers born in this area decorated churches from southern Italy to Russia. The names of the local artists famous during the nineteenth century may not mean much to us now, but as the owners of the most elegant confectioner's shops in any area, the families which emigrated from southern Switzerland and the Engadine continue to enjoy a reputation throughout Europe even today. Pastrycook or artist—these were the professions that members of the Giacometti family chose most often.

The brothers Alberto, Diego, and Bruno (the first a sculptor and painter, the second an artisan, and the third an architect), sons of the painter Giovanni Giacometti, are a remarkable, yet not unique, family of Swiss artists.

One of the family's fine pastrycooks, Antonio Giacometti, Giovanni's cousin—owner of the confectioner's shop Gilli e Bezzola on the Via Nazionale (219; 735)—put up the young Alberto in his house while he was studying in Rome in 1920-21. His grandfather, also named Alberto, had been a confectioner in Warsaw and a café owner in Bergamo until he returned to Stampa, where he settled down with his wife, Ottilia Santi, to run the hotel Piz Duan, complete with a bakery and a grocery.

Alberto's father had many trying years as an artist behind him when, in 1900, at the age of thirty-two, he married twenty-nine-year-old Annetta Stampa from the neighboring village of Borgonovo. He lived with her there for six years at Cat-Dolf, a house belonging to her parents, which still stands at No. 60 Dorfstrasse. There, on the first floor, on October 10, 1901, Alberto Giacometti was born.

This "new hamlet" (*borgo novo*) lies two kilometers up the valley from Stampa and had already surpassed the county seat both in population and number of buildings. The church of San Giorgio with its cemetery is the most prominent building in the village and guards its entrance. Three great artists from the Giacometti family were to be buried here with official honors: Alberto's father, Giovanni Giacometti (1868–1933), whose funeral was attended by a Swiss State Government representative; the painter Augusto Giacometti (1877–1947),[1] whose reputation was well established in Germany and France; and the sculptor and painter Alberto Giacometti (1901–1966), from whom government delegations, friends, and art collectors from all over the world took their last leave. The man now living in the room where Alberto was born carried the dead sculptor in his cart from Stampa back to San Giorgio di Borgonovo.

The district of Stampa stretches northward along the steep pass road above Borgonovo, all the way up to Maloja. In Maloja-Capolago, where the sparse larch forests of the Engadine still grow—the chestnut trees begin farther down, just below Stampa—the Giacometti family used to spend the summer months and their winter holidays in an Alpine chalet converted into a studio. For, from November until late in February, the only sunshine in Stampa is that reflected from the rows of peaks towering seven thousand feet above the valley floor.

Sunnier Maloja was more to the artist and his family than a mere vacation spot. It was here, in 1894, that Alberto's father found his teacher, his mentor, Giovanni Segantini (1858–1899), and through him the direction his painting was to take. From their meeting a project resulted that was to have documented modern Swiss art for the world to see, an Engadine Panorama in several parts for the Paris World's Fair of 1900, planned as a monumental co-operative work by Segantini, Ferdinand Hodler, Cuno Amiet, and Giovanni

Giacometti. The project was never realized, though its conception was modern for the time—an echo of the artists' community at Pont-Aven, away from the metropolis and its influences and independent of the Impressionism then still prevailing in painting. It was an attempt to develop a contemporary style out of the encounter of independent artistic personalities with traditional cultural forms and allegorical images of the world. It was not as a provincial painter of landscapes that Giacometti's father worked in Stampa and Maloja (and his godfather Cuno Amiet in the Swiss peasant village of Oschwand), but in the mainstream of the European avant-garde, like many others in Arles or L'Estaque, Dachau or Murnau, in Worpswede or on the Marquesas Islands. So the talk in the Giacometti household during the years when Alberto was still attending the village school and drawing Roman battle scenes and biblical landscapes with colored pencils (804) centered on the latest news, about Symbolism and Art Nouveau, Van Gogh and Gauguin, Cézanne and Rodin, Synthetism, Divisionism, Fauvism, Cubism, Futurism. Nor were the Old Masters slighted: at ten, Alberto initialed his drawings with a monogram borrowed from Dürer (804).

But of course it was his impression of landscapes and nature which played the dominant role in Alberto's childhood, even influencing much of his later work; walking through the Engadine forests, it is easy to find "the corner of the forest I saw many times in my childhood years, and the naked trunks of the trees (behind them you could see huge blocks of gneiss) with almost no branches, except at the very top; they always reminded me of people stopped dead in their tracks, talking to one another." (14)

Giacometti's *Seven Figures, One Head* (*The Forest*, 1950; page 124) documents his childhood experiences as well as a much later impression, "which I had had the previous autumn [1949] when I saw a clearing (it was actually more of an overgrown meadow with trees and bushes, on the edge of the woods) which attracted me very much. I wanted to paint it, to use it in some way, and I left with regret at having lost it." (14) Something of this vision found its expression in *Nine Figures* (*The Glade*, 1950; page 125). And some of the *Busts of Diego* done in 1954 (pages 200 and 201), with their massive, fissured chests and shoulders and their small heads, withdrawn in space, resemble the jumbled, cleft mountainsides crowned by narrow rocky peaks, a seemingly unbridgeable distance away, as he saw them from the Maira Valley.

But it is not quite so easy as that; the essence of Giacometti's art is not revealed to us by a trip through the Bergell Valley and a visit to Stampa. Unlike Cézanne, whose tenet "The cylinder, the sphere, the cone," and particularly his way of applying color, are easier to understand when one has seen the overgrown stone quarries near Aix-en-Provence, a visit to the place where Giacometti

lived and worked does not give us any insight into his sculptures and paintings; and, in the case of his landscapes and drawings of interiors, we are invariably surprised at the comparative banality of the real mountain scenery or the real lamp in the Giacometti house compared to the forms the same objects took in the inaccessible image-world of his art. Here we are face to face with the essence of Giacometti's art. Take, for example, the chair from his family parlor; many of Giacometti's drawings of it are entitled, simply, *The Chair*. A chair is a tangible, material object, devoid of mystery—as in the paintings of Van Gogh—as long as it stands turned toward us on a diagonal. But when we see it directly from the front and concentrate on it, it suddenly ceases to be just another object of daily use—it becomes our opposite, our impenetrable vis-à-vis. This could be taken as a definition of how Giacometti understood the appearances of reality.

The less the look of Giacometti's home locality serves to deepen our understanding of his work, the more compelling is our feeling of an incredibly powerful presence and a complete congruence between the person and his place of origin. It is as if the magical relationship that once existed between the boy Alberto and the things outside him had not yet lost its power (4; 5). For his friends in Paris, Alberto Giacometti always had something of the mountain man from the Bergell about him in his clothes and speech. But the opposite also holds true: one will never be able to pass by the Giacometti house in Stampa—to paraphrase Goethe—without feeling the nobility lent by an exceptional man to the place he once entered.

The family moved into this patrician house in the center of the village in the spring of 1906. After the birth of Alberto's brother Diego in 1902, and of his sister Ottilia in 1904, his parents spent many months looking for larger quarters, until his father's brother Otto bid 7,600 Swiss francs for the three-story red building, complete with a stable, diagonally across from the Albergo Piz Duan, and rented it cheaply to the artist (807). The woodshed in front of the house, connected to it by a narrow passageway, was converted into a studio, where Giovanni began working in the fall of 1906. Alberto, then a young schoolboy, obtained his first impressions of art here, combined with the good smell of oil colors and the comfort of a warm stove in winter (22). Later, he wrote about his father's studio: "I believe there were things there that affected me then and still do to this day." (22)

Life Patterns

Alberto Giacometti began his life under the most favorable conditions. He was born with many first-rate talents. Among these were not only gifts for drawing, painting, and modeling, all developed at an early age, but also an ability creatively to blend vivid imagination with a sharp eye for reality.

He possessed in great measure another happy ability, that of overcoming much of life's inevitable pressure either by laughing it off self-assuredly or by living it through in his imagination; even as a boy, he had found in drawing a way to digest difficult impressions gained from his environment or from other works of art (60; 67). The supernatural was no stranger to him either—quite the contrary: just as a huge block of stone could seem to him like a creature with a terrible, seductive power over him (5), he later felt the existence of a universal magic which entered his life, and which he accepted with the realization that, apparently, everything happened at that point in time when it *had* to happen (8; 69).

From the very start, however, he knew how to counteract arbitrariness with his own brand of order; as the oldest child he was said to have insisted that all the family shoes be arranged according to their sizes, and in no other way—and his brothers could send him into a terrible rage just by arranging them otherwise. His friendships among the artists of Montparnasse were characterized by an unflagging loyalty to everyone and everything, once his choice had been made. That was his way of keeping moderation and order in all his relationships.

Although they came from almost identical backgrounds, Giovanni, Augusto, and Alberto Giacometti led three quite different lives; of necessity, however, the same basic pattern shows through now and then. This pattern surely played an important role in situations where Alberto Giacometti had to make decisions affecting his existence as an artist. This was quite clearly the case in his choice of profession, as can be seen from Alberto's own account of his decision to leave secondary school (which both Giovanni and Augusto had attended) before graduation: "Because my father had nothing against it, my mother didn't have anything against it either: after all, she'd married an artist." (53) Until their death, his father was living proof for Alberto that it was possible to be an artist; his mother embodied the power of order and the necessity of caution. Following his father's advice, the eighteen-year-old Alberto enrolled at the École des Beaux-Arts (School of Fine Arts) in Geneva.

In the eyes of Giovanni Giacometti, Geneva (the only center of art Switzerland had had since 1800, thanks to the personalities of Toepffer, Calame, and Menn) was the city where Ferdinand Hodler had chosen to live and where he himself had had a successful exhibition the previous year. After a few months of teaching his son in his own studio, Giovanni sent him to Geneva in the hope that the stay would help Alberto decide whether he wanted to be a painter or a sculptor.

His teacher of painting at the École des Beaux-Arts in Geneva, David Estoppey (1862–1952), had studied with the leading Swiss plein-air painter, Barthélemy Menn, and then in Paris from 1885 to 1900, where he became an exponent of the Divisionist theory of painting. Alberto Giacometti was lonely, unhappy, and dissatisfied with himself and the world during his first weeks in Geneva (807); he reacted by leaving the academy and enrolling in the School of Applied Arts, the École des Arts Industriels: he had left the academy after "three days," as he wrote Pierre Matisse in 1947 in such a pointed tone that we need not take the number literally (13). Actually, he continued to go there afternoons all the while he was in Geneva (807). Concerning the "three days" it supposedly took him to decide to change schools, two young Giacomettis before him had left Stampa to enroll in an academy of fine arts—Giovanni at eighteen in Munich, Augusto at twenty in Paris—only to switch to an applied-arts school almost immediately: Giovanni after one day and Augusto after a week.

The sculpture class at the École des Arts Industriels was taught by Maurice Sarkissoff (1882–1946), who, in 1911 and 1912, had belonged to Archipenko's circle in Paris and who had been a student of Giovanni Giacometti's sculptor friend Auguste de Niederhäusern (1863–1913; more will be said about him later). Sarkissoff had taught the figure class at the fine-arts academy up to the end of the 1918–19 school year and had just been appointed Professor of Sculpture at the school of applied arts[2]—perhaps another reason for Alberto to change schools, in accordance with the pattern established by his father and relative.

A similar "pattern" played a role once again, years later, when he chose a foreign art capital to live and work in.

This time it was the son who was considering a city where Hodler had lived: Vienna. In the letter to Pierre Matisse in 1947, he justified his choice on financial grounds, because, as he said, Swiss money was worth more in Austria than at home due to the inflation (13). But he was also well aware of the fact that Hodler had established his European reputation in Vienna—and Giacometti's compositions were very much influenced by Hodler's at that point in time. Vienna was not to see him, however; instead, following his father's advice, he went to Paris and enrolled in a private academy. He justified this final decision in a way that could hardly be more typical in terms of recurring "patterns": "My father thought it would be good to work at a private academy, as he [and Augusto Giacometti also] did when he was young, to draw and paint there: I didn't want to do it at first,

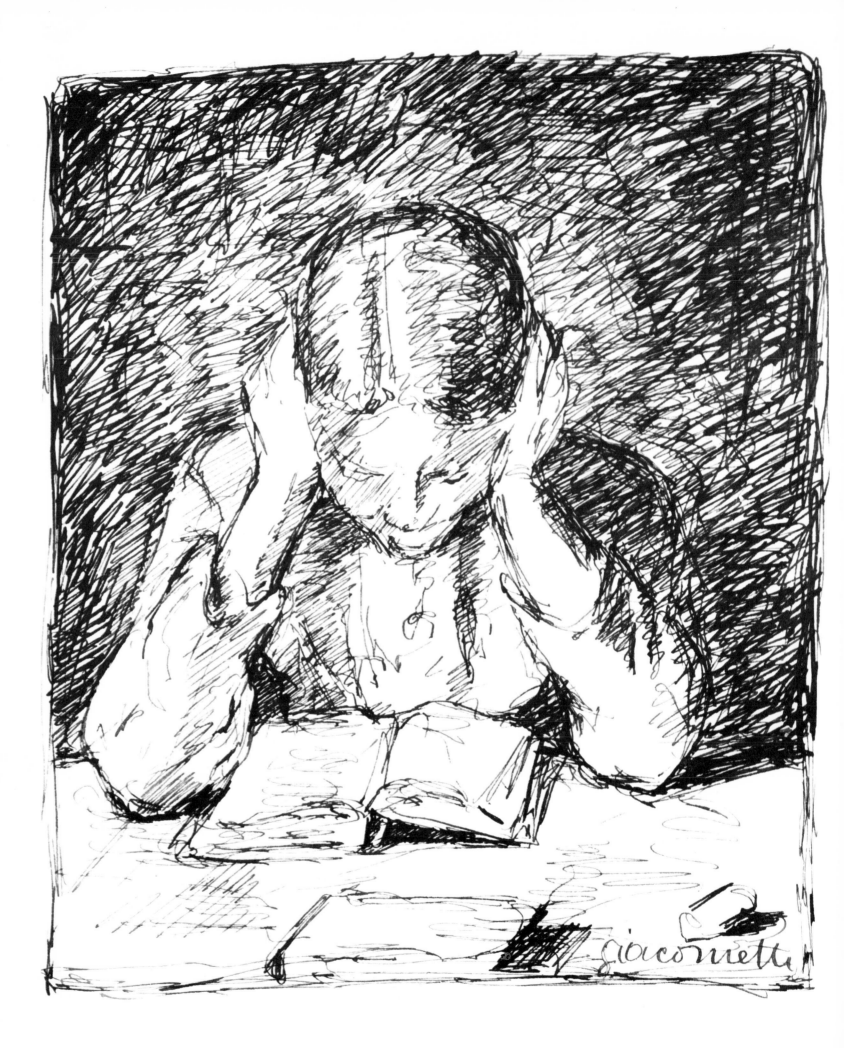

14

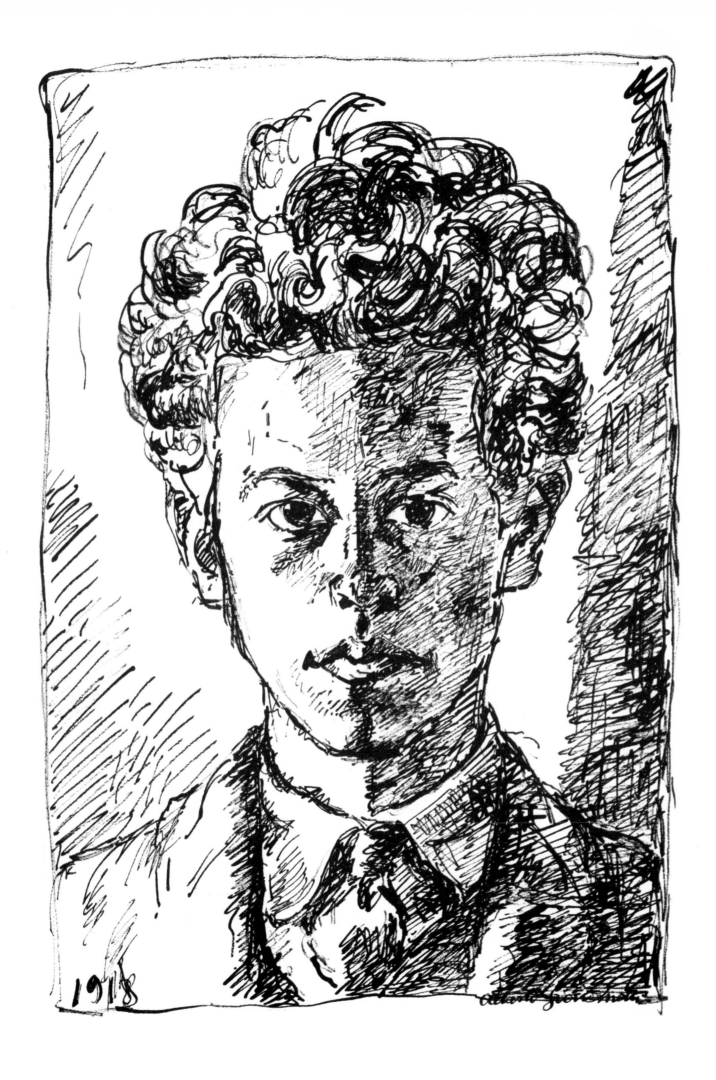

1918

15.

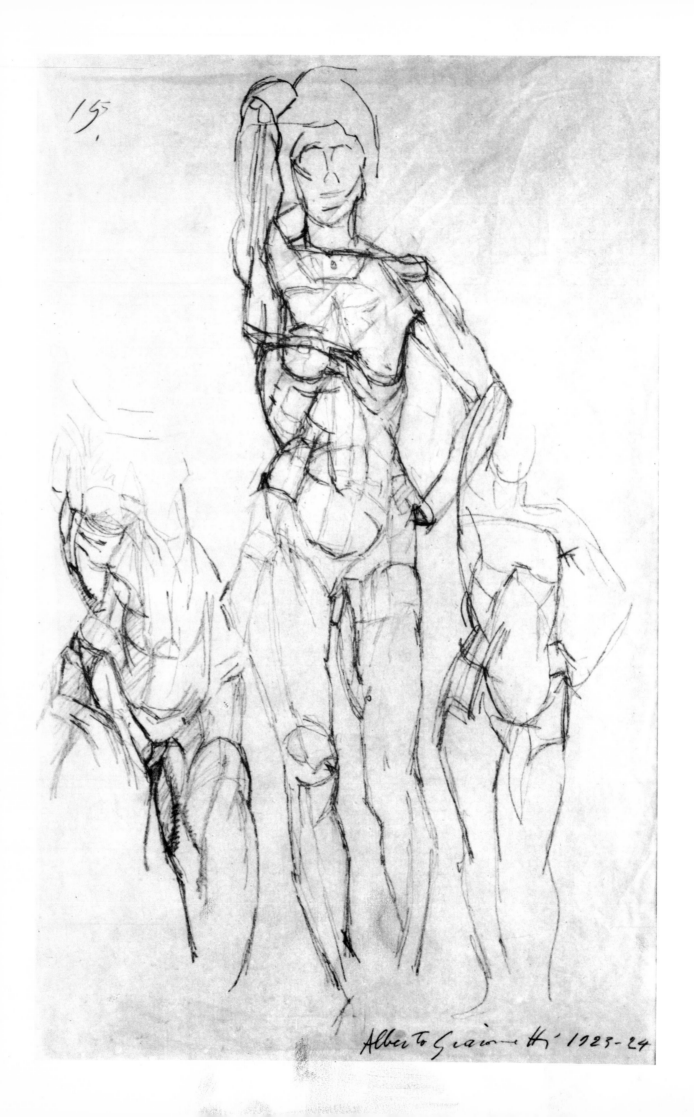

Alberto Giacometti 1923-24

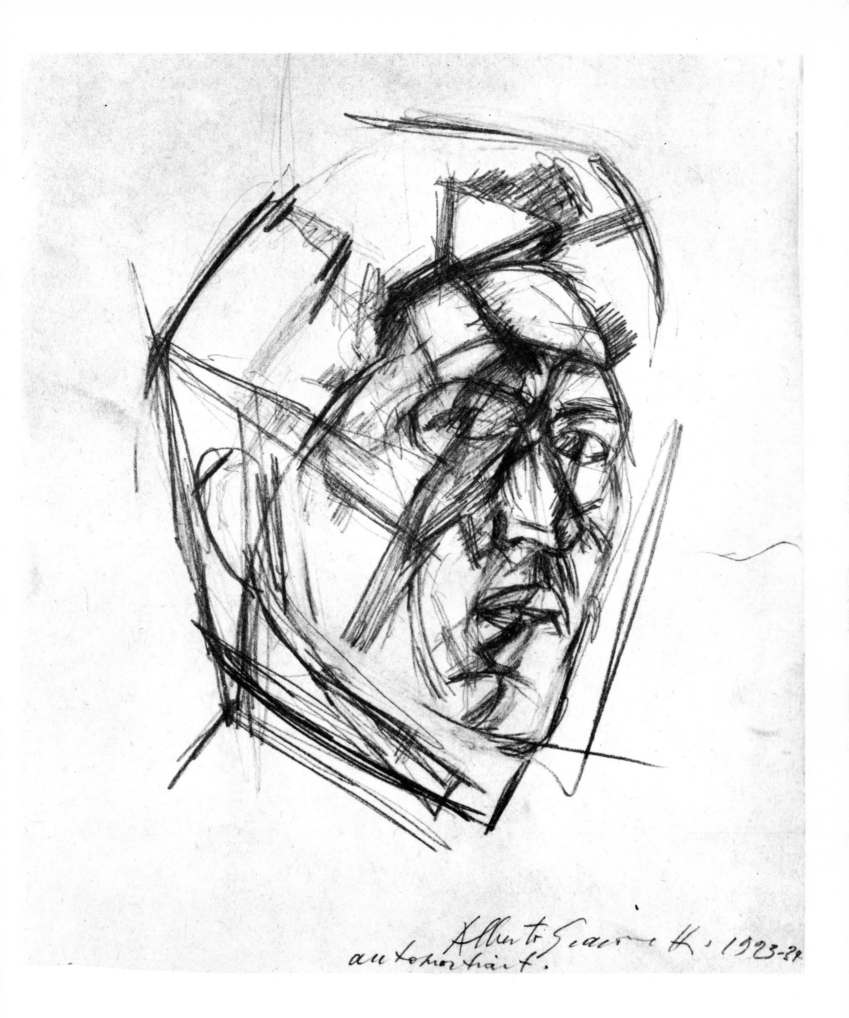

Alberto Giacometti · 1923-24
autoportrait.

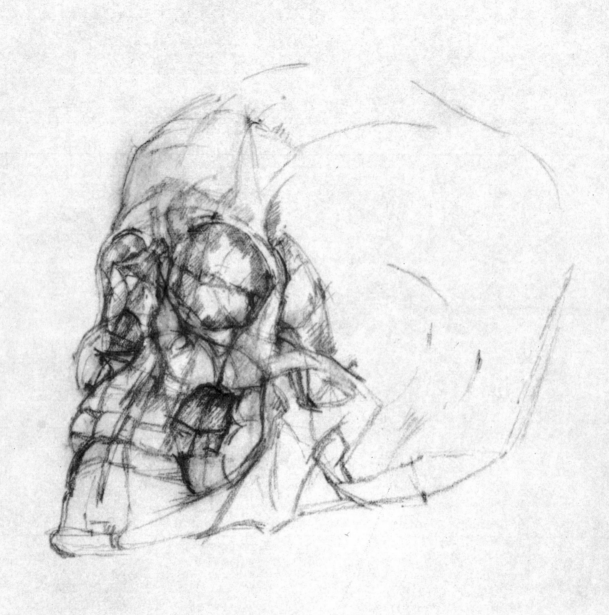

Alberto Giacometti
1923

so he stopped insisting on it—that convinced me to do it after all."
(53) Here the basic pattern shows both front and back, so to say: his
negation of the prescribed path, then his acceptance of it after all,
simply because it was no longer required of him. In spite of all the
independence of mind that characterized Giacometti from the
beginning, a quality that led to deep crises during his studies in
Geneva and Paris, his parents determined the direction of his life
for many years. From 1922 to 1924 Giacometti spent only a few
months at a time in Paris (309).

It speaks for Giovanni Giacometti's warm personality that the
father-son relationship now deepened to a comradeship in the best
sense. It even happened that when Giovanni visited Alberto and sat
with him among the students in the Grande Chaumière, he felt
within him a desire to stay in Paris and make a new start (53). Not
until 1926 or 1927 did he hint to Alberto that he might begin thinking
about earning his own living (67). In the fall of 1927, his father
suggested a joint exhibition (with Alberto's sculptures) in a Zurich
gallery (306).

By this time, Alberto had developed an individual style. His
career in Paris began in 1928 with a successful exhibition of his
plaque sculptures in the Galerie Jeanne Bucher (67). In spite of the
immediate interest shown in his work, he remained in a way true to
his background during that year and the next by exhibiting, together
with the Swiss Serge Brignoni, as the only sculptor among a dozen
painters, in the group shows of the Italian artists in Paris (307; 308).

Stylistic Heritage

What Alberto Giacometti learned about painting from his father
and applied to his work up until about 1925 deserves to be highly
rated. The technical and compositional skills that he thus acquired,
supplementing his natural talents, made his early work seem as-
tonishingly mature.

Giovanni Giacometti's work must have been influenced primarily
by Cézanne's at the time his creative young son took conscious
notice of it. Of course it had gone through many stages before
Cézanne's example became uppermost: Munich School plein-air
attitudes played an important role, then Impressionism, and finally
the chromatics of Pointillism, to which Giovanni Giacometti had
been exposed during his studies in Paris (1888–91). His ink and
pencil drawings were done in a style similar to Van Gogh's and his
woodcuts resembled Gauguin's in manner. The oils he painted after
1905 put him in the first ranks of Swiss painting. They show how he
overcame the decorative tendencies and heavily symbolic Art

Nouveau themes characteristic of his earlier work; he replaced
them with powerful Fauvist color and, to some extent, the Expres-
sionism of the painters of *Die Brücke*.

Giovanni Giacometti began his study of Cézanne's work when
Alberto was ten or eleven years old. His paintings began to take the
form they were to have for years afterward: Piz Duan mountain
outside the window was painted like Cézanne's *Montagne Sainte-
Victoire*, the fruit bowl on the dining-room table became a Cézanne-
like still life with apples (page 289, figs. 1 and 2), and the regulars at
Stampa's local café were composed like Cézanne's *Card Players*.
So it was with good reason that, decades later when he was not
getting anywhere with his painting, Alberto Giacometti called on his
patron saint and helper in time of need: the same Cézanne who had
been the authority in his father's house (723: 42).

Much of this background is evident in Giacometti's early drawings,
woodcuts, and paintings. Later watercolors he did in Geneva
and Rome (1919–21, colorplate 1), however, show evidence of a
divisionistic technique that his father had never attempted. The
painting Giovanni Giacometti was doing at the time developed
more and more in the direction of the woolly *macchiaioli* style of his
Lombardic contemporaries; a few of Alberto's works of 1919–21
show this technique as well.

But the art of Cézanne and Hodler still retained the upper hand;
the question was, more Cézanne or more Hodler?

This alternative was one of the most hotly discussed subjects in
art during Giacometti's youth. An influential book appeared at the
time entitled *Cézanne and Hodler* and subtitled "Introduction to the
Problems of Contemporary Painting," written by Fritz Burger
(Munich, 1913; 2nd and 3rd editions, 1917 and 1918).

The rather academic question whether the future of painting
belonged to the Hodler school or to Cézanne's followers—and
thereby to modern French painting—was crucial to certain members
of the German cultural elite who thought of themselves as "Ger-
manic" and greeted the outbreak of hostilities in 1914 as a provi-
dential new beginning; Swiss art was involved, but only indirectly.
One of Alberto's old schoolfriends tells us how passionate were the
discussions about Hodler's rules of composition in the boarding
school at Schiers (109). He says Alberto observed more than he
participated in these sessions, but that he once blurted out: "Hodler
is my brother Bruno's godfather," which meant, in essence, that he
was much more deeply involved in the conflict than were his eager
friends. He was well aware that Hodler had opened the door wide
for modern painting in Switzerland, but he had seen, too, in his
father's studio—the studio of one of Hodler's intimates—that the
problems which particularly concerned him were to be found in the
painting of Cézanne.

Of course, no young painter could live in Switzerland in the decade after 1910 without being stimulated by Hodler's art. When Giacometti painted a mountain panorama at eighteen, he composed it like Hodler and executed it like his father—like Cézanne. An oil sketch he did in 1921 shows the direct quality of Giacometti's approach to Hodler's art. It is called *The Stoning of Saint Stephen* (732 c; page 289, fig. 5), and with it, the young painter graduated from the school of composition represented by Hodler's late work. Like Hodler in his sketch for *The Battle of Murten* (1915; page 289, fig. 4), Giacometti compressed the tumult into two active figures, rhythmically placed on either side of their victim, who is bent over in the Hodlerian manner. When he painted the warrior on the right, Giacometti surely had Hodler's *Woodcutter* in mind, which was reproduced on the Swiss fifty-franc note from 1910 to 1955. And, like Hodler, he used a strong, compact background to hold the picture plane—a mass of onlookers behind the three main figures, all of their heads on the same level parallel to the painting's edge. Hodler's sketches for *The Battle of Murten* had been a much talked-of subject among painters since 1915, especially since he never painted the fresco—he died in 1918—and these sketches represented his last solutions for a composition with several figures.

Even Giacometti's later portrait and landscape drawings, in their composition and the quality of their line, show clear signs of his inheritance from Hodler. Frontality, interior framing, elements parallel to the picture edge, the shape of the figure and its relationship to the picture plane—in all these elements and also in the multiple line which activated the imprecise contours of things, creating a bridge between their corporeality and the space surrounding them, Hodler's art can be discerned behind Giacometti's paintings.

Giacometti's father acquainted him with Cézanne and Hodler at an early date; his godfather brought him into contact with the art of Gauguin and the School of Pont-Aven. Before leaving Geneva for Stampa at Easter time in 1920, somewhat earlier than planned, the eighteen-year-old Alberto spent some time with Cuno Amiet in Oschwand, where they sketched landscapes together in rural surroundings, and where the painter modeled a bust of the young sculptor (804).[3]

Cuno Amiet (1868–1961) was the closest friend of Giovanni Giacometti, and had studied with him in Munich and Paris. Then their paths had parted, and Amiet had gone to Pont-Aven, where he spent enough time to absorb the Post-Impressionist style completely into his work. He had not met the volatile Gauguin when he was there in 1892 and 1893, but he had heard so much about him then and later in Paris, and he apparently passed so much of this on to his godson, that Alberto talks indirectly about a Gauguin phase

in his letter of 1947: "I was convinced," writes Giacometti about his aesthetics of 1920–21, "that it was simply a convention that the sky was blue, and that it was, in reality, red." (13) Strindberg, in 1895, characterized Gauguin in exactly the same way in the foreword to a catalogue, as one "who denies and defies and would rather see the sky red than be like the rest and see it blue." Gauguin's conviction, expressed in 1893, that naturalist art since the time of Pericles had brought centuries of mistakes and defeats and that the truth was to be found in primitive and Egyptian art, is echoed in Giacometti's credo from 1925 on, and above all in the remarks on the essence of style (what Gauguin had called "the principle") he made after the Second World War (61; 217; 817).[4]

A similarly radical statement is not apparent in Amiet's own art. Without having had to develop from a Post-Impressionist into an Expressionist—his sensibility was too closely allied to the French for that—his paintings were respected at the exhibitions of *Die Brücke* in Dresden as those of a comrade-in-arms, and he was awarded membership of the group in 1906, a year after it was founded. His later work can be best compared to Henri Matisse's painting. Amiet's way of modeling figures with colors and composing backgrounds had a definite influence on Giacometti's figurative paintings and especially on his self-portraits of 1921 (page 25).

These and other developments in art after Cézanne were much talked about in Giacometti's father's studio, but nothing concrete in terms of painting resulted. The year 1907, when Giovanni Giacometti visited the Cézanne Memorial Exhibition in Paris and experienced the triumph of the Fauves, was also a milestone in the history of Cubism and interest in African art. At the time neither was present in Alberto Giacometti's stylistic heritage.

His father was apparently quite excited, at least in principle, with the Futurist Exhibition of 1912; he was not able to see it, but had the catalogue sent to him in Stampa. But their total break with formal tradition was too much for him: "Extremely interesting," he wrote. "The Post-Impressionists, Synthetists, Cubists, and whatever all the rest of them are called, are all obsolete. But that's exactly what I like about the Futurists, that they offer a totally new theory about art and life; as to what they achieve artistically, it seems to me to prove that even the most interesting theories still don't constitute art." (807) This opinion, together with his admission of 1915, "I can't make head or tail of Kandinsky" (807), set the pattern for Alberto Giacometti's later, frequently expressed reservations about abstract art in general and Cubism in particular (60; 71; 723:31).

Concerning Giacometti's knowledge of African sculpture, we can be sure that it goes back to an earlier time than is generally supposed in the literature (702). A friend and patron of Cuno Amiet

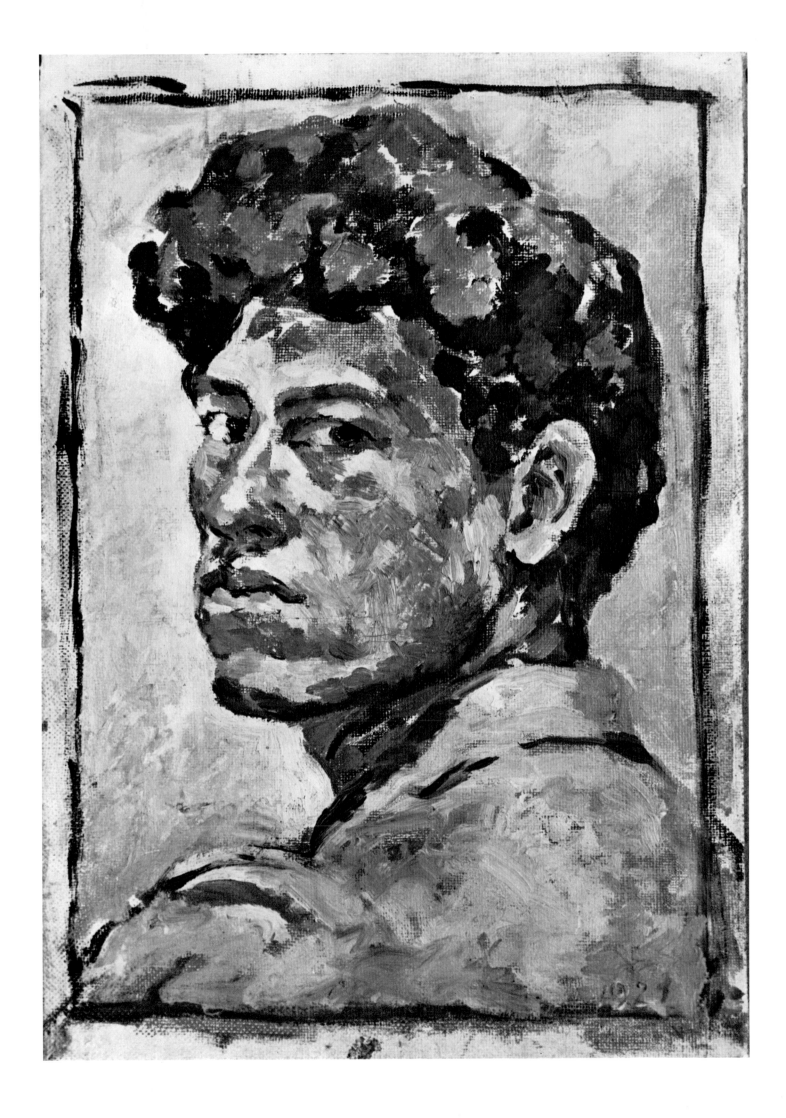

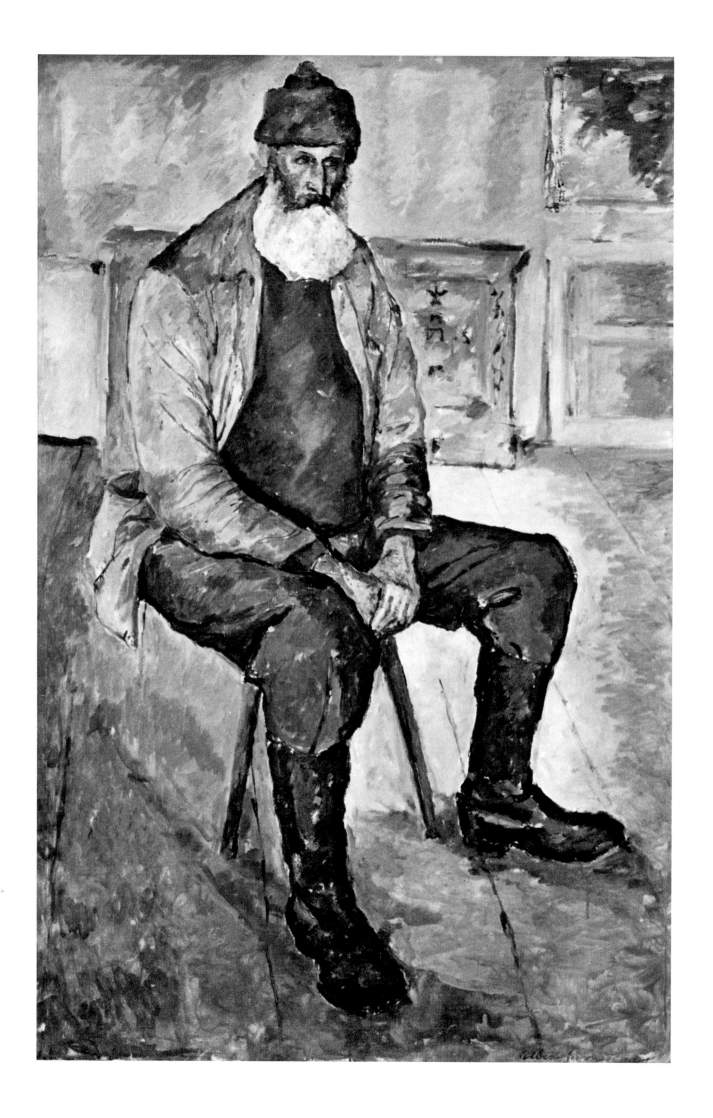

26

27

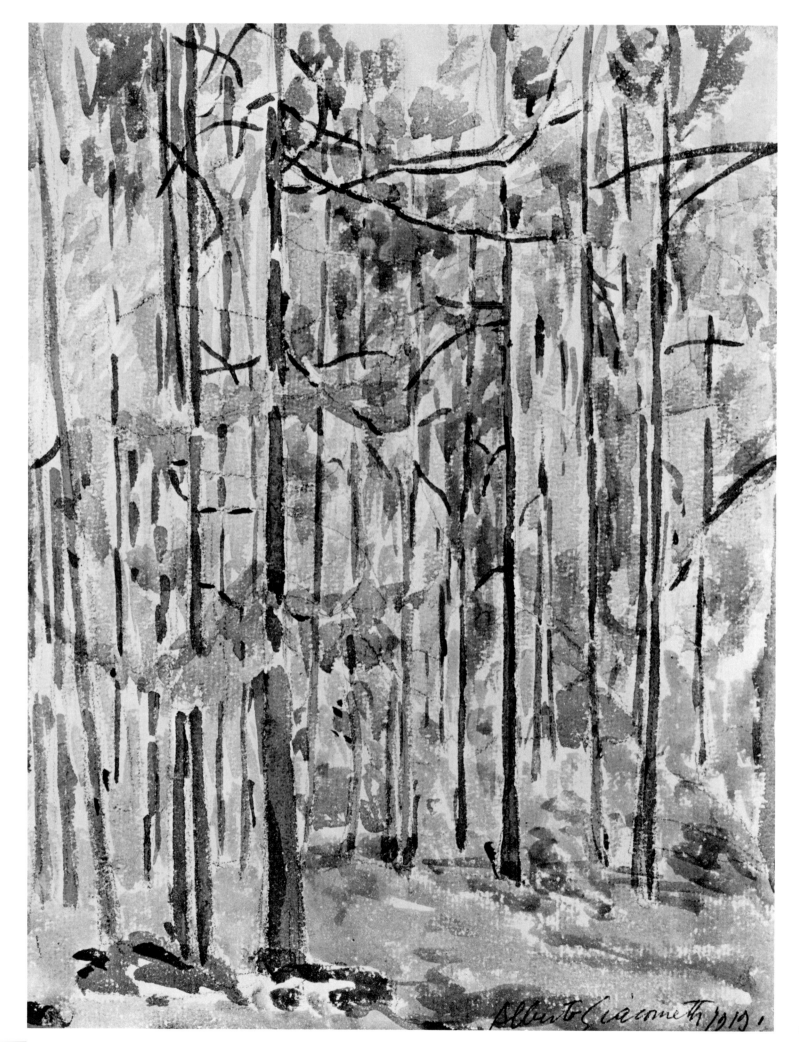

Alberto Giacometti 1919.

and Giovanni Giacometti, Josef Müller, had already begun his collection of African sculpture in Solothurn, a city not far from Oschwand where Alberto was staying with Amiet. Alberto must have seen this collection, which is now among the most extensive of its kind in Europe, when he visited Solothurn at the time (804). (Müller also gave Giacometti his first portrait commission in the winter of 1925–26 in Paris.) When Giacometti arrived in Paris in 1922, African art had already begun to exert a great influence on artists and knowledge of it was so widespread due to the exhibitions, publications, and essays devoted to it in art journals that Jean Cocteau (in an essay in a special number of *Action*, 1920) had long since expressed his sorrow that interest in African art had become the fashion, just as Japanesery had been a few decades earlier.[5] The value of primitive sculpture was recognized as early as 1905 by the Cubists; its Surrealist interpretation dates from the Dada years about 1915.

If the young Giacometti was unaware of the manifestations of Zurich Dada in 1916–17, it was because his father and Augusto Giacometti, although they respected each other's opinions, avoided each other's company. Otherwise Augusto could have told Alberto how he, often accompanied by Hans Arp, stuck his head in the door of all the cafés on the Limmatquai to frighten good citizens with the cry, "Vivat Dada!"[6] Fifteen years before Man Ray's *Destructive Object* (1931) and Alberto Giacometti's *Suspended Ball* (1930; page 57), Augusto Giacometti invented the first "Moving Object" (*Objet mobile*): he transformed a pendulum into an artwork created only for the moment by hanging different colored forms on it—five years before Picabia, the Paris Dadaist, said of his drawings that their aesthetic life was limited to two hours, and then erased them.

Giacometti's main desire between 1925 and 1935 was to fill these "gaps" in his knowledge. Despite their innovations, his works from this period were basically stylistic recapitulations of Cubism, African art, and Dada; his mentors—Laurens, Lipchitz, Brancusi, Freundlich, Duchamp, Miró, Arp, Breton, Gonzalez, and even Picasso—were all nearly a generation older than he.

Strangely enough, we know comparatively little about the works of sculpture the young Giacometti saw in his father's house. We do know of one statue which impressed him as a child—a portrait bust of his father done in 1905 by Auguste de Niederhäusern, who had been an assistant of Rodin's for many years. (The bust is still in the house at Stampa; plaster casts of it are in the art museums of Chur and Aarau, and there is one in a private collection in Winterthur. Page 289, fig. 6.) There is an amusing (and significant) anecdote about this bust—as a boy, Alberto once painted it over in naturalistic colors: "Only then did I find that the bust looked finished and that it represented a portrait of my father." (53)[7] This did not seem to

upset his father. It upset his fellow students much more, when, years later in Bourdelle's studio, he painted a plaster figure naturalistically. They laughed so loudly at him that he was afraid to show it to Bourdelle (55). This in spite of the fact that his teacher was himself working on polychrome portrait sculptures at the time; Bourdelle wrote about them in a letter dated 1924: "This is the beginning of the most significant work in my oeuvre... This one bust with the blue hat—and my other sculptures, polychrome portraits—is the most outstanding example of my art."[10c]

Rodin was definitely given first place among the sculptors Alberto's father discussed with him over books of reproductions. The "reproduction of a small bust on a pedestal" that gave the thirteen-year-old "the immediate desire to do the same," was probably that of a small Rodin portrait bust (61; 67). Rodin's importance for Giacometti's work as a whole has been made much of in the literature (572; 702), although the artist himself never mentioned it. Nevertheless, behind our discussion of Giacometti's work will lie the thought that Rodin was almost as decisive for his sculpture as Cézanne and Hodler were for his painting.

The year 1920 was to be particularly significant for Giacometti's later artistic development. Firstly, Giacometti became acquainted with the sculpture of Archipenko, which was given a special exhibition in the Russian pavilion at the 1920 Biennale, which Alberto visited with his father.[8] Family tradition has it that he had already met Archipenko and had traveled from Geneva to Paris to visit him; in any case, Giacometti knew Archipenko at a fairly early date, possibly through his teacher, Sarkissoff, otherwise he could not have taken Archipenko's studio, then not in use (1922), as his first Paris address.[9]

A second significant impression came in the form of an Egyptian portrait bust in the Archaeological Museum in Florence (page 289, fig. 10), seen in the fall of 1920. Giacometti described it as "the first sculpture of a head that seemed lifelike to me." (17) The richer Egyptian collections in Rome were one of the main reasons the young sculptor moved there from Florence. There, too, he was deeply affected by Baroque portrait sculpture—the third strong impression within the year; the way Bernini caught the glances of his subjects was to bear fruit in Giacometti's later sculpture. Bernini's art of staging, where a momentary impression becomes sculptured existence, found an echo in Giacometti.

A year later Antoine Bourdelle, the sculptor one does not like to call Giacometti's teacher (although of course he was just that, and decisively so), traveled to Florence, Rome, and Naples. At sixty-one, he saw the art of Rome for the first time, accompanied by the architect Auguste Perret and a lady who dutifully recorded his comments for publication.[10a] He walked past Bernini's sculptures

without a word, and thought more of Michelangelo as a painter than as a sculptor, but he was impressed by the Early Renaissance frescoes in the Sistine Chapel. Notes made by some of Bourdelle's students tell us so much about his other preferences and his dogmatic approach to art that we could reconstruct, if we wanted, a detailed picture of the curriculum at the Grande Chaumière when Giacometti was studying there; to put it briefly, most of the teacher's opinions could not have been more opposed to those of his student. Bourdelle's rhetoric was probably the most incomprehensible thing about him to Giacometti—he loved to go on about the Beautiful and the Classical. Bourdelle's work, which had quality in the eyes of Giacometti's father because it was thought to embody Rodin's heritage, in spite of its tendency to Classicism (and because the man who produced it had a strong personality and an independent stance toward the École des Beaux-Arts), probably did not have a significant influence on Giacometti's creative development, because Bourdelle was stuck stylistically in the first decade of the century, as if African sculpture, Cubism, Futurism, Dada, and Constructivism had never existed. But he must have had a spiritual power, a charisma perhaps, that held the young Giacometti despite his testimony: "Bourdelle's class wasn't of much use to me." (61) If this was really the case, one wonders why he kept attending it from time to time for five years. When he left Bourdelle's tutelage, it was with the ideas and goals which were to determine much of his later work.

We have already mentioned Bourdelle's polychrome sculpture, the first examples of which are dated 1921; shortly before his death in 1929, he had all the materials for a large multicolored figure laid out in his studio when he remarked to his companions: "Now my real work begins,"[10d] a phrase very similar to the one used by Giacometti to describe himself in the last year of his life when he was at the height of his fame (149). This statement of Bourdelle's, and perhaps also the remark he made when he was forty, that his later sculpture was made possible by what he had learned from drawing with pastels—compare Giacometti: "Everything changed a bit in 1945 because of drawing" (13)—may be taken as indications that he and Giacometti were basically quite similar, internally divided, creative personalities. They both agreed on the necessity of incessant drawing. "Sculpture depends on drawing," said Giacometti, but Bourdelle said it first; and what counts is the wholeness of the model and the isolation of details: "The model is an infinity in which you must see and analyze every detail.... You could check and recheck your work for a hundred years on these lines." Bourdelle passed such thoughts on to his students,[10f] and Giacometti remembered them with the much more drastic, dramatic, and hence famous sentence: "If one were to begin analyzing a detail, the point of a nose, for instance, one would be lost. You could spend your whole life without arriving at a result.... The distance from one side of the nose to the other is like the Sahara...." (13) The key position of the nose in the whole figure; seeing the living human face as an experience always more significant than art; the ineffability of the style of Egyptian sculpture—these are some of Bourdelle's thoughts which affected Giacometti throughout his life.

What Sartre wrote about Giacometti in 1947 (383) is remarkably paralleled by a short essay Anatole France wrote on Bourdelle: "While I was sitting for my portrait [1924], Bourdelle told me about his work of the previous evening. He spoke of a very, very small statuette, a tiny but beautiful figurine.... When I met him three days later, I wondered why he no longer mentioned it. Bourdelle asked me, 'What statuette?' 'But you surely know which one—the very, very small statuette, that tiny but so very beautiful figurine.' 'Oh! That little statuette! Garbage. I threw it away.'"[10c]

The tense relationship between Bourdelle and Giacometti (105) came out into the open when the teacher said of the post-Cubist *Torso* (page 40) his student exhibited in the 1925 Salon des Tuileries: "One makes things like that for one's self, at home, but one doesn't show them." (55) Bourdelle's true attitude to modernism was different, however; during one of his classes in 1922 or 1923 he said:

You hear every sort of imbecility about Cubism! The poor public! Modern tendencies in art deserve to be watched carefully. Cubism was not only far from being the madness the art pontiffs declared it to be, it was a necessary regulative to the disordered fantasy other styles were suffering from.... We should be thankful to Cubism for the healthy results it had, even if they consisted only in creating a brusque reaction against the pomposity of Academic art. Perhaps we shall experience a new Renaissance one of these days![10f]

Finally, there was a piece of advice Bourdelle gave his students which Giacometti must have had in the back of his mind when he was through with post-Cubist figures and Surrealistic objects: "To keep your efforts within some sort of bounds, you should limit your field of observation now and then: make portrait busts, lots of them. That is very healthy practice. You can concentrate better, because you are occupying yourself with a narrower range of materials. That is real research work, believe me!"[10f] In the remarkable five-year period, from 1935 to 1940, that Giacometti spent studying the model, he held strictly to this principle and did nothing but model portrait heads.

PERIODS AND SUBJECTS

Introduction: The Oeuvre. Changing Form—Unchanging Compositional Idea

Among Alberto Giacometti's recorded statements, there is one that throws a particularly sharp light on his life's work. He talks about the uncertainties which beset him in 1934 after he had finished his Surrealistic objects: "I saw the human body anew, as an aspect of reality which particularly appealed to me, as did the abstract forms, too, which seemed to me true for sculpture; but, to put it bluntly, I wanted to represent the one without losing the other." (13) He put this statement into practice in 1934 with the stone he carved for his father's grave in the cemetery at Stampa-Borgonovo (page 290, fig. 20). Its self-sufficient, nonobjective form suggests the gentle curves of a crouching human figure.[11]

The concepts "truth in art" and "the reality of life" in the quote above allow us to see all of Giacometti's work, from beginning to end, in terms of one set of mutually interdependent opposites. If we replace the concept "truth in art" with the word "style," which has always been used to mean the same thing, then we may describe the poles between which Giacometti's work alternated as those of "style" and "reality." The different periods he went through may be described in terms of how close the works are in each case to one of the two poles: to the working out of a concept of style or to the effort to create an image of reality.

Working on this basis, there is no real satisfaction in using handy labels to divide off the "Cubist" and "Surrealist" phases from Giacometti's "actual" work. And of course it is not sufficient to classify his oeuvre according to formal differences—into periods of matchstick-sized figures, beanstalk statues, fuller figures, giant sculptures, and so on. If we want to describe the growth and change in Giacometti's work, we shall have to use concepts which attempt to pinpoint the "inner reason" of each piece, by getting as close to the heart of Giacometti's work process as possible. We shall call this "inner reason" the *conception* that he had of each piece before starting work on it; the creation, actualization, and fulfillment of his conceptions may be called the *creative process*. This includes all the conscious and unconscious decisions which give each piece its particular, unique form.

We have already mentioned the two diametrically opposed conceptions covering the year 1934: on the one hand, that of works which, having no superficial resemblance to forms in nature, are valid only as self-enclosed sculptural forms; on the other hand, the work of art as an attempt at creating images of reality. Three further conceptions may be mentioned: the artwork as a visual model of experienced reality (1930–34); the artwork as a mirror image of the appearance of reality (up until about 1945 or 1946);

the artwork as a metaphor for the appearance of reality (from 1947 on). These three periods were then superseded by a paired conception which contained the polarity of 1934, signifying that Giacometti's method had attained its twofold goal: on the one hand, the artwork as an ever closer approximation to the reality which always exists outside of art (paintings and statements he made from 1956 to his death); and on the other hand, the artwork as a final, grand gesture of style, which is in itself an autonomous reality, a "double" of reality (the art of the Egyptian Old and Middle Kingdoms, for example, or Giacometti's sculptures from 1958 on).

It is characteristic of Giacometti's artistic personality that, for him, the gap between the conception of an artwork and its realization was itself one of the elements of the creative process; expectation, in the form of tension or suspense, kept his creative thought and production alive. From the time he was twenty-five at the latest, he lived with the idea that soon he would reach the goal of his life's work: "In fourteen days," he used to say, or: "I see a great breakthrough coming...." (197; 817)

We have described Giacometti's oeuvre in terms of a continuous series of forms or *Gestalten*; his letter to Pierre Matisse, quoted above, also contains a thematic program: "And then, too, I wanted to make compositions with figures." (13) This reveals the hidden thread that runs through all of Giacometti's work, the vision of a composition with several figures. He uses the word "composition" in its traditional sense here, as it applies to Rodin's groups: the combination of figures and forms into a metaphorical whole which serves as a sort of spiritual balance sheet.

By interpreting the works individually, we shall try to determine the basic vision underlying the entire oeuvre; at this point, we can say only that, in general, Giacometti's figure compositions are attempts at creating what are usually called myths: representations of basic human truths. Giacometti himself formulated this when he wrote: "Every moment of the day people come together and drift apart, and approach each other again to try to make contact anew. They unceasingly form and reform living compositions of incredible complexity. What I want to express in everything I do, is *the totality of this life*." (70)

1914–1919–1924
Youth—The Academy

The very young Giacometti had no artistic problems. He was able to represent anything he chose, in sculpture, painting, or drawing; he had not yet begun to doubt artistic conventions. A sculpture—

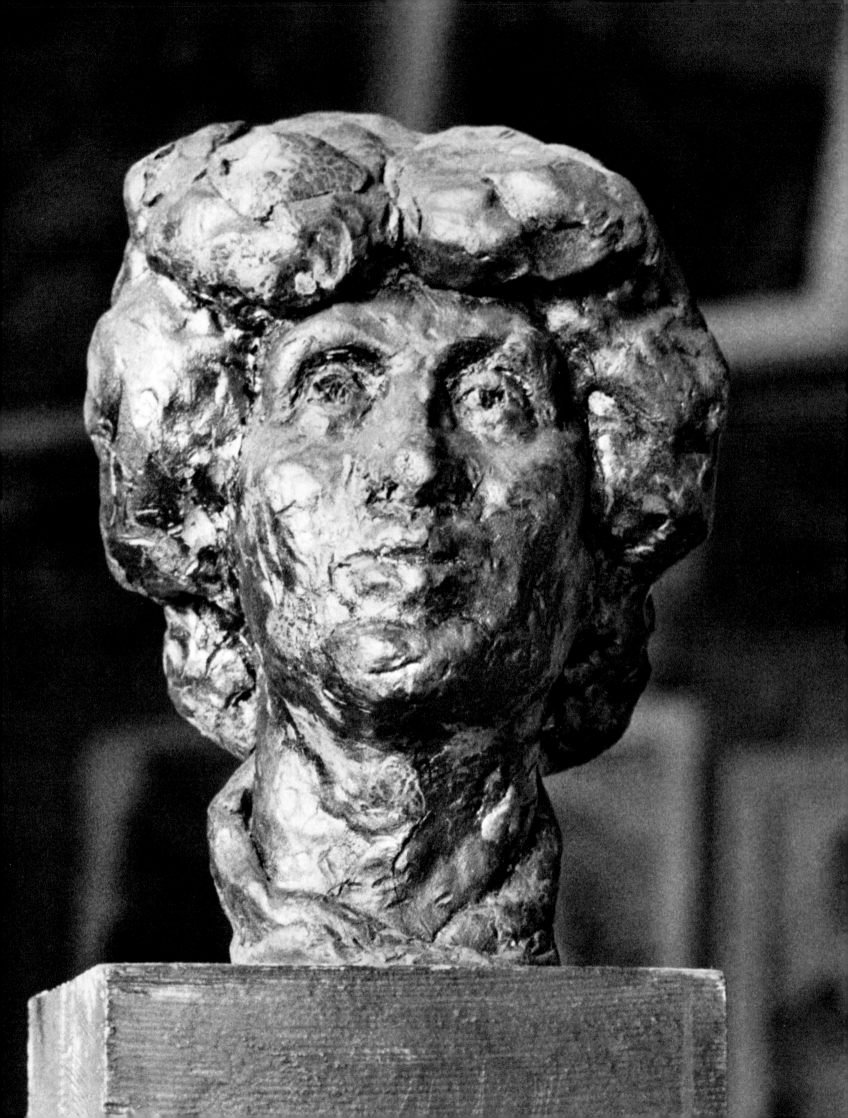

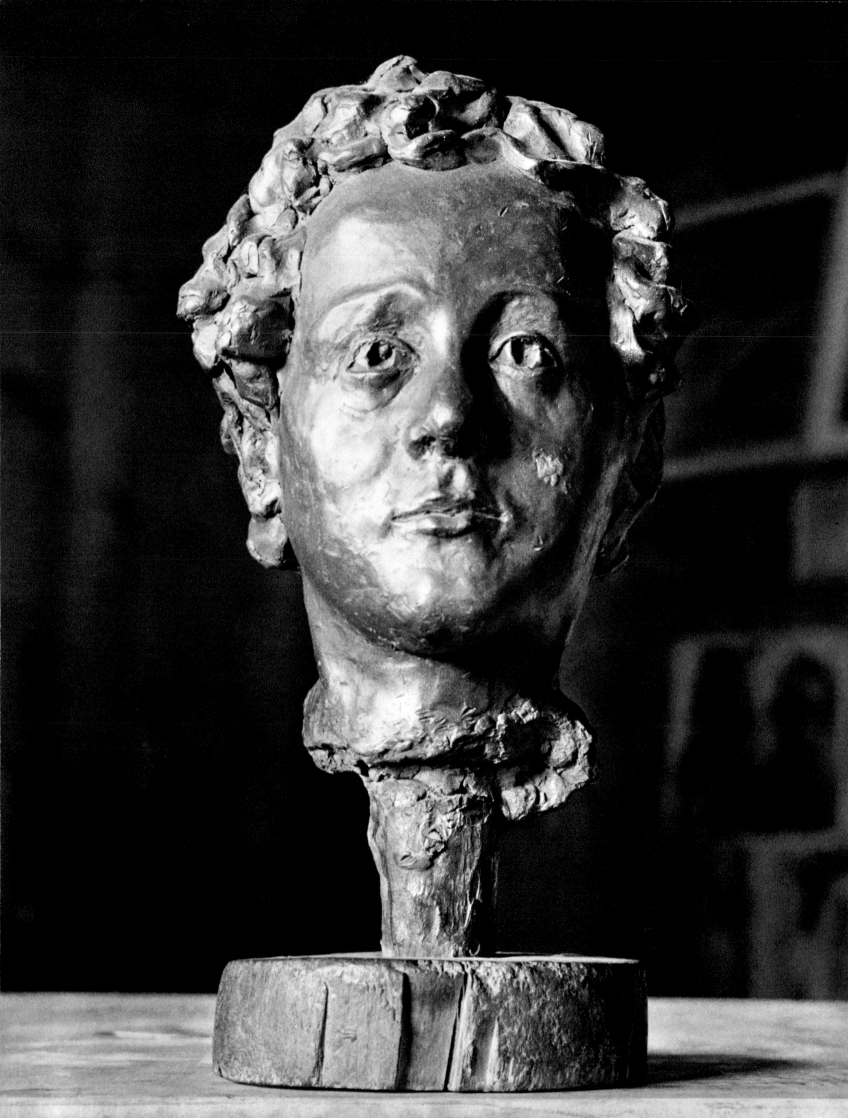

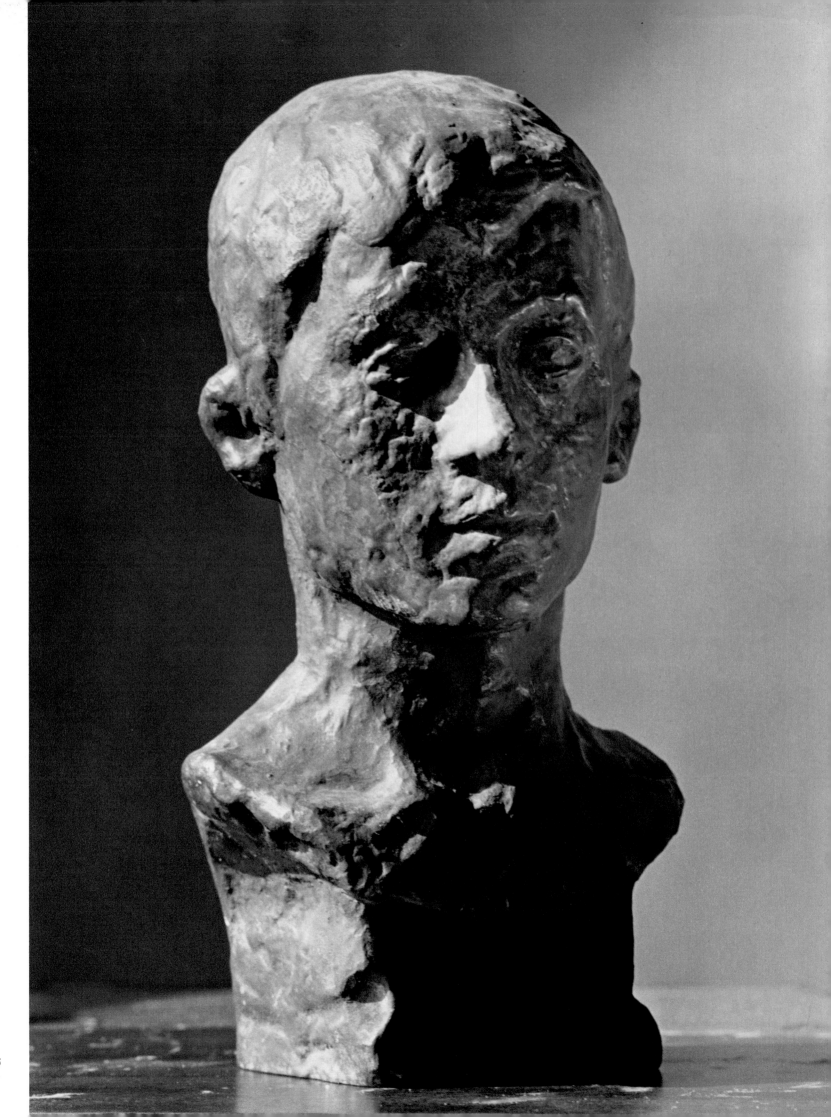

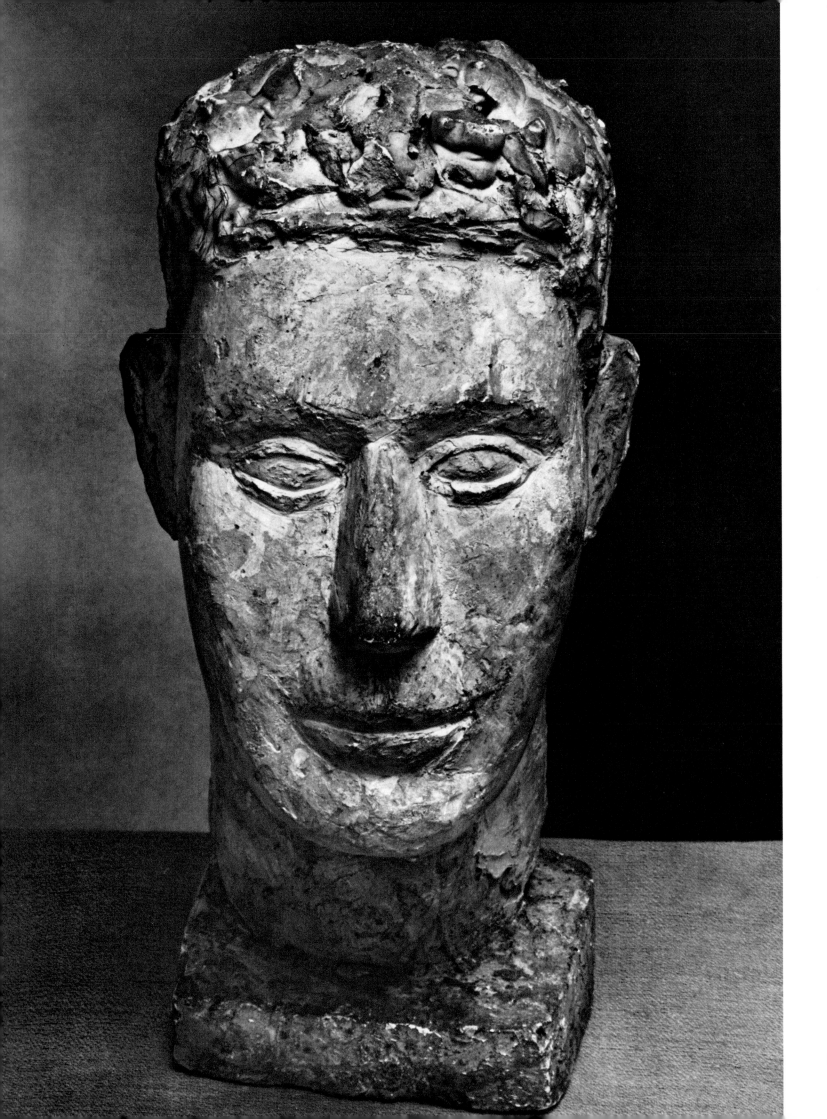

36

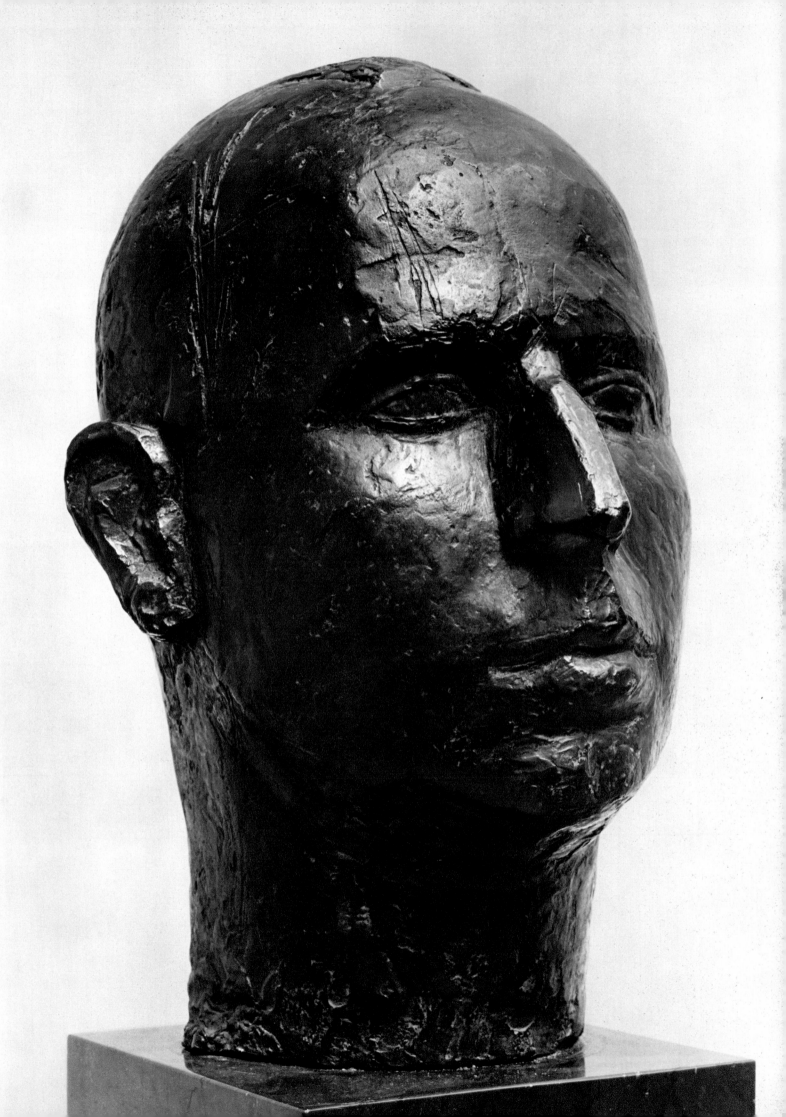

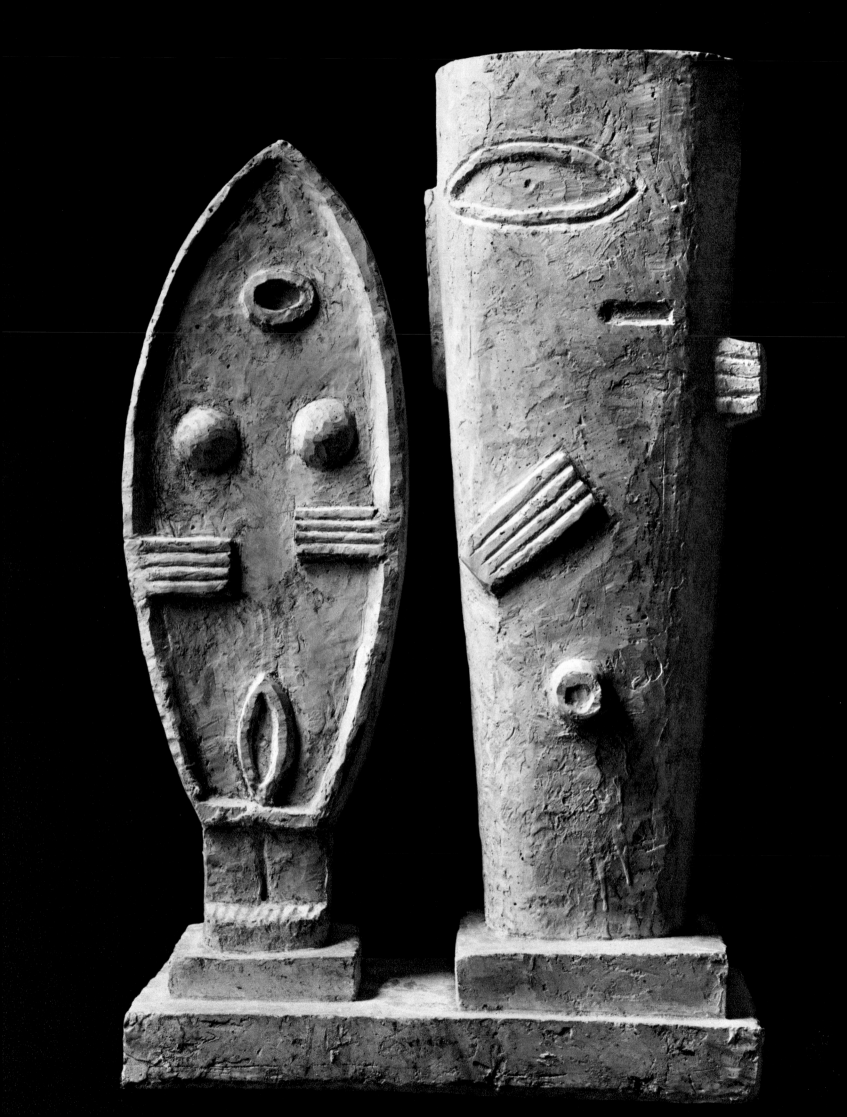

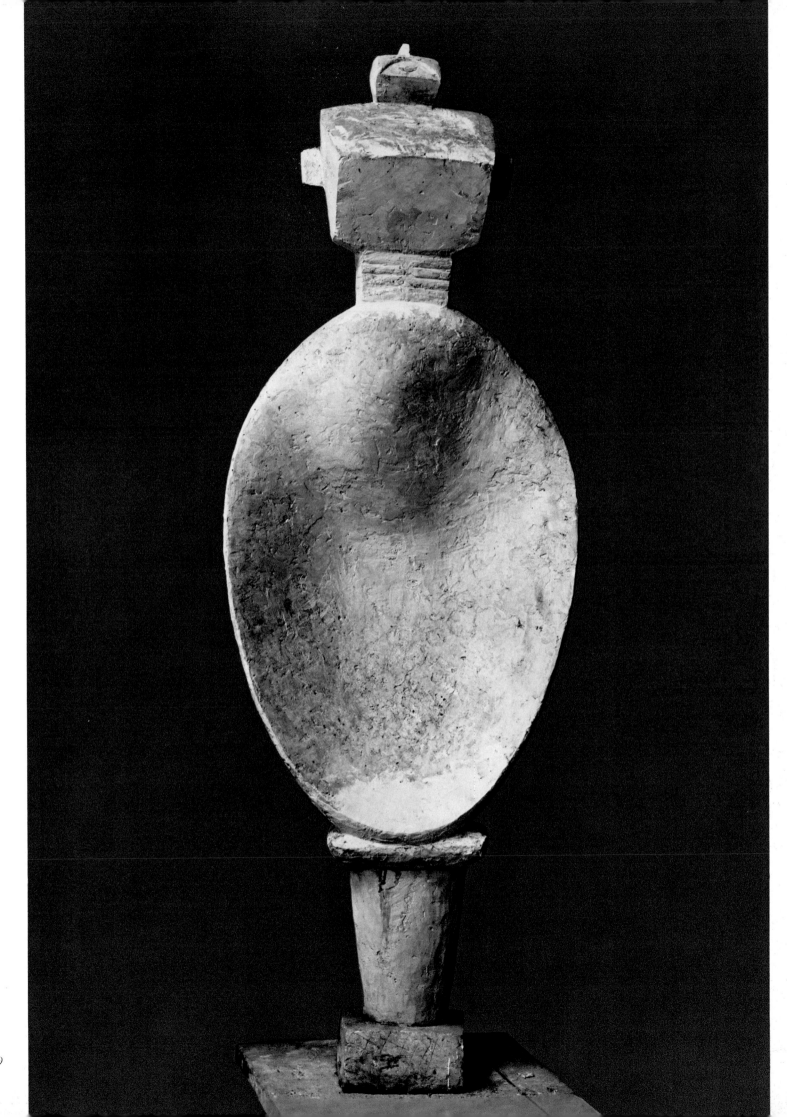

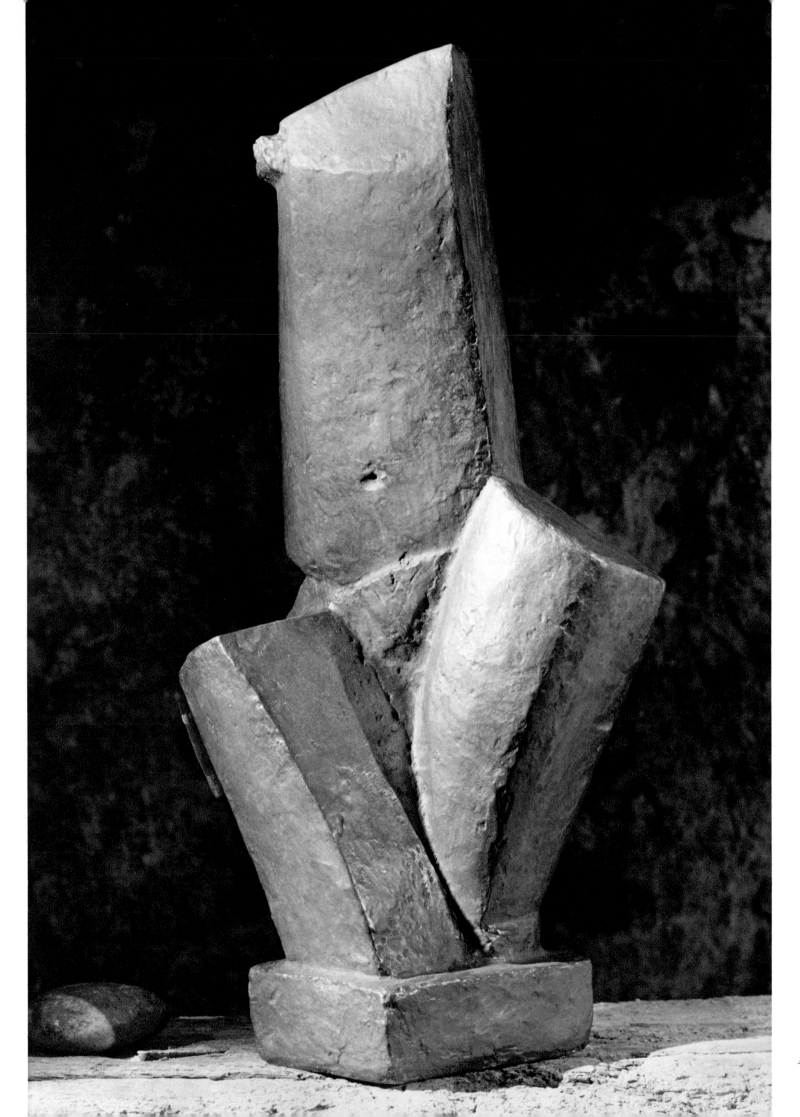

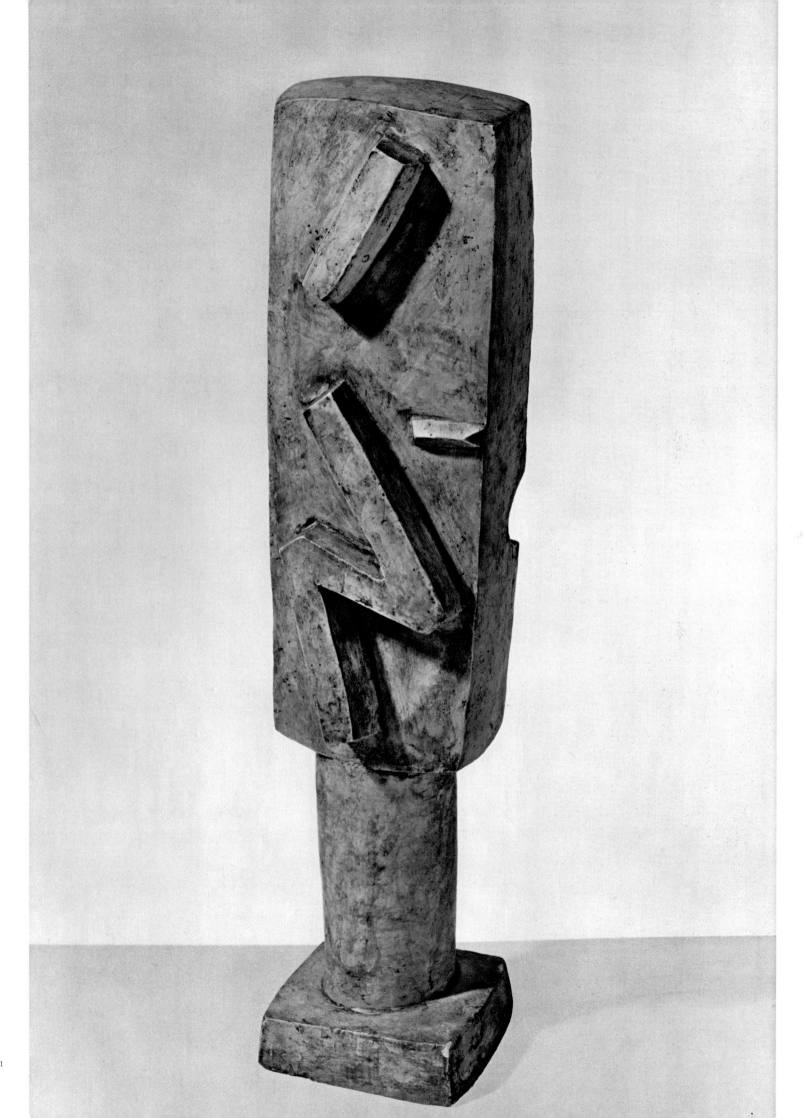

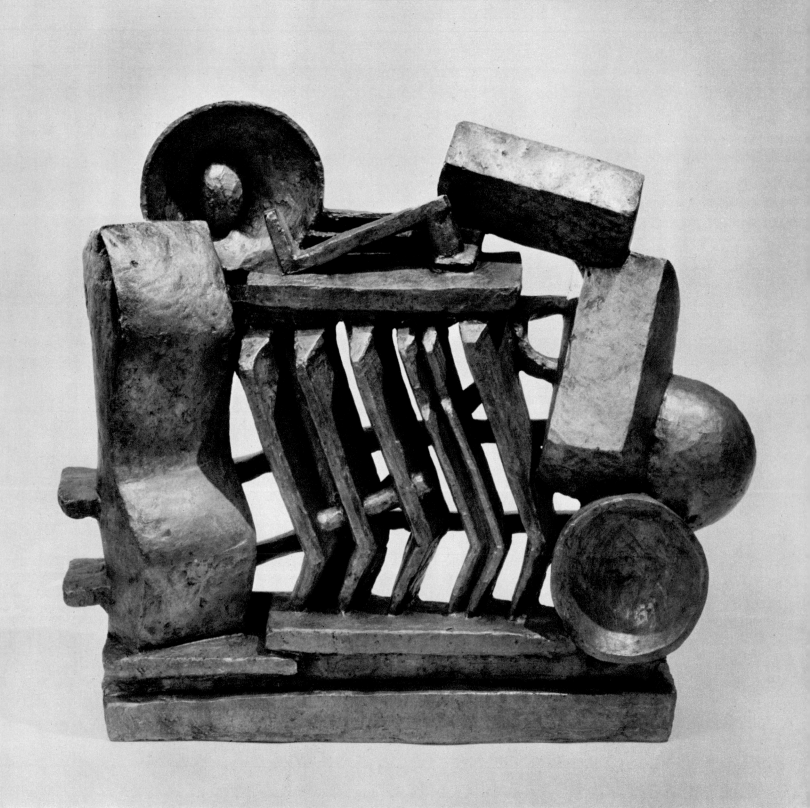

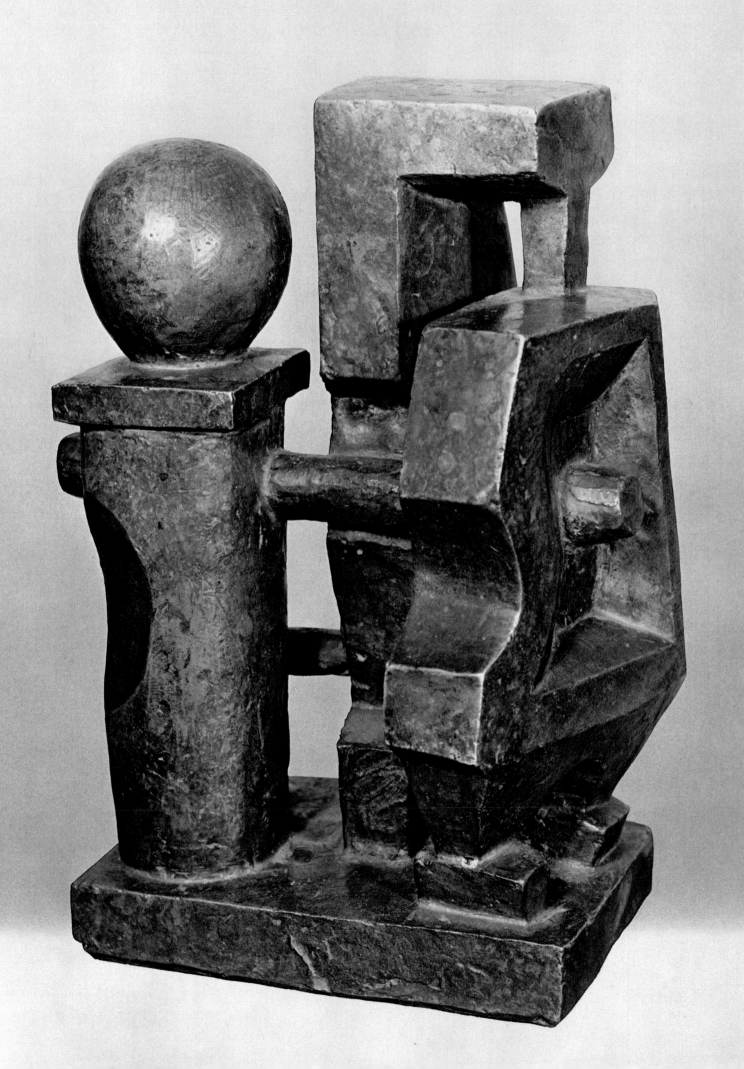

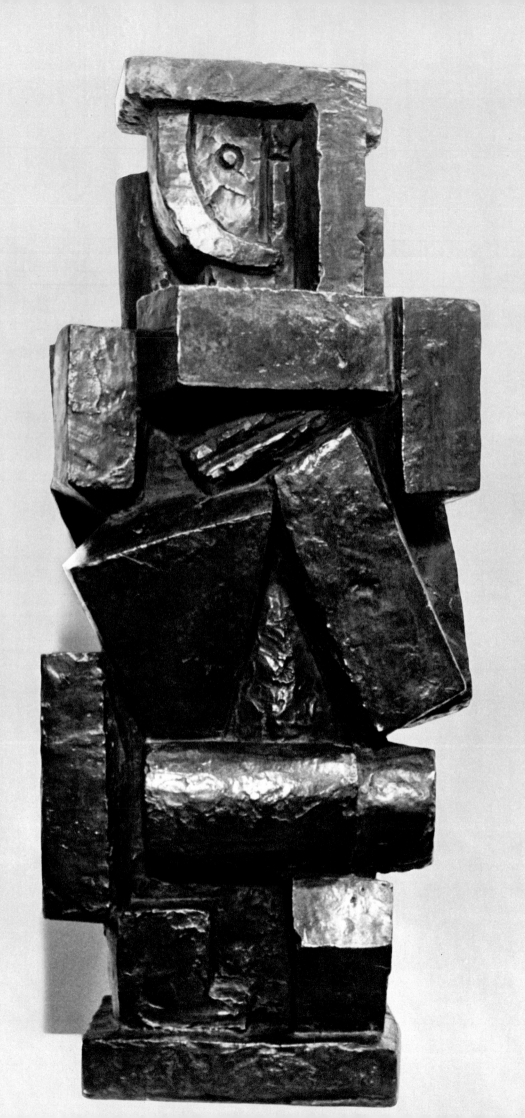

44

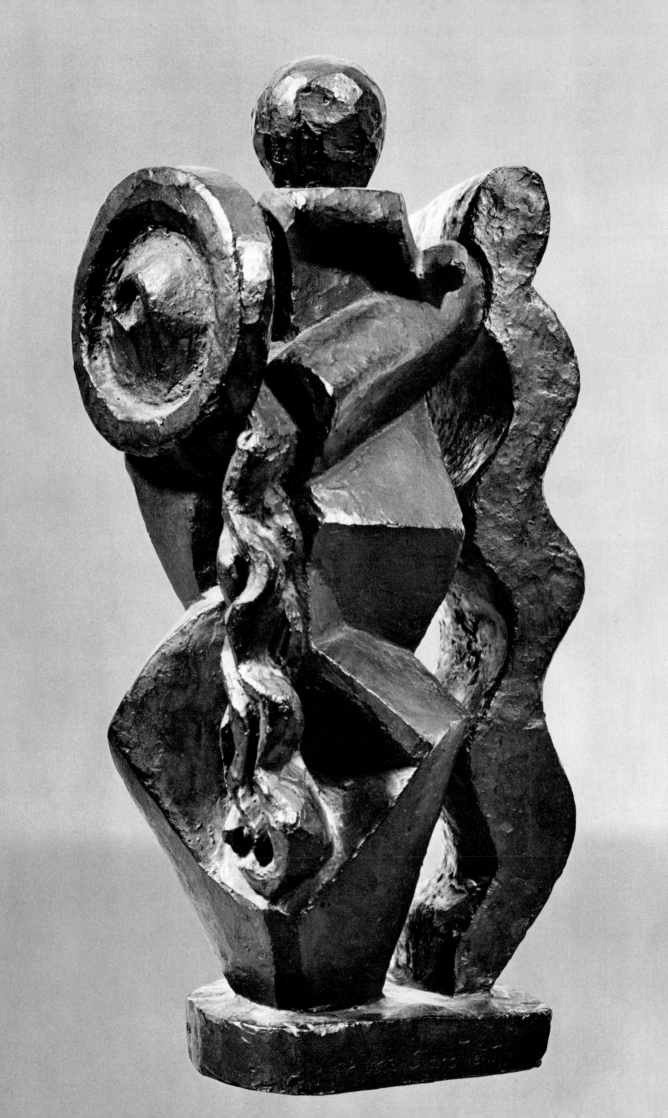

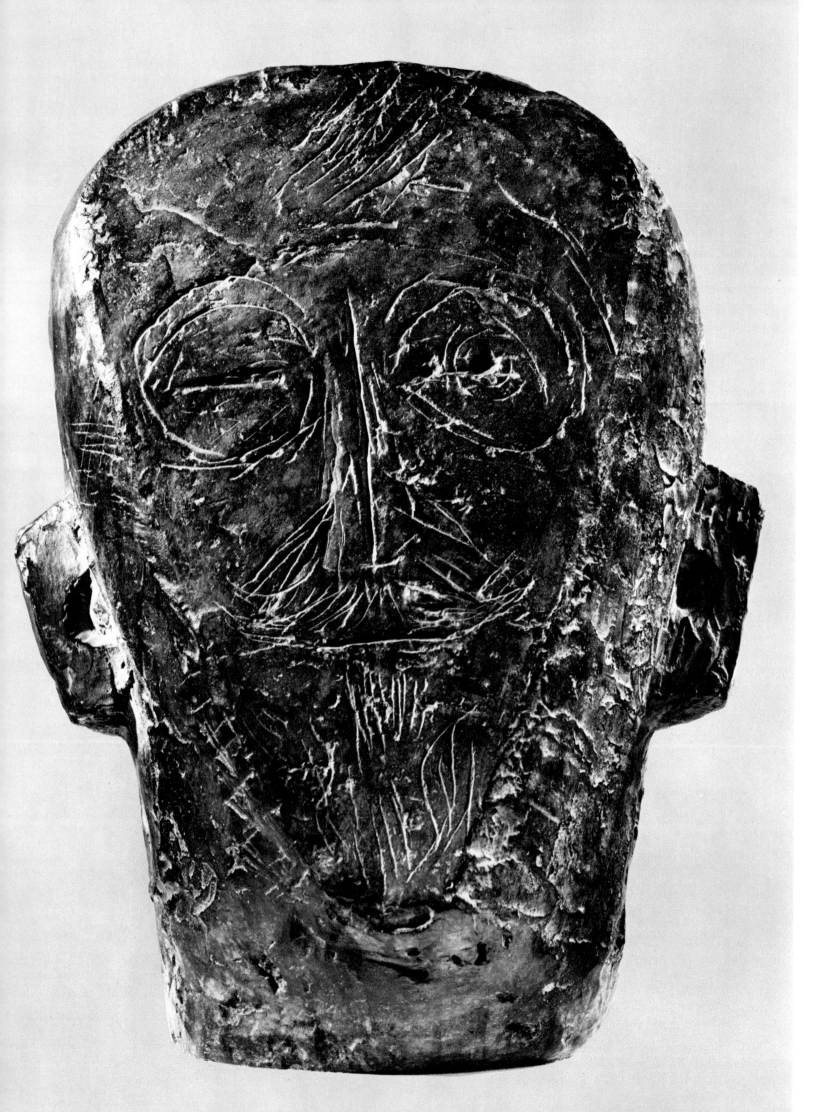

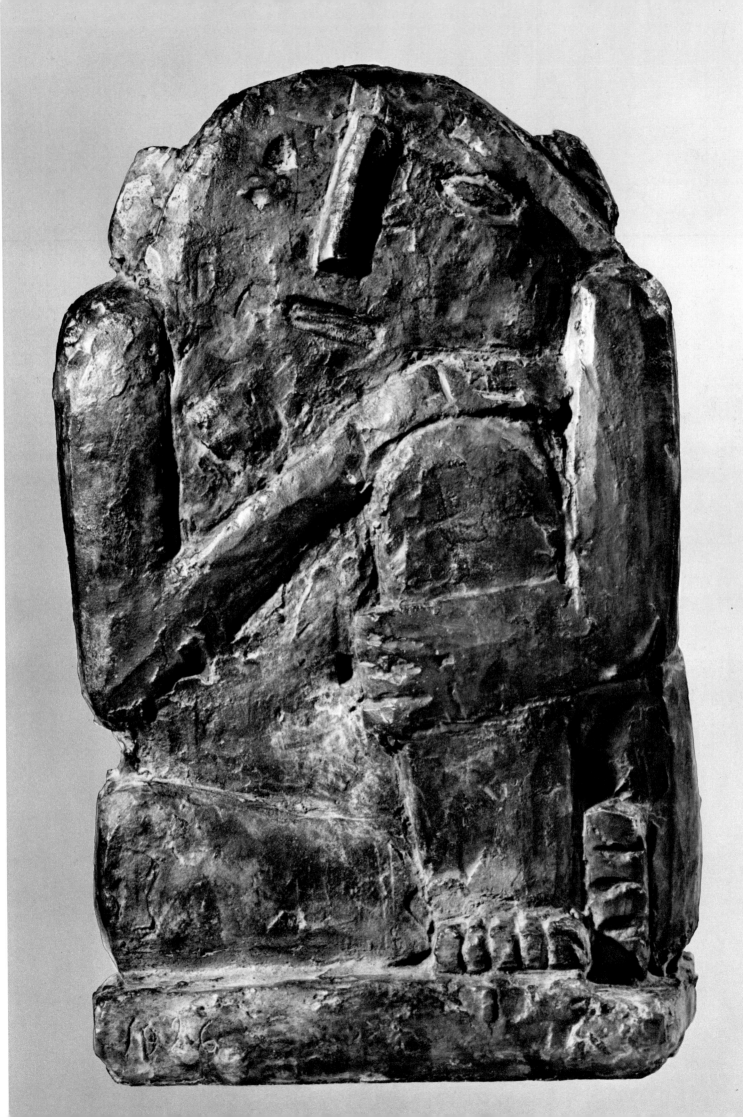

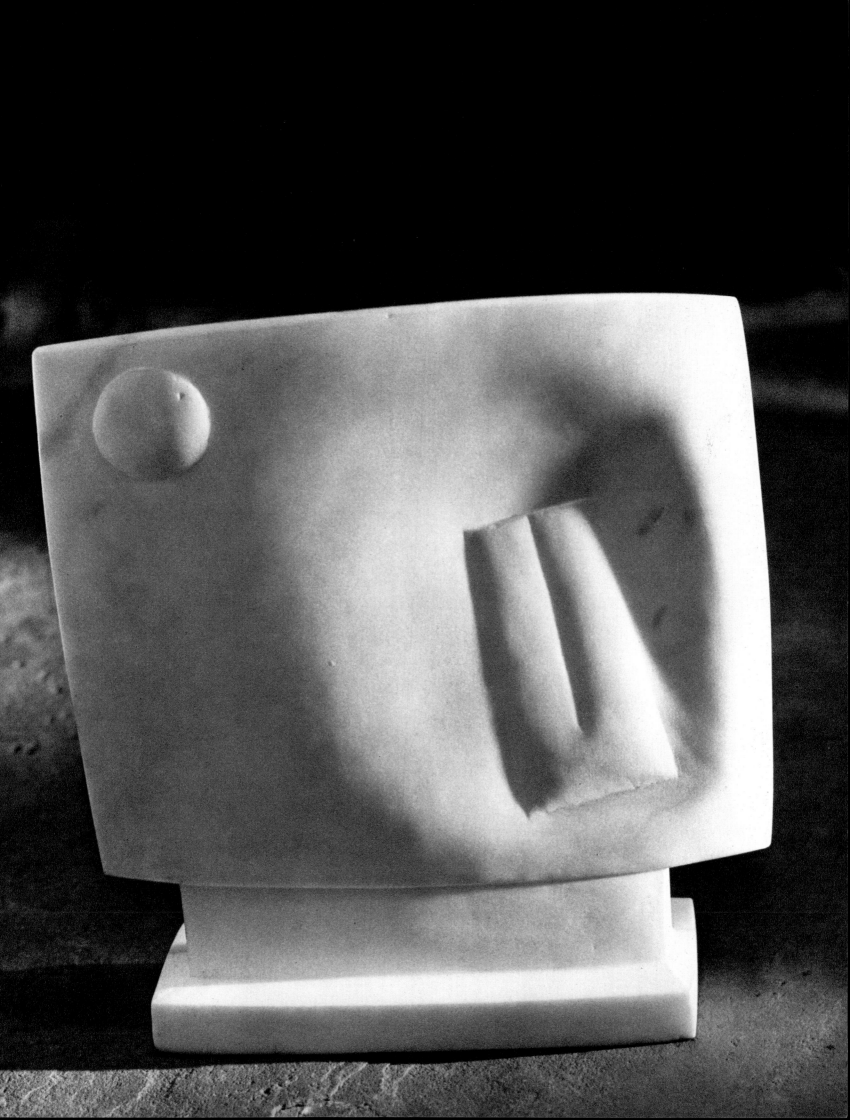

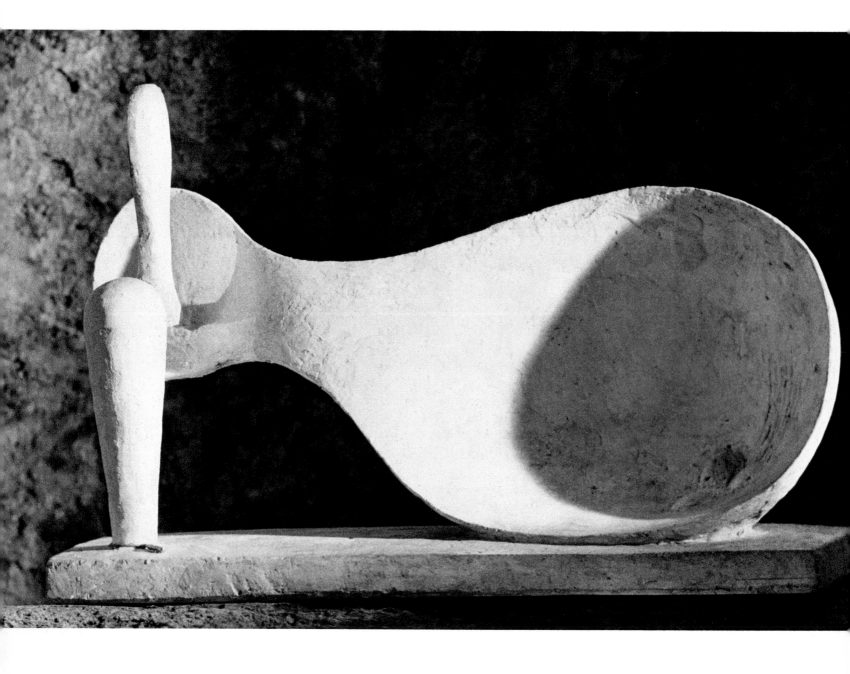

51

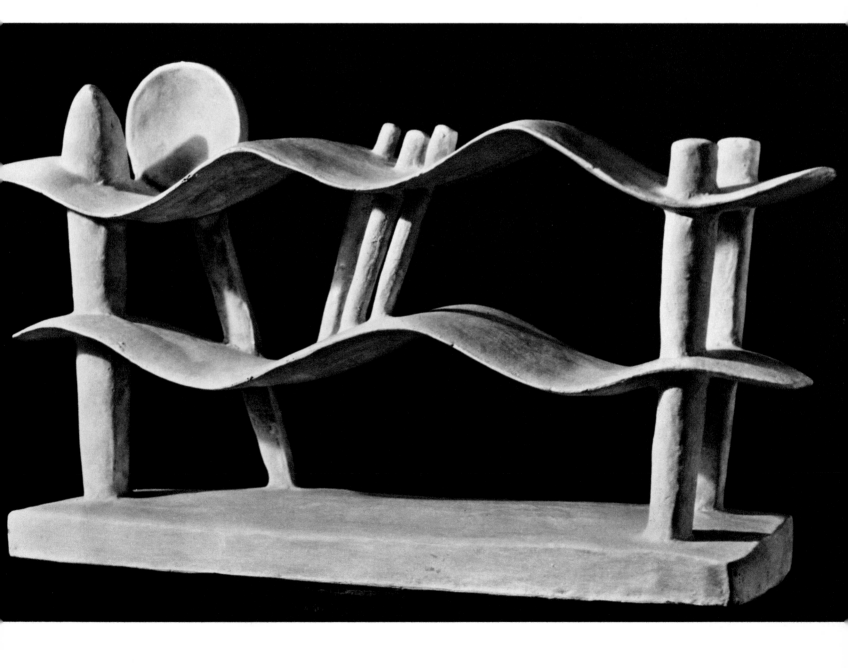

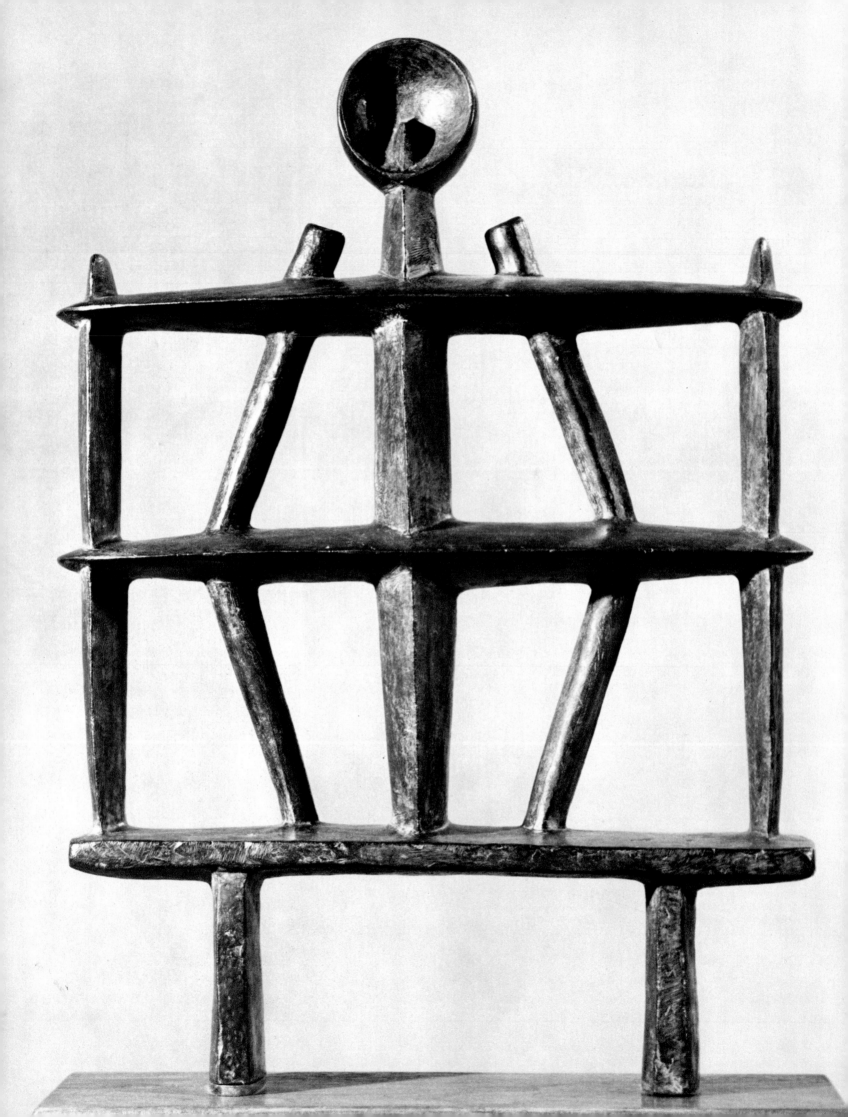

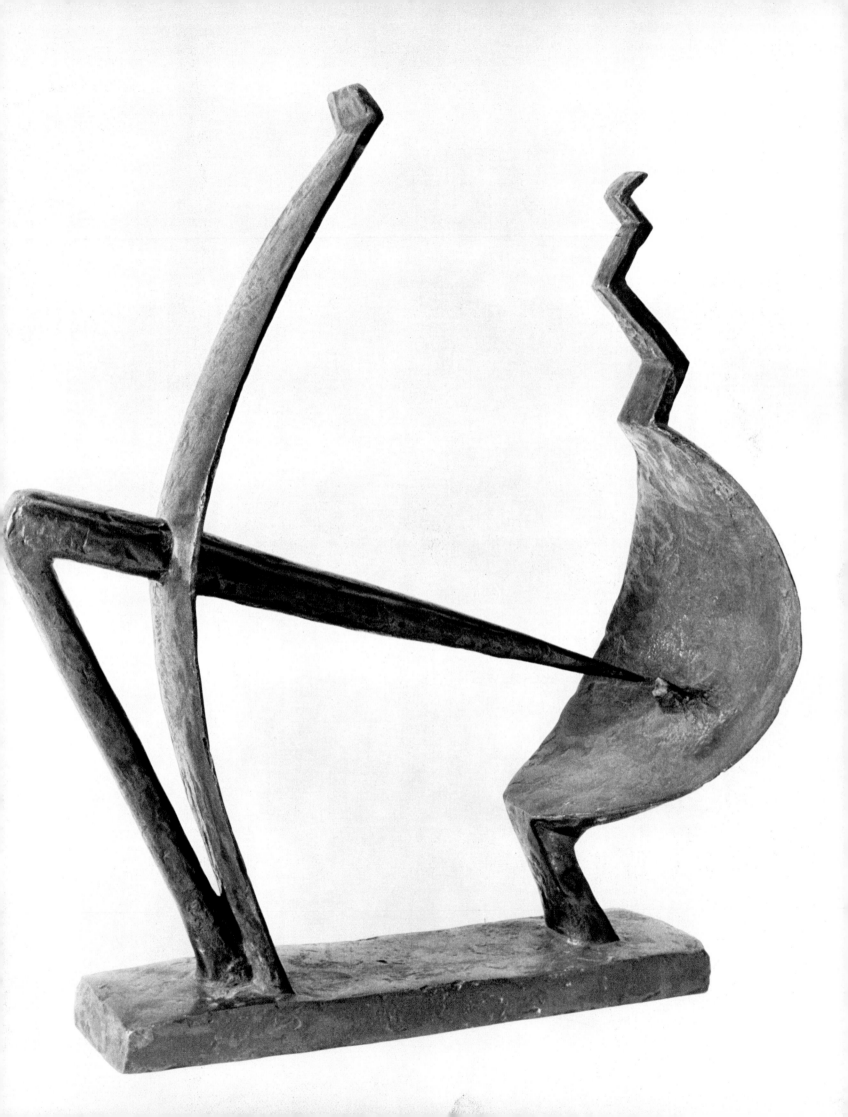

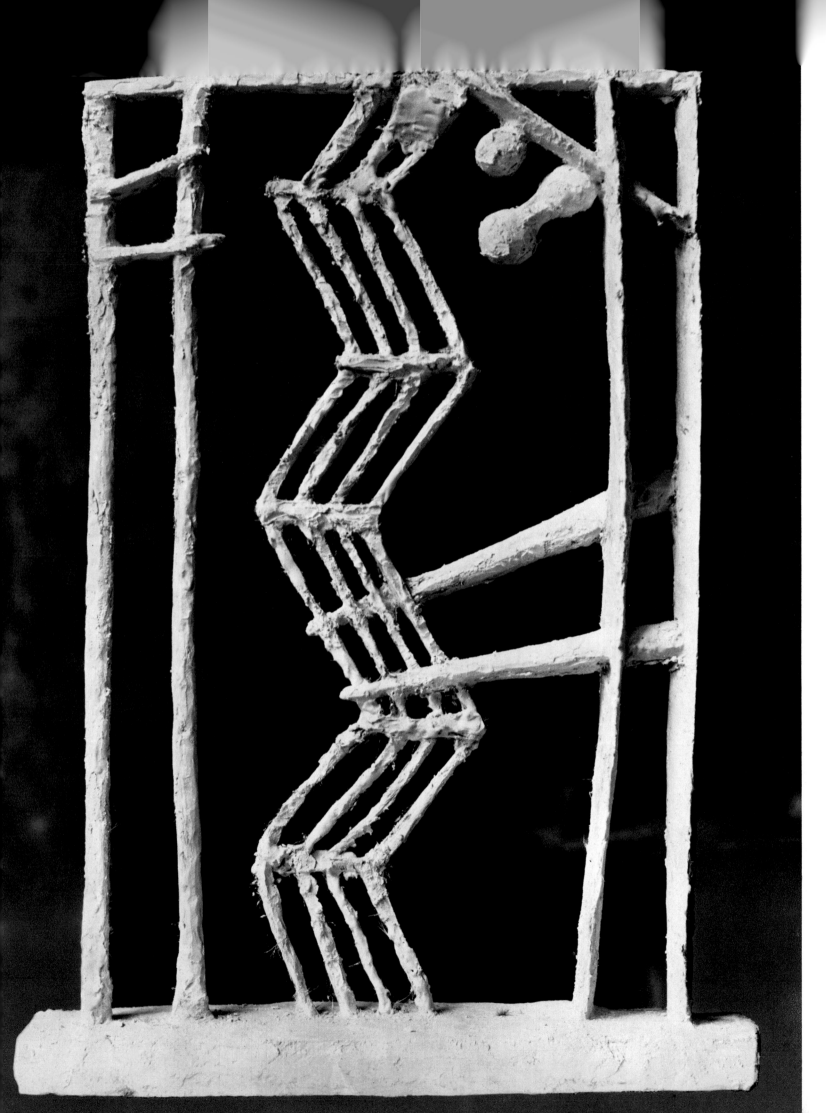

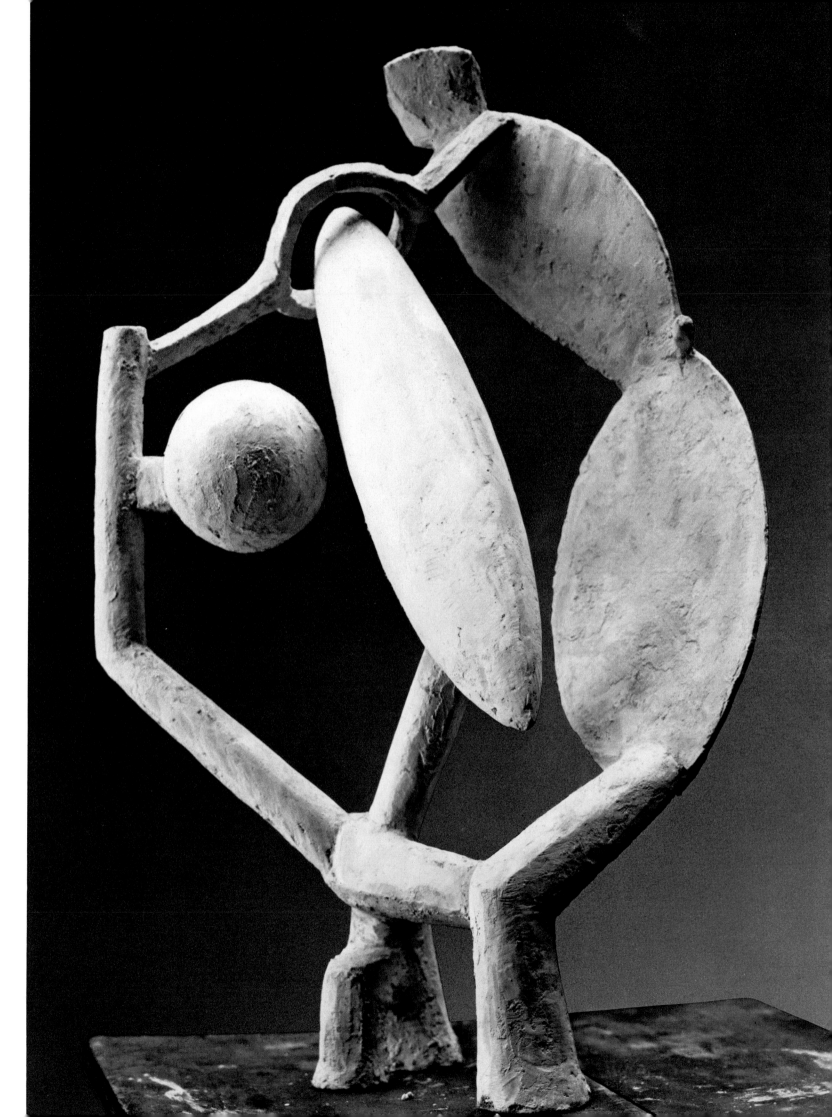

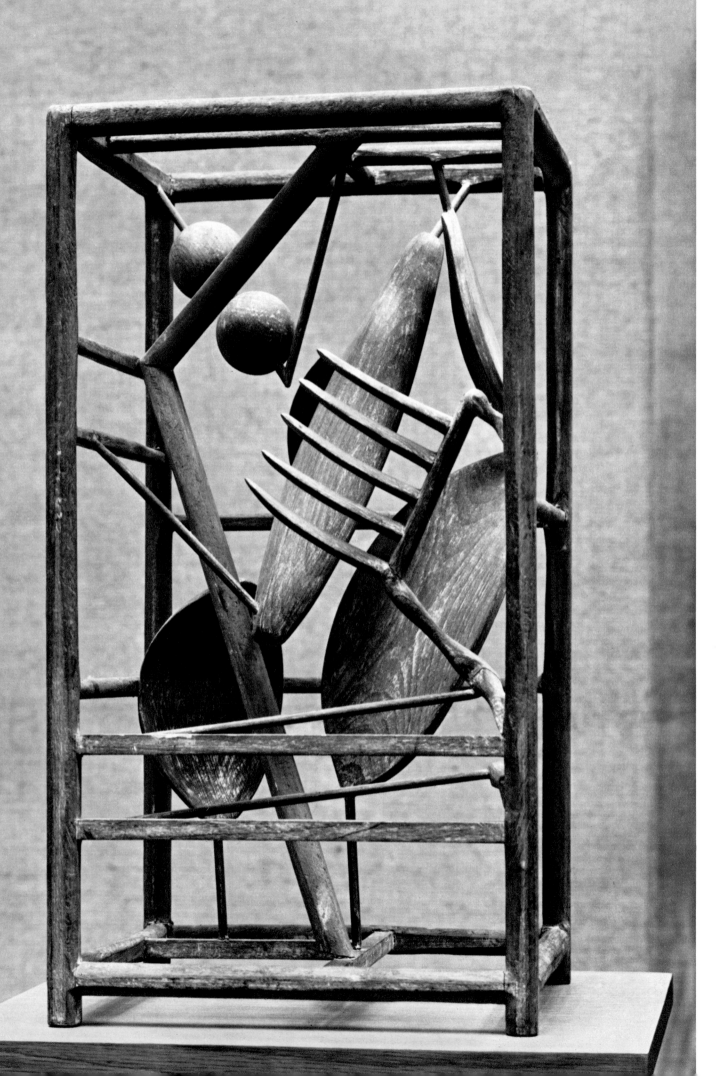

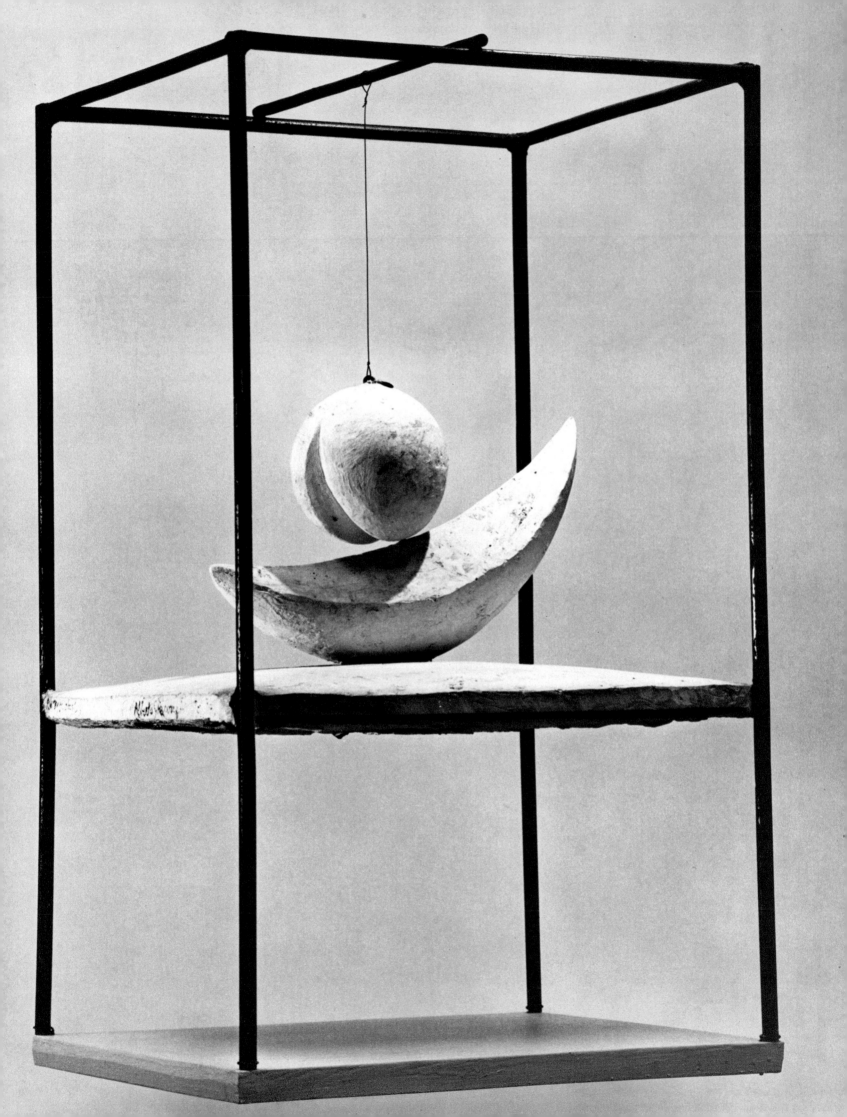

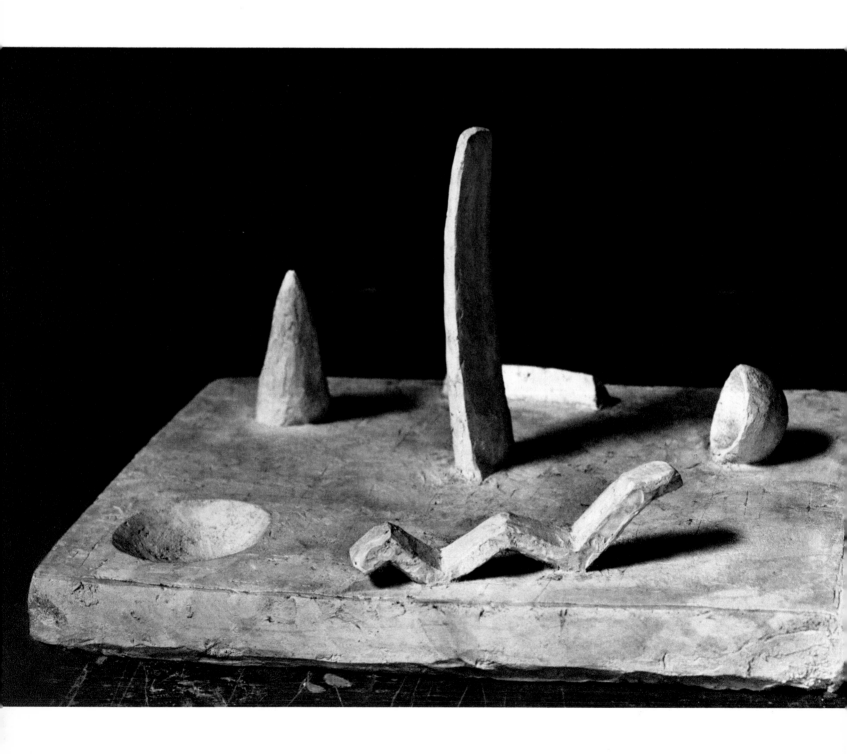

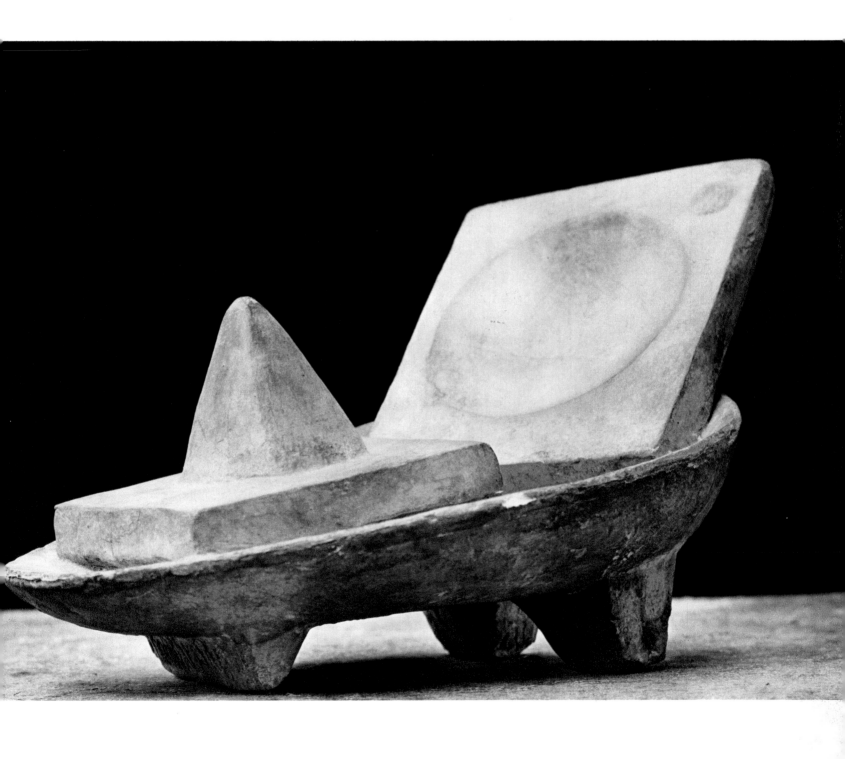

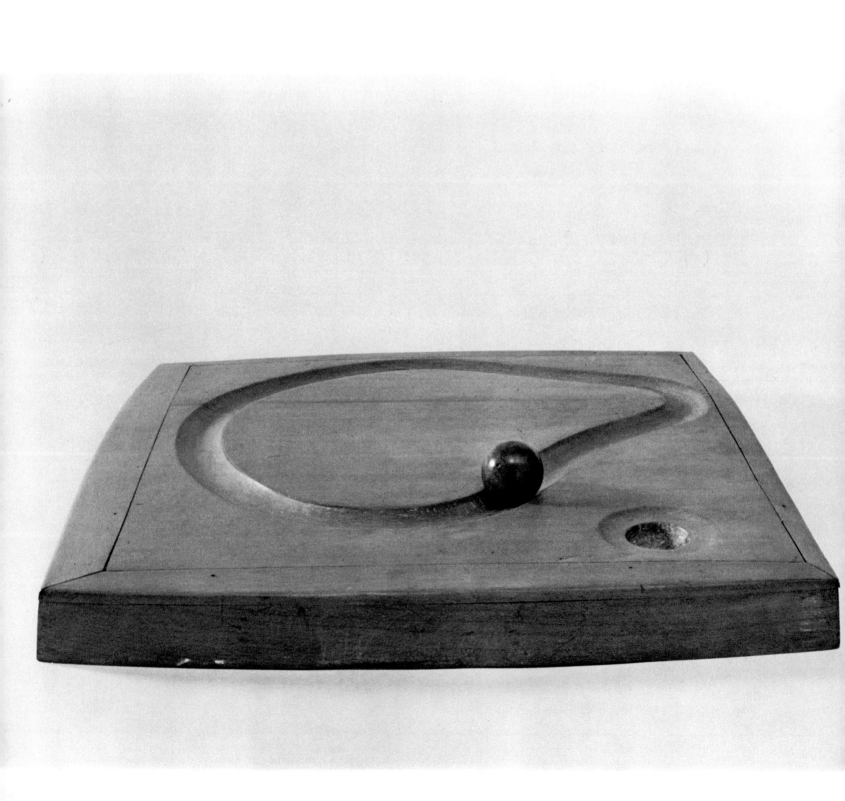

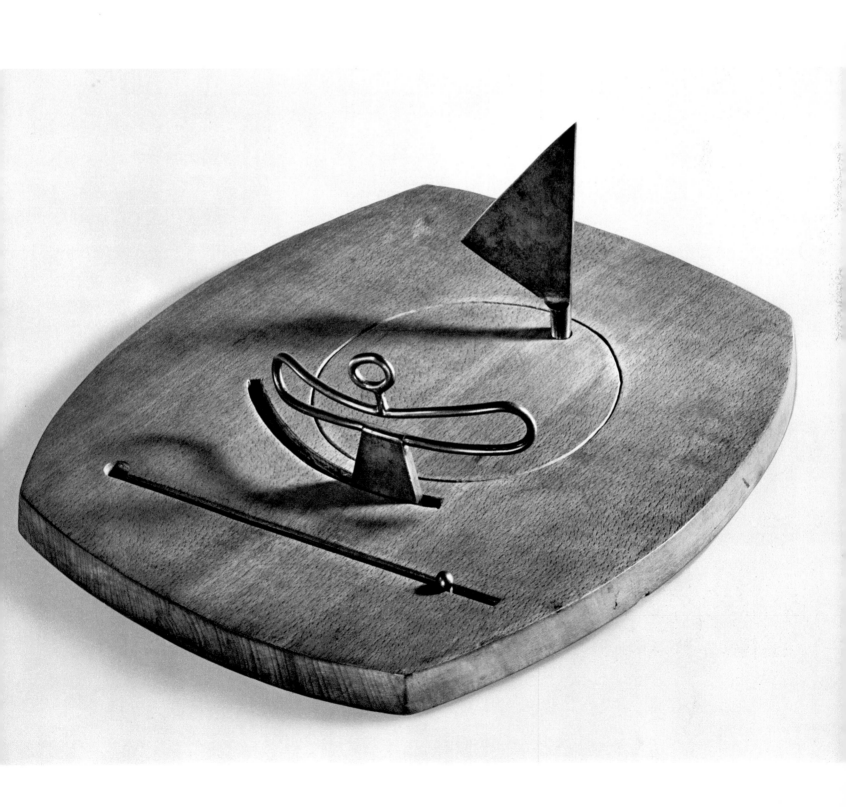

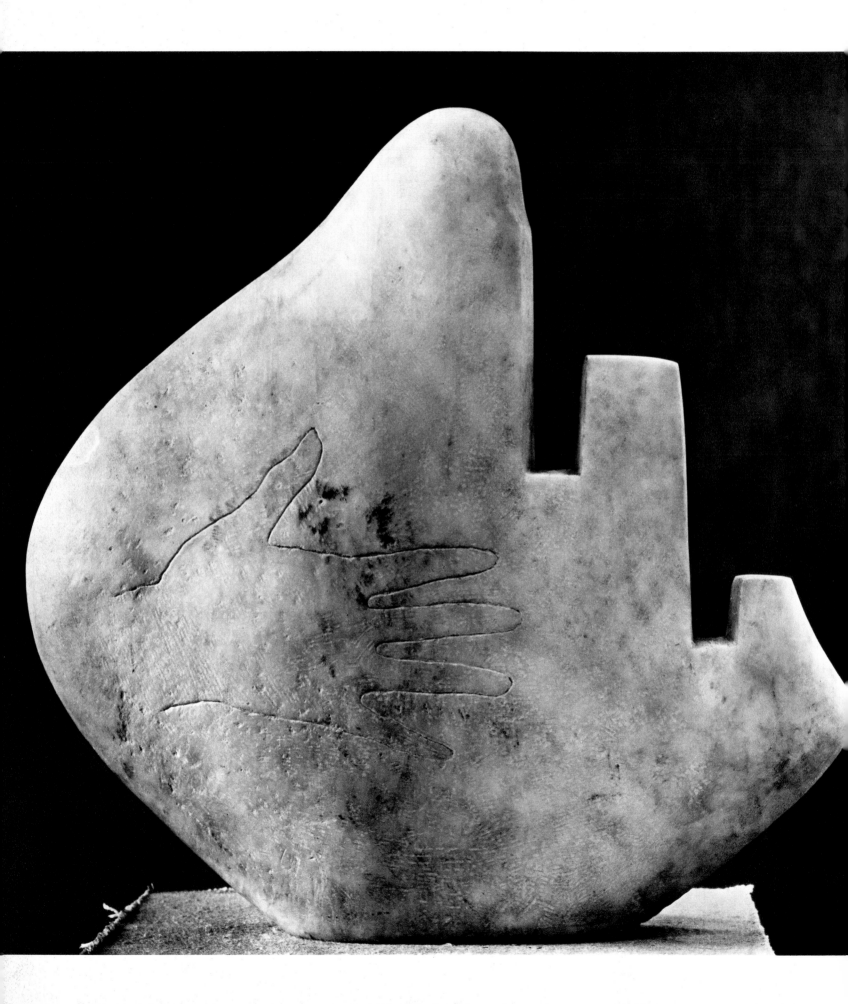

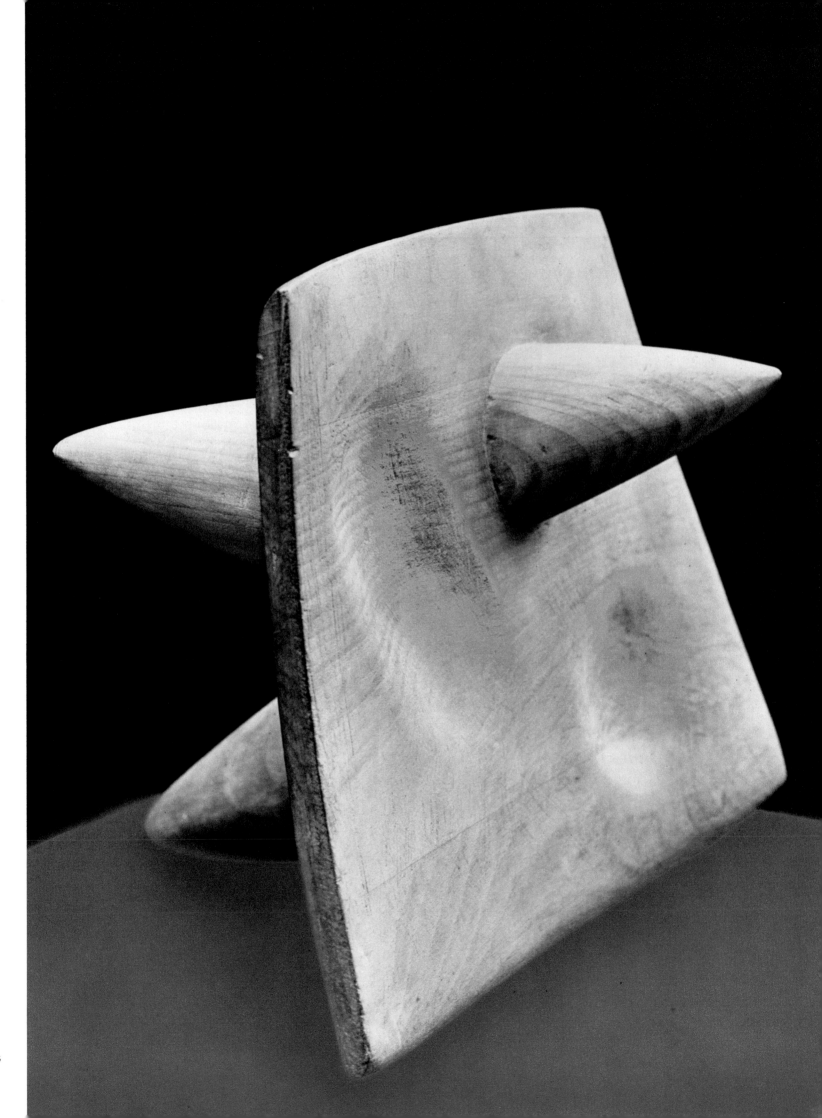

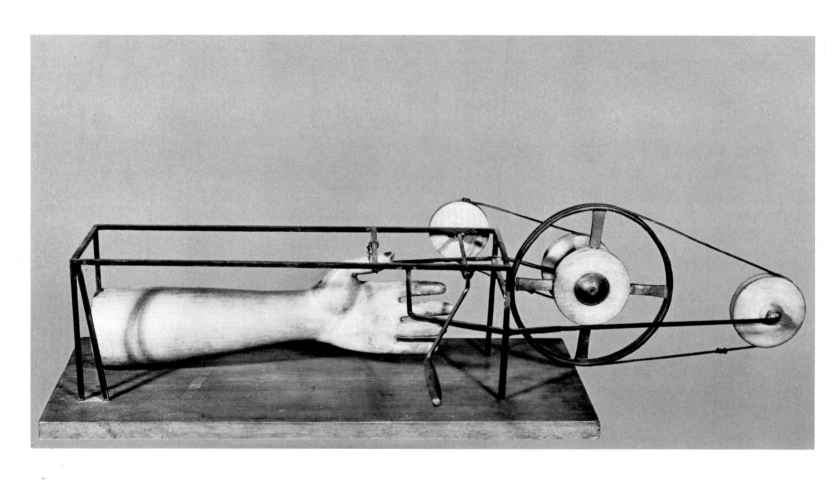

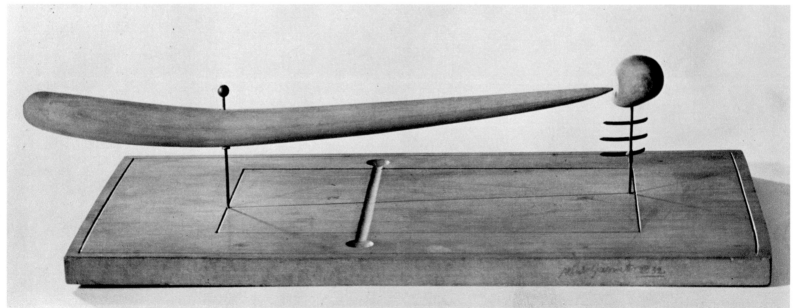

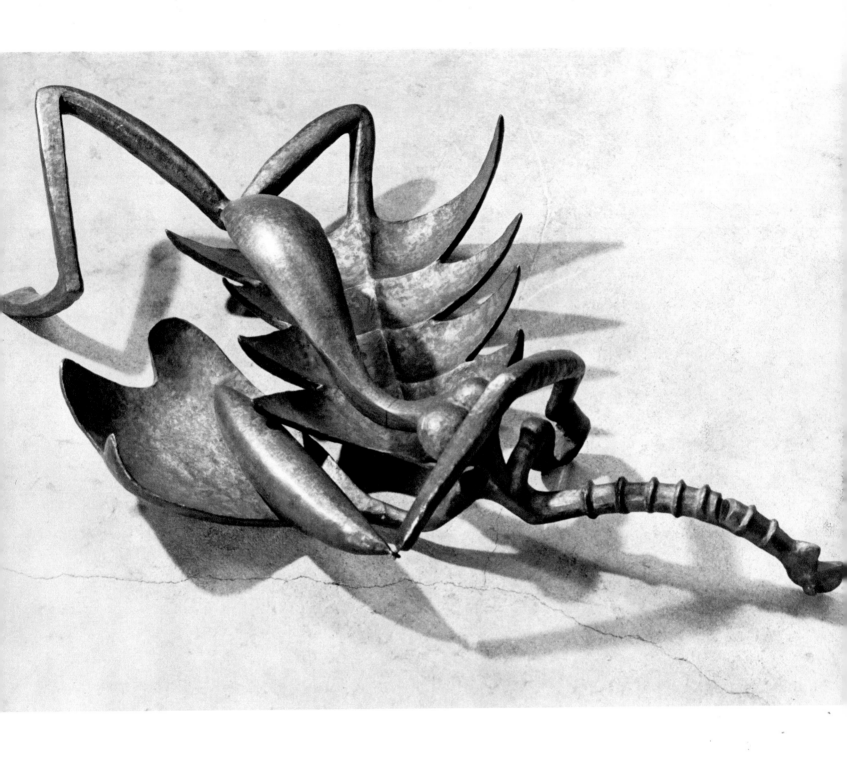

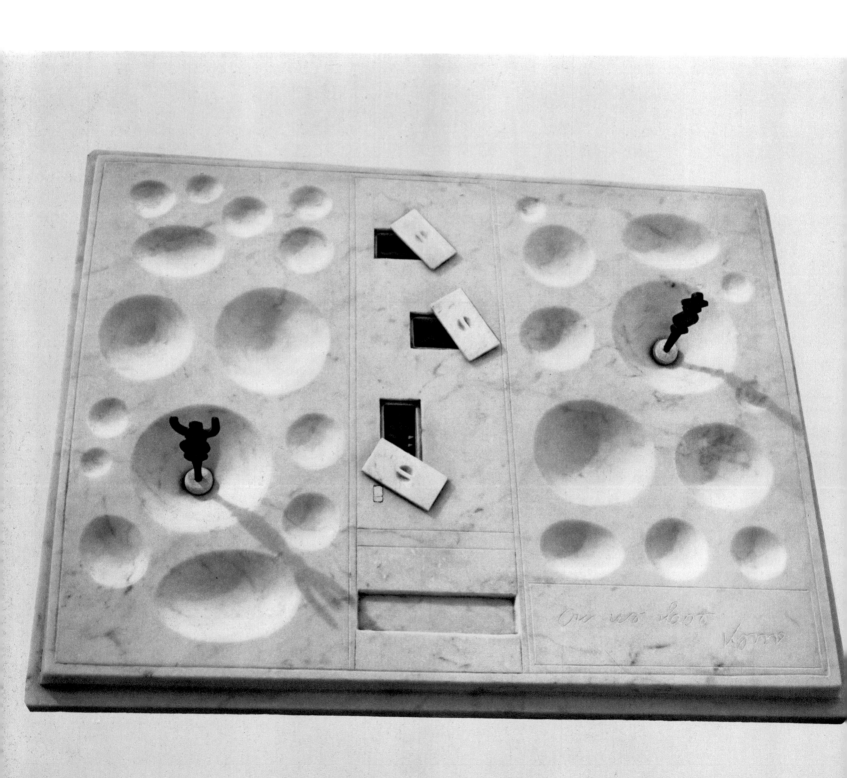

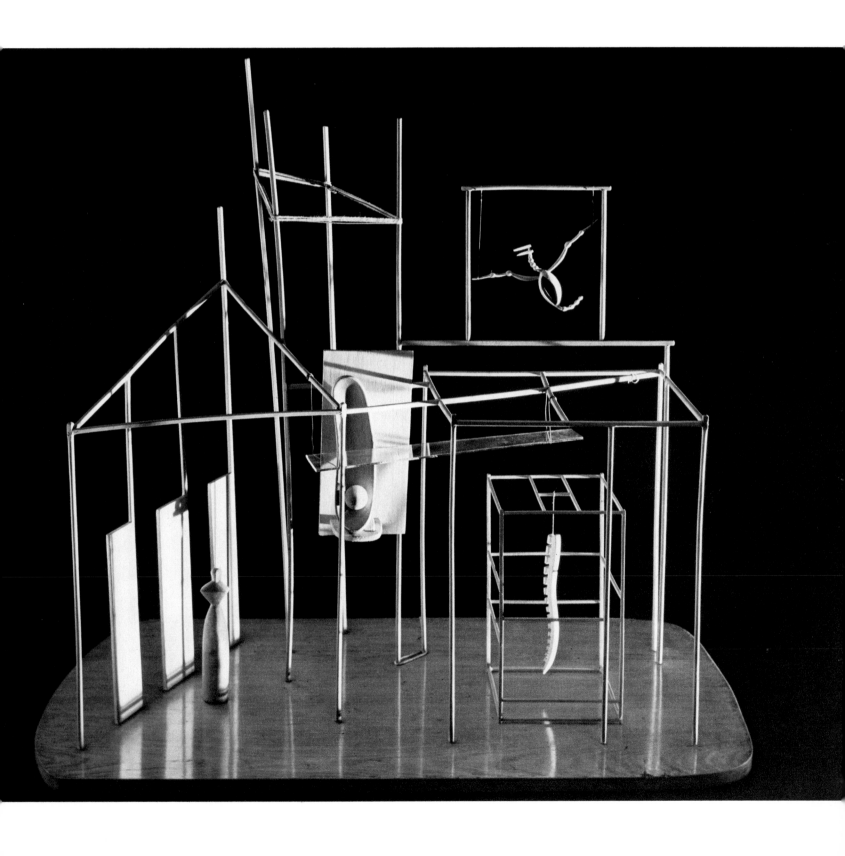

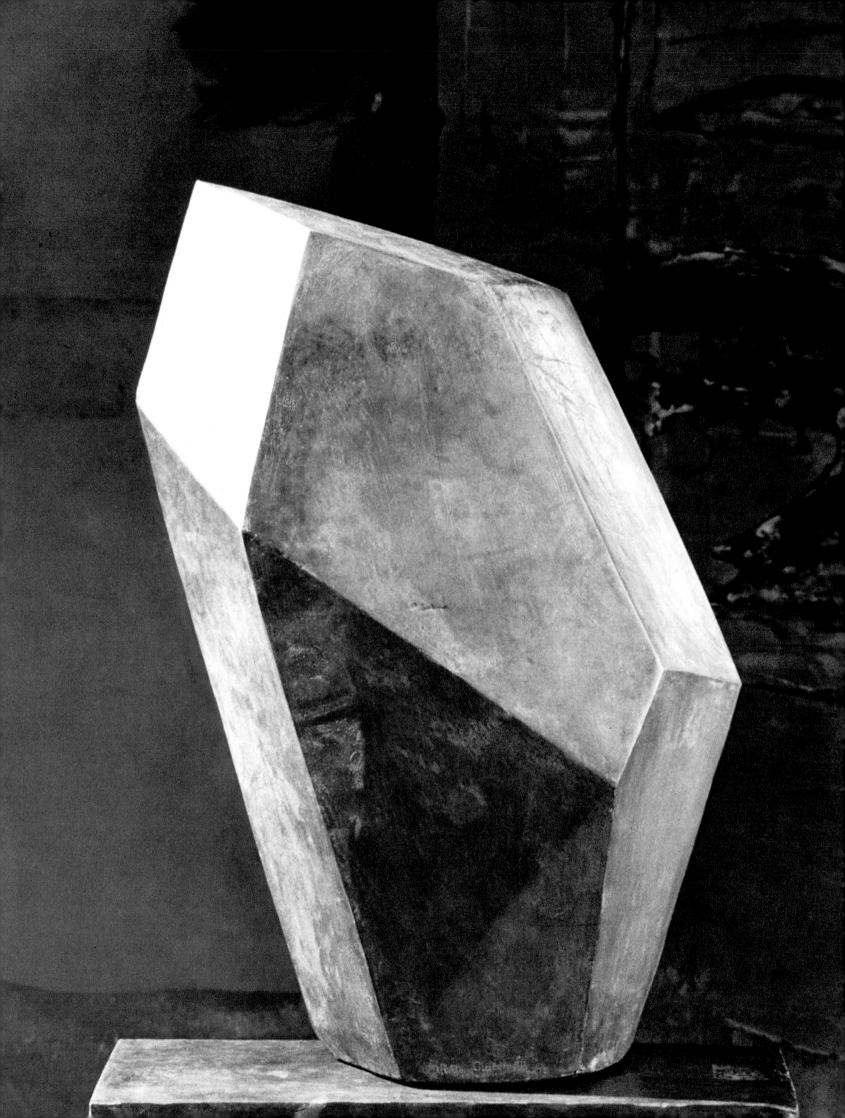

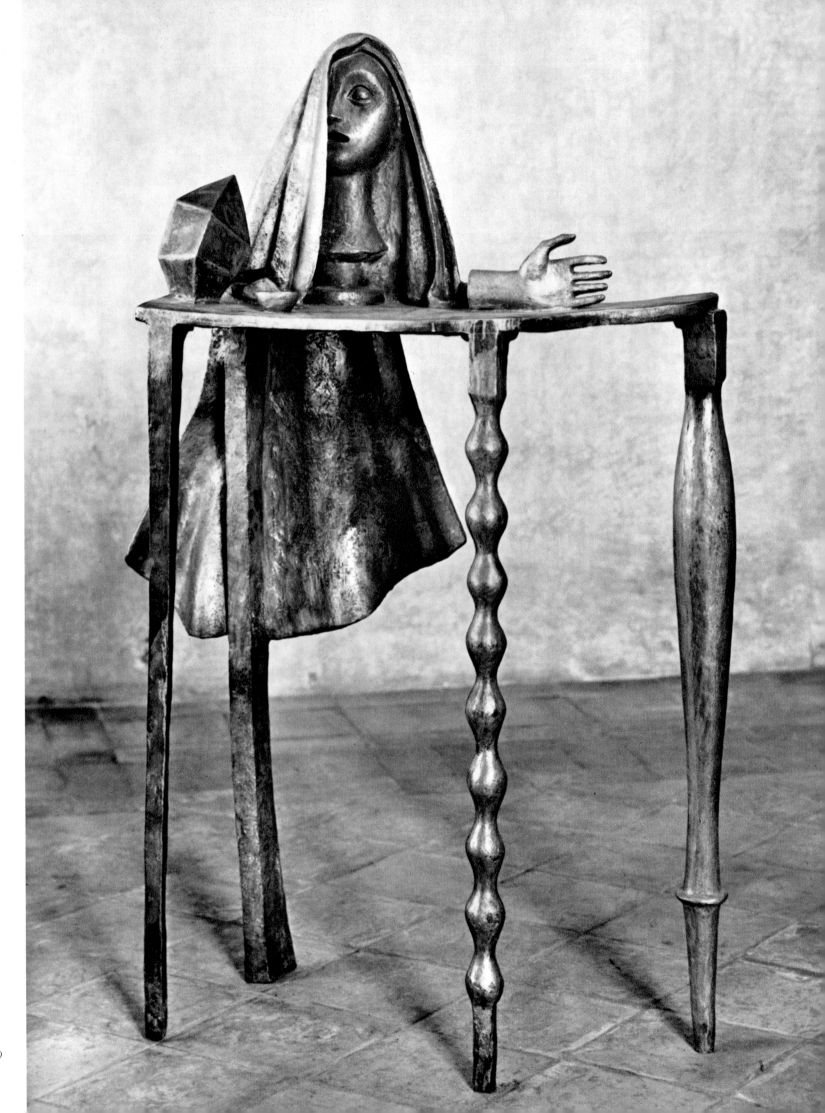

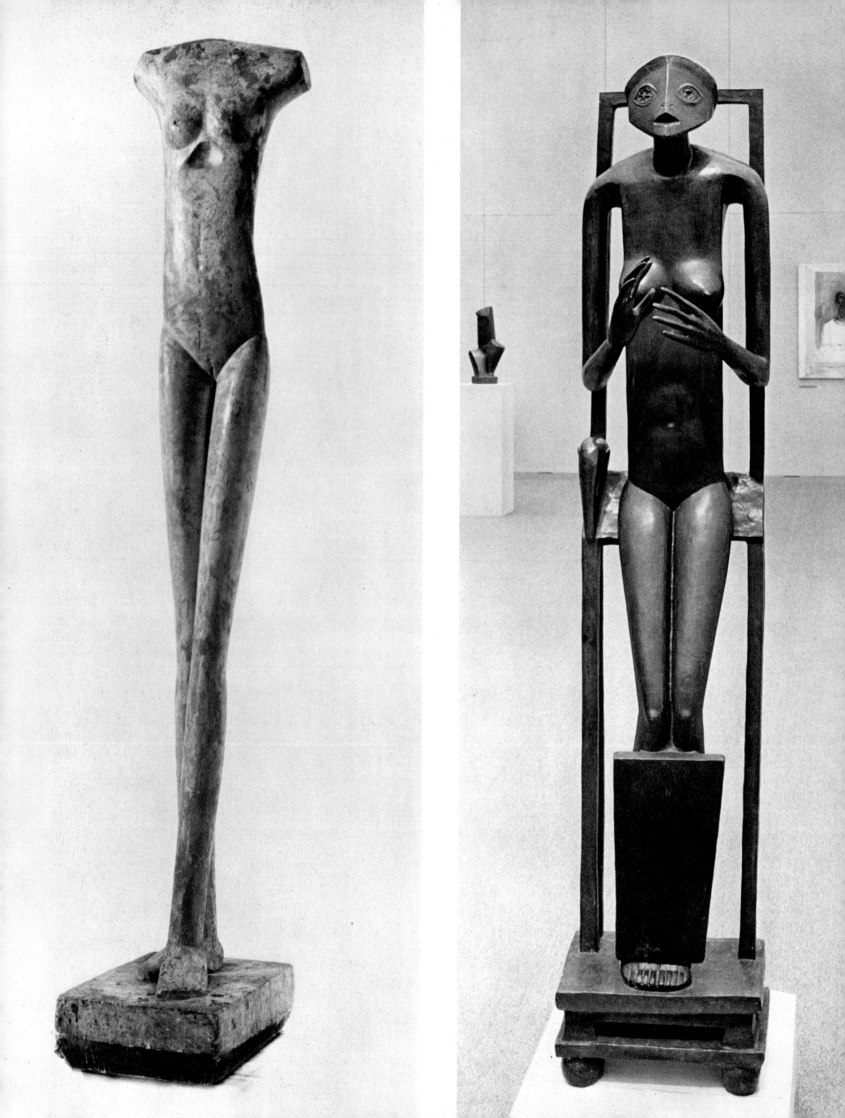

71

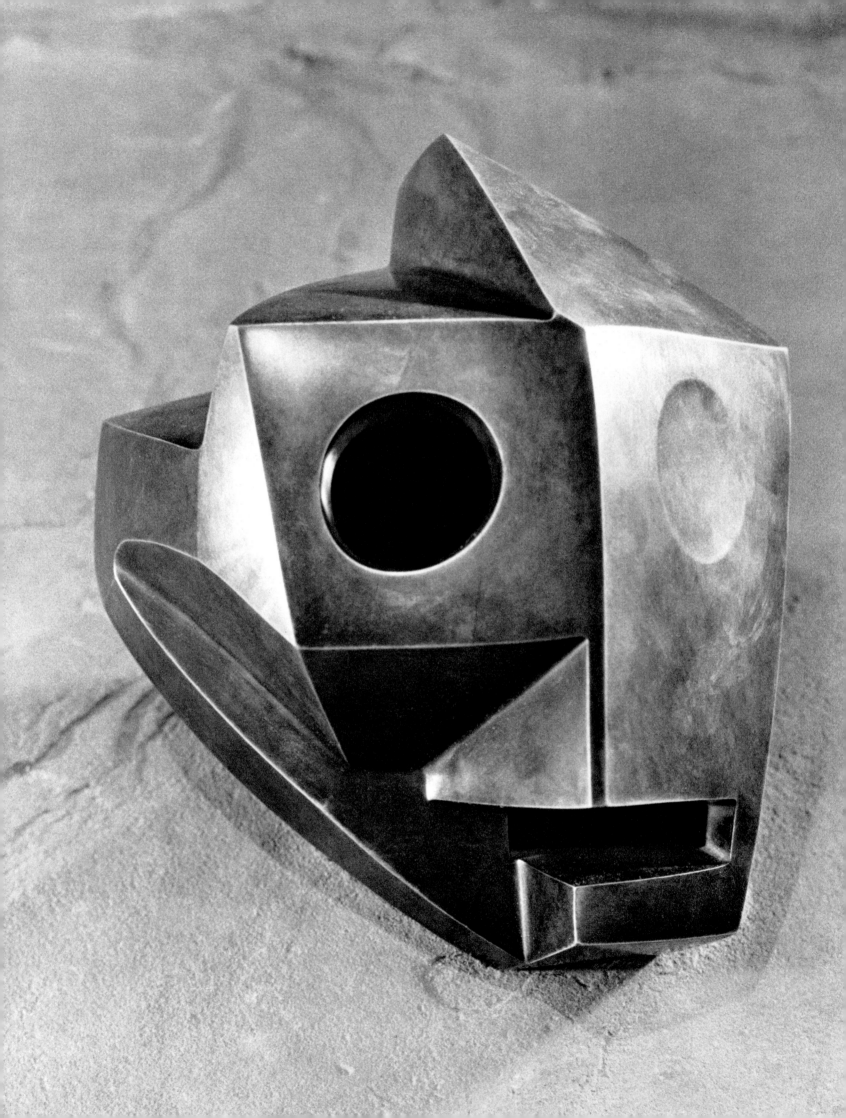

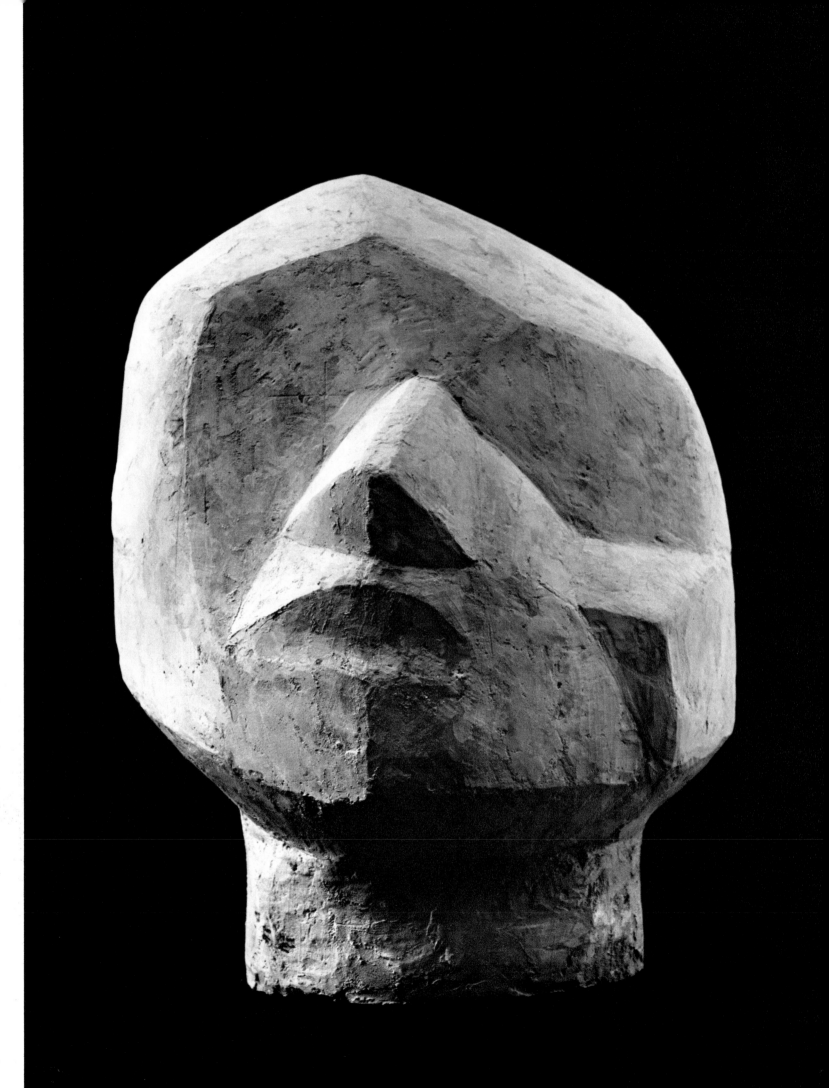

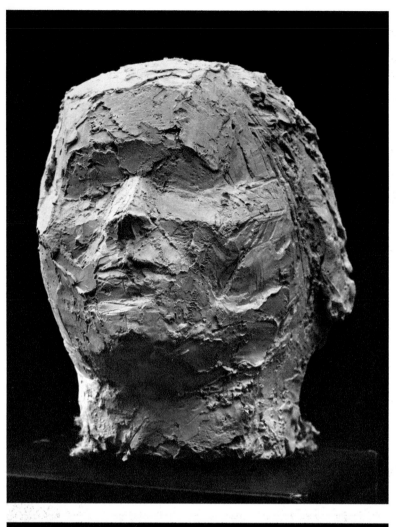

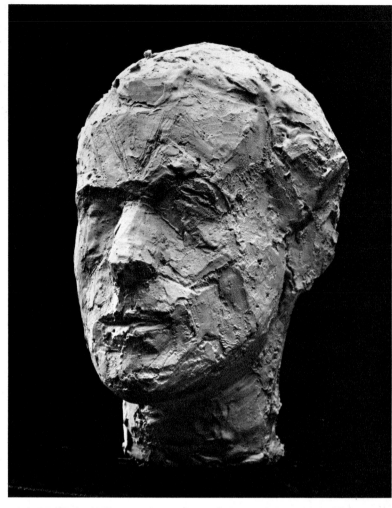

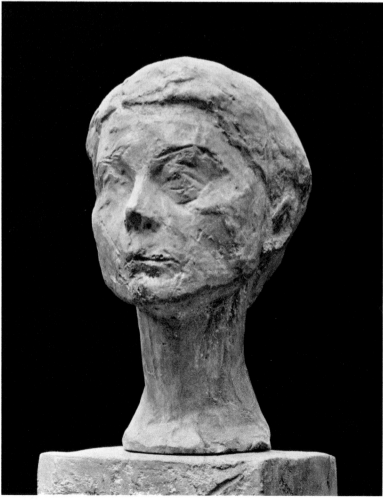

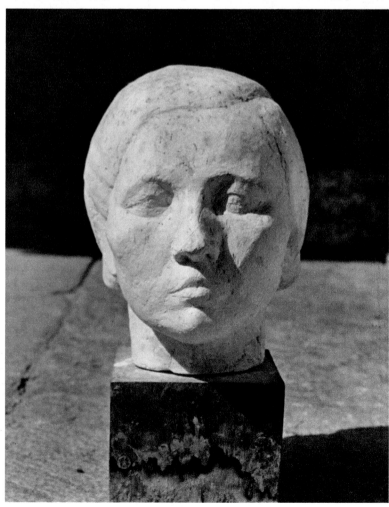

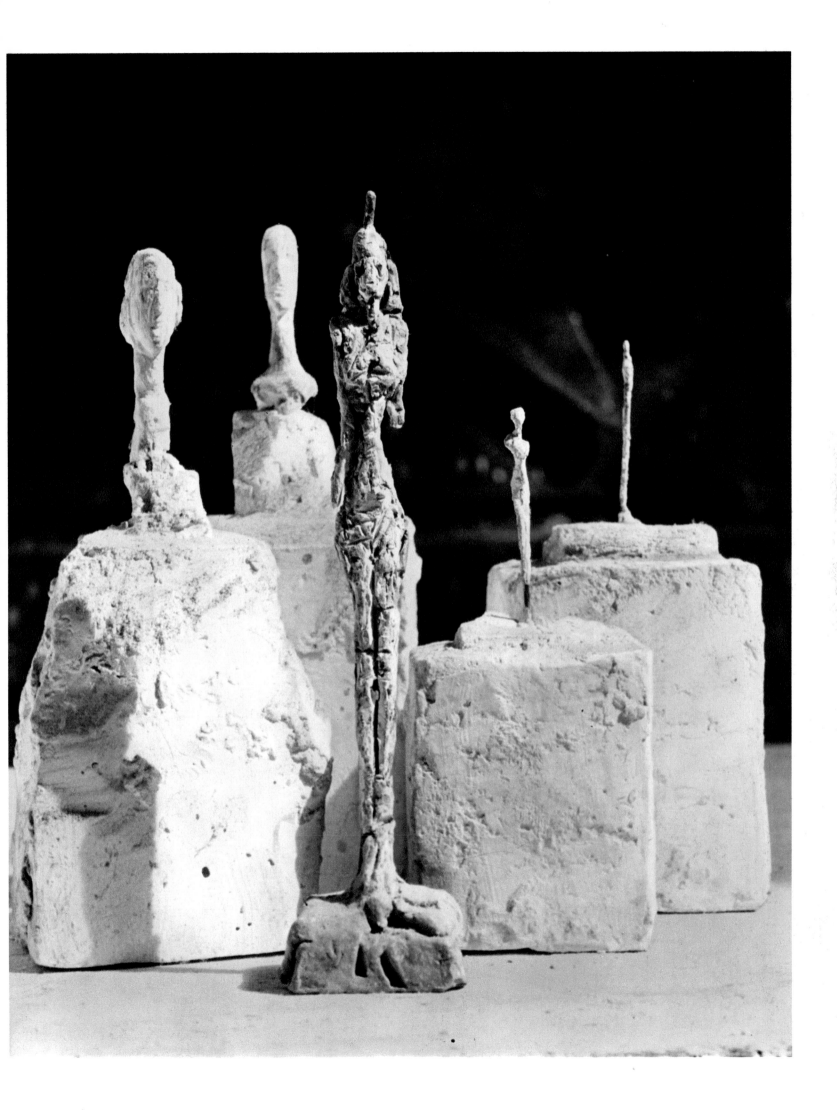

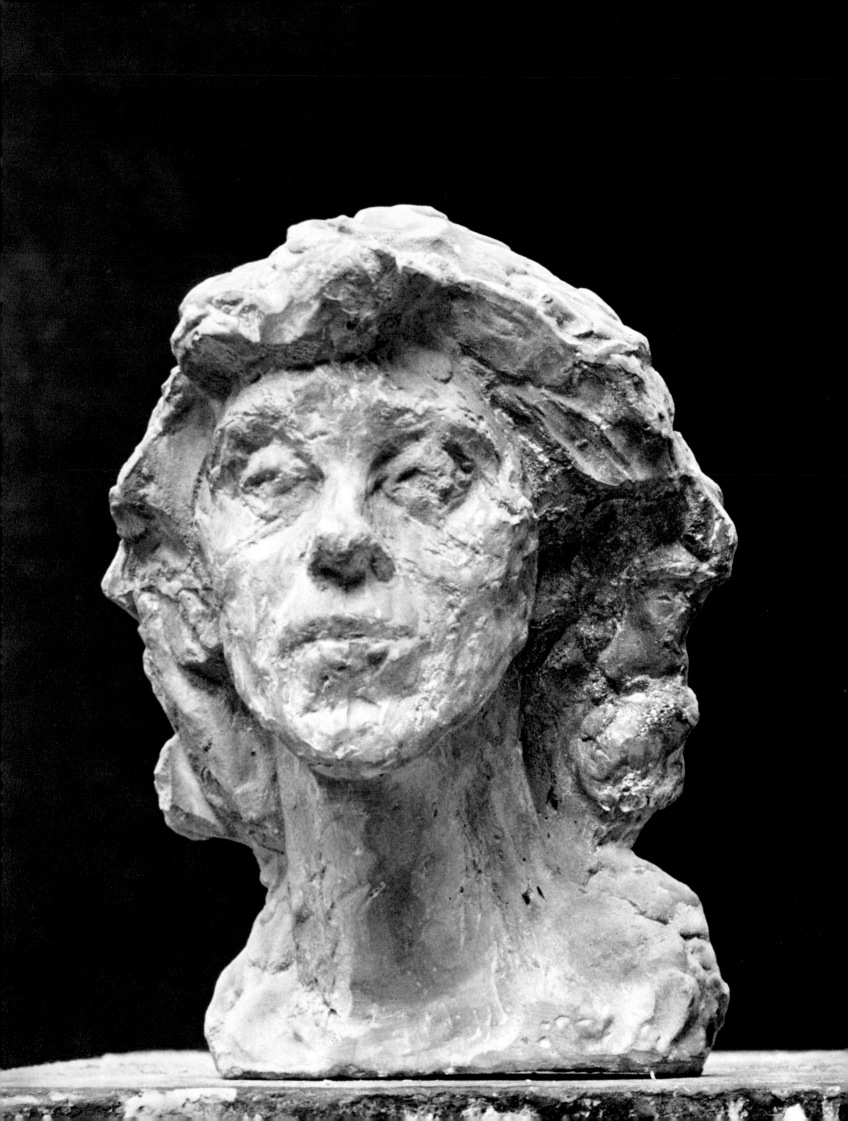

the reproduction of a portrait bust—had opened the door to him for creative work. It encouraged him and served as the pattern for the first sculpture he did, at the age of thirteen (60; 61). As long as he continued to draw on his youthful enthusiasm for art which was stimulated by artworks around him and by his family and friends, nothing was impossible for him. By copying from reproductions, he learned to compose surprisingly well. As a young boy he was already making sensitive portrait busts and drawings worthy of an expert craftsman. For example, his pen-and-ink self-portrait of 1918 shows disciplined skill (page 15). Its incisive line not only possesses a complexity of meaning as contour, modeling, and shading, it also has a rich life of its own.

Giacometti lost the happy assuredness he showed in this drawing for the first time in 1919. Confronted with real objects, "I suddenly realized that I couldn't do a thing, and I wondered why. I wanted to work to find out why." (723: 44) This first crisis came at the onset of adolescence; a second, in 1925, came at its end. The art on which he had modeled his youthful technique lost its authority. He began to see reality in his own way, through his own eyes. A good example of this is the anecdote about how the eighteen- or nineteen-year-old Alberto drew a still-life of pears in his father's studio "at the usual still-life distance. But they kept getting smaller and smaller.... My father got irritated and said: 'Now start doing them as they are, as you see them!' And he corrected them to life-size. I tried to do them like that, but I couldn't help rubbing out; I rubbed them out, and half an hour later my pears were exactly as small to the millimeter as the first ones." (637)

His father must have thought these results disastrous, but he unwittingly brought them about himself by asking his son to solve two contradictory problems simultaneously: drawing the pears both as they were and as he saw them. Alberto drew them exactly as he saw them, as the focus of his field of vision when looking at the pears from the "usual still-life distance." And because he identified the edges of his sheet of paper with the boundaries of his field of vision, the pears had to be tiny in relation to the whole. So the young artist performed a (perhaps naive) masterpiece of phenomenological observation, whereas his father—backed up by traditional realistic aesthetics—succumbed to the fallacy that the *known* reality of objects—as they are— is the same as their *perceived* reality—as we see them; in other words, that pears can be realistically represented on paper "lifesize," as if we held them in our hand.[12]

Giacometti experienced an even more drastic confrontation with reality when drawing from the model at the Geneva Academy; now the conflict came completely out into the open. Two sources tell us something of the nature of the problems he faced. According to one, instead of drawing the buxom model full-figure, as he was told,

Giacometti drew only her foot—and that huge (136). According to the other source, he quarreled with the professor of sculpture, who wanted his students to work with large, complete volumes from the start; Alberto built his sculptures up particle by particle (55). Both anecdotes show that a new approach had replaced that of his early work and his father's realism. Alberto no longer based his work on the pattern of another, admired artwork, but on visual reality, which he approached carefully, step by step, piece by piece.

Up until 1924 or 1925, Giacometti was happy in the belief that art could capture the reality of a person or object by representing its natural shape, its outer shell. His inner conflict, acute in 1919 in Geneva, in 1920 in Rome, and especially in Paris in 1925, was not yet caused by the discovery that this was a priori impossible due to the nature of reality itself—the essence of reality lies in its primary, elusive, and ultimately ungraspable existence—it was caused by the fact that he found it impossible to overlook or leave out any detail of the strangely valuable reality he saw before him.

Reality—that surely means every particle of the stuff reality is made of; no part of it, no matter how tiny, can be overlooked. But reality is also the whole, not only the sum of its parts. It is the presence of a totality which has to be surveyed at a glance. The uncertainties of Giacometti's early work lay in this contradiction: in order to create a work of art, he had to learn to perceive the whole of the reality before him at a glance, but he found it impossible to leave out even the smallest detail.

The students of figure drawing and sculpture at the Grande Chaumière in Paris were offered a popular, strictly formal solution to this conflict. To get a hold on reality, it went, you must box in the whole of the object before you with lines, putting dots at key points on the contour and drawing straight lines connecting them, thus dividing the volume into planes, or facets (185). Giacometti's self-portrait of 1923–24 (page 19), done in this manner, is a competent but unsatisfying academic drawing. Like a cut diamond, the irregular volume of the head has seemingly been brought under control by Giacometti's artificial method; every plane segment seems to capture reality as a totality, yet a real understanding of the head and of its existence as a whole is missing. (In 1934 Giacometti tried this manner again, in his *Head (Skull)*, page 72.) What we do see for the first time in this self-portrait is the quite unacademic technique Giacometti was to use in his mature style to create space around the heads: the zone of gray (smudged with an eraser here) next to the contours.

Sculptures such as the head of his brother Diego (1924–25; page 289, fig. 9) and the portrait of Josef Müller (1925–26; page 37) show the degree of visual realization Giacometti was capable of at twenty-four. They are strong plastically, capture the personalities

sensitively, and are rich and mature in form. Bourdelle had good reason to recommend that they be cast in bronze and exhibited in the Salon des Tuileries (175).

When Giacometti said in 1925 that he had to make a completely new beginning, it was not because he could not create anything worthwhile with the means at his disposal, but because he had something altogether new in mind.

1925–1930–1934
Mannered Figures—Visual Models

The break in my remarks at 1925 does not coincide with the end of Giacometti's sculpture studies at the Académie de la Grande Chaumière. His new conception—"inventing works in my mind" (13; 50)—enters at this point, but he still saw his basic task as gaining an understanding of the appearances of reality and coping with them on paper or in clay. Drawing from the model now lost much of its importance for him, but he never ceased it completely and took it up again with a vengeance in 1935.[13] Even though confrontation with reality remained the central problem, it began to take on new aspects in Giacometti's thinking. Beginning in 1925, he attempted to find new methods, because he could not seem to get at the essence of things using the pre-Cubist conception he had developed, and because the art he began to see in Paris at the time gave him a "new desire" (as had art of another sort in 1914) to work out his own, personal pictorial language.

Figures in the Post-Cubist Manner (1925–1929)

Giacometti's development as an artist between 1925 and 1930 in certain ways paralleled his assimilation of French. During the three previous years in Paris, he had translated his thoughts into French before speaking or writing them, but in 1925 we notice him acquiring many more indigenous speech patterns (mostly Montparnasse artists' jargon), which he used as a native. By 1925 Giacometti had absorbed enough from his surroundings, and was sure enough of his store of creative tools, to be able to "make fluent use" of many different sculptural formulas in his own work.

His new goal was to create artworks on ancient themes—the head, the figure, man and woman—not as images of these subjects alone, but as visualized concepts. This conception of art, new to Giacometti, conformed to a principle which had had validity in both painting and sculpture since the turn of the century. Given its most

viable form by Cubism, this principle was something limited, closed: a figure done in the Cubist style justified itself only in terms of Cubist stylistic principle and not in terms of any relationship to natural form.

The sculptures Giacometti began working on now conformed to this general principle; we should like to call those he did up to 1930 *mannered figures*, and those done subsequently, to 1934, *made objects* and *visual models*.

Many of them were formally inspired by not one but several sources, but even the most critical formal derivation cannot rob Giacometti's post-Cubist figures or his later Surrealistic affect-models of their sculptural quality. No matter how many examples of primitive and archaic art or contemporary painting and sculpture one names as sources, Giacometti's works retain their integrity and overpowering presence.

The most important pre-1935 works—the *Plaques* of 1927–28, the figurative symbols and the perforated "skeletons in space" (13) of 1929, the spatial cages of the *Movable Silent Objects* (1) of 1930–31, the *Emotive Sculptures* of 1932 (13), and the compositions of 1933–34 —were worked out in terms of what we have called the creative process, using creative logic, even though he borrowed many forms from others; he was influenced only to the extent that what is called "inspiration" really consisted of remembered forms coming from his subconscious (7).

For the visual "realizations" of 1925 to 1929–30, Giacometti made good use of the post-Cubist sculpture of Henri Laurens and Jacques Lipchitz, as well as of the nonrepresentational, symbolic presences found in African sculpture. These two means of expression complemented each other in his work. Since Rodin, Despiau, Bourdelle, and Maillol, female beauty has been represented by limiting it to the torso, sacrificing arms, legs, and head to the convention. Giacometti also used this theme for the first in his series of "realizations." *Torso* of 1925 (page 40) was in the post-Cubist manner; *The Spoon Woman* (1926; page 39) was also a torso, conceived as a paradigm of woman—the part below the curve of the "spoon" is a pedestal and does not represent the lower limbs (729: 49). *Torso* is, in the first instance, a construction of balanced masses and vectors, and only secondarily a woman. In no sense is it a stylized female form: the thighs act more as buttresses than as columns, and their upper surfaces are turned away from the body, with no transition to the hips.[14] In this piece, his first, very individual and highly charged torso, Giacometti utilized, down to the last detail, the techniques of Cubist painting and the examples of Henri Laurens's and Jacques Lipchitz's sculpture. He took over a traditional visual vocabulary and made it his own, a language which, strictly understood, need have nothing to do with the language of nature or the reality of

natural forms, but which Giacometti characteristically—more so than either Laurens or Lipchitz—used extraordinarily sensually and formulated with reference to observations of reality.

African art plays exactly the opposite role in *The Spoon Woman*. One could even go so far as to say that, in contrast to *Torso*, she is woman first and composition of forms second. Whatever the real reason behind this work's creation—and the accounts are highly contradictory (718; 729)—no formal moment was as significant in its conception as Giacometti's discovery that the bowls of Oceanian wooden dippers were women's bodies (page 291, fig. 26); not that they looked like the female form but that they *were* torsos, in the sense that, for a child, a piece of wood wrapped in a rag *is* a doll. This is what Giacometti learned from the carvings of Central Africa and Oceania. The essence of reality he found impossible to capture in the realistic portrait bust of his mother of 1925 (723: 44) can be evoked as a believable, magic presence of life by using equivalent forms, signs, and symbols. Through a direct transposition of form into being, a figure done in this manner becomes a cult object.

Of course, the corn ladles from New Guinea that inspired Giacometti are not cult objects, but useful objects, tools; he made more of them than he saw in them; he let himself be inspired by their bowls, which are "bodies" with women's heads on them, and by some African Negro sculptures, for the chest and head of his piece. Laurens and other Cubist sculptors also realized the naive eloquence of African art, but, except for Brancusi, only Giacometti was able to achieve such magical presence using its forms.

Comparisons with other artists are important for almost all of the work that followed. Similarities with the work of Laurens and Otto Freundlich characterize Giacometti's *Cubist Composition* (1926; page 44), *Composition* (*Man and Woman*, 1927, page 42), *Construction* (1927; page 45), and *Reclining Woman* (1929; page 50). Closer to Lipchitz's formal thinking, which Giacometti followed quite closely from 1928 to 1931, are his *Woman Dreaming* (1929; page 51), *Man* (erroneously called *Apollo* (611), 1929; page 52), *Three Figures Outdoors* (1929; page 54), and *Tormented Woman in Her Room at Night* (page 293, fig. 41). Later, Archipenko's sculptures seem to have been the examples Giacometti turned to for ideas (*Woman, Head, Tree*, 1930; page 55, and the slender female figures of 1932–34), but Gonzales and Picasso also played a role. It would be more meaningful to compare works here than to name names, even if this should create the false impression that Giacometti got his decisive formal ideas from this or that particular piece; this applies also for formal comparisons with works of African art (page 291, figs. 23–33).

Primitive art and its forms were uppermost in Giacometti's mind when he made his *Man and Woman* (1926; page 38) and *Little Crouched Man* (1927; page 47). The Surrealists were also interested in African sculpture in the early thirties; they concentrated more on the object and its fetish character than did Giacometti, who was primarily interested in questions of composition and design: *Model for a Square* (1932; page 58), *Disagreeable Object* (page 291, fig. 33), *Disagreeable Object, to Be Disposed Of* (1931; page 63), *Invisible Object* (1934; page 70), and *1+1=3* (1934; page 71).[15] A knowledge of African and Oceanic art was something taken for granted in cultured Paris circles at the time, particularly among artists, at least since Paul Guillaume's first exhibition in 1919 (Apollinaire wrote the catalogue introduction shortly before he died; Picasso, Tristan Tzara, André Breton, and others lent works from their collections), up to the time of the state-sponsored colonial exhibitions which artists, including Giacometti, countered with their own anti-colonialist action in 1931 (708:88). As early as 1929, Christian Zervos had dedicated the second issue of *Cahiers d'art* to the art of Oceania and its significance for contemporary art; his lead article was entitled "Artworks of Oceania and the Present Crisis of Consciousness" (*Cahiers d'art*, Paris 1929: 57–58).

It would be wrong, however, to see these similarities in form and *Gestalt* as strictly formal quotes. Giacometti knew something of the content of African sculpture, which his friend Michel Leiris, who was versed in ethnology, could have interpreted to him, and he also knew how to use it to enrich his own work. If a comparison between his *Little Crouched Man* (page 47) and similar figures from the Congo is justified, one should also bear in mind that these figures were meant for bachelor's graves, to express "the sadness of a man who had no family" (see M. Leiris and J. Delange, *African Art*, London and New York, 1968)—certainly no accidental choice of subject for Giacometti in his first years in Paris (803)—or that they were placed there by a close friend to express his love for the deceased (page 291, fig. 28; see *Wegleitung*, Rietberg Museum, Zurich, 1965, fig. 83). The form of the gravestone Giacometti carved for his father reflects the same sentiment through similar formal means.

Model for a Square (page 58) tells in legendary form with stereometric figures what Giacometti was later to express in mythic form with human figures in the "totality of life" compositions: the expulsion from paradise.[16] Original sin takes on simple forms in this piece: a cone for "woman," a tall stele for "tree," a hollow hemisphere for "head" (thus, for knowledge, reflection, for that which hinders man's integration into nature and which has come between man and woman). These three simple elements were to play the main roles again much later in Giacometti's composition for Chase Manhattan Plaza in New York. That the nonobjective, geometric forms were intended metaphorically is an impression strengthened by *1+1=3* (page 71; a pregnant woman), *The Palace at 4 A.M.* (page 67; the male "self-portrait" in the center), and perhaps also

by *Woman, Head, Tree* (page 55), or *Man (Apollo)* (page 52; sphere and hemisphere as a head). It is particularly important that we see the zig-zag shape as a snake, because Giacometti represented this animal here in the form of the primitive snake-fetish Michel Leiris or Georges-Henri Rivière pointed out to him in the Musée de l'Homme in Paris.[17]

Between these two creative periods, in which Cubist style and primitive sculpture taught Giacometti important lessons in form and content, lie the superb series of *Plaques* (1927–28), with which he had his first real success as a sculptor. We know of no contemporary art which might have influenced these pieces. Giacometti tells us how he worked an entire winter long (50) on *Observing Head* (1928; page 48); significantly enough, these sculptures were not the result of "inspiration." These are his first really important works —and they are the first workings-out of problems of perception he had been battling with for years. He now found a temporary solution to many of the problems he had had at the academy: the difficulties involved in modeling a head from life, such as too many details, no possibility of a consistent approach, huge distances from one side of the nose to the other, the need to spend one's whole life analyzing the complex constellation of forms in the face, and so forth (13). Stylistic conventions had helped him compose figure subjects, but portrait heads were another thing altogether. The individuality of the person he was representing in clay made a confrontation with reality, where no conventional stylistic crutch could help, inevitable. His search for a personal style progressed very slowly through the series of heads of his father and mother, which grew flatter and more two-dimensional with every repetition (page 290, figs. 11–15).

These were his first formulations of an observation which was to have great consequences later—that reality seen from a distance is perceived as a whole and, as such, sacrifices its three-dimensionality and tangibility. In one of these portraits of his father (page 46), the head and personalized features are done in diametrically opposed styles: a smooth plane has been cut diagonally into the sculpted head and the features engraved onto its surface. The second, extremely flattened version of the bust of *Josef Müller* (1927; page 290, fig. 13) has a coordinate axis engraved on its forehead, the traditional means used by artists since the Renaissance to indicate in sketches that the two-dimensional figures are to be understood as volumes. Here, the sculptor has taken a convention in drawing and has made of it a technique of sculpture, to accommodate sculptural form to the two-dimensionality of real objects seen from a distance.[18] Those heads of his parents which are more reliefs than sculpture in the round belong to the last stage in the development leading up to the vertical, delicately modulated planes of his *Observing Head* (page 48). Giacometti had reached his goal: his first personal style.

What had helped most in his search were the conclusions he drew from the great pre-Grecian styles. The flat plaques, like tense sails filled with wind—delicate depressions and engraved forms their only concessions to figuration—have the stylistic assuredness of the primitive and the archaic. Christian Zervos was the first of many to name the art of the Cyclades as the pattern on which Giacometti's *Plaques* may have been based (311); it would, however, be quite difficult to find a reproduction which convincingly supports this assertion. Zervos also recognized disparities between the *Plaques* and those marble idols of 3000 B.C.: "A Cyclades plaque seems self-sufficient with its few [sculptural] suggestions. But in reality it meets all the requirements of sculpture. That is why a work of this kind would lose none of its greatness even if a part of it important to its figurative meaning were to break off, for each fragment is full to the bursting point with plastic force." (Giacometti said the same of Sumerian sculpture, but not until 1957 (20).) Zervos's quite justified criticism goes on: "If, on the other hand, some piece or other were to break off the work exhibited by Giacometti [*Man*, in the Galerie Bernheim, 1929[19]] one would discover that the piece became incomprehensible, so greatly does its unity depend on fictitious rather than any real and present sculptural quality." (311: 472) This is true. In some of the plaques which followed *Observing Head*, entitled *Man* or *Woman* depending on their details (which were rather more skillfully placed than sculpturally necessary), the metamorphosis of Giacometti's style applied more to artistic figuration than to his perception of reality.

The *Plaques* were Giacometti's first step in "freeing himself from Cubism." This is the phrase Lipchitz used to describe the development of his own style during the same years;[20] his transparent bronzes of 1926–30 (*sculptures ajourées, transparentes*) offered Giacometti new pictorial material for some of the pieces he made in 1929 and 1930, but which were filled with very personal and vehement feeling (*The Couple*, page 53, *Three Figures Outdoors*, page 54). At the same time, Picasso and Gonzalez were creating their wire sculptures and stick figures, inspired by Russian Constructivist work of the early twenties; on these Giacometti also based compositions (which were subsequently lost—he sketched two of them in *Movable Silent Objects* (1)) that were precursors to his cage sculptures (*Suspended Ball*, page 57, *Cage*, page 56) and paved the way for *The Palace at 4 A.M.* (page 67). After 1930, Lipchitz returned to a stylized pseudo-Cubism with monumental proportions. Giacometti, however, ten years his junior, saw the Surrealists as the avant-garde: "It was the only movement where something interesting was happening." (67)

Surrealist Visual Models (1930–1932)

The Surrealist creative principle whereby material chosen at random is juxtaposed according to pseudo-logical aesthetic ideas (which require no justification because the unconscious act of creation justifies anything and everything) to produce the strongest possible emotional effect: this represented, for the twenty-nine-year-old Giacometti, a release from the strict stylistic inbreeding characteristic of post-Cubism. He began to build on the success he had scored in Breton's circle with his *Suspended Ball* (page 57), a transition piece from the disciplined, economic use of form to playful visual juggling (with erotic overtones). In the Surrealist conception of art, he found a way to express the emotional and philosophical content of his idea of the "totality of life." But he was first and foremost a sculptor who coincidentally worked for a time as a Surrealist. That is why his works—together with those of Hans Arp—are among the best and most significant the Surrealist movement produced.

Giacometti's Surrealist interlude of 1930–33, which he picked up again between 1947 and 1951, almost cries out for an analysis of the sources and meanings of the forms it produced. One often has the impression that Giacometti's ambition during this period was to give fresh sculptural form not only to his experiences but also to other works of art that he could not purge from his thoughts in any other way.[21]

The *Project for a Passageway* (1930–31, page 293, fig. 43; in 1947 Giacometti retitled it, more innocuously: *Design for a Corridor* (13)) reminds one of the title and formal language of Marcel Duchamp's painting *The Passage from Virgin to Bride* (page 293, fig. 40). The piece—seen full-length from above—seems to be the plaster model of an erotic fantasy. Duchamp and Giacometti gave an anatomical expression to the content of Gauguin's symbolically titled composition *The Loss of Virginity* (1890), which is represented by a naked girl stretched out on the ground before a fox. Giacometti incorporated the equivalent of the fox's role into another work done at almost the same time, *Disagreeable Object* (1931; page 291, fig. 33). The quasi-medical directness of his treatment of sexuality reveals that Giacometti now belonged to the inner circle of Surrealists around André Breton.[22] The *Gestalt* of the female in his copulation piece transposes not only the title but also the formal content of Duchamp's Futurist-Constructivist painting quite well into sculpture. Giacometti's contemporaries were well aware of these associations; Anatole Jakovski's criticism of a Surrealist exhibition held in 1933 is a case in point: since Duchamp, nobody had come up with anything new, he said, and now everybody had had enough of ovaries and castings of certain parts of the body, all painfully psychoanalytical and terribly overdone (331).

The cones and spheres of Picasso's series of *Projects for a Monument* (1928–29; page 293, fig. 38) must certainly have coauthored the forms in Giacometti's *Suspended Ball*, but Giacometti made of them something so new and immanently necessary that the work had a strong effect on his new friends among the Surrealists (373) and still has now on anyone who sees it. It is among his most brilliant and very personal creations. The framework surrounding the hanging object delineates a limited space, but only incidentally; it functions primarily as a platform and setting for the visual model. In his sculpture *Cage* (1931; page 56), which is similarly rich in content, the box around the forms serves to represent space to an even greater degree, insofar as it heightens the already passionate drama of love, violence, and death played within its narrow confines.

Giacometti used his "cages" to dramatize themes and forms (a ball for a head, probably masculine; a pointed shape or spindle for the phallus; a spherical segment, squat cone, and oval plates for the female body, zig-zags for the backbone, rib cage, or skeleton) which he and other sculptors and painters, even non-Surrealists, used; but in these pieces they are compressed both in terms of space (narrow, enclosed) and in terms of time (as in a play) so that the work becomes a showcase, a private theater of revelation and mystery: this is the Surrealist conception of art and Giacometti's contribution to the art of Surrealism. I have been able to formulate no better interpretation of Giacometti's difficult pieces *Three Figures Outdoors*, *Suspended Ball*, and *Cage* than that given by a few selections from Henry Miller's *Tropic of Cancer* (1931–33):

> In a sense Van Norden is mad, of that I'm convinced. His one fear is to be left alone, and this fear is so deep and so persistent that even when he is on top of a woman, even when he has welded himself to her, he cannot escape the prison which he has created for himself. "I try all sorts of things," he explains to me. "I even count sometimes, or I begin to think of a problem in philosophy, but it doesn't work. It's like I'm two people, and one of them is watching me all the time. I get so goddamned mad at myself that I could kill myself . . . and in a way, that's what I do every time I have an orgasm. . . ."

Giacometti, like Miller, transcends the sexual problems he describes by generalizing them. In the title of one of his works, *Woman, Head, Tree*, he names the elements for the myth of the expulsion from paradise, which very apparently represent much more than one act of copulation. Like Giacometti, Henry Miller used the metaphor of a head locked in a cage to describe the battle of the sexes, a hopeless battle: "The drama, he thinks, is going on inside the cage. The cage, he thinks, is the world. Standing there

alone and helpless, the door locked, he finds that the lions do not understand his language. Not one lion has ever heard of Spinoza.... The lions, too, are disappointed. They expected blood, bones, gristle, sinews...."

The theme of cruelty, of inflicted and suffered pain, was among the shock techniques of Surrealism from the time Buñuel made the film Un Chien Andalou in 1929. Giacometti, too, used such techniques in his sculptures, but he always saw something beyond them. The original title of Point to the Eye (1932; page 64) was Dissolving Relations. This piece is also a visual model: an elongated, phallic cone and a skeleton with backbone, rib cage, and skull stand at opposite ends of their shared base, separated by a notched line, the point of the cone almost entering one of the skull's eye sockets: an optical shock, an extremely direct representation of the emotional experience of a love affair which has come to an end, which has to be broken off in spite of its continued potency.[23] We see the same masculine aggressiveness in the jointed doll in The Hour of the Traces (page 293, fig. 36); a heart hangs within the framework on which the doll is standing; this "hour that leaves traces" is the moment of both conception and death at once. Both works have this incomprehensible and yet necessary polarity in common.

Woman with Her Throat Cut (1932; page 65) is the second version of an original which was closely related to Picasso's and Lipchitz's work, called Tormented Woman in Her Room at Night (1932; page 293, fig. 41).[24] Only fragments of this have survived; we know how it looked complete only from photographs. Its theme is more powerful than that of Woman with Her Throat Cut: nightly recurring, existential anxiety is more terrible than a quick and cruel death. Though what Giacometti expressed in this first version is a common, generalized human experience, in the later version he evidently tried to find his own, more organic forms, though they were still not quite independent from Picasso and Lipchitz, in order to create a more striking metaphor of existence than he had found in the earlier, post-Cubist composition.

Even the human fingers threatened by the moving cogs and wheels in Caught Hand (1932; page 64) express, as naturalistically drawn as they are, more than mere pain. The original title Courrounou U-Animal (323:338) defined mankind (the hand is definitely human) as the angry creature (courroux = anger) at the mercy of the machine (courroie = transmission belt).[25] When one thinks how often the theme of torture as the nexus of man's existence arose in the work of Giacometti's contemporary, André Malraux (in La Voie Royale, 1930, for example: torture as the test of the final, irreducible reality of man), it cannot satisfy us to interpret Giacometti's sculptures of cruelty simply as Surrealist shock objects. An author who was later to have great importance for Giacometti, Hegel, formulated the

warring, suffering, and fear of mankind's existence after paradise had been forever lost: "Spiritual reconciliation [can] be seen only as an attempt to grasp the movement of the spirit, as a process in the course of which unending strife and battle take place, and [in which] pain, death, the deep despair at nothingness, the torture of the spirit and physical being occur as a significant moment" (Aesthetik, Werkausgabe 1843, Vol. 10²:127).[26]

Giacometti expresses all the potency such a "significant moment" contains in the cocked sling threatening a flower in Endangered Blossom (1933); here, too, the Surrealist model of a moment of crisis becomes, in Giacometti's hands, a model of the world.

The attempted reconciliation of the spirit with itself, represented as a continuing process filled with strife, pain, despair, death— Giacometti realized this Hegelian description in a series of works expressing the "totality of life" as the polarity of death and rebirth.

No More Play (1932; page 66) is a death-happening. In the center, the graves are waiting; one already holds its skeleton. Grave and coffin have been fused together with an amazing economy of sculptural means, and their covers lie ready to close them. Craters on both sides of the row of graves denote a battlefield. In one of the indentations stands the motionless figure of a woman. Opposite her, with the graves between them, a headless figure raises its arms in the gesture of capitulation: man surrenders, man is through playing the game, the game is over, or, much more: no more playing here, death plays for keeps.[27]

Another "game board" of this period seems to express the opposite sentiment: life is like a game without end, without redemption or rest, an eternal circuit. If we interpret the ball in its circular groove correctly (Circuit, 1931; page 60), as a metaphor for "man"—or perhaps more exactly as a masculine head, as in the Model for a Square (page 58), Woman, Head, Tree (page 55), and Suspended Ball (page 57)—then this piece presents the myth of paradise lost in the most elementary terms: the ball will never reach the hole ("woman") next to its circular path.[28] It is easy to see the similarity of this composition with that of a much later work, The City Square (1948–49; page 122), where four men walk back and forth before a woman without nearing her. (We shall show in another context how this composition affected Giacometti's concept of the Chase Manhattan sculptural group.)

For a detailed understanding of Giacometti's development, it would be important to know the chronological sequence in which No More Play and Circuit were made. It is, I think, logical to see Circuit as formally the more organic, more conclusive, and clearer statement and hence the later of the two versions, just as the later Woman with Her Throat Cut states the theme of the Tormented Woman in Her Room at Night in a formally more balanced and

classical manner: Giacometti's stylistic development did take this direction during the course of the year 1932. The next work he did was *Life Goes On* (1932; page 293, fig. 42), in which one can see a direct counterpart of *No More Play* insofar as Giacometti etched their complementary titles conspicuously into their bases.

In very early and much later reproductions, this piece carried other titles,[29] but the sentence engraved on it is the key to an understanding of both its form and content: the large object standing on the indented plate is a pregnant woman's body; her head is indicated by a hemisphere and her backbone by the steplike serrations on her side; on the other side is the arch of her belly. She has turned her back on the deathly scene: directly behind her lies an open grave. The rest of the surface, with its two cones and a crater, seems to represent a battlefield, like the cratered landscape of *No More Play*. The most important part of the sculpture is, however, the woman's body, carrying within it the seeds of continuing life. Giacometti executed this figure separately and on a larger scale in his piece *Caress* (1932; page 62) just as he did with the elements of *Model for a Square* (page 293, fig. 39): apparently we are on the track here of the same composition approached by several series of visual realizations.

It is tempting to see *Caress* as an abstract sculpture belonging to the family of Hans Arp's formal innovations, made at about the same time, but its title forces a figurative, almost anecdotal interpretation. Here again, the convex curvature is the belly of a pregnant woman, and the staggered cuts on the edge of the piece are shorthand for the backbone. The hands on both sides of the slender (if seen frontally) arched body are those of the man, caressing the woman. The interpretation "renewal of life" comes immediately to mind (as it does with a slightly later piece, *1+1=3*; page 71); the woman with child is seen subjectively, from the man's point of view. The only part of his own body he sees are his hands. When looking at this work, the observer automatically shares the point of view of the man (or the artist)—a unique experience, one that we meet here for the first time, and one that introduced a new theme into the art of sculpture. The first time this piece was reproduced, it was with the title *Despite the Hands*; Christian Zervos explained that Giacometti wanted to leave the hands of the plaster model out of the final version in marble (323: 342). If this title actually expresses the original idea behind the piece rather than having been chosen for a reproduction "in spite of the hands," then one could interpret the hands' movement over the unborn child as aggressive, hostile, yet ineffectual—in the same sense as the "man" in *Man, Woman, Child* (page 61) is a sharply pointed triangle directed against the "child," which is always protected by the "woman" moving between them.

The most mysterious work of this period is *The Palace at 4 A.M.* (1932; page 67); Giacometti himself spun a web of legend-like statements around it from the beginning, in which others have been caught up (7; 117; 718; 729; 810). It has been called the masterpiece of this period, but how strong is its sculptural effect really? Compared with *Cage* of 1931 (page 56), which Giacometti executed in wood in 1934 and called *The Palace at 4 A.M. III* (the third version) (363:77), it looks like a stage design next to a fully worked-out dramatic presentation. Taking the first two versions of this piece, in plaster (323:342; page 294, fig. 51), and in wood (7:46), the plaster model, which still has all the feeling of being a rough design, is the more authentic of the two.[30]

Giacometti borrowed the basic structure of his palace from a reproduction of a set design done in 1922 for the Meyerhold Theater in Moscow (page 294, fig. 47). He also made use of a photo of another set design—a scene from Tairov's staging of Ostrovsky's *Storm* at the Moscow Chamber Theater: the different levels, the platform running from one to another, and above all the female figure standing in front of the rectangular forms at the left, with her spool-like armless body (actually, she has her hands behind her back and her elbows give the silhouette) all point up this relationship (*Cahiers d'art*, 1928:75). But Giacometti says the woman and rectangles have another meaning: she is his first memory of his mother in a long dress before a curtain: "*I opened my eyes for the first time* in front of this curtain." (7) There is probably another memory bound up with this figure and its background—that of a painting by his father: *The Stone Carriers of Promontogno* (1896; page 294, fig. 49). This could very well be the first painting the boy Alberto consciously saw, identifying the women in their traditional costumes with his mother. We may assume that Annetta Stampa, then twenty-five years old, stood for the main figure in the painting; at least that is how the family story goes. It must have touched Giacometti to rediscover one of the stone carriers he remembered in the Tairov stage photo, wearing the same costume and standing in the same position, down to the angle of the elbows.

However, the most direct derivation of Giacometti's rectangular pieces and stage sets of the *Palace* was from the Surrealist landscapes of Jean Lurçat, which Christian Zervos proffered in *Cahiers d'art* (1929:198–207; page 294, fig. 48) as an alternative to Cubism. Proscenium-like planes float at different levels through these paintings, against a background which could just as well be clouds as water, in a light which is neither that of night nor day; each painting has three stages for dreamlike plays separated from each other by spare constructions of boards, poles, and walls. If we look at their color scheme, composition, and "mood," we realize that these paintings are variations on a theme Arnold Böcklin treated in an idealistic-realistic manner in *Toteninsel (Island of the Dead)* (1880,

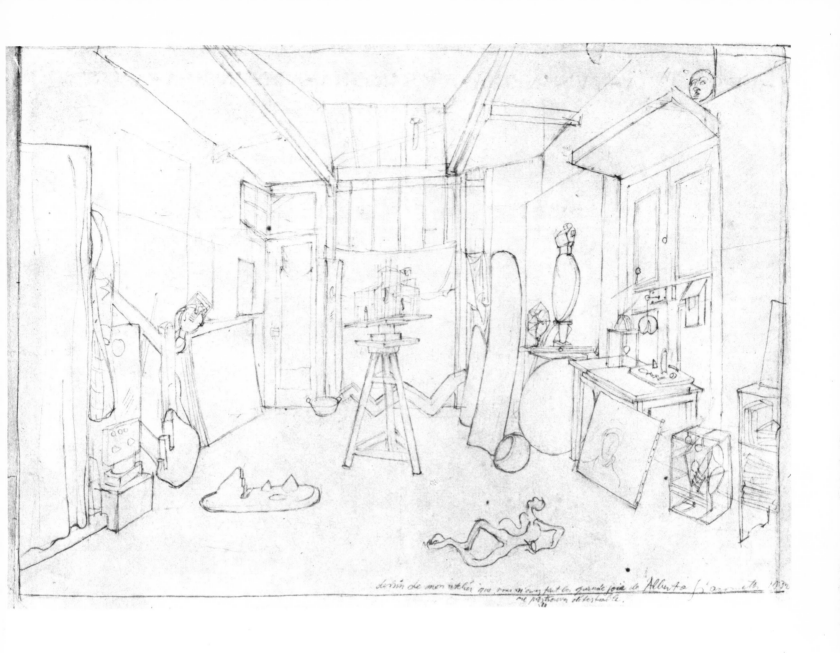

dessin de mon atelier que vous me envoye fait la grande joie de Alberto Giacometti 1932
ne pas trouve et tout a le.

Alberto Giacometti

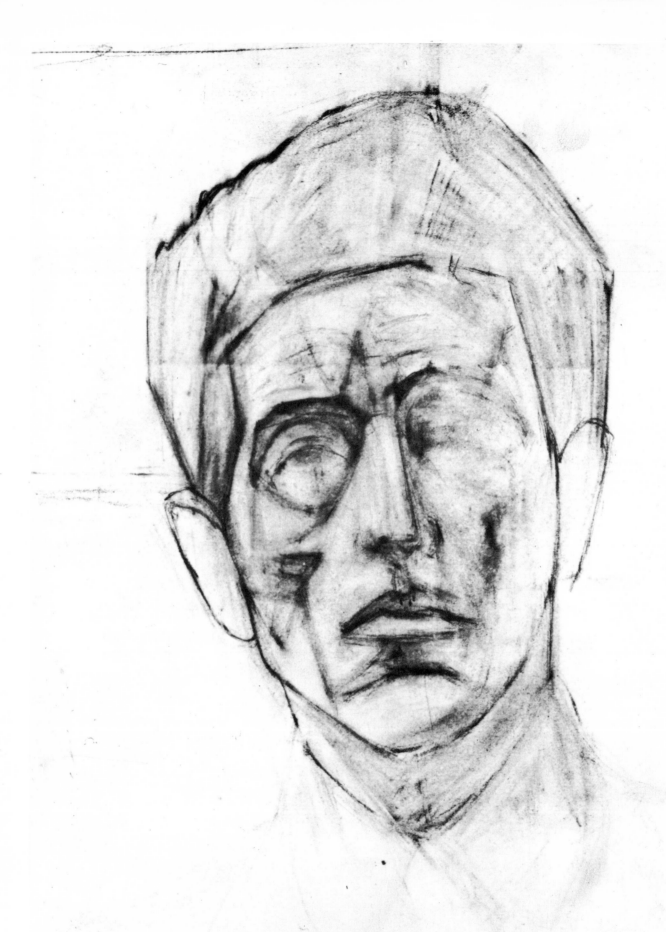

Alberto Giacometti 1935.

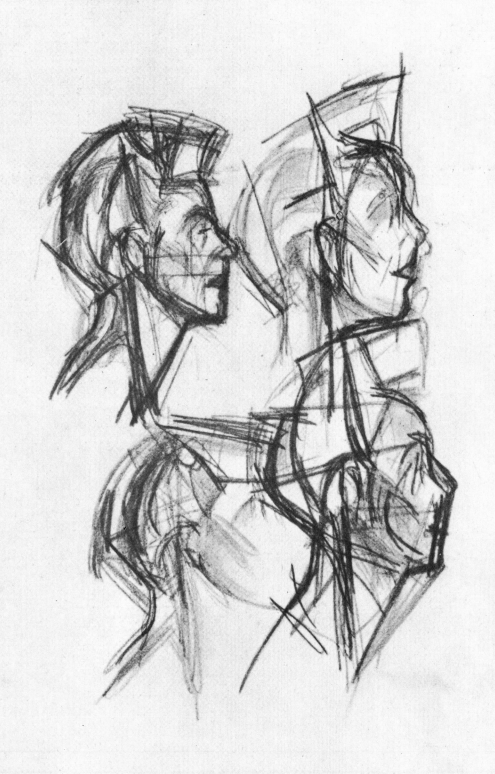

Alberto Giacometti

89

Alberto Giacometti
1942

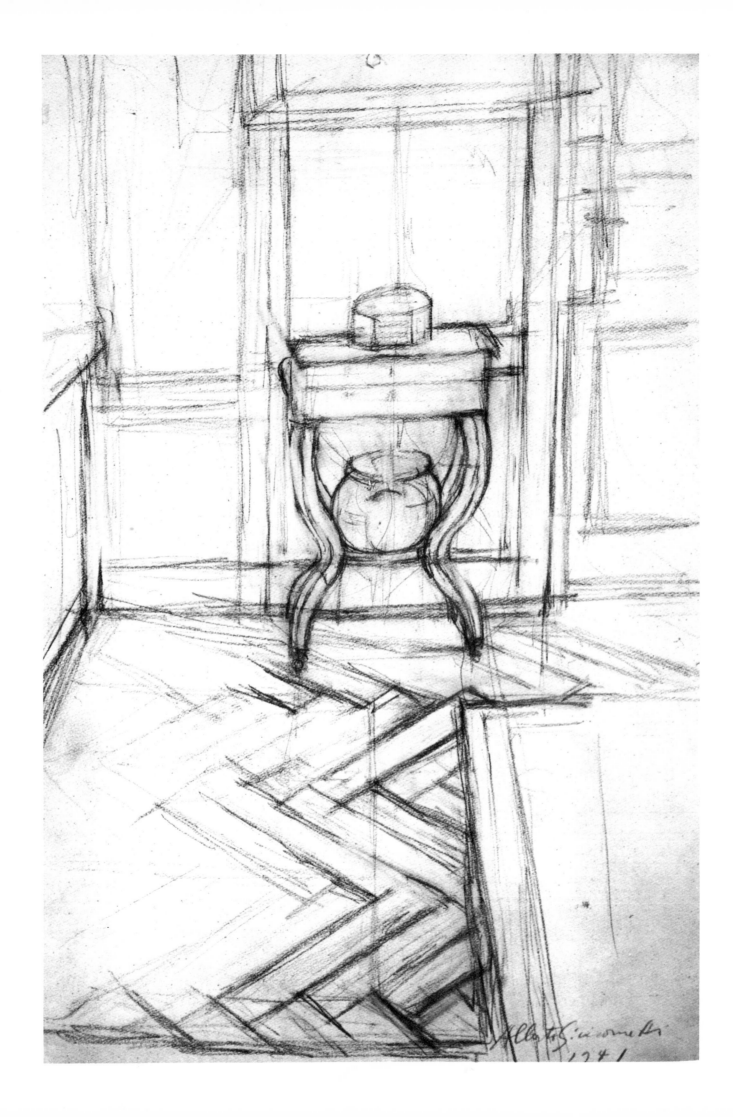

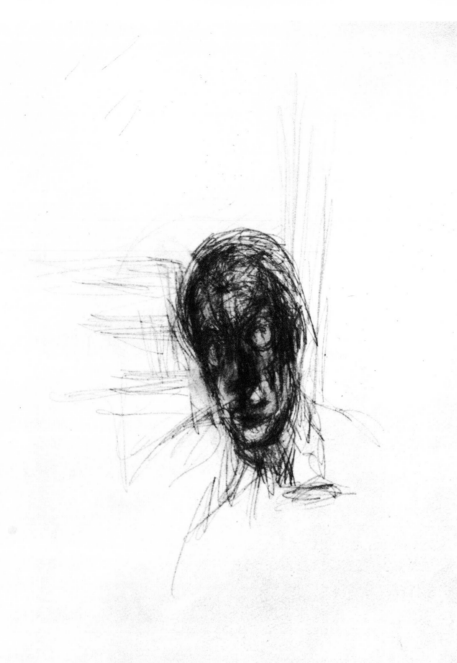

Alberto Giacometti
1946,

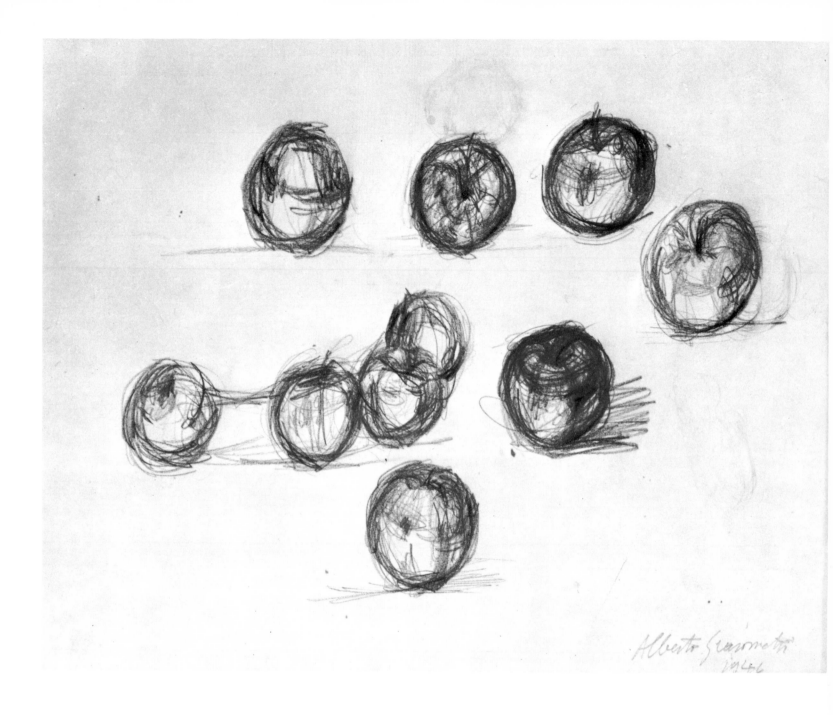

98

Alberto Giacometti,

Kunstmuseum, Basel; page 294, fig. 46). It seems almost as if the Surrealists were competing among themselves to find new pictorial realities in this "bourgeois," heavily symbolic, and almost occult painting; we have no explicit proof to support this contention, but paintings made by other artists at the time show the degree to which Böcklin's *Toteninsel* occupied the Surrealists' attention[31]—and Giacometti's, as seen in *The Palace at 4 A.M.*

Giacometti's composition is the mirror image of the *Toteninsel*. There are the three elongated rectangles, all in the same perspective (the doors to the tombs), overshadowed by the triangular form of the cliffs; on the other side the rectangular, flat-topped building (the chapel; in Giacometti's *Palace*, the two frameworks with backbone and bird skeleton); and in the middle, between the two massive blocks, rise the long verticals of the cypresses, just like the four masts of the central tower in Giacometti's composition. Halfway up the tower a platform for the central figure is suspended, representing Giacometti himself (7)—in Böcklin's painting, it is a bright rocky spur. The shrouded figure in Böcklin's boat reminds one in its symmetry of Giacometti's "mother" figure.

Any uncertainty as to the relationship between the two compositions disappears when we look at the platform of Giacometti's *Palace*: it corresponds to the water that Böcklin painted like the surface of a mirror, reflecting the island cliffs and isolated from foreground and background. Man Ray photographed the *Palace* in exactly this sense in 1932 (323:342; page 294, fig. 51): the base was invisible and the composition "floated" before a black background. Brassaï photographed the mirror effect of the platform in 1933 (7:46). This photo also approximates the Böcklin painting, especially as the base lies in shadow. The newer Museum of Modern Art photos of the *Palace* were made, quite correctly, without the lost base (731:45).[32]

Giacometti made autobiographical comments about *The Palace at 4 A.M.* which reveal nothing about these formal relationships; they tend instead to mystify the piece, as this half-revealing, half-concealing sentence shows: "After the object-artwork has been produced, I may recognize images, impressions, and events in it that have (without my knowing it) touched me deeply, and also forms which are familiar to me, although I am usually unable to identify them, which makes them all the more confusing to me." (7) But this is all part of the Surrealist approach to artwork. It is a piece of stylized prose which does, however, contain some valuable hints; Giacometti goes on to say in so many words that the piece was a psycho-drama, that the figure on the left was his mother, that the backbone and bird skeleton stood for his experience with a woman he loved who "concentrated *all of life* within her" (7), and that the pod-shaped form in the middle symbolized himself.

Thus far the palace-island, like others of Giacometti's works, treats the general theme of procreation and death. For the personal emotion that went into the work, we must turn to the sketch Giacometti made on the reverse of a drawing of the *Palace*, now in the Basel Museum: a severe profile of his mother, facing left, with staring eyes, enclosed in a rectangle; to the right of this, a female nude in pencil, the contours softly repeated again and again, without arms or eyes (defenseless), sitting in profile to the right; another person, indicated only by hands and eyes, caresses her belly (page 294, fig. 52). Shortly thereafter Giacometti made a sculpture with this theme, the small bronze *Mother and Daughter* (page 290, fig. 19).

Giacometti quite often played the novelist when commenting on his work. He once said slyly of *Disagreeable Object, to Be Disposed Of* (page 63) that its real title was *Family Portrait*, "and it is by no means an abstract piece. Back then I was in love with a girl who had a sister who was lame. That—these conical pegs—is her, her sister, and their little brother. . . ." (372:178)

We have to admit that this piece is best understood if we see the front of it as a face, as in *Observing Head* (page 48) of 1928, and the two pegs on the flat back simply as supports (like the original base in the form of a stool for *Cube*, 1934), which hold the face-plate in a diagonal position. Thus the stylized representation of the face becomes an object, and the base a part of the artwork.

This kind of mystification, these associations and autobiographical quotes, as well as Giacometti's deference to the rules of the Surrealist game, rob *The Palace at 4 A.M.* of its direct sculptural force. But for the next two years, Giacometti apparently thought of his work in terms of the staging of ideas, in a more or less coded form. We should like to call these pieces "résumé compositions," aesthetic progress reports of a sort, and name a sculpture and a drawing as examples: *The Table* (page 69; page 294, fig. 53) and *Moon-Happening* (*Lunaire*; page 87), both of 1933.

In *The Table*, Giacometti put the cards he had been playing up to now on the table, so to say. This piece was done for a Surrealist exhibition in the Galerie Pierre Colle in June, 1933, a collection of about a hundred "objects." Dali wrote a catalogue text, which was not printed due to the protests from Giacometti and Ernst; it included the following note: "Does anyone still remember that dirty painter who called himself Cézanne?" (159) A long list of the colorful objects was printed however; among them were "symbolically functioning proofs of friendship." (324) This might have been a reference to *The Table*, for the forms and sculptures Giacometti arranged on it are homages to Brancusi, Léger, Laurens, Magritte, and perhaps others, who had all contributed to his style.

With the typical Surrealist penchant for bridging the gap between art and reality, Giacometti supplied, as a part of the artwork, the

table on which his proofs of friendship were to be spread. He repeated this idea several times later, once for the Pierre Matisse Gallery exhibition in 1950, when he supplied long-legged, table-like bronze bases for *The Cage* (page 129) and *Four Women on a Base* (page 128).

Giacometti's Surrealistic *Table* is in many ways similar to René Magritte's painting *The Difficult Passage* (1926; page 294, fig. 55), where a similar small table is given a fourth, human, leg; a dummy's hand with projecting thumb lies on the table, just as in Giacometti's work; a lathe-turned baluster stands next to it, with an eyeball for a knob—the right rear leg of Giacometti's table is a cross between this baluster and a human leg. Its right front leg is a homage to Brancusi's *Endless Column* (1918). The bust of a woman quotes the two plaster busts of girls in Magritte's picture *The Two Sisters* (1925); the curtain which hangs down behind the table in that painting has been transformed into a scarf covering one of the woman's eyes—as in Henri Laurens's *Head of a Woman*, done in 1922 (her braid of hair is also an early formal quote from Brancusi's *Endless Column*). But the woman—only her upper body visible above the table surface, holding a small stoppered bottle before her—she comes from Léger's *Large Breakfast* (1921) or from one of his earlier or later variations on the theme (*Woman at Table*, 1920; *The Little Meal*, 1922). She has long, wavy hair that (like the scarf in Giacometti's piece) almost covers one eye (page 294, fig. 54).

In 1914 Léger had interpreted the same motif in Cubist terms (*The Small Breakfast*) of cylinders, cones, and cubes, which he reformulated at the beginning of the twenties as spheres, circles, and arcs. Léger's aesthetics are quite clear here: he wanted to find an organic transition between the purely geometric forms of Cubism and the natural forms of the human body. And this was precisely Giacometti's goal in the years 1933–34. The polyhedron on Giacometti's table—a precursor of the slightly later piece, *Part of a Sculpture* (*Cube*; page 68)—represents, in extreme abstract form, a head (723:49). The mannequin's hand on the table is the opposite, an extremely figurative and nonabstract way of formulating human reality. Perhaps it represents the whole body, just as the similarly drawn hand in *Caught Hand* (1932; page 64) defined the human being as an animal experiencing pain and anger.[33]

For Alberto Giacometti, this résumé of post-Cubism and Surrealism contained the seeds of the problem which he had described in his first letter to Pierre Matisse: a work of art must have a style that is aesthetically as precise and true as a nonobjective geometric body—which he had put on the left-hand side of his table—and yet be filled with all the conscious and unconscious human experience gained, in real life, from contact with others, from the touch of a hand: the hand on the table stands for these. The woman with her half-covered face is like a sphinx deciding a question of fate. The

small dish with its long-necked bottle is a brilliant touch—it invests the work with a touch of reality—the sideboard— and is piquantly erotic, too.

The pen-and-ink drawing entitled *Lunaire* (page 87; *Moon-Happening* might be a suitable translation), which Giacometti probably did in 1933 (722) and not in 1935 (708), also treats the theme of approaching stylistic change in his art in the form of a psycho-drama. Dense cross-hatching shrouds the scene in a gray fog. At the lower right is the nonobjective form of his sculpture *Cube* (page 68), done from a plaster model he had made, lighted from the left as if by a spotlight. Above it, a human head appears out of the darkness, lighted not from the left but from the right. Judging by the proportions, the invisible body of the man (which we might imagine to be as slender as Giacometti's post-1932 female figures) could be standing just as far forward "on the stage" as the polyhedron. What does the dialogue in this "moon-play" sound like? One would like to think of it in terms of a debate between Brancusi's conception of art and Rodin's; between a self-sufficient, nonobjective art form and a metaphorical, associative one: precisely Giacometti's quarrel with himself at this point in his development. That the polyhedron is also a self-portrait may be assumed from the fact that Giacometti later etched a self-portrait onto one facet of his *Cube*. The right-hand contour of the cube in the drawing is missing; the future, hidden in darkness (as Paul Klee would have said), is open. But the iconographic source for it is to be found in Dürer's etching *Melancholy*.

Metaphors of a Compositional Idea (1932–1934)

We would be placing the emphasis wrongly for the years 1930–35 if we were to touch only on the Surrealistic works Giacometti did at that time. In 1932, the attraction of André Breton and his circle began to dim for him, and he turned to Louis Aragon (803). For a few months Giacometti dedicated his work to the Marxist revolution —much more intensively than Breton, who put "le Surréalisme au service de la Révolution" (the title of his magazine from 1930 on) in name only. Using a self-chosen pseudonym, *Ferrache* (approximately: "Iron rod," from "*fer*" and "*cravache*"), Giacometti drew political, social-revolutionary caricatures for the periodical *La Lutte* (*The Battle*—according to its program, an anti-religious, anti-imperialist battle) published by Louis Aragon and Georges Sadoul (104; 206). He answered a poll sponsored by the magazine *Commune* on the question of the future of painting ("*Où va la peinture?*") with a drawing which showed a man greeting the masses demonstrating for justice and freedom with his raised fist (225). And, in a style similar to Socialist Realism, he sculpted a banner carrier with a

huge flowing red flag; he destroyed the piece only a short time later.

The commercial work Giacometti did to support himself should also be mentioned here. "I really didn't want to play the artist and make a career for myself.... I thought about pieces of jewelry I could design." (67) And then he made them, for Elsa Schiapparelli. Working together with his brother Diego, Giacometti applied just as much work and skill to the interior decoration of the Schiapparelli and Lelong fashion houses, to the backgrounds for Man Ray's fashion photos (201:225), to plaster draperies, and decorative objects of terra-cotta and bronze, as he did to his art. Working for the mondain interior decorator Jean-Michel Frank (from 1929 on) meant being on a par with men like Christian Bérard or Henri Laurens and furnishing exclusive private houses in Paris, business offices in New York, and apartments in Teheran (61; 104). Even Jacques Lipchitz made sculptures for the Louis XV salon of Coco Chanel, a newly risen star in Paris and Elsa Schiapparelli's most serious competitor. These sculptures were just as often works of art (*Reclining Woman*, 1927) as they were purely decorative objects (andirons for the fireplace). It would be wrong to characterize Giacometti's *Fire-Dogs* (738: fig. 4) as works of art or to catalogue them as an especially expressive variation of Surrealism because of their frightening snouts; but the geniality of the forms he chose for their rib cages, their backbones, or their "disagreeable objects" help us better to understand similar forms as they appear isolated in works such as *The Hour of the Traces* (page 293, fig. 36) or *Point to the Eye* (page 64).

Aragon tells us that, in deference to these commissions, Giacometti decided not to publish a particularly biting caricature which might have offended Jean-Michel Frank's clients and in which Elsa Schiapparelli would surely have recognized herself (104). Here, Giacometti became personally entangled in the conflict the Surrealists were going through: on the one hand, fashionable people like the Vicomte de Noailles were the Surrealists' patrons—he commissioned several pieces from Giacometti—on the other hand, the revolutionary program demanded solidarity against the *Salon Hyenas* (as one of Giacometti's political caricatures is called). By acting on principle, Giacometti acted in character.

Giacometti's various stylistic attempts and areas of work flowed together in 1933 and 1934 to form one large uncertainty in his mind. He felt that he had "let himself be developed" instead of developing (67), that he was "off the track" (723:59), that people expected "nothing more than variations" from him (67), that "the mystery" (61) was missing from his work if it was no longer creative and there was absolutely no difference between a vase for Jean-Michel Frank and the things he called works of art (61). A round plaster vase by Giacometti was reproduced as *Untitled Sculpture* (1936; page 290,

fig. 21) in an international survey of nonobjective, geometric avant-garde art done at the time (364: pl. 7; very similar pieces were reproduced as a vase and a lamp pedestal in *L'Œil*, Paris, 1963, No. 101: 49 and 54).

Giacometti refused to be involved in the object-cult of Surrealism or the form-cult of the *Abstraction-Création* group, which was attempting to unite various streams of concrete painting and sculpture in the Paris of the time. He felt he would have to put himself to the test of drawing from the model again some day, "although I was certain from the start that I would fail again." (61)

Contained in these statements is a possible way out of the crisis: working eye to eye with reality, letting the consequences be what they may. This is exactly what Giacometti decided to do in 1935. At first he trusted himself only with rather obscure compositions, but his conception soon began to change, and the law governing the development of a pure, personal style began to take effect. This time, Giacometti found no solutions to his problems in the work of Laurens and Lipchitz. He began to search for that absolute, closed, and hence seemingly classic style that Duchamp-Villon, Brancusi, Archipenko, and Arp had already found or were in the process of finding. He wanted a style to express the mysterious but concrete presence that supraindividually composed forms lent to, say, tailor's dummies or show-window mannequins (he did a female figure in 1933 called *Mannequin*, with the head and neck of a bass viol on her shoulders), those commercially useful representations of the typical, average human form, of man in the abstract.

The density of form he often achieved is shown by his group *Mother and Daughter* (1933; page 290, fig. 19). To understand this small bronze, one has to know the joke Giacometti told one of his relatives about it—that it represented a mother bringing her daughter to a brothel. This interpretation was meant perhaps only half-jokingly; after all, the piece shows a mother figure (the same one that appeared in *The Palace at 4 A.M.* the previous year) and she is hand-in-hand with a striding young girl, as if she were a link in the unending chain of generations of mothers—a composition and an idea Giacometti very likely intended to express in *Walking Woman* (page 70) and *Invisible Object* (page 70) and very definitely repeated in *1+1=3* (page 71), all done about that time.

Giacometti began now to model his work on Egyptian sculpture, in which the laws of style, natural forms, and expressive content were all successfully united; his goal was a similar unification. The hierarchical, frontal figures of the Old and Middle Kingdoms that simply sit or simply stand, for all eternity, taught him that complex truths, which he had tried, up to now, to express in stage sets and machine-like compositions and in his visual models, could be expressed in one single human figure.

Giacometti's *Walking Woman* (1932; page 70) is at least as much indebted to the slender, simplified Egyptian princesses with their one foot slightly advanced in the direction of death as it is to Archipenko; the strange, interpretation-defying plate and the toes of the woman in the *Invisible Object* (page 70) came from the crouching cubelike figures of the Hatshepsut period exhibited in the Louvre. The figure itself (we have already mentioned an Oceanic death idol as a possible pattern for it) shares the secret of its raised arms and hands holding the "invisible object" with a statue of which Giacometti made a drawing, Queen Karomama, of one of the later dynasties, who carries before her an invisible idol holy to Isis (703: pl. 30).

This esoteric approach to art was still very much in the spirit of Surrealism, of course: Giacometti was still seeing enough of André Breton for Breton to be able to report on Giacometti's difficulties in working (118). But we should like to think the title contains an ironic twist with which the artist distanced himself from his work: an *invisible* object carries Surrealist object-oriented art ad absurdum. And because this piece was once called *Mains tenant le vide—Hands Holding the Void—*(13ª; 122:351), one detects an ambiguity worthy of Duchamp: *Maintenant le vide*, and now—after everything else—emptiness.... The bird of death at the side of the chair's seat says clearly that the composition means something else, too: it treats the same myth Paul Gauguin once called *Where Do We Come From? What Are We? Where Are We Going?* (1897, Museum of Fine Arts, Boston). In this painting the Tahitian women, the birds, the god-image, and the landscape have been composed into an allegorical frieze of death (left), birth (right), and life (center); Giacometti, however, compressed into a single figure all the different arm positions (therein lay his main problem in designing it, according to Breton), poses, faces, and meanings, and transformed it into a metaphor.[34]

Can we even guess at the identity of the invisible object? The two "realizations" that preceded this piece, *Mannequin* and *Walking Woman* of 1932, both have a triangular indentation under their breasts at about the height of the heart, but on the center axis of the body. The cone-shaped female figure of *1+1=3* (1934; page 71) has a similar hollow, and hands are drawn on the surface in the same position as those the *Invisible Object* figure holds out before her. So it could be that the hollows also represent the "invisible object"; or, better, the spaces left for it. Is it the seed of a new life, waiting to be fertilized? There is no doubt that these four female figures treat the same basic theme, like the pregnant torso caressed by similar hands, standing before an empty, waiting grave in the piece with the engraved motto *Life Goes On* (page 293, fig. 42). The theme is one of the continuation of life (striding forward in

the case of the walking woman) and is the counterpart of the death theme in pieces like *No More Play* (page 66).

The series taken as a whole shows that Giacometti was not merely making Surrealist objects during these years, but was trying to actualize a comprehensive compositional idea. (This will be examined in greater detail below.) The idea was inspired by the "two or three young girls" he saw in Padua in May, 1920 (17); he formulated it for the last time in the *Standing Women* for Chase Manhattan Plaza in New York (page 260).

Giacometti wrote of his sculpture *1+1=3* that it was the last figure in a series where he tried to combine the natural human forms which fascinated him with the nonobjective forms which he thought were correct for sculpture (13). He said he had failed with this piece. Another of his works succeeded better: *Head (Skull)* of 1934 (page 72). According to the title Giacometti gave it in a sketch he made of it in 1947 (13ª), it is meant to be a skull (*Tête-Crâne*). It is formally related to the face of the woman in the *Invisible Object* (page 70), but the abstraction is carried much further, its effect resting almost solely on its diagonal planes and reentering corners, which is why the work was recently dubbed *Cubistic Head* (733; *Cubist Head* would have been better). It is extremely expressive in spite of its high degree of abstraction; seen in profile from the left, the head, with no neck or base separating it from the surface on which it rests, reminds one strongly of the "head" in the composition *The Hour of the Traces* (1930–31; page 293, fig. 36) as well as the *Head on a Stalk* (1947; pages 114 and 115)—which suggests that this theme, too, occupied Giacometti for decades, from the head of the dying Van M. (12; 67) to the *Chiavenna Head* of 1964 (page 266).

In terms of content, this sketchy Cubist head or skull seems to be a supplement to the *1+1=3* composition. In 1926 Giacometti began to juxtapose the opposites, man and woman, in a series of similar works; in 1930 or 1931 he began substituting a head for the whole man, placed over and against the full female figure, and in 1932 the polarity of life (going on) and death entered the picture. Were both works, even though they were individually conceived, meant as congruent parts of the same compositional idea, Giacometti's vision of the totality of life?

The key may lie in the other version of the male head Giacometti did in the same scale of *1+1=3* and which, like it, he left unfinished (page 68). He exhibited it in Lucerne in 1935 under the title *Part of a Composition* (338: No. 33). In 1947 he did a drawing of this very abstract, monumental head in the list of works he sent to Pierre Matisse, and called it simply *Cube*. In the drawing, it rests on a pedestal set on four thin poles which resembles an African ceremonial chair. He and his brother Diego constructed it expressly for

Cube. Giacometti told James Lord in 1964 that *Cube* was meant to represent a head (723:49). But it is not an "abstracted" or "stylized" representation of a real head; *Cube* is a *monumental head on a pedestal*, in other words, a representation of a work of art, not of reality, which calls to mind the huge late-Roman bronze heads of Constantine and also the Constantius in the Capitoline Museum in Rome, a piece which earlier stood out in the open on the Capitoline Hill.

The male represented by a sculptured head: as the thinking, seeing artist reproducing himself (Giacometti engraved a self-portrait into the surface of *Cube* before having it cast in bronze); the female in $I + I = 3$ as the continuum of reality—that was the "totality of life," at least as Giacometti saw it at the time. In April, 1933, Picasso did an etching, one of a long series on *The Sculptor and His Model*, which shows a nude young girl in the foreground gazing at a large sculpture of a man's head on the modeling table. With his myth-creating powers of expression, Picasso prefigured in this etching a compositional idea that was to obsess Giacometti for decades.[35]

Circuit (1931; page 60) formulates—as did *Model for a Square, Woman, Head, Tree,* and *Suspended Ball* before it—the head (male) as a ball, which rolls unceasingly around the circular path cut into the board (the "square"), again and again passing the indentation (woman), which would mean repose, the final goal. It is easy to see the compositional similarities of this piece with a much later work, *The City Square* (1948–49; page 122), where four men walk back and forth before a stationary woman, never reaching her. Ten years later another piece based on the same composition appeared, the project for the Chase Manhattan Plaza group: a man walking, a stationary woman, and a huge head on a pedestal. Here we see, for the third time, how one compositional idea kept its force over a number of decades; the form it took here is a sculptural synthesis of two visions of 1920 and 1921. When Giacometti began working from the model again, he was concerned solely with "collecting enough sketches to have them at my disposal later; in other words, in order to make compositions and create works." (60)

If we admit that the conceptual significance of these works and the length of time they took to do indicate how important their theme was to Giacometti, we can understand why, in late 1934, his friends heard him say that he had no other ambition besides getting his sculptured heads to "work" (159): the head was the key to his great compositional idea of the "totality of life."

When Giacometti began drawing from the model once again it was, as Sartre said, exaggerating only slightly, a question of all or nothing (383). It was an experiment to see if the art of sculpture was still possible. While the Cubist, Surrealist, and nonobjective styles all held to the old conception of the nature of sculpture—that it was the rendition of a volume, a three-dimensional object, in space,

which stood as an analogue or cipher for reality—Giacometti used the old themes to try to get at a new conception of sculpture. Getting a head to "work" meant for him giving the image all the power contained in the living reality of the head, and communicating just how powerfully the existence of an object affects the artist.

Somewhat later Giacometti wrote that the object played the decisive role in every artwork, even if the artist himself was not aware of it: "The plastic quality of a work of art always depends on how strongly the artist was concerned by his subject; the power of the form always corresponds to the intensity of this concern." (11) In order to reach a deeper understanding of a work of art (Giacometti closes in this essay on Callot), one must find the source of the work's theme and how it affected the artist—and not necessarily with Freudian methods. This conclusion is not only a complete repudiation of Surrealism, it also hints that Giacometti's themes and subjects came from a deeper level than his affective biography. They represent visions, and the realizations of these visions may be called by the name always given them in the history of art and civilization up to now: myths—symbols for the most ancient and basic realities of life.

1935–1940–1946
Art as a Confrontation with Reality and Existence

By the mid-thirties the *années folles* of Montparnasse and the "moveable feast" that Hemingway and many others enjoyed in Paris were a thing of the past. *Cahiers d'art*, the most important forum for contemporary art in Paris, organized an auction of many works which it had collected and published with conviction, "to heat the stove during the crisis."[36] The great Surrealist exhibitions were still to come, but the fact that Surrealistic activities spread out into so many areas after 1935 was an indication that the period of highest creative intensity had passed. Avant-garde magazines conducted surveys on the future of painting, on the crisis in art and the crisis in sculpture—and, significantly enough, on the crisis of the Surrealist object (336; 343). Some thought it was time for a new Cézanne to appear on the scene (331); but Derain, for years a symbol of secure market values, extolled as "France's greatest living painter" (by, among others, the painter André Lhote and the art historian Élie Faure), was unfortunately not the new Cézanne. Alberto Giacometti saw two things in Derain's example: the scurrilous, cultured, yet superstitiously intense life at the time the Breton circle courted Derain, applauding the master when he launched the *bon mot* about his Bugatti being more beautiful than all the artworks

in the world; and then, in 1935, Derain's breakdown when his dealer Paul Guillaume died. If Giacometti was deeply affected by Derain's *Still Life with Pears on a Dark Ground* the following year (18), it was not due to the picture's quality or lack of it; he realized a truth about fate and Derain's situation: the artist confronted by a reality which is always larger than he is and which condemns his works to failure before he begins them; the artist who cannot believe in any of the artistic conventions, yet who wants to produce a classic art and to reproduce a little of the appearance of things, who carries on the battle, which can never be won, with a bit of blue and a bit of red on his brush. Derain, the bravest and most frustrated artist, Giacometti said twenty years later, his most important teacher after Cézanne (18)—not in terms of artistic technique, of course, but as a pattern for the artist's life.

All the great works of the time reflect what began happening in Europe in 1933: instead of *Swimming and Saving Games* (1932) Picasso turned the emotion of his expressive forms into a cry of fear in *Guernica* (1937). And when Malraux programmatically named his book on the Spanish Civil War *Hope* (1937), Sartre, a year later, found the word which was to stand like a banner over the next decade: *La Nausée* (1938)—"disgust" might be a better translation than the generally accepted *Nausea* (see note 54). The suffocation of the prewar years replaced a frenzied peace. Breton's autobiographical novel about the years of dream-realities, *L'Amour fou (Insane Love)*, was an anachronism when it appeared in 1937. The philosopher Maurice Merleau-Ponty countered Breton's pseudo-perceptions about the confrontation of the ego with things as described in the chapter "*L'Équation de l'objet*" in which Giacometti is also mentioned (118); the parallels between Merleau-Ponty's writing of 1936–45 with Giacometti's work of the same period are astounding; Giacometti was working intensively at reproducing in sculptural form the way a person really appeared to him from a distance, and Merleau-Ponty was writing his principle work, *The Phenomenology of Perception*.[37]

The New Beginning (1935–1940)

Giacometti's separation from the Surrealists was not the cause but the result of his new creative search. One could call the break in 1935 a brave and "existential" decision, a free choice; in any case, he had to take the consequences: "I lost all my friends and the interest of the dealers in the process." (67)[38] But his decision was made only with the intention of getting away from the feverish activity of the Surrealists and the social revolutionaries just long enough to work out his own "compositions with figures" (13) by a careful study of

reality, trying to find his way back to a closer fidelity to reality and a more powerful means of expression.

What he had in mind was not necessarily in contradiction to the general Surrealist approach, but his thoughts were incompatible with the latest, more dogmatic and nonaesthetic, Surrealist productions. Giacometti's goal was to replenish his imaginative store by turning back to nature, so that he might formulate new (and this time, original) stylistic laws to help him express his personal vision. An important part of his personal conception of art was the value he attached to his perception and observation of reality; this being the case, his work was never really compatible with the associative super-real creative methodology of Surrealism. But it was only much later that Giacometti ran up against the last, impenetrable (and even unreachable) level of reality, that of *true* realities; in 1935 he wanted nothing more than to look at and, if he could, comprehend reality, using it to create myths like those the vehicle of Surrealism had carried in his best works before 1935.

André Breton misunderstood Giacometti completely when he remarked on the frivolity of his work: everybody surely knows what a head is (107). Giacometti never intended to fall back on naturalism; he was working toward a phenomenological realism. How right he was to consider this a great adventure (61) became clear after fourteen days of studying the model. The reality of a living human head held him because he felt that it was impossible to approach it at all. He was having the same trouble as the painter G., described by Baudelaire in his *Le Peintre de la vie moderne* (1860; the painter was Constantin Guys): "It even sometimes happens that painters like G., who have long been accustomed to using their memory and enriching it with images, find their time-tested abilities disturbed and feel lamed when confronted with a model and its abundance of details." Giacometti described his difficulties in much the same way: "At first I saw nothing... (70) Nothing was as I had imagined it." (13) "I saw only the uncountable details of the head. The more I studied the model, the thicker the veil between its reality and me became. I ran into insuperable difficulties." (61)

What was the "veil" between the reality of the model and the sculptor viewing it? Giacometti had once used a similar metaphor in his poem *Le Rideau brun* of 1933; expressed in prose form, it goes like this: "No human face is as strange to me as a countenance which, the more one looks at it, the more it closes itself off and escapes by the steps of unknown stairways." (3) It was two years before Giacometti began to lift the *Brown Curtain* (so the poem's title in English); the stylized forms of his *Mannequin, 1+1=3* (page 71), *Invisible Object* (page 70), *Cubist Head* (page 72), and *Cube* (page 68) released him from the obligation of studying the model to learn the language of the head and face. The veil that fell between reality and

he artist was woven of all the stylistic conventions that Giacometti had learned from boyhood and which had helped him formulate his works up to this point: "At first one sees the person posing, but little by little all the sculptures one can imagine interpose themselves." (61)

But now Giacometti wanted to see nothing else except what he *really* saw: reality.

Thus he began the project which was to occupy him until his death. It was the cornerstone of his later oeuvre, a project which had remarkable parallels with contemporary thought; when Giacometti said: "There were too many sculptures . . . and when they were all pushed out of the way, an unknown person sat there, so that I no longer knew whom I was looking at and what I saw" (61), he was describing a basic experience in the perception of the Other, as not only Merleau-Ponty, Sartre, and Camus, but also Beckett and many of the *nouveau roman* authors were to do. However, at this point Giacometti was initially and primarily concerned with the pictorial problems of "compositions with figures," whose content still came from earlier experiences.

Of course he could have sculpted a head—if not in two weeks then in four—which would have had real formal quality. Those sculptures of Diego, Rita, and Isabelle which have survived prove this (pages 73, 74). *Egyptian Woman* (1936; page 290, fig. 17) is also a case in point. For even if his works of 1936–39 are not particularly original, they do have a compact, "leathery" tension which communicates some of the individual's presence as Giacometti experienced it. The construction of the heads, both as drawings and in their final sculptural form, is based on the scheme of geometric facets Giacometti had used at the academy in 1922–24 to capture the total volumes of heads. Looking at this series as a whole, one sees that, first, this geometric scaffolding loses more and more ground to modeled, natural forms with each successive head (they lose "style" and gain naturalness, which seems at first to be a regression to more traditional sculptural ideas), and that, secondly, the heads become progressively smaller. This diminution in size stemmed from discoveries Giacometti was making in the field of perception.

"In order to see the head as a whole, I had to place the model farther and farther away. The farther away she was, the smaller her head became." (61) This sentence seems to be perfectly logical. But according to Merleau-Ponty's *Phenomenology of Perception*, this is not at all the case:

Is not a man two hundred paces away smaller than one who is five paces away? He is smaller when I take him out of the total perceptual context and measure his apparent size. Seen from another point of view, he is neither smaller nor the same size; rather, he is beyond the concepts "size" and "smaller"; he is the same man seen from a distance. One can only state that a man who is two hundred paces away offers my eye fewer perceptions of less clarity. . . . One can also say that he takes up less space in my field of vision, if one keeps in mind that "field of vision" is not a measurable concept. When one says that an object takes up less space in one's field of vision, that means in the end that its form is not rich enough to exhaust one's ability to see sharply. . . . Thus its apparent size cannot be separated from its distance: it is an integral part of it, just as, vice versa, distance is a part of apparent size. (*Phénoménologie de la Perception*, 1945:302.)

So Giacometti's observation was correct, but the conclusion he drew from it—in his many statements on the subject (60; 61; 64; 71) as well as in his work—confused two things: he did not get any closer to the total, overall form of the head by putting distance between himself and his model, as he had intended; instead, he approached the form of the head *as seen* from a distance. He thus discovered a new theme, a new subject for his work: he introduced the depiction of physical distance into the three-thousand-year-old art of sculpture.[39]

Initially, Giacometti's new work attested to the real distance between the object and the eye perceiving it. Later, he filled this effect of distance with a metaphorical content (and his figures and heads were then no longer tiny, but tall and thin) the better to express the distance to the soul, the unique reality of the Other. In order to reach this point, Giacometti, who had begun by replacing familiar and conventional ways of seeing with true records of actual appearances, had to work out new artistic conventions himself—pedestals of a certain size for certain-sized heads, for example, or whole towers of pedestals, larger and larger bases for ever more tiny figures, platforms, walkways, boxes, cages. . . . And from a certain point on, he must have understood smallness as an art form, as a style, to be able to say that he wanted to create the effect of a deity in the size of a matchstick (158).

In order to confront reality in every possible way, he experimented for a time with plaster casts taken directly from the model. The results were "terrible. These large formless surfaces may represent the physical reality of a person, but they in no way resemble a fellow human being, they resemble nothing that we see of him." (67)[40] Distance plays a part in the way we really see a person. But frontality is part of meeting him: "One doesn't walk around a man like a tree." (217) These are two insights Giacometti never forgot.

The external truth Giacometti discovered when confronted with the model was soon enriched with an affective content, the mental image of a friend as he had seen her on the Boulevard Saint-Michel. This image sparked the process by which Giacometti's figures began

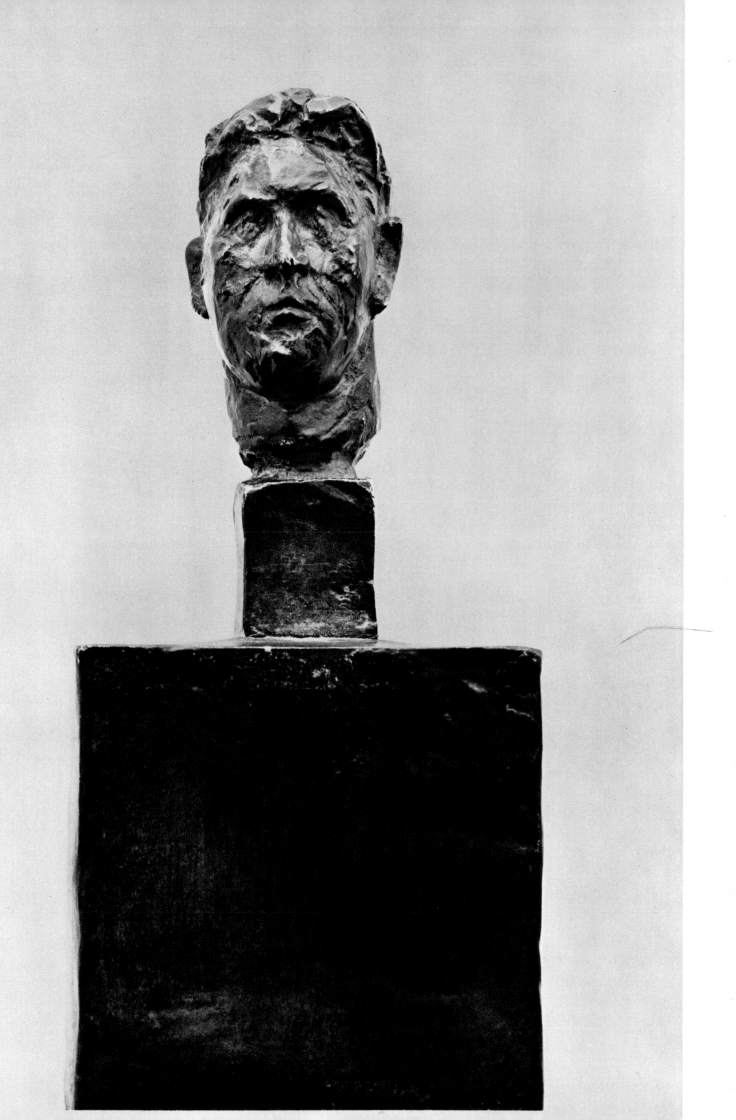

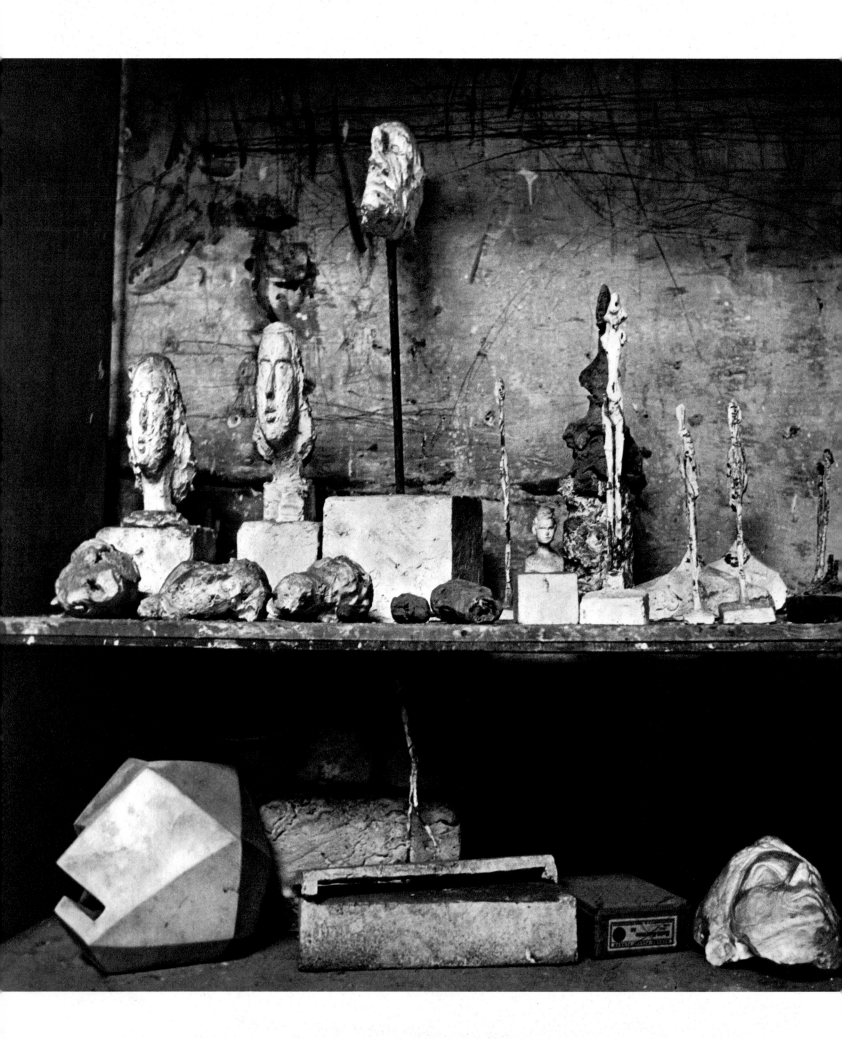

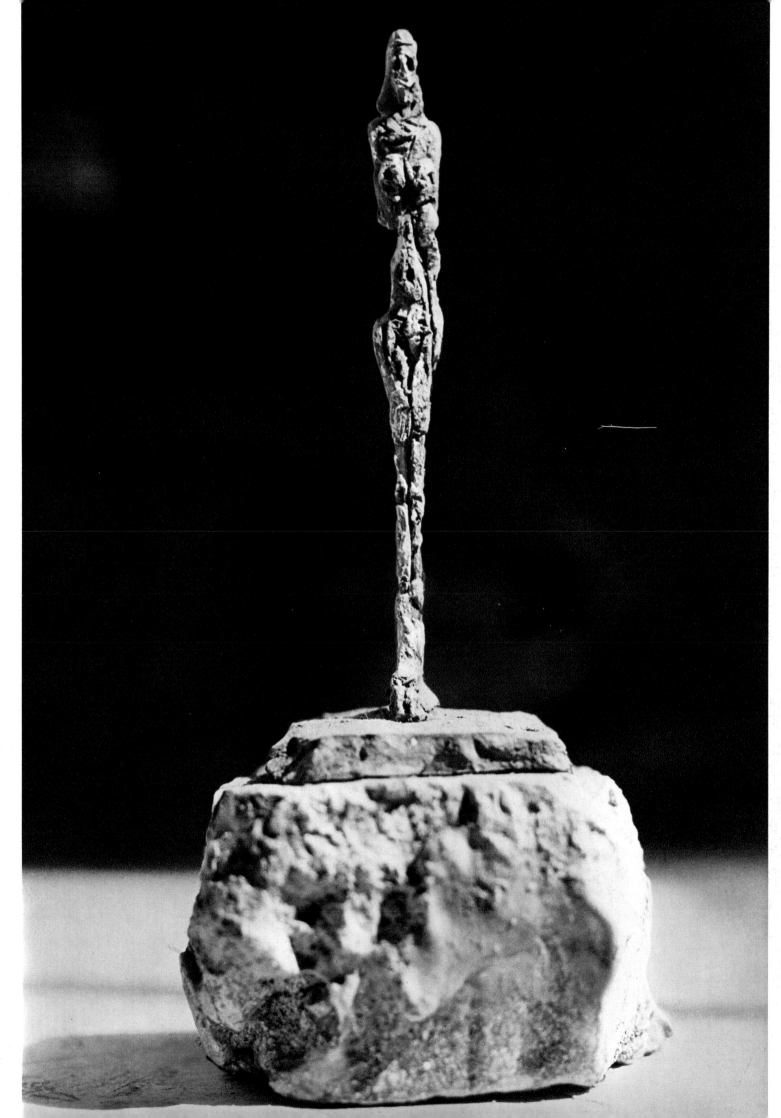

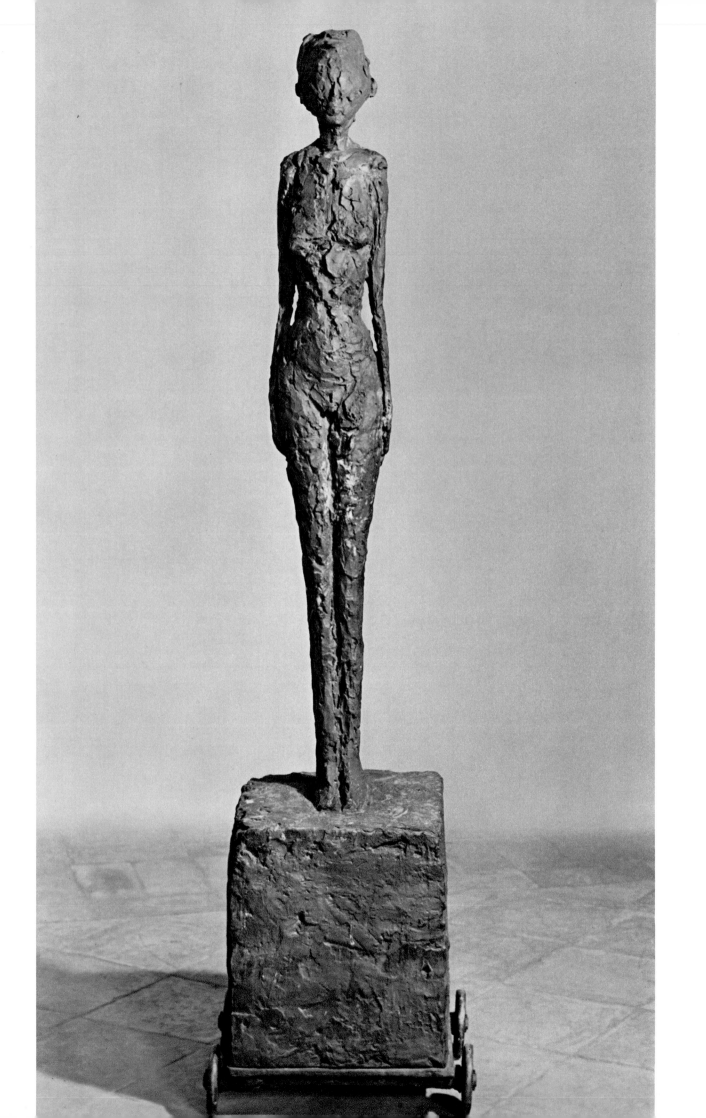

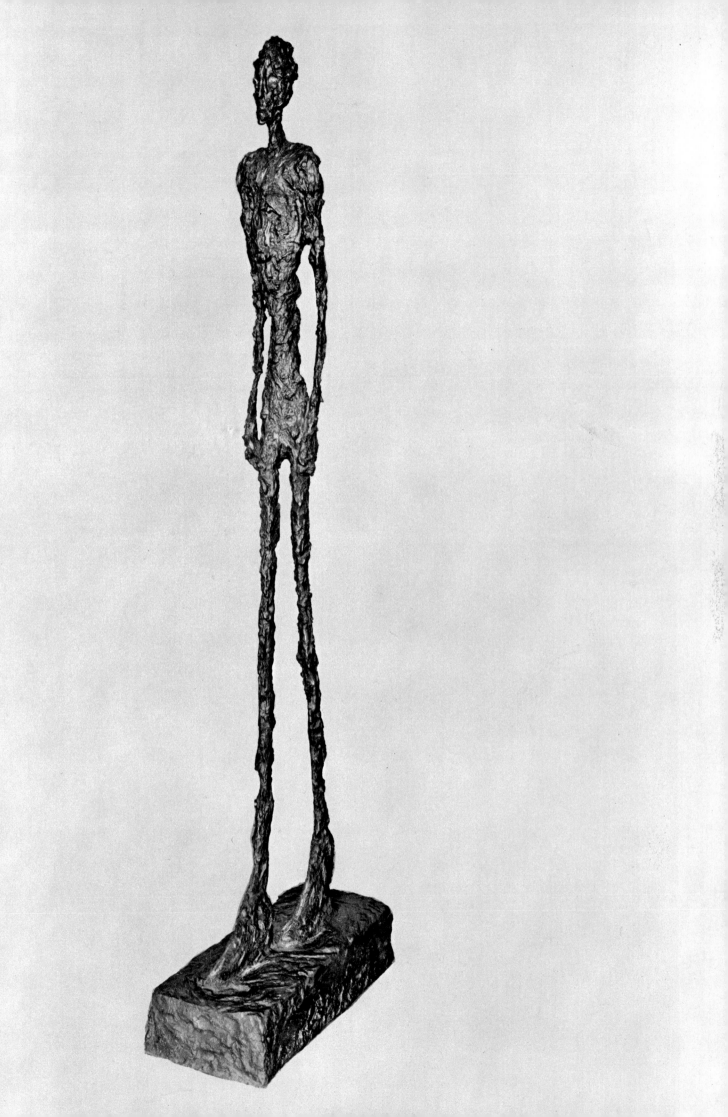

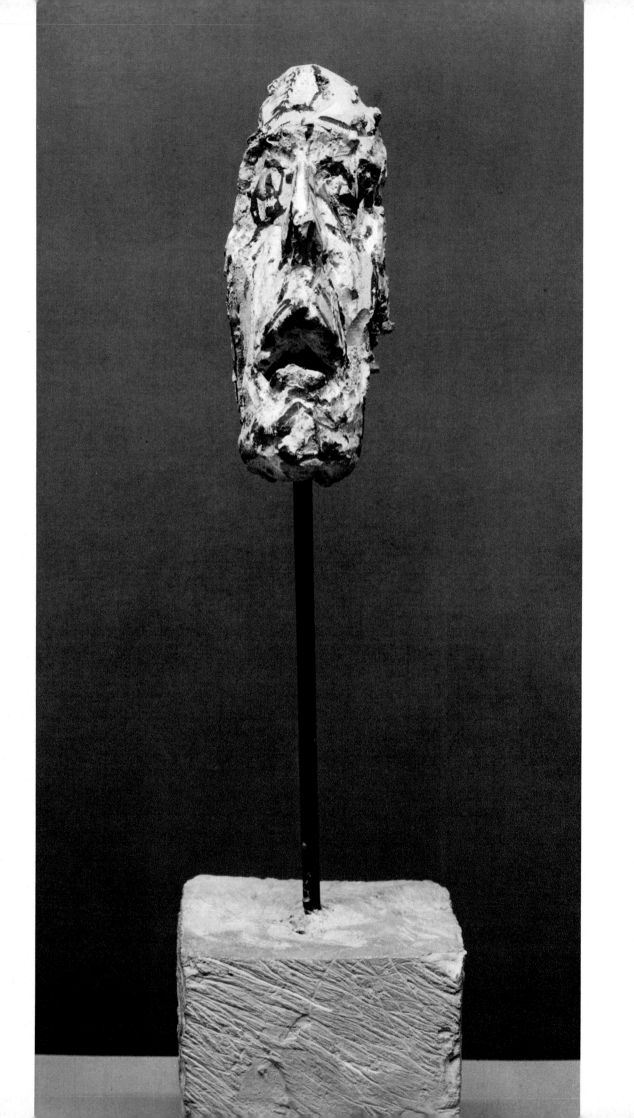

114

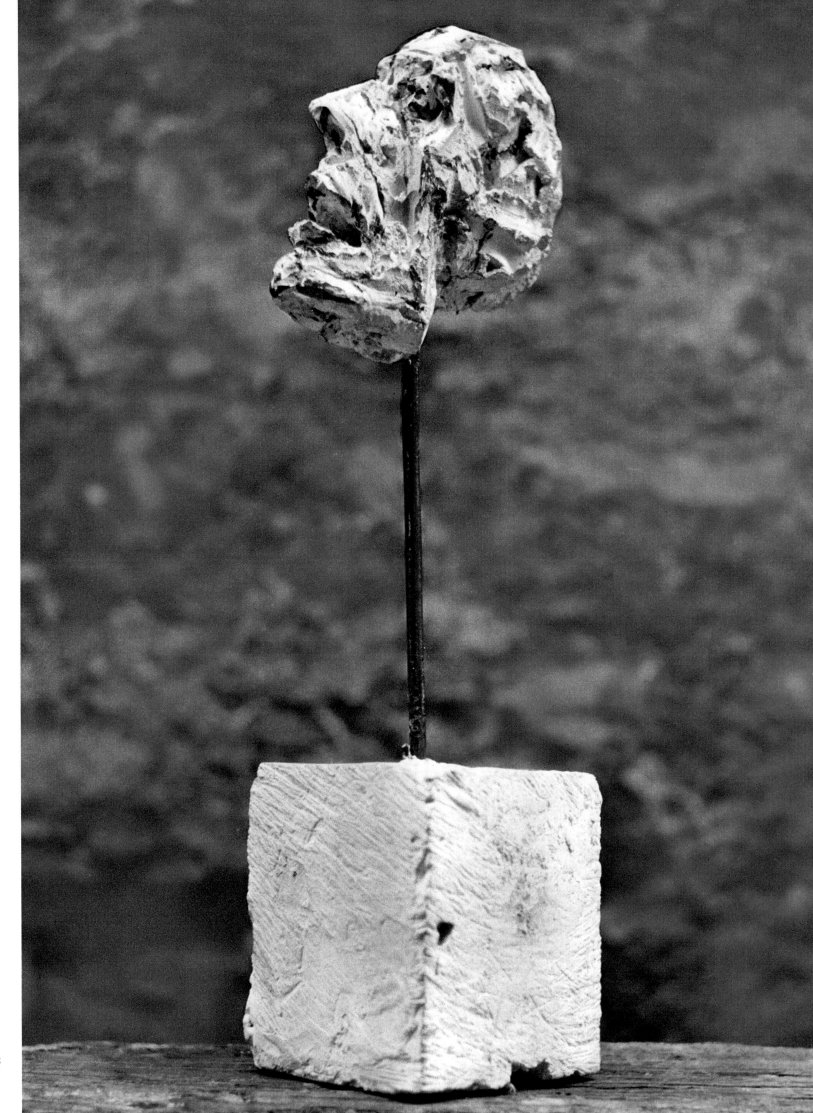

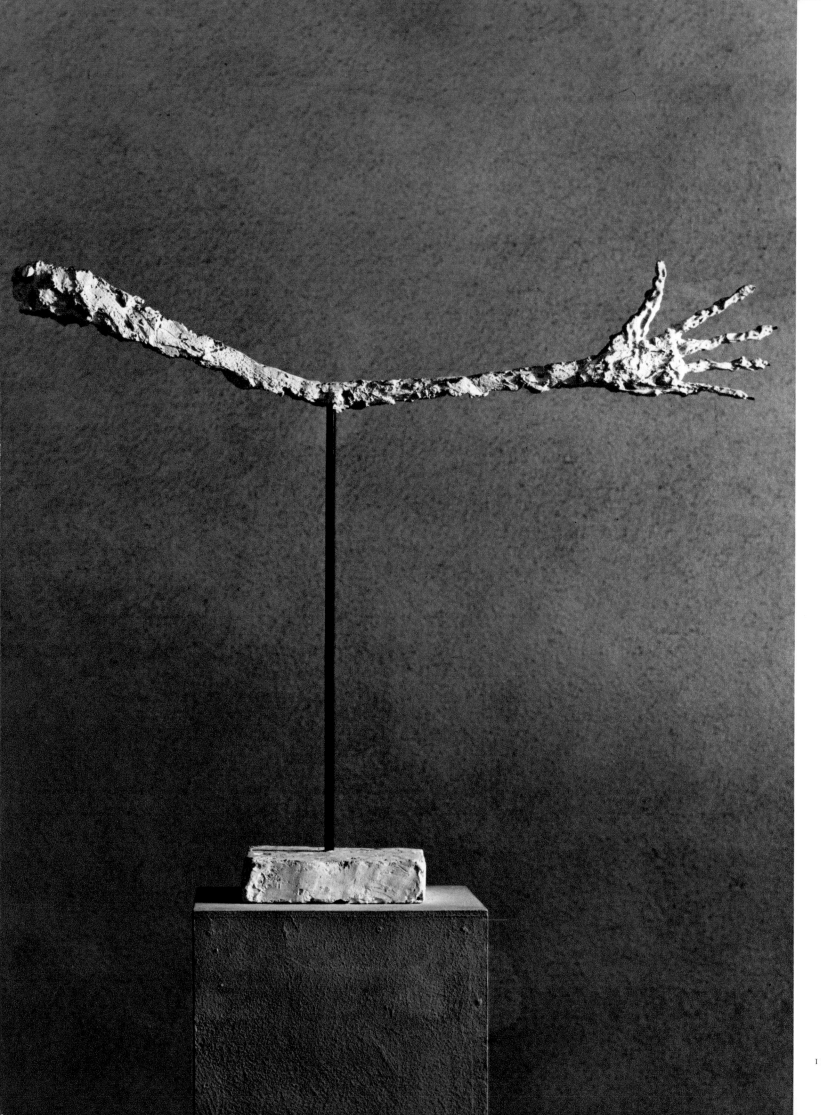

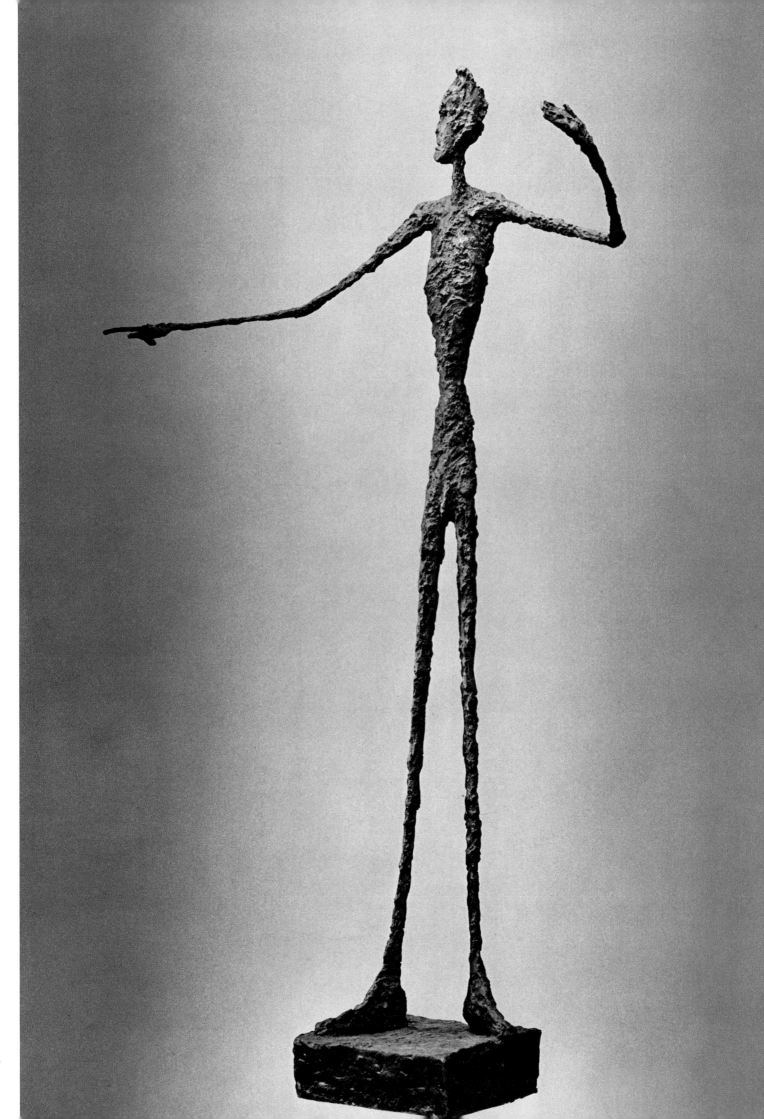

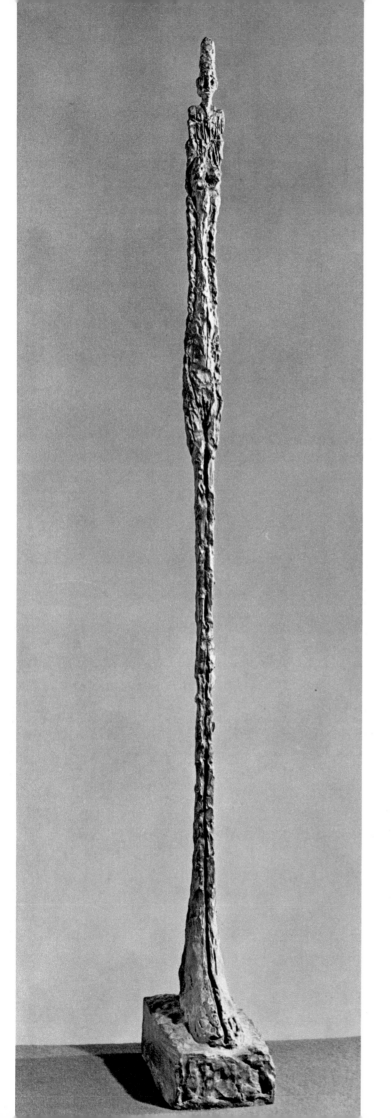
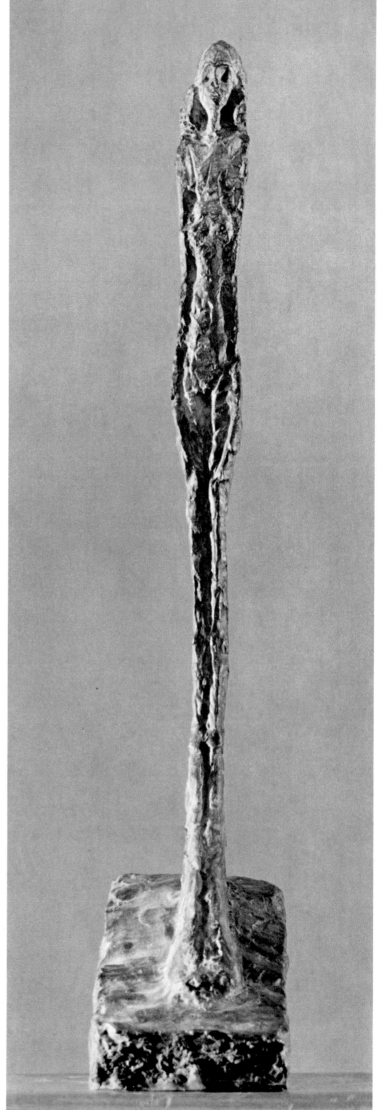

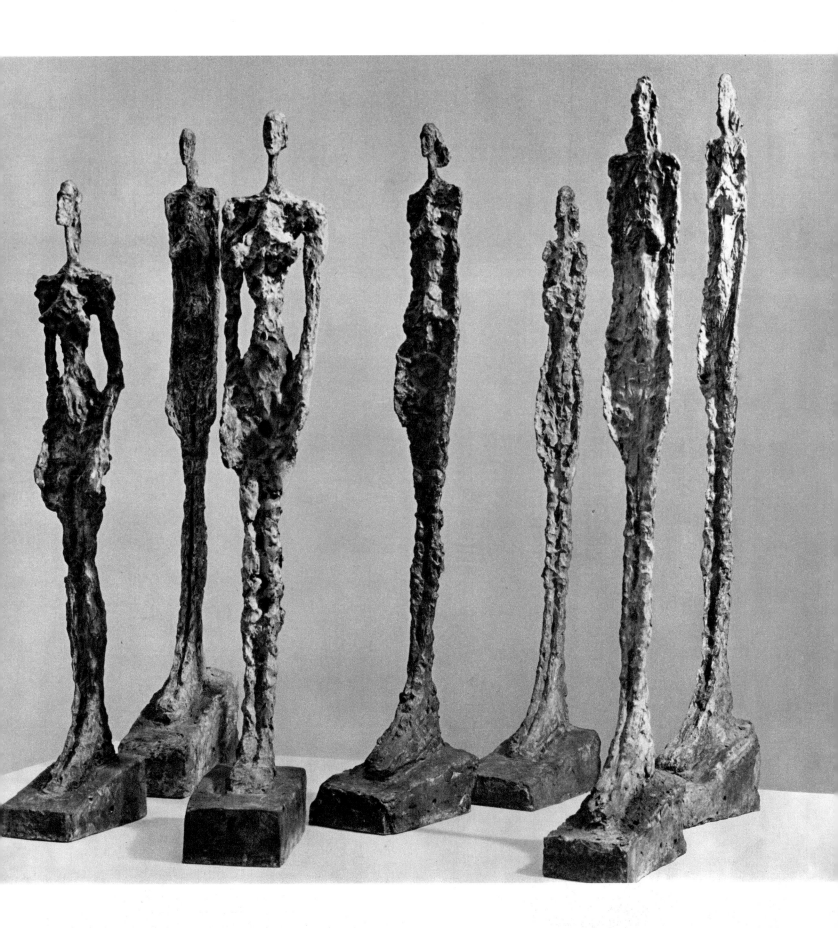

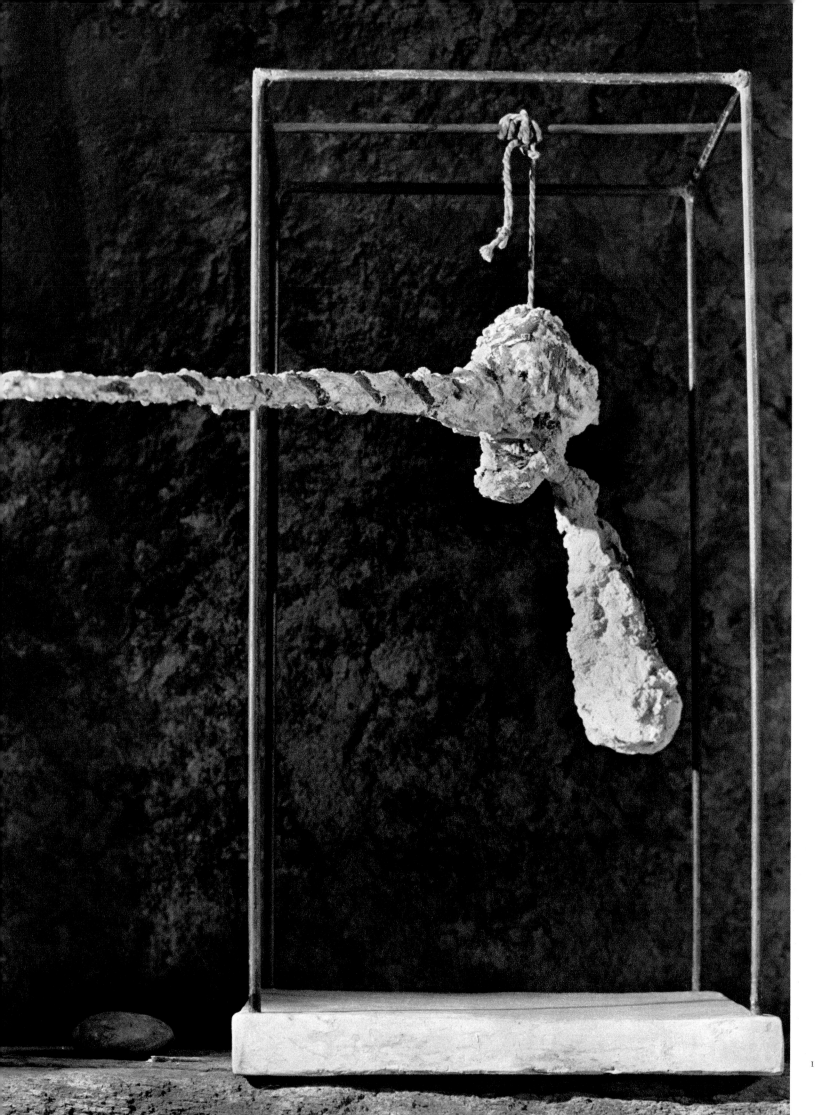

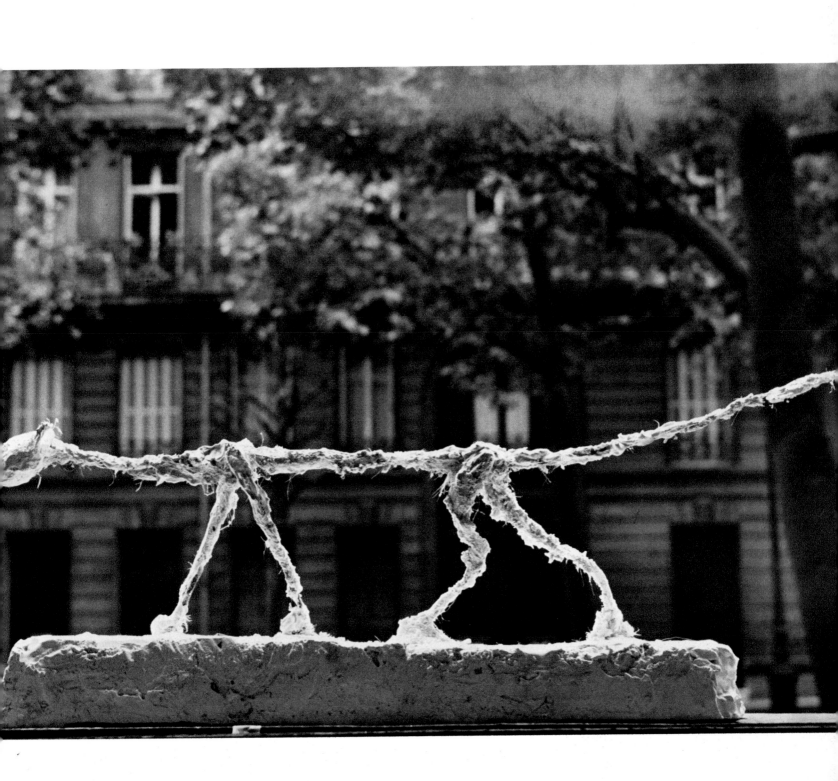

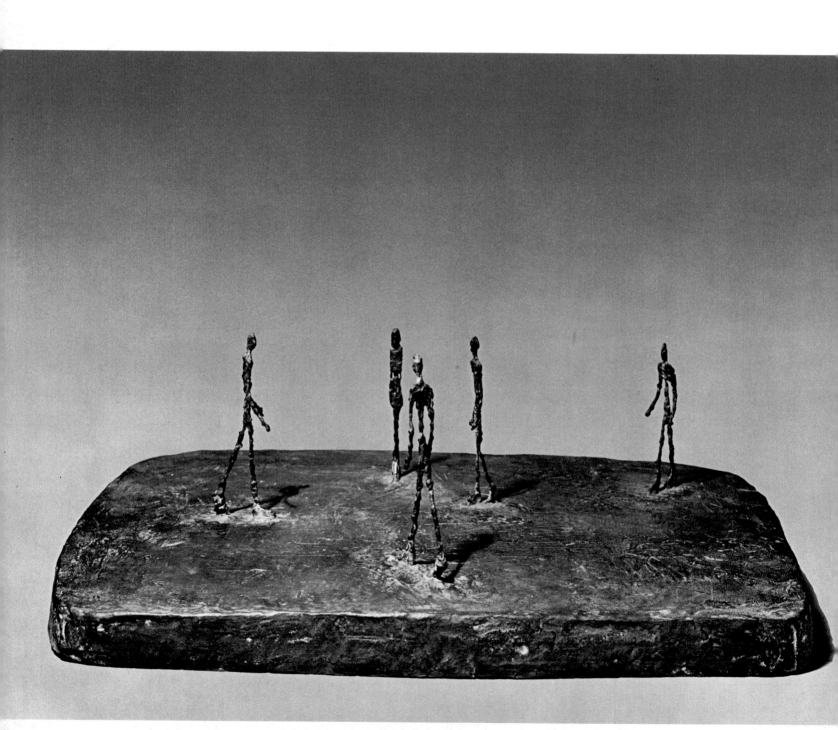

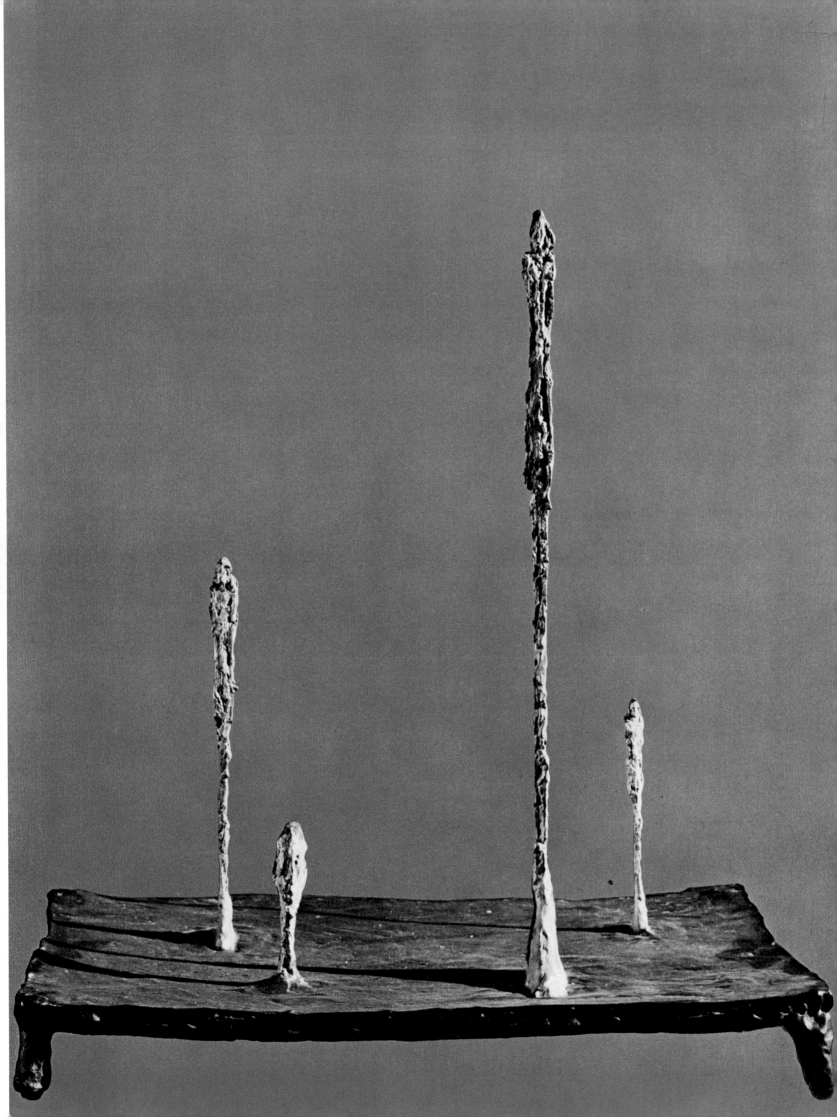

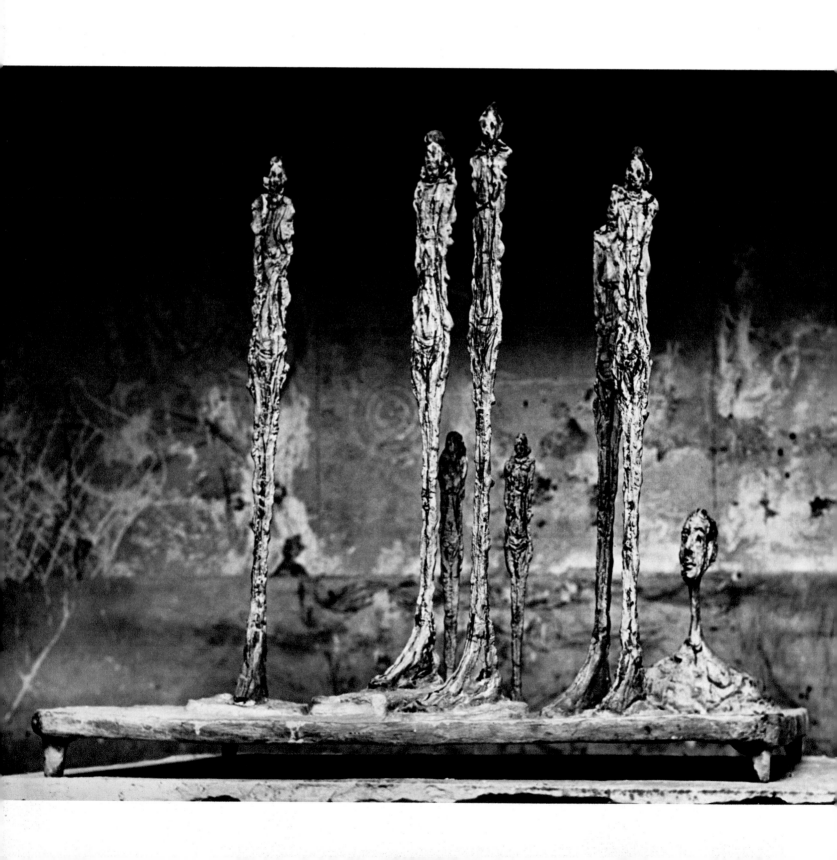

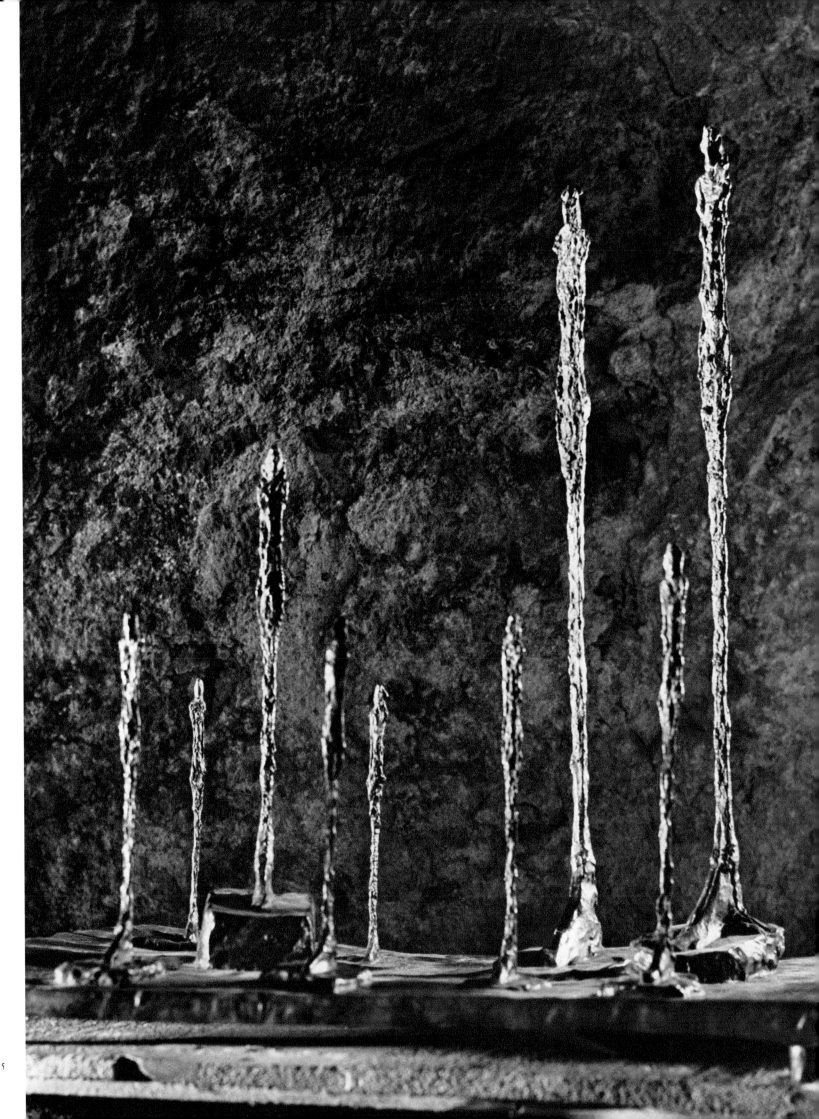

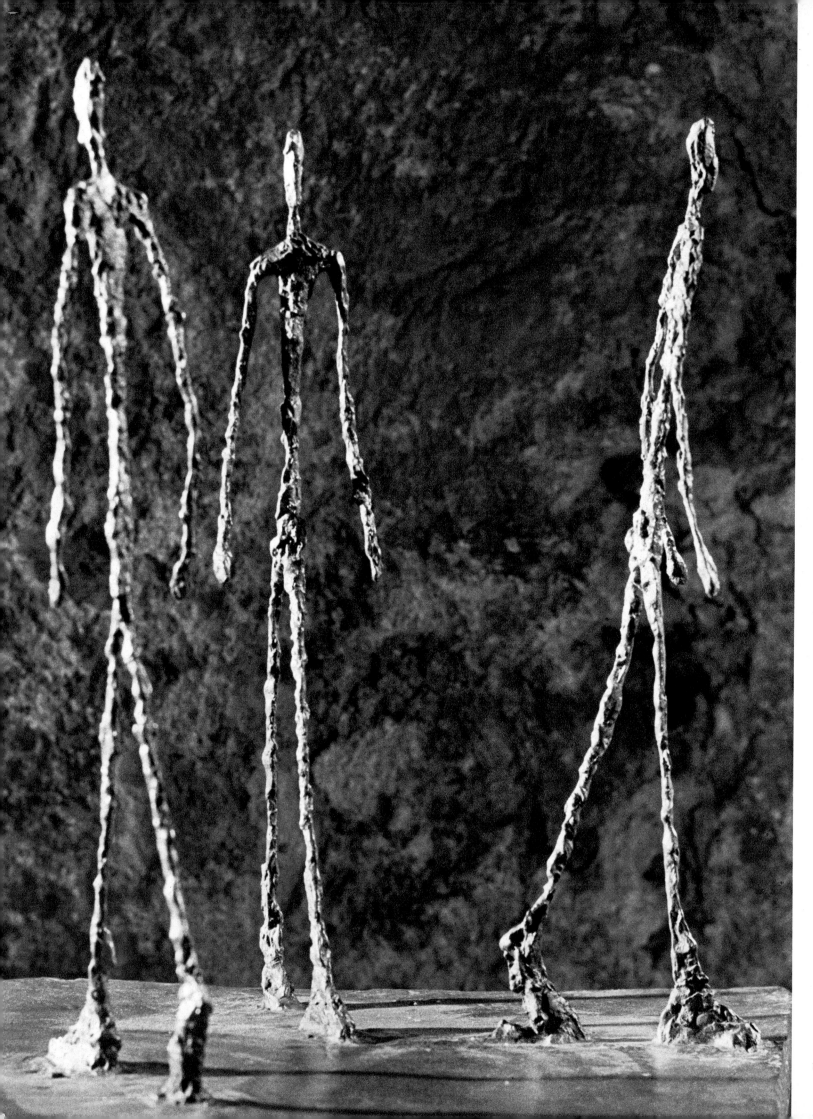

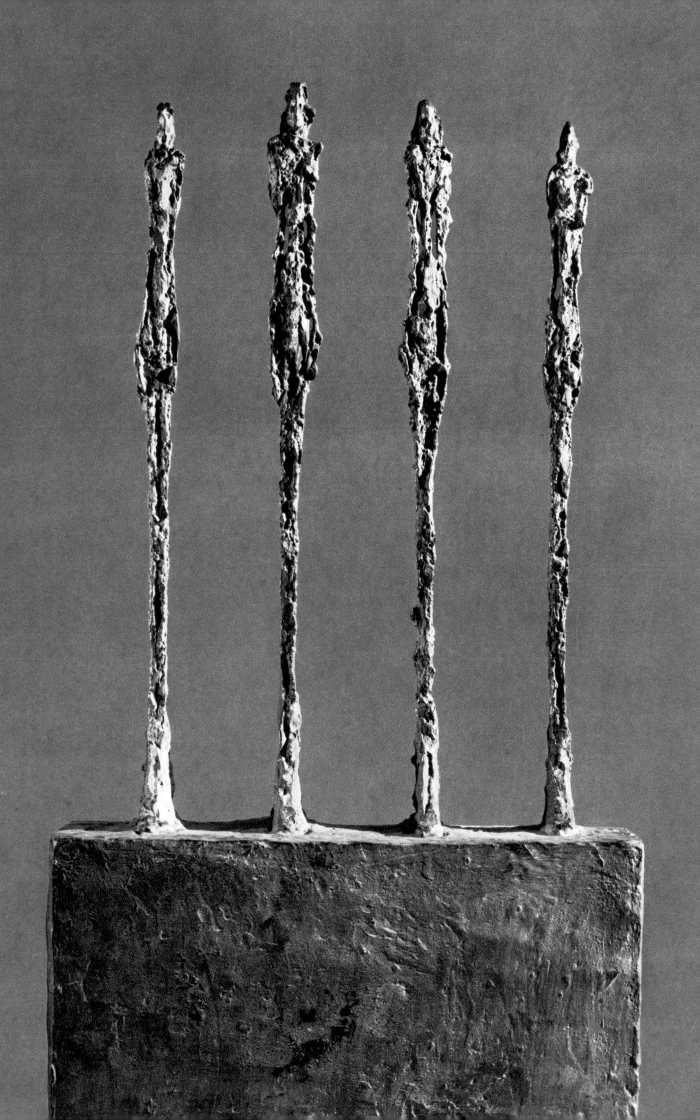

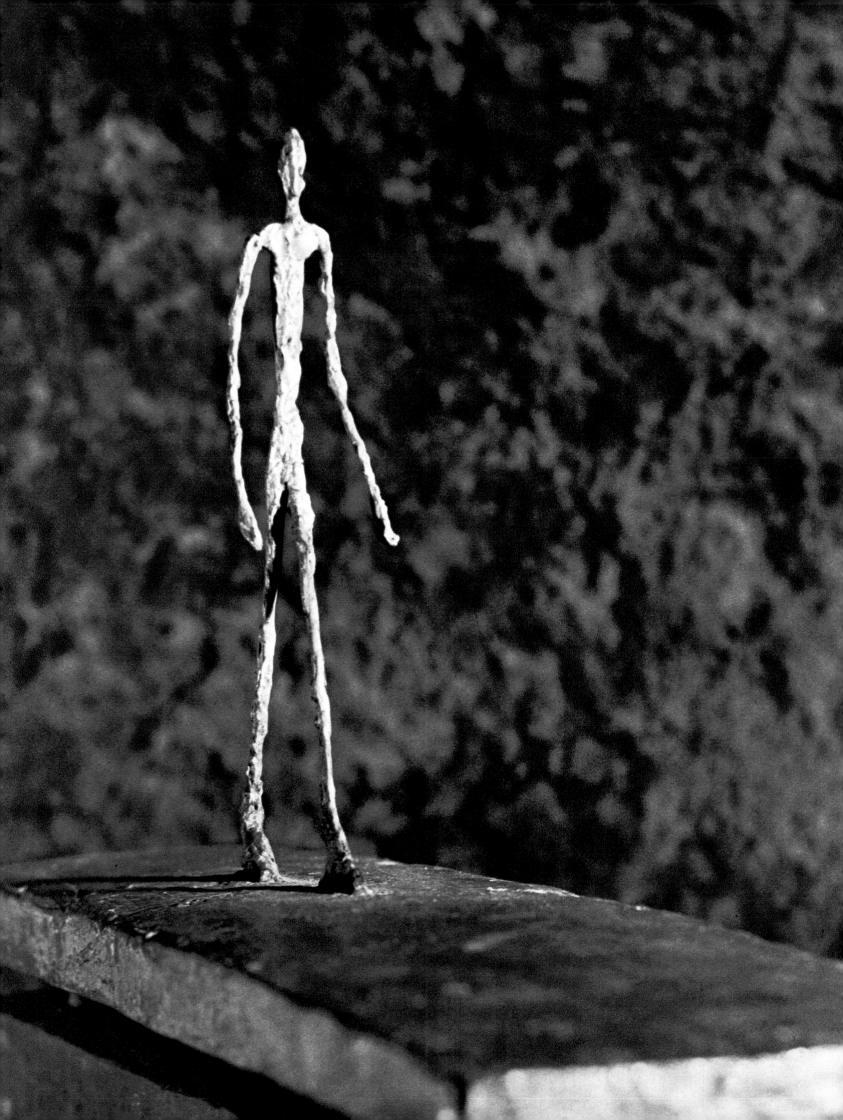

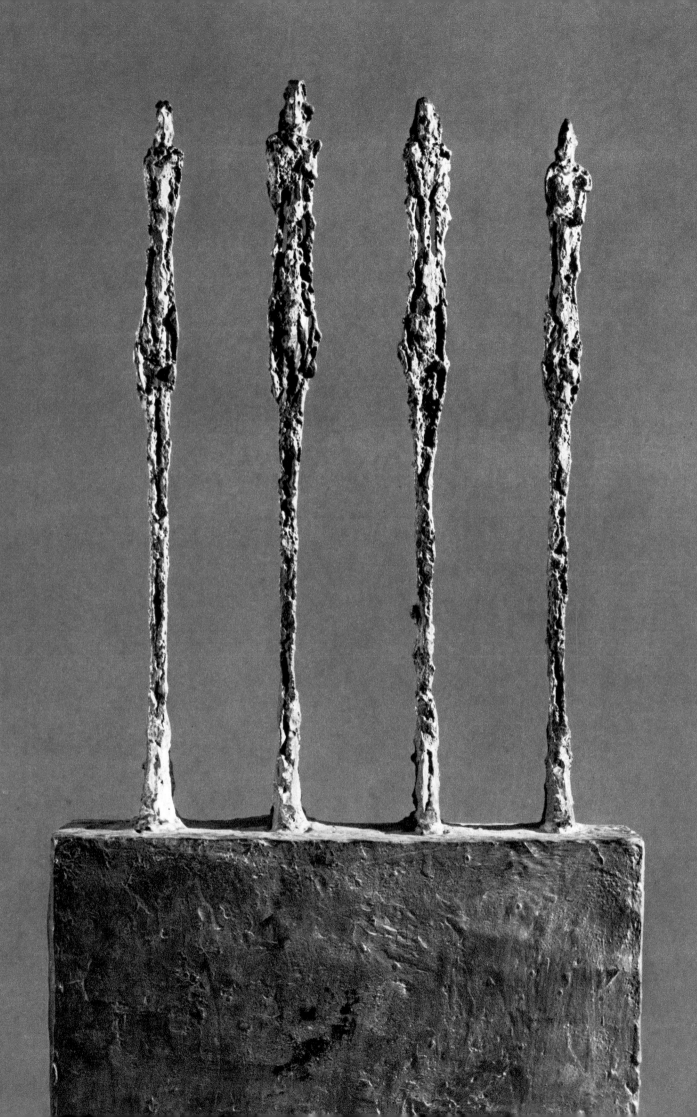

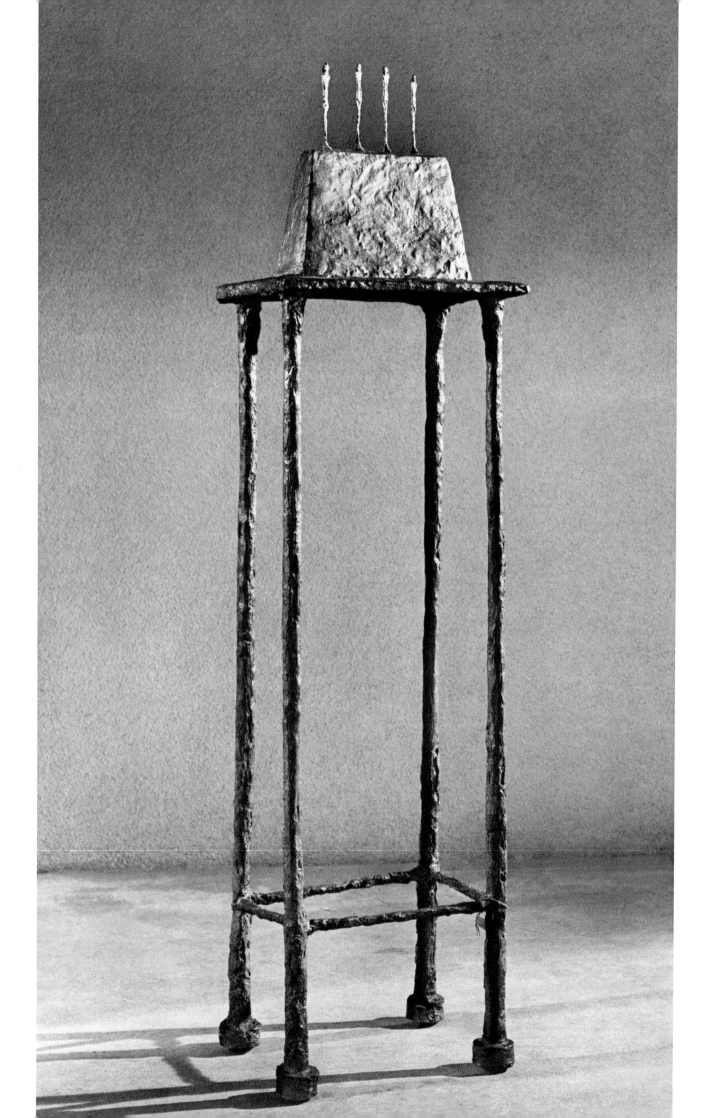

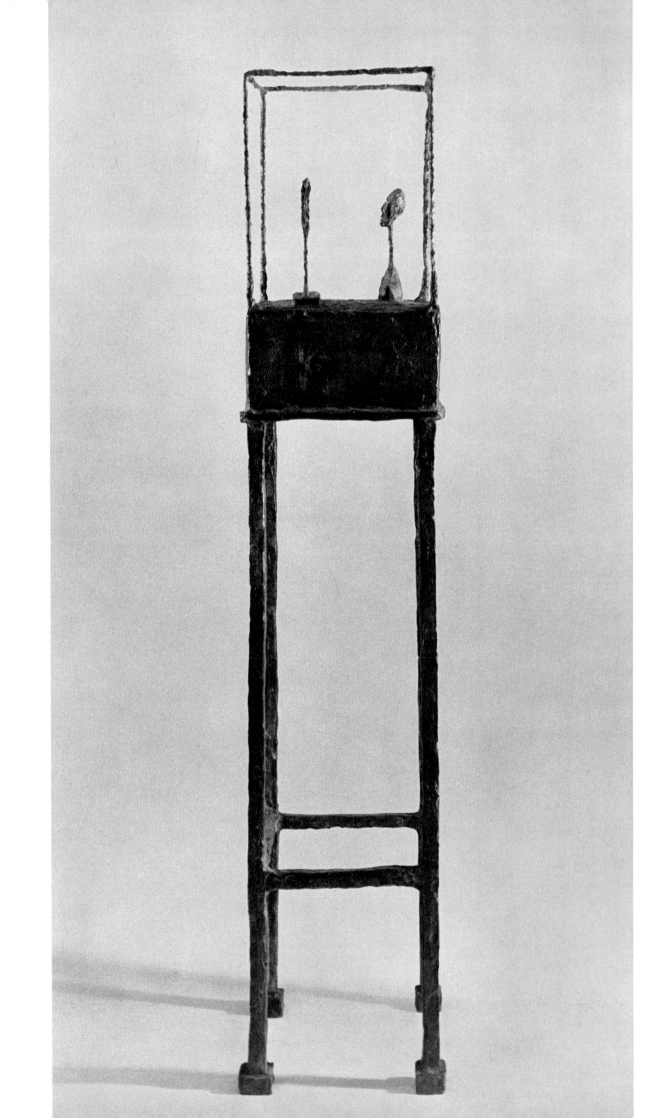

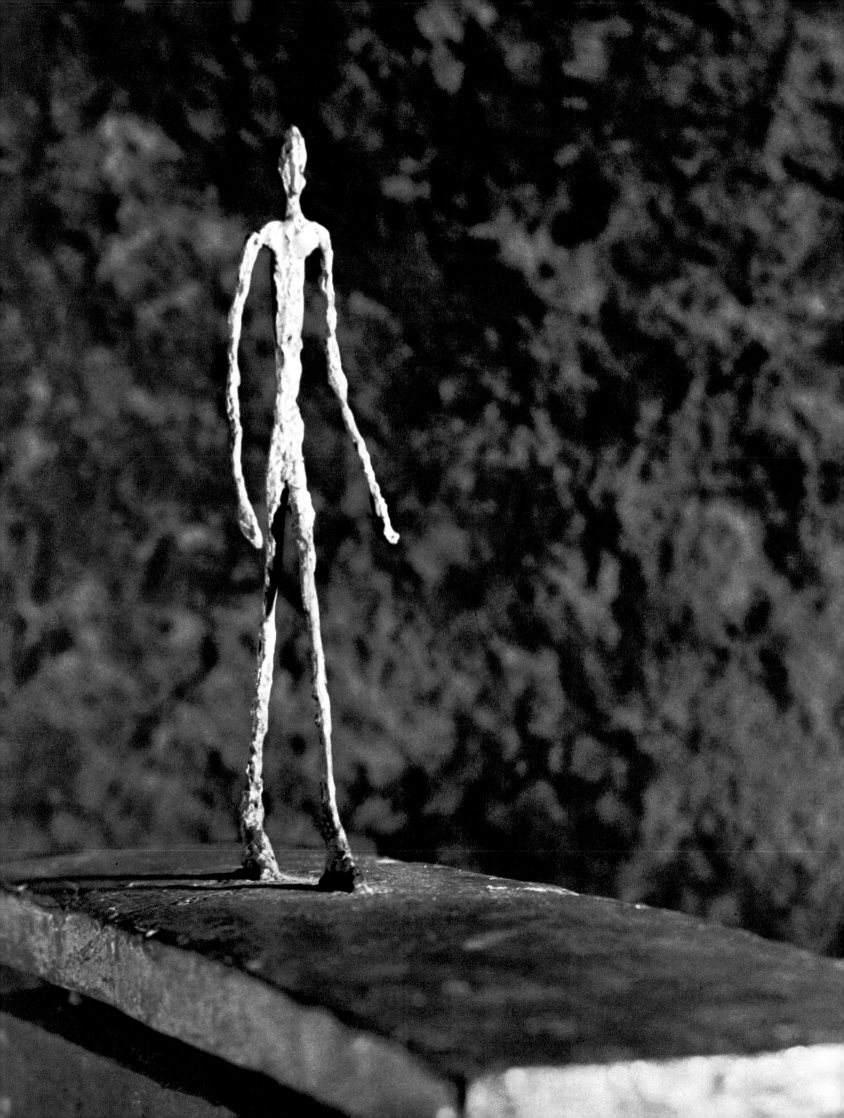

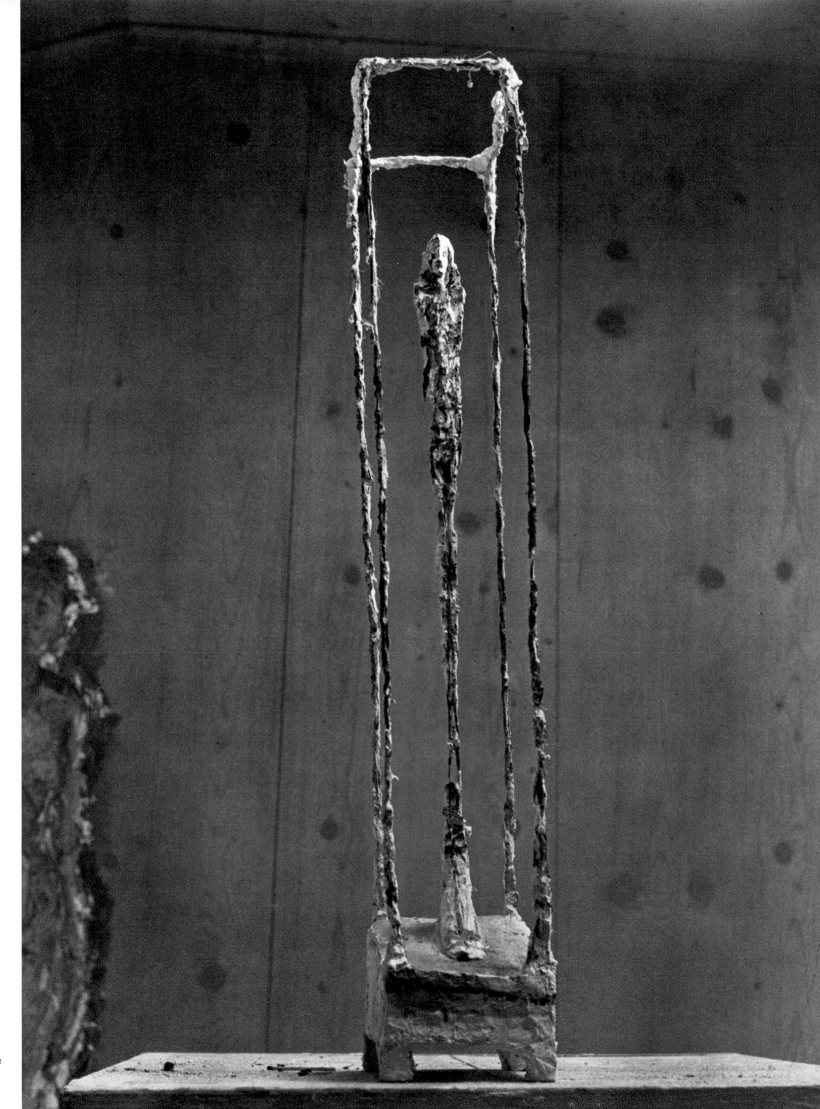

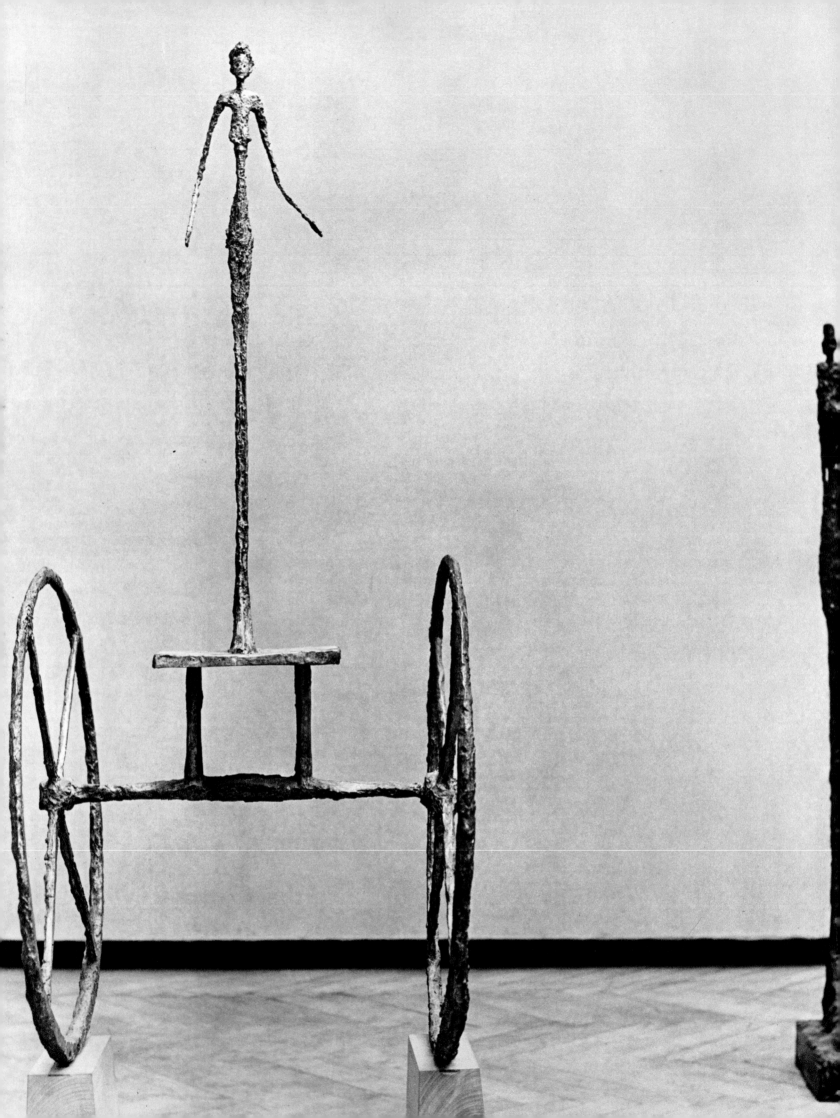

getting smaller and smaller. He planned a statuette to show the girl as he remembered her at parting (67). The anecdotal character of this situation lets us define the smallness of the figure not only in terms of distance, but also in terms of the way she appeared in the artist's field of vision: as she walked away, she slowly shrank to a thin line, a tiny spot among the myriad details of the street scene. A tiny spot, however, whose importance in the life of the man watching her disappear balanced out the rest of the scene and condemned it to irrelevance. The person remained significant and her identity clear to Giacometti, who remained behind, even though he saw progressively less form, shape, and color and the details dissolved; the tiny "un-form" kept its full potency of meaning and undiminished existence for the person seeing it. This was something that had to be expressed in art.

Through such observations and experiments in perception, Giacometti developed an unusual degree of capability in seeing small, distant figures in terms of their absolute size and relating them to their distance from his eye. He developed a sense of distance we would like to call, to use an analogy with the "absolute pitch" in music, an "absolute eye." This means that, without using any points of reference between himself and the model, he could immediately judge the distance and the resulting size of anyone's head, whereas we, hindered by our visual training, immediately and automatically convert the apparent smallness of any distant object into its "actual" size. We never connect distance with diminution in size, as does the painter at his easel. Giacometti's optical memory became so exact with time that, when he resumed work on a canvas he may have begun months earlier, he knew, to the centimeter, whether or not the model was sitting the same distance from him as in the earlier session. This ability brought experience with it, and a very personal way of seeing things: he saw nothing and no one lifesize. "Lifesize does not exist. It is a meaningless concept. Lifesize is at the most your own size—but you don't see yourself." (71) It is quite true: even someone standing right next to us does not appear lifesize, he is smaller to a degree proportional to his distance from us. You could see him almost lifesize if you brought your eye within millimeters of his, but then you would see (try it with a mirror) not the other person, nor his body, nor the life in his eye, but only a tiny patch of skin.

These observations and the practical work that resulted from them led Giacometti to a new concept of art: art as research into reality. Not only that reality embodied in the artist's model alone— "Reality receded more and more, behind more and more veils . . ." (61)—but a reality which also includes the observer, the artist. Reality meant, for Giacometti, the concrete situation of artist and model in their interaction, which includes the distance between them. The reality of the model is her appearance to the artist, how he perceives her. An artwork should capture the appearance of reality seen by a living eye.

But if the final product of this confrontation with reality was to be a work of art, Giacometti had to find a *Gestalt*, a style. He was clear in his mind about the optical laws governing the appearances of people at a distance as early as 1940, but it was not until 1947 that he was able to find a way to represent their existence.

The Artwork as the Appearance of Reality (1940–1946)

As always after having studied the model for a time, Giacometti now began, around 1940, a new series of works based on the experience he had gained. His thinking went like this: if the reality of a figure is always and only seen at a distance, takes up only a small part of the field of vision, and has fewer visible details without losing its identity, then, when it comes to realizing these figures as a work of art, the reverse must be true: if it is possible properly to relate the lack of detail in the figure with its small size and retain some of the figure's corporeality as seen frontally, then the work will be a representation of a figure as seen from a distance and thus will possess a quality very nearly that of living reality. Hence the figure could become a double of the reality from which it was taken, and which (ideally) could not be differentiated from it. This effect would have to depend, among other things, on the observer's willingness to overlook the material existence of the artwork as much as possible. So, thought Giacometti, as much clay or plaster as possible had to be taken away from the ever tinier figures until they "fell into dust at the very last touch of the spatula." (13)

We should look for a moment at this paradoxical extreme case, that an artwork should reach its highest perfection at the point at which it materially dissolves, because this (im-) possibility lies at the heart of all of Giacometti's later work. He came closest to achieving it in the figures which owe their effect of a living totality to the very fact that they are but fragments, and this in a much more radical sense than torsos, which are based on an aesthetic concept long since conventionalized.

From this point on, any discussion of the works in abstract, nonobjective terms such as planes, volumes, lines, and space, is on the wrong path. Content is everything now—at least this was Giacometti's intention. The polarity evident in his aesthetic conception of 1935, between the nonobjective form, "which seemed to me true for sculpture," and the human body, "as an aspect of reality which particularly appealed to me" (13) lost one of its poles in 1940. Aside from the bases upon which his figures stand, there is no more nonobjective, "true" form in them. And, if possible, he wanted to purge

volumes and planes from his compositions; they were to consist solely of appearances, to affect the observer as presences.[41]

In the years 1942–43, Giacometti's study of the model, which was to have lasted only two weeks—just long enough for him to grasp the construction of heads and figures so that he could go on to the "compositions with figures" he had planned (13)—came to a temporary close. He tested what he had learned by doing his first "realization" in years. For his theme he turned back to the female figure of 1932–33 with its trancelike movement, and reinterpreted it in a standing pose, set on a base with wheels—hence the title, *Woman with the Chariot* (page 112).

Legend has it that this piece was lost, or at least forgotten, for a long time, and that it does not fit into the developmental logic of the ever smaller figures he made between 1935 and 1945. It is only a bit less than lifesize; the figure itself, without its base, is a little more than three feet tall. One must keep in mind, however, that Giacometti began decreasing the size of his sculptures with the intent of lending a greater degree of truth to his compositional ideas of 1932–34—*Walking Woman* and *Nude Woman*. *Woman with the Chariot* represents an intermediate stage between his last works of the Surrealist period and his first elongated postwar figures, which were still basically Surrealist in conception. The subject and the way in which he realized it were truly super-real; Mario Negri describes it as if he had discovered a mystery cult:

I shall never forget the deserted studio in Maloja, where the light fell vertically into the bare room. . . . Unmoving in the thin air, almost like a vacuum, stood an unfinished statue frozen in plaster (I don't know how many years she had stood there already): naked and delicate in her simple pose, her long arms pressed to her sides—like an antique deity in a deserted temple. . . . She was not standing on a typical pedestal, but on a cube-shaped base with four small wooden wheels, like a child's toy, as if she had to leave this place, as if she were intended for a long, un-believably long journey. (605)

This piece is really a kind of cult object: not a representation of a female form, but an event in time, the existence and disappearance of a woman. In contrast to Giacometti's movable sculptures of the early thirties, the solid axles beneath the base allow it to be moved in two dimensions only—forward and backward. If she had been made in any other way, her character as a symbol for the appearance of reality—achieved here again with machine-like parts, just as in the early visual models—would have been less believable.[42]

The fact that this piece can be moved only at right angles to the frontal plane determines the observer's standpoint; almost all of

Giacometti's subsequent works reveal their meaning only when they are seen from the front, and only frontal photographs can communicate the meaning of a real confrontation with a Giacometti sculpture. Pictures taken from other angles are of course justified to document the existence of any three-dimensional artwork, yet Giacometti's efforts are directed almost exclusively toward expressing the very opposite of material existence—the immaterial presence of another person's being-in-the-world.

Cast in bronze, with movable wheels, *Woman with the Chariot* still communicates only the effect of motion, enhancing the total effect of the piece very much as Giacometti might have intended. Three years later, in the almost identical work *Figure of a Woman in Process of Completion* 1946 (378: 257), he omitted the wheels from the base; but, to achieve the same effect of a presence coming into being, he left out the woman's arms—judging from the position of her shoulders, she would have been holding them behind her back—and cut off the back of her head with a diagonal plane. Apparently, he employed fragmentation here as a substitute for the movable wheels (page 296, fig. 70).

Giacometti used a base set on wheels once more in 1950, in *Chariot* (page 132); this aspect of the work should be treated here, because Giacometti expressly said that it was directly related to the period before he began his "realizations," his serious work of the forties (14). Here, he transformed the virtual movement of *Woman with the Chariot* into metaphorical movement: the wheels have a strictly allegorical function; not only are they of a piece with the axle, but their forward movement is hindered by chocklike blocks. This change in the motif is very consequentially accompanied by another difference: the woman's figure is much more slender, much lighter, standing almost on tip-toe, with her arms outspread for balance, or as if to take flight.

All the sculptured figures and heads Giacometti did between 1940 and 1946 have in common a cubic pedestal or series of pedestals stacked one on top of the other. This is also true of the composition with a female figure which was called *Study for a Monument* (page 296, fig. 68) when it first appeared in 1946; a variation of the same composition done in 1947 was entitled *The Night*; only photographs of both works survive today (378:258; 382:40). In a drawing of 1943, the same motif of a woman walking as if in her sleep with forearms extended was called *Tight-rope Walker* (382:28; page 296, fig. 67). All three titles indicate that the composition in all its variations was meant as an allegory in the Rodinesque sense.

The woman is taking long strides forward; she has raised her forearms to the horizontal, more so than would be necessary in the act of walking—so far that one is reminded of the woman's hands holding the void (see page 104) in *Invisible Object* (page 70)—

as if she was carrying something in front of her (in the two sculptures), or had to keep her balance at a difficult moment (in the drawing). The street along which she is walking is indicated by a long rectangular plate in the plaster models, which in turn is keyed into a massive cubic base—one thinks back to the base construction of *Cube* (in 1949 and 1950, many of Giacometti's compositions were keyed into their bases with similar pins). The base of *Study for a Monument* could also represent a coffin with its cover propped up over it, as the sarcophagi in the Egyptian room in the Louvre are presented to view; this comparison is of interest only when one sees how Giacometti handles exactly the same motif in 1950 in his *Woman in a Barque*: as an Egyptian burial figure (page 295, figs. 59 and 60).

This idea, in all its different variations, belongs in the category of Giacometti's "compositions with figures," for which he prepared himself from 1935 on by studying the appearances of reality. It is a much more powerful version of the idea contained in embryo in *Walking Woman* of 1932 (page 70). His new female figures now have a living reality, a presence. The figures are alive, and express life insofar as they are attempts to come as close as possible to reality as it exists, to be doubles of reality; the women of *Woman with the Chariot*, *Figure of a Woman in Process of Completion* and *Chariot* must be understood as steps toward the achievement of this goal. *Study for a Monument* contains one aspect of Giacometti's conception of the "totality of life": the continuation of life over the abyss (the *Tight-rope Walker* drawing), through the night (the variant, *The Night*), above the kingdom of death (base as sarcophagus, later as death-barque).

At the time of its conception, Giacometti's monument, had it been built, would have been a reminder of the Occupation of France. Aragon wrote that, after the war, he and Giacometti were considering such a monument, which, unfortunately, never got past the speculative stage (104). How much purer were the means of expression at their disposal, compared, say, to those of Bourdelle, to carry on the tradition of the French war memorial![43]

Aragon also encouraged Giacometti to do another memorial sculpture, expressly in memory of the French resistance fighters (138): the portrait bust of *Colonel Rol-Tanguy* (1945–46; page 109). There is no particular connection in terms of composition or content between these two works, and yet—the striding female figure and the man's head on a pedestal—these are two of the elements that Giacometti studied again and again for his "compositions with figures" and employed for the representation of the "totality of life" (after *Model for a Square*, 1932, and *Cage* of 1931, especially in *Part of a Composition: Cube*, in *Walking Woman* and *Nude Woman* of 1932–34 and later in *The Forest* and *The Cage* of 1950 and in

the Chase Manhattan group of 1960–65). But both works of 1946 were a long and significant step away from being successful designs for monuments: in neither was the natural form Giacometti saw transformed in great enough degree into "style," so they failed to be immediate metaphors of existence. Their superb effect—and this holds even more for the undoubtedly striking miniature figures of the same period—cannot be denied, but it was achieved by "staging" of a sort: a tiny figure on a mammoth cube, a small head on twin stacked cubes, a striding figure on a rather forced, overconstructed pedestal (page 110). The style of this sculpture did not yet have the power of reality.

The austere portrait head of *Colonel Rol-Tanguy* (page 109) is something completely new in the history of sculpture after Rodin and Bourdelle, Duchamp-Villon, and Brancusi; when one compares it with Giacometti's own portrait bronzes of 1925 or his studies of heads of 1935, one can see very clearly the path he took over two decades. For, in addition to the impressionistic richness of its surface (Rodin), the classicistic "fruitful moment" of its style (Bourdelle) and "the forms that are true in sculpture" (Duchamp-Villon, Brancusi), this head has a presence which comes closer to giving the impression of reality than any of his earlier work. But Giacometti had still not solved the most important problem of representation in all the aspects of this piece where its material remains matter and its formulations remain forms, instead of being immediate reflections of the appearance of reality. We still see the smooth cheekbones as abstract surfaces; the beautifully articulated frontality of the face and features is not carried over successfully into the sides and back of the head; the breadth of the head works against any living intensity it might have had (only a short time later the heads became narrower); the glance, as convincingly as it is expressed, still does not communicate directly to the spectator (a problem that Giacometti wrestled with to the last). There is something basically self-contradictory about the tower of cubes on which the head rests: as a means of lending dignity to the piece, it is successful in giving the head distance and a personal aura, but the cubes look more and more like stage props the more lifelike the head appears.

The size relationship between head and pedestal was still an unsolved problem for Giacometti, one which was to occupy him for years. In the large number of works he made very quickly in 1947 in preparation for an upcoming exhibition at the Pierre Matisse Gallery in New York, he often sidestepped the conflict by introducing rather irrelevant plates or iron rods between the sculpture and its base (as in *Man Pointing*, page 117; or *Head on a Stalk*, pages 114 and 115). But when he began to work seriously on this contradiction, he began to transform the bases of his pieces by making them mere *representations* of bases and began to pay special attention to the connection

between figure and base, between vertical and horizontal, between living reality and artistic convention. One among many possible ways of doing this is to tilt the base at an angle toward the viewer, giving it—and the enlarged instep of the foot resting on it—the appearance of reality, the ground seen at an angle from above and from a fixed distance. The chests and shoulders of Giacometti's busts have a twofold significance; they are both foils to set off the head and replacements for the pedestal.

Two developments, according to Giacometti himself, made the year 1945–46 one of new beginnings: he began to draw intensively (13) and decided not to let his figures become any smaller (61). The drawings he made in the early forties are unsure in several ways; the foreshortening is sometimes faulty and the joints of his figures often stiff; his nudes are often forced relentlessly into one-point perspective, and even the attempts he made to alleviate these difficulties show his insecurity—stretching the figures, or blackening them almost beyond recognition with his pencil. With the post-1945 drawings, however, it is clear that Giacometti gained a new sureness, for he was working toward the new massless and weightless style with which he attempted to represent the figure as a living reality, surrounded by its individual envelope of space; in 1947, he succeeded in transposing this style into sculptural terms (page 296, figs. 71–74).

The drawings Giacometti did after works by other artists helped him to understand how to transform an infinity of natural details into coherent style. And his decision not to make his figures any smaller than they already were likewise shows a desire to crystallize a style. One has to ask what Giacometti meant when he said he had "decided on it"; perhaps he was expressing his intention to break out of the isolation of his studio to place his new sculptural discoveries beside the work of his contemporaries: not the strange, tiny studies that had already become legendary by the early forties (107; 155), but in a size comparable to that of other work being done at the time, in a more traditional size. We also know, from Sartre's description, that Giacometti's decision and the works in plaster and bronze that followed it were necessary measures to help him overcome a period of material hardship (383).

1947–1951
Realizations in a Massless, Weightless Style

In time, I realized what sculpture is all about. . . . Have you ever noticed that the truer a work is the more stylized it is? That seems strange, because style certainly does not conform to the reality of appearances, and yet the heads that come closest to

resembling people I see on the street are those that are the least naturalistic—the sculptures of the Egyptians, the Chinese, the archaic Greeks, and the Sumerians. (61)[44]

This insight is the foundation upon which all of Giacometti's most important work, from 1947 on, was built. It and his "composition with figures" program are the twin columns supporting the great arch of his oeuvre of 1935 to 1965.

What Giacometti meant with his remark about style lending truth to a work of art is illustrated by an experience everyone has had: the compelling reality of a circus clown's classical mask, even when seen from the last row of seats. The vertical lines of greasepaint above and below his eyes give this effect, a transformation of the human features which lends the clown's physiognomy the ability to communicate, as a whole and at once, an existing reality.

Giacometti was faced with the necessity of altering the conception of his figures completely and transforming them into non-naturalistic, aesthetic presences, which meant much more than simply stylizing them by making them rougher or smoother, larger or smaller, putting them in cages or mounting them on huge pedestals.

The fact that his post-1947 figures are "beanstalks," "thin as a rail," or "skeletal"—and they are so patently all these things that the popular conception of his work rests exclusively on such comparisons—and that they changed later, becoming more voluminous "again": this is all rather unimportant. Elongation of the figure is significant only as a method Giacometti employed in his search for an image of reality, a double. He found it by developing and then abandoning approach after approach until he found the equivalent of living reality in a concept of "style," the *one* style that corresponded to *his* way of perceiving the outside world. All artists, at all times in history, have been through this process, of course, and it was nothing new to Alberto Giacometti either. In 1920 it was an Egyptian bust in Florence (page 289, fig. 10) that seemed to him to approach the appearance of reality. Significantly enough, he did not commit his thoughts about it to paper until later, about 1947 or 1948 (17), when the subject took on special importance for him. In the mid-twenties he discovered that a primitive sculpture from New Guinea or one of Brancusi's abstract *Birds* contained more of the stuff of reality than, say, a Roman portrait head (217); and in the winter of 1927–28 he began to express in his own "flat" heads and figures the lasting impressions his experiences and perceptions had had on him. Now, in 1947, he realized that insights like these were to be the new and only possible guidelines for his work. From that point on, Giacometti took it upon himself to observe reality more carefully than ever before. Later, in 1962, he expressed it like this: "People speak of styles as those observations of reality that are

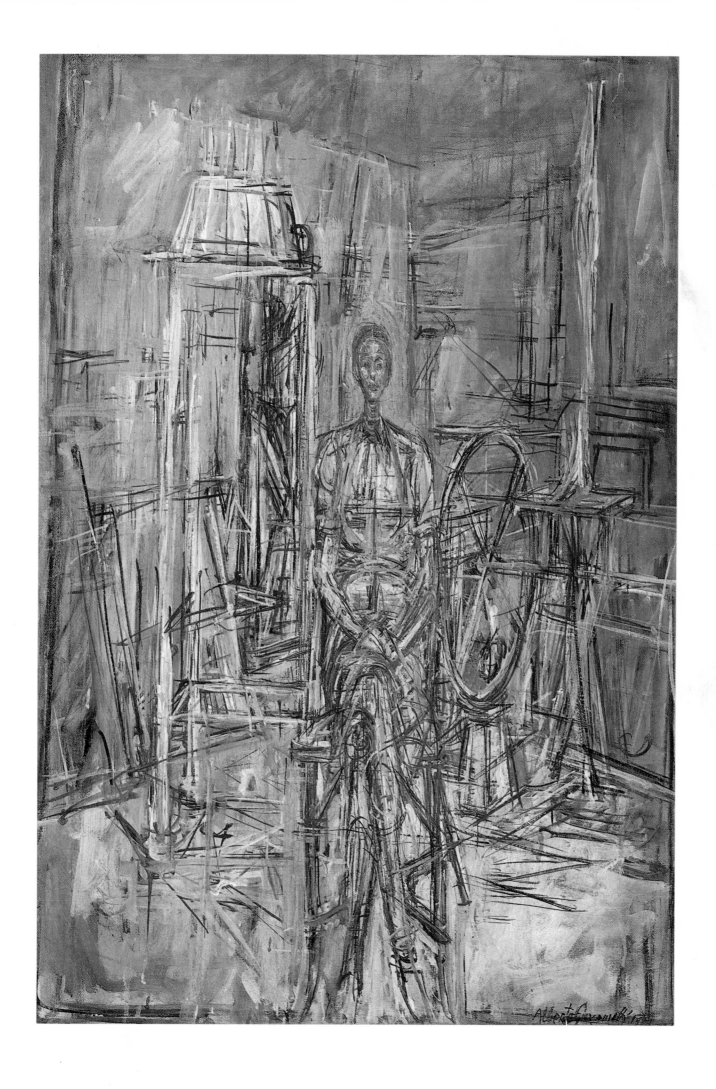

fixed forever in time and space. I know that if I could succeed in representing a head in a way that came close to the way I see it, it would be, for the others, style." (62)

So, after having fought a long and winning battle against a long series of artistic conventions, and after having accepted, for ten years, only the appearance of reality as his guideline, he came now to a new acceptance of the meaning of style in art. One can easily imagine the important role Egyptian sculpture and the early Greek *korai* must have played in this realization when one sees the exciting illustrations *Cahiers d'art* published in 1946 of many works that no longer survive today (378; page 296, figs. 68–70). But we have to differentiate here; seminal ideas that Giacometti may have picked up from these ancient styles have nothing to do with forms that he may have copied or imitated. Giacometti's works are not imitations of elongated Egyptian figures nor do they borrow, as is often asserted, from Etruscan sculpture (543:94); Mario Negri saw the basic dissimilarities correctly: an Etruscan figure, tall and thin as it might be, is still a sculpture in the round, an object to take in one's hand. Giacometti's elongated figures, conversely, are sculpture only as long as they are seen from a distance; seen close up and held in the hand, the sculpture disappears and the image dissolves. All that remains is the material comprising them (605).[45]

The key question about Giacometti's tall, thin, post-1947 figures is this: why should this particular style be an image of reality or, more, an embodiment of the appearance of reality, if his stylizations—the stylized figures and objects of the past two decades—proved to be paths leading away from reality? This is where Jean-Paul Sartre's observation that Giacometti's figures suddenly "shoot up into existence" comes to our aid (383). The young Giacometti must have felt something similar in Padua in 1920 when he became suddenly aware of the existence of three girls walking in front of him: "They seemed immense to me, all out of proportion to normal size. . . ." (17) And in 1946 Giacometti, describing an experience he had had in 1921, of the gigantic appearance of a man stepping suddenly out from between the columns of the temple of Paestum, used Sartre's verb: "He shot up in front of me." (12)

It could well be that the immediate visual experience of something unexpected is more often accompanied by the impression that the thing seen is higher or taller than that it is wider or broader; but the author is not aware of any research into this phenomenon.[46] Of course, a person approaching us grows larger, and—assuming for the moment that we are in possession of Giacometti's "absolute eye"—fills the vertical axis of our field of vision first, and only later, when he is very near, the horizontal one. By looking fixedly at a person standing in front of one, it can readily be seen that the most important fact about his appearance is the long, dark, vertical mass

of his body; its boundaries are unclear. But this rationalistic perception test provides no real key to Giacometti's art. To use the aesthetic language at our disposal, we should have to say that the significant thing about his newly found personal style is its absolute correspondence with one characteristic of the appearance of things: it is, as far as practically possible, devoid of mass, weight, and material presence. His sculptures are thread-thin and feather-light; his paintings are a net of gray lines; the lines in his drawings are broken, interrupted, often only a series of dashes and dots, often only ghosts of lines . . . his works are, like real things, presences seen at a distance, weightless and intangible (page 296, figs. 71–74). The only thing one can get a physical grasp on is the material of which they are made; its exact relationship to the artwork itself is almost incomprehensible. An artwork can compete with reality only as an appearance, a presence which stands an unbridgeable and irreducible distance away, if it is not to lose the contest from the outset.[47]

The years from 1947 to 1951 were especially fruitful for Giacometti and were decisive for his reputation as a sculptor. Two factors came together at this point: Giacometti had found his personal style; and a great interest developed—particularly in the English-speaking countries, Switzerland, and Holland—in French postwar art, whose "Existentialism" (in both the philosophic and fashionable sense) was seen as the most appropriate outlook on life in the postwar world. During these five years, Giacometti did a number of pieces expressly for exhibitions. Their popularity, bolstered by Sartre's catalogue introduction (383), fed the growing prejudice about the works' "existential" content (503); people began to speak of them as having put Sartre's "phenomenological ontology" (the subtitle of *Being and Nothingness*, Paris, 1943) into visual terms, a highly doubtful and rather superficial interpretation.

In the previous chapter it was suggested that the "compositions with figures" that Giacometti had been working toward since 1935 had finally found their true form. Giacometti repeated many of the subjects he had used in the early thirties for many reasons, not least because he wanted to test his new pictorial language. He said of the *Chariot* that it dated back to an idea he had had in 1938, that he had seen it finished in his mind's eye for a decade, and that, in 1950, he found it impossible *not* to execute it, "although, for me, the theme already belonged to the past." (14)[48] It definitely belongs to the series of women as symbols of continuing life he began in 1931–34 and added to in 1943.

A piece like *Man Pointing* (1947; page 117) is directly related to *Mannequin* (1933): both describe space through a figure which marks the limits of its presence with an extended, space-encompassing arm. Ernst Scheidegger's popular photograph of *Man Pointing*,

made at the intersection of Rue Hippolyte-Maindron and Rue du Moulin Vert (very near to both Alberto and Diego Giacometti's studios), gives the impression of a traffic policeman—perhaps with Alberto's consent.[49]

The Hand and *The Nose* fit well into the group of Giacometti's other Surrealistic conceptions. *The Hand* (page 116) is a new version of the hands in *Caught Hand*, *The Table*, and *Show-Window Requisite* (see note 33). *The Nose* (1947; page 120; page 295, fig. 62) extends the theme of *Point to the Eye* (1932) in a way fundamental to our understanding of Giacometti's new style. Here, again, the frontal point of view is the best one for the observer—and now it is our own eye that is endangered by the grotesquely long and pointed nose and not the head-form in *Point to the Eye*.[50] There is no more drastic expression of the extent to which the viewer must involve himself in every Giacometti figure and portrait head, a necessity if they are to come into their own and "be": "To be" always means, in Sartre's words, "to be *for* someone." If the observer is willing to play along and take the standpoint meant for him, the best standpoint from which to see the piece—the artist's—then the work is more than a reproduction of the appearance of reality, it shares with reality the power of being (of being for someone else).

Everyone has had the comparable and quite mundane experience of walking between the rows of graves in a cemetery. One stops in front of this grave or that and turns to face the gravestone and read its inscription, the name and dates of the deceased—and to evoke an image of the person's lifetime from these sparse data. At this moment of confrontation, the dead person "is" a reality, a presence. This is exactly the kind of confrontation one should make with Giacometti's figures. One must see them and read their terse forms from the front, straight on, in order to experience their presence in its full intensity.

The differences between Giacometti's earlier and later treatment of the same themes have a more personal aspect, too: from an emphasis on the aggressiveness and physical confrontation between the sexes in earlier pieces (the copulating *Couple*, 1929, page 53; *Cage*, 1931, page 56), Giacometti became more contemplative—he reduced the male figure to a head gazing at the female in *The Forest* (page 124) and *The Cage* (page 129) of 1950. His image of woman changed from that of an object and plaything (*Man, Woman, Child*, 1931, page 61; *Woman with Her Throat Cut*, 1932, page 65; *Manne-quin*, 1933) to that of an inviolate being (*Standing Woman*, 1946–47, page 111; *Large Standing Woman*, 1949, page 118). This development is especially clear in *Four Women on a Base* (1950; page 128). According to the artist, it represents the dancers in a nightclub where the patrons were offered more than purely visual sensations (14). Giacometti not only realized that the girls' deepest selves were inviolate, un-

touchable; he also solved a seemingly insoluble sculptural problem, one Hegel had thought was strictly limited to the province of painting: "The most important function of a painting is to exist only for the subject (for the observer) and not for itself. The observer is present and reckoned with from the beginning, and the work is created only for this fixed point of the observer." (*Aesthetik*. Berlin, 1843, vol. 10³:127).[26] The tapered, trapezoidal base of *Four Women* is a foreshortened reproduction in one-point perspective of the waxed dance floor, which was off-limits for the bar's clientele and separated them from the four nude girls; the figures of the girls are projections on the horizon of the way they appeared from where the artist was standing. Thus, even as sculpture, the four girls appear as disembodied, unapproachable objects.

Once again, as was the case between 1930 and 1934, Giacometti conceived of many sculptures and worked them out in detail in his mind long before executing them. And, as before (as he had already explained with reference to *The Palace at 4 A.M.*), it was getting the correct scale which determined the sculptures' aesthetic success or failure (56). Giacometti wanted to represent exactly what he had seen, either in his mind's eye or when drawing from life, and his "absolute eye" allowed him to use only the one, correct scale which corresponded to his experience.

This problem of the "right" scale was compounded by a number of secondary questions about the position of the figures in space, the amount of space surrounding them, in front and behind them, the space intervals between them and in relation to the observer's position, difficulties with bases and pedestals, and so forth. The importance Giacometti attached to strictly sculptural problems—especially how to differentiate between figures standing "nearby" and those "far away"—is wonderfully demonstrated by two variations he did on the same theme. To *Four Women on a Base* (page 128) he opposed *Four Figures on a Pedestal* (1950; page 127), four female statuettes grouped on a block-shaped base. In contrast to the distance he felt between himself and the dancers in the Le Sphinx cabaret, this second piece is said to have been inspired by the crushing, even frightening, lack of space in a tiny room on Rue de l'Échaudée (14).[51]

The different parameters of distance we see in *Four Women on a Base* and *Four Figures on a Pedestal* are communicated only partly by the trapezoidal base on table legs in the first and the horizontal block pedestal of the second; the different relationships between the width of the figures and the spaces separating them also play an important role. David Sylvester noticed how slender the (distant) statuettes and how large the space intervals between them were, and that the four (nearby) figures had comparatively little space between them in proportion to the fullness of their bodies (637);

when Giacometti made sketches of the two pieces, he exaggerated this difference even more (14).

After such observations, one is even more chary of the common interpretation of Giacometti's isolated, space-surrounded, and caged figures as symbols for "the loneliness of man" or "the impossibility of communication." "At least I didn't mean them in the illustrative sense," Giacometti recalled in 1963 (65). So in the case of the three or seven or nine female statuettes he installed on common bases and entitled *City Square (Three Figures, One Head)* (page 123), or *The Forest (Seven Figures, One Head)* (page 124), or *The Glade (Nine Figures)* (page 125), all of 1950, one certainly cannot say that the figures are isolated one from the other because each one has its own little base or because they are all staring straight ahead "without communicating," as proof of the loneliness theme. No, except when he mounted a male head on the same base with female figures, Giacometti was concerned primarily with problems of composition: arranging figures of different sizes at various intervals on a common platform. Making the height of the figures a function of their distance from the observer in terms of one-point perspective resulted (in *Three Figures, One Head*) in a composition that was much too lifeless (14). Something else was needed—a man, as head or bust, looking at the stationary women from a point of view different from that of the viewer. This required another, separate system of perspectives, especially as Giacometti still held to his plan for a lifesize "composition with figures," for which all these works are like small-size projects.

Giacometti experimented for two months to find a solution to this problem. Logic was of no help in visualizing two different standpoints in one sculpture—two different people looking from two different directions and from two different distances at the same object, the woman.

He is said to have found the solution accidentally. To make space on his worktable, someone moved his statuettes to the floor. "I saw that they formed two groups which corresponded exactly to the composition I had been striving for. I mounted the two groups [*The Forest* and *The Glade*] on bases without changing their positions and began to work on the figures, without altering their dimensions at all." (14)

We have good reason to consider this catalogue text another example of Giacometti's bent toward Surrealistic poetry. In the interpretation of the piece's content that follows the excerpt quoted above, he did not fail to mention either miraculous accidents, childhood memories, or animistic bewitchment. But every solution he found was the result of work, of a conscious search for a "find" which had not yet arrived. They were not lucky throws of the dice, they were the few right throws among many, and Giacometti

recognized them when they came. The groups that resulted corresponded to "the composition I had been striving for." No chance accident persuaded Giacometti to abandon the impossible idea of a double one-point perspective from two standpoints—it was the organic movement of the person clearing the table, bending over several times to put the figures, two by two, on the floor, turning his body rhythmically in the same way over and over again, reaching a bit further every time to find a new spot on the floor, not paying attention to the size of the figures—he unconsciously followed the natural law of grouping that Giacometti had been searching for.

Spatial relationships, the representation of distance, problems of perception—these are not the only things we are concerned with here. Giacometti was looking for a "composition" not only in the aesthetic sense, but also in the metaphorical sense. And always the same one, that of the "totality of life." Precisely the "accidental" situation, with its organic-rhythmic determinants as described above, expressed a *life*-situation. Life played into the hands of the artist.

The two most important "realizations" of these fruitful years are *Imprisoned Statuette* (page 131) and *The Cage (Woman and Head)* (page 129), both of 1950. It would be wrong to see the first piece, a woman standing on an inclined base, her aura of space demonstratively cut off by the bars of a cage (another example of the museum display case as an integral part of the work) as merely a study for *The Cage*; from the right point of view, the tilted platform and large feet are powerful, and the somewhat overlarge head offers a real confrontation, an experience even more compelling than one has with *The Cage*. But, more than anything else, this work, like the two pieces with four standing women each, reflects a perceptional problem. The actual composition Giacometti was striving for, the metaphor, comes through only in the later piece, *The Cage*—just as *The Forest* and *The Glade* express most fully and clearly the compositional idea initially touched upon in *Four Women on a Base* and *Four Figures on a Pedestal*. The observer definitely remains on the outside looking in when he sees *The Cage*, which, like the works of 1930–33, was conceived of as a visual model. It is difficult to believe that the only thing the piece was concerned with was problems of optics.

Man and woman—the man, only a bust with a long neck and head tilted slightly back, seen in profile; the woman seen from straight on, standing silently, her hands pressed to her sides—this is, naturally, a comment on the distance between the sexes and the impossibility of their reconciliation after being banished from paradise. But the figurine on her separate small pedestal could also have been meant as an "artwork within the artwork," the artwork being a metaphor for ongoing life, just as all of Giacometti's

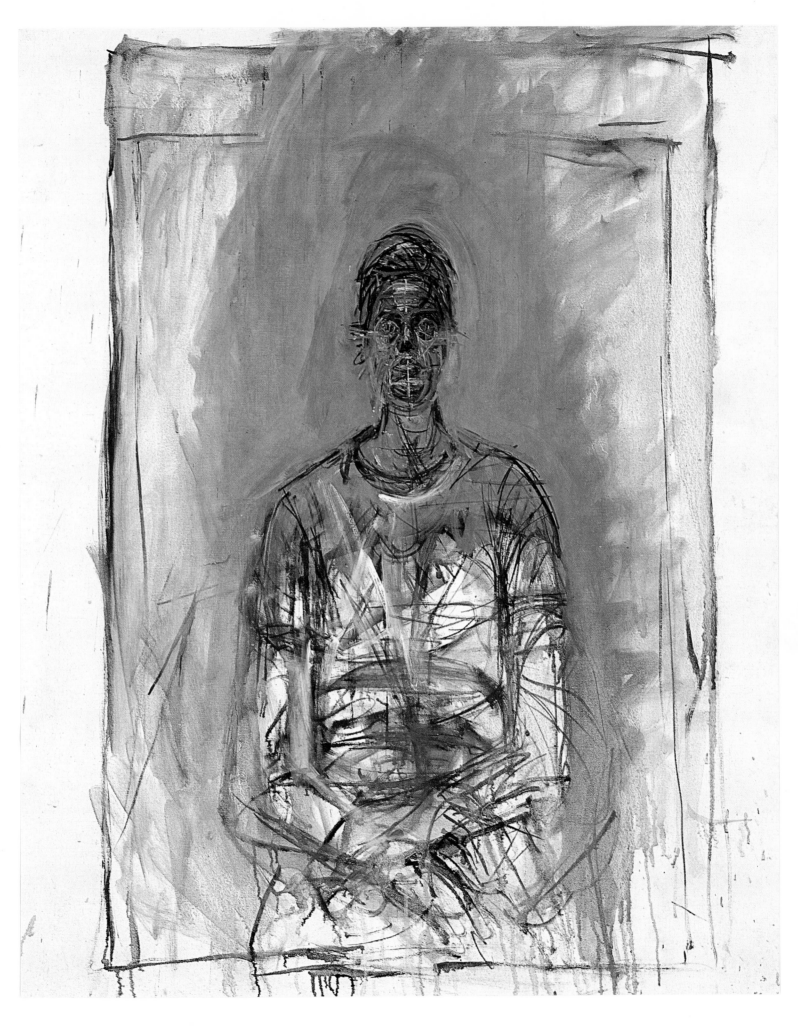

standing women since 1932 had been, whether walking, pregnant, or on wheels; and the whole piece a metaphor for the only creative power granted man within the framework of his reality: a visionary's understanding of the world and the ability to express it in art.

For an intellect like Alberto Giacometti's, though, the situation of the artist confronting his artwork can only be meant as a metaphor. The male bust does not face the statuette frontally, as the artist would his model, nor does he see her in profile, as the sculptor his work (though the photograph might give that impression). The man is gazing behind and past the "artwork within the artwork" into space, as if he had seen a vision.

In the first sketch—and one can really call it a vision, because Giacometti saw the completed composition before him before he began working on it (14)—the woman had raised, outspread arms. The gesture meant something, but proved "artistically insupportable" (14) when he tried to transform it into sculpture. Aside from the rather uninspired interpretation that the nude woman with outspread arms was opening herself fully to view and thus surrendering, we know of no other satisfactory interpretation; but perhaps there is a deeper meaning in this nude—or rather, in the impossibility of representing her as "artwork within the artwork." *The Cage*, made for the exhibition held during the winter of 1950–51 at the Pierre Matisse Gallery in New York, is also a piece that summarizes Giacometti's earlier achievements: its bronze showcase-like framework—which was given Plexiglas walls in later exhibitions—shows how far Giacometti had come in finding forms for his themes "standing female figure" and "male bust." It is most meaningful in terms of content when we interpret it as a self-portrait—the artist and his work—similar to the series of etchings Picasso did in 1933.

At the same time as Giacometti was working on this composition, deciding to simplify the woman's gesture and represent her standing motionless—in other words, making "style" of a momentary visual impression—Albert Camus wrote the following in his *Man in Revolt* about the sculptor's task:

> The greatest and most ambitious of all the arts, sculpture, attempts to fix in its three dimensions the fleeting figures of man and to reunite the disorder of his movements in the unity of a great style. Sculpture pays not a little attention to resemblances (in fact, it requires them), but it does not seek them above all else. What it has sought in the great epochs is the gesture, the expression, or the empty glance that contains all the gestures and glances in the world. Its intention is not one of imitation, but of stylization, to catch in one significant expression all the passing furor of the body and its infinite variations of attitude. Only then does it erect on the pediment above the tumultuous city the model, the type, the perfect, immobile symbol which, for a moment, cools the incessant fever of man. The lover, robbed of love, can finally circle around the Greek *korai* and gain for himself that which, in the body and visage of man, survives every degradation (Paris, 1951: 316–17).

We shall be able to give no better interpretation of the compositions that follow—*Standing Woman*, *Large Standing Woman*, *Women for Venice*, and the larger-than-life *Standing Women* for New York—than that of Camus.

1952–1956/1958–1965
The Artwork as an Autonomous Reality

Giacometti's compositions between 1947 and 1950–51 immediately regained for him the acceptance he had had twenty years earlier with his post-Cubist mannered figures and Surrealistic visual models. We have shown how much they owed to the concept of style, which he now began to take seriously again, and to the Surrealist conception of the artwork as an embodiment, a model, of thoughts and feelings. He had now succeeded in combining all his experiences and compositional ideas and giving them expression in his art—with the exception of that visionary "composition with figures" which was to symbolize the "totality of life" through four sculptural elements: a standing woman, a walking man, a head, and a place or situation. (We speak of a place, in the sense of an area, rather than of space, because Giacometti never considered the representation of space in and of itself as a sculptural problem; he always thought of it in terms of a quality possessed by each individual figure, like an emanation or field of force surrounding it; 51).

During the fifties Giacometti attempted no new compositions, perhaps because he had no concrete commissions to do so, but more likely because he wanted to work intensively on all the problems these four elements contained. It is difficult to place all the pieces he did at this time chronologically; they included busts, half-figures, and nudes standing motionless, most of which were studies from life—his brother Diego posed for many heads and busts (pages 200–203), and his wife Annette for half and full figures (pages 196–98). The only composition in the strict sense was his group *Women for Venice*; the Biennale in 1956 was one of the few exhibitions at the time which challenged Giacometti to make new "realizations." His one-man shows (Chicago 1953, Paris 1954, Krefeld-Düsseldorf-

Stuttgart, London, New York 1955, Bern 1956) took on a progressively more and more retrospective character. The series *Women for Venice* (page 119) is in itself a small retrospective of the stylistic formulations that Giacometti had used between 1947 and 1956. Each figure differs a little from the last: now a bit closer to a naturalistic representation of the model, now more stylized, like the *Standing Women* of 1947–49.

As far as the *Busts of Diego on Steles* (page 259) go, we can only assume their relationship to a compositional idea—they are sculptures that represent a sculpture or parts of one, perhaps meant to be used together with a *Standing Woman* to form a whole composition, similar to the *Part of a Composition: Cube* of 1934.

It was the commission, from the architect Gordon Bunshaft, to create a monumental sculpture for the plaza in front of the new Chase Manhattan Bank skyscraper which first set the problem of actually assembling the elements in a concrete composition (1959–60). Giacometti had completed only a model for this composition before he died (see pages 185–86), so one might assume that he had studied only the individual elements of the project, which remained fragmentary, if it were not for the feeling one has about the works from 1960–62 that each one of them, in itself, is capable of containing and expressing the entire composition. The last concept Giacometti had for this commission—and for the ultimate expression of the "totality of life"—was a single, larger-than-life female figure (175; 729).

A short comparison of the period of 1935–46 with that of 1952–65 will help our theoretical analysis of Giacometti's final period. Although his development took place in the open, in full public view, and was accompanied by Giacometti's own comments and statements to a degree never before the case, this period is much more difficult than any other to describe precisely. When we name dates in the discussion that follows, it will be only as approximate points of reference in a flowing creative process which cannot be chronologically documented with any precision.

The year 1951–52 brought with it a new beginning similar to that of 1935: Giacometti again stopped making his "realizations" and began to study the reality in front of him. The year 1956 brought a crisis similar to the one he had gone through in 1939–40, when his figures became tinier and tinier: now his portraits "disappeared" from the canvas with the last brushstroke (231; 723), just as his earlier statuettes had crumbled at the last pressure of the modeling knife (13). We can compare the unique "realization" of 1942–43 (*Woman with the Chariot*) with the compositions *Women for Venice* and *Diego-Steles* (1956–58). From 1958–59 on, a new stylistic conception changed the relationship between artwork and reality, analogous to the development of 1946.

This last period of Giacometti's work, from 1952 to 1965, represents his final attempt to create an art which was worthy of comparison to life, to capture forever, through style, some of life's limitless reality, to oppose the timeless to the temporary. This time, painting played as large a role in his creative process as sculpture. Drawing served Giacometti above all as a way of approaching reality, while the prints he began turning out in 1951 were rather forced "realizations" and contained few new artistic solutions.

The change that came with the early fifties was more significant than any of Giacometti's earlier new orientations, even though the initial problems were the same as those of 1919, 1925, and 1935, when he had begun to mistrust artistic convention and "style" and look for new ways to represent reality. This time the power that was to alter the "typical Giacometti style" of the postwar years was not to come from a mere "phenomenology of perception" as it had in 1935, when Giacometti's work brought him to the hypothesis that reality was first and foremost a system of appearances for the eye to perceive—and that an artwork thus had to represent an appearance in the eye of the observer. As a result of experiences he had had immediately after the war, which can be summarized in his sentence: "The essential thing [about reality] is that which is" (56:181; the visionary experiences of 1945–46 will be discussed in Part Three), he realized that the artwork does not have to compete with the appearances of reality alone, but with its being and existence. In 1951 Giacometti began to speak of a Polynesian fetish being better than an Egyptian sculpture, because it reproduced not only an image of reality but reality itself; not the eye—the glass eye of the Egyptian *Scribe* in the Louvre, say—but the glance; it was not a representation of reality, but a double of reality (50).

Now, Giacometti expressed his conception thus: "I am searching for absolute resemblance [to reality], not its appearance." (65) In making this his goal, Giacometti felt himself at odds with his contemporaries but within the centuries-old traditions of art and even in conformance with the constants of civilization's history. He saw his approach to reality as a task which required no justification because it supplied its own justification, whether one was successful or not. The "great adventure" (61) was to see that which *is*, and even, finally, to discover the nature of being—the quality of life in living beings and how it differs from death. If an artwork were ever to be successful in this way, that would mean that it would "be" just as reality "is." Art would almost have to become magic.

Giacometti held to this goal until about 1956 or 1958. He had to give it up because the idea of a "magical" creation also involved the creation of an imaginary space, valid only for the work of art itself. So his last goal was to create a double of reality in real space, a sculpture in a city square peopled by living men and women.

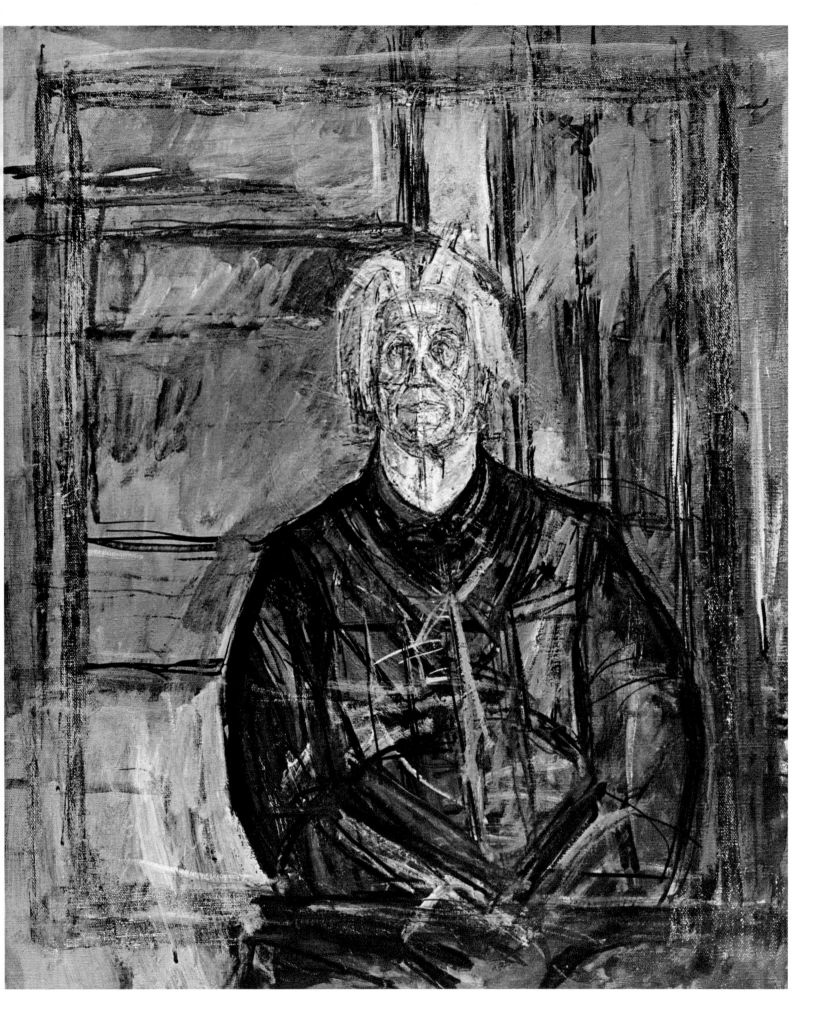

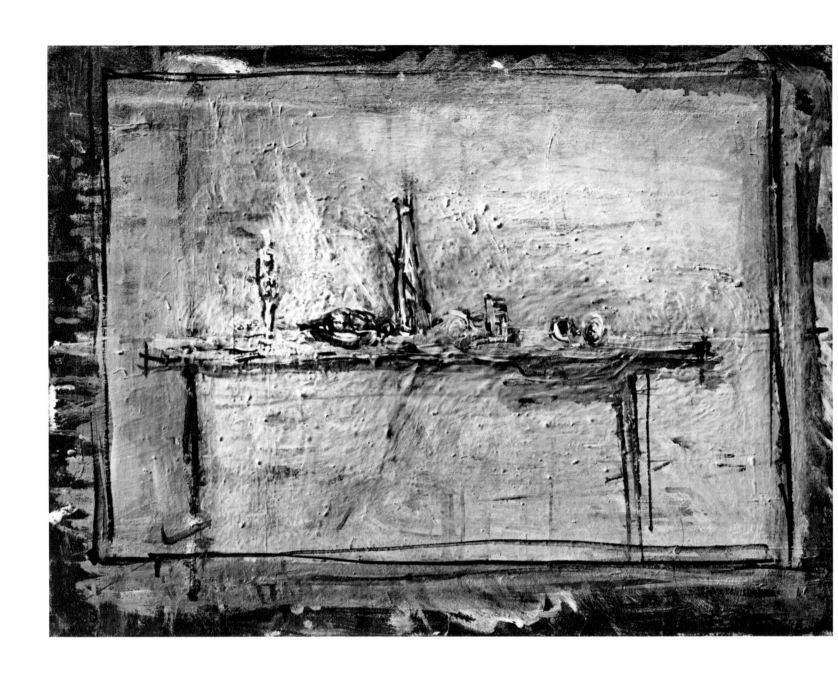

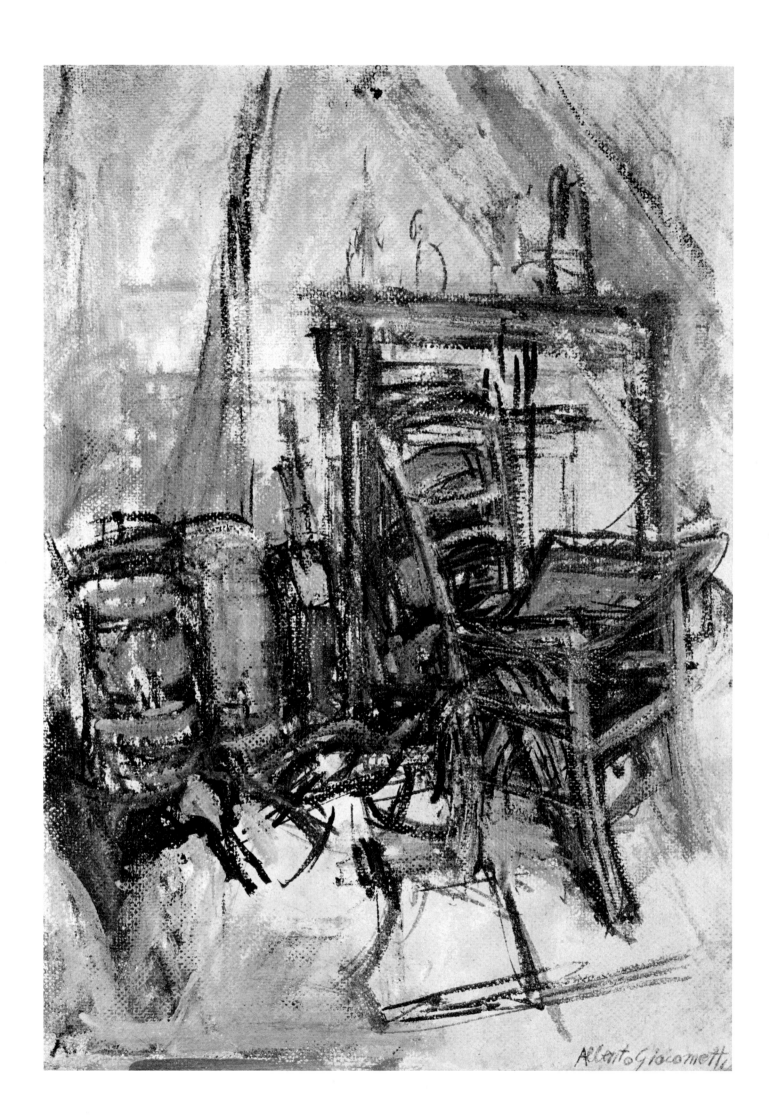

Alberto Giacometti

147

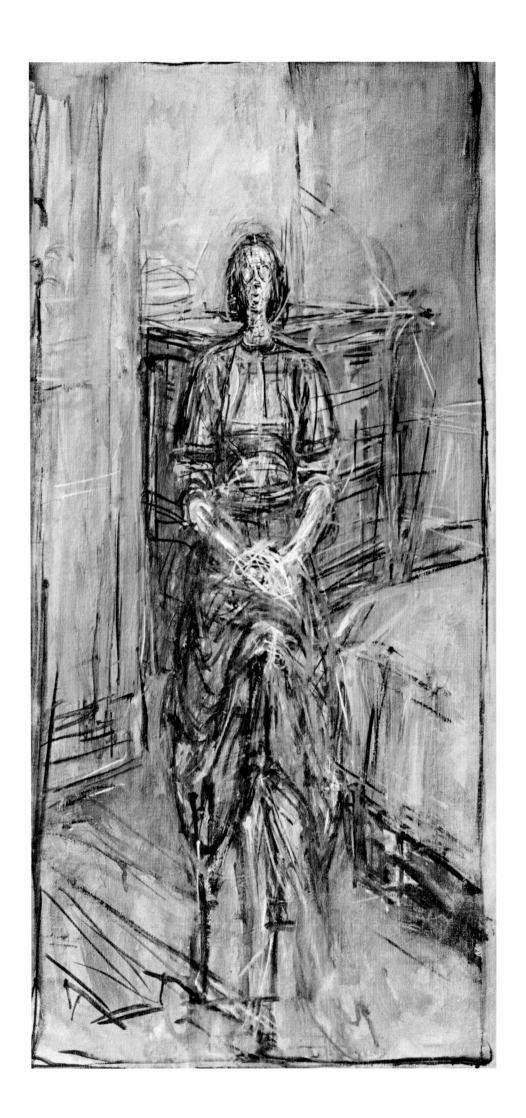

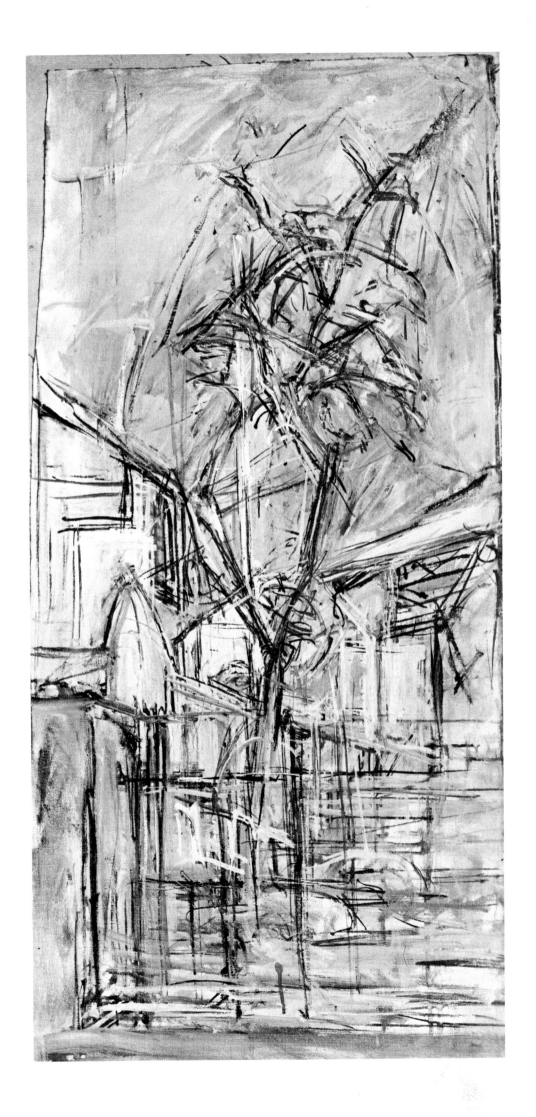

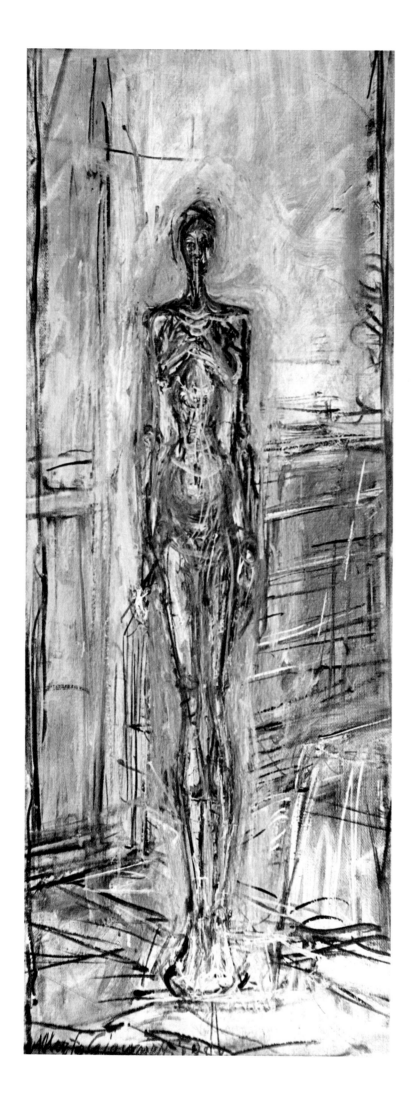

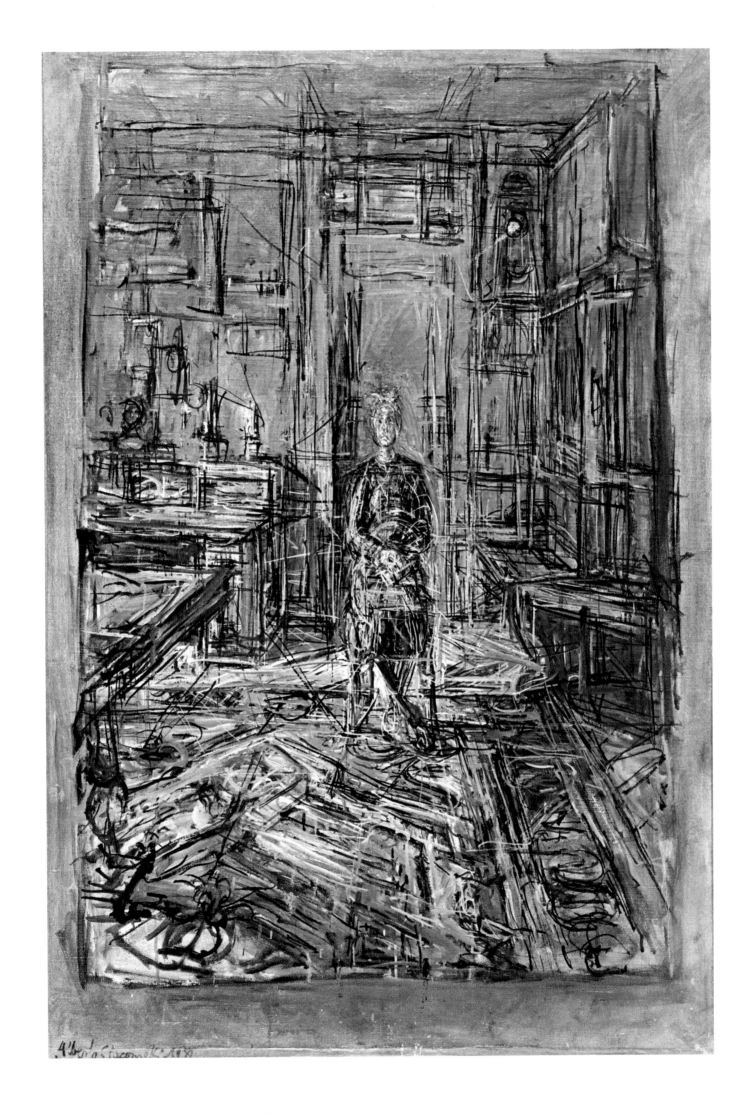

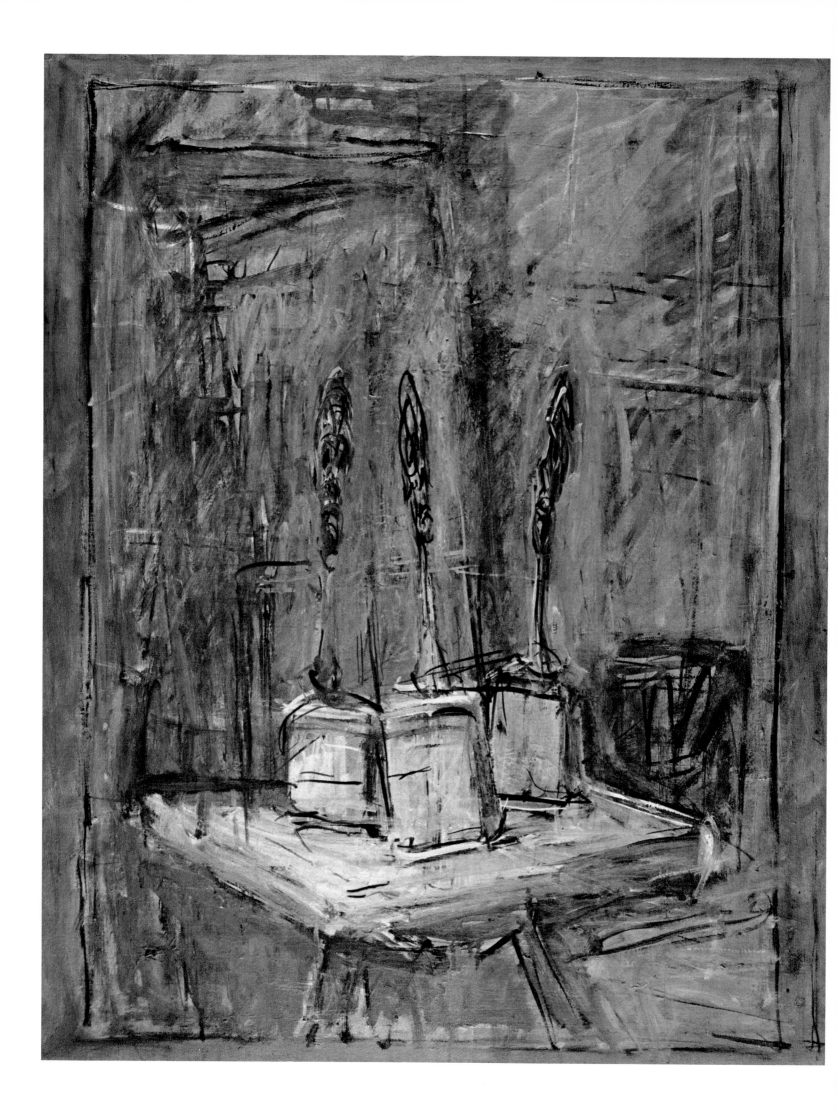

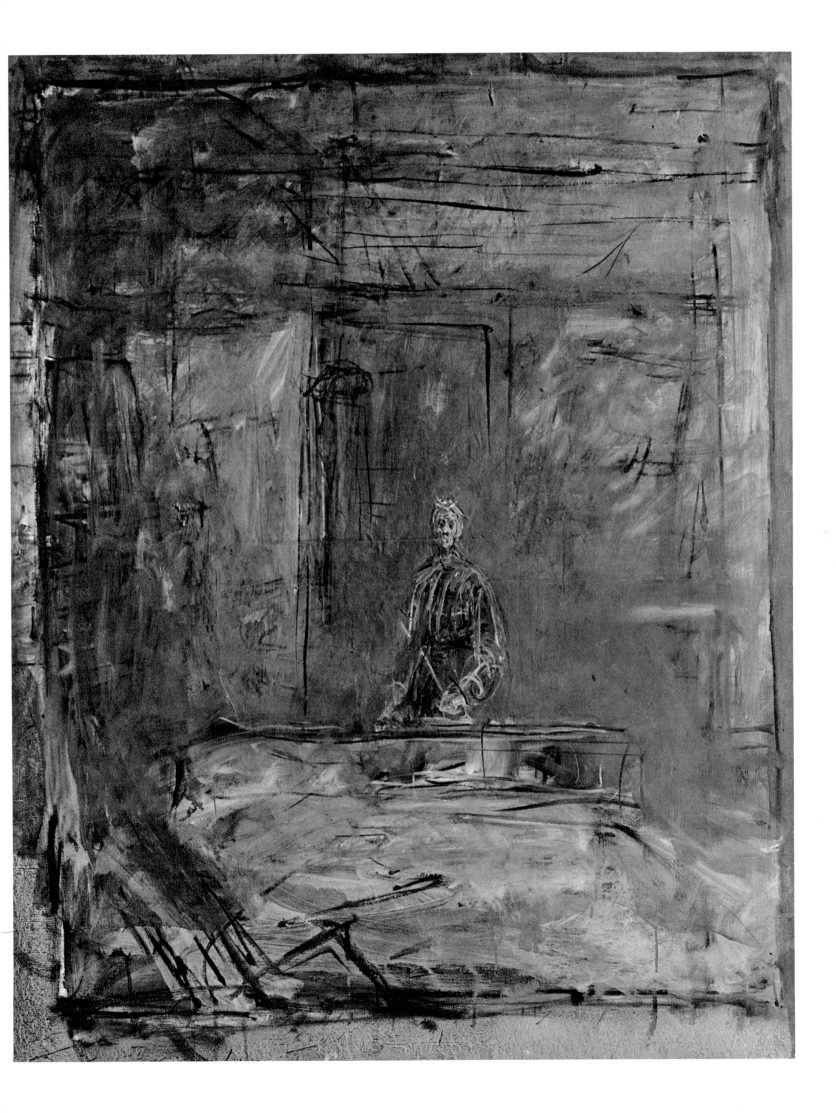

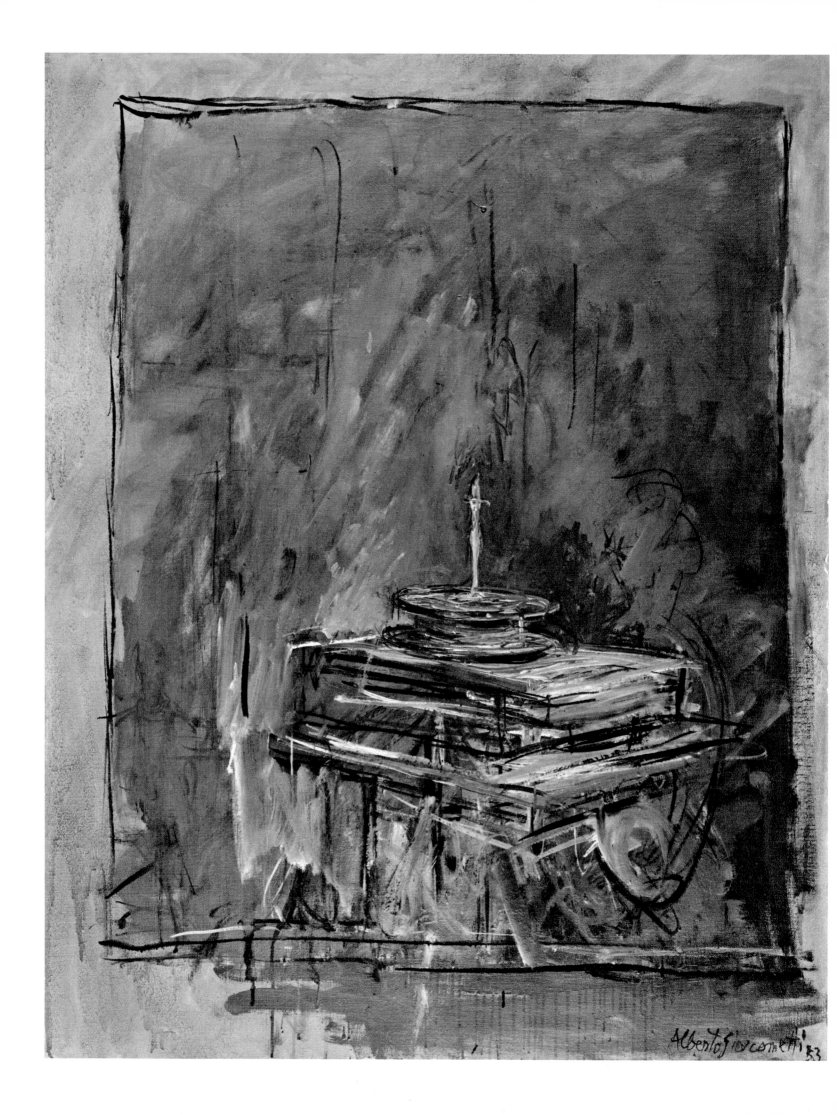

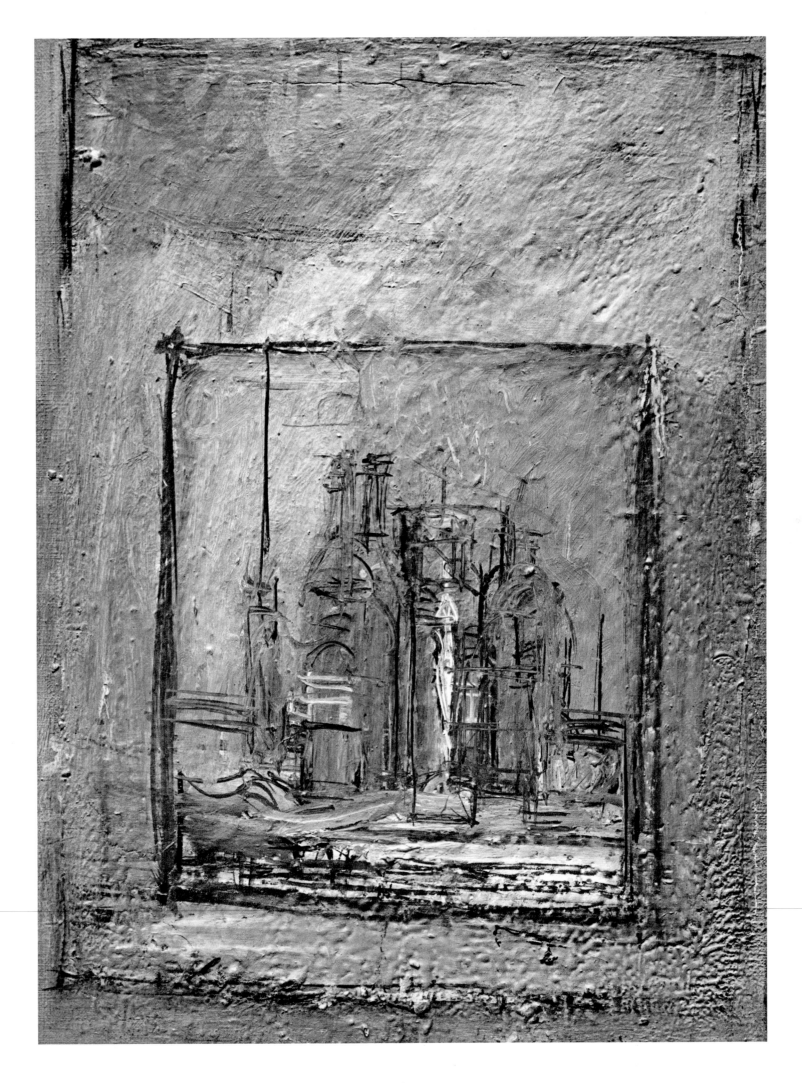

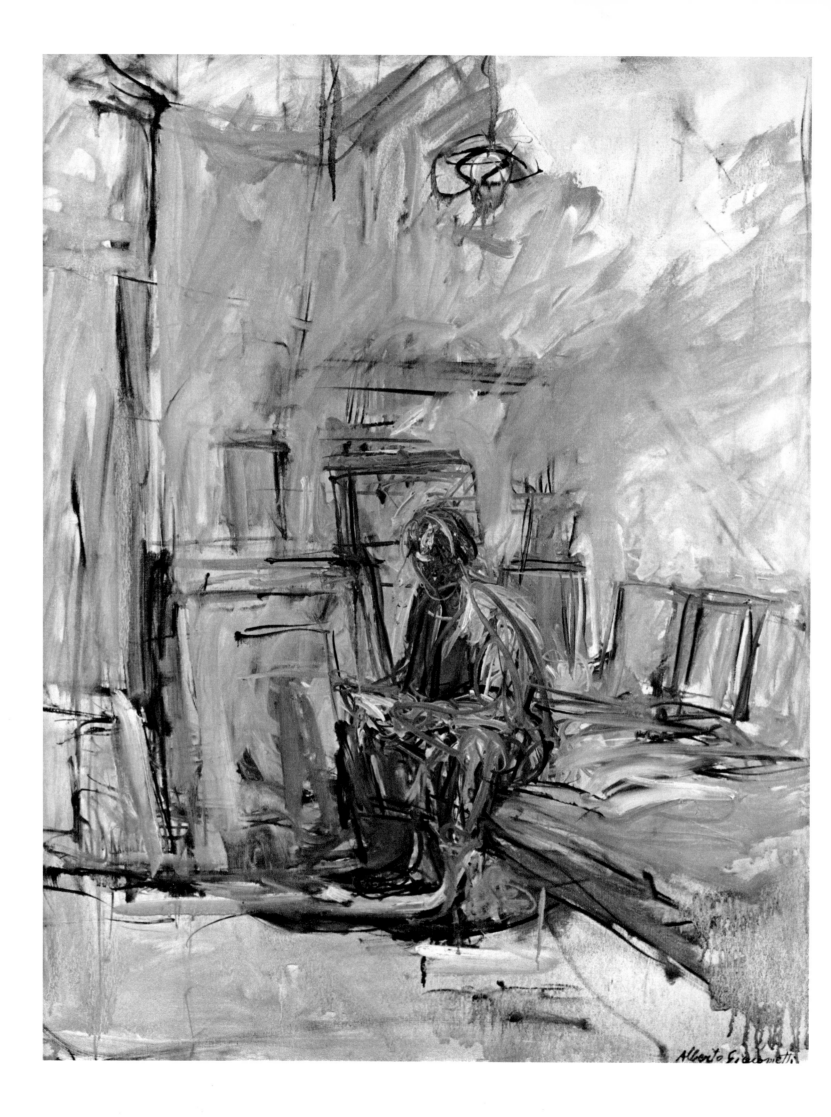

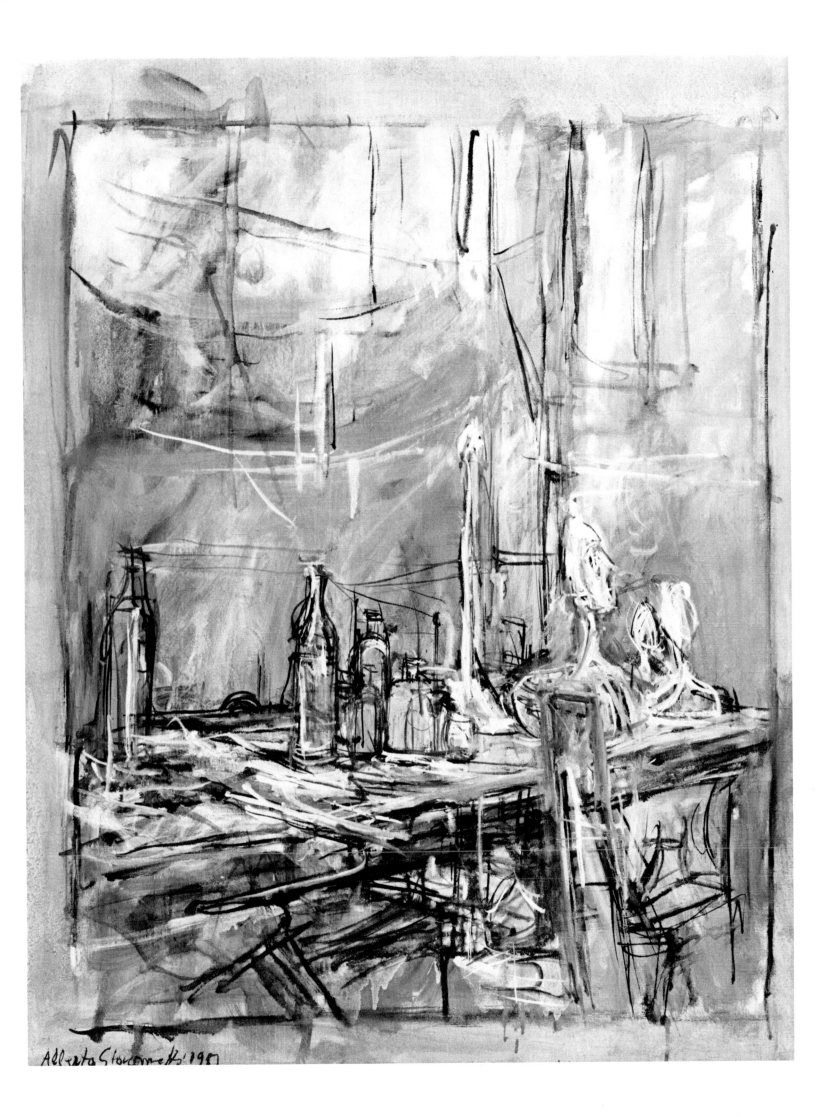

Alberto Giacometti 1951

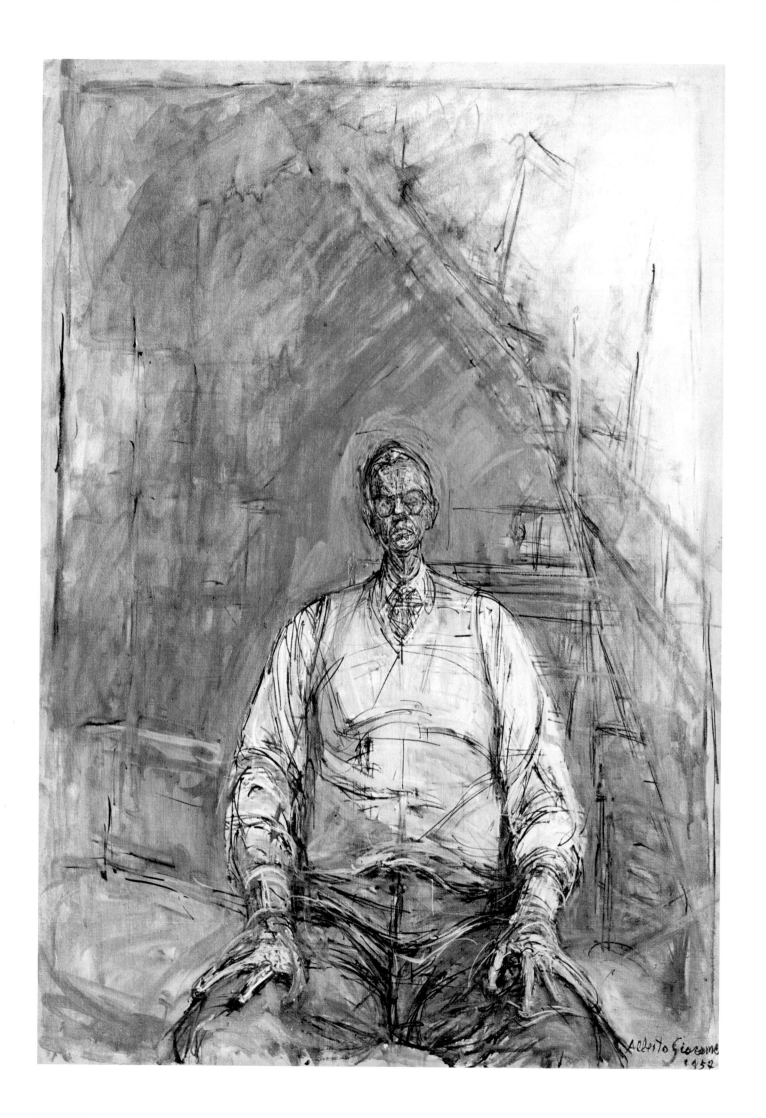

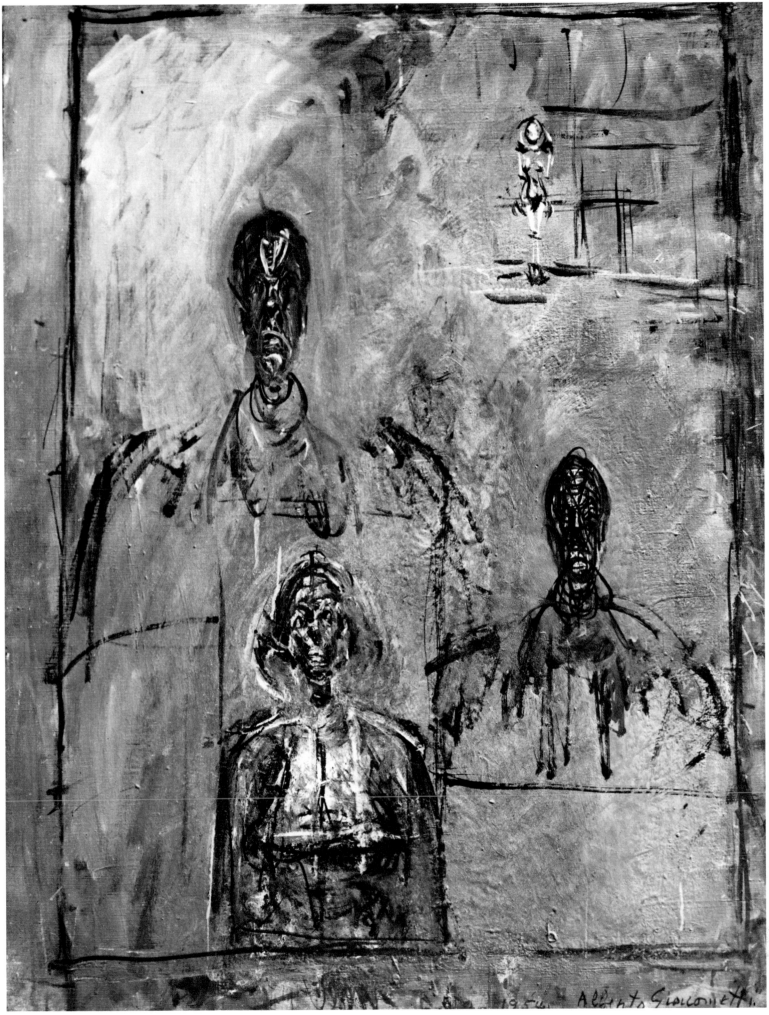

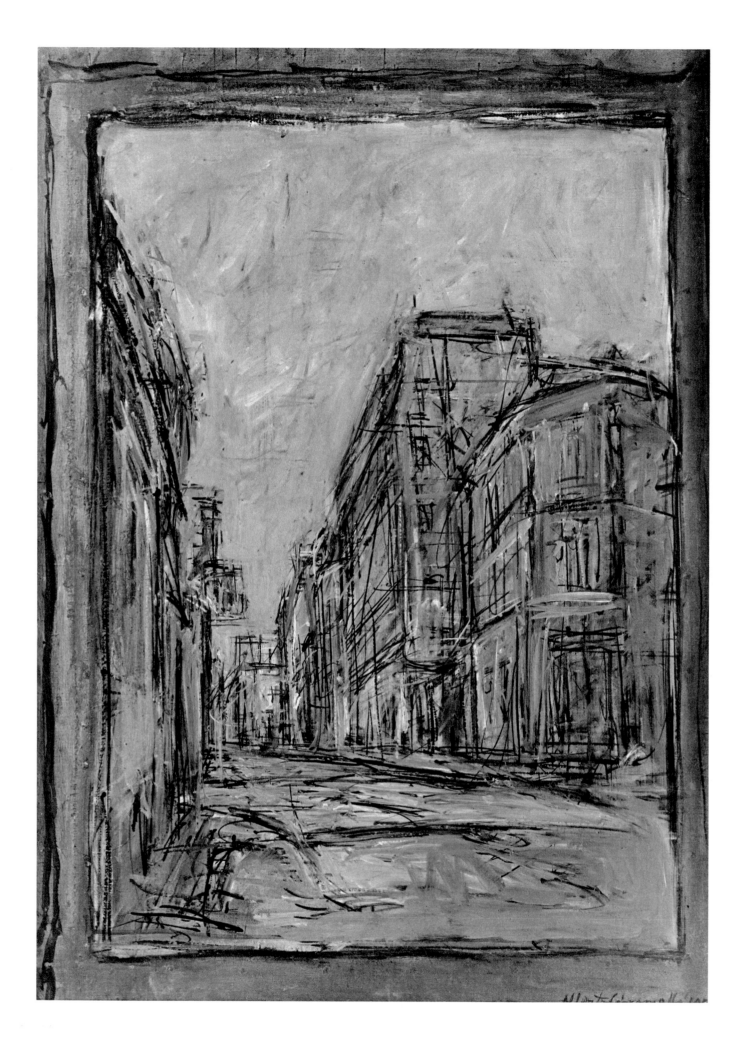

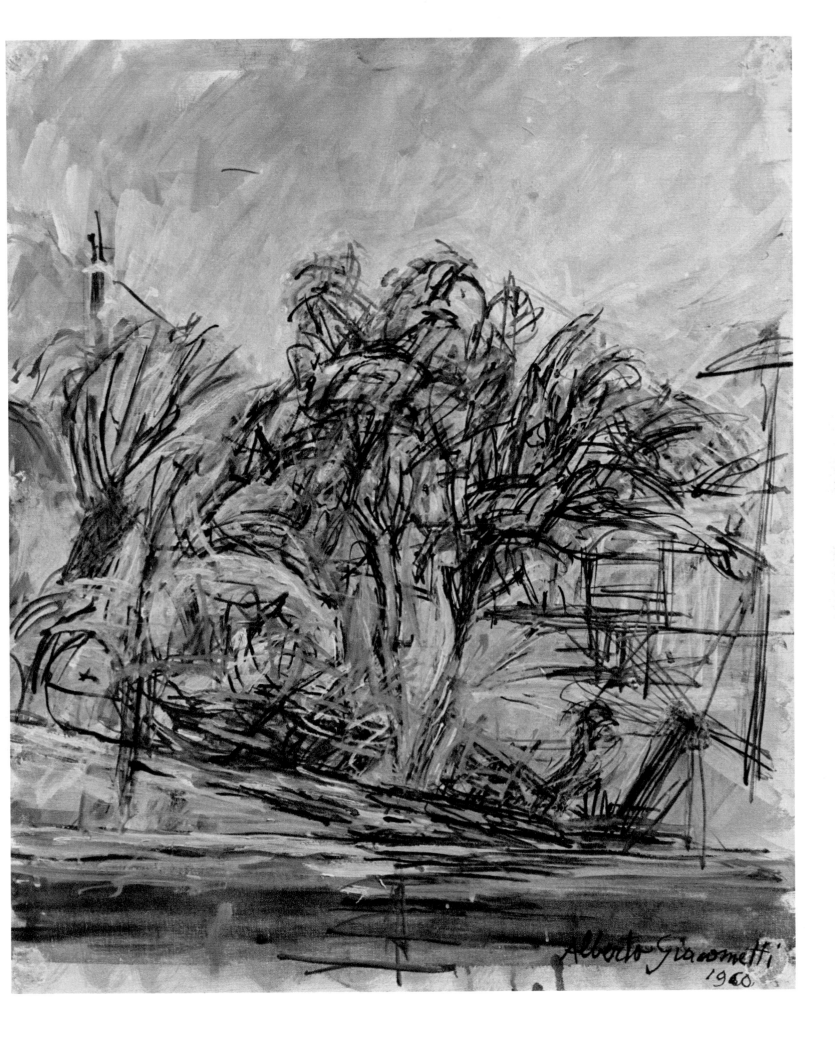

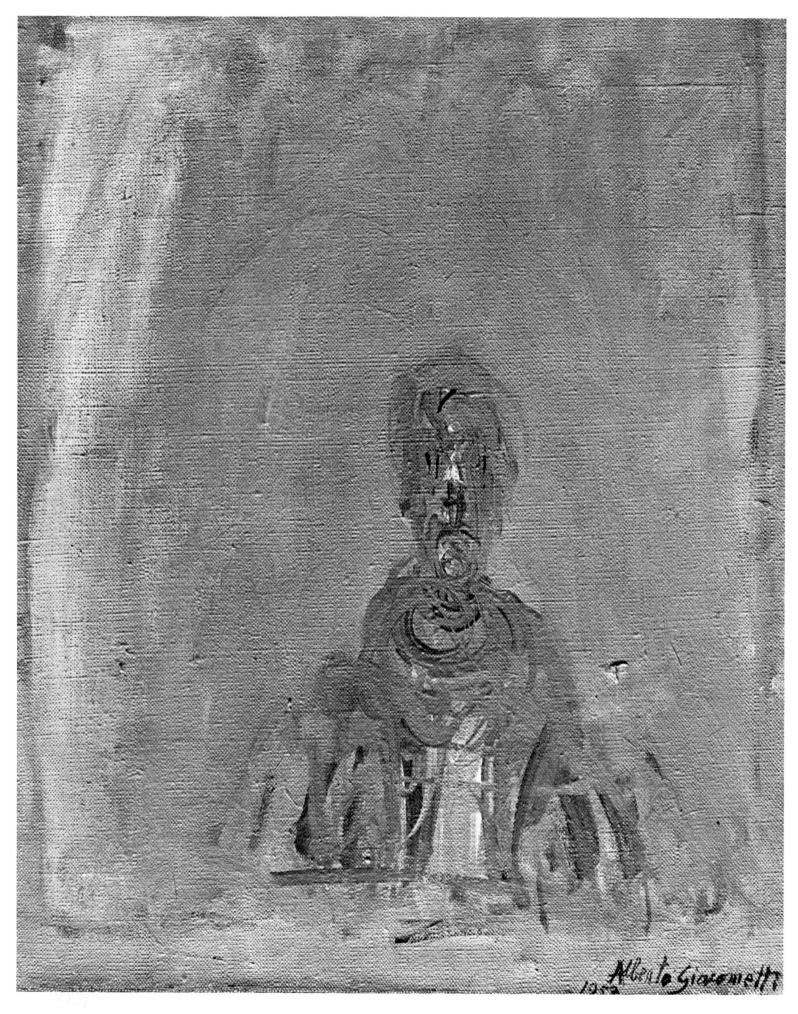

162

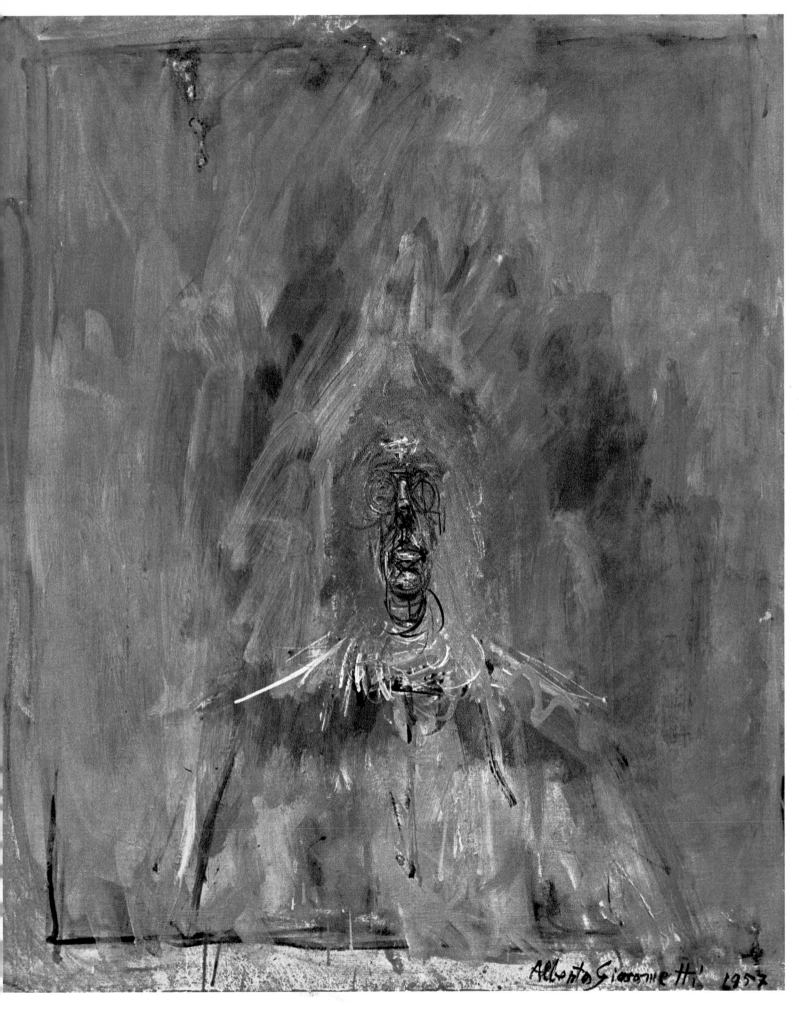

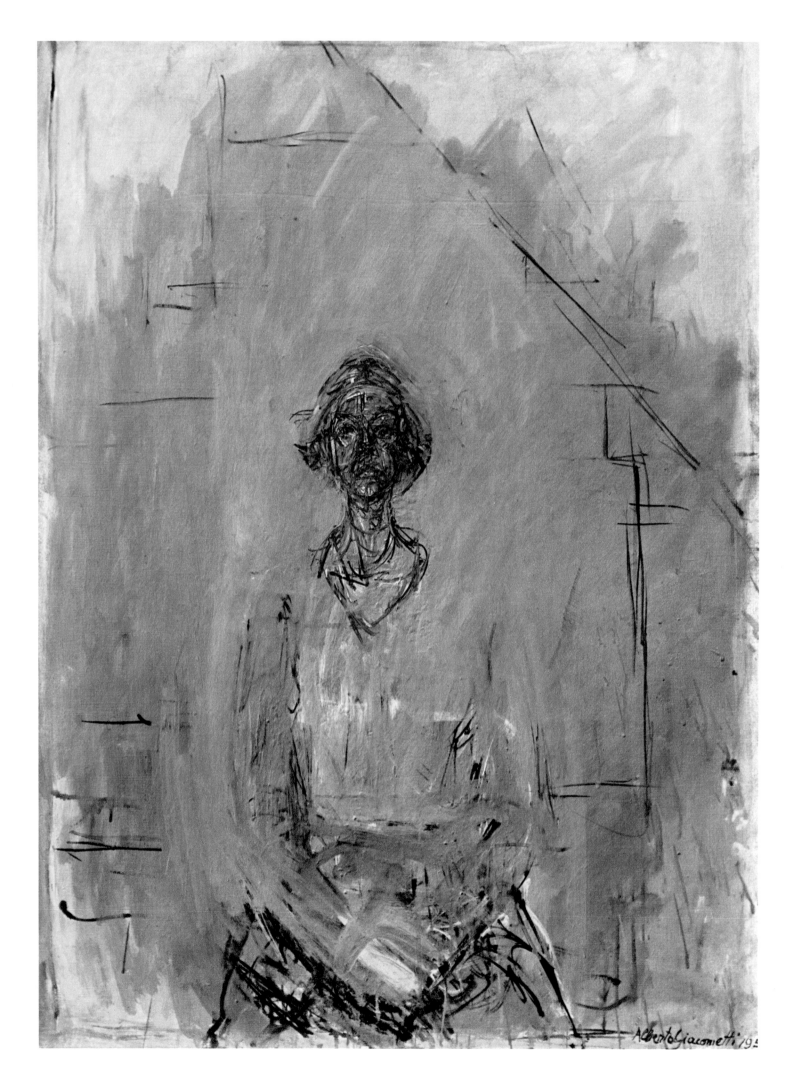

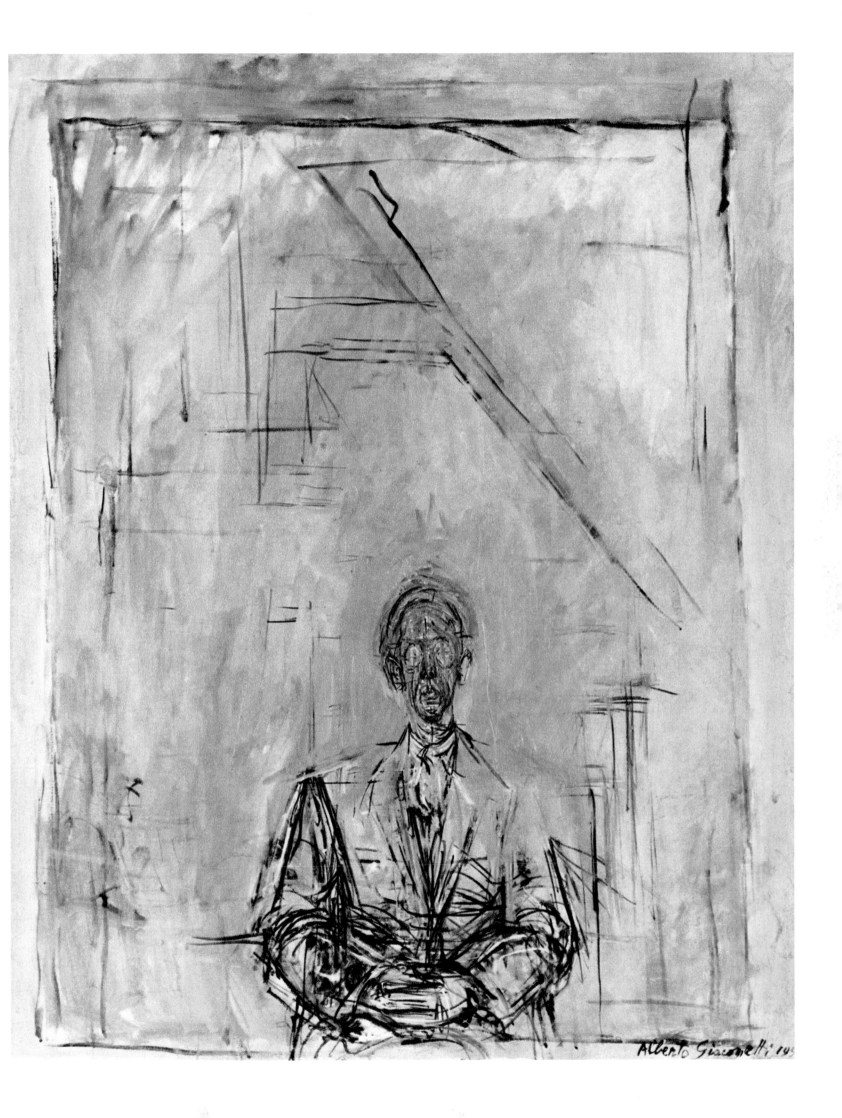

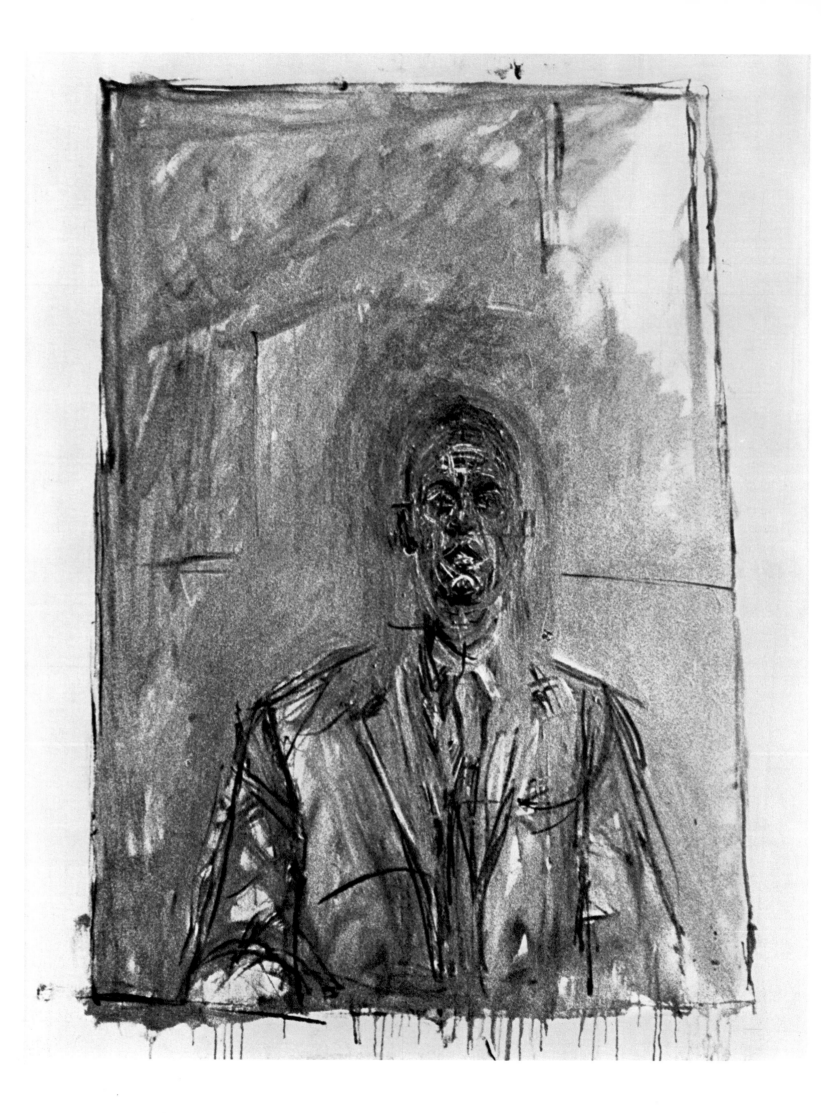

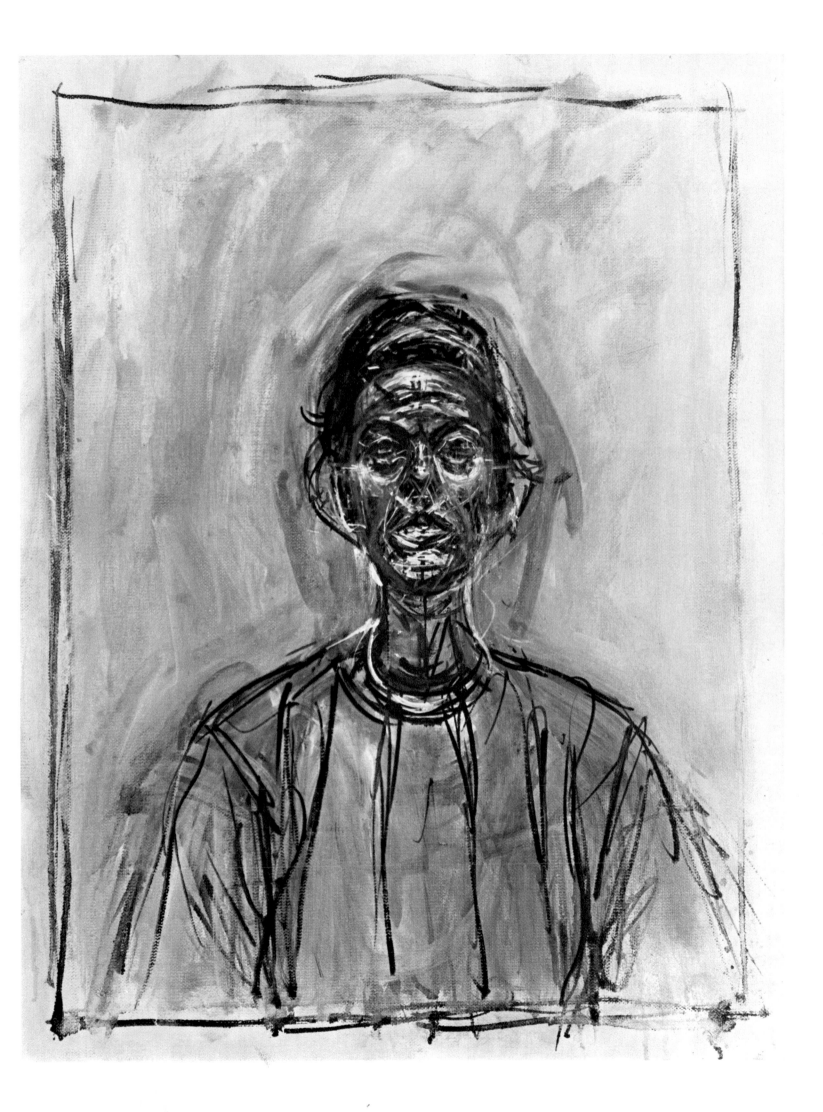

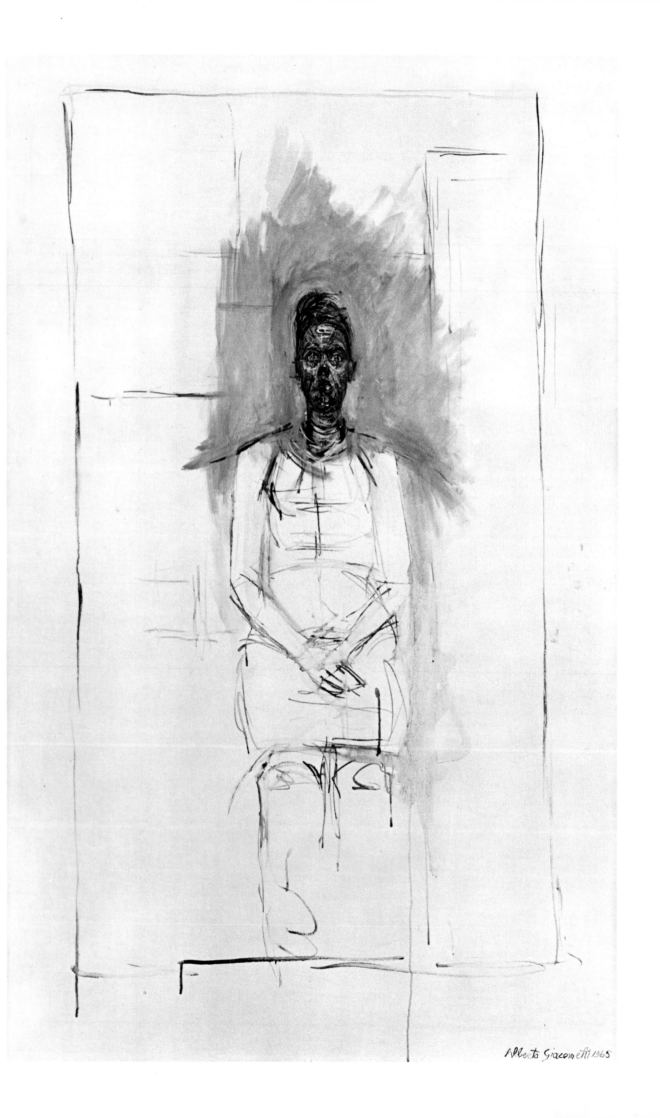

Alberto Giacometti 1965

The Artwork as an Evocation of Reality in Imaginary Space
(1952–1956/1958)

"I should like to do her like Marilyn Monroe, but she keeps getting thinner and longer, longer...." (112) Giacometti's own description of the problems now facing him could not be more concise. Marilyn Monroe, twenty-six years old and at the peak of her beauty in 1952, was the embodiment of voluptuous womanhood for Giacometti, the exact opposite of the dematerialized, bony figures with which his name was now identified. She was also the personification of an idol, such as he aspired to create in his work—just as Federico Fellini, a tortured visionary artist like Giacometti, was to do a little later with Anita Ekberg in his film *La Dolce Vita* (1960). With *Large Standing Woman* (1949; page 118), Giacometti had succeeded in raising a statue of a woman to the level of an idol, thus fulfilling the purpose of style in sculpture as defined by Camus; but he knew now that reality had caught him up, for Hollywood had already stylized a *living* girl into an idol (conforming at least to the letter of Camus's challenge), while his own figure drew its stylistic strength from an Egyptian burial figurine....

This comparison is not as far-fetched as it may seem: Alberto Giacometti's idea of the best contemporary portrait painting was the faces on film posters and movie marquees; "but they were apparently done from photographs." (723) Giacometti wanted his art to resemble nature to such a degree that the stylistic means required to create this resemblance remained invisible in the finished product. But so long as his figures kept becoming "thinner and longer, longer..." he was on the wrong track with his concept of the mannered figure.

When we look at the small, buxom nudes of 1952–53, some of them entitled *Little Monsters*, we can see that Giacometti modeled them with something approaching violence, to try to rid himself of the style that had come so close to mastering him. Many of his other figures at the time—*Model Study*, *Plump Woman*, and *Annette with Grand Hairdo*, to name only three—all of them corpulent and strangely naturalistic, were also attempts to banish the emaciated figures that had developed out of his adherence to the phenomenology of perception (page 197).

The broad shoulders and massive upper bodies of the busts purposefully contradict their narrow heads; many a finely articulated or leaf-thin head rests on mountainous square shoulders set perpendicular to the observer's line of vision, as if to stop his gaze at a barrier. Shirt collars, shoulders, busts, upper bodies, all began to take on the function of pedestals for sculptured heads. For the conventional cubic base was no longer enough—unless, of course,

it was meant expressly as a *representation* of a pedestal. Chest and shoulders fixed the head's position in space; they moved it, in accordance with the laws of perspective, the desired distance away into an imaginary space, providing the transition into this space by means of their vanishing lines and foreshortening. The length, width, and depth of the bust determined the boundaries of this imaginary box of space, within which the portrait, in turn, gained an imaginary reality. Giacometti, like the Mannerist painters, even went so far as to exaggerate and distort the proportions in his portrait sculpture and paintings (*Diego*, 1954; *Thompson*, 1957, page 158): the hands or the arch of the chest in the foreground, apparently too large, the head pulled far back into its imaginary space and apparently too small—"too large" and "too small" according to our habitual way of seeing, that is, which automatically corrects our optical impression (the optical reality) of a person sitting before us. Giacometti could mention Cézanne's *Boy with a Red Vest* in his defense; the boy's overlong arms are an exact and correct reproduction of visual reality (71: 123). When Giacometti represented a figure in the way we "really see it," before our eyes and brain automatically transform distorted proportions into the conventions of perspective, then his work contained something of the "raw material" of reality. Our eyes must work at it and transform it exactly as if it were reality—this is the source of the feeling one obtains from Giacometti's work, that it possesses a certain imaginary reality.

Giacometti now began again (as he had in the twenties) to paint his sculptures, "so that the whole statue succeeds in creating the same magic one feels when confronted with reality." (50:20) When talking with Georges Charbonnier about this (in 1951) he said he did not want to go so far as to equip his sculptures with real clothes and hair, because that would dilute his own creative contribution with the chance effects of nonartistic materials, but he did begin to represent objects and clothing in some detail, as in *Diego with Sweater* (page 257) and *Diego in Turtleneck*.

With his *Busts of Diego* of 1954 (pages 200 and 201), profiles so narrow they might almost be cut out of tin, Giacometti demonstrated that, even when we see a face from the front, we are aware of the full extent of its depth. By forcing our eye to accommodate itself to a work of art just as it does to a real head, the artist has found a way of giving his work some of the logic of reality. This is exactly what Giacometti did, both in sculpture and in painting. He created works where we have the definite feeling that the Adam's apple is a bit closer to us than the throat, and the nostrils closer than the eyes, and the cheekbones closer than the earlobes. Giacometti's eye worked like the finely adjustable lens of a camera pointed at a person two to five yards away and focused to the

fraction of an inch on the point of his nose or its base, on his eyebrows or his eyes, on his temples or his ears. If the observer makes this changing focus his own when looking at a Giacometti sculpture, he will experience—from one accommodation of his eyes to the next—how the face has depth, how the head exists as a reality in space.[52]

Such a head had to be as narrow as an ax-blade seen straight on, so as to force the viewer to take it in from the point of the nose to the ears in one quick glance past the flattened cheeks; also, the "cutting edge," in the figurative sense, is an expression of the active existence of the Other.

From 1951 on, Giacometti made use of a method in his paintings and drawings that, in sculptural terms, had led to his cage pieces (*The Cage, Imprisoned Statuette*) and also to *Four Women on a Base* (all 1950)—the limitation of the imaginary space by visible boundaries, namely by frames within the frame. Giacometti had painted or drawn frames around his images even before he left his father's tutelage; he had also seen them in Hodler's work and applied the technique to his own early drawings. From 1947 on, the inner frame once again became the rule, but, particularly between 1951 and 1954, he used it with the intention of transforming the innermost picture plane into a mirror space. We use this term because the border that separates the real frame from the drawn-in, inner frame functions like the frame of a mirror, separating the reflected image from the wall on which the mirror is hanging; but the mirror image itself is like an opening in the wall—the entrance to an imaginary space "behind" the wall.

The figures within the inner frame had the effect of mirror images, virtual realities in an imaginary space reserved for them. They possessed an extraordinarily strong resemblance to hallucinations. But, just as a mirage is not seen as simply a reflection caused by hot air, or as an optical illusion, but is thought actually to exist, so the image in the mirror space of Giacometti's paintings was not meant as a representation, appearance, or metaphor of a real person, but as the evocation of a reality as seen through the medium of magic.

In addition, the inner frame opened up (to extend the mirror analogy) a distinctly appreciable, doubly-deep space. For, just as one's own mirror image appears to be twice as far away as one's own distance from the mirror, the image in the mirror space in Giacometti's paintings profits from the distance which seems to lie "behind" the canvas surface; when the areas separating the inner frame from the picture frame were done in flat gray or left unpainted, this effect was even stronger. This space "behind the canvas" was exclusively reserved for the imaginary reality of the painted figure; and, if this figure had its own, evident space in

which to manifest itself, then it took on an individual existence of its own.

Giacometti became a consummate magician when, instead of organizing his picture space in terms of perspective or mirror image, he transformed the canvas into a fog-filled space in which, sketched in ghostly white and black, the head of Diego materialized gray on gray. A series of photographs of the same portrait in different stages (708:144–47) and a series of Diego portraits in different degrees of completion (Giacometti-Stiftung, Zurich) remind us of the gestures of a spiritualist conjuring up an imaginary person before a curtain and then letting him disappear again from sight behind it.

In the essay he wrote on Giacometti's painting in 1954 (621), Jean-Paul Sartre actually did call the artist a magician and conjurer, who performs his show while painting; he predicted that one day we would be startled when confronted with one of Giacometti's portraits of Diego, one apparently no different from earlier ones; and yet we would feel the same shock as when a stranger pops up in front of us late at night. On that day, said Sartre, Giacometti would have come closer to attaining the impossible than any other artist ever had before him; his portrait—still an image, not yet quite reality itself—would affect us with all the power of a corporeal presence.

The reports Giacometti's models wrote about portrait sittings (53; 231; 713; 723) tell us a great deal about his way of working— how he might get excited or depressed before the sitting, how he would get stage fright facing a fresh canvas, how it often took several minutes for him to find the right sitting position, adjust the canvas to the correct height on the easel, and place the model at exactly the distance marked on the floor in red; how he raised his brush for the first stroke like a violin virtuoso . . . and how the portrait developed under his quick brushstrokes within seconds, the result of absolute concentration . . . how he painted it over again in thin gray just as quickly . . . and brought it forth again and brushed it out again, ten, fifteen times, over and over again, even though it might have become too dark for him to be able to see the model at all.

Parallel to these techniques of re-creating the presence of a being, Giacometti spent more and more time working on what he considered the essence of living creatures: the eye and its gaze. The plaque he made in 1928, probably the first piece he did in a totally individual style, was called *Observing Head* (page 48), and he had also made an intensive study of the sculpture of past epochs— primitive, Egyptian, Baroque—to see how they treated the gazing eye; but, beginning in 1950, the gazes of his sculptures not only became more naturalistic, they came to be the first steps in his

work's steadily increasing similarity with the essence of reality—its expression of being.

The only difference between a living person and a dead one, said Giacometti in 1951, was in the look of their eyes (50). Every meeting with another person was a meeting of the eyes, he said; one always looked at the eyes of even a blind man (817). Foremost in Giacometti's mind to the last was his desire to give his painted and sculpted figures a lifelike gaze.

In his conversations he not only came back again and again to the gazing eye as the key to the representation of life, he also said that the success or failure of a work depended on the few cuts or brushstrokes meant to suggest the eye; and, vice versa, every feature of a face and every detail of a figure were mere accompaniments to this one key factor. But what makes up the gaze? Is it the eyeball? The pupil? A tiny wrinkle at the corner of the eye?

The strange thing is, when you represent the eye precisely, you risk destroying exactly what you are after, namely the gaze.... And the funniest thing is, that in a primitive sculpture—African or Oceanian—where two shells are set in the head for eyes, the head looks incredibly alive, its gaze is almost shocking. In none of my sculptures since the war have I represented the eye precisely. I indicate the position of the eye. And I very often use a vertical line in place of the pupil. It's the curve of the eyeball one sees... but that's where the problems come in ... and they're the reason why I work. For what occupies me most is getting the curve of the eyeball. That seems to me the most difficult thing. When I get the curve of the eyeball right, then I've got the socket; when I get the socket, I've got the nostrils, the point of the nose, the mouth ... and all of this together might just produce the gaze, without one's having to concentrate on the eye itself. (817)

Giacometti's goal of infusing life into an entire portrait by creating the impression of a gaze is strangely paralleled by the thoughts Hegel expressed in his lectures on aesthetics (1818–29) postulating a Romantic art:

What is missing in the images of the [classic Greek] gods is the reality of the subjectivity which exists for itself.... On the exterior, this fault is revealed in the fact that the expression of the simple soul, the light of his eyes, is lacking.... The most elevated works of sculpture represent personnages with no gaze; their innermost soul does not look out [of their bodies] with the spiritual concentration that the eye reveals. The light of their souls is shed outward and belongs to the observer, who is not able to regard these figures eye to eye, soul to soul. The god of romantic art, however, is a god who sees, who knows himself, who is subjective in his inner personality, opening his innermost soul unto itself. (*Aesthetik*. Berlin, 1843, vol. 10²: 124–25.)[26]

There was no sculpture during the nineteenth century that fulfilled Hegel's expectations of giving light to the eyes of busts and heads, not until Rodin. And even Rodin, like Bernini, always tried to create the gaze by using the same system of a notch in the smooth surface of the eyeball. Giacometti, supported by his careful study of primitive sculpture and paralleled by the demonstrations of Gestalt psychology, was the first sculptor to think of putting the whole of the person represented into his gaze.

The Crucial Turning Point (1956–1958)

The summer of 1956 brought a break in Giacometti's artistic conception, something highly unusual for a fifty-five-year-old, successful artist. "It seemed to me that I'd made some progress, a little progress, till I began to work with Yanaihara. That was about 1956. Since then things have been going from bad to worse." (723:44) Even Sartre, who is only too quick to find a philosophical-literary explanation for despair, noticed it: "Giacometti was *really* desperate at the time." (713) We know from his earlier crises (in 1919, 1925, and 1935) that Giacometti's despair at his inadequacy meant that a change of course was coming, a new conception to replace the old. This new change is impossible to date precisely; we only know that the post-1958 works differ considerably from those done before 1956. So we can say that the years 1956–58 mark a break in Giacometti's work, the last of its kind. His portrait painting was most affected by this, but because the change was much more than one of "style" or painting technique or choice of colors, because Giacometti destroyed and then rebuilt the relationship between his art and reality, it was a thoroughgoing change of conception, substantially altering both his sculpture and his drawing.

Giacometti's self-appraisal to James Lord on September 26, 1964, though, dealt only with his painting: "I started out with the technique that was available to hand, which was more or less the Impressionist technique, and I worked with it until about 1925. Then suddenly, while I was trying to paint my mother from life, I found that it was impossible. So I had to start all over again from scratch, searching ... till I began to work with Yanaihara." (723:44)

The particular difficulties Giacometti faced in the "era of the Japanese," as Sartre put it in a conversation with Genet (713), must now be examined. It was in 1964 that Giacometti summed up his work to that point with the phrase: "Since then [1956], things have

been going from bad to worse," so the crisis—at least in painting—seems to have lasted much longer than the period under discussion here. Apparently Giacometti never quite found the solution; but the greatest strength of his new and last conception lies precisely in the impossibility of its realization.

Alberto Giacometti's art had always been a measuring-up to the enormities of reality, but when he met up with them again in 1956 in the face of Professor Isaku Yanaihara of Tokyo, his inability to cope with them hit him all the harder for his earlier successes. Two demands he made of his work involved him in irreconcilable contradictions: on the one hand, his paintings and sculptures (of his wife and Diego, for example) were meant to represent *not* the momentary image of a unique individual, but the basic realities of a human figure as an idol, of a gazing head as an expression of the life force. On the other hand—as he began to realize when confronted with the face of a foreigner, an Oriental face—reality manifests itself always and only in the form of special cases: individuals. His previous goal and the way of seeing associated with it had become conventions.

One of Giacometti's conversations with his new model points this up very well: Professor Yanaihara had put off his return to Japan for months, and had canceled trips to Egypt and India, in order to sit for his portrait:

Yanaihara: "Couldn't you continue with Diego or Annette what you have discovered with me?"

Giacometti: "Yes . . . but anyway, it's your portrait I want to paint, not someone else's." (231)

The crisis of 1925 had begun in exactly the same way, when Giacometti started the portrait of his mother from life—in other words, when it was a case of representing an individual reality. In 1933 he had described the difficulties arising from a study of the model in his poem "Brown Curtain": "No human face is so strange to me as a countenance which, the more one looks at it, the more it closes itself off and escapes by the steps of unknown stairways." (3) He had tried to overcome his difficulties in 1935 by placing the model a long distance away and attempting to reproduce appearances in his art. After 1950 he had avoided them by using all the means at his disposal to evoke the individuality of the model in fleeting magical scenes. Now, when it was a matter of capturing the unique and concrete presence of another person in real space, when his art was to be a "double" of reality, no artistic method or style seemed to help: the pedestals and cages, the thin and fragmented figures, the mirror spaces and depth adjustments—even the gray surfaces behind the heads and figures that, like a magician's silk handkerchief,

helped make the portraits almost hallucinatory—all that had to be (more or less) discarded. But Giacometti must have known that a portrait of the kind he wanted to create was, in principle, impossible. For, to apply a thought Giacometti expressed about Annette to Yanaihara: "Nothing is more like Yanaihara—and only Yanaihara—than Yanaihara himself."

So what is the purpose of art, if any?

Giacometti's despair had brought him to exactly the same impasse Marcel Duchamp had arrived at rather earlier. Giacometti, who confidently felt like "wringing sculpture's neck" in 1941 (107), described it thus: "Of course a painting exists only in the eye of the beholder; but Duchamp wanted his creations to exist without any help whatsoever; he began by making copies in marble of sugar cubes . . . then it was enough to buy plates and glasses and sign them. Finally he had no other choice but to fold his hands in his lap." (107:502) Nothing is more like a plate, a glass, Annette, Yanaihara than a plate, a glass, Annette, Yanaihara themselves.

But Giacometti could not "fold his hands in his lap." "What else am I supposed to do in life?" Giacometti asked himself at his lowest point in 1956. "Giving up painting and sculpture seemed to me such a very sad idea that I didn't even feel like getting up in the morning and eating. So I started to work again." (64)

All of Giacometti's skepticism about art now came to a head—every artwork is doomed to failure from the beginning; the artist must first fail if he expects to get any farther with his work; it does not make any difference if an artwork is good or not—all the doubts he had ever had about his own work came out over and over again in his conversations, which undoubtedly express his very deep and personal feelings about the relationship between art and life. But this will be discussed in Part Three, which deals with his person, the legend that has grown up around him, and his relationship to Samuel Beckett. For, as a practicing artist, Giacometti believed to the last that he could do the impossible: "When you don't know how to hold the modeling knife any more, when you are completely lost . . . and when you keep on anyway instead of giving up . . . then there is a chance you will get a little farther. And then you not only have the impression you're advancing a little, you suddenly have the feeling—even though it might be an illusion—that a huge break-through is coming." (817; September, 1965)

On the morning after one of the nightmarish nights during his crisis-ridden work with Isaku Yanaihara, the artist said to his model: "I don't know if it's good or bad, but I don't really care. I'm going on no matter what. . . . *Never in my life have the possibilities been so good.* . . . Five minutes ago your face was as good as finished. . . . Even your eyes were exactly right. But it's all gone again. There's nothing left to see on the canvas. . . ." (231)

173 *Large Standing Nude* 1962 ▷

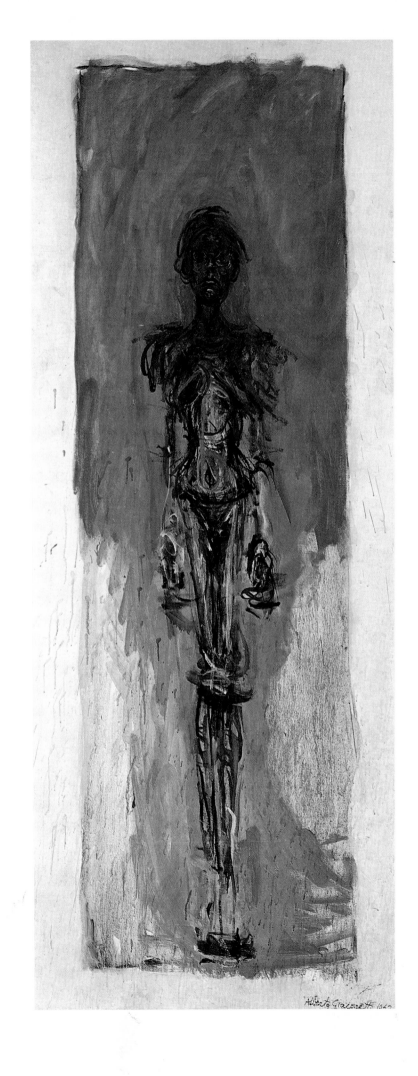

How can we interpret Giacometti's despair? And that he painted over the portrait when it was as good as finished, even to the eyes? The answer is to be found in Giacometti's conception of his work and the problems he had with his technique. For the questions he asked himself were very concrete, not at all general, let alone philosophical.

"When I succeed in doing one part of it right, when I get one single line right, then it [Yanaihara's portrait] will appear again immediately and be a superb painting. How lovely it will be!" Its success seems only a matter of technique and skill. "But I can't imagine how it will look when finished—and that's why my work isn't getting anywhere." (231)

What Giacometti says here about the painting—that he cannot see the finished work before him—he said about his sculpture in the winter of 1951–52: "I don't see any sculptures, I see blackness." (15) This came after the era of "realizations" of 1947–51 when, after having left his own stylistic conventions behind him, he was confronted once again with reality: "Oh, I see a marvelous and brilliant painting, but I didn't do it; nobody did it." By this he meant reality. "If I could make a sculpture or a painting (but I'm not sure I want to) in just the way I'd like to, they would have been made long since (but I am incapable of saying what I want)." (15) Here he is referring to his stylistic insecurity, which lasted into 1956. This is the reason why Giacometti produced almost no "realizations" (in his sense of the word) during the fifties.

Therein lies the reason for his crisis. It was all the deeper (and actually insoluble) for the fact that it involved more than finding a new style—meeting the power of reality with yet another kind of stylized figure—unless he could find one which took the form of a "perfect naturalism" so convincing as to make the work of art identical with reality. But an artist who does not believe in style—if style in art is a measure of its difference from reality—is either forced to give up or is led to the paradox that his work can make progress only when he omits everything on his canvas that seems to belong to the realm of art and style and not to reality: by destroying more and more, in other words. This is how Alberto Giacometti expressed it a few weeks before his death: "I've made tremendous progress: now I can make advances in my work only by turning my back on its goal; now I create only by destroying." (25; October 18, 1965; similarly when talking to James Lord, September, 1964; 723:45.)

This sentence could have been written 133 years earlier by Balzac. *The Unknown Masterpiece* (the title of his novella of 1832) of the painter Frenhofer, a disturbed genius (his name derived from the word "*frénésie*"—madness) disappears more and more under a layer of muddy gray the more the artist strives to paint a perfect trompe l'oeil illusion. Those who see his painting know that it was once complete, a perfect illusion, by the foot in one corner of the canvas, painted with an almost hallucinatory fidelity to life. Balzac's story contains disconcerting parallels with the diary excerpts Isaku Yanaihara published describing his portrait sittings for Giacometti (231); Giacometti's paintings of 1956 and 1957 could even be used to illustrate it.[53] The incredible demands both Frenhofer and Giacometti made of their art probably represent a basic truth about the way artists approach reality. Cézanne, too, recognized himself in Balzac's portrait of Frenhofer; Rilke described this in his *Notes on Cézanne* (*Briefe über Cézanne* [Wiesbaden: Insel, 1952]): "Cézanne stood up in the middle of the meal when his visitor told him about Frenhofer and, speechless in his excitement, pointed to himself again and again, meaning 'it's me, me.' . . . Balzac had suspected that an artist could suddenly be confronted with something so enormous in the act of painting, that it could never be mastered."

Giacometti's meeting with that something, which he could not have mastered in terms of style even if he had wanted to, represented a turning point for him between 1956 and 1958. "One might imagine that making a painting is simply a question of placing one detail next to another. But that's not so. That's not so at all. It's a question of *creating a complete entity all at once*." (723:59) This was to be Giacometti's conception from now on.

It was based on the fact that, in reality, we do not identify another person by adding together a number of details, we do it all at once and of a piece; we perceive the complete entity of the other immediately, and that determines his individuality. But because (according to Giacometti) every head conforms to a basic pattern and no two heads are different except by a few millimeters one way or another, the individual entity of the person sitting for his portrait must suddenly appear when the artist draws the one correct line, or makes the one correct cut, on an image of a head, which conforms to the generally correct proportions (707:40).

His new conception also shows why Giacometti did not care particularly if a piece turned out to be good or bad; he was not so much interested in the results as in the act or gesture of creation. He would continually paint over a portrait that "had been as good as finished five minutes ago"—both Isaku Yanaihara and James Lord watched despondently as their portraits appeared and disappeared, in seemingly endless succession (231; 723)—only to work it up again, always searching for the few correct strokes. For the artist is working at the height of his powers only when he can imitate reality just as quickly as it presents itself to his eye.

David Sylvester tells how Giacometti used to model (and destroy) lifesize clay figures with unbelievable rapidity (638). The film by Ernst Scheidegger and Peter Münger shows how he captured the likeness of Jacques Dupin on canvas in a little over two minutes

(817). But the question is: from what point on is the "complete entity" of the sitter present on the canvas? Probably—as in the preliminary landscape sketches left by Cézanne—after the first few brushstrokes.

The Artwork as a Double of Reality in Real Space (1958–1965)

From 1958 on, Giacometti's paintings—and, from 1959 on, his sculptures, too—have a sculptural consistency that lasted to the end of his life. One could even call it his last style. For he had to have a style; there is no artwork without style. This word is more than ever justified here. It should be understood to mean approximately the opposite of the "personal style" of an artist, which is, once it has been found, more of a *manner*. "Style," said Giacometti to Pierre Schneider in the Louvre in 1962, "is thought of as a way of seeing something which is fixed in time and space. If I could succeed in representing a head in a way that came close to the way I see it, it would certainly have what the others would call style. God knows I haven't got that far yet. But my sculptures have something anyway, something that I. . . ." He left the sentence unfinished (62).

Giacometti found a solution to his dilemma by finally denying the existence of the polarity between art and reality, between the forms which had seemed to him "true for sculpture" and the aspects of reality that had "appealed very much" to him (13). "When I'm working I never think about expressing myself; I say to myself: copy that cup. This cup, that's enough. And in the end, of course, it's *my* cup." (67) Giacometti was at last able to overcome and extend Sartre's principle: "The reality of this cup is that it is there and is not me." (*Being and Nothingness*)

Giacometti was able to create "realizations" during the last years of his life because he had discarded the hypothesis that had supported his work for twenty-five years: that reality had to be represented as the appearances the eye sees from a fixed distance. "Being" is, after all, more than just "being for someone"; the study of reality cannot be undertaken only in terms of a "phenomenology of perception"; representation of living reality involves much more than evoking a magical image in an imaginary space.

It remains for us to analyze the artistic means Giacometti used to make the cup "his" cup, and to grasp the significance of "seeing something fixed in space and time," which for us "others [becomes] what we would call [his] style." (62)

By studying the style of Giacometti's most recent work, we must try to determine how he saw a head or a figure, but we shall be very careful not to extend our discussion to an interpretation of the content of his work, a doubtful undertaking.

The first thing that meets our eye is the spherical shape of the heads of this period. They have been built up around a central point inside the head; this point is the vanishing point for all the spatial references and perspective lines (and perhaps the human qualities as well). The three co-ordinates cross here at zero and radiate from this point to form a system which lends the figure its corporeality and defines the space in which it exists. And in the figurative sense we might even say: this point also represents zero on the "time co-ordinate"—the figure "is." What it is for the observer—or, figuratively, what one person is for another—depends on the distance co-ordinates emanating from the image of the head—whether in a painting or a sculpture—to the eye of the observer: they are unchangeable and irreducible.

This structure of the head—comparable to an atomic model—carries in it both all that is permanent and that which is continually changing, because it consists only of lines of force and not of objective imitations of surfaces and lines. More than his other work, Giacometti's drawings and the paintings done only with dark brushstrokes show how his line, rather than following the contours of an object, delineating shadows, or representing any sort of objective reality, runs around avoiding the individual forms—which seem tangible, but are only implied, coming into being only in those places *not* touched by his brush or pencil.

The "brown curtain" between the artist and his model had been pulled aside. Giacometti began to create portrait heads (all the rest of the body fell into the unfocused border areas of his field of vision) without trying to compete with reality, but as artifacts which were as true to nature as possible and sovereign in every detail—artifacts that carry the seed of truth within them. As for the wonderful lifelike quality of his work, especially of the eyes and gaze, the artist limited himself to creating the conditions for its appearance. No reference to the supernatural is intended.

All great art leaves spaces for the "actual," the real, to creep in; Chinese landscape painters quite literally left central parts of the silk untouched, so that a miles-deep perspective might open up in the space of an inch; Rembrandt and Claude Lorrain were no different: their brushes left the essential spots on the paper untouched where they wanted to create the illusion of open space or the reflection from the surface of a river. Cézanne applied small polygons of color to his canvases for the sake of the spaces between them which remained free. And Giacometti did likewise, finding, at last, a way of representing the human head, a way that he had sought since 1934 with the metaphor of the *Invisible Object*: a presence which exists in space but has no formulation. "In none of my sculptures since the war have I represented the eye precisely. I indicate the position of the eye. . . ." (817) The more one tries to analyze any one of Giaco-

ILLUSTRATIONS ON PAGES 177–184

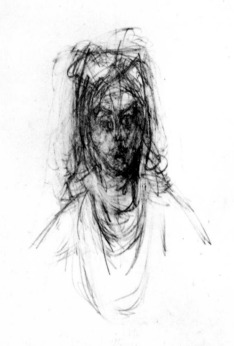

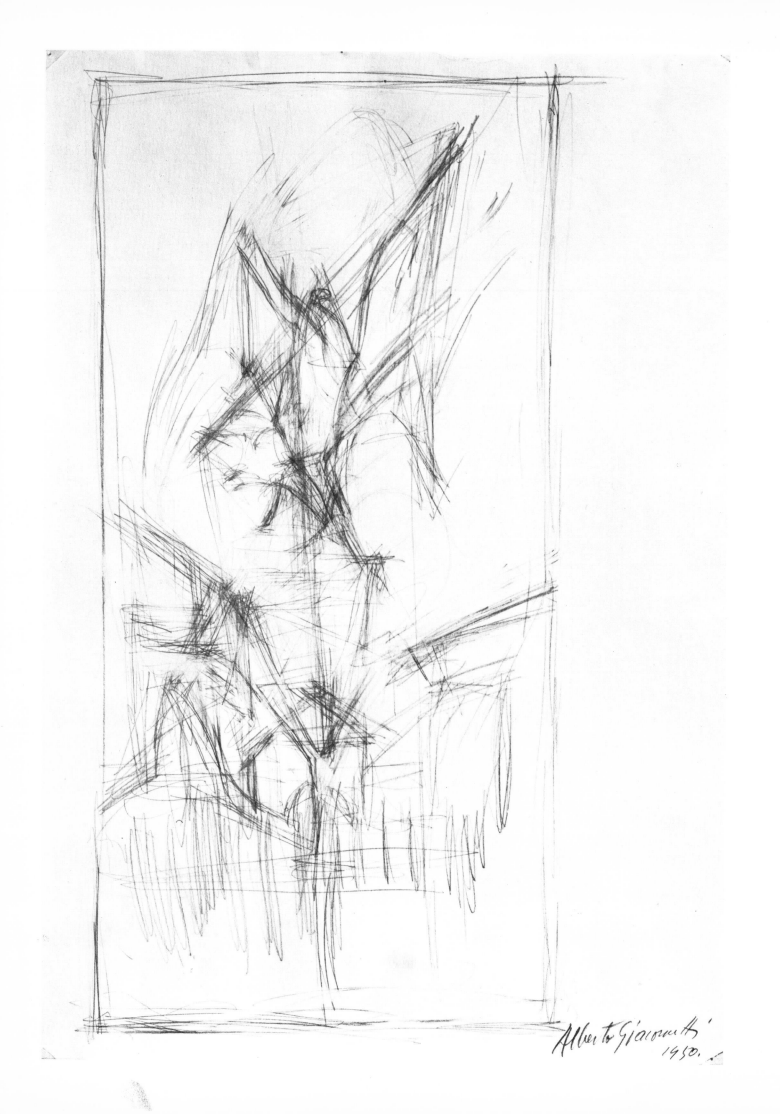

Alberto Giacometti
1950.

178

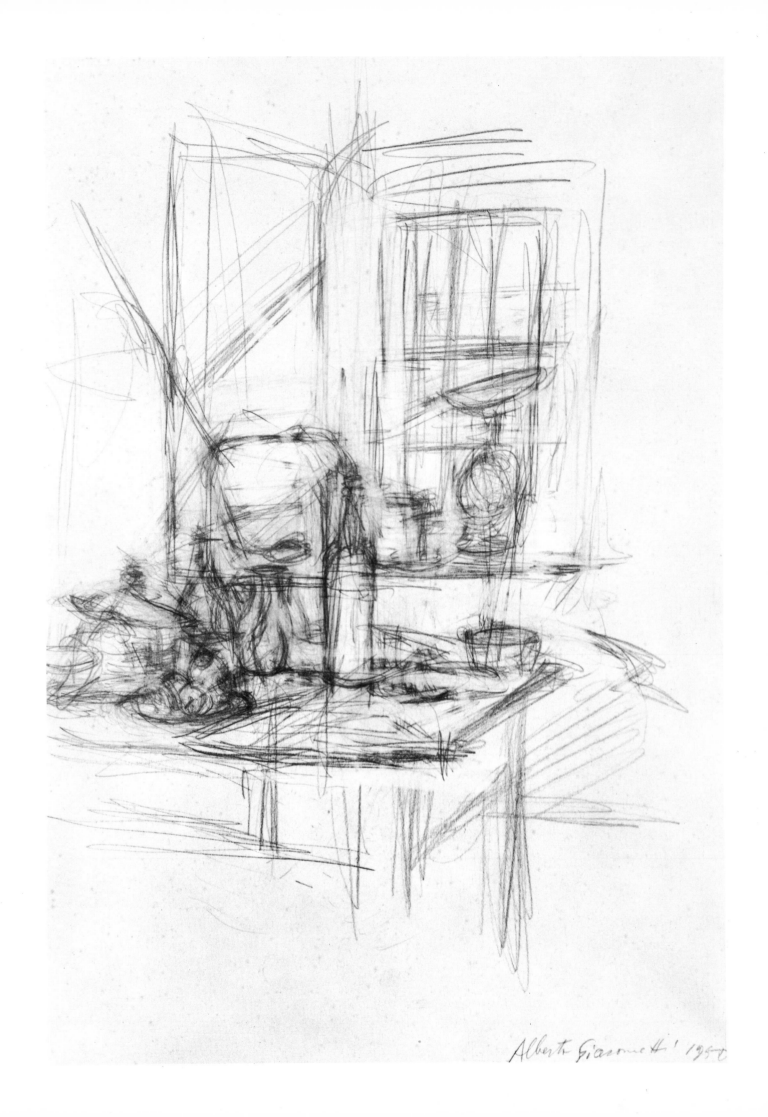

Alberto Giacometti 1950

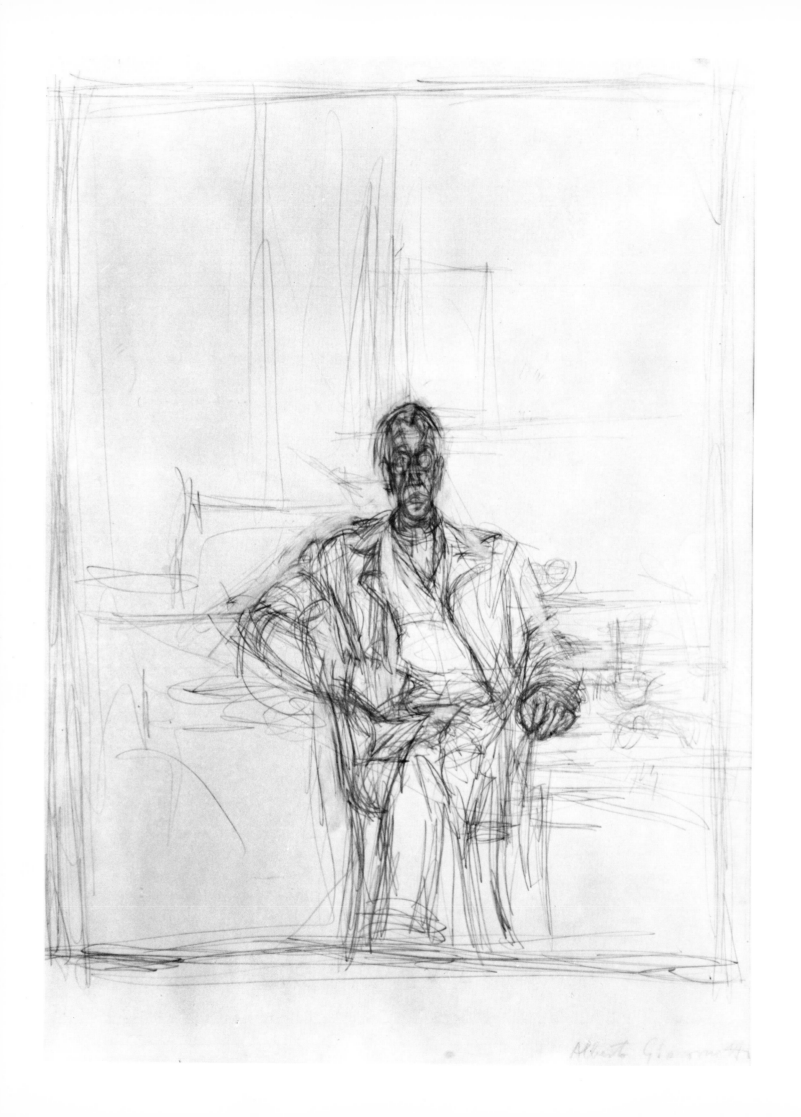

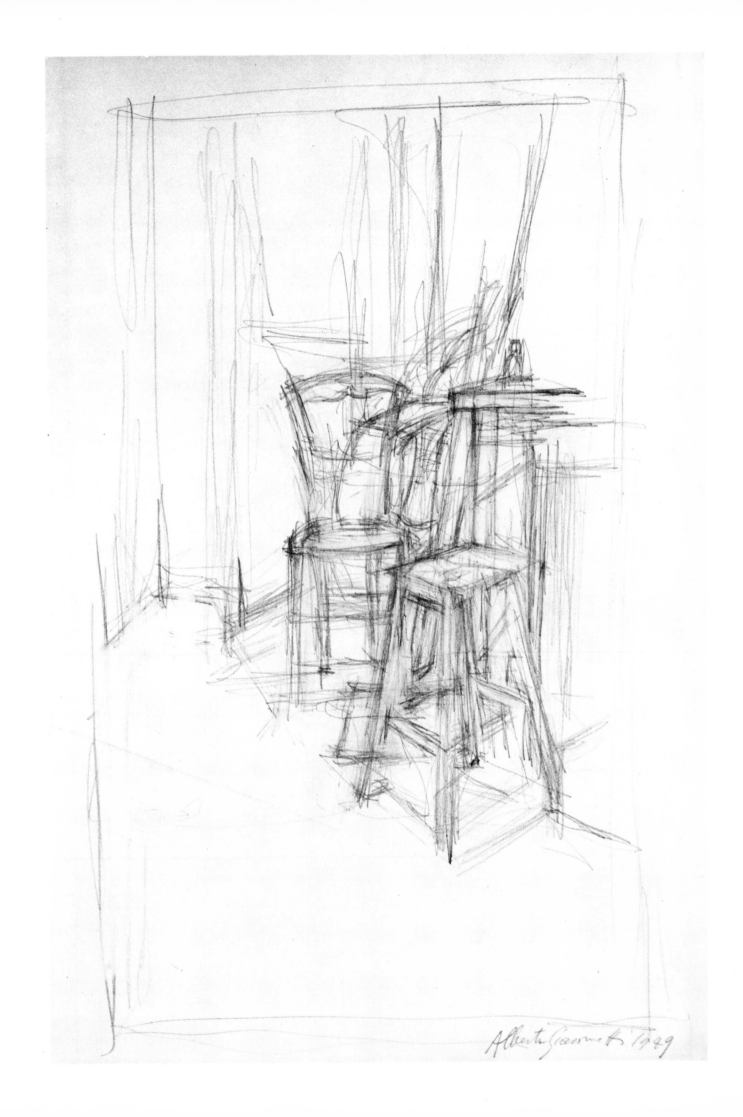

Alberto Giacometti 1949

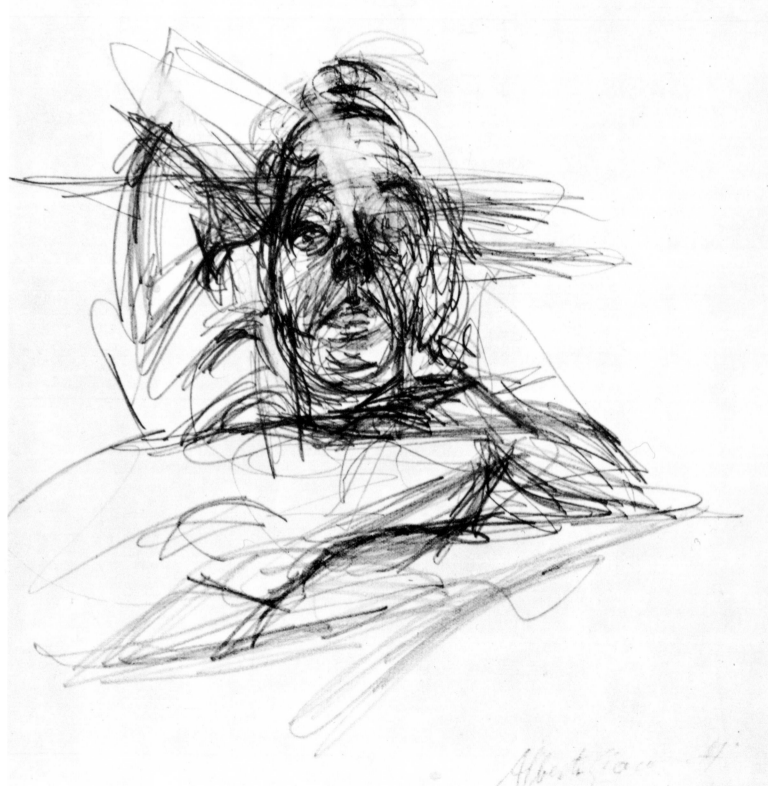

metti's works, or even to fix it through very close observation, the more radically its presence eludes us. But when resignation sets in, and we begin to think that there is not really much to it at all—perhaps it is the tiny vertical grooves above the eyes in the busts of *Annette* and *Elie Lotar* that provide the key to the whole effect, or the highlights in the portraits of *Caroline* and *Aïka*, or the net of lines in the drawings of *Diego's Head*—we are just turning away when it happens: everything falls into place at the periphery of our vision and becomes, instead of line, highlight, and groove, the presence of a person.

When everything works: the bridge of the nose, the arch of the eyebrows, the nostrils; when the whole figure works (every detail being linked to the others, and everything depending on the first line), when all the conditions exist for the figure to be able to gaze at us, then the presence of reality in a work of art comes to life, without stylization and without artistic gesture.

Seen in this light, we begin to understand the pressure Giacometti worked under to the last. The relationship between his activity and the work developing on his modeling table or on canvas took on a new magnitude: he really was forced to take away, destroy, paint over, so that the work could come into being "within the negative imprint of his art." And he had to do it again and again, more and more often, the greater his skill became, in order to transcend skill, and confront a reality ever increasing in size and complexity. "If I were ever able to render a head as it really is, that would mean I could grasp hold of reality—I would be omniscient. Then life would cease." (59)

Except for the landscapes, interiors, and still lifes, Giacometti worked exclusively during his last years, day and night, on his portrait studies of seated models (drawings, paintings, and sculptures) and on a few figures with the titles *Standing Woman* (page 260), *Walking Man* (page 261), *Head on a Pedestal* (page 255). His most important models were Annette Giacometti (he made particularly good series of her in 1962 and 1964), Diego Giacometti, Caroline (from 1960 on), Isaku Yanaihara (1959 and 1960), and Elie Lotar (1964 and 1965); now and then, when he had the time, he made portraits of friends and personalities of the art world. They always took the form of heads, with the shoulders, busts, or half-figures added only as "pedestals." Giacometti preferred to do the same head over and over again, to get behind the apparently so familiar features to the inexhaustible newness of reality: "Diego has posed ten thousand times for me; the next time he poses I won't recognize him. I should like to work with him some more, to test what I see." (64)

There is no reason to differentiate between "studies" and finished "realizations" during this period. Perhaps the more complete pedes-

tals of some of the pieces indicate they were meant as "realizations"; but Giacometti realized his work at this point by studying, observing, and experimenting with new but hardly classifiable artistic techniques. Whatever the case may be, anyone who encounters one of the bronze *Annettes* in a museum or at an exhibition, numbered like a dynasty of queens from *I, II, III* to *VIII* (1962) and *IX* (1964), does not doubt that he is looking at a complete, "realized" artwork.

Unlike the vivacious, radiant, and almost sparkling Annette busts, the serious, introspective, and sunken busts of men of 1964 and 1965 cannot be seen in groups—their compelling power would be lost (pages 266, 268–72). These were Giacometti's very last works; Elie Lotar modeled for most of them, Diego Giacometti for the rest. They are the most rudimentary representations of corporeality one can imagine, almost negations of the organic existence of their subjects, but for that all the more deeply probing, knowing, silent, like the faces of old men. (Photographs of the sitters have almost no resemblance to the sculptures, which suggest self-portraits.) They do not look directly at the observer, though their gaze is piercing; one has the feeling that they do not acknowledge his presence but look right through him, the vector of their gaze connecting the interior of their heads ("their personalities") with the visionary experience of an external reality. They are the nuclei of personalities, and they dominate the surrounding space with their silence.

The fact that these were the last works Giacometti completed before he died lends these heads the character of a final achievement, thus lifting them out of the realm of pure art. One should like to compare them with no less a work than Michelangelo's *Pietà Rondanini*. But can such a comparison be justified only on nonartistic criteria? Unfortunately, though exhibitions have brought these last heads to public notice, an appreciation of them as works of art belonging to the history of mankind is yet to come.

We shall avoid describing the end of Giacometti's long decades of work in terms of his success in achieving his goals. The "composition with figures" Giacometti had been striving for since 1935 as an expression of his vision of the "totality of life" never took shape. But the highly developed elements for this composition do exist; the art historian might put them together as a sort of theoretical footnote, "reconstructing" what the artist was not able to do before his death.

We should like to conclude with the following theories:
—that the *Group with Three Figurines*, made known to the public in the form of bronze castings at the Paris Exhibition in 1969 (the originals are in James Lord's collection), is related to the Chase Manhattan Plaza commission; Giacometti made the group in 1959. It consists of a *Standing Woman*, a *Walking Man* (each on its own base),

and a *Man's Head* on a high pedestal; James Lord remembers how the artist demonstrated the architectural surroundings for the pieces in his studio with sheets of cardboard;

—that this miniature group, between 2 $^3/_8$″ and 4″ high, was the design for a composition which Giacometti tentatively finished in 1959–60 with the four larger-than-life figures *Standing Woman I, II, III,* and *IV* (between 8′ 10 $^1/_4$″ and 9′ 1 $^1/_2$″ in height; page 260), the two lifesize sculptures *Walking Man I* and *II* (72″ and 73 $^5/_8$″ high respectively; page 261) and *Large Head* (more correctly: *Head on a Pedestal,* 37 $^3/_8$″ high; page 255). We know from many sources that Giacometti had intended these large bronzes to be set up outdoors; David Sylvester, for instance, heard him say that the large female figures "were made from a sort of nostalgia for the idea of having a big sculpture out of doors." (637)

—that the busts of Diego and Elie Lotar (1964–65) must be seen as representing the mode of expression and power that Giacometti wanted to work into his monumental art; with them, he carried his idea of the *Head Sculpture* to its extreme conclusion. He was never able to formulate a standing female figure with the same consummate force. The theme of "man walking" no longer belonged, in this last phase, to the "composition with figures" for a city square; (175)

—that, in the weeks before his death, Giacometti decided the New York commission could be executed and was ready to begin work on it. At the end of September, 1965, he had studied the site at the Chase Manhattan Plaza himself, had decided on a single monumental figure seven (175) or eight meters (729:200) in height (approximately 23′ and 26′ 3″ respectively), had found the best spot to erect it, and had checked the dimensions with a surveyor's pole (156; 175); in late November he said that now he knew the site, the sculpture would give him no more trouble. But we probably have to assume that the task of expressing the unbelievable power of his last portrait busts in a monumental standing figure would have raised many new artistic problems.

If the plaza sculpture had been raised in New York, it would have been a monument of Surrealistic presence amid the chaos of the modern metropolis: "The model, the type, the perfect, immobile symbol on the pediment above the tumultuous city," as Camus said in 1951, expressing that "which, in the body and visage of man, survives every degradation."

THE PERSON, HIS WORKS, HIS CONTEMPORARIES

It's not always easy to say which of both, the painting or the artist's talk about it, is the egg and which is the hen.

Samuel Beckett

The Giacometti Legend and Giacometti's Statements

Alberto Giacometti seemed to his contemporaries to be the very incarnation of the artist personality. And he did feel the relationship between art and life so intensely that he reminds us of the first artist-magicians among the prehistoric cave dwellers, who "discovered" art as a way of confronting a hostile world. Significantly enough, the first essay devoted to Giacometti's later work begins with the sentence: "A long look at Giacometti's antediluvian face is not necessary to divine the pride with which he places himself at the beginning of the world." Sartre wrote this in 1947; he went on to introduce Giacometti as a contemporary of the cave painters of Altamira: "Everything is yet to come; for the first time a man has had the idea of carving a man's image out of a block of stone." (383)

Giacometti's extraordinary personality inspired many such comparisons. The mythical dimension came early: "He is the man who burns," said Anatole Jakovski in 1934: "I have seen his face—always pale, his eyes blazing, his hair charged with electricity, attracted by celestial gravitation. You speak to him and he replies: 'It's terrible.'" (337) The young Giacometti seemed to this writer to incorporate both Michelangelo's "*terribilità*" and the expressive power of his statue of Moses. To interpret his art, Jakovski used comparisons similar to those Sartre was to use thirteen years later: "A diluvian bird in a cage. Prehistory mimeographed." Both authors knew how well Giacometti's work lent itself to being interpreted as symbolic of contemporary life: "Giacometti is probably the most sincere witness to the current catastrophe. No one else has expressed the anxiety [*angoisse*] of the present as he has" (Jakovski, 1934).[54] This is only part of the truth; Giacometti's true worth lies in his expression of general human experience: "Everyone's talking so much about this existential fear and anxiety [*angoisse*] as if it were something new! On the contrary, everybody at every time has felt it. Just read the Greek and Latin classics. . . ." So Giacometti in 1962 (63).

But the highly charged confessions of his friends and his own truly unusual personality led his contemporaries to clothe him with legends. He was legendary on the level of anecdote: his appearance, his working habits, his acquaintances were enough to keep people talking. "Elegant as a tramp, dust-blown, his hair a battlefield, and his face marked by an ancient wisdom—that's Giacometti, the most famous and best-paid living sculptor." (67) And at the level of artistic inspiration, philosophic insight, and human solidarity Giacometti had almost mythic proportions in this modern world: the sculptor César writes: "When I was young I wanted to be like Giacometti. He was a kind of monument, a fantastic type. A myth surrounded him. His example as an artist has always counted more for me than [his] art and still does." (128; 129) And a prominent Paris museum director confessed: "In spite of the detachment of genius, he was the only person I could sometimes tell everything to. He knew everything and understood everything." (172)

The extent to which Giacometti had become a myth for a younger generation came out very clearly in a scene from the film *A Man and a Woman* (Claude Lelouch, Paris, 1967): unrelated to the plot—unless it represented a statement of their deepest common values—the lovers in the film quoted Giacometti: "I would save a cat from a burning house before I'd save a Rembrandt."[55] During this dialogue, the scene focused by the camera has some analogies with two Giacometti sculptures, *Walking Man* and *Dog*. Another example: a young man, in answer to a question in a television survey, was very outspoken about what he felt was Giacometti's moral influence: "There are famous people who don't give you anything, but there are famous people who give you a lot, even if it doesn't seem like it. I'm just saying this about Giacometti even though I don't know him at all, but I know that he gives you something, because once I got a gift from Giacometti; not a word, but a feeling, which is much more than a word." (803) A girl commented starry-eyed: "When I see Giacometti I get the feeling of great warmth . . . physical, moral: I think he's a beautiful person in every sense of the word." Another girl: "I like Giacometti's head. His face helps me to live. I don't know why, but some things are inexplicable, aren't they?" (803) And a man: "He was like that—although I really didn't know him well—his death robbed me of a support and left me helpless, exposed." (197)

It was possible for Giacometti to help even people who did not know him because he lived his life with exemplary seriousness; his art itself had much less of an effect upon people, even to this day. They admired him because he made no compromises in his life and work; and his biography took on a special power in people's minds through its unique mixture of unreliable information on the one hand, and his own extraordinarily concrete autobiographical statements on the other.

With few exceptions, this study of the life and work of Alberto Giacometti is based strictly on published sources. It speaks for his personal magnetism that so much private and even incidental information about him has found its way into print over the years, and that so many descriptions of his studio and photographs of even unfinished works have been published. This agrees fully with what

Giacometti wanted to reveal to the public: *all* of himself; his thoughts *at the moment*; his work and skills as far as he had brought them: "That's where I am today," he would say. "It is out of the question ever to finish a painting." (71) But this too—like the "existential" interpretation of his work—is only part of the truth, and just as tinged with literary overstatement: the dictum about failure is Samuel Beckett's measure of an artist's greatness. Another part of the truth lies in Giacometti's judgment: "When I see an exhibition of my own things, I'm the first to think that they are better than anyone else's. But then I realize that that has absolutely no relation to what I hope to be able to do." (723:30) If we want to get closer to the whole truth about Giacometti, we must turn to his oeuvre.

We cannot overlook the fact that much of what Giacometti said about himself was stylized talk; some patterns are not hard to find. Yet many of his pointedly anecdotal and stylized statements were, in a deeper, aesthetic sense, true if coded messages about his experiences and the way he dealt with them. Giacometti was such a personal and compelling writer that it is not hard to prove his literary talent; the best example might be the often-quoted letter he wrote to Pierre Matisse in 1947 (13). He began with a sentence in the present tense giving his reason for writing: "Here is the list of sculptures I promised. . . ." Already in the second sentence he was into a description of the development of his art over thirty years, which went on to fill nine typewritten pages, scattered over with sketches, representing it as a logical, personal process from beginning to end; but, when writing on his post-Cubist sculptures, for instance, he noted only that Cubism per se ought to be mentioned in passing, "but to explain why would take much too long." The next-to-last section of his letter is both magnificent and a little capricious, where he leads up to a description of his latest work without really committing himself: "So, that's about as far as I've got up to today, no, that's how far I was yesterday. . . ." He found it impossible to talk about the very last day, the present day; when he came to this point he said, significantly, that he could not make sketches of his latest sculptures, meaning they had not yet found shape. Cleverly, he closed where the present began, namely in the café where he was sitting writing: "I've got to stop now, they're closing the place, I have to pay." The only way to recognize this letter for what it is—a finely honed tour de force—is to have a facsimile of it before one (13; 715; 731): what seems like the product of an hour's impulsive writing has actually been typed out and thoroughly edited, even the last sentence about the café closing, although the image of Giacometti sitting at the Coupole or the Dôme with a typewriter in front of him is absurdly funny.

It is important to note here that many of Giacometti's autobiographical statements were not written until decades after the experiences described had happened, and in words which correspond to Giacometti's feelings at the time of writing, not at the time of the event. He liked to write and he wrote a lot (66) and more than once he told some fortunate listener "his whole life story in three hours." (104; 206) For, as he said, "everybody has the need, say, when he has taken a trip or had a fine evening, to tell about it. . . . But telling about something means creating it. . . . What we know about Caesar's reality and Napoleon's deeds is what they wrote in *De Bello Gallico* and *The Memorial of Saint-Helena*, right?" (803) And what we know about Giacometti's life comes in great part from the epic of his life as told by him. It is easy to see that he wanted us to understand it—and his work—as a logical, coherent whole.

Another thing that strikes us immediately about Giacometti is the extent to which he collected his own finished work or reproduced it in other mediums, assuming, of course, it had pleased his critical eye in the first phase. What other sculptor painted, drew, lithographed, etched images of his own works as often as Giacometti? His large exhibitions were all retrospectives which—with the exception of the New York show of 1965, which began with his *Torso* of 1925—included drawings he had made when twelve or thirteen years old; no critic has found this fact strange up to now. For his London exhibition in 1965, Giacometti even went so far as to make a new version of his *Suspended Ball* of 1930 because the plaster original was in Zurich at the time and the wood version in New York. He ordered bronze casts to be made of some of his plaster sculptures of the twenties as late as 1964–65. All this shows how literally Giacometti thought of his work, and of his life too, as a unified whole. More than once he made a compendium in drawings of the most important sculptures of a period. The most wonderful of these must have been the two-page layout in a November, 1962, issue of *France-Soir*; Giorgio Soavi described how the pages were filled to bursting with ballpoint-pen sketches, like an opening night at the theater, with an overflow crowd of his earlier and current subjects: "*Annette, Walking Man, Pierre Matisse, Bouquet, Mountain Landscape, My Mother, Women for Venice, Diego, Yanaihara, The Cat, The Leg, Caroline, Genet, Dubuffet, The Chair, The Dog, The Hand*, heads, heads, and more heads. More than forty. Probably fifty." (735)

Giacometti's faith in his oeuvre as a whole seems belied by the derogatory statements he made about some of his earlier pieces and those he destroyed. He once told Sartre: "I was satisfied with them, but they were only made to last a few hours," (383) but Sartre must have known that Giacometti was borrowing one of Picabia's famous poses. (Picabia had once invited his friends to a two-hour-long art exhibition and then destroyed the works afterwards, explaining that they had been given only two hours' "aesthetic life" to live.) And even though, a few weeks before he died, Giacometti

wrote the disturbing sentence: "None of that means very much at all—painting, sculpture, drawing, writing, literature—the attempt is everything," (28) we must not forget the other side of the coin: the last piece the dying Giacometti held in his hands was a new version of a sculpture which had been damaged at an exhibition, *Four Figures on a Pedestal*, 1950.

Giacometti's "Visions": Art and Reality. Life and Death

There were certain experiences that profoundly influenced Giacometti's life and formed the personal content of his oeuvre. They proffered sudden, basic insights into the reality of life; another age would have called them visions. They came, in Giacometti's words, "like a curtain suddenly opened," "like a fissure in reality" (17), "like a hole in my life," "as if I had crossed the threshold into a new world" (12). The feelings which accompanied each experience may have been different, but the basic insight was always the same: he felt confronted with reality, a reality that works of art—his own and others'—had to measure up to.

In 1920 Giacometti experienced Tintoretto's art as "a new world that reflected the real world surrounding me"; this "real world" was the gray-green, shimmering, wonderful city of Venice, which filled the young artist with feelings of unexpected intensity (17). Tintoretto's painting was an adequate expression of the precious and temporary emotional reality Giacometti was experiencing, "like light or breath." But the Arena Chapel in Padua brought him a contrary shock: "Giotto's force imposed itself on me irresistibly. I was pressed back against the wall by those immutable figures, made as if of basalt, with their precise and true gestures . . . which could have taken no other form than the form they had." (17) The reality Giacometti saw in Giotto's work was independent of subjective emotion; it was true, unchanging with time.

The opposing qualities of Tintoretto and Giotto might be compared with the polarity of Giacometti's own work from 1925 on. Often his works were like formulas for emotions, images of his subjective interpretation of objectively unknowable reality; often they were more like formulas for existence, metaphors postulating an objective, immutable truth behind reality as he experienced it. In the discussion of his works above we quoted the corresponding polarity of forms, those "that appealed very much to me about reality" and those "that seemed true to me for sculpture." (13) This polarity retained its significance for the rest of Giacometti's life; in 1962, for instance, he said of Tintoretto's *Self-Portrait*: "This is

one of the pictures I liked most in the Louvre when I first arrived in Paris. You can't get any closer to it, it always remains at a distance, like reality." And of Cimabue's *Madonna with Angels* he said: "This is the picture I loved most because it came closest to the truth." (62)

On the same evening that the truth of Giotto's painting had revealed itself to him—without quite compensating for the loss of Tintoretto's reality—both were overshadowed by a new insight, an insight into *real* reality, living reality, the opposite of art. Neither Giotto's nor Tintoretto's version of reality could measure up to Giacometti's vision of the two or three girls in the shadowy streets of Padua: "Their whole presence and their movements affected me with terrible violence." (17)

This one decisive event revealed the factors that were to make "*the* Giacometti" of Alberto Giacometti (723:48). He deserves to be ranked highly not only as an artist, but as a person who was gifted in putting questions a certain way. Remember that as a fifteen-year-old he was uncertain whether to become an artist or a chemist; in 1919 he felt he still needed time to make the final decision (53). Of course he had taken art and his own joy at making it for granted from childhood on, but he continued to doubt its basic worth because there was something more important: the reality of life, which, as a boy, he had felt he had to "dominate, with my crayon as my weapon." (67) And there was also something more serious: the question as to the nature of reality and how it could be grasped. Giacometti knew he had to ask himself the meaning of the simple words: here, now, being.

This is the same question philosophers and scientists ask themselves; the final answer comes—with a sudden certainty—only to the visionary.

Each of Alberto Giacometti's works was a partial answer. If they seemed insufficient to him, it was because no matter how much progress he had made from piece to piece, the evidence they supplied never measured up to the proof of his visionary insights, which determined his one, impossible goal: "It's a question of creating a complete entity all at once." (723:59)

In spite of the utopian nature of this aim, Giacometti did find one artwork, in the fall of 1920, which seemed almost to fill its demands: the 18th Dynasty Egyptian *Male Head* in the Archaeological Museum in Florence (page 289, fig. 10). It was "a little like a re-created double of the three young girls in Padua." (17) At this point he had finally chosen his profession; he had just started on a nine-month study tour to Rome; his father said at the time that there was no other profession for Alberto than that of painter and sculptor, for he lived it.[56] This Egyptian fragment was the first artwork that seemed to him to bear any resemblance to reality—why?

The answer must be formulated in the same terms we used earlier

to describe Giacometti's postwar work. This Egyptian head—and Cimabue's frescoes in Assisi, and the Early Christian mosaics in SS. Cosmas and Damian in Rome only a short time later (17)—brought home to the young sculptor, apparently for the first time, the power style could have in lending an artwork the appearance of reality. Giacometti's "realizations" of 1947 fit in here (their effect depended on style) because he did not write down and interpret the insights he had had in 1920 until after the war.[57] His "youthful experiences" are perhaps more related to the thoughts he described in postwar terms (his visionary experience of 1945 or 1946 will be discussed below), but this does not preclude the possibility of their actually having taken place. The same Egyptian head had already inspired him once, in 1936–37, when he solved the problem he had been facing for a year—the impossibility of capturing the reality of his model Isabel Lambert Rawsthorne—by stylizing her head and calling the result *Egyptian Woman* (page 290, fig. 17).

During the fifties Giacometti reached an unusual conclusion: "Every work of art is born for absolutely no reason at all—unless it is because of the immediate sensation of the present the artist feels when he looks reality in the eye. Whether he does it as a scientist or as an artist, the process is the same." (61) Working on this assumption, Giacometti built up a unique hierarchy of art and reality: "Whether an artwork is a failure or a success is, in the end, of secondary importance. . . . If I have learned to see a little bit better, then I will definitely have gained something and the world around me will be richer . . . for I have come to know the world as something that surpasses me so much that I can't even make the attempt to approach it." (56)

This classification of the artist's task also determined Giacometti's approach to other works of art: "What interests me about all painting is its resemblance to reality, that is to say, that which helps me discover more about the external world. . . . I'm thinking about certain pictures in restaurants, pictures I can look at throughout the meal, and I look at them with all the curiosity I would give to [more important] paintings," he said in 1957 (56); in 1962, even the masterpieces in the Louvre no longer stood the test: "I used to love the paintings and sculptures in the Louvre to the extent that they revealed to me more than I could see in reality. When I go to the Louvre today, I can't resist looking at the people looking at the pictures. The sublime [reality] for me is to be found more in those faces than in the artworks." (61) And after he had spent hours in the British Museum (in the summer of 1965) contemplating the artworks he now preferred to all others—Egyptian paintings and a T'ang figurine—he spoke of a girl he saw later in a café in terms of the experience he had had in the spring of 1920: "One living girl like that is worth more than anything in any museum." (125) His

last statement on this theme, made six weeks before he died, was: "The difference between any artwork and immediate reality is too great, and now I'm interested only in reality. I could spend the rest of my life copying a chair." (25)

The "two or three girls walking in front of me" in Padua not only gave the young Giacometti a sudden insight into the polarity of art and reality, they suggested to him the reasons for reality's greater power: "Their whole presence and their movements" were manifestations of life (17).

The meaning of death was revealed to Giacometti in the fall of 1921. The corpse of a man taught him that death robs a person of his reality and replaces it with a cold and total absence.

The confrontation came at an inn in Madonna di Campiglio in South Tirol, at about the time of his twentieth birthday, when his traveling companion died before his eyes within a few hours of an acute kidney disease. The man, named Van M., court librarian from The Hague, had been a chance acquaintance. He had engaged the young artist to accompany him on horseback from Innsbruck over the Alps to Venice. But now, all of a sudden, his real destination was revealed. As Giacometti began to make sketches of him on his sickbed—the sharp profile, the hollow cheeks, the open mouth gasping for breath—he was suddenly overcome with the fear that his companion was going to die, there and then. The reality of this made him lay down his pencil. (12)

Van M. died. His existence, his reality had come to an end: Van M. was "no longer there," he was only absence.

The young Giacometti knew of other artists who had stood at the deathbed of a companion: Ferdinand Hodler, six years earlier, with his friend Valentine Godé-Darel; Giovanni Giacometti in 1899 at the bier of his teacher and friend Giovanni Segantini; Cuno Amiet drawing the dead Hodler in 1918. All had painted portraits of the deceased. Hodler, Giovanni Giacometti, and Amiet had found an outlet for their feelings in painting, but Alberto recovered himself through literature.[58]

It was a rainy day, and he was trying to read the book he had brought with him, *Bouvard et Pécuchet* by Flaubert, with an introduction by Maupassant entitled *Étude sur Gustave Flaubert*. This essay touched him particularly, because in the hour of his companion's death he could apply to himself Maupassant's interpretation of one of Flaubert's youthful experiences. Giacometti never forgot this essay, and he mentioned it twenty-five years later when he wrote about Van M.'s death for the first time (12).

We quote not from this but from a later comment of Giacometti's:

My life changed on that day, and I'm not exaggerating. The child has a feeling of complete assurance . . . he thinks he can

live forever. And who doesn't have the feeling that he's going to live forever? All that started to fall apart for me when I was twenty . . . a precarious feeling! And that a man can go like a dog. . . . The more I think about it, that drama was the reason I've always lived provisionally, why I've had a horror of all possessions. Establishing yourself, furnishing a house, building up a comfortable existence, and having that menace over your head all the time—no! I prefer living in hotels, cafés, passing through. . . . (67)

But Giacometti had read the following in Maupassant's preface on that day in 1921:

Are the completely happy, strong, and healthy people well enough prepared to comprehend, penetrate, and express life, our life so tormented and short? Are they at all capable, these exuberant creatures, of grasping the extent of the misery and suffering that surround them, of seeing that death strikes unceasingly, every day, everywhere, ferociously, blindly, fatally? So it is possible, nay, probable, that that first blow . . . imprinted melancholy and worry on the spirit of that robust fellow [Flaubert]. It is probable that, as a result, a sort of apprehension about life remained; a habit of seeing things from then on in a more somber light, a suspicion about events, a mistrust of apparent happiness.[59]

Throughout the following year, Giacometti intended to write down his experience; he spoke of it again and again (12). He was unable to give it pictorial expression, for his naturalistic manner (like Hodler's and his father's) was a poor vehicle for his insights. Not until the metaphoric *Skull* (708:96; a painting he did in 1923, clearly based on Cézanne's example) and the styles of primitive sculpture and Surrealism came to his aid was he able to approach the theme. (We are thinking of the *Little Crouched Man* of 1926, a figure in mourning, and of *The Hour of the Traces*, 1930, a male skeleton-figure with its expression of suffering.) And not until 1946 was he able to write about his experience in prose—Surrealistic prose: *The Dream, the Sphinx, and the Death of T.* (12)—after the death of a neighbor reminded him of the horror he had felt in 1921. (Giacometti wrote this piece at about the same time he made his *Head on a Stalk*, 1947, so we cannot exclude the possibility that their themes were related.)

These and later records are our only clues to the impact the death of his companion made on the twenty-year-old Giacometti. Hence it is not anachronistic to describe the awakening of his youthful consciousness as "existential." And this quite clearly reveals the romantic roots of existential thought. For when Giacometti said, in 1962 and 1963—using very similar words each time (67; 803)—that, until that decisive day in Tirol, he had thought of death as a solemn release from life, he was applying to his own life the differentiation that Hegel had made between the classic and romantic death experience:

One cannot say that the essential significance of death was understood among the Greeks. . . . They envisaged death as an abstract transformation, without fear or terror, as a cessation without immeasurable consequences for the dying person. But when subjectivity, in its spiritual oneness with self, takes on an infinite importance, then the negation which is implied in death is a negation of this subjectivity itself, and thus is terrifying, a dying-out of the soul, which finds itself—as an intrinsically negative quality—closed off from all joy forever, absolutely unhappy, surrendered unto eternal damnation. (*Aesthetik*. Berlin, 1843, vol. 10²: 127–28.)

This was the insight that made the hours Giacometti spent at the bedside of the dying Van M. such a decisive experience for him. He had to admit to himself that reality, being, and movement, had an opposite pole: death, which is complete absence and hence impossible to formulate.

In 1953 Giacometti could still write in a letter of condolence: "Death is such a great mystery to me that I can't even attempt to say anything about it." (804) A few years later, however, he felt it his duty as a friend to speak about it in public: in 1963 when Georges Braque died (24) and in 1965 on the death of the art historian Gotthard Jedlicka (27). But in both cases he emphasized that the word "death" remained abstract for him, because the deceased was just as present as the living man had been; he denied the fact of absence. Now he could make a sketch of the body and note under it: "Georges Braque, le 31 août 1963."

There are two apparently contradictory records of Giacometti's thoughts at the time. According to the first, he sketched Braque's body "just like anything else, trying to get it right." (172) According to the other version, Giacometti said afterward: "I tried to do his portrait as a dead man, but that was impossible. In every drawing I finished he was the living Braque. That's curious, isn't it?" (116) Both times, his artist's version of death had transformed the inexpressible fact into a presence. He spoke in the same subjective way about the death of his mother, again emphasizing that being and absence were absolutely unrelated: "I'm convinced that nobody thinks about having to die. Even a second before he dies he doesn't believe it. How can he? He's alive, and every part of him is alive,

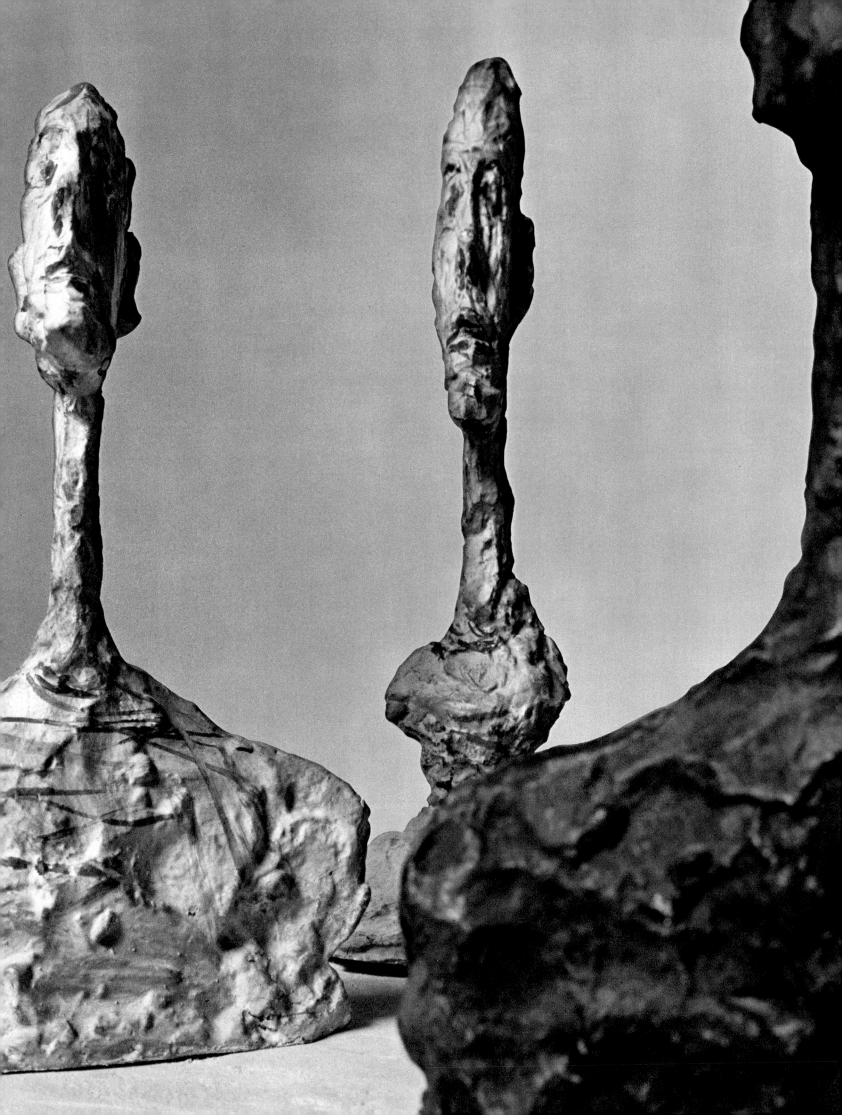

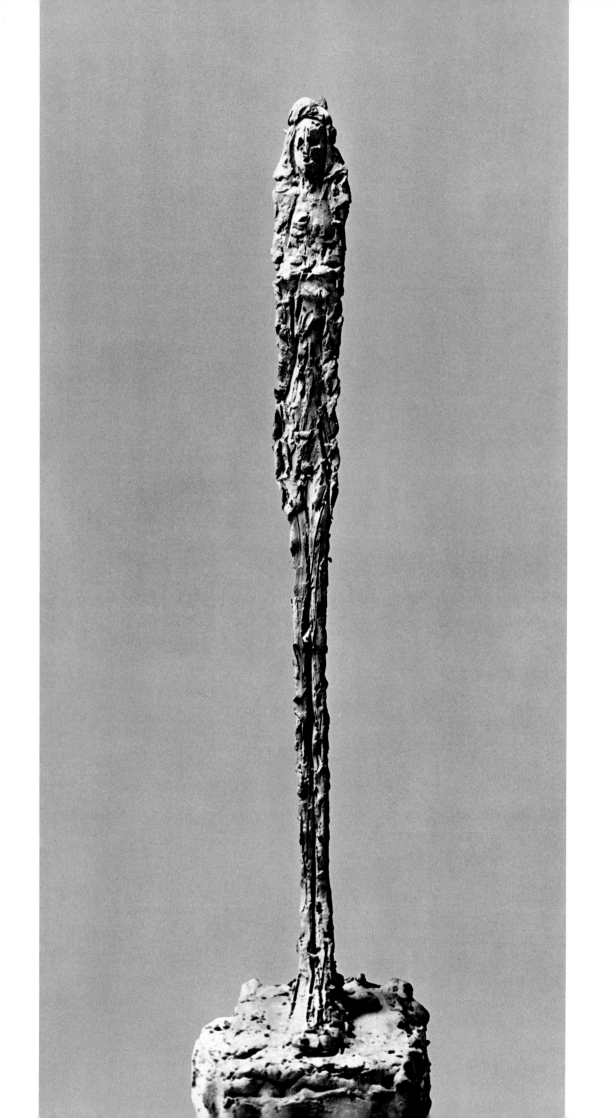

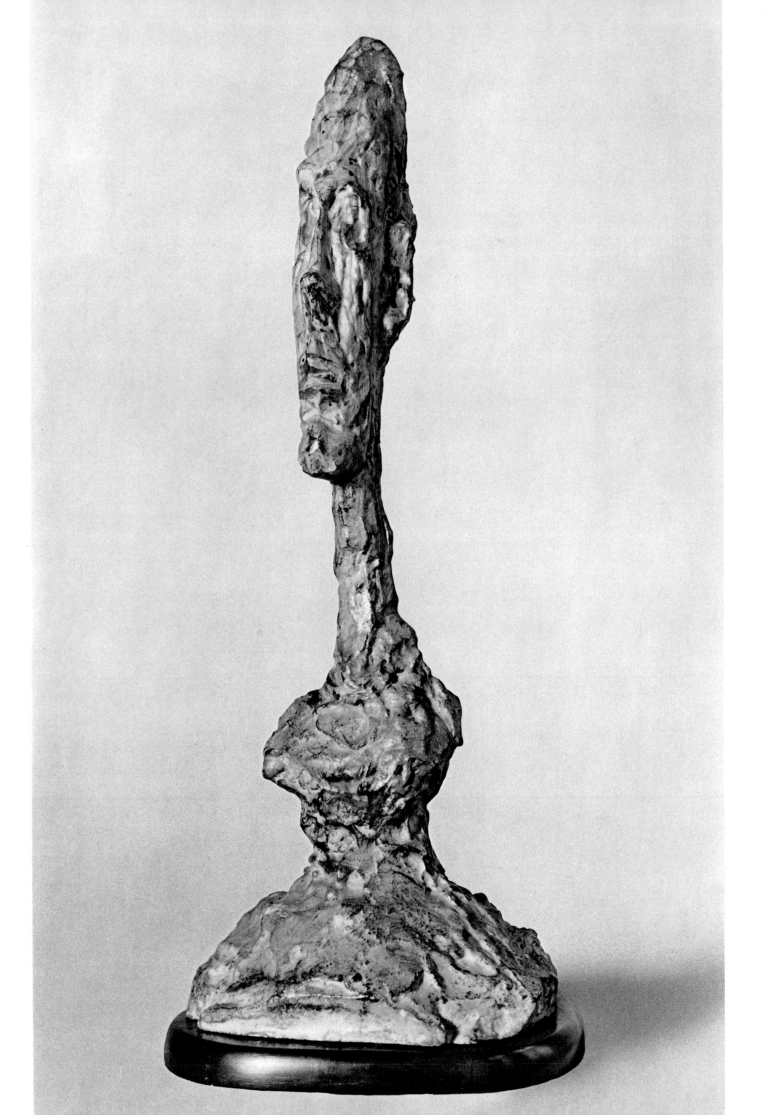

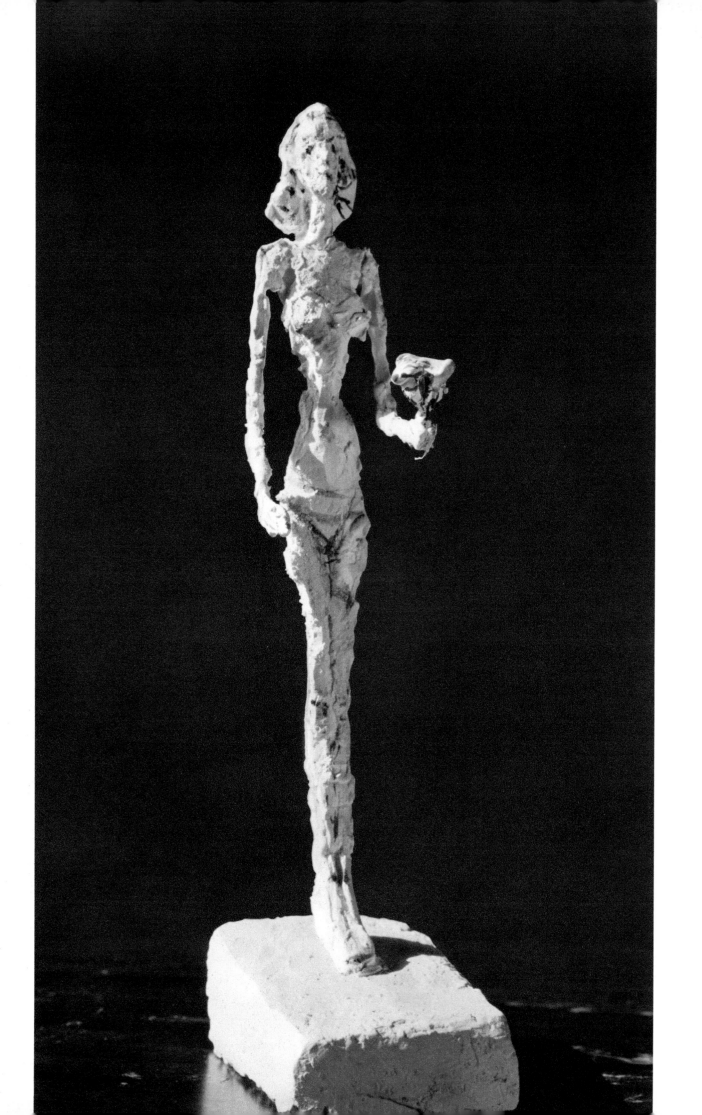

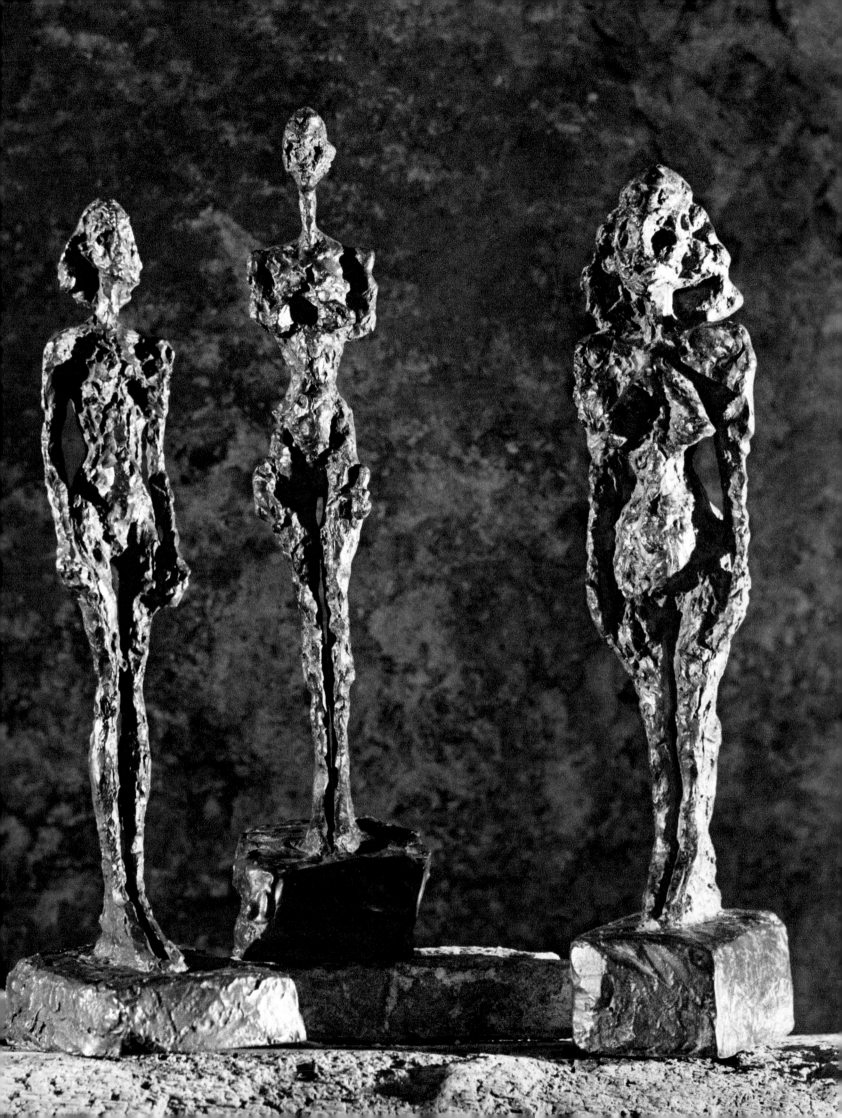

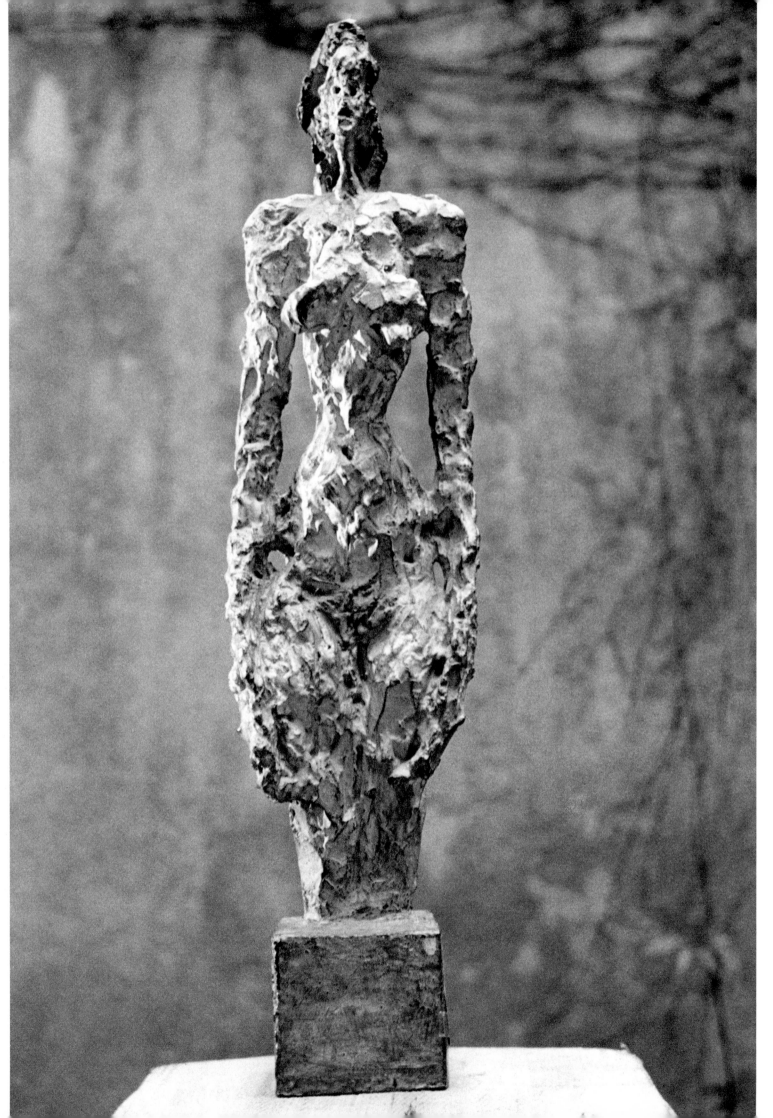

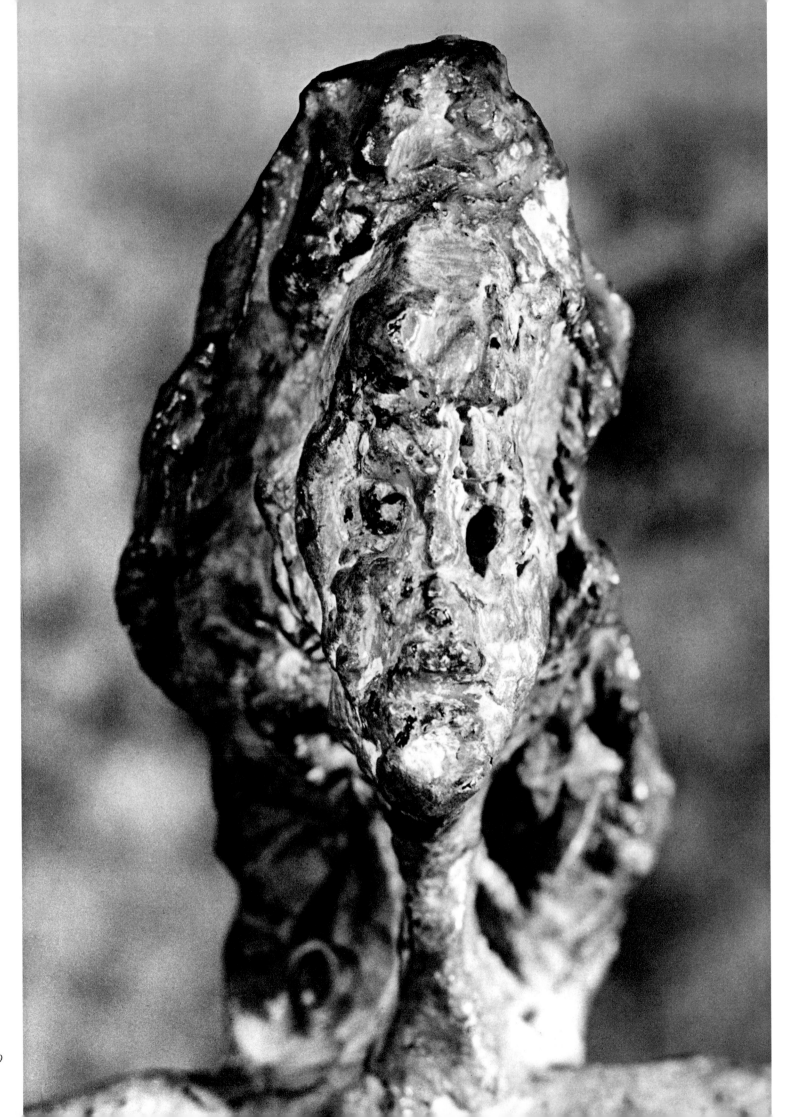

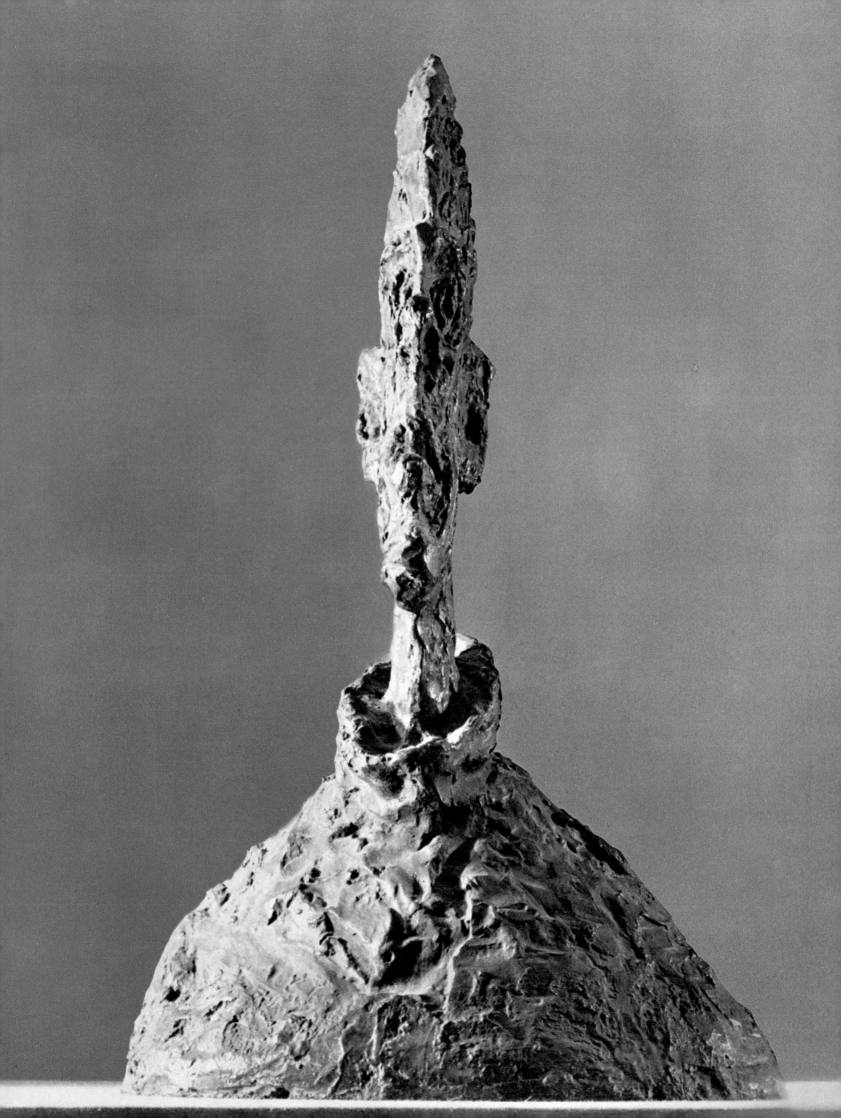

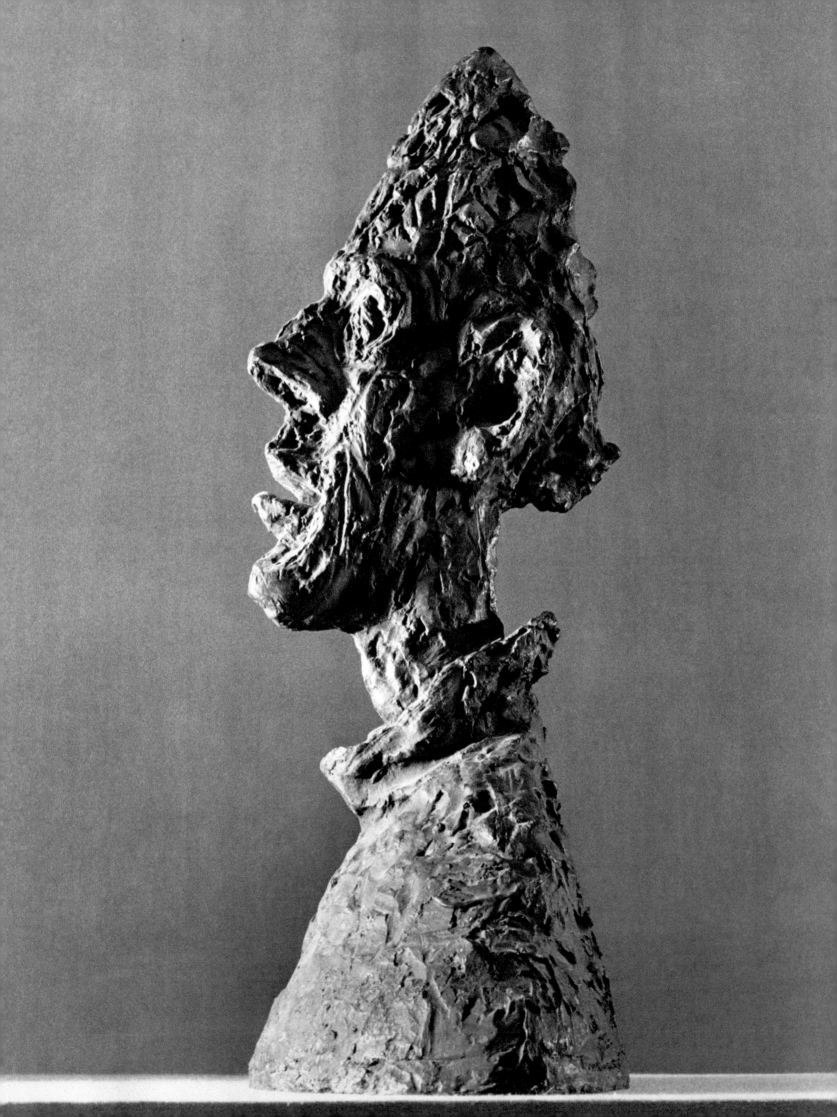

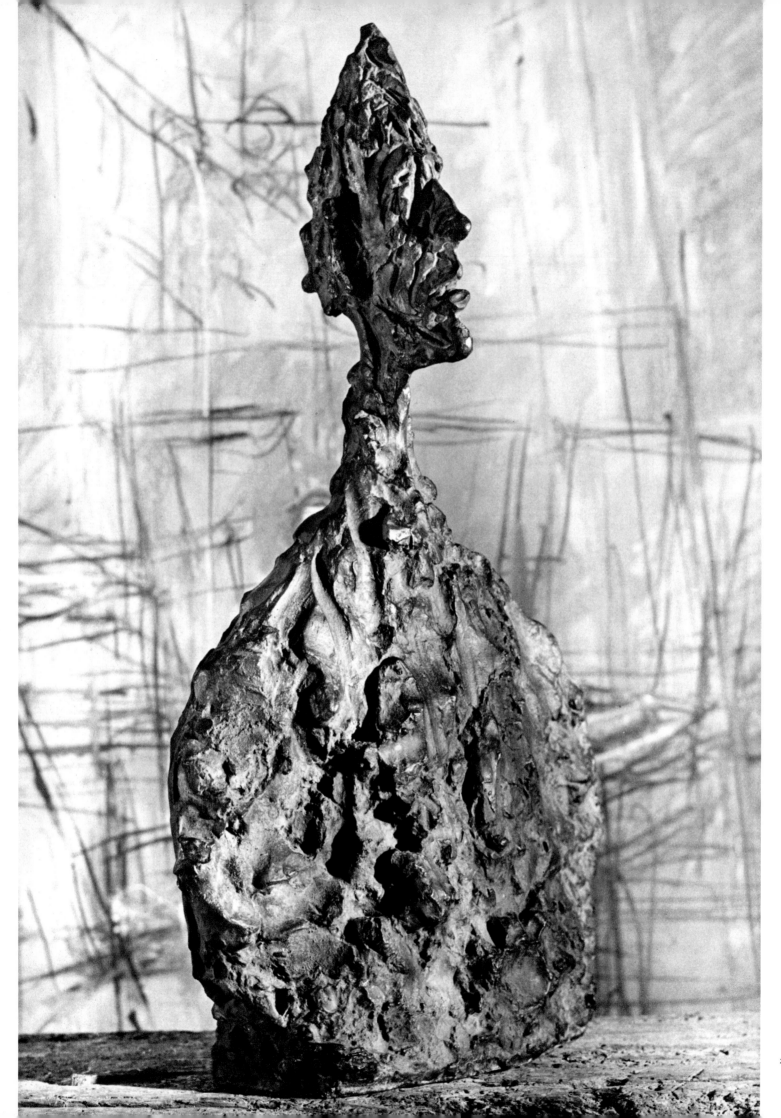

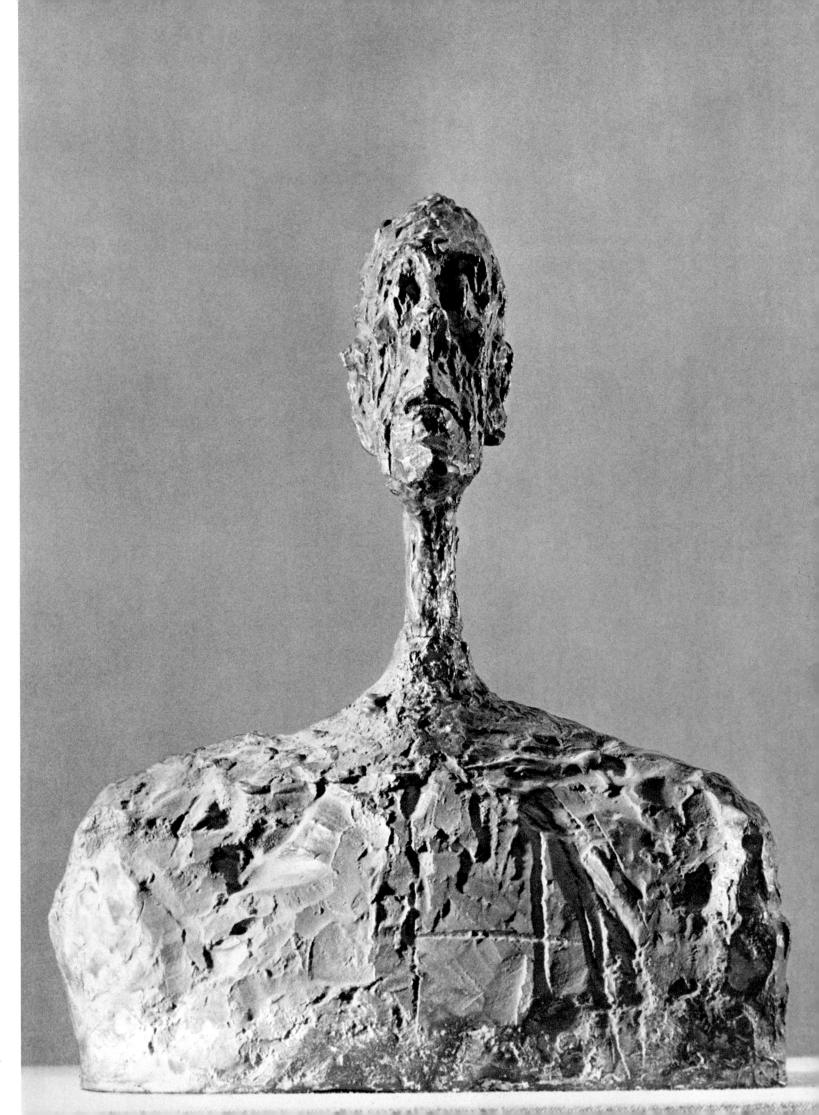

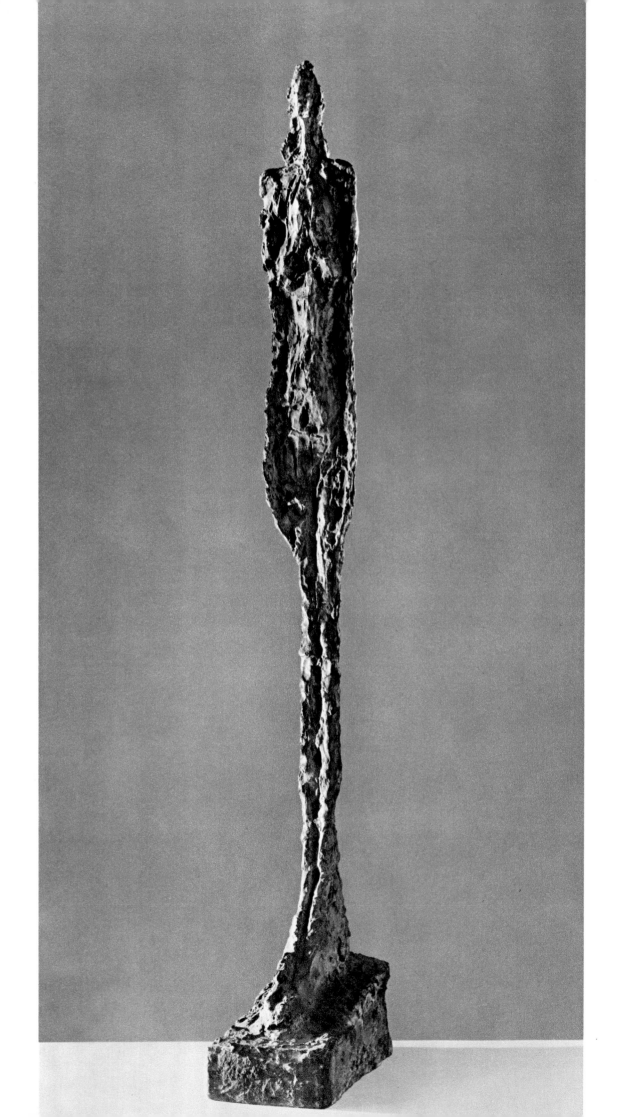

and even in the fraction of a second before he dies he is alive, and it's impossible for him to be conscious of death, and if he speaks, say, then he doesn't stop speaking, he goes on speaking, but he's dead. . . . Is he dead?" (69)

"Crisis" as a Literary Pose

André Breton and Paul Éluard organized a poll in the fall of 1933 which gave Giacometti the opportunity to tell about "the decisive meeting in [his] life and the extent to which it appeared accidental or necessary"—thus the poll's title (8). He was not really free to answer in any way he chose, for the comments had to fit stylistically into the issue on Surrealism of the magazine *Minotaure* (December, 1933). He wrote not a word about his experience in Madonna di Campiglio —his companion's death could not very well be described in terms of the startling combination of chance and significance that was the Surrealist convention,[60] and which demanded that a seemingly everyday event shock one beyond all expectations—as the girls in Padua had shocked Giacometti, for instance. Van M.'s death, on the other hand, was a terribly serious reality which did not lend itself to Surrealistic documentation, no matter how rash or extreme in form. That there are moments when a person becomes fully conscious of the reality of his own life and a communication takes place between the external world and one's own inner law, and that this communication is the only thing in life that really counts was a generally accepted phenomenon, described by Michel Leiris among others; in his first essay on Giacometti, Leiris called it a "crisis." (309)

In answer to Breton's and Éluard's question, Giacometti remembered an October night in 1930 when he had seen "the walk and the profile—a tiny part of the profile, the concave line between forehead and nose—of a woman . . . [a woman] who, since then, like a white thread on a lake of cold liquid asphalt, has been traversing the space in the chambers of my soul." (8) The fact that this meeting, in spite of its accidental nature, impressed Giacometti by its necessity, and that everything happened on the very day it simply had to happen (so Giacometti closes his essay), sounds so much like the voice of André Breton's authority speaking that we cannot discuss this event and the philosophy behind it without mentioning Breton's book *Les Vases communicants* (Paris, 1932). In it Breton describes how, in April, 1931, he followed a young woman through the streets to her destination, a hospital; he associated the hospital with the birth of the woman's child, his own death, and the birth of his own daughter, "which happened at exactly the hour it had to happen, not earlier and not later" (which was probably quite true).

In spite of this similarity, Giacometti's vision on that October night must be taken seriously as a creative experience. The fact that he remembered precisely the angle of the woman's nose as it met her forehead is indicative of more than his own personal sculptural problems. Many years later, this theme arose again with an insistence which transcended the level of sculptural technique: if he could only succeed in getting the bridge of the nose right, "the bony triangle between the eyebrows and the base of the nose," (156) then the eyes would be right, the gaze, the whole face, the whole figure, as Giacometti used so often to say during the fifties and right up to the end (56; 71, etc.), and he meant by this that he would then have succeeded in giving the figure or the head the truth of reality suddenly perceived.

The turning point in Giacometti's life and artistic career was the crisis of 1934–35 when he began to draw from the model again. He felt the decisive "breakthrough" was around the corner; he began to see everything in a basically different way from before—significantly enough, this did not come in the wake of a vision, but was the result of creative work toward a conscious goal based on a conscious appraisal of his previous work. But for Giacometti's seclusion of 1935–45 to find a permanent form of expression, for his own and truly individual art to come to fruition, the incentive from visionary "breakthroughs" proved necessary after all.

Simone de Beauvoir remembers that Giacometti's main worry in 1941 was whether he could master the boundless and frightening emptiness of space: "For a long time, when he was walking down the street, he had to test the solidity of the house walls with his hand to resist the abyss that had opened up next to him." (107) The key words here are *résister au gouffre* (resist the abyss). Sartre used them also, in 1947, in describing an experience that must have been similar to Giacometti's: once he had experienced the fear of emptiness, and "for months he came and went with an abyss at his side." (383)

Giacometti himself spoke of the abyss for the first time in the late fall of 1946, in *The Dream, the Sphinx, and the Death of T.* (12). Although literary criticism is actually outside the bounds of this chapter, it must be said that Giacometti's essay is based on two literary traditions. He communicated his thoughts and described his experiences in a Surrealistic manner: an associative or "automatic" linking of dreams, accidental meetings, conversations, visions, and daily occurrences carries the information.[61] But the key experiences in the tortuous piece are shot through with thought patterns and sometimes even whole phrases from the "existentialist" thought of Maurice Merleau-Ponty, Jean-Paul Sartre, and Albert Camus. A few examples will show how literally this statement may be taken, even with regard to the abyss experience.

Giacometti remembered having two separate but mutually compatible visions: "When I awoke this morning I saw my towel for the first time, that towel without weight and with an immobility such as I had never seen it before, as if suspended in a fearful silence. . . . There was no longer any rapport between things, they were separated by endless abysses of space [*gouffres de vide*]. I looked at my room in terror, and cold sweat ran down my back." (12) And: "A few months earlier I experienced the same thing with living beings. That time I began to see the heads in a void, in the space that surrounded them. The first time I saw the head that I was looking at completely closed in, immobilized within an instant, I trembled with terror as never before in my life . . . and cold sweat ran down my back." (12)

Both experiences involved a perception of spatial depth, and both led to attacks of terror. They were, by definition, "existential" experiences. Maurice Merleau-Ponty gave the then current explanation of this in his main work *Phenomenology of Perception* (Paris, 1945: 294, 296): "The classical conceptions of perception have in common that they deny the visibility of spatial depth. . . . But, in a more direct way than the other dimensions of space, depth forces us to reject [perceptional] prejudices and recover the primary experiences the world offers us; of all the dimensions, spatial depth is the most 'existential' because it is not bound to the object itself, it apparently has to do with the act of seeing and not with the things seen; it announces a certain indissoluble bond between things and myself. . . ." "This perceptional experience shows . . . that 'being' is a synonym for 'being at some place'" (op. cit.: 291). Giacometti seems to have heard about similar conclusions, judging from his conversations with Sartre in 1941.

His experience with the towel reminds one of those epoch-making pages in the novel *Nausea* (Paris, 1938), in which Sartre describes a similar shock given him by the sight of a stump of black root: "That moment was extraordinarily odd. There I was, immobile as ice, plunged into a horrible ecstasy. But at the very height of this ecstasy I realized something new—that being was simply being there, existing; that I apprehend everything that exists—but I shall never be able to fathom it." (Paris: Collection Pourpre, 1950: 185.)

The way Giacometti described his experience, the perceptional hock of seeing heads in empty space was bound up with a vision of death: "It wasn't a living head anymore . . . but a thing simultaneously alive and dead. . . . All living things were dead, and this vision often recurred, in the Métro, on the street, in restaurants. When the waiter at Lipp's bent over me, he became immobile, his mouth open; there was no connection with his preceding movements, none with the following moment—his mouth open, his eyes fixed in absolute immobility." (12)

He reinterpreted this experience many times, once in an interview with Pierre Schneider: "I experienced a complete transformation in my vision . . . a movement became a series of unmoving poses . . . one following the other, but unconnected, detached. When the waiter opened his mouth to say I don't remember what, the movement of his mouth seemed to me a series of unconnected, fixed moments, completely discontinuous." (60) Again, this is a perception that could well be compared with Sartre's observations and philosophical conclusions:

And then it began to move before my eyes: the wind shook the tops of the trees. It didn't bother me to see things in motion. I said to myself: movement is not an absolute, it is a flux, a series of intermediate steps between two existences. Finally I would surprise existence in the act of its coming into being. But after three seconds I had to give up hope. I could not put my finger on the "flux" of existence. Everything that exists comes from nowhere and goes nowhere; suddenly it's there and just as suddenly it's gone. Existence is without memory. (Jean-Paul Sartre, *La Nausée*, 1938. Paris: Collection Pourpre, 1950: 187–88.)

Giacometti's similar experiences—he never tired of describing them—were accompanied not by a feeling of nausea, but by fear, trembling, and a cold sweat. "Men became an unknown species, mechanical; the idea of something mechanical was part of it. Each person's consciousness and everything he said was like a mechanism. . . . Unconscious mechanisms, the people in the street, coming and going, a little like ants; everybody seemed to have a goal and to be going in a direction, alone, that the others were ignorant of. . . ." (60)

In *The Myth of Sisyphus* (Paris, 1942) Albert Camus explained why insights like these were accompanied by nausea (in Sartre's case) and fear (in Giacometti's):

At any street corner the feeling of absurdity can strike any man in the face. Men, too, secrete the inhuman. At certain moments of lucidity, the mechanical aspect of their gestures, their meaningless pantomime, makes silly everything that surrounds them. . . . As it is, in its distressing nudity, in its light without effulgence, it is elusive. . . . It is probably true that man remains forever unknown to us and that there is in him something irreducible that escapes us. . . . This discomfort in the face of man's own inhumanity, this incalculable tumble before the image of what we are, this "nausea," as a writer of today calls it, is also the absurd. (New York: Vintage.)

Both the living and nonliving heads Giacometti saw from his table in the café are so reminiscent of one of Baudelaire's famous parries that it would be wrong not to quote it here: "What are you doing here, Baudelaire?" asked Charles Monselet when he saw the poet sitting on the terrace of the Cadet, a boulevard casino. "Mon cher ami, I'm looking at the death's heads walking by!" This anecdote (we quote the version Jules Claretie published in *Le Journal* of September 4, 1901) found its way into every postwar book and essay on Baudelaire, as did the word "abyss." Giacometti knew of both, if not directly, then from Sartre.

The same year Giacometti described the moving death's heads and the abyss that had opened up between his towel and all the other objects in his room, Sartre interpreted Baudelaire's *Intimate Writings* (*Écrits intimes* [Paris, 1946]) in very much the same words he used to describe Giacometti's "abyss" (383); simultaneously, Benjamin Fondane's study *Baudelaire and the Experience of the Abyss* appeared (*Baudelaire et l'expérience du gouffre* [Paris: Seghers, 1947]). This was a key word during the war and postwar years.

Baudelaire, in 1857, had spoken of Pascal's abyss in *Les Fleurs du Mal*. Sartre may well have had Baudelaire's line "*Pascal avait son gouffre, avec lui se mouvant . . .*" in mind in 1947 when he wrote the sentence: "*Giacometti allait et venait avec un gouffre à son côté . . .*" (Giacometti came and went with an abyss at his side). So there seems to be a centuries-long "tradition" of abyss experiences—but putting it that way contradicts the uniqueness of the experience for each individual.

Baudelaire's poem, literally translated, goes as follows:

Pascal had his abyss, it followed beside him—
Alas, it was everything—action, desire, dream . . .
Above, below, all round, the horizon, the sandy waste,
Silence, space both frightening and captivating. . . .

Baudelaire's reference was to a sentence from Pascal's *Pensées* (1657–62): "Nothing is more intolerable for a man than to be in true repose, without emotion, without anything to do, and without diversions or work. Then he feels his nothingness . . . his emptiness. . . . And from the depths of his soul comes boredom . . . despair." (Paris: Édition Pléiade, 1950: 875.)

They all were describing the same thing: Pascal with *l'ennui*, Baudelaire with *le gouffre*, Sartre with *la nausée*, Camus with *l'absurde* —and Samuel Beckett with the whole of his *Waiting for Godot*, written in 1947.

The relationship between Beckett and Giacometti will be discussed in another chapter, but a few lines from Beckett have their place here. They are from his novel *Murphy* (1936) and parallel Giacometti's existential experience with space. Mr. Kelly is talking of flying a kite: "Already he was in position, straining his eyes for the speck that was he, digging in his heels against the immense pull skyward." (London: Routledge, 1938.)[62]

This takes us back to the period when Giacometti was sculpting heads from life and a statuette from the visual impression of his girlfriend as he had seen her around midnight at a great distance on Boulevard Saint-Michel (64). His heads and figures were becoming smaller and smaller; of course he really saw them small, but he did not interpret them as "lifesize figures far away" but as "tiny figures on my retina, separated from me by a corridor of space." But at that time Giacometti had not yet spoken of an "abyss"; not until 1941 did his visions find the existential interpretation that Simone de Beauvoir remembered from her conversations with him (107). Were these experiences somehow related to the abyss that "opened up next to him" and forced him to hug the house walls to resist it?

The word abyss itself belongs to the postwar period; Simone de Beauvoir wrote her memoirs many years after Giacometti's and Sartre's statements. The fact that Giacometti began having attacks of dizziness as early as 1941 is an important indicator of an illness he suffered from, but the content of his conversations with Simone de Beauvoir had more to do with his problem of seeing things at a distance. "Up until the war I used to think I saw people lifesize at a distance. Then, little by little, I realized that I was seeing them much smaller—and even near to me, not just far away. The first few times it happened, I was walking. It surprised me, but I got used to it. Then I began to notice it at other times. Now it's that way all the time." Thus Giacometti remembered his early experiences (71). Beauvoir's narrative meets Giacometti's at the point where she explains the smallness of his sculptures in phenomenological terms: "A face, he told us,"—she is speaking of herself and probably Sartre—"was an indivisible whole, a mood, an expression. This had brought him to the point of modeling those heads with almost no volume, which, he thought, expressed the unity of the human figure as it is contained in a living gaze. He thought he might someday find another means of saving it from vertiginous dispersion in space." (107)

Giacometti had told François Stahly shortly before the war: "I'm trying to give the head the right size, the actual size it appears to a person when he wants to see the head all at once, with complete visibility. What impresses us about its appearance can only be seen from a certain distance." (217)

Concerning Giacometti's dizzy spells, there is one eyewitness account by a man who guided him through the sheltered cloisters

of Basel Cathedral. The two men had hardly stepped out through the small choristry door onto the terrace high above the Rhine, when Giacometti grabbed hold of his arm and pulled him along into the shadow of the apse wall. This was no literary ploy this time. It was the symptom of a pathological vertigo.[63]

Man Alone Facing the Enormities of Reality

The shock of the abyss experience (*le gouffre*), the feeling of nausea upon confronting the silent emptiness of existence (*la nausée*), and helplessness at the estrangement of man from his environment (*l'absurde*) can be summarized as the experience that insight into reality brings with it a dissociation of the ego from the world. The opposite of this is an experience which will help us, by way of comparison, to put Giacometti's way of seeing the world into a larger context and connect it with the new creative freedom he began to enjoy from 1947.

Giacometti's friends and models described over and over again the walk between his café and studio: Giacometti used to stop on the Rue d'Alésia and gaze at the tops of the acacia trees that give this street its optimistic Southern European character. "He loped slowly into the street. Here, a long halt: for several minutes he gazed silently into the sky. At our last meeting he had stared at the treetops on the Rue d'Alésia." (66) "What moved him more than anything else was the trembling of the trees in his quarter at daybreak." (172) Genet wrote the most beautiful evocation of the Rue d'Alésia and remembered Giacometti saying: "It's lovely, lovely. . . . " (713) Yanaihara heard Giacometti say: "How beautiful! If one could only paint a tree! But painting a face or painting a tree, that's the same thing. Because I can't paint faces I can't paint trees." (231) James Lord has the most exact memories of all: " 'It's beautiful,' he said. Then he murmured, 'One should be a tree.' For another five minutes, at least, we stood there, while he gazed down the long vista of trees, nodding his head slightly, seeming physically to absorb the scene." (723:33) Giacometti must have found these trees not only relaxing for his overworked eyes but also an opposite pole for his work and an inspiration for new work. "One should be a tree. . . ."

"If I were a tree among trees, life would have meaning, or, rather, this problem would not be a problem, for I would be a part of the world. I would *be* the world to which my consciousness now puts me in opposition." This thought is Albert Camus's, from his book *The Myth of Sisyphus* (Paris, 1942), and it shows his spiritual brotherhood with Giacometti—this comes out especially in this book and in

Man in Revolt of 1951, but also in his autobiographical introduction to the new edition of *Light and Shadow* (1957). Camus's authority in Giacometti's thought was exceeded only by that Samuel Beckett had from 1952 on.

We know that Camus objected to his thought being called "existential" in the same sense as Sartre's world view. We shall use Giacometti's emphasis on trees as an analogy to point out how his philosophy diverged from that of Sartre and approached that of Camus. Both Camus and Giacometti, as artists, produced alternatives to reality; as artists, they had to believe in another dimension in spite of everything.

Analytical psychology has converted the situation of a person standing before a tree into a test of projection; the psychologist tells his subject to draw a tree, and his efforts and the way he goes about it—this is true of dreams also—represent his relationship as an individual to the world.[64]

Between 1949 and 1952, Alberto Giacometti used, with a drawing technique rare for him—colored pencil—to represent a man gazing at a tree much larger than himself (736:64 and 68, reproductions; 715: plate 1; page 296, fig. 77). If he ever illustrated an "existential" idea in his work, it was here; but it was not one of Sartre's themes he expressed.

"I stood up and left the park," Sartre writes in *La Nausée* following the "shock" quoted above. "I came to the gate and turned around. I stood there and looked back in for a long time. The smile of the trees: that means something; in it lay the veritable secret of existence." What is the real secret of the whispering trees? "We were a collection of thwarted existences, stumbling over one another, we did not have the slightest reason to be here, every existence was confused, vaguely unquiet, with no sense of rapport with the others. . . . Why so many trees of the same kind? So many existences shattered and obstinately rebuilt only to be shattered again. . . . These trees, these huge, ungainly bodies—reaching up into the sky? Despairing is more like it. They had no desire to exist, but they could not prevent it happening, that's all."[65]

One is reminded of Giacometti's sculpture *The Forest* (page 124) of 1950—one contemplative, gazing head opposed by seven female statuettes. Can it be that he thought of them as failures, superfluous existences? This composition did remind Giacometti of "the corner of the forest I saw many times in my childhood years, and the naked trunks of the trees . . . with almost no branches, except at the very top; they always reminded me of people stopped dead in their tracks, talking to one another." (14) But though Giacometti often said that he saw "the real secret of existence" in these trees, these women, he did not see it as a joyless, despairing coexistence. On the contrary:

They [the other painters] don't paint trees any more because they've realized it's beyond them and that it's impossible to do justice to them; they give it up because they say: "When I paint a tree, it'll just turn out to be a common little tree like all those before it." And what surprises me even more—they think their tree *has* to turn out conventional. Copying a tree as you see it can only result in an uninteresting picture of a tree. But for me reality is just as virginal and unknown as the first time somebody tried to represent it. That means that for me all the images that have ever been made of it were incomplete. . . . I see reality, the external world, be it a head or a tree, differently than the representations of it that have been painted up to now. Partially, yes, but I see something else that's not there in the sculptures and paintings of the past. And that from the day I began to see. (60)

The day Giacometti "began to see"—this refers to another of his "visions." It came to him on a day in 1945, after he had been to the cinema, on Boulevard Montparnasse; it was "a true revelation, the great shock that completely destroyed my conception of space." (67) One could speak of Giacometti's having overcome the existential interpretation of reality if it were possible to prove, other than by literary quotations, that he actually had believed in existentialism up to that point. "On that day—I still remember exactly how I walked out into the Boulevard Montparnasse—I saw the boulevard as I had never seen it before." (56) "Everything was different. The depth of space metamorphosed the people, the trees. . . ." (67) "Boulevard Montparnasse was dipped in the beauty of the Thousand and One Nights." (60) "On that day reality was revaluated for me, completely." (56) "From that day on, because I had realized the difference between my way of seeing a photo or a film and comprehending reality, I wanted to paint and sculpt what I saw." (67; 56)

All at once, with the discovery that marvels were to be found, not on the movie screen but in the faces of people and in the trees on the boulevard, the "phenomenology of perception," which had enjoyed ten years' validity, fell to pieces. Things, people, trees did not exist *for* someone—they simply *were*.

"Before the war I had the impression of things being stable. Today, not at all. So little so, that the landscape I see, and the trees I see when I go to the café, are different every day. That's something new for me. The world amazes me more and more every day. It becomes more vast, more marvelous, more incomprehensible, more beautiful. Details excite me, small details, like the eye in a face, or the moss on a tree." (61)

Albert Camus wrote about this way of seeing the world, an artist's way: "And here are trees, and I know their rough bark. . . . How can I deny this reality when I feel its power and force? Yet all the science on earth cannot convince me that this world is mine. . . . Meant to end in omniscience, science ends in hypothesis, its lucidity foundering in metaphor, its uncertainty finding its resolution in a work of art." (*The Myth of Sisyphus* [Paris, 1942])

Giacometti took Camus's thoughts as the basis for all his work to come: "When you decide to determine as exactly as possible what you see, it doesn't matter if you do it as a scientist or as an artist. A scholar who specializes in one area or another finds that the more he discovers, the more is yet to be discovered, and he, like the artist, shouldn't hope ever to reach complete knowledge. Anyway, complete knowledge would be the same as death. Art and science try to understand, comprehend. Success and failure are both secondary." (61)

Giacometti held to this to the last; he even reversed the values: "The more you fail, the more successful you are. When everything is lost and when you keep going instead of giving up, then you experience the one moment where there's a chance you will get a little bit farther. You suddenly have the feeling—even if it's only an illusion—that something new has opened up." (817) Giacometti gave this insight artistic form, the symbolic content of which surpasses even the limits of death: two symmetrical panels for the E. J. Kaufmann mausoleum at Bear Run (in the park of the house Frank Lloyd Wright built over a waterfall in 1936). Each panel shows a figure looking up into a long-trunked tree, a very personal metaphor which expressed in another way the message he had communicated in the gravestone for his father (1934), with its combination of Egyptian relief and Early Christian symbol of eternal life. James Lord suggested to Edgar Kaufmann Jr. that he commission Giacometti to do this work.

Giacometti assumed the proportions of a legend in the eyes of his contemporaries because he lived out the myth of Sisyphus: "Creativity is a moving testimony to the one dignity of man," said Camus. "The conscious revolt against his condition, perseverance at a task thought to be meaningless. . . . And all that 'for nothing,' repeating himself, marking time. But perhaps the great work of art does not carry its importance so much within itself as in the approval it demands of [the artist] and in the opportunity it gives him to overcome his blindness and to approach a little closer to naked reality." (*The Myth of Sisyphus* [Paris, 1942])

So Giacometti's experience of 1945 brought with it "the great shock that completely destroyed my conception of space and finally put me on the track I'm on today," (56) a change in his point of view that was permanent and of more than a technical nature. His new conception of space, replacing the idea of making objects smaller to express the "pull" of space on them (an approach still built around traditional one-point perspective), took shape over

many years. It was an expression of the reality of the world in a much deeper sense than his phenomenological-existential treatment of the artist and model theme, which he (and Sartre) still basically experienced from the standpoint of a third person (and too emotionally, according to Camus and Beckett) and recorded as if for a third party. But there is no third party and no higher court that is interested in *how* the artist sees and suffers reality; what is important is *that* he sees and experiences it. "This adventure is new," Giacometti realized. "It began about in the eighteenth century with Chardin, when the artist began to take his object more seriously than serving the church or pleasing the king. He was finally left to himself!" (61) The only thing that counted for the artist was keeping in touch with reality: "I see something, I find it marvelous, I'd like to try to paint it. Whether it's a failure or a success—in the end, it's not important. . . . I will definitely have gained something and the world around me will be richer, for I have come to know the world as something that so far surpasses me that I can't even make the attempt to approach it." (56)

Learning, through failure, to accept the world as something greater than one's self, and to be richer for the experience—in other words, seeking "redemption" in an immanent transcendence—nothing could be closer to Camus:

Man may authorize himself to denounce the total injustice of the world, but he cannot affirm its total ugliness. There is a transcendence we experience—every beautiful thing is a promise of it—that leads us to prefer this limited and incomplete world to any other. Art leads us to the origin of the revolt against the world, to the extent that it attempts to stamp its form on values in the perpetual process of becoming. (Albert Camus, *Man in Revolt* [Paris, 1951])

Man at Zero on the Space-Time Co-ordinates. Reality Cannot Be Understood, Only Described

When the curtain rose on the opening night of Samuel Beckett's *Waiting for Godot* (produced by Jean-Louis Barrault) at the Odéon Theater, Paris, in 1963, revealing Alberto Giacometti's stage set, only the artist's best friends could know how closely he and Beckett had worked together on it: "It was supposed to be a tree," Giacometti remembers, "a tree and the moon. We experimented the whole night long with that plaster tree, making it bigger, making it smaller, making the branches finer. It never seemed right to us. And each of us said to the other: maybe." (735) That Giacometti

had to do a tree for the set of *Waiting for Godot* was one of those lucky accidents which become significant due to their fruitful results. His plaster tree was more than the site of the action; it had something of the world's axis about it—Vladimir and Estragon were to wait for Godot there—and it also symbolized the tree in paradise, that eternal enigma. Vladimir and Estragon imagined they could find redemption by hanging themselves from its branches, but they came no closer to this redemption than did Giacometti's walking men and gazing heads reach the female figures before them.

Giacometti must have felt himself almost personally related to Beckett's characters. He had limited his life to creative thinking in his cell (his studios in Paris and Stampa) like—to name only one, perhaps the most important—Mahood in *The Unnamable*, who lived in a jar and functioned only as a disembodied head. For years Giacometti had experienced space only by means of stick and crutches, like the narrator in *Malone Dies*. It would not be hard to draw up a long list of similar motifs both artists used as metaphors of experience; Giacometti's wheeled pedestals and the bicycle in *Murphy* and *Molloy*, or the table with wheels in *Malone Dies*, for a start.[66] Or woman as the holy, intact whore: "The one closed figure in the waste without form," Beckett wrote in *Murphy*—analogous to Paul Éluard's Surrealistic line "*De grandes femmes annulent le désert*" (Giant women annul the desert)—while the one supremely important thing about the male of the species for both Beckett and Giacometti was his head. Every character in Beckett's novels and plays who has reduced his existence to the bare minimum corresponds to what Giacometti told Jean Genet in 1954: "I shall never succeed in putting into a portrait all the power contained in a head. Just the fact of living requires so much will and so much energy." (713)

The development of Giacometti's and Beckett's work shows that they both battled with the problems that arise in every artist's search for a personal style, particularly when he is striving to match his art with his vision. In the period after 1935, when Giacometti was attempting to break through artistic conventions to the reality of the head, Beckett was finding that the conventional way of saying things had become so banal and empty of meaning that he had to stress he *meant* what he said; in *Murphy*, it took this form: "She looked ill (she was ill)" and "All the color (yellow) had ebbed from his face." And, just as Giacometti discovered that the reality of a head was both an indivisible whole, and a myriad of details as little connected with each other as front view with profile, Beckett's remark in *Murphy*: "The face is an organized whole" was amended later by the observation: "He presented his profiles, between which there was little resemblance, many times

n rapid succession. . . ." In this early work Beckett speeded up the action whenever he felt it necessary by inserting the remark that the story had been "expurgated, accelerated, improved, and reduced to give the following." This amounted to an aside to the reader that he was about to use a literary convention—a "style." In his next novel, *Malone Dies*, he expressed his acceptance of stylistic convention in the sentence: "What half-truths, my God. No matter. It is playtime now." (New York: Grove Press, 1956) The portrait head Giacometti did in 1936, *Egyptian Woman* (page 290, fig. 17) perhaps the only "realization" among all his studies of 1935–40, marked a similar acceptance of sculptural conventions on his part: the classicistic smoothness of the volumes of the face ("What half-truths, my God"), the strict formal shorthand ("expurgated, accelerated, improved, and reduced . . .") and the linear abbreviations for details such as the eyes and lips ("No matter. It is playtime now").

In the subsequent years both artists prepared the series of works which, when they appeared between 1947 and 1952, established their reputations. Giacometti, with his weightless and massless standing figures, had found a style with which to represent the interaction and distance between observing subject and observed object; Beckett, with his extraordinarily strict and concrete language, succeeded in hovering somewhere between storyteller and story itself, a condition in which every sentence he wrote carried the seeds of an impenetrable reality within it.[67]

Beckett wrote *Murphy* in 1936–38. His trilogy *Molloy*, *Malone Dies*, and *The Unnamable* was written shortly after *Murphy* and not published until 1951–53. *Waiting for Godot*, performed for the first time in 1953, was written in 1946–47.[68] We have already mentioned the fact that the same years, 1947–51, marked the period of Giacometti's great "realizations" and first public successes. Thus Beckett and Giacometti simultaneously took over the leadership in giving expression to contemporary consciousness.[69]

Neither man was much interested in creating allegories; both placed something before us which was, basically, sufficient unto itself and meant to be taken literally: this was the only form a work of art could take at the time if it was to stand the test of reality. But art can be true only if it is a "double of reality," to use Giacometti's phrase. Beckett's characters and plots, which really must be taken literally, are true in that they conform to a deeper reality which serves as a background for their actions.

Giacometti's recorded conversations of 1952 and 1953 and his text *A Blind Man Extends His Hand in the Night* show how very close to Beckett he was (15; 50; 52; 53). The sculptor had Beckett's manner of writing and speaking just as much in mind as—in earlier periods—the Surrealistic wordplays and existential thought patterns.

Let us turn again to Beckett's *The Unnamable*, published in 1952. This book begins with the problem of how to identify another person: "Impossible to say. He [Malone] passes close by me, a few feet away, slowly, always in the same direction. I am almost sure it is he. The brimless hat seems to me conclusive." (New York: Grove Press, 1958.) On April 1, 1953, Giacometti said to his visitor Gotthard Jedlicka: "It's remarkable. I know you, of course— I even know what kind of hat you were wearing thirty years ago; I'll make a drawing of it for you some time. And when you approach me on the street, I seem to know you . . . but now you're sitting opposite me, you're like a stranger!" (53)

In *The Unnamable* Mahood says the following about an unknown person: "The other advances full upon me. He emerges as from heavy hangings, advances a few steps, looks at me, then backs away." Precisely at the time this was published, Giacometti was trying to capture some of reality in his portraits by painting them on a nebulous gray background, like a heavy curtain, and painting them over again, repeating the process many times before he was satisfied with the likeness (see page 170). During this period Giacometti also began to cut his figure sculptures off at the hips; compared to the ubiquitous bust, a rare sculptural form (*Diego*, 1954; *Annette Sitting*, 1956). He arrived at it simply by reproducing only that part of the figure which was within his field of vision: the seated model from the head to the hips. And that is exactly as much as appeared to the eye of many of Beckett's characters: "I see him from the waist up, he stops at the waist, as far as I am concerned."

Mahood's predicament, his legs and torso in a jar, his motionless head the only part of his body visible, reminds one of the covers of Egyptian burial urns (*canopi*) in the shape of heads, or the people ensconced in jars in Rodolphe Toepffer's early nineteenth-century caricatures—apparently every basic image has a long history. Beckett's Mahood faces the world frontally, which gives rise to many situations in the novel that correspond with Giacometti's experiences. And Mahood emphasizes over and over that his head is "round, solid and round" and "a big talking ball"; Giacometti had already formulated this comparison in sculptural terms in his early work (*Suspended Ball*; *Woman, Head, Tree*; *The Cage*). This worked the other way round, too: Giacometti's *Monument to a Famous Man* (1953; page 296, fig. 75) reminds one strongly of Beckett's Prometheus, that "miscreant who mocked the gods, invented fire, denatured clay and domesticated the horse, in a word, obliged humanity."

What is the final, mitigating desire that Beckett has the Unnamable express? "A face, how encouraging that would be, if it could be a face, every now and then, always the same, methodically varying its expressions, doggedly demonstrating all a true face can do,

ILLUSTRATIONS ON PAGES 213–224

Alberto Giacometti '

Alberto Giacometti 1952

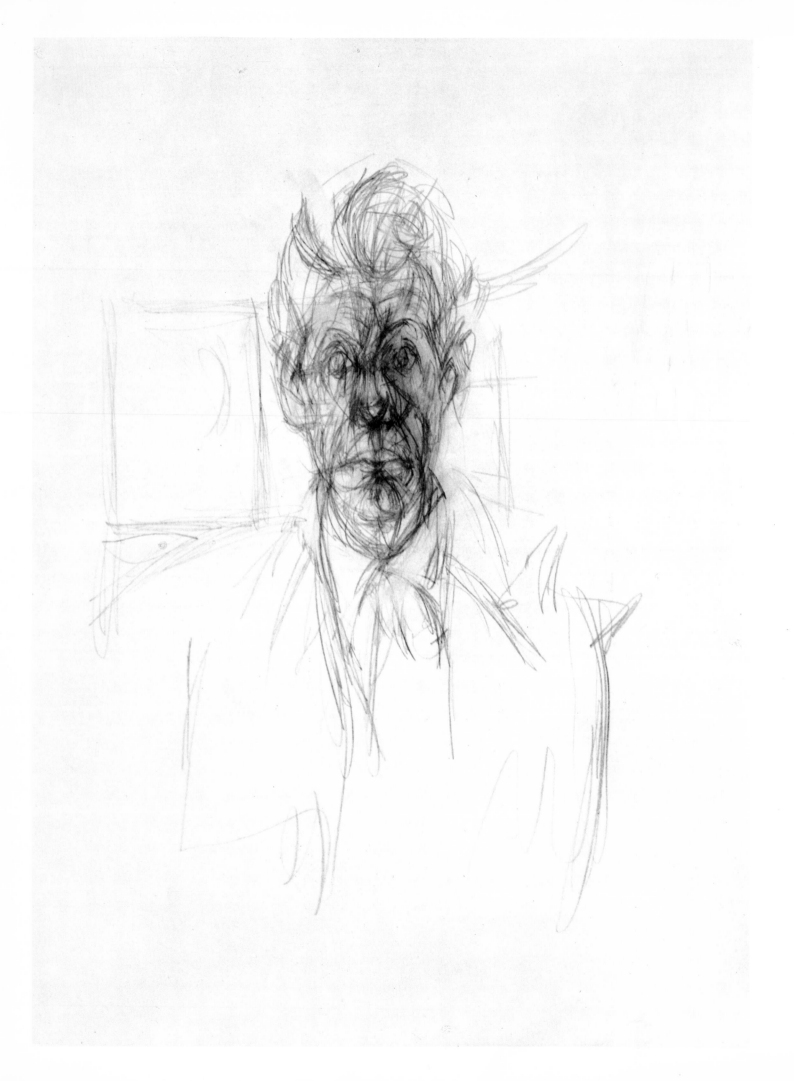

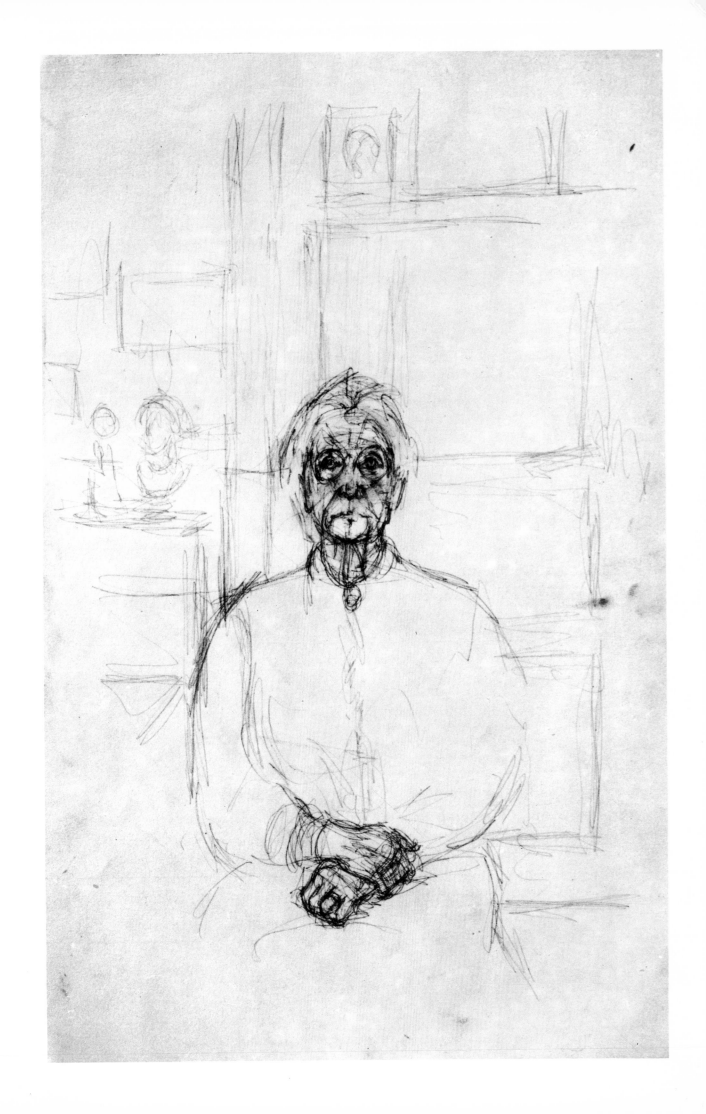

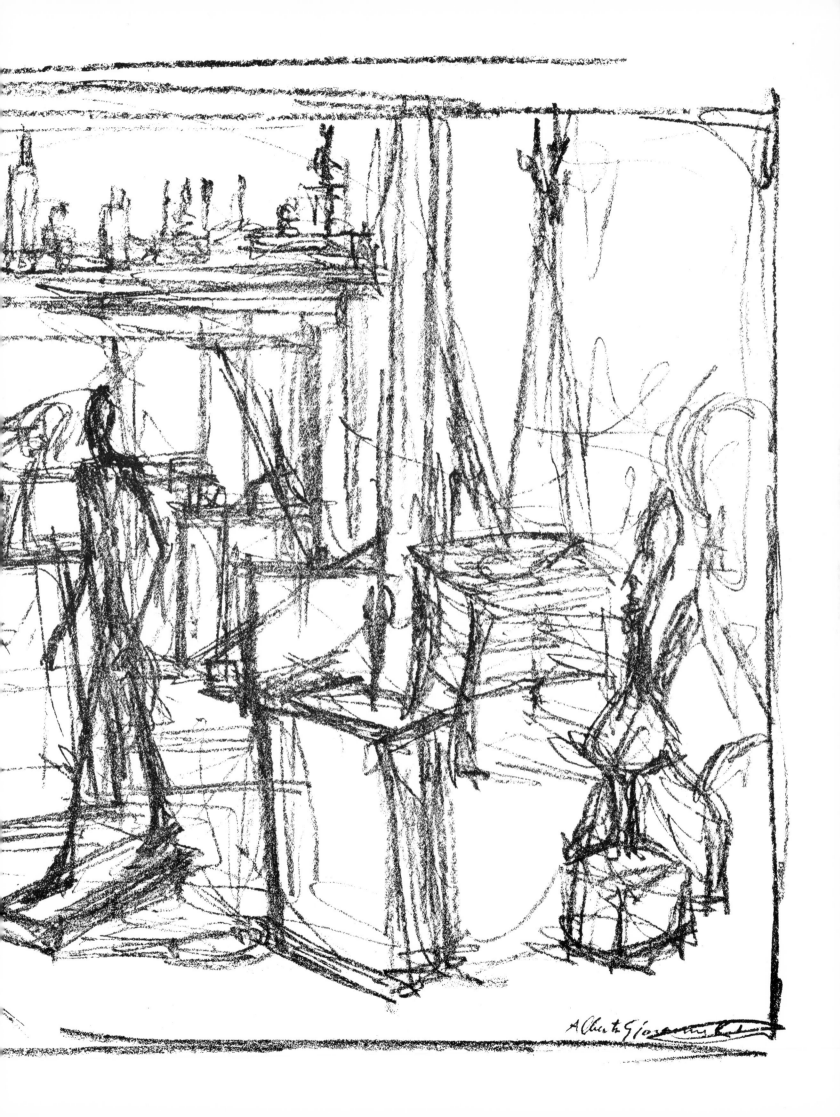

30.V ou 2.VI.54

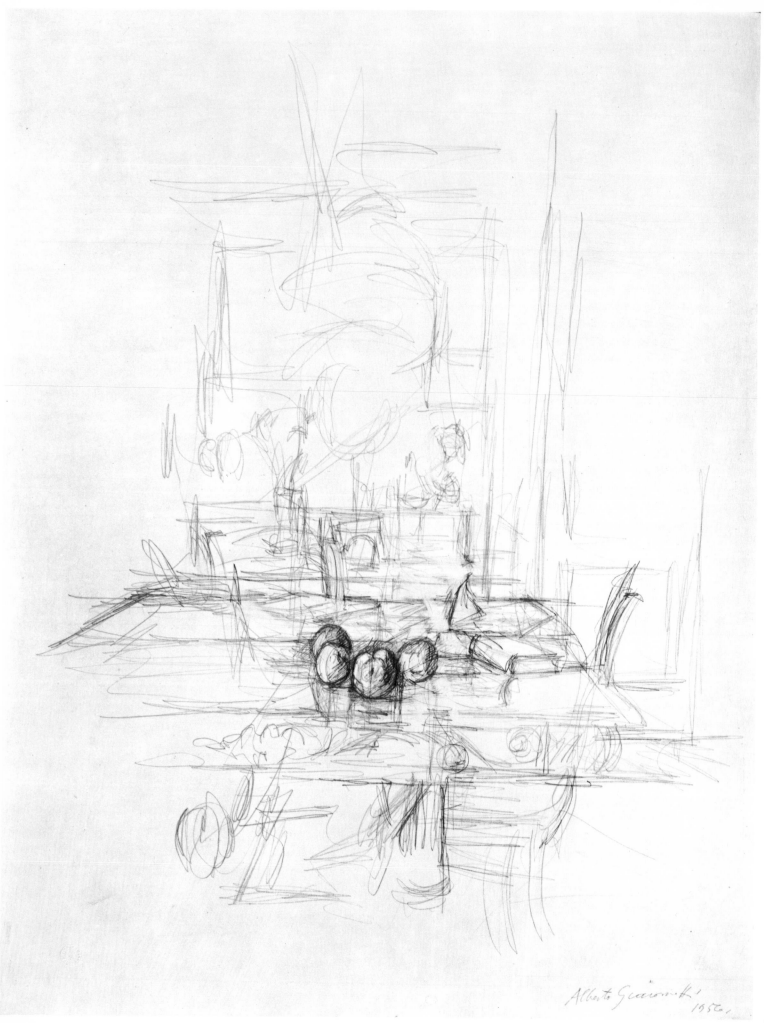

Alberto Giacometti
1956

Paris 11 septembre 1956.

224

without ceasing to be recognizable as such. . . ." For years, every time Giacometti saw a face it was a challenge to his art, it made him want to work all the harder; therein lay his desire for meaningful contact with people and the depressing experience that the more he looked at a face, the less recognizable it became.

During the fifties Giacometti's interest in the human face took a characteristic turn: he began to see the living reality of the Other in his eyes, like Beckett's Mahood: "This eye, curious how this eye invites inspection, demands sympathy, solicits attention, implores assistance. . . . It's it you see and it alone, it's from it you set out to look for a face, to it you return having found nothing. . . ." Giacometti had once remarked how one always looks even a blind man in the eye (817), and he said again and again that he was working to get the eyes of his figures right, their glance, their gaze; and that if he could get that part right, then the whole of the face, the head, and the figure would fall automatically into place (56; 817).

These examples bring us to the spot where both the sculptor and the writer have the core of their understanding, to the point where the space co-ordinate meets the time co-ordinate at zero, where the individual *is*—without qualities or characteristics, unless these be revealed in his account of his own past and of the outside world as far as he is aware of it; joyless, unless his joy take the form of a thin thread of solidarity with other humans; helpless, unless the need to see, to think, and to speak—"Who's speaking?" asks Beckett over and over—or to sculpt, paint, or draw—"Why have I always had the need to make heads? Why am I a painter? Why am I a sculptor? I don't know," Giacometti told André Parinaud in 1962 (61)—be considered a gift of communicating a universal experience. This experience is analogous with the psychedelic experience, which, to use Alan Watts's words, "frees you from your usual identity. . . . Now, when I look someone in the eye, I always see the center of the world there." (*L'Express*, Paris, September 7, 1970)

Outside this center, the zone of contact in which we experience reality extends gray into the distance; Beckett could almost have been speaking for Giacometti when he wrote: "Air, the air, is there anything to be squeezed from that old chestnut? Close to me it is gray, dimly transparent, and beyond that charmed circle it deepens and spreads its fine impenetrable veils. . . . This gray, first murky, then frankly opaque, is luminous none the less. . . . And come to think of it this gray is shot with rose, like the plumage of certain birds, among which I seem to remember the cockatoo." (*The Unnamable* [New York: Grove Press, 1958]) As always with Beckett, this motif may be understood both literally and in a deeper sense. "Whether all grow black, or all grow bright, or all remain gray, it is gray we need, to begin with, because of what it is, and of what it can do, made of bright and black, able to shed the former, or the

latter, and the latter or the former alone. But perhaps I am the prey, on the subject of gray, in the gray, to delusions." (Op. cit.)

In 1958 Giacometti told Gotthard Jedlicka:

When I see everything in gray and in this gray all the colors I experience and thus want to reproduce, then why should I use any other color? I've tried it, because I never intended to paint only . . . with gray. As I was working I had to eliminate one color after another, no—one color after the other dropped out, and what remained? Gray! Gray! Gray! My experience is that the color that I feel, that I see, that I want to reproduce—you understand?—means life itself to me; and that I totally destroy it when I deliberately put another color instead. A red that I put violently into the picture damages it simply because it forces a gray out, a gray that belongs there, at exactly that spot. (53)[70]

In 1952 and 1957 Giacometti published two poetic texts that resembled Beckett's work in more than content alone: *A Blind Man Extends His Hand in the Night* (15) and *My Reality* (19). The first title, with its absolute darkness an opposing force to the grayness of his unseen environment, is a poetic phrase which condensed everything Giacometti had to say about himself and the individual at the zero point on the space-time co-ordinates, and it is also the most concise summary imaginable of Beckett's works.[71] When one has read *The Unnamable*, paying special attention to the rhythm of Beckett's sentences, *A Blind Man Extends His Hand in the Night* reads like a précis of that book, down to the melody of its words and phrases. This is especially clear in the prose cadences running through several pages toward the end of *The Unnamable*, and in the main character's clownlike redemption from life's suffering—the saving quality of his wordplays and the detached humor with which he describes himself.

Giacometti's *My Reality* is a dramatic and tragic self-portrait, an essay composed in a single cadence, more forceful and dynamic than Beckett, but related to the final insight quoted below like an impulsive boy to his older brother:

But little by little I'll get used to it, admonished by them, used to the scene, used to me, and little by little the old problem will raise its horrid head, how to live, with their kind of life, for a single second, young or old, without aid and assistance . . . and how to succeed at last where I had always failed, so that they may be pleased with me, and perhaps leave me in peace at last, and free to do what I have to do, namely try and please the other, if that is what I have to do, so that he may be be pleased with me, and leave me in peace at last, and give me quittance, and the right

to rest, and silence, if that is in his gift. It's a lot to expect of one creature.... (*The Unnamable* [New York: Grove Press, 1958])

But Giacometti's artistic credo goes:

Of course, I paint and sculpt and have since the beginning, since the first time I drew or painted, in order to grab hold of reality, to defend myself, to nourish myself, to grow; grow so that I could defend myself better, the better to face life, get a hold on it, advance as far as possible in every direction and every way, protect myself from hunger, from cold, from death, be as free as possible; as free as possible to try—with the best means at hand—to see and comprehend my surroundings better; comprehend better so that I could be as free and open as possible to devote myself, devote myself as intensively as possible, to the work I do, follow my adventure, discover new worlds, fight my battle—for pleasure? For happiness? A battle for the sake of pleasure, to win or to lose. (19)

Even Giacometti's last motto was measured against Beckett's in *The Unnamable*: "I don't know, I'll never know, in the silence you don't know, you must go on, I can't go on, I'll go on." These words end the book. "I don't know, am I a comedian, a *filou*, an idiot, or a scrupulous fellow. I only know that I've got to keep trying to draw a nose from nature"—thus ends Giacometti's summary of his own development as an artist, written on October 18, 1965 (25).

This last sentence—Giacometti's last conception of how art might approach reality—contains the seed of the program of a new literary style, the *nouveau roman*. When we speak about this style here, we are already dealing with the effects Giacometti's work had on other artists in other fields.

At the close of *The Dream, the Sphinx, and the Death of T.* Giacometti outlined what was to become the inner organization of the *nouveau roman*. After attempting to record a series of experiences from his past and present, bridging the gaps between them and giving them some semblance of order with the help of Surrealist logic, he turned to a sculptural image to clarify his thoughts—a round flat disk mounted on four legs:

A disk of about two meters radius and divided into quarters by lines. On each quarter was engraved the name, the date, and the place of the event to which it corresponded. At the edge of the circle in each quarter-segment rose a high, rectangular plate. On each of these the story that corresponded to the segment was written. With strange pleasure I watched myself walking round the time-space disk and reading each story as I came to it. I was free to begin where I felt like it, for example with the dream of October, 1946, and then, after walking round again, to stop a few months previously, at my towel for example. (12)[72]

Alain Robbe-Grillet wrote sixteen years later: "Time no longer exists in the modern novel. The problem of memory has become so important simply because there is no time factor involved in memory."[73] And walking round Giacometti's time-space disk is in a very real sense the content of Michel Butor's novel *Passing Time* (Paris, 1956): "I walk around and search for the reason for myself on this uncertain field which I have become." If one knows Giacometti's art and reads the *nouveau roman* authors, one is struck by the remarkable feeling of very literally having read the plots somewhere before—in Giacometti's sculpture and paintings.

Walking, continuous and unending walking, as a theme related to a male character, is not limited to Butor's work. In Claude Simon's *The Palace* (Paris, 1962) everybody is underway, "it doesn't matter where to, as if walking were the only thing that counted, no matter the direction," without really arriving anyplace, unless it be a short stay in a woman's bed or a longer one in death. When women enter the action, they are described through men's eyes or they look at their own image in the mirror. Being watched, they are at the mercy of men and are spellbound (Nathalie Sarraute, *The Planetarium* [Paris, 1959]) or stand in catatonic isolation: "Women, their arms stretched out before them, standing motionless in the crushing crowd, as if frozen, miming statues...." (Nathalie Sarraute, *The Golden Fruit* [Paris, 1963]) "How do we see people?" asks Claude Simon;[73] his answer immediately calls to mind Giacometti's *Woman in a Box Between Two Houses* (1950; page 296, fig. 76): "Through small gaps, an hour long, two hours, three hours a day. And where are they the rest of the time? They disappear into great holes. One sees them no more...."

The situation between man and woman, as formulated sculpturally by Giacometti in 1950 in *The Cage*, is the framework of Robbe-Grillet's novel *Jealousy* (Paris, 1957): the husband together with his wife, who has become like a stranger to him, in the cage of jealousy, with nothing to do but look at her.

In addition to the space-time disk, these authors apply to interpersonal relationships Giacometti's principle of the painted, impassable "mirror space." Thus we might see these two aesthetic means as Giacometti's contribution to modern literature.

It seems significant that all of Giacometti's relationship to contemporary thought is documented primarily in literary terms; it is difficult to judge the impact his work has had on the visual arts (there is no reason to discuss his imitators here). Giacometti's oeuvre

of sculpture and painting is singular and unique, a great accomplishment like the work of Michelangelo or Cézanne, but no school grew out of it. We shall probably find in time that Giacometti's work was a takeoff point for new creative thinking in many different directions and styles, the results of which can hardly be predicted now, but about which we can say that their basic theme will be the relationship of the individual to reality and that the results will show our reality in a new light and also throw light on new aspects of reality; the point of reference for any statement about the interdependence of space and time is the here and now of the individual at the center of his world, at point zero.

Maurice Merleau-Ponty—the philosopher who, between 1935 and 1945 and parallel to Giacometti, worked out a phenomenology of perception—formulated it like this in his last essay (summer, 1960):

Nothing remains for our philosophic thinking but to explore the contemporary world. . . . [Our] space is no longer that Descartes spoke of: a net of relationships between objects as it would be described by a third person studying my way of seeing [them], or by a geometrician who reconstructs it but remains detached from it; it is a space which radiates out from me as the zero point, the center. I do not see its exterior limits, I see it from the inside out and am enveloped by it. After all, the world lies all round me, not in front of me. . . . All the research thought to be closed is now reopened. What is depth in space, what is light? . . . So the philosophy that has to be developed is that which animates the painter, not when he expresses an opinion about the world, but at the instant his vision becomes the grand gesture [of creation] that Cézanne described as "*penser en peinture.*" (*L'Œil et l'Esprit* [Paris, 1961])[74]

When Alberto Giacometti began in 1960 to put the individual at the zero point in a spherical co-ordinate system, he did something that corresponded closely to the conception of time and space which found its practical application in the countdown and was experienced by the men who piloted rockets into space: time measured backward and forward from the main event, the takeoff or landing, and space experienced in terms of the distance from the earth or the time required for the return flight. Giacometti arrived at this conception almost against his will. All he wanted to do was make "very ordinary heads" (812) and with these heads and figures ordinary metaphors: compositions like Rodin's *Burghers of Calais*, perhaps less anecdotal and without that piece's distribution of roles among its figures, but monuments nevertheless, to be erected in the traditional manner in public places. There does seem to be a certain nineteenth-century air about most of Giacometti's "realized" works. He may even have

been fortunate in not being able to finish his more monumental pieces and groups and having to be satisfied with processes rather than results. That in itself is modern: "Four centuries after the 'solutions' of the Renaissance and three centuries after Descartes, the [representation of] space is a new challenge which must be solved not 'once in a lifetime' but throughout one's lifetime." (Merleau-Ponty, *L'Œil et l'Esprit*)

Simultaneously, Giacometti proved his timelessness: "If something brings creation to an end, it is not the victorious and illusory cry of the blinded artist: 'I have said everything,' but the death of the creator which closes his experience and the book of his genius," wrote Albert Camus in *The Myth of Sisyphus*. In this sense, as a Sisyphus figure, Giacometti belongs among the artists who set a milestone not only for their own century but for a millennium. None of his works taken individually prove this assertion, but all of his works taken together do.

A man's sole creation is strengthened in its successive and multiple aspects: his works. . . . [They] may seem to be devoid of interrelations. To a certain degree, they are contradictory. But viewed all together, they resume their natural grouping. From death, for instance, they derive their definitive significance. They receive their most obvious light from the very life of their author. At the moment of death, the succession of his works is but a collection of failures. But if those failures all have the same resonance, the creator has managed to repeat the image of his own condition, to make the air echo with the sterile secret he possesses. (Albert Camus, *The Myth of Sisyphus* [New York: Vintage])

Documentary Biography

This biographical section consists of selected quotations from the numerous documents on Giacometti's life, linked by brief explanatory paragraphs. Every quotation not preceded by its author's name is a quotation from Giacometti's own conversations or writings. The numbers in parentheses at the end of each quotation refer to the sources listed in the bibliography on pages 311 to 324.

Since such a listing of documents and sources requires some kind of thread to give it coherence, the quotations have been carefully chosen and occasionally shortened. In a very few cases their sequence has been altered. However, all are given verbatim and their accuracy may be checked at any point by reference to the original sources.

The documentary fragments pieced together here form only a small part of the total. We intend to edit a historical-critical Giacometti Reader, which will contain all the available original source material, including full texts of all the interviews Giacometti gave. Any comments or corrections, or any new information, documents, or letters would be greatly welcomed by the author and by James Lord for the purpose of this publication.

1901

Alberto Giacometti was born on October 10 in the Alpine farming village of Borgonovo near Stampa (Canton Graubünden) in the Italian-speaking Bergell, Switzerland. His father Giovanni Giacometti (1868–1933) was a Post-Impressionist painter; his grandfather, Alberto Giacometti of Stampa, was a baker and innkeeper. Cuno Amiet (1868–1961), a Fauvist painter, was his godfather (804).

He alludes to his first visual impressions and earliest recollections of his mother Annetta Giacometti-Stampa (1871–1964) in his commentary on the sculpture *The Palace at 4 A.M.*:

In the statue of the woman on the left I recognize my mother, just as she appears in my earliest memories. The mystery of her long black dress touching the floor troubled me; it seemed to me like a part of her body, and aroused in me a feeling of fear and confusion. All the rest has vanished, and escaped my attention. This figure stands out against the curtain that is repeated three times, the very curtain that I saw when I opened my eyes for the first time. Caught up in an endless spell, I stared at that brown curtain, and a strip of light crept under it onto the floor. (7)

1902

Birth of his brother Diego, who became an artisan and shared Alberto's life and work from 1925 on.

1904

Birth of his sister Ottilia; she married and moved to Geneva, where she died in 1937 while giving birth to her son, Silvio Berthoud. Alberto made

many drawings and sculptures of this boy, his nephew and only descendant, in Geneva in the years 1942–45; later, he instructed him in painting in Stampa (807).

1906

The family moved to the red stone house in Stampa, newly purchased by an uncle, Otto Giacometti, and located directly across from Alberto's grandfather's house. His father converted the barn nearby into an atelier (807). Alberto did not install his own studio there until much later; before that, he used to work in the bed-sitting-room of the main house and in the house at Maloja.

1907

Birth of his brother Bruno, who later became an architect; Ferdinand Hodler (1853–1918) was his godfather.

As a child—of between four and seven years—the only things I saw in my surroundings were things that pleased me. Those things were, more than anything else, trees and cliffs, but rarely more than one object at a time. I still remember that for at least two summers long, out of everything around me only one large rock interested me, which was about eight hundred meters away from the village—only that rock and everything immediately related to it. It was a gold-colored monolith whose base hid the entrance to a cave [called "Pepin Funtana" (140)]. . . . My father had showed us that monolith one day. It was an important discovery for me. The rock became my friend immediately; I thought of it as a living thing that was friendly to us and called to us, smiled at us, like someone you have known and loved and are surprised and deeply happy to find again. From that day on we went there every morning and every afternoon. . . . My happiness was at its highest when I could crouch down in the deepest little hollow. I could hardly control myself, all my wishes had come true.

When I started school, Siberia was the first country I thought must be wonderful. I imagined myself there and saw myself in the middle of an endless plain covered with gray snow; the sun never shone and the cold was always the same. The plain was bounded at a great distance by a monotone, black pine forest. I looked out at the plain and the forest from the little window of an "Isab"[75] (this name was significant to me) where I was staying and where it was very hot. Nothing more. But I imagined myself being at that place quite often. (5)

1910

From 1910 on, the Giacometti family spent the summers and Christmas holidays at Maloja on the Silsersee (Engadine), a mountain village 2,400 feet higher than Stampa. Their chalet became an important work place for both father and son. A cousin of Alberto's remembers:

Renato Stampa: *No getting around it, the Giacometti cousins were the first to climb up to Maloja every spring at the end of May, where they spent the whole summer in the small house at Capolago that my aunt Annetta had inherited from her uncle Rodolfo Baldini [1842–1909, a confectioner in Marseilles]. In the*

fall the painter's family came back down into the valley in style in an elegant, rented coach. But I remember how my uncle, Alberto's father, told me once that after he had paid the driver he didn't have a single centime left in his pocket. (219)

Alberto's active imagination expressed itself, as might be expected of a boy his age, first in fairy-tale drawings and later in daydreams:

As a child, what I most wanted to do was illustrate stories. The first drawing I remember was an illustration to a fairy tale: Snow White in a tiny coffin, and the dwarfs. (60)

I remember that I couldn't go to sleep at night unless I had lived through the following experience in my imagination: I walked through an overgrown forest in the twilight and came to a gray castle that was hidden in the most secret and unknown place. Here I killed two men who weren't able to defend themselves.... Then I raped two women after having torn their clothes off; one of them was thirty-two years old, dressed in black, with a face white as alabaster; the other was her daughter, with white veils fluttering round her. I killed her too, but very slowly (in the meantime night had fallen)... and every time a little differently. Then I burned the castle down and went to sleep, satisfied. (5)

I see my father walking up and down in front of his easel and I still can smell the good smell of the colors and feel the warmth of the stove in winter. There was no greater pleasure for me than to run into the studio after school and sit in my corner by the window to look at books and draw. I think these are things that affected me then and still do today....

Of course I was very much influenced by my father, but I was attracted almost as much by the illustrations of paintings I discovered in books in the studio.

Even after I had begun to work in a completely different manner from my father, he showed the greatest understanding imaginable for everything I did and was interested in everything I made and everything that occupied me. I can't imagine any happier childhood than the one I spent with my father and my whole family— mother, sister, and brothers. (22)

Renato Stampa: *What especially drew me to the Giacomettis' house was the friendly, open harmony that always prevailed in their family. The most wonderful thing was the big gaslamp that hung over the family table with its wide shade that filled the room with a greenish light. Back then, the Bergell houses didn't have even such elementary things as water and electricity. The installation that supplied the Giacometti house and his grandfather's inn Piz Duan with gaslight was one of the wonders of the valley. (219)*

Ever since I first saw reproductions of artworks—and that must have been early in my childhood because my earliest memories are mixed up with it—I've always had the desire to draw the ones that appealed to me most....

I began to copy artworks before I thought about why I was doing it. Probably to give form to my preferences—this picture rather than that one. (25)

1913–16

In 1913, Alberto did his first painting, a still life with apples, and his first watercolor of a landscape, the Silsersee as seen from Maloja. He made his first portrait busts in the winter of 1914–15.

I see myself in Stampa in 1914 sitting at the window, concentrating on copying a Japanese woodcut; I could still describe it down to the last detail. About 1915, Rembrandt's Supper at Emmaus. *(25)*

Early on I began to draw from nature, too. I was convinced I had mastered it so well that I could copy anything I wanted.... I thought I was great, I thought nothing was impossible for me with that wonderful technique, drawing, and I thought I could copy absolutely anything and that I understood it better than anybody else. (60)

I watched the hay harvest. I drew the farmers. I drew to get outside myself, to overcome. The pencil was my weapon.... I prided myself on it. Nothing could resist me. (67)

From a letter of March, 1915: *I have modeled the heads of Diego and Bruno, and they were very restless models. Our teacher is very good; he is teaching us how to do woodcuts. I like that very much too. (804)*

I had seen a reproduction of small busts on a pedestal, and instantly I felt the desire to do the same. My father bought me some plasticine, and so I began. At first it was great fun and I thought I would get the hang of it very quickly, and that I could approximately reproduce what I saw before me. (61; 67)

In our house in Maloja stood a plaster bust that Rodo [Auguste de Niederhäusern] *had made of my father* [page 289, fig. 6]. *I thought the white color of this bust was unbearable. How little it resembled my father! Once, when my father had left the house for a short time, I decided to paint the bust. I took my palette and brush and went to work. I painted the eyes blue, the hair, the mustache, and the beard red, and the skin pink. I was satisfied with the result. I found that only then was the bust finished, only then was it a portrait of my father—and I was sure I had done the most important work on it. My father was a little surprised. Maybe he thought I hadn't shown enough respect for Rodo's work, but he didn't reproach me for it. (53)*

Giovanni Giacometti (from a letter of April 26, 1916): *Alberto... has also made progress in drawing and painting. He has a lot of willpower, and everything he begins he does thoroughly, even in play. (807)*

1915–19

Alberto Giacometti was enrolled at the Protestant secondary school in Schiers (near Chur) and was assigned to a preparatory class until he had improved his written German. In April, 1916, he was transferred from the first directly into the third class. As luck would have it, some of his fellow students (among them Christoph Bernoulli) were very interested in modern painting and worshiped Giovanni Giacometti as the revolutionary of color, even before they had met him and his sons Alberto and Diego.

Christoph Bernoulli: *One day a man with a red beard came to the Schiers school, a man whose unusual appearance greatly excited us: it was the painter himself. With him was his son Alberto, fourteen years old. A lion—even if rather a shy one—was among us. Alberto was appointed my pupil; the poor boy was*

supposed to learn Latin from me. He was afraid of me because I bored him, as he confessed to me much later. I, on the other hand, was afraid of him, because his strange superiority made teaching him quite difficult. Nobody could pull his mouth to the side in such a kindly, disarming way and show such fine mockery in the corners of it as Alberto. (109)

My father didn't force me to go to Schiers; he only said I might give it a try. At that time I didn't know what I wanted to be—sculptor or painter or chemist. Nevertheless, I furnished a small studio in Schiers with everything a sculptor and painter needs; I spent all my free time there. The teachers didn't bother me and the students didn't bother me either. (53)

When I was sixteen years old, I painted with the technique of the Divisionists. I held the opinion that Cézanne and the Impressionists had come the closest to nature. (55)

Christoph Bernoulli: In the first two decades of our century the problems of painting occupied us young students passionately. Hodler was the artist we debated, and his "rhythmic clouds" over Lake Geneva and the Rallying of the Students from Jena were the subject of heated discussions. Alberto used to observe, more than take part, in these controversies, but the way he listened was really impressive. And when, in childlike pride, he unexpectedly said: "Hodler is my brother Bruno's godfather," we were speechless with wonder. But his mastery of drawing was even more unbelievable to us—his watercolors still showed the influence of his father. In drawing, a new path opened up to him very early on (in spite of a certain similarity between his handwriting and that of his father). (109)

1919

As a young man I thought nothing was impossible for me. That feeling lasted until I was seventeen or eighteen years old. Then I suddenly realized that I could do absolutely nothing, and I asked myself the reason. I decided to work to find out why. (723)

After I had finished the first part of the examinations, I asked my father for a three-month vacation to find myself again. That's how seriously I took myself then! My father and my teacher agreed to it as if it were a completely normal wish; it was only arranged for me to enter the same class when and if I came back—without an examination. (53)

Giovanni Giacometti (from a letter of March, 1919): Now he has a few pleasant months ahead of him, and it is quite all right with me to have him here during that time. We shall work together, and I can observe his talents and development more closely. (807)

Once, in my father's studio, when I was eighteen or nineteen, I was drawing some pears which were on a table—at the usual still-life distance. But they kept getting smaller and smaller. I'd begin again, and they'd always go back to exactly the same size. My father got irritated and said: "Now start doing them as they are, as you see them!" And he corrected them to lifesize. I tried to do them like that, but I couldn't help rubbing out; so I rubbed them out, and half an hour later my pears were exactly as small to the millimeter as the first ones. (637)

After those three months I had no desire at all to go back to Schiers. Perhaps that was wrong? I don't know. But my father agreed to it, and because my father had nothing against it, my mother didn't have anything against it either: after all, she'd married an artist. "Do you want to be a painter?" my father asked me. "A painter or a sculptor," I replied. He advised me to go first to the École des Beaux-Arts in Geneva. (53)

Fall, 1919, to March, 1920

Alberto Giacometti lived in Geneva at 79, Rue des Eaux-Vives; at first he was not happy, but in the spring of 1920, after he had been introduced to a number of artists (among them Kurt Seligmann, 1900–1962; Hans Stocker, b. 1896; Hans von Matt, b. 1899; and Pierre Courthion, b. 1902) his spirits rose again.

School didn't suit me at first, and then I felt myself very much a stranger in the life of this city, which I find quite cheerful now, by the way. I know quite a lot of artists. (804)

Pierre Courthion: I see him next to me at the École des Beaux-Arts, in old Estoppey's studio, where he had set up his easel near mine. A rather bloated, buxom girl, Lulu, was modeling in the nude. As is customary, we were supposed to put the whole body on paper—head, arms, and legs. He, Giacometti, objected. He maintained (and how right he was!) that you should draw only what interested you. He insisted on it—which irritated the teacher—and drew one of the model's feet on his Ingres paper, simply huge. (136)

Hans von Matt: If Alberto hadn't been with Estoppey for more than three days, it would have been impossible for us to become such good friends. I can still see very clearly before me one of his pictures that he made in class, and it couldn't have been painted in three days. It was built up very impressionistically of brushstrokes almost all the same size, with no contours at all and in very bright, fresh colors. None of us painted like that. One noticed his father's schooling (yet he didn't paint as boldly as his father, rather more lyrically), but also his own temperament. (824)

Giovanni Giacometti (from letters): Then he went to the École d'Art et Métiers, but didn't find what he wanted there either. Now he is only taking sculpture lessons from Sarkissoff, who lets him work on his own [January 30, 1920].... Alberto still goes to the École des Beaux-Arts in the afternoons.... He is leaving Geneva earlier than expected because he wants to be here at Easter [March 14, 1920]. (807)

1920

At the end of March, Alberto Giacometti spent about ten days with Cuno Amiet in Oschwand (Canton Bern); his godfather modeled a bust of him. Alberto drew silverpoint portraits, painted still-life watercolors in a Cézannesque manner, and composed landscapes at Amiet's side. On the return trip to Stampa he saw modern paintings and African sculptures in the Josef Müller collection at Solothurn.

ILLUSTRATIONS ON PAGES 233–244

233

234

Albert Giacometti
1960.

Alberto Giacometti 1960

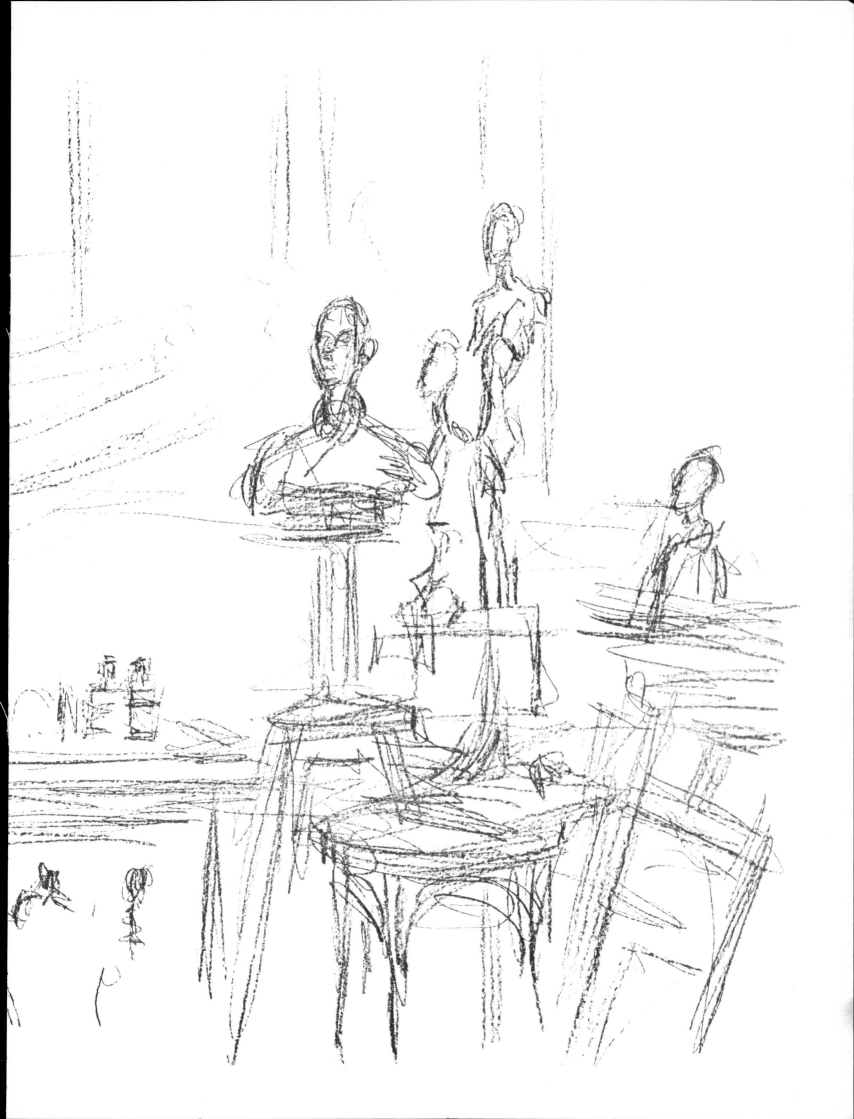

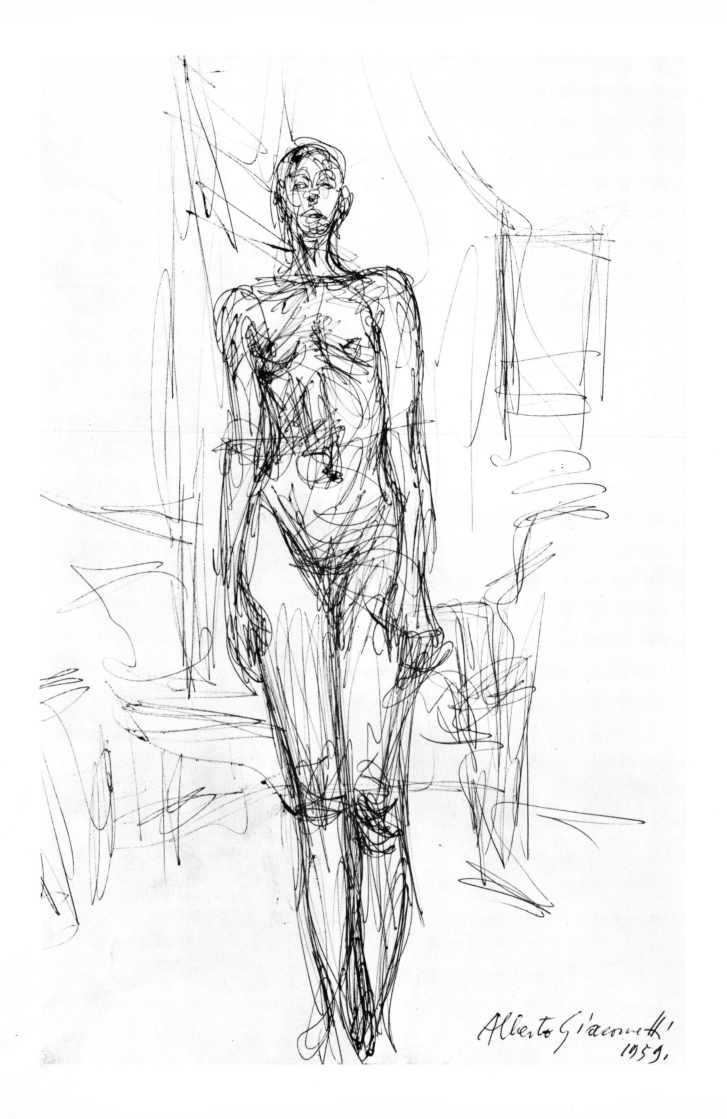

Alberto Giacometti
1959.

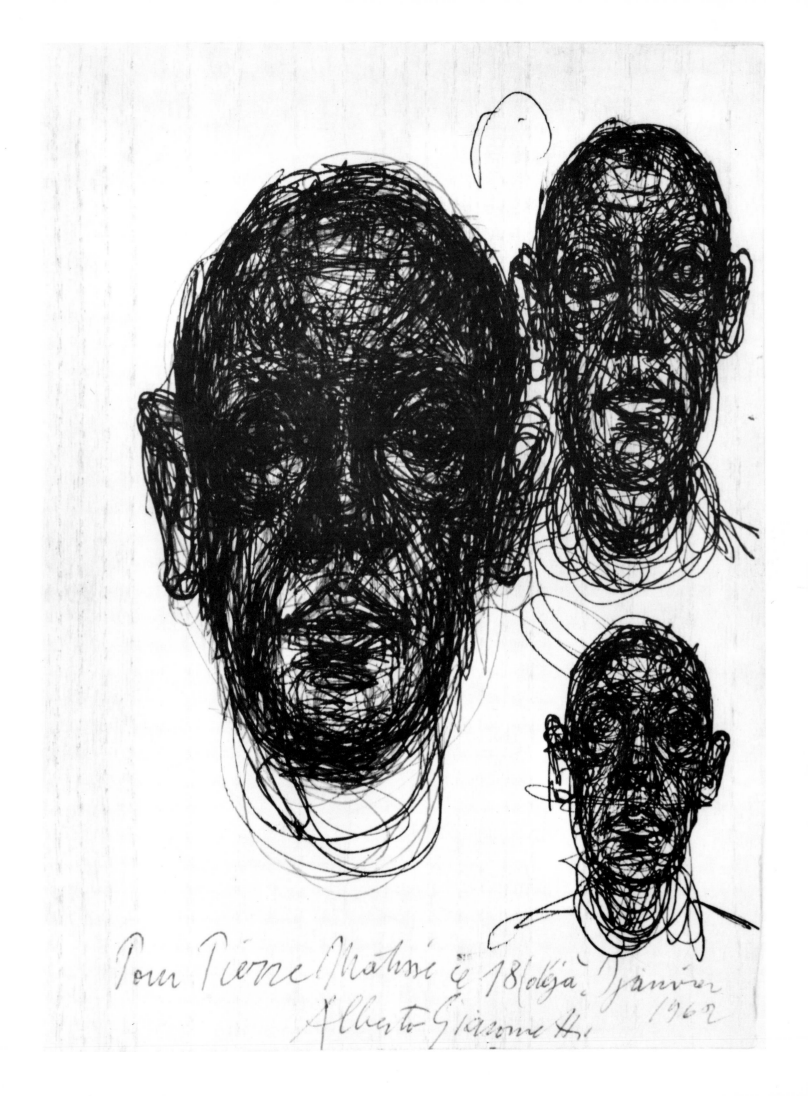

Pour Pierre Matisse & 18/olga, Janvier
Alberto Giacometti 1962

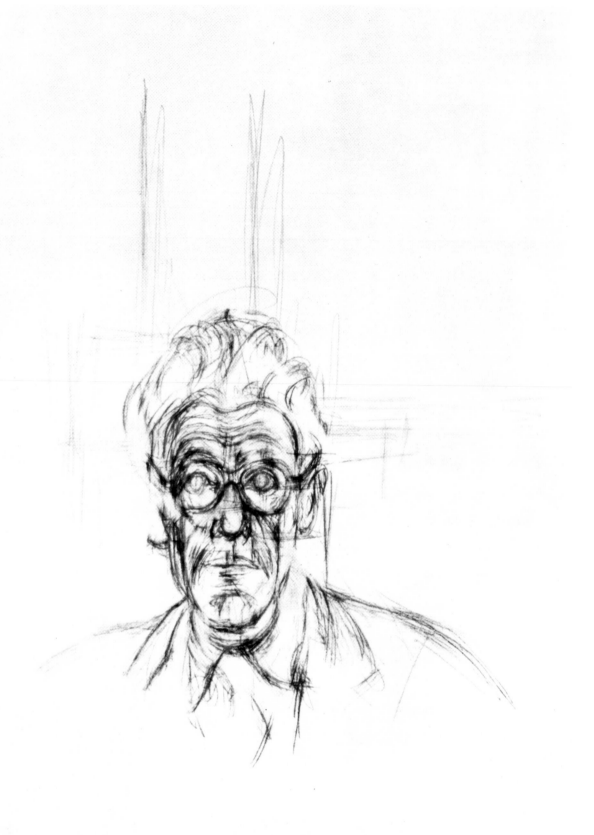

244

From a letter of April 10, 1920 (to Cuno Amiet): *Now I am finally home after all that traveling! It went very well, and the walk to Solothurn was very amusing in spite of the rain. . . . Next week, if I get my passport, we're going to Venice. . . . I got my things, but I forgot the silverpoint up there [in Oschwand], on the table in the atelier. I hope to get the wonderful photographs soon, so that I can show the bust around too.* (804)

In May, Alberto's father took him to the Biennale in Venice; Giovanni went there in his official capacity as a member of the Swiss art commission.

Giovanni Giacometti: *On the whole, the Swiss section is much liked by the artists because one finds artists there who remain true to their nature and to themselves, and because they bring a new note [to painting].—I can't begin to describe what Venice is like. You have to experience that light, that sky, those colors. You live there as in a dream. You wander through beauty. . . . Through the glory of Veronese and Titian you come to the overflowing and unlimited, fantastic genius of Tintoretto. They are unexpected, unbelievable, incomprehensible revelations.* (807)

I still remember an impression I had on the journey at a little station in the hills of Brianza, where I saw the sun swimming gigantic and red in the haze just above the horizon, and the surprise when I arrived in Venice: the light, transparent gray, the green-gray dome of the church opposite the station—everything looked fragile and a bit broken-down.

 During my stay in Venice, I loved and was carried away only by Tintoretto. I spent the whole month running through the city; the thought that I might miss seeing even one of his paintings that was hidden in the corner of a church or someplace left me no peace. Tintoretto was a wonderful discovery for me; through him a curtain went up on a new world, and this world was the reflection of the reality that was all around me. I loved him with an exclusive and one-sided love and felt only enmity and antipathy for the other Venetian painters, for Veronese and Titian (but not for Bellini—I admired him, but from a distance, so to speak—he wasn't necessary to me at that moment). Tintoretto was right and the others were wrong. On the very last day I went to San Giorgio Maggiore and to the Scuola di San Rocco to say farewell, farewell to one of my best friends. (17)

On the return trip father and son stopped in Padua.

Giovanni Giacometti: *And in Padua there is Giotto! The thing that strikes you first is the serene and clear composition and the large, rounded forms. You can't pull yourself away from that inner truth, from that immediate naturalness. A window opened before my eyes. That I still presume to take a brush in my hand is only human and forgivable.* (807)

On the same afternoon, I had hardly stepped into the Arena Chapel when the frescoes of Giotto gave me a crushing blow in the chest. I was suddenly aimless and lost, I felt deep pain and great sorrow. The blow hit Tintoretto too. Giotto's force imposed itself on me irresistibly. I was pressed back against the wall by those immutable figures, made as if of basalt, with their precise and true gestures, heavy with meaning and often infinitely tender—such as Mary's hand touching the cheek of the dead Christ. It seemed to me that no hand could ever make any other gesture in a situation like that. . . . The thought of abandoning Tintoretto disturbed me. . . . I felt if I did, I would be losing something I'd never recover, a brightness, a breath of air, both of which were infinitely more precious than all of Giotto's qualities, though I was convinced he was the stronger of the two. On that very same

evening these contradictory feelings shrank to nothing when I saw two or three young girls walking in front of me. They appeared immense to me, all out of proportion to normal size, and their whole presence and their movements affected me with terrible violence. I stared at them like a madman, fear shot through me. It was like a fissure in reality. Everything meant something else, the connections between things had changed. The works of Tintoretto and Giotto seemed small, meaningless, weak, and insipid, like monotonous, shy, awkward stammering. But precisely what seemed to me so important about Tintoretto was a faint image of this apparition, and I understood why I didn't want to lose him at any cost. (17)

Giacometti's experiences in Padua were followed by several months of study in Italy, from the fall of 1920 to the summer of 1921. In Rome he lived with his father's cousin, Antonio Giacometti, in the Monte Verde quarter, a quiet neighbourhood south of the Gianicolo. His daughter Bianca sat for Alberto several times for portrait sculptures.

That fall I found that same image again, but many times stronger, first in Florence, in an Egyptian portrait bust—the first sculpture of a head that seemed lifelike to me—and in Cimabue's works in Assisi, which filled me with overpowering joy. And also a short time later in the mosaics of SS. Cosmas and Damian in Rome. All of these works seemed to me to a certain extent like re-created doubles of those three young girls in Padua. Cézanne has taken on the same quality for me, and it's because of this that he has a special place in the art of the past century. (17)

Giovanni Giacometti: *After Alberto had painted for four weeks in Florence, he went via Perugia and Assisi to Rome, where he arrived safely, his excitement not letting up in the slightest the whole time.* (807)—*For him there is no other profession than that of sculptor or painter; he lives it to the utmost.*[76]

From a letter of January 29, 1921: *I was in Florence for a month, but because I wanted to work there and didn't find anything, I came via Perugia and Assisi to Rome in the hope of finding plenty of academies and open painting classes here. Of course the first few days I just wandered around from one corner of the city to another, but when I began to look for something, I didn't find anything, nothing at all: the academies were overflowing, the free courses had ended, the evening classes were impossible to attend—not one bit better than Florence, in other words. But the city is wonderful . . . you can have everything you want here: museums, churches, wonderful ruins . . . lots of theater, lovely concerts almost every day . . . for the present I'm staying here.* (824)

I stayed nine months in Rome where I never had enough time to do all I wanted. I wanted to see everything, and at the same time I painted figures, somewhat Pointillistic landscapes (I was convinced that it was simply a convention that the sky was blue, and that it was, in reality, red), and compositions inspired by Sophocles and Aeschylus whom I was reading at the time. I spent a lot of time in museums, in churches, in ruins. I was particularly impressed by the mosaics and the Baroque works. (13)

I filled my notebooks with sketches of everything I saw. . . . I have lost many of them since, particularly the small ones with the drawings I did from originals in Rome. . . . The Rubenses in the Borghese gallery were one of the great discoveries that day . . . and a painting by Pinturicchio, and all the other Quattrocento frescoes in the Sistine chapel. (25)

The whole winter long I had a girl friend pose for me, six months in all. I had also begun two busts, one of them small, and for the first time I couldn't find my way, I was lost, everything escaped me, the head of the model before me became like a cloud, vague and undefined. . . . It had become completely impossible for me to reproduce the whole form of the head. . . . When I left I threw the head in the wastebasket. (13)

In the early summer of 1921 Alberto traveled to Southern Italy with Arthur Welti of Zurich (1901–1961, author and radio collaborator).

On the train from Paestum to Pompeii I made the chance acquaintance of an old Dutchman, Van M., Royal Librarian from The Hague. Back in Stampa, as a joke, my friend sent me a little newspaper clipping saying that this Van M. wanted to get in touch with the young man he had met on the train. I thought he had lost something and wrote to him. He suggested that I accompany him again on a journey. He liked me. He was old and alone. I wanted to see Venice again. (67)

Alberto met Van M. in Innsbruck that fall. His companion died at an inn at Madonna di Campiglio.

I was just about broke. He wanted to pay. We rode over a pass on horseback. In Tirol he caught cold. The next morning he was in such pain he was banging his head against the wall. He was suffering from kidney stones. They gave him shots. I spent the day at his bedside and read—I still remember—an essay on Flaubert by Maupassant. It was raining. From time to time he said something: "Tomorrow I'll be feeling better. . . ." By late afternoon I had the feeling his nose was growing longer. He was breathing heavily. His cheeks were sinking in. I was very frightened: he was going to die. The doctor came: "Hopeless. His heart is giving out, he won't live out the evening." That was a nasty trap for me, the opposite of everything I had known about dying.

In a few hours Van M. had turned into an object. A nothing. That meant, of course, that death could come at any moment, to me, to the others. . . . It was like a warning. It had begun with so many accidents: the acquaintance, the train compartment, the notice in the newspaper. As if everything had been planned so that I would be a witness to that wretched death. My life changed on that day, and I'm not exaggerating. . . . All that started to fall apart for me when I was twenty. (67)

Before that I had never been face to face with death. I didn't have that feeling of doubt yet, because in the few deaths I knew of—as I said, I had never seen a dead person close up—it had happened as if life had no power or continuity or lasting quality—no, I can't find the right word—in short, as if death were something that belonged to life, gave it some value, or glory, and as if one had the time to prepare for it. But when I saw how it could really happen—immediately, the minute I saw how this person was dying, no—immediately, everything was threatened, right? I felt so threatened that I didn't dare go to sleep. But I fell asleep anyway and felt in my sleep how my mouth was open—just like the dying man's! I woke up and did everything I could to keep from going back to sleep, for fear that I would start to roll my head from side to side like he had done. (803)

The first thing I wanted to do was pack up and leave. But there was something dubious—he had a red spot on his chest. I had to stay there the whole day, watched by a gendarme. When they finally let me leave I went to Venice after all. Two days of sitting in cafés, running after girls . . . I spent my last soldi and then went home. The more I think about it, that drama was the reason I've always lived provisionally,

why I've had a horror of all possessions. Establishing yourself, furnishing a house, building up a comfortable existence, and having that menace hanging over your head all the time—no! I prefer to live in hotels, cafés, just passing through. (67)

1922

On January 1, Giacometti went to Paris. Until 1924 he returned to Stampa every few months; from August to October, 1922, he was in Switzerland to do his military service. At first he established himself in Alexander Archipenko's Paris atelier. (Archipenko had opened a school for sculptors in Berlin in 1921, but decided in 1923 to move to New York and gave this atelier up.)

My father thought it would be good to work at a fine-arts academy as he did when he was young, at the Académie de la Grande Chaumière, to draw and paint there. I didn't want to do it at first, so he stopped insisting on it—that convinced me to do it after all. (53)

I would have preferred in a way to have gone to Vienna where life was cheap. At this period my desire for pleasure was stronger than my interest in the academy. (13)

I see myself again in my Paris atelier, coming home, leafing through books and copying some Egyptian sculpture or other, or a Carolingian miniature, but also works by Matisse. (25)

Antoine Bourdelle's class at the Académie de la Grande Chaumière consisted of a weekly two-hour monologue before his students' works. Notes on this have survived:

Daniel Marquis-Sébie (1922–23): *Thursday. Eleven-thirty. A taxi stops in front of No. 14, Rue de la Grande Chaumière. A Polish fellow goes from group to group putting a finger to his lips: "Monsieur Bourdelle is here"! The master appears in a short, full, slate-gray work coat. He laboriously breaks a trail through the students and the forest of modeling stands. "Before I correct your work, mes amis, I should like to express a few thoughts. Seeing an object correctly does not mean judging the model by the shape of her nose. Rather, you should observe carefully how the nose is related to the lower edge of the forehead, what its relationship to the eyes is, and learn to see things in depth. In short, that means getting hold of reality from close up. That is the task of intelligence. Let it be said that the man who could represent this object precisely (this lump of clay I'm pressing flat between my hands for example) would be a very great artist. And, in the truest sense of the word, seeing an object exactly as it is requires an intelligent talent for observation and an orderly spirit." . . . The master walks on, stopping before each student's work: "Ah! Here we are approaching a real understanding of sculpture. These are good beginnings, this is built from the skeleton out. I'll wager it's the work of a Swiss." Over the top of his pince-nez his gaze takes in the room. The student in question steps forward. "You're Swiss, aren't you? Yes, this is all rather nice, however, there is a but: the motifs are too pronounced and I miss the relationship between them. The style is too fragmentary, and you've got too far away from the harmony of total form that characterizes the model. You've got to avoid this isolation of individual forms. One has to bind the whole together smoothly and harmoniously, sensitively."* [10f]

I was at the academy under Bourdelle for a total of five years. Bourdelle's class didn't help me much. We had to do full-length figure studies after the model. I noticed that my way of seeing changed every day. Either I saw the volumes or I saw the whole. And because the model posed for only short periods at a time, she had moved before you had even had the chance to grasp anything. (61)

Impossible to grasp the entire figure (we were much too close to the model, and if you began on a detail, a heel, the nose, there was no hope of ever achieving the whole). But if, on the other hand, you began by analyzing a detail, the end of the nose, for example, you were lost. You could have spent a lifetime without achieving a result. The form dissolved, it was little more than granules moving over a deep black void. . . . I could no longer bear a sculpture without color and I often tried to paint them naturalistically. (13)

I got the model to come to my place and painted my plaster sculpture from life. Then I wanted to show it to Bourdelle, but when I brought it with me into the atelier, the other students let out such howls of scorn that I decided not to. (55)

1923–1927

Often, upon returning from Stampa or Maloja, where he regularly spent the summer months, Giacometti was forced to change his residence in Paris: from a pension near Rue Mouffetard to the Hôtel Notre Dame on Quai Saint-Michel to the Hôtel de la Paix on Boulevard Raspail. At first he saw much of artist friends he had known in Switzerland, among them Hans Stocker and Leonhard Meisser.

Leonhard Meisser: *He very often painted in the hotel. I remember particularly two colorfully very compact portraits he worked on for a long time. He talked a lot about his father then. . . . Alberto was already a passionate draftsman at the time and was a master of an original kind. To get to the basics of a face he would indicate the significant points with dots and connect them with fine lines, like a complex system of co-ordinates. Then he would work exclusively after the model. He achieved absolutely lifelike portraits with this method. (185)*

The second year I got hold of a human skull quite by accident—somebody lent it to me. I had such a great desire to paint it that I stopped going to the academy for a whole winter. I spent the whole winter in my hotel room painting the skull; I wanted to understand it and copy it as exactly as possible. Days went by in the attempt to find the root, the source of a tooth . . . which lies very high up near the nose, to follow the tooth as exactly as possible in all its twistings. The result was that it became impossible for me to copy the entire skull; I had to restrict myself to studying more or less the lower part of it: I mean the mouth, the nose, and the curvature of the eye sockets at the most, and nothing that lay above them. (50)

During my time at the academy, there had been a disagreeable contrast for me between life and work, one got in the way of the other and I could find no solution. The fact of wanting to copy a body at set hours—a body that otherwise left me cold—seemed to me an activity that was basically false, stupid, and which robbed me of many hours of my life. (13)

When I came to Paris, the mad years of Montparnasse were coming to an end. And there's nothing harder for a foreigner than to make contact with the French,

is there? It's like a wall. I came to Paris and knew the artists at the Grande Chaumière, that is, all foreigners, except for one Frenchman, whom I saw very little of anyway, and up until 1930, no, 1928, I had got to know only one Frenchman. . . . At first I joined up with some Jugoslavs because they were working together at the Grande Chaumière, then a few Swedes. But actually I lived without many acquaintances and felt quite alone. I didn't complain. (803)

Emmanuel Auricoste: *I was still a very young man in 1926 when I entered the Grande Chaumière for the first time and met Giacometti in the famous atelier where Bourdelle—a very superior and fascinating teacher—taught. Giacometti already had the lined face and wild head of steel-wool hair that he was to keep for the rest of his life. He frightened me. His curt sentences, his sullen looks, and his independence of Bourdelle and the others in the atelier seemed to put an unbridgeable distance between him and me. And yet he attracted me. (105)*

In 1925 Alberto and Diego Giacometti rented their first private atelier in a modern building set aside for artists at 37, Rue Froidevaux. One of Alberto's first portrait commissions was a sculpture of Josef Müller, a Swiss art collector who lived in Paris from time to time. The more post-Cubist and primitive sculpture Giacometti saw, the uneasier his relationship with Bourdelle became. But his teacher was one of the vice-presidents of the Salon des Tuileries with its yearly quota of two thousand works from four hundred artists; he let Giacometti exhibit each year from 1925 on with one traditional and one avant-garde work: in 1925, Abstract Composition (*The Torso*) and Bust (*Head of Diego*); in 1926, Sculpture (*The Couple*) and a bust; in 1927, Figure (*The Spoon Woman*) and a head.

In 1925 I exhibited an abstract sculpture in the Salon des Tuileries. Bourdelle told me: "One does something like that at home, for one's self, but one does not show it." (55)

James Lord: *He also made a bust in Bourdelle's class that Bourdelle liked very much; he advised him to have it cast in bronze. Giacometti refused. Agreeing, he said, would have meant not only that his work was successful and worth preserving, but complete, final, unchangeable. And that, he said, would have blocked his path to further work. (175)*

Giacometti had his first exhibition in Switzerland at the Galerie Aktuaryus in Zurich in November, 1927. It included (aside from paintings by his father) busts of his brother, his father, and a girl, all conceived of as mannered figures rather than portraits, which led to misunderstandings:

Hermann Ganz (reporting in *Kunst und Künstler*): *Several busts simultaneously exhibited by his talented son Alberto (Paris) still lack living individuation yet reveal sculptural instinct. (306)*

During his first years in Paris, Giacometti visited the sculptor Henri Laurens in his studio on Villa Brune, a private drive on the periphery of Montparnasse.

The bright street at eleven in the morning. "I'm going to see Laurens." The yellow trees of the Villa Brune, the railway embankment. The tall gray door of the

atelier. My nervousness when I knocked. "And what if he's not at home?" My disappointment during the long silence, my joy at hearing footsteps approaching inside. Laurens's smile, the color, the shape of his head at that moment, like his sculptures, satisfied me as soon as I saw them. The good feeling the first time I saw a work by Laurens, triggered by the relationship of height to width. The immediate certainty: "This sculpture is good, once and for all time." (10)

Giacometti must have seen Jacques Lipchitz often and the work of Brancusi and Duchamp-Villon now and again, though no record of this exists. From the first, he frequented the natural history and primitive art collections in the Musée de l'Homme and the Jardin des Plantes, as well as visiting the exhibitions at which the Surrealists showed their objects together with Polynesian fetishes.

When I was still at secondary school I thought that a Roman portrait bust resembled nature's example very closely; today, after having learned to look at nature and people a little more carefully, I know that a sculpture from New Guinea or one of Brancusi's birds are closer to nature than a Roman portrait bust. (217)

Basically, Western or, say, Greco-Roman sculpture, which wants to represent the head as it is, is the most abstract and constructed sculpture there is. The sculpture of Africa or Polynesia, where they make large, flat heads, corresponds much more closely to what we perceive of the world than Greco-Roman sculpture. But now people have turned it upside-down and think a head looks more like a Greco-Roman sculpture than anything else and that an African or Polynesian sculpture is completely invented. (803)

1927

Giacometti moved to his atelier at 46, Rue Hippolyte-Maindron. At first he used to sleep at the nearby Hôtel Primavera in the Rue d'Alésia, but eventually he took up residence in his atelier. It was to be his place of work until his death.

It's funny, when I took this place in 1927, I thought it was tiny. It was the first place I found, and I had no choice. I planned on moving as soon as I could because it was too small—just a hole. But the longer I stayed, the larger it grew. . . . I could do anything here. I've already made my big sculptures here, the ones of the Walking Man. At one time I had three big ones—two of those and one other— here all at the same time. And I had room to paint beside them. If I had a larger atelier, the space I'd utilize wouldn't be any larger. (71)

Françoise Gilot/Carlton Lake (1946–47): "You ought to see Giacometti's atelier," Pablo said to me one evening. . . . A few days after that, on our way to lunch, we went to Giacometti's studio, in the Rue Hippolyte-Maindron, a pleasant little street in the Alésia district. It is a quiet, humble quarter with small bistros and craftsmen's shops and an air of timelessness and bonhomie that has been lost in many parts of Paris. To get to Giacometti's studio we passed through a door off the street into a little yard with small wooden ateliers up and down both sides. Pablo pointed out to me Giacometti's two adjoining rooms and, on the other side of them, another atelier where Giacometti's brother Diego was working.
Diego, a very gifted artisan, devoted himself entirely to his brother's work. . . . Giacometti was well known and respected for many years before he ever managed

to make a decent living. Diego did the work that one or two assistants would normally have done—assistants that Giacometti was in no position to afford. Diego also made very handsome objects designed by his brother—table-lamp bases, floor lamps, doorknobs, and chandeliers—which helped support them. (152; Penguin ed., pp. 201–2)

I never wanted to play the artist and make a career. I was in the position of a young man who sort of makes a few tries just to see what happens. As long as my father supported me I never even thought of making art my career. But about 1926 or 1927 my father said I should try to stand on my own feet. I thought about pieces of jewelry I could design. (67)

In the winter of 1927–28 Giacometti arrived at his plaque sculptures, which quickly brought him fame as an avant-garde sculptor.

I tried to re-create, in my studio and from memory, what I had felt when looking at the model in Bourdelle's atelier. But what I really felt narrowed itself down to a plaque which stood at a certain angle in the room and carried only two marks: if you will, the experience of verticality and horizontality that one has with every figure.

In order to work out these plaques I began to model from memory as much as possible of what I'd seen. In other words, I began to analyze a figure—the legs, the head, the arms—and all of it seemed false to me, I didn't believe in it. To get closer to my idea, I had to sacrifice more and more, limit myself—leave off the head, the arms, everything. So what was left of the figure was only a plaque, and that didn't happen on purpose and didn't satisfy me, just the opposite. It was always disappointing that what I really mastered in terms of form reduced itself to so little!

It took a long time before I arrived at these plaque sculptures. A whole winter long I worked on them and other things of the same kind. Here I should add that I began two or three motifs in different ways, but the same thing always came out in the end. . . . They seemed to me to correspond in a way to things and to myself. But this wasn't so certain either—did I actually want to make something I saw in things, or express the way I felt about them? Or a certain feeling for form that is inside you and that you want to bring outside? (50)

1928

A *Plaque-Head* and a *Plaque-Figure* exhibited in the Galerie Jeanne Bucher—which also showed Laurens and Lipchitz and was to have works by Giacometti on its program until 1940—attracted immediate attention.

Finally I was able to come to a decision—in order to get some money—to take two of my plaques, those doubtful attempts, to Jeanne Bucher. Eight days later they were sold and I had three contract offers on the table in front of me. On the one hand I was happy, because of my father. But on the other, I said to myself: "How can people be taken in so quickly—and by such nonsense?" (67)

Jean Cocteau (diary entry, winter, 1928–29): *I know of such powerful, light sculptures by Giacometti that one is led to speak of snow that preserves the footprint of a bird. (133)*

When I met Masson through my work at an exhibition, he introduced me in the space of a few days to a good number of those friends who are still friends today:

Bataille, Leiris, Desnos, Queneau, and many more, you know, and from that moment on it was as if I had always lived in Paris. That started in about 1928. (803)

Giacometti showed several times in group exhibitions of Italian painter friends (Campigli and others); in 1927 and 1928 in the Salon de l'Escalier (Théâtre des Champs-Élysées), in 1929 in the Galerie Zak. The conservative Italian art journal *Emporium* printed some annihilating criticism together with an illustration (page 290, fig. 18):

Ugo Nebbia: *Only the uncreative persist in this provocative direction, which is quite well enough known, whereas the intellectually alive have got hold of themselves again.* (307)

1929

Pierre Loeb, since 1926 the Surrealists' preferred art dealer, signed a one-year contract with Giacometti. Georges Bataille printed in his journal *Documents* a text on Giacometti with photos of his work, both by Michel Leiris. E. Tériade chose two works (*Man* and *Three Figures Outdoors*) for the representative international sculpture exhibition in the Galerie Bernheim, where current trends in French and German sculpture came together; Christian Zervos wrote at length on this show in *Cahiers d'art*, the periodical with the highest standard of writing of the period on modern art and architecture.

Christian Zervos: *Giacometti seems to have set himself the task of proving that sculpture is not above all that disappointing art which takes artisanship as its measure. So long as he is content to let his work express poetic intentions and leaves it at that, he misses the full measure of his art. Even if he is concerned not to get caught up in superficial appearances, he should not believe that he has to suppress the substance of sculpture itself along with its arbitrary outer covering.* (311)

Michel Leiris: *I like Giacometti's sculptures, for everything he makes is like the fixation of one of those moments we experience as crises, which live from the intensity of a quickly perceived and immediately internalized adventure. Everything in his work is wonderfully alive, just as authentic fetishes (those we can trust, because they objectify our wishes) are alive.* (309)

Carl Einstein: *We miss Arp in this exhibition. . . . All our sympathy to the names Lipchitz, Laurens, Brancusi, and Giacometti.* (312)

Charles-Albert Cingria: *For a few years now I've been marveling at the persistence with which chance brings me into contact with a young man who has a head like an Etruscan sculpture. . . . The last thing that would have entered my mind was that it was Antonio Falconetti [Alberto Giacometti] standing before me, the sculptor-wunderkind all Paris is talking about. A really very prominent person, whose name I don't want to keep mentioning [Jean Cocteau], seems to have given the signal for his fame. However, someone else got in ahead of him: the Surrealist (at the moment no longer Surrealist at all) poet Michel Leiris.* (132)

René Gimpel (diary entry of November 14, 1929): *Georges-Henri Rivière [the acting director of the Ethnological Museum in the Trocadéro] says that among sculptors Giacometti is important.* (153)

1930

The work Giacometti showed in Pierre Loeb's gallery in the Miró-Arp-Giacometti exhibition put him into the center of the Surrealist camp overnight.

Nesto Jacometti: *In Pierre Loeb's window, in front of a Miró painting with a shooting star, there was a strange machine construction of wood, signed "A. Giacometti"—a real mill to grind up the seeds of overbred aesthetic culture.* (158)

Dali and Breton saw my Suspended Ball *in the exhibition at the Galerie Pierre. Then they invited me to take part in their manifestations. Surrealism was the avant-garde at the time. It was the only group of artists where something was happening.* (67)

Salvador Dali: *Symbolically active objects which possess only a minimum of actual motoric depend on the delusions and fancies that arise through the functioning of subconscious desires. . . . A wooden ball with a female notch floats suspended on a violin string over a moon-scythe form whose blade almost touches the groove. The observer is forced by his instincts to move the ball along the blade of the scythe, which is only possible over a short distance due to the shortness of the string. . . . Symbolically active objects resist all purely formal interpretation. They depend on the erotic imagination of each individual and stand outside sculpture.* (314)

Maurice Nadeau: *Everyone who saw the hanging, slit ball in motion over the blade felt a strong and indescribable excitement, not without its portion of subconscious sexual arousal. But there was no satisfaction of any kind forthcoming— rather, the feeling made one more and more uncomfortable. It showed that something was missing and gave one a desire for something that would never come and yet was always on the verge of coming. Now the door was open for a whole series of such objects. Dali made more of them than anyone else, even Breton, Man Ray, or Oscar Dominguez. One should not underestimate this new step in the area of automatic creation. Here, it did not lead to representation. Here, it had become a part of the life experience itself, or rather: here life was in the service of automatism.* (373)

André Breton: *What is Surrealism? It is, among other things, Alberto Giacometti's battle with the angel of the invisible who made an appointment with him in the blossoming apple trees.* (119)

Georges Sadoul: *In late 1930 I was introduced to Alberto Giacometti, who had just been taken into the Surrealist group. At about this time he and his friend Luis Buñuel invented a certain magic object, The Giraffe. In 1930 he gave Surrealism a new impulse with his kinetic objects. He started the fashion for Surrealistic objects with symbolic or erotic overtones, and it became the duty of every self-respecting Surrealist to make them.* (206)

Nesto Jacometti: *In the heart of Montparnasse—Alberto wandered around there, already with his gloomy expression and hesitating walk, sometimes alone, sometimes in respectable Surrealist company: Max Ernst, Brauner, Éluard, Desnos, Salvador, Caiman the brave, etc. A little later, others joined them: Diego (first period—as the man of the world) and two muses from Basel: the dark Meret [Oppenheim], a coal mouse, and the blonde Irene Zurkinden, a silver fox. Evenings one went up to the Place Clichy, led by Breton or by the Chien Andalou [Buñuel], to scoff at the prick of morality.* (158)

Man Ray: *Giacometti seemed to be a tortured character. He was never satisfied with his work; he never thought he had carried it far enough—or the opposite: too far—he would let his things lie around in his cramped, overflowing atelier and begin another piece in a completely different style. For a while he returned to painting: his forms without color and his experiments with line seemed at the time to show that he had finally reconciled himself to being on a never-ending search for his own ego. No matter the path he took, his work was always the positive expression, the absolute reflection of this ego. He had a good mind and a way with words and could speak brilliantly about many things. I liked to join him in a café and would watch him as I listened. His unusual face and his greyish skin—like a medieval sculpture—made him an excellent subject to photograph. When I was doing fashion photography, I had him do bas-reliefs with the money I had available for backgrounds; the motif of birds and fish he used was repeated several times on the surface. . . . I photographed a number of his surrealistic works and had them published in an art magazine [Cahiers d'art]; by way of thanks he gave me some of the sculptures he was doing at the time. (201; 323: 337–42)*

Brassaï: *When I photographed the famous* Suspended Ball *or* The Palace at 4 A.M. *Alberto told me that he had visualized all of these objects in almost final form, that he had executed them without any thought about their significance, and that their meaning was revealed to him only later. This fragile palace, he told me, with its wooden backbone, bird skeleton, doll, and a ball fixed to an oval plate, was a remembrance of a recent love affair. (117; 328)*

For six whole months I passed hour after hour in the company of a woman who, concentrating all life in herself, magically transformed my every moment. We used to construct a fantastic palace at night—days and nights had the same color, as if everything happened just before daybreak; throughout the whole time I never saw the sun—a very fragile palace of matchsticks. At the slightest false move a whole section of this tiny construction would collapse. We would always begin it over again. (7)

But all of that led me farther and farther away from outside reality. I had the tendency to be interested only in the construction of the objects themselves. And those objects were in a way too perfect, too classical. Added to that, real life confused me and seemed different to me. Everything was so grotesque then, worthless, discardable. . . . Even the eroticism that I put into my objects; objects without any basis and without value, throwaways. (13)

I remember an October night in 1930. I still see the walk and the profile—a tiny part of the profile, the concave line between forehead and nose—of that woman who, since then, like a white thread on a pool of cold liquid asphalt, has been traversing the space in the chambers of my soul. This meeting gave me and gives me, in spite of the surprise and astonishment I felt, the impression of having been inevitable. I feel that every meeting that moved me came on the day and at the moment it had to come. (8)

1931–32

The year of the exhibition "Jeunes artistes d'aujourd'hui" in the renowned, rather conservative Galerie Georges Petit; the *Cahiers d'art* critic (1931; 378) pointed out the dangers inherent in what he called Giacometti's pseudo-brilliant work. Carl Einstein devoted five illustra-

tions to Giacometti in the *Propyläen Kunstgeschichte des 20. Jahrhunderts* (2nd edition). Giacometti took part in the "Pavillon anticolonialiste de la Grande Batelière"—the title is an indication of the increasing political engagement of artists as a result of the Depression and the rise of Fascism. Giacometti began to recognize the contradiction between the Surrealists' self-dramatization and social reality.

The Surrealist group split into factions over the question as to the extent and kind of political commitment within its ranks; Breton toyed with the idea of Surrealism in the service of revolution (his magazine was now titled *Le Surréalisme au service de la révolution*), but Aragon decided to devote himself fully to the class struggle. Giacometti's social-revolutionary engagement lasted a full season.

One of the reasons I was interested in Surrealism was not so much their behavior as their political opposition. Aragon's standpoint interested me more. When he left the Surrealists because of it, I left them too for the first time. (803)

Louis Aragon: *I don't remember where, why, or through whom we met the first time. He hadn't been in Paris long and so he seemed very young to me. He was actually only three or four years younger than I, but because I had already lived in Paris for eight or nine years I felt a generation older. When we [Elsa Triolet and Aragon] were living on Rue Campagne-Première he came over often; that was when I had separated from my old friends. At that time Alberto was on my side and supported my league against imperialism or my agitation against religion by doing political drawings. . . . Those that were meant for publication in our paper* La Lutte *he signed with a pseudonym. He did this at my suggestion and chose the name himself: "Ferrache" [approximately: "Iron rod" from "fer" and "cravache"]. It wouldn't have served any purpose if one could have identified the caricaturist as the sculptor who had designed furniture for Jean-Michel Frank and whose clientele—connoisseurs in Paris, New York, and Teheran, you could count them on your fingers—would have been shocked. (104)*

Boris Taslitzky: *When the magazine* Commune *sponsored a poll on the theme "What is the future of painting?" Giacometti answered with a drawing: a man standing in the street greeting with his raised fist a struggling humanity, marching toward the concrete realization of their thousand-year-old right to justice and liberty. It was the period of the fiercest battles against the Fascists and it was very significant that one of the greatest artists of his time publically chose the party of conscience. (225)*

The Galerie Pierre Colle sponsored Giacometti's first one-man exhibition in Paris in May, 1932. Christian Zervos devoted a profusely illustrated essay in *Cahiers d'art* to his work.

Giovanni Giacometti: *Alberto wrote me today, very satisfied with his exhibition. One of the first to appear on opening day was Picasso. It is said to have been a great success, and now I'm anxious to read the notices. (145)*

Christian Zervos: *Giacometti is the first young sculptor to profit extensively from the examples of the pioneers (Brancusi, Laurens, Lipchitz). The newness of his work lies in personal expression, in joy at adventure, in the intellectual alertness of the artist, and, above all, in the primordial power that infuses the whole. At present, Giacometti is the only young sculptor whose work justifies and continues the new directions in sculpture. (323)*

Anatole Jakovski: *Giacometti is probably the most sincere witness to the current catastrophe; no one else has expressed the anxiety [angoisse] of the present as he has. He is the man who burns. I have seen his face always pale, his eyes blazing, his hair charged with electricity, attracted by celestial gravitation. You speak to him and he replies: "It's terrible."—A diluvian bird in a cage. Prehistory mimeographed.* (337)

Neue Zürcher Zeitung (M.K.): *From the salons one knows this versatile, original sculptor whose work, with its strongly erotic overtones, wakes all sorts of philosophic moods* [weltanschauliche Stimmungen]. *It is a grotesque world that is opened up, often eerily distorted, often under the influence of mechanical compulsion. Here and there a soft, melancholic music sounds from strange plaster surfaces with slight depressions as their only expressive element. Giacometti makes his appearance as a poet in wire, plaster, and bronze, a poet of whom one cannot always be sure that he is not making fun of himself or the others now and then.* (320)

1933

In February and March Giacometti attended the Surrealist meetings led by Breton and Éluard, where suggestive questions of a pseudo-psychoanalytic and rather exhibitionistic sort were used to conduct "experimental research into irrational knowledge." Here is a selection of Giacometti's answers:

Which sex has the crystal ball? Hermaphrodite.—How does it end? It explodes.—On what part of a bed would you put it? At the height of the heart, when the bed is empty.—What crime is associated with it? Cruelty, violence.—At what spot on a naked dead woman would you place a piece of pink velvet? On her chest, over her breast.—What disease do you associate with that? Dementia praecox.—In what would you wrap it? In two naked arms.—What language does it speak? Ancient Egyptian.—How would you kill it? With a dagger.—What perversion was very widespread in the year 409? They tickled the hips of young girls with a feather while they ran past.—How did they pick up girls back then? You hid yourself at nightfall and when a girl came past you threw yourself on her and raped her. (6)

In June Giacometti participated in the Surrealist group exhibition at the Galerie Pierre Colle with "objects" of all kinds, from natural objects to "interpreted" found objects to artworks. The strong Salon des Surindépendants group (Arp, Brauner, Dali, Ernst, Giacometti, Miró, Oppenheim, Man Ray, Tanguy, and others) found in the avant-garde writer Anatole Jakovski a critic who opened their eyes, or at least Giacometti's; in the piece quoted below he might have been alluding to Giacometti's plaster sculpture *Project for a Passageway*:

Anatole Jakovski: *One's now seen quite enough of them, the ovaries and plaster castings of buttocks in "psychic superelevation."* . . . *The way is open for a new Cézanne to fuse the mutually contradictory elements and infuse them with life; to make works of art and not give demonstrations.* (331)

During those years I executed only sculptures that were complete in my mind's eye. I limited myself to constructing them in space without stopping to ask myself what they might mean. . . . *But when the object is there in front of me, then I can*

recognize *images, impressions, and experiences—transformed and at different levels—which have moved me very deeply, often without my having noticed it; and forms I feel especially close to although often I can't say where they come from, which makes them all the more disturbing for me.* (7)

The fact that I made decorative objects to earn my living for the best interior decorator of the time, Jean-Michel Frank (whom I liked very much), seemed to the others like a step down. Nevertheless I tried to make a vase, for instance, as good as possible, and I realized then that I worked on a vase just as I would work on a sculpture and that there was absolutely no difference between what I called a sculpture and what was just a vase. But I thought that a sculpture should be something different from an object. In other words, I had failed. I had lost touch with wonder, mystery. If my work wasn't creation then it was no different from a carpenter's work when he makes a table. So I had to go back to the source of art and start all over again from the beginning. (61)

1934

The Julien Lévy Gallery, New York, showed twelve post-Cubist and Surrealist Giacomettis in an exhibition entitled "Abstract Sculpture by Alberto Giacometti."

The erotic kinetic objects of 1930–32, by then famous, were left out of none of the Surrealist exhibitions of the time: 1934, Brussels: "Exposition Minotaure"; Zurich: "Was ist Surrealismus?"; 1935, Copenhagen: "Exposition Cubiste-Surréaliste"; Santa Cruz de Tenerife: "Exposición surrealista"; 1936, Galerie Charles Ratton, Paris: "Exposition Surréaliste d'Objets"; London: "The International Surrealist Exhibition"; Zurich: "Zeitprobleme"; Museum of Modern Art, New York: "Fantastic Art, Dada, Surrealism."

Surrealist dialogue, 1934: *André Breton: What is art?—Alberto Giacometti: A white oyster in a washpan.—Breton: What is the head?—Giacometti: Where the breasts are fastened on.—Breton: What is your atelier?—Giacometti: Two walking feet.* . . . (9)

The ambiguous title of Giacometti's best piece of the year was in itself a rebuff to the Surrealists' cult of the object: *Invisible Object* or *Hands Holding the Void: Mains tenant le vide = Maintenant le vide.* André Breton tried to win Giacometti back to the fold by devoting a long essay to the story of this sculpture's genesis, but in addition to the misunderstandings it contains, it reveals not a little jealousy:

André Breton: *The state of expectation is wonderful, no matter whether the expected arrives or not. That was the subject of a long chat I had with my friend Alberto Giacometti—whose sensibility is to my way of thinking unchallenged—one evening and the evening before, when a beautiful Saturday last month [April, 1934] induced us to walk out to Saint-Ouen to the flea market.* . . . *Giacometti was working on a female figure [Invisible Object] which, although it had occurred to him a short time before in its finished state and took form in plaster within a few hours, still went through a few transformations in the course of work.* . . . *The length of the arms, which depended on the position of the hands before the breast, and the features of the face, were still quite uncertain.* . . . *Looking at that lovable creature with its restrained directness and twin character of bad*

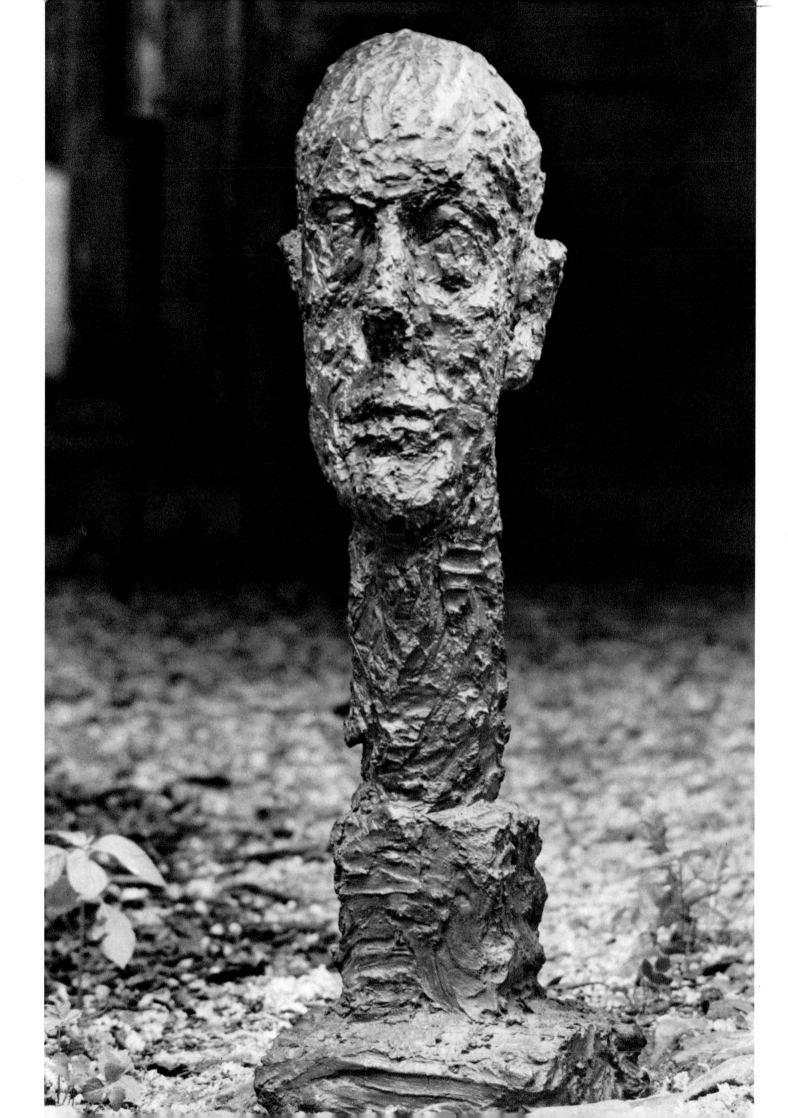

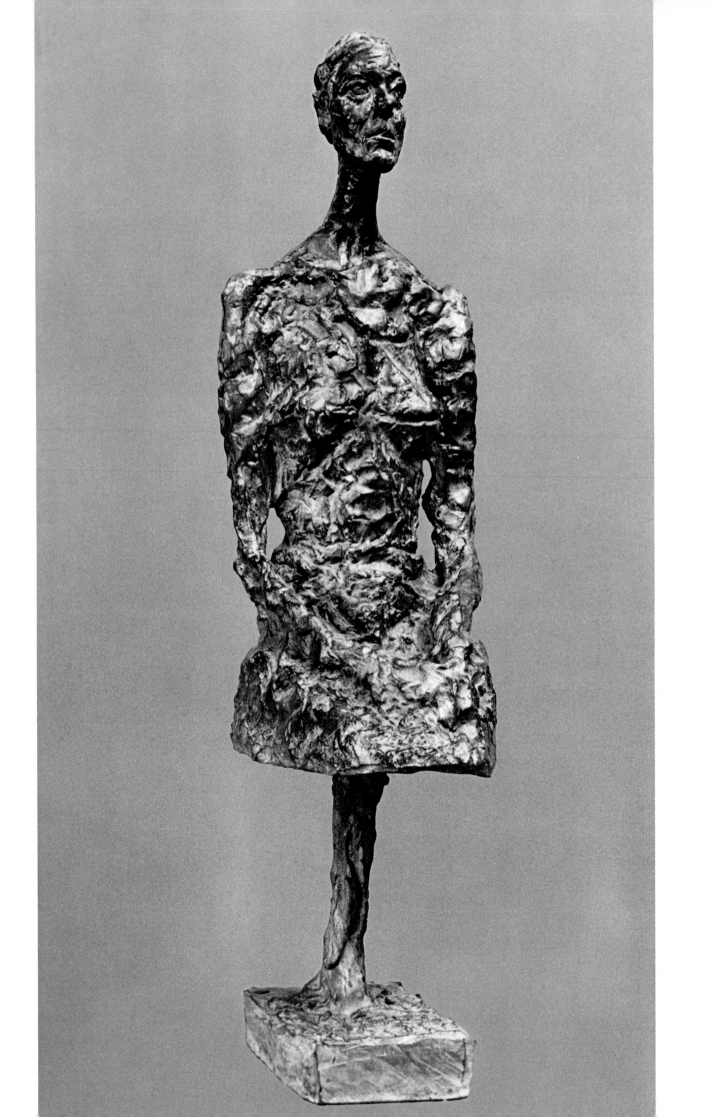

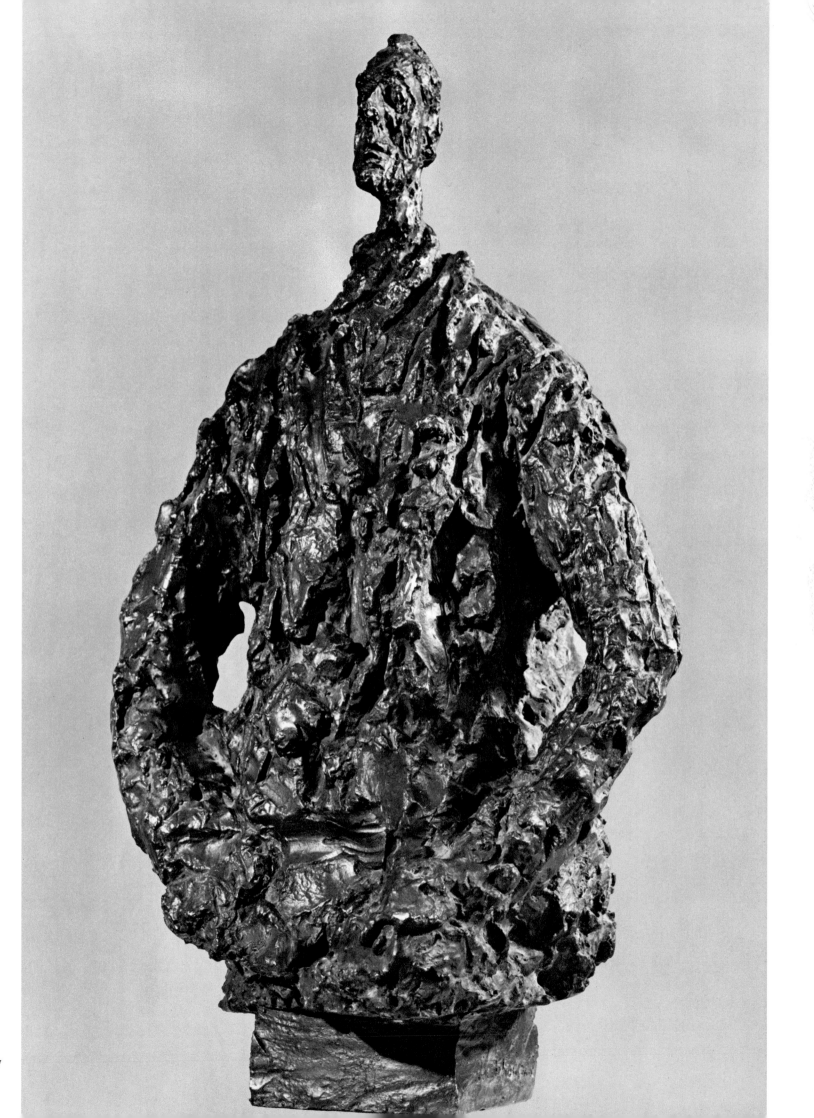

257

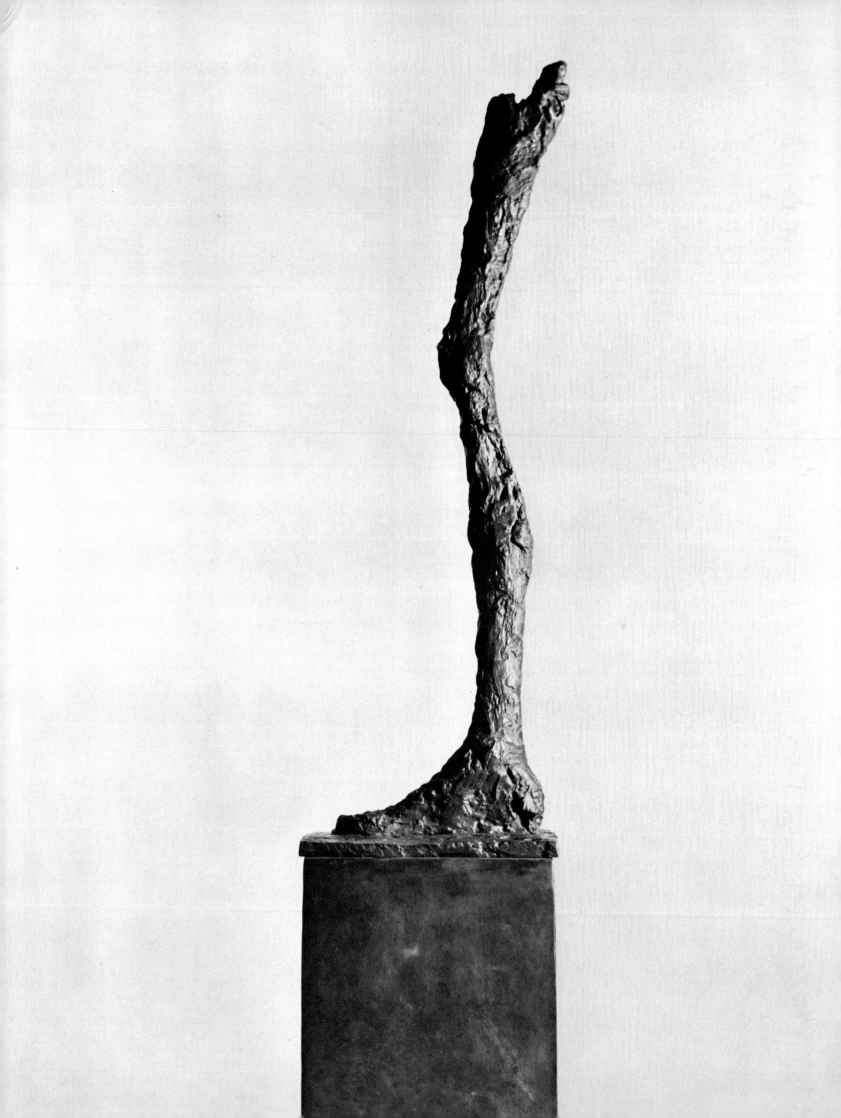

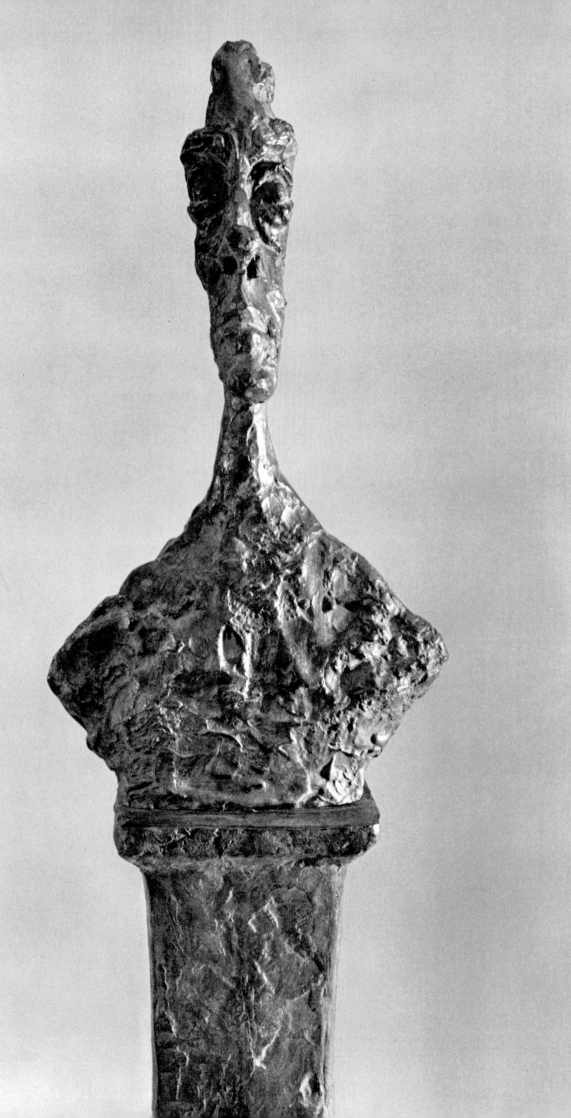

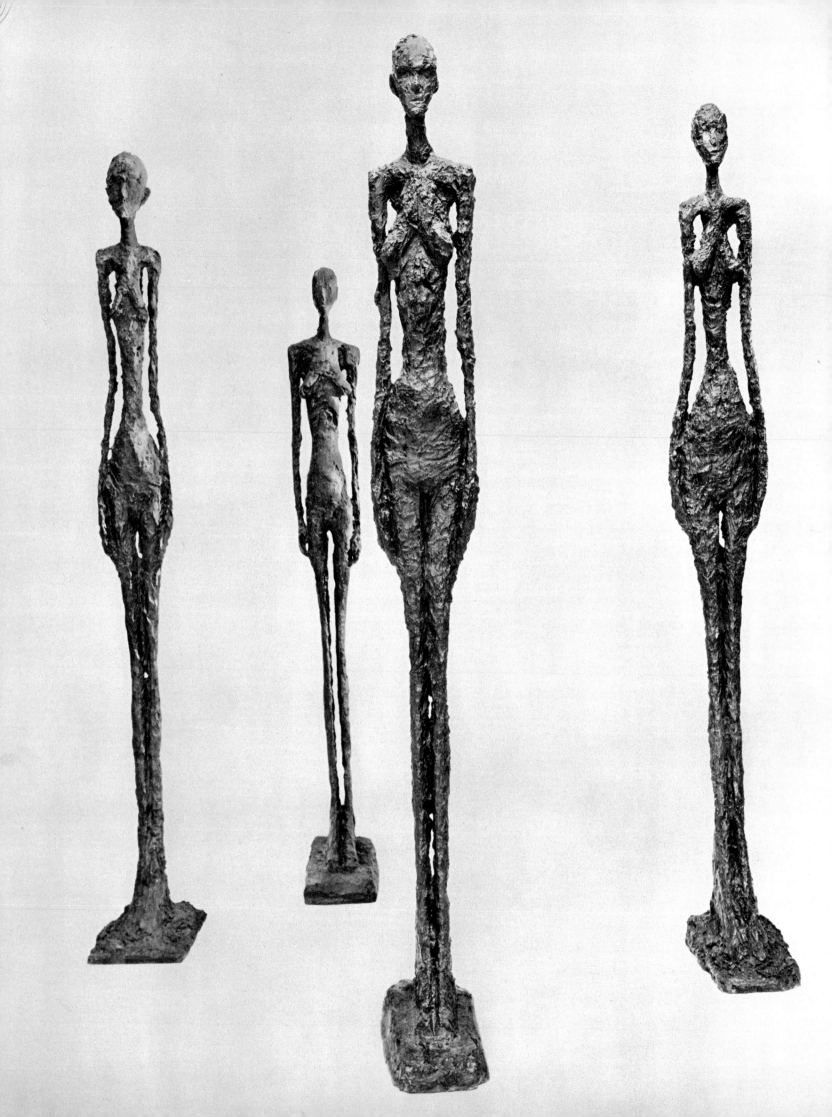

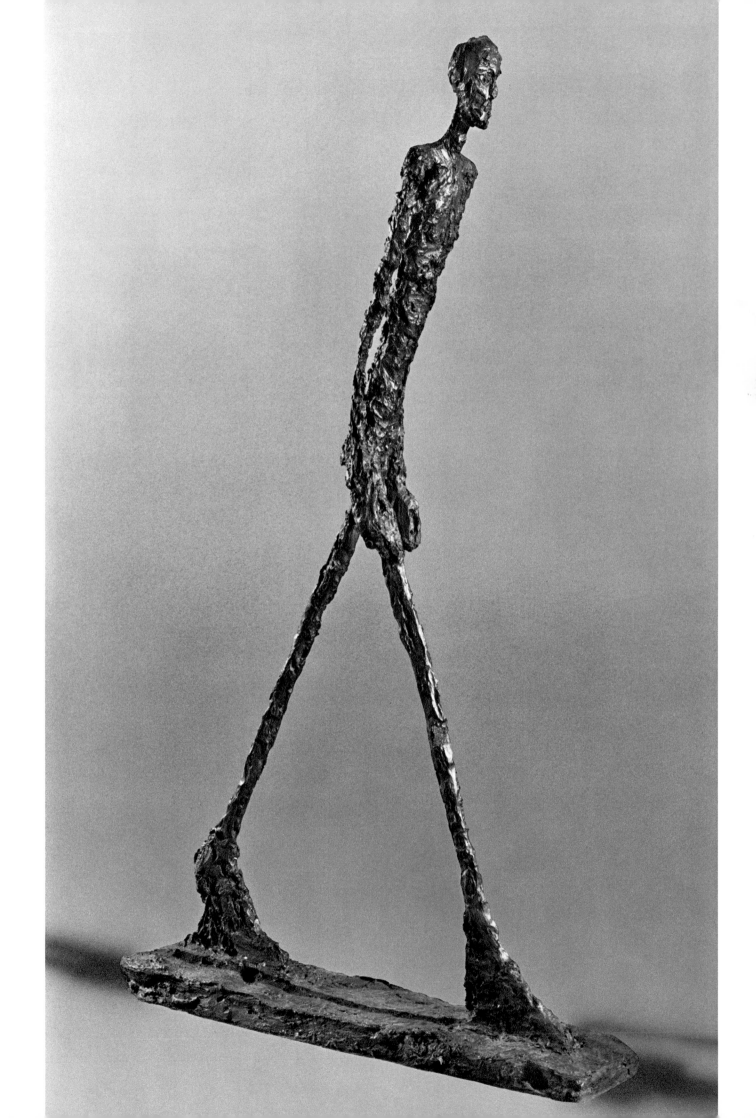

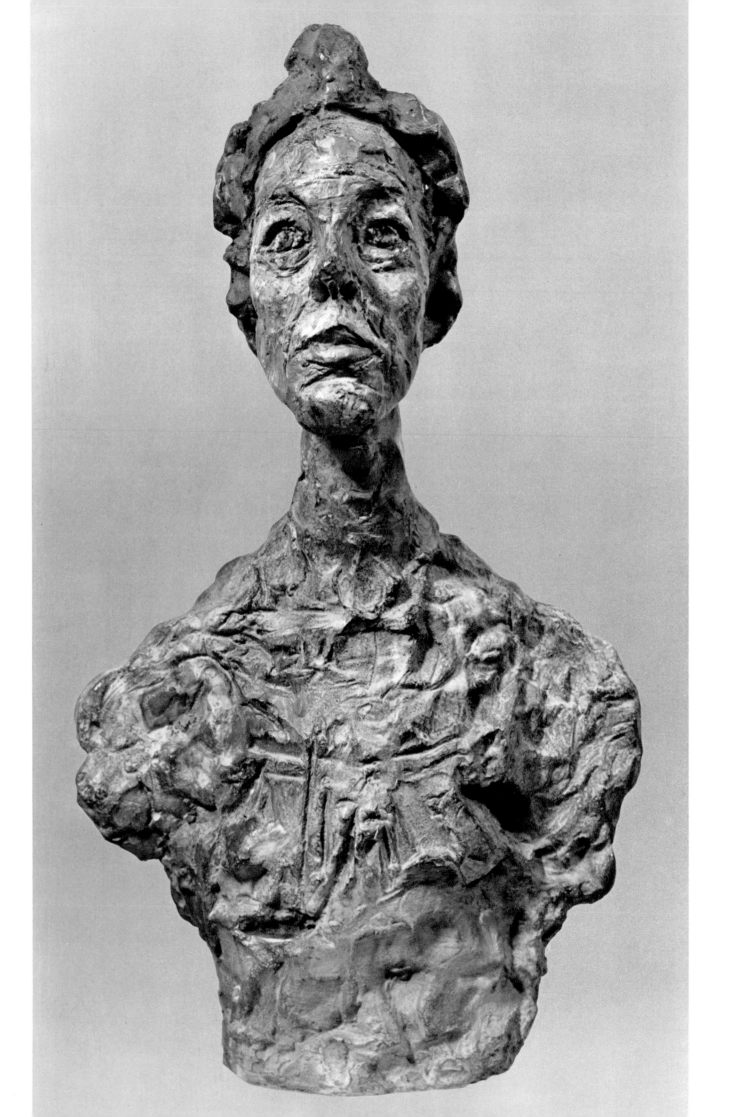

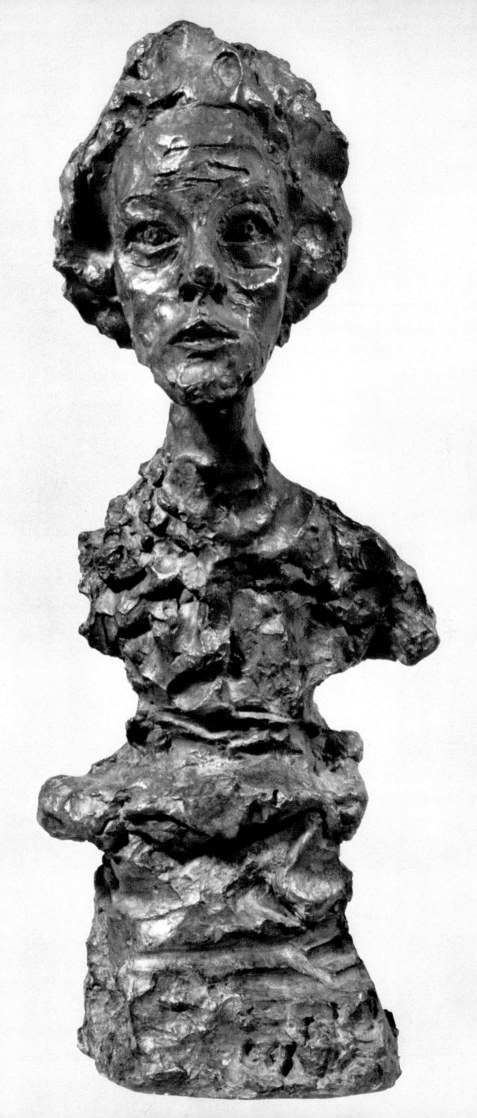

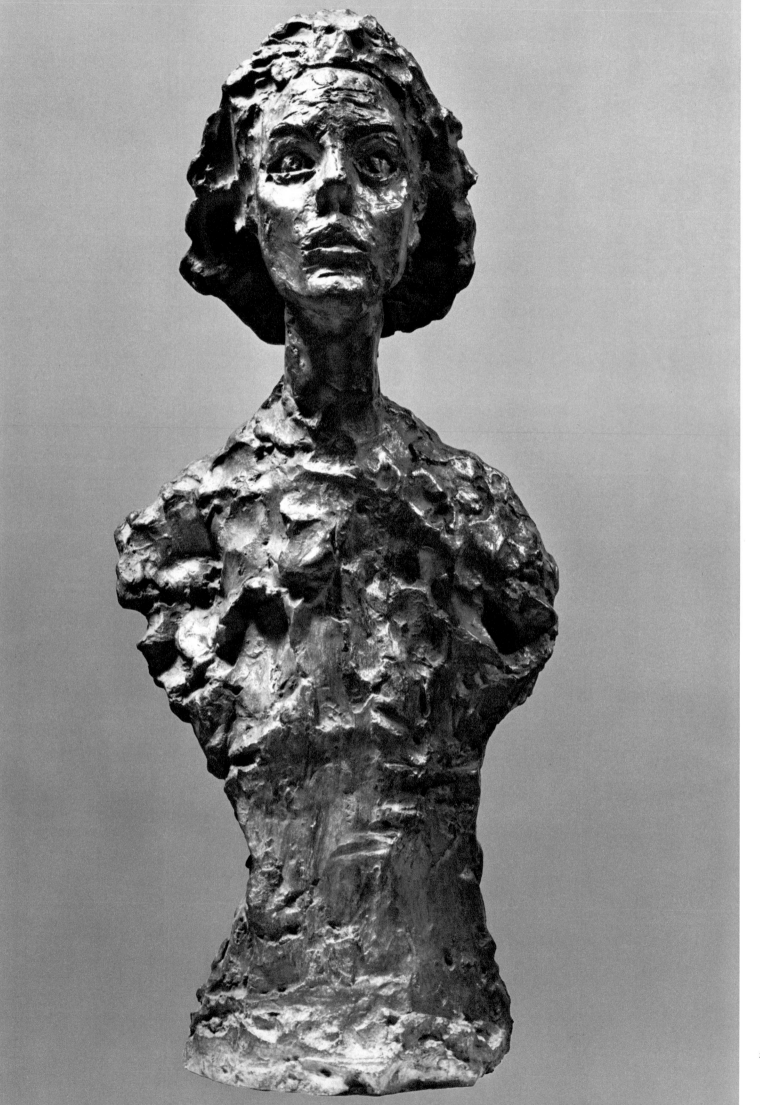

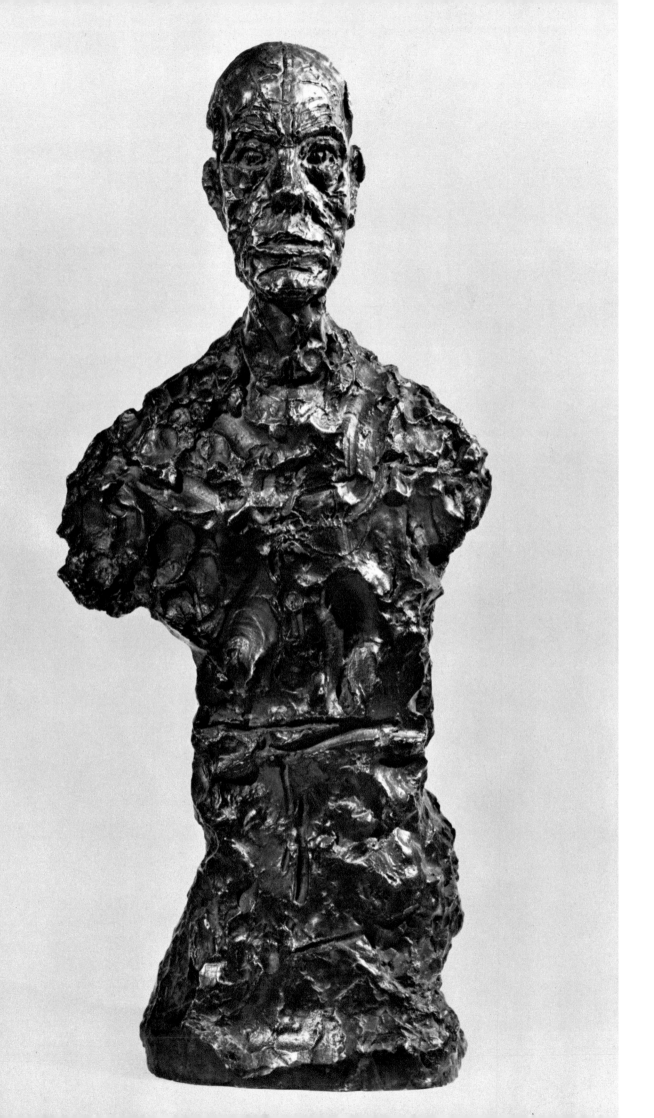

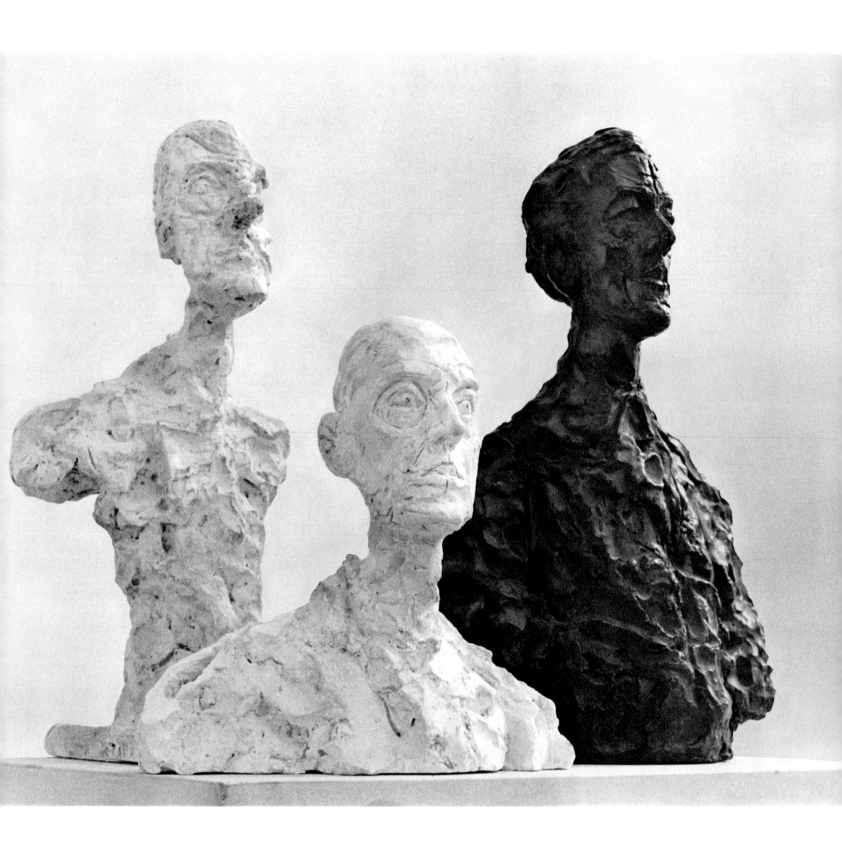

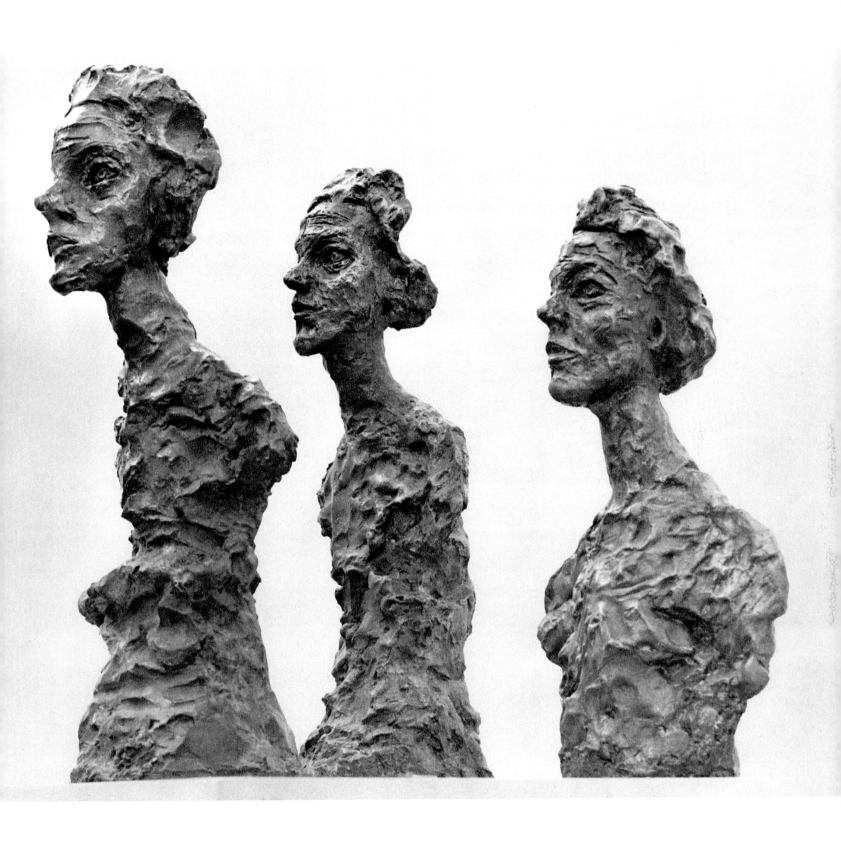

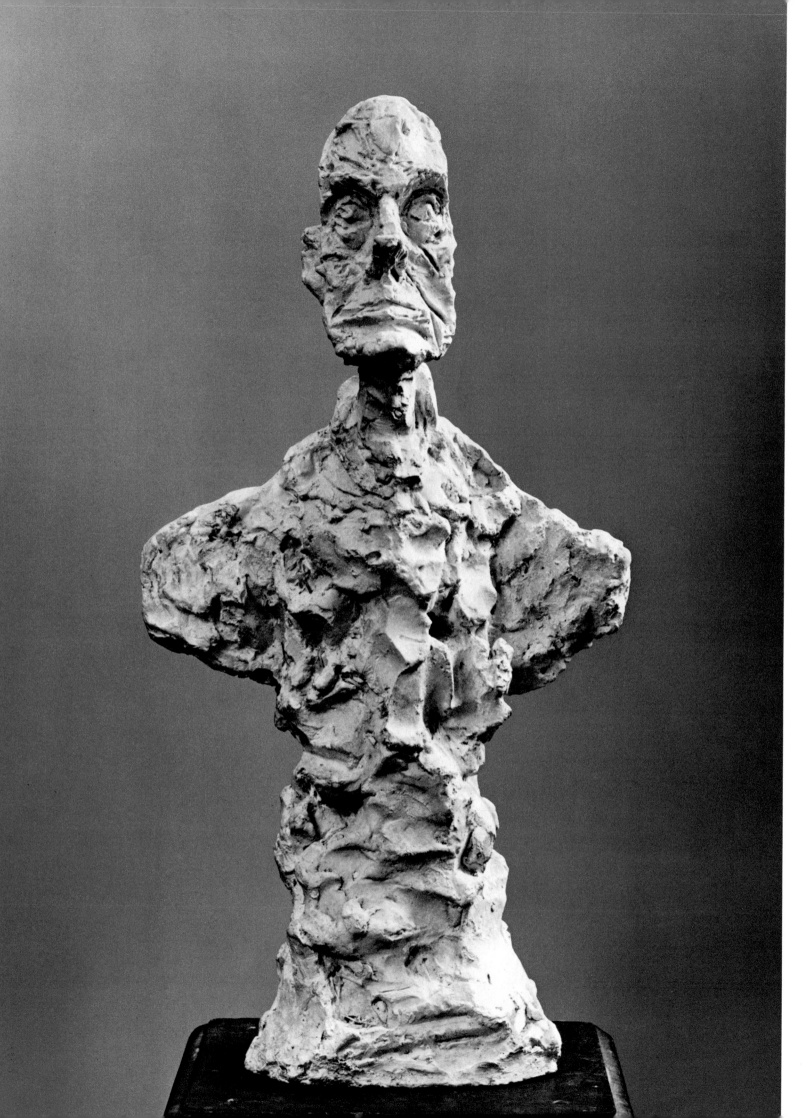

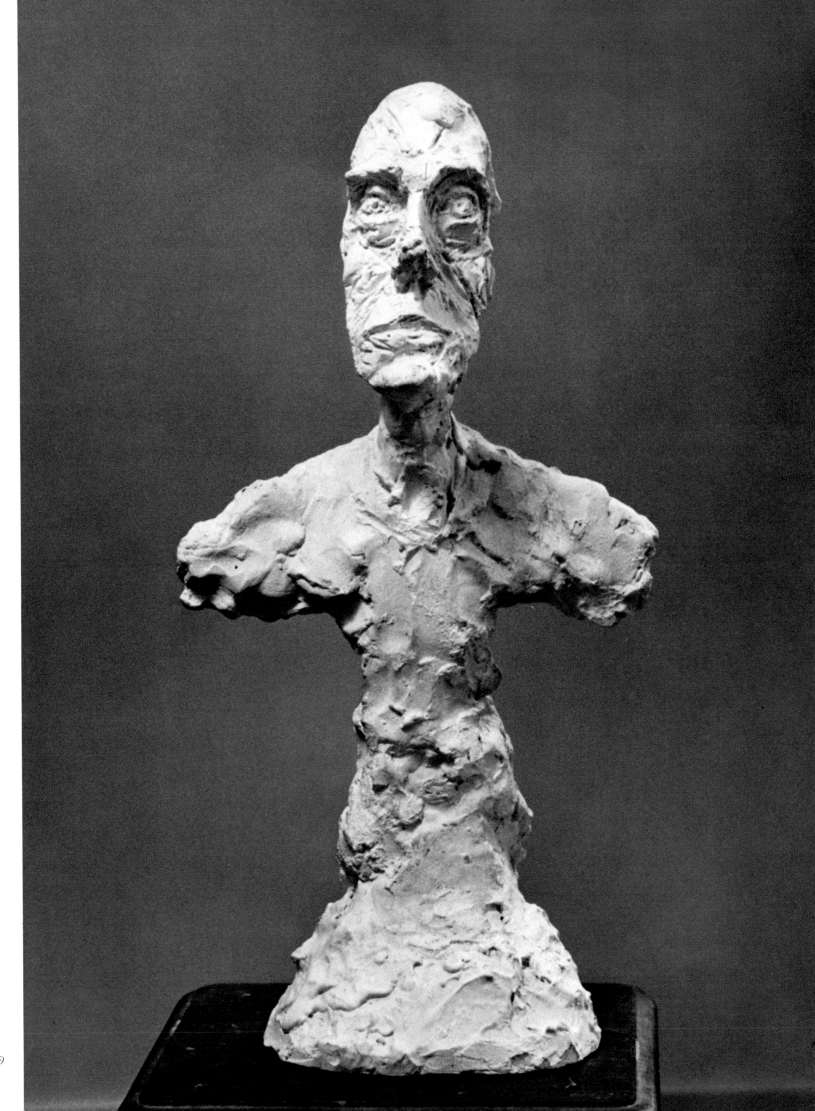

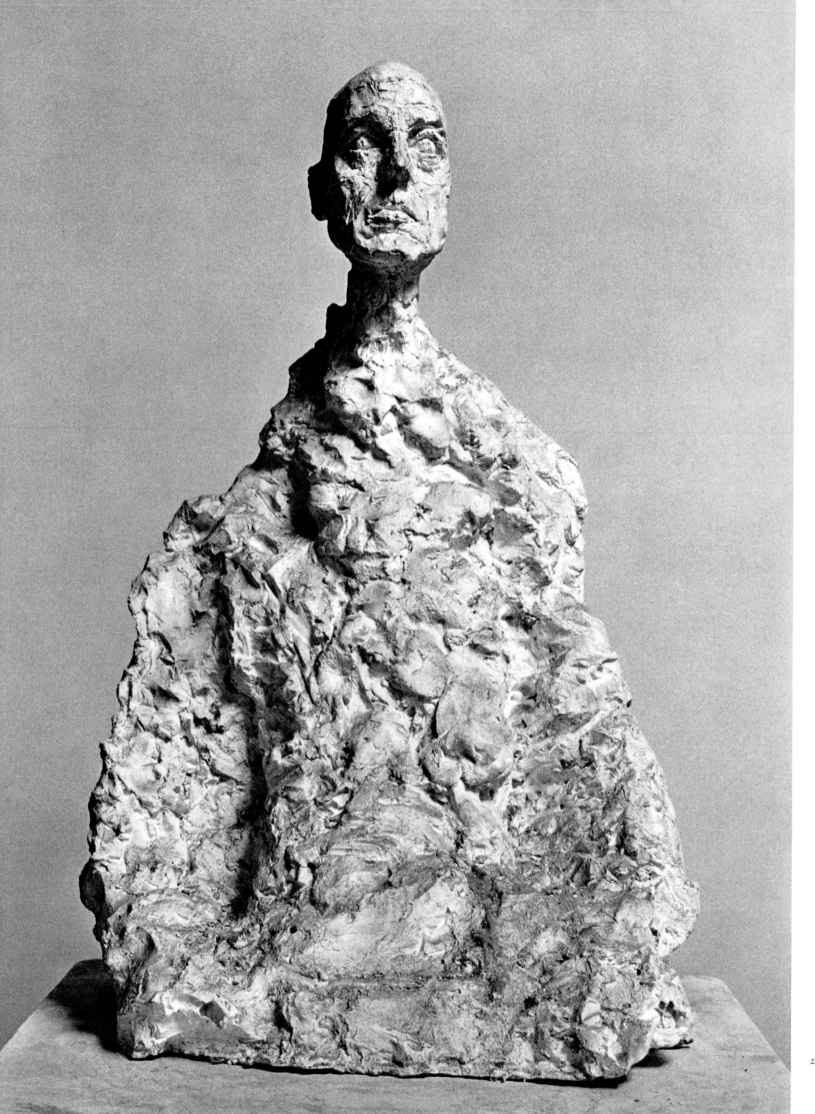

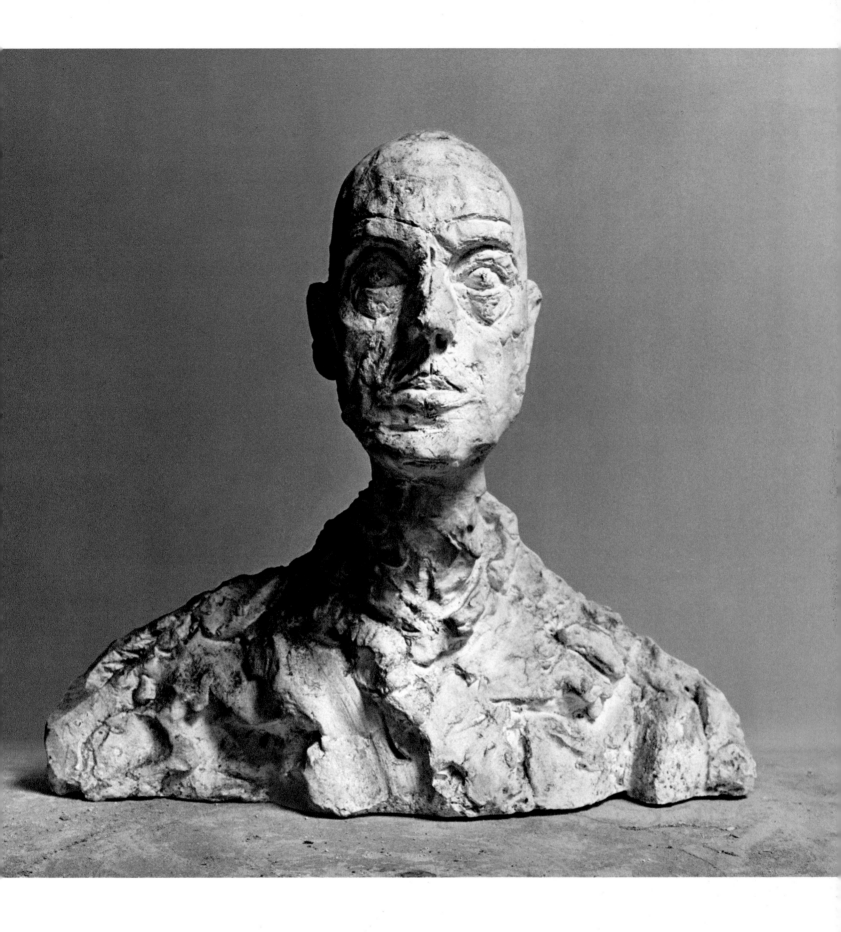

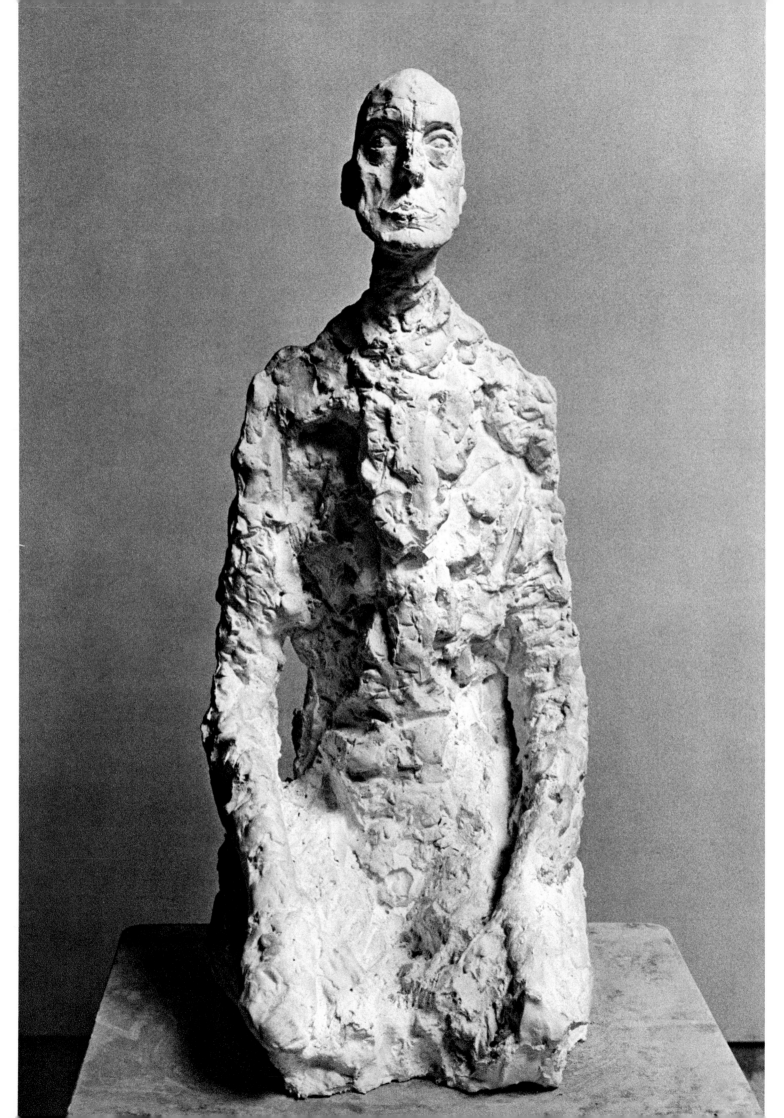

onscience and thankfulness had unsettled me, and its very tenderness—so long as all of this had not yet found its final formulation—led me to condemn every female influence on Giacometti as dangerous. (118)

That sculpture, Invisible Object, which Breton preferred to all the rest, upset my whole life again. I was satisfied with her hands and her head because they were just as I had intended them. But I wasn't satisfied in the least with the legs, the body, or the breast. They seemed too academic, too conventional. That made me want to work from life again. (55)

As late as 1938, the *Invisible Object* had been shown at the international Surrealist exhibition in the Galerie Beaux-Arts in Paris, but in the *Dictionary of Surrealism* which served as its catalogue, Breton wrote under the reference "Giacometti" only: "Former Surrealist sculptor." (120) On the whole, the year 1934, which marked the halfway point of Giacometti's life, was one of reflection and decision-making.

With time I realized that I had let myself get involved. Without wanting to, you let yourself be influenced by superficial things, you want to win, be successful. You let yourself be challenged to a contest. You work to impress people. Or you begin to repeat yourself. "Make variations," they told me when I was depressed, when I wasn't getting anywhere. I was on the wrong path, a downhill path. (67)

There was also a need to find a solution to combine things that were rounded and calm with those that were sharp and violent. It is this which led during those years to objects going in directions that were quite different from each other . . . and to very abstract objects which then led me to figures and skull-heads. (13)

That summer Giacometti took Max Ernst with him to Maloja; they hired a team of horses to drag large round stones smoothed by the water up to the house where they could work on them. Giacometti began to see new sculptural possibilities in natural forms. He placed one of these stones on his father's grave (Giovanni Giacometti had died on June 25, 1933) at the cemetery in Borgonovo-Stampa, a stone which embodied his and Max Ernst's visual thinking at the time.

Max Ernst: *Alberto Giacometti and I are afflicted with sculpture-fever. We work on granite blocks, large and small, from the moraine of the Forno Glacier. Wonderfully polished by time, frost, and weather, they are in themselves fantastically beautiful. No human hand can achieve such results. Why not, therefore, leave the spadework to the elements and confine ourselves to scratching on them the runes of our own mystery? (142)*

I saw anew the bodies that attracted me in reality and the abstract forms which seemed to me true for sculpture, but I wanted to create the former without losing the latter. (13)

I knew that one day—no matter how it came about or what I was working toward—I would be forced to sit down on a stool before a model and copy what I saw. And with no hope of succeeding. In a way I was afraid to have to start this again, but on the other hand I knew it was unavoidable. I was afraid of it but I had hope. Because the abstract things I was doing then were at an end, once and for all. Going on would have meant making still more of the same kind of thing—but that adventure was over for me. The thing just didn't interest me any more. (60)

Marcel Jean: *Near the end of the year 1934 we heard him say that everything he had done up to then had been masturbation. And that, at the moment, he had no other aspiration than to make a head "work." So he began to do portrait busts of his brother Diego, working days at a time and getting the general forms down. . . . The last time Giacometti worked together with the Surrealists was when he made two sketches for a program of lectures with slides in June, 1935—which, by the way, did not take place. (159)*

My final separation from the Surrealists came from the need to work from life, to hire a model. (803)—I was thinking about working from the model for about a week and then having enough basics down to make something out of—I mean, to make compositions and create works. (60)—When I did that, the Surrealists considered it a reactionary and treacherous activity or whatever. (803)

Simone de Beauvoir: *Breton was disgusted. "A head, everybody knows what a head is!" Giacometti used to quote this sentence himself, full of indignation. (107)*

René Passeron: *One evening Giacometti was dragged in an underhand way by Benjamin Péret, Breton's faithful follower, before a fully attended meeting of the group, where he was immediately made to justify his defection. (194)*

I said: "Don't bother, I'm going." And because they couldn't decide on any reason to expel me, there was no public excommunication. But I lost all my friends. But now, in spite of everything I feel happy—from the day I was out on the street again, having decided anew to reproduce the human form as truly as possible, like a beginner at the Grande Chaumière. (67)

1935

Giacometti began his reckless artistic adventure: confronted by the reality of the model sitting before him, he wanted to break through centuries-old visual and aesthetic conventions to the point where his works were no longer objects but realities in themselves. His study of the model was the first step toward an all-encompassing composition he had in mind.

François Stahly: *When I visited Giacometti for the first time in 1935, some of the Surrealistic constructions were still to be seen in his atelier. They had apparently been moved out of the way at random and now lay there, some of them piled one on top of the other and some badly damaged in places. Giacometti's interest was somewhere else. He was working on a portrait that he had already destroyed several times and begun anew. Numerous studies had been drawn directly, layer upon layer, on the opposite wall. In spite of the smallness of the room, one had the feeling of emptiness upon entering. Everything seemed to turn on one neuralgic point: the work of the moment. Everything else, all the diversity of things that life tends to bring daily into a room, had fallen here like withered leaves, and now lay on the floor, forming rubbish piles that got deeper and deeper as the years passed. (217)*

For two weeks I had wanted to make some studies simply by copying, without trying at all to give them form. Five years later I still hadn't finished them. (67)— At first I saw nothing. Nothing was as I had imagined. A head (I quickly abandoned figures, that would have been too much) became for me an object completely unknown and without dimensions. Twice a year I began two heads, always the same ones, never completing them. (13)

I came to the same insoluble difficulty as in 1925. . . . I modeled just as I had as a student. The more I studied the model, the thicker the veil between its reality and me became. At first one sees the person posing, but little by little all the sculptures one can imagine interpose themselves. And the more the real image disappears, the stranger the head becomes. Nothing seems certain anymore, neither the appearance nor the size, nothing, absolutely nothing! There were too many sculptures between my model and me. And when they were all pushed out of the way, an unknown person sat there, so that I no longer knew whom I was looking at and what I saw. (61)

1936

From 1935 on I never made anything the way I wanted it, not even one single time. It always came out different. Always. I wanted to make commonplace heads, commonplace figures. I never succeeded. But because I always failed, I always wanted to try again and again . . . I wanted to get to the point of making a head the way I saw it, you know? Because I never succeeded, I kept trying. You've really got to be a little stupid to keep trying. Actually I should have given up when I saw that I couldn't do anything. If I were a little more intelligent, I would have given it up, but as I would rather do this work than any other. . . . (812)

Well, if you will, it's a rather unusual thing for a person to spend more of his time trying to copy a head than in living life—telling the same person to sit still on a chair every evening for five years, and trying to copy him without succeeding, and never stopping. It's really not an activity one would call normal, is it? One has to belong to a certain society if it's even to be tolerated; in other societies it wouldn't be tolerated. It's an activity that is of no use to the whole of society. It's a purely individual satisfaction. Extremely selfish and thus basically antisocial. (61)

But the funniest thing about it is that if I were to succeed in making a head like I want . . . nobody would be interested—that's possible, isn't it? If what results is a very banal little head? Just like any other? Should I say: All right, this is the head, just like I've always wanted to make it? Ah, bravo, right? Basically, that's what I've always wanted to do since 1935—and I've always missed the mark. Probably because it's impossible. (812)

1937

I had a girl friend, an English girl. It's not my fault that the statuette I made of her came out so small. That was in 1937. Because I still found it impossible to get a head right, I wanted to do full figures. I wanted to make them this big [Giacometti points to his forearm]; *they came out this big* [half his thumb]. *Why, I understood only later. Namely: I wanted to copy this woman as I had once seen her some distance away on the street—it was very impressive and I haven't forgotten it. That was on the Boulevard Saint-Michel, about midnight. I saw all the black above her, the buildings—so, to communicate the impression I had then, I should have painted her, not modeled her. Or I would have had to have made a gigantic pedestal so that the whole would have corresponded to what hit my eye.* (64)

1938

An event unconnected with Giacometti's work brought it to a stop for a few months: a car ran over his foot. There was no danger of amputation,

contrary to the legend established among art critics as an explanation of the "big feet" in his work, but he had to walk with the aid of a stick for years. Neither his stay in the hospital nor the stick seem to have disturbed him overmuch; the accident brought a temporary respite from the impossible task he had set himself; yet he denied again and again the correctness of Jean-Paul Sartre's version of the period (in *Les Mots* [Paris: Gallimard, 1964], p. 193).

Sartre told the story of my accident the way it suited him. But it was completely different. And his conclusions were wrong. (735)—*In Stampa I sat down and wrote down exactly what happened, down to the last detail—twenty-eight pages. And as I was doing it I realized again that it was as meaningful-meaningless, as meaningless-meaningful, as my life, as life itself is.* (69)

It was this way—I had a model. I was walking to and fro in my studio in front of this woman. She was standing still. I said to her: "Look how well one can walk on two legs. Isn't it wonderful? Perfect balance." I shifted my weight from one foot to the other, turned around suddenly without losing my balance. "Perfect, isn't it? That is really something extraordinary." (735)

Later, but on the same night, I accompanied my girl friend on foot from the Café de Flore to the other bank of the Seine. Our relationship had been so unsatisfactory for so long that I had decided that evening to break with her. "I'm losing my footing completely," I had said to her among other things. On the way back I was crossing the Place des Pyramides looking for a taxi. A car came rushing at me across the square. I ran to a traffic island but that didn't help. I was hit, thrown down. I didn't feel the slightest pain, it happened so quickly. But I knew all the same that something had happened to my foot, because it was sticking out from my leg like a part of my body that didn't belong to me any more. I grabbed at it, pulled it back into place, and it remained in that position, and I thought that everything was all right again. . . . They X-rayed my foot and only then did they discover that it was broken. It took a long time to heal. But it was a good time for me; hadn't I predicted or anticipated what had happened? Isn't it strange how something you say can come true like that? And once again life took care of bringing to an end a situation which had become unbearable for me. (69)

Jean Genet: *He told me that he was quite happy when they told him that, as a result of the operation, he would limp and have to use a cane from now on.* (713)

Michel Leiris: *But then Giacometti decided one fine day to do without the help of his cane and, hardly had he made the decision, than he could walk without support (just as his erect standing figures need neither cane nor crutch).* (167)

1939–40

François Stahly: *When I went to see Giacometti again shortly before the war, many other* [heads] *had joined company with the first* [which Stahly had seen in 1935]. *But they had all become extraordinarily small. Some of them were no bigger than an almond. "I try to give the head the right size, the actual size as it appears to a person when he wants to see the head with complete visibility. Our eye can see things whole only on a small scale. As soon as we approach things closer, exaggerations and distortions in perspective set in which destroy the impression of the whole. But in sculpture everything depends on the impression of the whole. It must be there without our having to walk around the sculpture. When a person appeals*

o us or fascinates us we don't walk all around him. What impresses us about his appearance requires a certain distance." I left the atelier ill at ease. I had the feeling that either an obsession or a certain need to be original—which precisely among the Surrealist artists had ruined so much worthwhile work—had caused this micromania, and was sorry not to have said that one can stand at the required distance in front of any sculpture in order to receive the correct impression of the whole. Yet it was suddenly clear to me that this argument was wrong. Sculpture as it is practiced today takes into account—or, rather, usually does not take into account—the relativity of space. That unarticulated space which enlarges or diminishes when one comes closer or draws back cannot be calculated accurately as a conscious component of the artwork, unless the artist can prescribe a fixed standpoint for us. (217)

During those years I couldn't save as much as one single work. By the way, between 1935 and 1947 I didn't have a single exhibition. (67)—I saw in a head only the uncountable details. In order to see it as a whole, I had to place the model farther and farther away. The farther away it was, the smaller the head became. All that depressed me. (61)—At that time and until the war the odd thing was that, when I was drawing, I always drew things smaller than I believed I saw them : that is, when I was drawing I was astonished that the thing became so small; when I wasn't drawing I felt I saw heads the size they really were. And gradually, above all since the war, it has become so much a part of my nature, so ingrained, this kind of vision I have when working, that I have it even when not working. I mean that now I can never get a figure back to lifesize. When I'm outside a café and see people passing on the opposite pavement, I see them very small, as tiny little figurines, which I find marvelous, but it's impossible for me to imagine they are lifesize. They become no more than appearances at that distance. If the same person comes near, it's another person. But if they get too near, six feet, say, I don't really see them any more : they're not lifesize at that point either ; they fill your whole visual field, don't they? And you see them out of focus. And if you get a bit closer still, there's no seeing them at all any more. Anyway it's not done, I mean you would touch each other. Which takes you into another domain. (637)

Peggy Guggenheim: I wanted also to buy a sculpture of Giacometti's. One day I found a badly damaged plaster cast of his [Tormented Woman in Her Room at Night] in an art gallery on the rive gauche [Jeanne Bucher]. I went to see him and asked him if he would mend it for me, if I bought it, as I wanted it cast in bronze. He told me that he had a much better one in his studio [Woman with Her Throat Cut]. As it proved to be just as good, I bought this one. His studio was in a tiny street off the Avenue du Maine and was so small I don't see how he could have worked in it. He looked like an imprisoned lion, with his lionesque head and an enormous shock of hair. His conversation and behavior were extremely Surrealist and whimsical, like a divertimento of Mozart.

After he had had the bronze cast, he appeared one morning on my terrace with what resembled a strange medieval animal. . . . Giacometti was extremely excited, which surprised me very much because I thought he had lost all interest in his earlier work, having long since renounced abstractions in order to carve little Greek heads, which he carried in his pocket. He had refused to exhibit in my sculpture show in London [1938] because I would not show one of these. He said all art was alike. I much preferred my bronze, which was called Woman with a Cut Throat. (155)

To my horror my statues got even smaller after 1940. It was a horrible catastrophe. I remember for instance that I wanted to sculpt a girl I loved from memory as I had seen her on the Boulevard Saint-Michel. I wanted to make her about eighty centimeters [31½"] high. To make a long story short : she got so small that I couldn't put any more details on the figure. It was a mystery to me. All my figures stubbornly shrank to one centimeter high. Another touch with the thumb and whoops !—no more figure. I began to think about it only later. At first I had instinctively made the sculpture so small to indicate the distance from which I had seen the model. From a distance of fifteen meters [fifty feet], that girl was not eighty centimeters tall for me but a little over ten. And then too, in order to give the appearance of the whole and not lose myself in details, I had to choose an even greater distance. But even then when I put in details it seemed to contradict the whole . . . so I moved farther and farther back still, until at last everything disappeared. (67)

1941

Simone de Beauvoir: In the course of the spring we [Simone de Beauvoir and Jean-Paul Sartre] struck up a new friendship. Lisa introduced us to Giacometti ; his handsome, bronze face, his disheveled hair and his vagabond's allures had long before attracted us. One saw him often in the company of pretty women. He had seen Lisa in the Dôme, had spoken to her, found her amusing. I asked her what she thought of Giacometti's work and she laughed helplessly : "I don't know, it's all so small." She maintained his sculptures were no bigger than pinheads. How could one pass judgment on them? He had a remarkable way of working, she added : everything he had made during the day he would smash before the night was out. Once he was said to have loaded all the sculptures in his atelier onto a pushcart and dumped them in the Seine.

Giacometti was a master with words when it was a question of describing people and situations and making them live. He was one of those very rare people who enrich one when they listen. An even closer tie of character existed between Sartre and him : both had bet everything on one card, the one on literature, the other on art ; impossible to say which of them was more possessed. Success, fame, money— Giacometti was indifferent to them all. He wanted only to reach his goal. But what was he really searching for? His sculptures confused me too when I saw them for the first time. It was true, the largest was hardly as big as a pea ; in the course of many talks he explained why. To his way of thinking nobody in the fine arts had yet succeeded in correctly representing the human form ; one had to start all over again. A face, he told us, was an indivisible whole, a mood, an expression ; but the lifeless material, marble, bronze, or plaster, was infinitely divisible. Every particle stood apart, contradicted the whole, and destroyed it, he said. He was trying to reduce the material of sculpture as far as physically possible. This had brought him to the point of modeling those almost volumeless heads which, he thought, expressed the unity of the human face as it is reflected in a living gaze. He thought he might some day find another means of saving it from vertiginous dispersion in space. Up to now he had found only this one way. His search appealed particularly much to Sartre. Giacometti's standpoint came close to that of phenomenology because he wanted to sculpt a face in a concrete situation, in its existence for others, from a distance, and in so doing he transcended the errors of subjective idealism and false objectivity both. I never tired of listening to him. For once nature hadn't cheated— Giacometti was what his face promised. One wasn't able to predict whether he would "wring sculpture's neck" or whether the mastery of the representation of space would be denied him. But even his efforts were more exciting than most people's successes. (107)

1942–44

On December 31, 1941, Giacometti went to Geneva, where he lived and worked in a tiny hotel room on the Rue de la Terrassière. (His mother was also living in Geneva at the time, caring for her grandson Silvio Berthoud, whose mother—Giacometti's sister Ottilia—had died in childbirth in 1937.) In order to support himself he did furnishings and interior decoration, jobs often passed on to him by his brother Bruno, who is an architect in Zurich; Diego stayed on in the Paris atelier. The strain of Giacometti's continuous and lonely work on his small sculptures was alleviated somewhat by a circle of friends he met with in the Café des Négociants on the Place du Molard. Albert Skira, who had published the art journal *Minotaure* in Paris, established his artbook publishing house in Geneva (initially with Pierre Cailler's help) and planned various periodicals in which Giacometti also took part.

Albert Skira: *During the war years, which Giacometti spent in Geneva, a deep friendship bound us together. Alberto lived in the small Hôtel de Rive, where his room served both as atelier and bedroom. It contained a bed and plaster. Whenever he visited me his face and hands were covered with a layer of white. Our conversations were always punctuated by "Ah, yes! Ah, no!" But if we kept it up then you noticed how much further Giacometti thought than the person he was talking with. When he raised his eyes his look was doubting, skeptical, piercing, and, in a way, ironic. He gave the impression of playing with you, and before you answered his questions he knew what you were going to say. I have never met anyone who could speak on so many different subjects with such authority.* (214)

Nesto Jacometti: *In Geneva. In a warm voice he said to me in Italian, our mother tongue: "I have to get to the point where my figures are as small as matchsticks. That's the reason I place the models at a distance, about fifteen meters away. I want a figure which can be grasped with a single glance and in its totality. Your eyes shouldn't have to jump from one end to the other or wander from one detail to another detail. No, rather: total seeing, absolute comprehension." Then he added, suddenly careful and anxious: "I mean, if that can be done, then you will see that my tiny figure, no matter what size it is, will take on the appearance of a god."* (158)

Albert Skira: *It had become customary to meet every evening for aperitifs— Alberto, his close friend Duclos, Roger Montandon, and I. We discussed so many projects! Among others a small, rather aggressive magazine whose table of contents, however, usually remained lying on the paper tablecloth next to the cover design Alberto had drawn. Nothing has remained of this project, for which we had already found the title: L'Œil—not even the huge eye that Alberto had designed for the title page. It was the heroic epoch which marked the beginnings of Labyrinthe. In the first number we published photos of Alberto which showed him at work in his pitiful hotel room. He required unbelievable quantities of plaster for his tiny sculptures. From the leftovers he modeled two large objects in the shape of vases which he gave me with the promise that later he would paint them; they have remained white to this day. Whenever there wasn't enough material for an issue of Labyrinthe I got in touch with Alberto. He always had an idea, whether it was a page for which he suggested an Egyptian relief, or a work by Konrad Witz, or an Arlequin by Derain, or a Greek dancer. "To understand an artwork better one must try to copy it," he used to say.* (213; 214)

1945–46

After the war, Giacometti returned to Paris, where he found his old atelier on Rue Hippolyte-Maindron unchanged. He lived there from 1946 on, joined a little later by Annette Arm of Geneva, whom he married in 1949.

Albert Skira: *One morning after the war had just ended I visited Alberto in his hotel room. He was to return to Paris the next day. I asked him: "Have you shipped your sculptures yet?" He replied: "No, I'm taking them with me." He pulled six matchboxes from his pockets. In them was the work of those years.* (213)

Louis Aragon: *In 1944—or was it already 1945?—we met Alberto again in Switzerland, a rejuvenated Alberto. His relationship with Annette had just begun. She was such a delightful girl! Always looked startled.* (104)

Simone de Beauvoir (Geneva, 22–23 May, 1946): *On this and the following evening we went out with Skira and Annette, a very young girl in whom Giacometti showed a lively interest. We liked her. I found that she was very like Lisa in many ways. She had the same brusque rationalism, the same cheek, the same thirst for life; her eyes devoured the world. She wanted to miss nothing and nobody. She liked strong emotions and laughed at everything.* (108)

Georges Sadoul: *Giacometti returned to Paris in 1946. His wife Annette became my secretary, so we saw each other quite often. Then Annette quit her work with me to devote herself to her husband and pose for him all day long.* (206)

Annette—all in all she cooked two or three times. We always went out to eat even for breakfast coffee. (735)

Alexander Liberman: *Giacometti's wife, Annette, is about five feet four, like a slender girl of fourteen. She always says the formal "vous" to Giacometti. Smiling often, she laughs with a girl's laughter. Her youth and a poetic quality of mood are a contrast to Giacometti's somber brooding. He sometimes teases her; with her child's face she breaks into large laughter. Then the wrinkles, the two deep furrows in Giacometti's face crease even deeper, and he beams like a mountaineer enjoying a good joke.* (54)

Jacques Dupin: *After Annette had posed the whole afternoon, Giacometti gazed intensely at her that evening in the café. Annette, surprised: "Why are you looking at me that way?" Alberto: "Because I haven't seen you all day."* (708)

Giorgio Soavi: *After the deluge of the war Alberto is alone. Picasso visits him every day for a week and tells him: "I've come to tell you something—you are the only one left."—"After the first few times," Alberto continued the story, "I wanted to be left alone for a while. But what happens? When I came home I found his notes under the door or Diego told me: 'He was here, he waited. Then he went away.'"* (735)

Françoise Gilot / Carlton Lake: *Whenever Giacometti came to the Rue des Grands-Augustins to see Pablo, they would discuss in the minutest detail whatever sculpture Pablo might be working on at the moment. One day Pablo seemed particularly pleased with a sculpture he had completed by incorporating in it a separate object with a life and identity of its own: the five-foot-four-inch female figure, one of whose forearms had been formed by the addition of an Easter Island sculpture*

276

nding in a hand. Giacometti studied it and said: "Well, the head is good, but perhaps you shouldn't leave the rest of it like that. Is that really what you intend to do? It seems to me it's more important for the work to exemplify the principle that's behind it than to benefit from some lucky accident. Better to get rid of the lucky accident, which is nothing more than that, and work up to the point where you can see that you've finished the thing in accordance with its generating force." Of all those who came to the Rue des Grands-Augustins I think Giacometti was the one with whom Pablo felt most inclined to discuss such matters, because Giacometti's preoccupations were never exclusively aesthetic. As Pablo pointed out, Giacometti was always asking himself fundamental questions to clarify the real point of what he was doing. (Life with Picasso [Penguin ed.], p. 204)

Pablo Picasso / Carlton Lake: Most sculptors are concerned with questions of style, something that doesn't change radically the heart of the problem. . . . When he makes those sculptures like people crossing the street, going from one house to another, you can't help saying that these are people who are walking in the street and that you're a certain distance from them. . . . ? Sculpture with Giacometti is the residual part, what remains when the mind has forgotten all the details. He's concerned with a certain illusion of space that is far from my own approach but it's something no one ever thought of before in just that way. It's really a new spirit in sculpture. (op. cit., pp. 204–5)

Simone de Beauvoir (diary entry of May 17, 1946): Giacometti speaks of Picasso, whom he saw yesterday evening and who showed him drawings. It seems that Picasso is happy when Giacometti says of his drawings: "Yes, one sees some progress. . . ." We should have had a tape-recorder here to record Sartre's and Giacometti's overpowering conversations. (108)

Jean-Paul Sartre: In space, says Giacometti, there is too much. This too much is the pure and simple coexistence of parts in juxtaposition. Most sculptors let themselves be taken by this. Giacometti knows that space is a cancer on being, and eats everything; to sculpt, for him, is to take the fat off space; he compresses space, so as to drain off its exteriority. This attempt may well seem desperate; and Giacometti, I think, two or three times came very near to despair. . . . Once he had a terror of emptiness; for months, he came and went with an abyss at his side; space had come to know through him its desolate sterility. Another time, it seemed to him that objects, dulled and dead, no longer touched the earth, he inhabited a floating universe, he knew in his flesh, and to the point of martyrdom, that there is neither high nor low in space, no real contact between things. (383)

Up until the war I used to think I saw people lifesize at a distance. Then, little by little, I realized that I was seeing them much smaller—and even near to me, not just far away. The first times it happened, I was walking. It surprised me, but I got used to it. Then I began to notice it at other times. (71)

Each time I had to readjust myself to space, measure the distances again that were between me and things and between individual objects. One could never know what was near and what far away. (703)

A few months earlier . . . I began to see the heads in a void, in the space that surrounded them. The first time I saw the head that I was looking at completely closed in, immobilized within an instant, I trembled with terror as never before in my life. That was no longer a living head, it was a thing I looked at like any other thing—no, not like some other object, but like something that was alive as well as

dead. I screamed with fear as if I had just crossed over a threshold, as if I had stepped into a world I had never seen before. When I awoke this morning I saw my towel for the first time, that towel without weight and with an immobility such as I had never seen it before, as if suspended in a fearful silence. It didn't have the slightest relation to the chair with no background or to the table, whose legs no longer stood on the floor, hardly touched it. There was no longer any rapport between things, they were separated by endless abysses of space. I looked at my room in terror, and cold sweat ran down my back. (12)

Simone de Beauvoir: For a long time, when he was walking down the street, he had to test the solidity of the house walls with his hand to resist the abyss that had opened up next to him. Then again, he had the impression that nothing had weight; in the streets and squares the passersby floated through the air. In the Brasserie Lipp he said happily, pointing at the walls all pasted over: "Not a hole, not one empty space, completely filled." (108)

Through drawing that all began to change a little. (13)—Not until 1946 and after was I able to perceive the distance which makes people appear real and not in their natural size. My visual field widened. (730)—The true revelation, the great shock that destroyed my whole conception of space and finally put me on the track I'm on today came in 1945, in the newsreel theater "Actualités Montparnasse." (Of course the film simply gave latent thoughts a concrete example, it wasn't the deepest reason.) I used to go to the movies quite often earlier. I went in, saw the film, left the theater, I was in the street again, in a café—it wasn't anything special, nothing really happened at all, I mean, there wasn't the slightest difference between what I saw outside in reality and what had happened on the screen. The one was a continuation of the other. Until the day they separated: instead of seeing a person on the screen, I saw—influenced by the drawings I was doing at the time—unfocused black spots that moved. I looked at my neighbors—and suddenly I saw them as I had never seen them before. Not what was happening on the screen was new, but the people who were sitting next to me. On that day—I still remember exactly how I walked out into the Boulevard Montparnasse—I saw the boulevard as I had never seen it before. Everything was different, the spatial depth and the things, and the colors and the silence . . . for silence played a role in it too—the film I had seen was a sound film. . . . Everything appeared different to me and completely new. Boulevard Montparnasse was dipped in the beauty of the Thousand and One Nights, fabulous, absolutely strange. . . . Now I was eager to see more. It was, if you will, a sort of perpetual enchantment of everything. Naturally I very badly wanted to paint, but it was impossible for me to paint what I saw. . . . On that day reality was revaluated for me, completely; it became the unknown for me, but an enchanted unknown. From that day on, because I had realized the difference between my way of seeing in the street and the way photography and films see things, I wanted to represent what I saw. (56; 60; 67)

After 1945 I swore to myself that I wouldn't allow my statues to keep getting smaller, not one iota. But then the following happened: I could keep the height but they got thin, thin . . . tall and paper thin. (67)

1947

The very tiny figures that Giacometti sent to various exhibitions in France (Avignon: Palais des Papes; Paris: Galerie des Arts) (381) were almost completely overlooked—the critics considered them to be only studies. But from the moment he began to apply the principles of phenomenological sculpture he had worked out during the war years to

pieces of a more normal size—which resulted, however, in his figures becoming very tall and thin—he became recognized from one day to the next as a representative of French (and, erroneously, Existential) postwar sculpture.

Encouraged by his former dealer Pierre Loeb, who exhibited his paintings and drawings in his art gallery, Giacometti made several etchings, for the first time since 1935: studio interiors with motifs drawn from his work of the years 1945–46, just as the art periodical *Cahiers d'art* (378) had compiled them in an exciting photographic series.

François Stahly: Shortly after the war there was an exhibition of a few of those small heads of Giacometti's in a Paris gallery. Some of them were hardly bigger than a tie-pin. A short time later I went to see Giacometti again and found him frustrated. He realized the absurdity of his attempts. In his atelier stood several slender, elongated plaster and clay sculptures. Some abandoned in the first stage of a sketch, others broken off and half-destroyed, they were all silent witnesses to continual new beginnings and frequent failure, in which, however, a consistent artistic vision was apparent: the concentrated essence of man in space. Giacometti's space was to be created solely by the work of art as an illusory, absolute space, reserved for the sculpture alone. (217)

In preparation for the Pierre Matisse Gallery exhibition in New York, Giacometti brought old and new compositions to realization—even some of those he would have found impossible to execute in 1925 and 1935. He had discovered the role of style, or, more precisely, he had discovered stylistic means with which his often surrealistically visionary themes could be united with the principles of perception he had worked out based on his study of the model and his drawings—a sculptural style without volume, without mass, and with but one dimension, that of height.

The explanation as to why my figures had become so thin didn't occur to me until later, on a day when I was carrying a sculpture to an exhibition. I picked it up with one hand and put it on the seat of the taxi. At that moment I realized that it was very light and that lifesize figures irritate me, after all, because a person passing by on the street has no weight; in any case he's much lighter than the same person when he's dead or has fainted. He keeps his balance with his legs. You don't feel your weight. I wanted—without having thought about it—to reproduce this lightness, and that by making the body so thin. (67)

In time, I realized what sculpture is all about. I understood new things and I looked at old things in a new way—how should I express it? Have you ever noticed that the truer a work is the more stylized it is? That seems strange, because style certainly does not conform to the reality of appearances, and yet the heads that come closest to resembling people I see on the street are those that are the least naturalistic—the sculptures of the Egyptians, the Chinese, the archaic Greeks, and the Sumerians. (61)

1948–49

For the catalogue of the exhibition at Pierre Matisse's gallery in New York (January–February, 1948), Jean-Paul Sartre wrote a detailed interpretation of Giacometti's figurative style, weaving into it some of his favorite themes on the perception of the Other,[77] which did much to propagate the idea of Giacometti's work as an "art of existential reality" or an art made up of "obviously existential formulations." (702; 729; 572)

Jean-Paul Sartre: After three thousand years, the task of Giacometti and of contemporary sculptors is not to enrich the galleries with new works, but to prove that sculpture itself is possible. There is a definite goal to be attained, a single problem to be solved: how to mold a man in stone without petrifying him? It is all or nothing. "Let me know how to make only one," says Giacometti, "and I will be able to make a thousand. . . ." So long as he does not know this, Giacometti is not interested in statues at all, but only in sketches, insofar as they help him toward his goal. He has not had a single exhibition in fifteen years. Finally, having a show has become a necessity to him, but he is nevertheless disturbed; he writes to excuse himself: "It is mainly because I don't want to be thought of as sterile and incapable of achieving anything; then too it is from fear of poverty (which my attitude could very well involve) that I have brought these sculptures to their present point [in bronze and photographed] *but I am not too happy about them; they represent something of what I intended just the same, not quite." . . . He has chosen for himself a material without weight, the most ductile, the most perishable, the most spiritual to hand: plaster. Never was matter less eternal, more fragile, nearer to being human.[78] . . . Giacometti has resolved in his own way the problem of unity of the multiple: he has just suppressed multiplicity. It is the plaster or the bronze which can be divided; but this woman, who moves within the indivisibility of an idea or of a sentiment, has no parts, she appears totally and at once. It is to give sensible expression to this pure presence, that Giacometti resorts to elongation. (383)*

Dore Ashton: As far as the interest of artists [in New York] goes, nobody, I think, has provoked more discussion than Giacometti. For us Giacometti is the bridge to the artistic thought of postwar France. The unmistakable Existentialist milieu of his work has attracted the attention of the most serious artists and writers and enriched the local art scene with an element that was completely unknown to it.[79]

Barnett Newman: Giacometti made sculptures that looked as if they were made out of spit—new things with no form, no texture, but somehow filled; I took my hat off to him.[80]

Just as the significance of style had now become clear to Giacometti, he began also to be conscious of the meaning of his themes—they were metaphors for reality. He began to probe more deeply into the incompatibility of art and reality.

Once I had to leave the Louvre, I couldn't take it any more. Not because of the artworks, but because of the reality of all those faces I met and which snapped at me as they went by. In the street the people astound and interest me more than any sculpture or painting. Every second the people stream together and go apart, then they approach each other to get closer to one another. They unceasingly form and re-form living compositions of unbelievable complexity. (70)—The men walk past each other, they pass each other without looking. Or then they stalk a woman. A woman is standing there and four men direct their steps more or less toward the spot where the woman is standing. It occurred to me that I can never make a woman in any other way than motionless, and a man always striding; when I model a woman, then motionless; a man, always walking. (60)—It's the totality of this life that I want to reproduce in everything I do. (70)

André Breton: [After the war] I could see that in sculpture Giacometti had succeeded in finding a synthesis of his earlier pieces as a result of the studies he was doing then; I have always been convinced that the conception of the style of our time depended on this synthesis. (123)

The opportunity to participate in the Biennale in Venice and his second exhibition with Pierre Matisse set Giacometti to working feverishly; now, more than ever, his realizations are successful, fed by memories, discoveries, accidents, and new ideas. His former schoolmates at Schiers, Lukas Lichtenhan and Christoph Bernoulli, organized Giacometti's first European one-man show after the war for the Basel Kunsthalle; the first Giacometti found its way into a public collection, that of the Basel Kunstmuseum: *The City Square* of 1948–49 (bronze casting 6/6 for 3,800 Swiss francs).

Every day during March and April, 1950, I made three figures (studies) of different dimensions and also heads. I stopped without quite reaching what I was looking for but unable to destroy these figures which were still standing up or to leave them isolated and lost in space. I started to make a composition with three figures and one head, a composition which came out almost against myself (or rather it was done before I had come to think about it), but almost immediately afterward I wished for things less rigid but not knowing though how to realize them.

A few days later, looking at the other figures which, in order to clear the table, had been placed on the floor at random, I realized that they formed two groups which seemed to correspond to what I was looking for. I set up the two groups on platforms without changing their positions and afterward worked on the figures altering neither positions nor dimensions. (14)

Willy Rotzler: *In spring, 1950, he was in the middle of extremely intensive and fruitful work on his skinny, fantastically elongated standing figures. His ground-floor room was filled with them in all sizes, states, and materials. Giacometti, cigarette never absent from his left hand, walked restlessly up and down, searching, like an animal in a cage. Then he carefully unwrapped the damp, clayey cloths from the figure on which he was currently working. Hesitantly at first, then as if an idea had unexpectedly occurred to him, kneading hurriedly, gouging valleys, building up ridges and knolls, his fingers crawled up and down the figure on its wire core. (204)*

During one year I visualized my figures all finished in advance (the motif took shape in my mind and then more and more I visualized its material and its size). Making it was only a question of craftsmanship. But now, if instead of shaping a purely internal event, an internal and emotional visual experience which already has a sculptural reality, if I want to try to give form to something that stands outside me, let's say a woman from life, then the question as to the correct size becomes a problem, because I don't know in advance what I'm going to do. What I see, I see before me, experience it, but I don't in the least know what means to use to give form to it. So what most probably happens is that I misjudge the dimensions at first. And if you want to reproduce what you see, the question of dimensions plays a terribly big role. It's enough to misjudge by five centimeters [two inches] up or down to miss altogether. (50)

Invited by France to participate in the Venice Biennale, Giacometti withdrew his work:

Carola Giedion-Welcker: *He was wandering around on the quay in Venice lugging an old gray suitcase, like a man who had just been drafted into the army. He sat down at our table and explained that his friend Henri Laurens had been pushed far into the back of the exhibition hall into the shadow of Zadkine, who was to*

receive the prize. He said he could do what he wanted with his own work and was going to save it from the arbitrariness of the judges. He packed it and carried it away—his gesture of friendship. (149)

Like the exhibitions in Basel and New York the previous year, his first Paris exhibition (Galerie Maeght) also included work from his early period. This fact, coupled with the explanations Giacometti gave in interviews to the press, radio, and, from 1962 on, television, shed light on the development of his oeuvre. Varying his words only slightly, he publically admitted again and again to the impossibility of ever reaching his artistic goals. Intentions had to stand in for realized works after the period of realizations during the years 1947–51.

If I could make a sculpture or a painting (but I'm not sure I want to) in just the way I'd like to, they would have been made long since (but I am incapable of saying what I want). Oh, I see a marvelous and brilliant painting, but I didn't do it; nobody did it. I don't see any sculptures, I see blackness. (15)

Francis Ponge: *Giacometti's many statements confirm it: if a sculpture (or any other work of art) develops out of an emotion (this sort of thing is easy to say—and it is a very imprecise statement), then the only emotion (always the same one) that Giacometti's work expresses is that of an appearance: the sudden appearance of an individual (the Other) to one's own consciousness. The mystery of the thing takes hold of him and assumes terrible dimensions; what remains is the presence itself, the threat: "One has to go home and do it from memory," says Giacometti, "in order to find out where one stands and what part of the vision is a lasting one." If you were to take away the feet of Giacometti's figures, their leaden jackboots, nothing would remain. . . . We've tried very hard, Giacometti and I, to find an explanation for this. The first thing he said was: "Seen from above." I was thinking more of the force of gravity. (199)*

Édouard Loeb (quoted by Herbert Lust): *I thought it might be interesting if Giacometti experimented further with lithography. Of course, I admired the etchings he'd done for Pierre [Loeb]. But somehow lithography seemed more in his line, more like his drawing, or at least more to my taste. As you know, art is a very personal thing. So Alberto agreed to do a sketch of me and a girl friend of mine. I had fifty of them printed and tried to sell them for five dollars each, but I don't think we sold more than one or two. At last I gave them away at Christmas and on other occasions. (727)*

Herbert Lust: *It all came about in rather an odd way, because there was nothing intentional about my collecting prints. . . . I had arrived in Paris in 1949; toward the end of the year John Russell introduced me to Giacometti, and from then on I made a weekly pilgrimage to his studio. Like many at the time, I judged Alberto solely as a sculptor. I tried to buy a bronze from him, but he was all sewed up by Maeght and Matisse. I could have bought a great oil for fifty dollars, but, still under Braque's spell, I thought it ugly. Determined to have something from him I bought a tree done in crayon for twenty dollars (the price he got from his dealers), but I did not think it important enough to frame. Later on, rummaging through a bin at the bookstore-gallery of Marcel Zerbib, I purchased for seven dollars the four etchings from the book Alberto had done with Pierre Loeb. If such a small sum seems*

unusual for four rare etchings the reader will be interested in knowing that nobody wanted them then even at that price. In the spring of 1951 . . . entering Giacometti's studio, I found the artist peering at some sheets crammed with violent black slashes. The sheet in his hand made me catch my breath. It was a lithograph of the studio with the statue of the Man Walking *cutting across the center. . . . "I worked hard enough at them. I had to think quite a bit about them. I'm not too sure of the medium yet."—"How do you feel, drawing your own statues?"—"Sometimes I'm surprised I was so good, and sometimes that I missed the mark so far." (727)*

1952

From now on almost every exhibition of twentieth-century art included sculptures, paintings, and drawings by Giacometti—in London (Royal Academy of Arts, Battersea Park), in Paris (Musée d'Art Moderne), in Zurich (Kunsthaus), in Basel (Kunsthalle: "Phantastische Kunst des 20. Jahrhunderts"), in the USA (traveling exhibition Philadelphia, Chicago, New York, 1952–53). The Institute of Contemporary Arts in London devoted two days of discussion to Giacometti: "Points of View on Alberto Giacometti" and "Recent Trends in Realistic Painting." The fact that his work was understood both as "fantastic" and "realistic" fits in well with the way Giacometti saw reality:

One day when I was drawing a young girl I suddenly noticed that the only thing that was alive was her gaze. The rest of her head, which was significant to me for the shape of the skull, meant no more to me than the skull of a dead man. In that moment I asked myself—and I've thought about it often since then—whether one shouldn't really sculpt a death's head. One does want to sculpt a living person, but what makes him alive is without a doubt his gaze. The heads from the New Hebrides are true, and more than true, because they have a gaze. Not the imitation of eyes, but really and truly a gaze. Everything else is only the framework for the gaze. . . . If the gaze, that is, life, is the main thing, then the head becomes the main thing, without a doubt. The rest of the body is limited to functioning as antennae that make people's life possible—the life that is housed in the skull. What happened to me was that at a certain point in time I began to see the people in the street as if their living essence were very tiny. I saw living beings exclusively through their eyes. (50)

1953

On January 5, Samuel Beckett's *Waiting for Godot* had its premiere. Exactly when Giacometti had met Beckett for the first time is not documented—it was probably before the war—but we do know that he felt a deep sympathy for Beckett's writings.

Gérard Régnier: *I can't resist repeating an anecdote here that was told me by the painter Byzantios: one evening, or one night rather, Giacometti came to sit next to Samuel Beckett in the Coupole. And he whom one normally listened to, around whom people gathered—he made an unprecedented effort to enter into his neighbor's thoughts, to surround him with an ever tighter net of questions, as if driven by unbounded curiosity—which Beckett, however, seemed not to notice. (202)*

Beckett and I saw each other now and then. He didn't like to be around people, in bars with women late into the night. He didn't like it. He must be shy. But when

we met accidentally, he and I used to stay together until six or seven in the morning. (735)

Giacometti took to heart what Beckett wrote of Bram van Velde (being an artist means failure; falling by the wayside is the essence of art) and made the clownery with which Beckett overlayed despair his own.

Why does one paint or sculpt? Nobody knows the reason. Nobody decides: now I'm going to make sculptures or now I'm going to paint. One just does it. One does it out of madness, out of obsession, out of a more automatic than conscious need. . . . I have always failed. (54)—If only one could draw! I can't. That's why I keep on drawing. . . . (53)

1954

Giacometti's tall, slender figures and ax-blade thin busts had already become proverbial. After he had solved the problem of creating presence, a new task arose: effectively to represent the unique within the general.

Jean Genet: *When people heard that Giacometti was making a portrait of me (my face might be called more round and broad than anything), they said: "He'll make your head as thin as a knife blade." He hasn't yet made the clay bust, but I think I know why he has painted lines on the various portraits which seem to stretch themselves out from the center line of the face—nose, mouth, and chin—back to the ears, and if possible around to the neck. Because, it seems to me, a face reveals its full expressive power only when it is seen frontally, and because everything must originate at this center in order to make what is hidden behind, alive and strong. (713)*

Jean-Paul Sartre: *When Giacometti once began to draw me, he exclaimed in surprise: "What density! What lines of force!" That surprised me even more than it did him, because I think I have a rather flabby, conventional face. But he saw a source of active energy in every line. (621)*

I shall never succeed in putting into a portrait all the power a head contains. Just the fact that one is alive demands so much willpower and energy. . . . (713)

I am always conscious of the weakness and frailty of living things and it seems to me that they need tremendous powers just to hold themselves upright from one moment to the next. (803)

1955

The special understanding Giacometti's work met with in the English-speaking countries, where large private and museum collections were built up within a few years, manifested itself in two simultaneous retrospectives in London (Arts Council) and New York (Solomon R. Guggenheim Museum)—a combination repeated in 1965. In 1954 his work reached the German audience through a traveling exhibition (Krefeld, Düsseldorf, Stuttgart).

All these years I've exhibited things that weren't finished and perhaps should never have been started. But, on the other hand, if I hadn't exhibited at all it would

have seemed cowardly, as though I didn't dare to show what I had done, which was not true. So I was caught between the frying pan and the fire. (723)

1956

Giacometti was invited to exhibit in the main section of the French pavilion at the Venice Biennale, for which he created two groups of four and six standing women each—*Women for Venice*. He had his name removed from the list of candidates for the sculpture prize because he had sent his best work (including five other *Women for Venice*, since destroyed) to a simultaneous retrospective at the Kunsthalle in Bern. (192)

David Sylvester: *A sculpture is no more definitive at the time it is given up to be cast than it was at other times when it stood there entire before being demolished.—This was made evident by the genesis of the series of ten standing figures about four feet high prepared for the 1956 Venice Biennale. Giacometti worked on a single standing figure throughout the early part of 1956 using the same armature and the same clay: his usual procedure. This time, on days when he liked what he had done, he had a plaster cast made of that state of the figure before carrying on. The ten figures that were preserved in bronze were a selection of those states. The last of the states was no more definitive than its predecessors. All were provisional. And, for him, all the standing figures and heads are states.* (638)

Diego Giacometti: *Every time he was having an exhibition I got up very early, went into his studio and found, say, two busts, four or five clay figures, and a large note: "Make me the castings by this afternoon, otherwise there's no sense in my exhibiting." What counted were these few pieces. Then I made them for him and took the plaster casts, still damp and dirty, to the exhibition. He wasn't satisfied with any of them; he wanted to make something better, and he didn't start working until the day before.* (211)

That summer Giacometti entered a crisis because he had begun to set new goals for his portrait painting—he wanted to achieve the uniqueness of personality. The crisis was triggered by his work with Isaku Yanaihara.

It seemed to me that I'd made some progress, a little progress, till I began to work with Yanaihara. That was about 1956. Since then things have been going from bad to worse. (723)

Jean Genet: *During the whole period he was struggling with the portrait of Yanaihara, I followed the troubled actions of a man who never deceives himself and yet always loses his way. He penetrated further and further into the realm of the impossible from which there is no escape. Sartre told me: "When I met him in the era of the Japanese he really wasn't getting anywhere." I replied: "He always says that. He's never satisfied." Sartre: "But at the time he was really desperate."* (713)

I kept painting on your [Yanaihara's] *face from memory until this morning, but the longer I paint, the more I find my work up to now has been completely wrong. I wasn't able to stop, and kept on out of spite until eight in the morning. Then I went to bed, but I kept on working in my dreams and everything was just as it was yesterday in reality, so that I wasn't able to distinguish between dream and reality. I painted and painted without getting your face on canvas as I saw it.*

It tormented me, the impossibility strangled me, I couldn't breathe. Then I wiped out the whole thing. When I awoke I felt relieved, but my throat still feels like it has a cord wrapped around it. I still haven't understood anything and I'm surprised I have the courage to go on today. (231)

Isaku Yanaihara: *As usual we met in the café. Yesterday he told me that he could probably finish my portrait today. But now he is exhausted and discouraged. In the studio he pulled himself together and was humming to himself: "Strapped to the galley, a galley slave for life, strapped in, a candidate for death. . . ." The work on the picture, which he scraped off with a knife yesterday, is going well. It seems to progress even better when his discouragement and fear have been especially bad the day before. "How's it going? Are you making progress?" I asked. "I don't know if it's good or bad, but I don't really care. I'll keep on no matter what. And I'll keep on for as long as you are in Paris. Never in my life have the possibilities been so good. Five minutes ago your face was as good as finished. The likeness was so good that I wanted to show it to you; even your eyes were exactly right. But now it's all gone again. There's nothing left to see on the canvas." "For God's sake, you should have shown it to me if you thought it was so good." "Oh, your face will appear again soon, and much more correctly than before. If I succeed in doing one part of it right, when I get one single line right, then it will appear again immediately and be a superb painting. How lovely it will be! But I can't imagine how it will look when finished—and that's why my work isn't getting anywhere."* (231)

Yanaihara still had eight days before he was to start on his three-month trip through Egypt, Mesopotamia, and India. Then he said: "Too bad about Egypt and India—I'm staying." And he stayed and sat for me until he had to resume his lectures again. We worked together every evening. And the longer I worked, the more his portrait disappeared. On the day of his departure, I said to him: "If I make one more stroke now, the painting will be lost completely." And I said to myself: "There's no use in trying; if I want to record what I see nothing will remain." But I also asked myself: "What else am I supposed to do in life?" Giving up painting and sculpture seemed to me such a very sad idea that I didn't even feel like getting up in the morning and eating. So I started to work again. (64)

Giorgio Soavi: *After three months Yanaihara had to leave. His duties at the university left him no choice. His absence disturbed Giacometti so much that he considered moving to Tokyo and continuing his work there. They wrote to each other. They began making plans for a reunion in Paris. Alberto sent Yanaihara a plane ticket, and he came back (1959–60) to sit for Giacometti in his Paris studio. Like in a fairy tale.* (735)

1957

The year of transition to what one might call Giacometti's "last conception." In 1954 he was still able to tell Jean Genet: "You have to make exactly what is standing before you—and you have to make a painting, too." He now said:

I see something, I find it wonderful, I want to copy it. Whether an artwork is a failure or a success is, in the end, of secondary importance. Whatever happens I get a little further. Whether I get further by failing or whether I get further by being successful, one way or the other it's a personal gain for me. Perhaps no picture comes of it—too bad. But if I have learned to see a little bit better, I will definitely have

gained something and the world around me will be richer, I mean the world in general, for I have come to know the world as something that so much surpasses me that I can't even make the attempt to approach it. I shall have gained, even if I have failed as a painter or sculptor, if I've succeeded in getting a little closer—maybe just a pitiful bit closer. I shall have gained a little from it.

Of course now it can no longer be a question of giving the others something or giving them nothing. If somebody looks at my paintings anyway, then that means at least there's a beginning in them . . . well, not absolutely . . . in any case, it's not important. . . . At the moment I don't know where I stand. Whether it's at zero or not. . . . Yes I do: at the moment I'm at zero both in painting and in sculpture. Later, people will be able to see whether I've made a little progress or not. But it doesn't depend on that. What more can I say? (56)

1958

Although Giacometti's painting had long been coequal with his sculpture, he began only now to gain a reputation as a painter; in 1958 a "small" Guggenheim Prize was awarded him (National Section, Honorable Mention),[81] and, in 1964, he won the "big" Guggenheim International Award for painting. A gray-in-gray oil sketch he did in 1957 brought him the first award.

People say I paint only with gray. "Paint with colors," my colleagues advise me. . . . Already as a boy I got to know the colors on my father's palette and in his paintings; he really understood the primary colors. And when I was young I painted with those colors, too. Isn't gray a color, too? When I see everything in gray and in this gray all the colors I experience and thus want to reproduce, then why should I use any other color? I've tried it, because I never intended to paint only with gray and white or with any one single color at all. I have often put just as many colors on my palette as my colleagues when starting in to work; I've tried to paint like them. But as I was working I had to eliminate one color after another, no—one color after the other dropped out, and what remained? Gray! Gray! Gray! My experience is that the color that I feel, that I see, that I want to reproduce—you understand?—means life itself to me; and that I totally destroy it when I deliberately put another color instead. A red that I put violently into the picture damages it simply because it forces a gray out, a gray that belongs there, at exactly that spot. (53)

Even with a model, [Picasso] visualizes his painting beforehand; so, whether he works from a model or without one, it's all the same. He immediately makes an abstraction, takes what he wants. But I don't. It's not a matter of choice with me. If it comes out black, that's not because I want to make it black. I try to do it with colors, but I can't put on color if I don't have a framework. And to construct that framework is already such a job, there's no end to it. . . . And to go from there to color is something which seems almost impossible for me. I don't know how it's done, I just don't see it. (71)

One might imagine that in order to make a painting it's simply a question of placing one detail next to another. But that's not so. That's not it at all. It's a question of creating a complete entity all at once. (723)

The most transitory things are not the flowers [for a still life] but us and the painting. The flowers continue growing undisturbed, and their melancholy has

nothing in common with our black thoughts. . . . Yes, it does—for people, life keeps going on, too, just as for flowers; they're never exactly the same; but people paint pictures, that's why everything's different for them. (16)

1959

Giacometti was requested by the architect Gordon Bunshaft to submit a project for the monumental sculpture group for the plaza of the Chase Manhattan Bank skyscraper. He began to work out a composition he had had in mind for decades, a representation of the "totality of life" with larger-than-life figures in a style somewhere between traditional three-dimensional sculpture and mythical hieroglyph: standing women, walking men, and a huge head on a pedestal. Progress was slow; the architectural setting seemed not to lend itself to a composition with several figures. Only after having seen the site in October, 1965 and deciding to limit himself to a single, twenty- to twenty-five-foot tall female figure was Giacometti sure he would find a solution; his death left the project uncompleted.

Louis Aragon: *I asked him once whether it wouldn't interest him to put up a sculpture in the middle of a city square—in Geneva or Paris. To tell the truth, he was waiting to be given a square somewhere in a city. But on condition that his demands be met. He didn't want to have to conform to the regulations of some city council. But if someone should give him a square, the Place Maubert, say, so that he could erect what he wanted there?—At that time (immediately after the war) that meant a small figure, standing directly on the pavement where the people walked, a very small figure with a wide space around it. He explained why: the smaller the figure was, the larger the square would seem—"Larger than the Place de la Concorde, non?"* (104)

Carola Giedion-Welcker: [At that time] *Giacometti had wanted to place his figures in the street so that, mixed into the secularity of day-to-day life, they might prove their sculptural existence and dignity. But when he had begun to work out this plan in more detail, he had met up with the resistance of the Paris officials.* (545)

Sigfried Giedion: *When the architect of the Chase Manhattan Bank skyscraper in New York created a large plaza in the center of the Wall Street area, he wanted to convince Giacometti to enlarge one of his statues [Three Men Walking, 1950] to eighteen meters [nearly sixty feet] and erect it there. Understandably, the artist declined to do so. One who is forced to live the absolute cannot make compromises.* (151)

1960

From 1960 on, Giacometti painted and sculpted almost every day for more than four years from his model Caroline.

She sits for me almost every evening from nine to midnight or one o'clock. In the past few years there haven't been more than four or five evenings that we haven't worked. (803)

Caroline. With one foot in the underworld. But she sat for me, well, every evening, even when we'd had a quarrel. She was crazy about sports cars. And because she'd modeled for me so often, hours at a time, unmoving, I wanted to reward her well for it. No matter how much I'd paid her, it seemed to me I'd never paid her enough, because her time was just as valuable as mine. Night after night we worked together, and she said: "Alberto, but this time you've got to buy me a Ferrari." I replied: "Why not?" But we had to work; I didn't want to stop because I was just getting somewhere, and many evenings went by like this. During the breaks Caroline always talked about the Ferrari. And when the sittings were over, the Ferrari had become almost real, as if she had already owned it and enjoyed it in advance. Really owning it didn't matter so much any more. Without a moment's hesitation she gave up the idea and named a car she wanted even more. We took long rides through the city. (735)

From 1960 on, there was clearly something in Giacometti's paintings that had been hardly noticeable in 1958—the intensity of the gaze. The meaning of the eyes and head for the presence of life in an artwork began to play an important role in his work.

What interests me most about the head—well, actually the whole head interests me, but I think now I might succeed in constructing the eye as exactly as possible, and when I've got that, when I've got the base of the nose.... But to take the eye: I mean the curvature of the eyeball—from that everything else should develop. Why? Probably because, when I look at someone, I look at the eyes rather than at the mouth or the point of the nose. That's the way it is: when you look at a face you always look at the eyes. Even if you look at a cat, it always looks you in the eye. And even when you look at a blind man, you look where his eyes are, as if you could feel the eyes behind the lids. The eye is something special insofar as it's almost as though made of a different material from the rest of the face. You could say that all the forms of the face are more or less unclear, are even very unclear; the point of the nose can hardly be defined at all in terms of its structure. Now the strange thing is, when you represent the eye precisely, you risk destroying exactly what you are after, namely the gaze. That's how it seems to me. There are few artworks in which the gaze exists.... In none of my sculptures since the war have I represented the eye precisely. I indicate the position of the eye. And I very often use a vertical line in place of the pupil. It's the curve of the eyeball one sees. And it gives the impression of the gaze. But that's where the problems come in.... When I get the curve of the eyeball right, then I've got the socket; when I get the socket, I've got the nostrils, the point of the nose, the mouth ... and all of this together might just produce the gaze, without one's having to concentrate on the eye itself. (817)

1961

Giacometti was awarded the Carnegie Sculpture Prize at the International Painting and Sculpture Exhibition in Pittsburgh.

I find it harder and harder to finish my things. The older I get, the lonelier I am. I suppose in the end I'll be very lonely. Yet, even if everything I've made up to now doesn't count at all (compared to what I want to do), and in spite of my certainty that I've failed up to now, and experience that everything I start runs between my fingers, I have more desire than ever to work. Do you understand that? I don't understand it, but that's how it is. I see my sculptures before me: each

one, even those I've apparently finished, a fragment, each a failure. Right, a failure! But in each is something of what I want to create someday. In one of them one thing, in the next another, in the third something missing from the other two. But the sculpture I'm thinking of contains everything that makes only a scattered and fragmentary appearance in the other sculptures. That gives me a desire, an overwhelming desire, to continue my work—and one day perhaps I shall reach my goal after all. (161)

1962

Giacometti is given a personal exhibition hall at the Venice Biennale, for which he makes feverish preparations; his efforts are rewarded with the First Prize for Sculpture.

Giorgio Soavi: Alberto was constantly in motion setting up the small and large sculptures, finding the correct angle for the compositions with several figures crossing a square; he was restless, driven more than anything by his dissatisfaction; he would have preferred to do everything over, or rather nothing seemed quite right to him. One evening he picked up his brushes and painted the sculptures; are they standing right or are they wrong, he kept asking. And once, late at night, after he had finally let his friends bring him, dead-tired, back to the Hotel Europa where he was staying, he crept away again a few minutes later, not wanting anyone to notice, more restless than ever, filled with activity, having decided again to change as much as he could. (216)

That is not strength of will. It's a mania! But mania is probably also a form of will.... (178)—It's certainly a mania, but at the same time there is the will to reach a goal, or rather, to free oneself. When I make sculptures, then it's ... it's to finish with sculpture as soon as possible. (803)—Basically, I am only working for the sake of the experience that I feel when working. I know that art is only one method. Why this compulsion to record what one sees? When one loses oneself in the task of recording as exactly as possible what one sees, it's a matter of the same need whether one is a scientist or an artist. Both art and science mean: wanting to understand. Success or failure is unimportant. It's the modern form of adventure for men who are left on their own. (61)—When working I've never thought of the theme of loneliness, and I never think of it now. But if so many people feel it, then there must be a reason. It's hard to say whether this interpretation is right or wrong. In any case there is no intention on my part to be an artist of loneliness—I don't have the slightest tendency in that direction. I should say rather that, as a thinking man and citizen, I believe that all of life is the opposite of loneliness, because it consists of a net of relationships with others. The society in which we live here in the West forces me in a way into the situation of doing my research into loneliness. It was hard for me to work for many years on the fringes of society (but I hope not on the fringes of humanity). The lonely position of the researcher is not, however, necessarily connected with the representation of loneliness. (58)—People talk so much about the discontent in the world and about existential anxiety as if it were something new! Everyone at every period in history felt it. You only have to read the Greek and Latin authors!—Naturally, progress in technology and science dominates man and forms him, but what's so new about that? Just think of the prehistoric man who invented the bow and arrow to kill wild animals. That was the first invention that began to change him.... Now they've invented the atomic bomb, which can kill a hundred thousand people at once. But the principle of violence is exactly the same and the threat hanging over man's

head has been exactly the same at all times in history. Man can dominate the atomic bomb, too ; if he doesn't want it to explode then it won't.

It is not true that the individual with his emotional life no longer feels himself the center of his world! What do you think really interests people from morning to night if it isn't their feelings, their work, friendship and love—especially love. They read the newspaper maybe ten minutes a day, they see that a satellite is orbiting around the moon, and then they immediately start talking again about work, and love. And not only that : often somebody will commit suicide because of love problems. And that means that if an individual would rather die than live without a person he loves, then the power of emotion does still dominate his world.—The unity of a person today consists of the integrity of his feeling. This affective integrity determines the relationships between people, otherwise there would be no attraction, no sympathy and no antipathy.—And as far as loneliness in the big city goes, it isn't any more oppressive than earlier in the medieval cities, where nobody went out at night without a knife in his pocket to defend himself.

The mass [of people] is for me nothing more than the being together of individuals. It's true that technology has imposed at least a superficial conformity on the masses. But do you believe that the ancient galley slaves or the first artisans at their looms led a less egalitarian life? The wonderful thing, the mystery, consists for me of the faces of individuals in the crowd. Once, in a museum I watched these faces and all at once I was aware of their extraordinary aliveness and inviolability, which is something so different from what is represented in artworks that art suddenly seemed frozen and dead to me. A kind of despair filled me, for I thought : No one has ever been able to really grasp the miracle of these faces and the life reflected in them.

That art today should express the social problems of our time, and man in space, or men in the mass or in industrial society—that seems childish to me. In reality everything that happens to a man belongs to his world : not only his work in the factory but his sadness and his way of falling in love. In art there is no one aspect of life that should be expressed rather than another. There is only the problem of expression. In the end, the most significant artist will be the one who creates the best artwork. (63)

1963

After an X-ray examination in October, 1962, turned up evidence of a stomach ulcer, Giacometti was operated on February 6, 1963. The follow-up examination that October showed that the core of the disease had been completely removed.

You know that I was very ill?—They cut out four-fifths of my stomach. I'll tell you—really and truly, it was cancer. And the strange thing is—as a sickness I always wanted to have this one. (69)

Louis Aragon: A short time ago he came with Annette for dinner. Alberto talked about his cancer. He did not keep it a secret. He talked about it the whole evening long with evident pride. He was angry with his doctor for not having told him the truth and also with Annette and Diego for having kept quiet. Did they think he was a child? He heard about it this way : when he went to Graubünden for some rest on the advice of a surgeon from the Medical Faculty, he took with him a letter this surgeon had written to his doctor with everything in black and white. And he didn't waste any time in showing Alberto the letter. All hell broke loose. But then Alberto said he was very proud to have cancer, and that it was an experience

not everyone had the chance of having. He said he was now among those fortunate people who have cancer and are better than the rest of us for it. And that he would soon be sixty-five years old, the average age for a man nowadays—what right had he to expect more? He had done only what he wanted his whole life long. Now his life was reaching fulfillment and he had lacked nothing. Wasn't that enough? Then, when I shyly referred to the pain, he said that pain was an experience too and that he was indifferent to suffering.—One tells something like this in forty lines. Our conversation lasted more than three hours. (104)

I'm still young, whereas all my contemporaries in Stampa are old men, because they've accepted old age. Their lives are already in the past. But mine is still in the future. It's only now that I can envisage the possibility of trying to start on my life's work. But if one could ever really begin, if one could have made a start, then it would be unnecessary to go any further, because the end is implicit in the realization of the beginning. (723)

What I'm looking for isn't happiness. For most people, being happy means simply working hard to keep oneself warm, to feed oneself. To make ends meet, basically. I work only because it is impossible for me to do anything else. (63)

1964

Several extensive English and American private collections reflect their owner's insight that only smaller or larger groups of Giacometti's work taken together can give a true idea of his conceptions and goals. In Europe the collections of the Fondation Maeght in Vence and the Giacometti Foundation in Basel, Zurich, and Winterthur gave witness to the unity of his oeuvre. Giacometti himself prepared several "résumés," from the famous letter to Pierre Matisse of 1947 to the Notes sur les copies two months before his death; several series of drawings also served to sum up his life's work. Besides working with Caroline, Diego, and Annette, who still sat for him regularly, Giacometti worked from now on with his model Elie Lotar, at first every weekend, then every day until the last week of his life.

Thomas B. Hess: I went to see Alberto the evening before I left Paris. The light was fading. He was leaning forward on his stool, pushing his nose to an inch from the nose of the sculpture ; the bald model [Elie Lotar] was perched a foot behind the sculpture-stand, and he was bending forward, too, his nose advancing as the tension in his shoulders began to tell. They made a pyramid of stress. "Hello," I said. "Ah," they breathed together, held the concentration for a moment, then slumped. You could barely see across the room ; the light was so thick it seemed filled with plaster dust. Giacometti smiled broadly and turned on a lamp. He looked radiant. "You see," he said, "you see," gesturing at the bust, "no, perhaps it's better not to look ; it's ab-so-lutely im-possible !" (156)

René Char: On that late afternoon in April, 1964, the old despotic eagle, the blacksmith kneeling beneath a fiery cloud of maledictions (unceasingly he lashed his work, that is, himself, with curses), revealed to me in his atelier the form of Caroline, his model : the face of Caroline painted on canvas—after how many blows of the talons, wounds, streams of blood? It was his kind of passion among all forms of love, above the pseudo-importance of corporeality, subject to death ; above all of us other glowing points of life, his contemporaries, hardly able to keep any distance between us. (131)

Whether a thing is successful or unsuccessful is a matter of complete indifference to me. A successful picture, a failed picture, a successful drawing, a failed drawing, means nothing. The failures interest me as much as the successes. So much so that if nowadays I have to have an exhibition—and I shall do this more and more—I shall exhibit precisely everything that comes to hand that I haven't destroyed. And one should rather show the least good things than choose the best ones. Because, if the least good stand up, surely the best will. If, on the other hand, you choose the ones that seem to be the best, you're deceiving yourself—because there are others which are less good hidden away somewhere; even if you don't show them, they exist. And if someone looks very attentively, he'll see the weakness even in the best ones. So this is why, nowadays, the choice for an exhibition—what's put in and what's not put in—is a matter of complete indifference to me. (638)

When I see an exhibition of my things, at the Maeght Foundation for instance, I'm the first to think they're better than what anyone else is doing. But then I realize that that has absolutely no relation to what I hope to be able to do. (723)

Giorgio Soavi: *Paris. It is the 11th of June 1964, opening day of the Chagall exhibition at the Galerie Maeght. And everybody's here. Among the two hundred people, some of whom have parked their Rolls Royces on the Rue Téhéran, are Miró, Prévert in hat and dark blue suit, the celebrated Chagall, looking older but as roguish as ever, Ylia in worker's clothes, and probably many more celebrities I don't know. See you later, says Alberto as we climb the stairs. As soon as he enters the confusion of the hall, everyone turns to look at him. I can see why. The shabbiest and most lovable fellow anybody ever saw just walked in; but I, having spent the whole morning with him, I can testify that Giacometti dressed up for the occasion, that he brushed his trousers and then, at the last minute, the taxi already waiting outside, that he bent down to look under the furniture for a brush and shoe polish. Even then everything wasn't quite as it should have been, for he dipped a large rag in water and wrapped his sculpture in it to keep it damp. Like someone lovingly applying a cool cloth to a friend's forehead. (735)*

While I was in Switzerland, I made a number of drawings—like that: a little table, some chairs. But the longer I worked at them, the more I realized that it was such a complex and difficult job, I could spend the rest of my life just drawing two chairs and a table. (71)—So I would have to give up painting and sculpture and heads and everything and reduce myself to staying in a room in front of the same table, the same cloth, and the same chair, to do nothing but that. And I knew in advance, the more I tried, the more difficult it would get. I'd reduce my life to practically nothing. Well, doing that would be a bit disquieting, because you don't want to give everything up. And yet it's what one ought to do. (638)

1965

Alberto Giacometti became a legendary personality during his lifetime, largely due to the countless articles published about him, even in popular magazines; the integrity of his thought and work ethos impressed people more than did his painting and sculpture.

Even if I made and destroyed the same piece over and over, and even if everything that's there when it's finished came out of one working session, it couldn't have been there without all the preliminary work. Basically, one never destroys anything.

Even when you think you're changing what you did yesterday and the day before, it isn't so, you don't destroy it. The little bit you gained by it, that remains. (638)

Georges Boudaille: *Alberto used to appear about nine or ten at night in the Vavin. He had got up nobody knew when and had eaten his breakfast in the café on Rue Didot at an hour when most people have their lunch coffee. Then he met his friends in the Dôme, where he drank Rossi with soda. At one o'clock in the morning or later he had something to eat. He had his usual table in the Coupole and in the Palette. He enjoyed talking with his friends, but with anybody else, too. Afterward he went home and worked until all hours of the morning. (116)*

Now it's past three in the morning. Before, in the Coupole, when I had eaten and wanted to read, I fell asleep; my dream-thoughts distorted and transformed what I was trying to read—a line, two lines in the newspaper, and my eyes kept falling shut. The cold outside, the cold and sleep drove me home; going to bed and sinking into sleep in spite of fear ... silence. I am alone here, outside is the night, nothing is stirring and sleep is overcoming me. I don't know who I am, what I'm doing, what I want; I don't know whether I am old or young, maybe I still have a few hundred thousand years to live until I die; my previous life is sinking into a gray void. (26)

Brassaï ("My Last Visit," March 22, 1965): *I found an emaciated, bent Alberto Giacometti, tottering around in his old clothes, his face lined more than ever by suffering. Yet the gleam in his eyes, which were red with sleeplessness, is still there, and his voice is still compellingly certain, as warm as ever. "Brassaï—photograph me like this. I'm a wreck. The future looks dark. I ask myself how long I can keep on working. I am on a dead-end street. I honestly don't know how I can get myself off it. And in spite of everything, as you can see, I keep working, keep doing my stuff. Yesterday evening I worked till midnight on this bust, which I still owe Maeght, then I went to the Coupole. I came back at three in the morning and, instead of going to bed, I worked until seven. I have had almost no sleep. I'm under such pressure to keep working on this bust that I haven't even had a cup of coffee." (117)*

Giacometti went twice to London to set up a retrospective at the Tate Gallery. He went on to New York for his big exhibition at the Museum of Modern Art and also to make measurements on the Chase Manhattan plaza for his sculpture commission; then to Denmark for his third large show of the year, at the Louisiana Museum in Humblebaek. The Stedelijk Museum in Amsterdam sponsored a large exhibition of his drawings.

I resisted the intrusion of success and recognition as long as I could. But maybe the best way to obtain success is to run away from it. Anyway, since the Biennale it's been much harder to resist. I've refused a lot of exhibitions, but one can't go on refusing forever. That wouldn't make any sense. (723)

Robin Campbell: *The exhibition closed at the end of August and Giacometti returned to London for the last time. He told us it was the best exhibition he had ever had and he was pleased that it had been a success. Giacometti went to the exhibitions of Henry Moore and Francis Bacon which opened while he was here. I remember he said: "Compared with Francis Bacon's my paintings look as if they had been done by an old spinster." ... He was excited most of all by a tall T'ang tomb figure of a woman in the King Edward VII gallery [of the British Museum]. He said he found this a supreme masterpiece and he spent at least half*

an hour walking round it, away from it and coming back to it again. The T'ang figure led him to say that more and more he preferred to anything else the impersonal and objective quality in early art: he had less and less liking for the kind of art where the artist puts his own feelings and attitudes into what he was doing. —At lunch afterwards . . . he made me, as he spoke no English, tell the girl who brought our food how pretty he thought her. "One living girl like that is worth more than anything in any museum." (125)

James Lord: *New York aroused him less to surprise than to excitement and curiosity. In the desire to orient himself as rapidly as possible, he bought a map of the city and studied it with care.—In the taxi he wanted to make a detour to see the Chase Manhattan Plaza. When he found himself suddenly at the base of that tall, smooth, severe facade, he was at once excited by the prospect of trying to create a sculpture which would be powerful enough to maintain its presence there. He walked with long strides in every direction back and forth trying to determine what would be the best site for such a sculpture. The more he gazed at that wide empty space in front of the building, the more excited he became. That same evening, about midnight, he insisted on returning to the plaza with his wife and a friend. He spent an hour there on the cold, deserted square trying to judge various locations and dimensions for the piece, and asked his friend to stand motionless here and there to gauge the effect. Several times during the following days he discussed the matter with the architect, Gordon Bunshaft, returning once again to the site, and he talked about it often in New York and later in Paris.* (175)

Much happened between September and November. Ernst Scheidegger and Peter Münger made a thirty-minute film with Jacques Dupin about Giacometti. For the publisher Tériade, Giacometti worked on a text to accompany an album of his lithographs, *Paris Without End* (*Paris sans fin*, 1969), which remained unfinished; Luigi Carluccio likewise was waiting for an introduction from Giacometti for a volume of the drawings he had made after old masters; he made three attempts to write it. On November 20, the French government awarded him the Grand Prix National des Arts. The Philosophy Faculty of the University of Bern awarded him an honorary doctorate. And many "last words" were uttered at the banquet given in his honor by the Swiss Federal President on November 27:

It is odd that I am getting so much attention now, because I am only a beginner. For if I ever succeed in doing something, I'm beginning only now to realize what it might be. Anyway, maybe it's better to get awards over with at the beginning, so that afterward one can work in peace. (175)—*Basically I'm just a great* arriviste. (163)—*I haven't yet found what I'm really looking for.* (149)

Eberhard Kornfeld: *The party which accompanied him to the station—after dinner with a group of young people—was like a triumphal march. He stood beaming from the window of the carriage: "See you later, in Paris."* (163)

James Lord: *He was exhausted. He no longer possessed the unbounded energy he had always seemed to have, and perhaps this was precisely the reason why he exerted himself more than ever, with a feverish compulsion. Finally he agreed to see a doctor. The next day he explained, sitting on the bed and smoking a cigarette, that according to the doctor's diagnosis he was suffering from chronic bronchitis and a slight distention of the myocardia; it was apparently not a disquieting finding. . . . Nevertheless, after a moment he added: "It wouldn't suit me at all to die now."—*

"It's silly to say a thing like that," said one of his friends. "Why? It's not silly at all. It really wouldn't suit me. I've everything still to do." (175)

Georges Sadoul: *In December he said he would never reach the goal he had set himself; for thirty years he had always believed that tomorrow would be the day. He told us his whole life story, in three hours. I knew that he felt not only very ill, but hopelessly ill. It was like his testament.* (206)

Actually I don't know what to think of anything. Every word [I write] shows only my vanity, my pretentiousness, my hypocrisy, even my pleasure at being witty and startling people, all qualities I was proud of showing off when I was twelve years old. Luckily a long interval came afterward, it lasted really until the very last years, but now I'm the person I was when I was twelve—not completely, I've made tremendous progress—now I can get somewhere only by turning my back on the goal. I can create only by dissolving. I don't know, am I a comedian, a filou, *an idiot, or a scrupulous fellow? I only know that I've got to keep trying to draw a nose from nature.* (25)

James Lord: *In the late afternoon of the day before he was to leave Paris for the last time Giacometti made one of the last of his countless taxi rides through Paris. He had himself driven to the store where for years he had been buying his materials. On the way home, as the automobile drove along the street that cuts through the Montparnasse Cemetery, he suddenly pounded his knee with the flat of his hand and exclaimed, "It seems impossible!" "What?" asked the friend who was with him. "To make a head as I see it," he answered.* (175)

Ernst Scheidegger (about the night from December 4 to 5): *Except for his coughing, which interrupted our conversation from time to time, he seemed to be in good spirits, full of energy, interested in all the problems that occupied us. . . . We met, as we had so often, after midnight in the bar of the Dôme. Alberto was already there with his two models Caroline and Lotar. They were alone on the heated terrace of the restaurant and sat there without speaking, as if something extraordinary had happened. Finally Alberto's departure for Chur, Lord's departure for New York, and my departure for Zurich got us to talking. It was one of the saddest nights I ever spent with Alberto. We spoke of nothing important, nothing intimate, very unlike the times we usually spent together. We all sat there, silent again. Around four o'clock we said our goodbyes—as so often in the last years. It was Alberto's last night in Paris. The same day, at ten o'clock that night, he left for Chur for his examination.* (209)

Renato Stampa (Chur): *When I came home on December 6, I was not a little surprised to find Alberto Giacometti there; he had left Paris the evening before after having worked all day, and arrived in Chur the next morning to report to the Kantonsspital. When my wife was called to the telephone . . . Alberto asked her if he could come over right away, like someone who was eager to have friends around him. After lunch he went to the hospital; he was in quite good spirits, because now, as he said, he would be able to rest for a few days.* (221)

Professor N. G. Markoff M. D.: *He arrived here exhausted, emaciated, gasping for breath, with all the signs of a failing heart and circulation. "Is it cancer?" was the first question he asked after his condition had improved with oxygen treatment. He was very happy when the X-ray and biochemical findings and the isotope examination of his liver using a colored scintigram also revealed no signs of a relapse of the cancer. The liver scintigram with its mysterious colored*

outlines impressed him so much that he wanted one of the pictures: "I'd like to look at it every day in my atelier." After a temporary improvement in his condition, during which time he worked on a design for a sculpture group, his circulation worsened quite suddenly shortly before Christmas. The gradual failure of his badly damaged myocardium became apparent with the appearance of serious lung congestion, fluid buildup in the chest cavity, and serious liver congestion. Alberto Giacometti knew of the seriousness of his condition. (179)

I'm convinced that nobody thinks about having to die. Even a second before he dies he doesn't believe it. How can he? He's alive, and every part of him is alive, and even in the fraction of a second before he dies he is alive, and it's impossible for him to be conscious of death, and if he speaks, say, then he doesn't stop speaking, he goes on speaking, but he's dead. . . . Is he dead? (69)

1966

Giorgio Soavi: [In early January] we talked on the telephone for a long time. The first time he was very lively; he said the treatment was taking a bit long and that he hadn't smoked for two weeks. "But as soon as I'm back in Paris, you come too. Or I'll call you when I pass through Milan. Then we'll go to Stampa. I want to do some drawings." On Sunday [January 9] I phoned him again. He was tired and spoke listlessly. And instead of saying "non va, non va" as he usually did, he repeated that he had done everything himself to get to the point he was at now. (735)

Professor N. G. Markoff M. D.: On January 10, when I had relieved his suffering and difficulty in breathing with another pleural puncture and we were alone for a short time in the examining room, he said: "Now I know that the cancer didn't catch up with me, but something decisive has to happen now. I must get back to Paris, even if it's only for a week." When I answered, positively but emphasizing the seriousness of his condition, Alberto Giacometti composed himself somewhat and that evening resumed work on his little sculpture group, the first version of which he had destroyed. A few hours before, while he was being taken to the X-ray institute, he had been extremely agitated and had said to the day-nurse: "I'm going mad. I don't know myself any more, I've lost all desire to work." (179)

Alberto Giacometti died on January 11, 1966, at the Kantonsspital in Chur.

Professor N. G. Markoff M. D.: On the evening of January 11 all signs of approaching death appeared. I shook hands with him silently in farewell and let his relatives and constant companions into the room to be with him during the last minutes of his life. Alberto Giacometti asked all of them—his wife Annette, his brother Diego, his brother Bruno, and Bruno's wife—to come closer, gazed at them, asked for Caroline, who was waiting at the door, and then took leave of them all silently, for he wanted to be alone. Only Diego, whose arrival from Paris he had awaited very impatiently, stayed in the room for a short time, until the dying man asked him to leave, too, because he wanted to rest. Then Alberto Giacometti went quietly to sleep. It was just as he had often described to me the death of his aged mother: "She faded slowly away. She died a gentle death. Now I know what that means." Alberto Giacometti died of an inflammatory heart condition which was clinically a heart attack and anatomically a serious myocarditis and pericarditis. It was a direct result of years of chronic bronchitis with bronchiectasis. I have been

a hospital physician for thirty-two years. That determines the point of view from which I write. The relatives of my former patient have given me permission to do so. (179)

On January 15, 1966, Giacometti was buried in the cemetery of San Giorgio at Borgonovo near Stampa; his brother Diego placed a bronze bird on his grave, very near the stone Alberto had made for his father in 1934.

Jacques Lassaigne: Numerous friends of Alberto Giacometti's were present at two o'clock in the afternoon that Saturday, January 15, 1966, to escort him to his grave. They had come from all over the world, from Paris, Basel, Zurich, Geneva, Turin, Milan, and New York, to the little village of Stampa in Graubünden. The entire village population lined the streets. Alberto was lying in the small log house which his father had equipped as a studio and in which he had done much work himself. (165)

Gaëtan Picon: A sliding panel at one end of the coffin made it possible to see his face. From behind the glass it appeared to me—only a segment of his face, really waxlike under the grayed locks of hair—like the face of some mythical ancestor of this man we had loved, and it looked as if it wanted to have nothing to do with all this around it. (197)

Jacques Lassaigne: A few personal works surrounded him like old friends, beginnings of paintings and sculptures which he had already reworked many times and which he now left behind, orphaned. . . . The coffin will be carried to the cemetery on a small horse-drawn cart. (165)

Michel Leiris: Alberto—
 A first name the blaze of the vocative
 Will never light again,
 For Giacometti has been exiled
 To the third person singular. . . . (170)

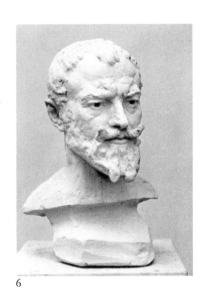

1

2

3

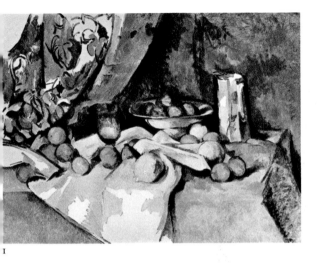

4

5

6

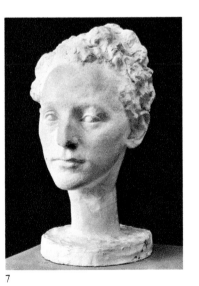

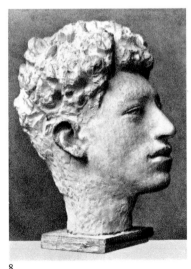

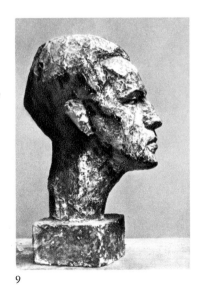

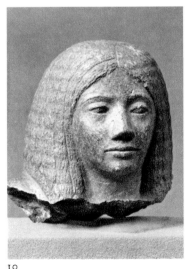

7

8

9

10

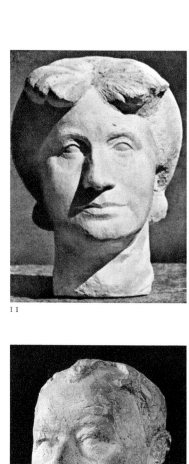

11

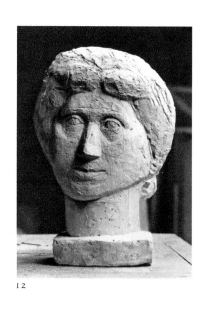

12

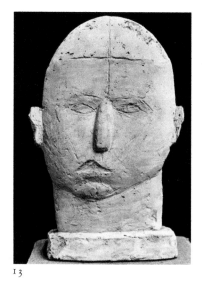

13

14

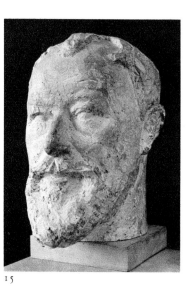

15

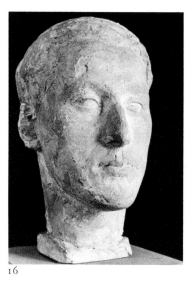

16

17

18

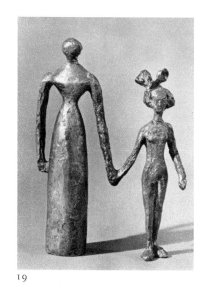

19

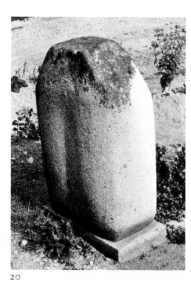

20

21

22

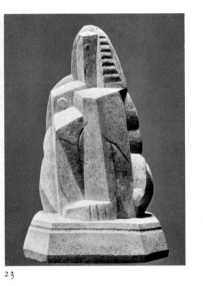

23

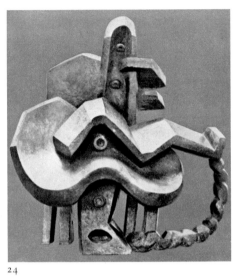

24

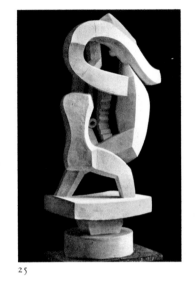

25

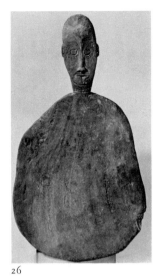

26

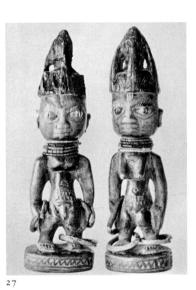

27

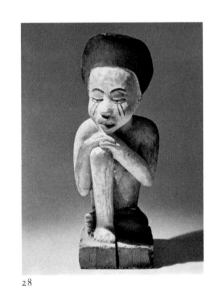

28

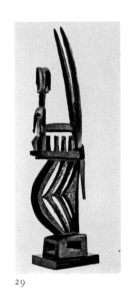

29

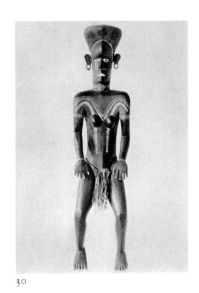

30

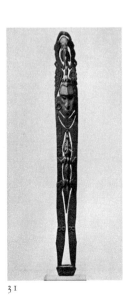

31

32

33

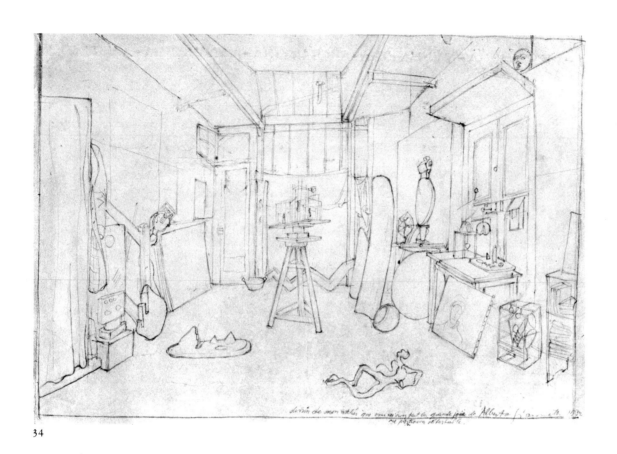

34

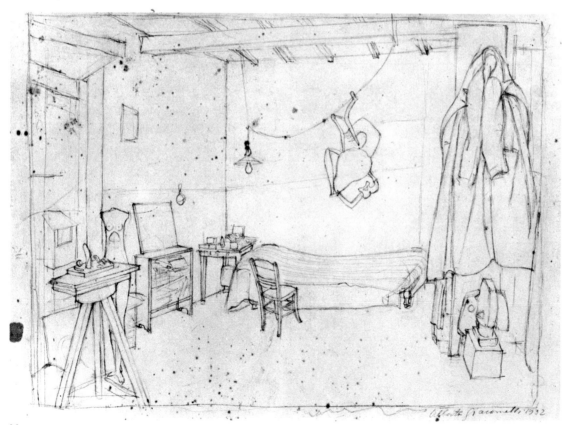

35

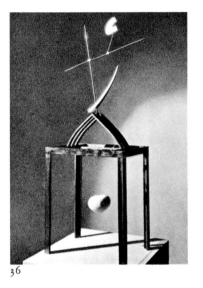

36

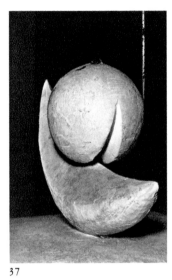

37

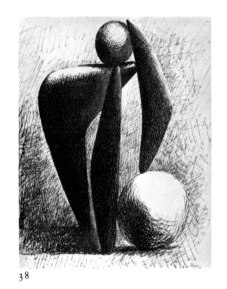

38

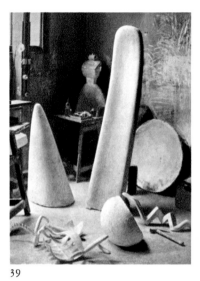

39

40

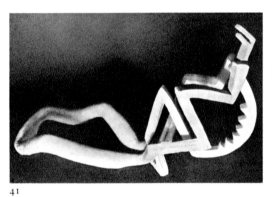

41

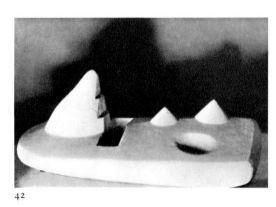

42

43

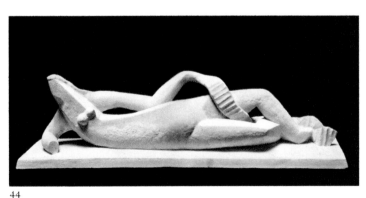

44

45

46

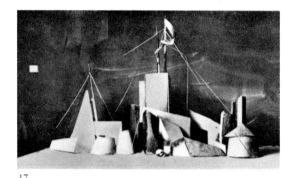

47

48

49

50

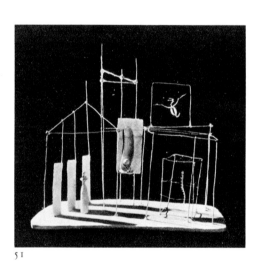

51

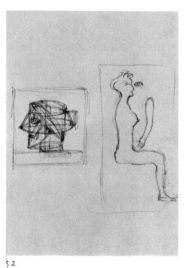

52

53

54

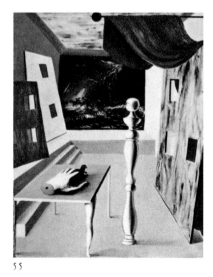

55

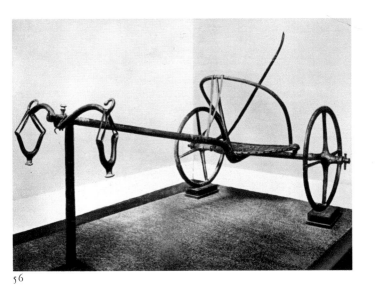

56

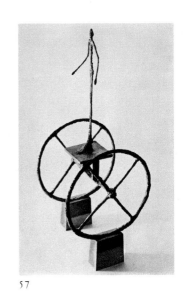

57

58

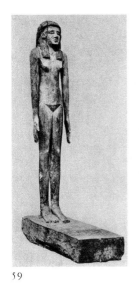

59

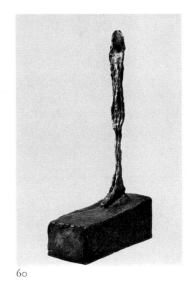

60

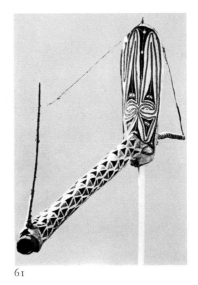

61

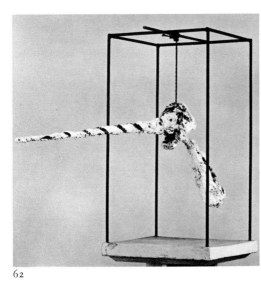

62

63

64

65

66

67

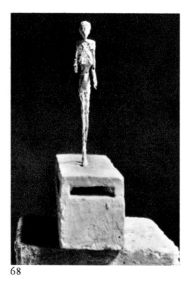

68

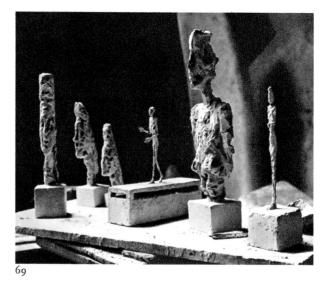

69

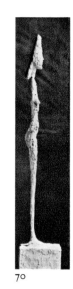

70

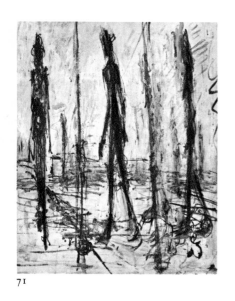

71

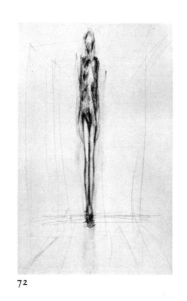

72

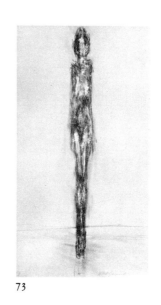

73

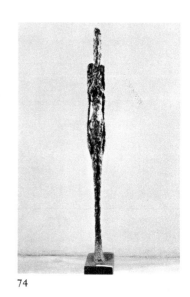

74

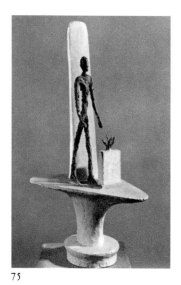

75

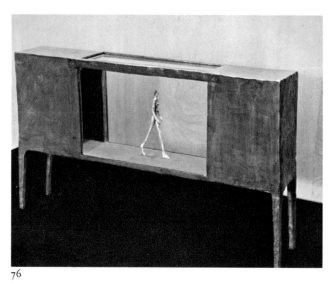

76

77

296

Notes

1 Augusto Giacometti was related as a second cousin to both Alberto's mother and father. His father was a confectioner who had, like Giovanni's father, returned from eastern Europe and become a farmer in Stampa. Both men had learned watercolor technique from a relative, Zaccaria Giacometti (1856–1897; Augusto's uncle and Giovanni's second uncle), a talented landscape painter who ran the school in Stampa.

2 Arnold Neuweiler, *La Peinture à Genève de 1700 à 1900*. Geneva: Jullien, 1945, p. 216. On Estoppey: ibid., pp. 138, 170, 214.

3 It is amusing that this bust (page 289, fig. 8) was on exhibit in Paris (at Bernheim-Jeune, in 1932) at precisely the same time that its model, a member of the Paris avant-garde in the meantime, was creating a furor with his own exhibition of Surrealist objects.

4 On Amiet and Gauguin see: Felix Andreas Baumann, "Cuno Amiet in der Bretagne" in the exhibition catalogue *Pont-Aven: Gauguin und sein Kreis in der Bretagne*. Kunsthaus, Zurich, 1966, pp. 45–48.—August Strindberg, "Lettre à Paul Gauguin"; in the exhibition catalogue *Paul Gauguin*. Galerie Durand-Ruel, Paris, 1895. Reprinted in Jean de Rotonchamp, *Paul Gauguin*. Paris and Weimar, 1906.—Charles Morice, *Gauguin*. Paris: Morancé, 1920.

5 On the importance of African art in the first quarter of the twentieth century see Michel Leiris and Jacqueline Delange, *African Art*. London and New York, 1968. The first exhibition of African art was private (*Art nègre et art océanien*. 1919, Galerie Devambez; catalogue by Paul Guillaume with a foreword by Guillaume Apollinaire) and the second public (*Sculptures africaines et océaniennes. Colonies françaises et Congo belge*. October, 1923, Musée des Arts décoratifs, Paris).—It is worth mentioning in this connection that it was an expert on the art of black Africa who wrote the first monograph on Giacometti's godfather Cuno Amiet (Eckhart von Sydow, *Amiet*. Strasbourg, 1913), while the first German art critic to write on Giacometti (310) and give him a place in the history of art (312) was none other than Carl Einstein, the author of the then very widespread illustrated editions *Negerplastik* (Berlin, 1915) and *Negerkunst* (Munich, 1920).

6 Hans Arp, "Tibiis Canere." *XXe Siècle*, No. 1. Paris, 1938, p. 44.

7 Polychrome sculpture had been a much-discussed subject ever since Max Klinger's *succès de scandale*. The young Giacometti may have received his most direct inspiration from Hermann Haller's painted terracottas; this young Swiss sculptor, then twenty-five, was introduced to the public in 1907 by Julius Meier-Graefe in the best German art magazine of the time, *Kunst und Künstler*. Meier-Graefe accompanied his laudatory essay with an illustration showing a painted, bearded man's head and the polychrome bust of a woman (page 432). The Giacomettis had this magazine and the boy might well have been impressed by the realism of these pieces, in which he might have recognized his parents; at least his father's beard and his mother's coiffure were there.

The idea that a sculpture, to be complete, had to be painted, occupied Giacometti's thoughts for the rest of his life. The reports of how he painted his sculptures the night before the 1962 Biennale was to open prove that he considered polychromy as the finishing touch (735).

8 Here the information passed on from biography to biography should be set right: Giovanni Giacometti did not go to the Venice Biennale in the capacity of commissioner of the Swiss Pavilion, he went as a member of the Federal Art Commission and, as such, would not have considered exhibiting himself, as has also been stated. The Giacometti paintings shown there were by Augusto. In addition to a large memorial exhibition for Ferdinand Hodler, who died in 1918, Switzerland showed the work of fourteen painters whose styles varied from pre-Impressionist to late Art Nouveau and Fauvist Post-Impressionism, and that of twelve sculptors, all classical and Rodinesque. France exhibited large numbers of Cézannes and Signacs. See *Catalogo della XIIe Esposizione Internazionale d'Arte della Città di Venezia*. 1920, pp. 39–41, 42–47, 123, 125.

9 Archipenko had opened a school of sculpture in Berlin in 1921; when he moved to New York in 1923, he gave up his Paris atelier for good, so Giacometti had to look for a new one (Alexander Archipenko, *Fifty Creative Years*. New York: Tekhne, 1960). We can be fairly certain Archipenko was not among Giacometti's teachers, though his earlier style appealed to Giacometti between 1930 and 1933 when he was making notes on the greatest works of modern sculpture. On Archipenko's work at the 1920 Biennale see: *Catalogo della XIIe Esposizione Internazionale d'Arte della Città di Venezia*. 1920, pp. 142–43.

10a Daria Guarnati, "Le voyage [de Bourdelle] en Italie." *Bulletin de la vie artistique*. Paris, December 1, 1922.

10b Gaston Varenne, *Bourdelle par lui-même. Sa Pensée et son art*. Paris: Fasquelle, 1937, p. 63.

10c Antoine Bourdelle, *La Sculpture et Rodin* [written 1918–22]. *Précédé de quatre pages de journal par Claude Aveline*. Paris: Émile-Paul, 1937, pp. XI, XV–XVI.

10d Pierre Descargues, *Bourdelle*. Paris: Musée Bourdelle, 1954, pp. 7, 76.

10e Sandor Kémeri, *Visage de Bourdelle*. Paris: Colin, 1931.

10f Daniel Marquis-Sébie, *Le Message de Bourdelle*. Paris: L'Artisan du Livre, 1931, pp. 86, 87 ff., 110–11, 122, 127, passim.

11 The gravestone is a variation on the mourning figure *Little Crouched Man* (1926; page 47); it is recognizable as a human torso especially from the back; as in *Torso* (1925; page 40), a vertical groove stands for the backbone. On its flattened front surface above the name of the deceased the stone carries a relief showing a bird on a branch—indicated by a simple triangle—and next to it a chalice; above the chalice is the sun, above the bird a star. The symbolism is simple: a bird with a chalice is the Christian metaphor for the certainty of eternal life; Alberto and his father saw this motif in May, 1920, on early medieval ambos in Venice and Torcello. Giacometti rediscovered the buriel bird on Polynesian ancestral sculptures and used it in *Invisible Object* in the spring of the same year. Hence the gravestone Giacometti made for his father is a sum of experiences and thoughts both personal and eclectic in nature.

After Giacometti's death, his brother Diego placed a bronze bird, modeled in the round, on his headstone in the cemetery at San Giorgio di Borgonovo.

12 The difference between Giovanni and Alberto Giacometti's approaches to reality, especially as regards composition, is pointed up by the following anecdote: the young painter Adolf Mohler, who so revered Giovanni Giacometti that he went on a pilgrimage to Stampa in the spring of 1919 ("Alberto got a bottle of wine out of the cellar") and worked in his studio for a few weeks in 1920, recorded these thoughts of his master: the very fact that the theme of a picture was seen in reality might almost be a guarantee of its artistic value. Mohler: "Standing at the window, he often observed groups of people which had formed by chance. At such times he would say to me: 'One can't compose better than that. Never!'" (187) Thus Alberto's father discovered readymade solutions for his realistic compositions; yet actually they were only momentary glimpses, true only for a second of time and hence inadequate as constellations of reality; the constellation that formed two seconds later on the village square would already have robbed the painter's composition of its verity.

One month later, in May 1920, Alberto had a vision which showed him a much more extensive reality. On a dark street in Padua, as the silhouettes of three girls appeared before him, he suddenly realized that reality is that Other which art can never hope to grasp (17). Many years later, after the second war, Giacometti echoed his father's observation: "At every hour the people stream together and drift apart. Living compositions are continually being formed and re-formed." (70) But his conclusion was

very different: "What I want to represent is the totality of this life." This is why a piece like *The City Square* of 1948–49 (page 122) is so different from Giovanni's *Village Square*: it is not a moment of reality frozen forever in bronze, but an artistic statement, whose style sets it above the truth of the moment and makes it timeless. Giacometti once said of realistic art: "A realistic picture is much too unreal a picture to become style [i.e. in his sense of style as the lasting fixation of a vision]. Its mistake lies in the fact that it corresponds to no reality at all." (62).

[13] This is especially true of the portraits and portrait sculptures he did of his father, his sister Ottilia, brother Bruno, and cousin Renato Stampa in Maloja and Stampa; from 1930 on they share a strange combination of angularity and smoothness of form (705:4).

[14] This is the piece's most evident difference from Brancusi's *Boy's Torso* of 1922, which is often said to have inspired it (572; 729; 801). Actually its entire conception is different; nor does the lateral cartilage attachment on the height of the left shoulder have anything to do with the stylized lip-form of Brancusi's *White Negress* (1924). Much more to the point is the comparison with Raymond Duchamp-Villon's *Torso of Young Man* of 1910.

[15] After seeing the drawing Giacometti made of *Disagreeable Object* in 1931 (1) one can extend the title: unpleasant to touch. In it, a hand with spread fingers touches the phallus form only very gingerly.

The woman of *Invisible Object* is similar to those wooden images the Polynesians made of their women when they died. These figures were always poised between a seated and upright position and were placed before the dead woman's hut before being burnt at the final burial ceremony. The hood, which in Giacometti's figure becomes hair, signified that the woman in question was a member of the upper caste or aristocracy. The bird on the seat in Giacometti's piece was also borrowed from Polynesian mythology. Giacometti himself indicated that he had seen just such a figure in the Basel Ethnological Museum (Inventory No. V b 8235; page 291, fig. 30). In a conversation with Jean Clay (67), he spoke of the reconstruction of a Polynesian ancestral house (this theme is important for the idea and configuration of the group *Women for Venice*) which he said he had seen there; it has stood for decades in the same room as the burial figure. Other visual impressions influenced the position of the arms and other motifs of the piece (see pages 103–4).

The sculpture $1+1=3$ reminds one of the Ekoi monoliths of Nigeria with their low-relief arms and eyes, but even more surprising is its similarity to the ninepins from the Sudan which friends of Giacometti (Georges-Henri Rivière and Paul Rivel) discussed in an illustrated article in *Minotaure* (No. 2, 1933, p. 4).

[16] The title of this composition, *The City Square* (1948–49; page 122) which Giacometti explained more directly than any other (68), indicates that it was a "realization" of the *Model for a Square* of seventeen years earlier. His final treatment of this theme, which might finally have led to a realization in the full sense of the word, was to remain in the project stage: his composition for the Chase Manhattan Plaza (1960–65).

[17] Illustration in *Minotaure*, No. 2, 1933, p. 26. Giacometti made plaster copies of all the parts of *Model for a Square* on the same scale as this snake-fetish (all illustrated in the two drawings he made of his atelier in 1932, page 292, figs. 34 and 35; and in Brassaï's photograph of 1932, page 293, fig. 39). A wooden model of the original plaster is in the Peggy Guggenheim Collection in Venice (543:91; 545:207). The large-scale outdoor version has to be executed in stone (illustration caption in *Cahiers d'art*, 1932, p. 341: "Projet pour une place en pierre"). Giacometti had intended the sculpture for use—people could walk around on it, lean on the shapes, sit on the horizontal block like a park bench (13a). Any comparison with other similar outdoor sculptures (by Le Corbusier or the later "environment" artists) must always keep one basic difference in mind, namely, that Giacometti was not at all concerned with "the successful play of volumes in light" (Le Corbusier) but with the situation of a myth in a setting enlivened by the presence of real people—like the village clearing used for cult or ancestor worship by so-called primitive peoples.

Critics misrepresent Giacometti's sculptures of this period when they describe them as compositions in pure form, for they are profoundly metaphorical. There is a remarkable difference between the seriousness of Giacometti's artistic achievements and the quick realizations of some of his contemporaries. For the same reason, formal comparisons with, say, the Etruscan bronze liver in the Museum at Piacenza (543:90; 572) or the rubbing board from the Cyclades (718:32, *Cahiers d'art*, 1957, fig. 34) are of limited relevance. We can learn more about Giacometti's conception of art by comparing the metaphor of *Model for a Square* with that of Böcklin's oil *Odysseus and Calypso* (1883, Kunstmuseum, Basel; Chirico paraphrased this picture as early as 1910; see William S. Rubin, *Dada and Surrealist Art*. New York: Abrams, 1968, p. 423). By employing the contrasted symbols for man and woman (column and cave, stele and hollow) they both portray the myth of the gulf between the sexes.

[18] Years later the co-ordinate axes appear again on the forehead of the busts of *Yanaihara* (1960) and *Annette VI* (1962), both done in the extremely corporeal style of Giacometti's last period. Perhaps they were meant to put some distance between the viewer and these sculptures in the round, which could so easily be interpreted as conventional, and also to document that, even in such immediate, realistic pieces, he was still concerned with symbolic representation of reality as seen from a distance.

[19] *Exposition internationale de la sculpture*. Tériade chose the work in this exhibition with the express intent of confronting older, more traditional German and French sculptors with the avant-garde. The show opened before all the German work had arrived, so initially a second Giacometti could be shown, his *Three Figures Outdoors* (illustrations in *Cahiers d'art*, 1929, pp. 465, 471, 473). This exhibition brought the twenty-eight-year-old his first taste of fame; he was celebrated as "the sculptor-wunderkind all Paris is talking about" (132); Jean Cocteau held forth about Giacometti a whole evening long to a chosen few (113); a report on cultural activities in Paris written in winter 1929–30 was titled *Falconetti as Sculptor*, coupling the fame of Mme. Falconetti, an actress who was receiving ovations in the part of Phaedra at the time, with Alberto Giacometti's sudden success (132). The German art critic Carl Einstein ended his report on the exhibition with an almost unbelievable leveling of the ranks: "Our sympathy goes to the names Lipchitz, Laurens, Brancusi, and Giacometti." (310:391).

[20] Quoted by Alfred Werner in "Lipchitz: Cubist" in the catalogue *Lipchitz, The Cubist Period, 1913–1930*. New York: Marlborough Gerson Gallery, 1968.

[21] Giacometti was, if not the only, surely the most serious of the Surrealists to apply the basically literary concept "plastic poetry" (*Poésie plastique* was the name Jean Cocteau gave to an exhibition of found objects in 1926; Le Corbusier had already exhibited natural forms as *Objets à réactions poétiques* in his Pavillon de l'Esprit Nouveau in 1925) and that of *Found, Interpreted, Symbolically Active etc....Objects* (the title of Breton's Surrealist exhibitions of 1933 and 1936) to purely visual, completely self-sufficient compositions which required no further comment to be understood.

[22] Like André Breton, several Surrealists had studied medicine and worked as attendants in psychiatric wards, which sheds light on many Surrealist practices (see Jean-Louis Argeliès, "Médecine et Surréalisme." Mimeographed. Montpellier, 1969). Giacometti took part in pseudo-psychoanalytic sessions for "experimental research into free-association" in February and March, 1933 (6), gatherings he thought both worthless and grotesque. This is probably the source of the strong

words he was using to condemn his Surrealistic pieces by the end of 1934 (159, 226), and very likely the reason he changed the titles of many of them in his letter to Pierre Matisse in 1947 (13; 13a).

23 From the time this piece was titled *Point to the Eye,* critics have been justifiably reminded of the scene in Buñuel's film *Un chien Andalou* (729) where a razor approaches a human eye and apparently cuts into it (actually, it is a sheep's eye). Giacometti had the chance to see the film in fall 1929 in a studio theater on Rue Tholozé. That same fall his friendship with Michel Leiris became especially close. At the time Leiris (like their common friend André Masson, the painter) was full of dramatic stories, among them his youthful experience of having shot his sister in the eye with an air rifle. Giacometti's sculpture *Woman with Her Throat Cut* borrowed its motif from another story of Leiris's, who, as a child, had had to undergo an operation which included a throat incision. During the same years, while Giacometti was working on these sculptures, Leiris wrote his life story (1930–35; published under the title *L'Âge d'homme.* Paris: Gallimard, 1939. Reprinted 1946).

24 First reproduced in *Cahiers d'art,* Nos. 8/10, 1932, p. 339; reproduced several times thereafter. One gathers from Christian Zervos's essay (323: 342) that Giacometti was not satisfied with the way he had conceived the reclining woman, and was working on a second version. This version, in preliminary form, appears in one of the two drawings he made of his studio in 1932: it is no longer as angular or Lipchitz-like as the *Tormented Woman* and not quite so organic or Picasso-like as *Woman with Her Throat Cut.* Brassaï's photographs in *Minotaure* (Nos. 3/4, 1933, pp. 46 and 47) show the final version, which Giacometti seems to have kept in his studio until shortly before the war, while *Tormented Woman in Her Room at Night* was found in a Paris gallery by Peggy Guggenheim in 1939; as it was damaged, she took it to him to be fixed, but he persuaded her to take *Woman with Her Throat Cut* instead (155). The fragments of *Tormented Woman* are in the Giacometti estate and have yet to be reassembled. The plaster piece hanging over the bed in the second studio drawing of 1932 (page 292, fig. 35) would appear to be yet another version of the same subject (page 293, fig. 45; see my report in *Du,* No. 563. Zurich, May, 1971).

25 Not only the motif of this piece justifies a comparison with the machine scene in Chaplin's *Modern Times*—like every Parisian at the time, Giacometti was an addict of Chaplin films (185). Just as the camera functions "subjectively" in that scene by showing the hero's arms from his own point of view, thereby putting the audience in his shoes and creating a direct identification with him, Giacometti pulls the observer into his machine by rep-

resenting only a lower arm and hand.—A still from one of Max Fleischer's animated films reproduced in *Cahiers d'art* (No. 6, 1930, p. 334) comes even closer to the situation of a directly involved, "subjectively filmed" hand.—The idea behind machine-sculpture goes back to Marcel Duchamp (*Glissière contenant un moulin à eau,* 1913, The Philadelphia Museum of Art) but Giacometti's piece reminds one more than anything of the apparatus used by itinerant knife-sharpeners, at that time a very common sight in the streets.

26 It is not impossible, but improbable that Giacometti read Hegel's *Aesthetik* in the original German. Whatever the case, a not documented biographical note is worth mentioning here: Jacques Dupin talked with Giacometti in 1960–61 and recorded that "in 1915 [in Schiers] interested in literature— German Romantics, Goethe, Hölderlin." (708:87) In a conversation with Carlton Lake in the fall of 1964 Giacometti mentioned a selection of Hegel's writings in French—identified by James Lord as that made by Bernard Teyssèdre from S. Jankélévitch's translation (Paris: Aubier, 1944) and called *Esthétique de la peinture figurative* (Paris: Hermann, 1964). Ten years earlier Claude Khodoss had edited another and better French selection from the translation by Bénard (Paris, 1840–57): Hegel, *Esthétique.* Paris: Presses Universitaires de France, 1954. Both indicate the interest of modern French thought in Hegel; such popularizations in study editions with a contemporary vocabulary were not made in German-speaking countries. For our purposes, a re-translation from the French comes closest to the texts Giacometti used. Here is a complete list of Hegel quotations cited in the main text, together with the page references for the French editions mentioned above:
Citations from Georg Wilhelm Friedrich Hegel, *Werke.* Edited by H. G. Hotho. Berlin, 1835 (2nd edition, Berlin, 1843). Vols. 10¹, 10², 10³, *Aesthetik:*
 10², p. 127 = Khodoss, 1954, p. 84 = Teyssèdre, 1964, pp. 62–63.
 10³, pp. 20–21 = Khodoss, 1954, p. 64 = Teyssèdre, 1964, p. 76.
 10², pp. 124–25 = Khodoss, 1954, p. 82 = Teyssèdre, 1964, p. 61.
 10², pp. 127–28 = Khodoss, 1954, p. 85 = Teyssèdre, 1964, p. 63.
What Giacometti told Jacques Dupin in the fall of 1965 about the significance of the gaze and the difficulty of representing it in sculpture (817; quoted on pages 171 and 283) has astonishing parallels in Hegel (10², pp. 392–96), but Giacometti wanted to do in sculpture what Hegel thought possible only in painting. The French selections named above do not contain this chapter, however. It is not impossible that, shortly after the war, Giacometti heard an echo of the widespread discussion of Jankélévitch's complete translation,

which was reissued in 1964 in two volumes with the titles *L'Art classique* and *L'Art romantique* (Paris: Aubier-Montaigne).

27 Historically and biographically speaking, *No More Play* was executed at the time the New York Stock Exchange crash had put an end to the golden twenties in Montparnasse and when socialist revolutionary demands faced Fascist reaction on all fronts. Giacometti joined the battle as only an artist can, at first in the Surrealist camp, later under Aragon's spell. Seen against this background, the formal inspiration for *No More Play* probably came less from Duchamp's *Monte Carlo* than from a drawing by Georges Malkine which, instead of open graves, has little swimming pools and, instead of people threatened by imminent death, bathers with their arms raised in joy—and its title is *Ecstasy!* (Illustrated in *La Révolution surréaliste,* No. 7, 1926, p. 14.) In terms of formal analysis, one thinks of Léger's playing-card compositions of 1927 and of the wooden game boards from Benin, one of which was in the African collection of the art dealer Charles Ratton, an acquaintance of Giacometti's.

28 There *is* a "solution" to this piece, which is as simple and meaningless as Alexander's cutting through the Gordian knot: one simply takes the ball out of its groove and sets it in the depression. This was how *Circuit* was exhibited in Paris in 1969–70, a typically feminine interpretation of the piece. Giacometti illustrated the correct position of the ball in his letter to Pierre Matisse in 1947 (13).

29 In 1932 it was reproduced over the caption *Fall of a Body Onto a Diagram* (323:341)—perhaps this title alludes to its formal similarity to that Etruscan bronze liver at Piacenza (see 543:90) which has various characters etched on its surface for fortune-telling purposes and which played a certain role in other works of Giacometti. In 1947 Giacometti renamed the sculpture *A Kind of Landscape: a Reclining Head* (13); this is very much in the tradition of the picture-puzzle landscapes that turn into heads when seen from the right angle. The Surrealists passed around just such an ambiguous painting done by Joos de Momper in the seventeenth century; they called it a *Tête-Paysage* (head-landscape; 159:235). In 1931 Dali found a photograph of Negroes sitting before a kraal, turned it on its side and published it as *Visage paranoiaque* (paranoid face) (159:217). Christian Bérard, who had been Giacometti's friend since 1928, painted a profile of a reclining head so large that it looked like a mountain range (*The Sleeper,* 1928). These three examples all have, more or less pronounced, the convexity on the one side and steplike serrations on the other of the body named *Landscape: Reclining Head* in Giacometti's *Life Goes On.*

René Magritte reversed the relationship when he painted the word "Montagne" (mountain) diagonally across the woman's face in his *Ghost-Landscape*. He probably inspired Giacometti to write the title on some of his things of the period; two essays he wrote in 1929 demonstrated the effect to be gained by it (in *Variété*, No. 8 and *La Révolution surréaliste*, No. 12).

All this cross-referencing may seem pedantic, but the relationships are real and point up a very important fact: Giacometti camouflaged many of his pieces with Surrealist mystification in the form of titles, anecdotes, and allusions, not only as a member of the group but also later in his letter to Pierre Matisse. And the work in question was, in reality, an integral part of the compositional idea he had been resolutely developing for three decades. Take the sculpture with the pregnant woman and open grave, *Life Goes On*. It surely transcends Surrealist ambiguity, even if it profited formally from it. The fact that Giacometti felt he had to justify a piece, which was aesthetically so strong and so rich in content, by applying to it the conventional wisdom of the Surrealists makes it all the more understandable that, after 1935, he felt free to work uncompromisingly (67; 723:48) and develop a program of sculpturally self-sufficient yet figurative compositions (13).

[30] Giacometti's *Palace at 4 A.M.*, that stage set for a psychodrama, inspired at least one stage designer, André Acquard, who made the set for the Paris premiere of Genet's *The Blacks*—a fragile scaffolding with chambers of space connected by gangways (illustrated in *Projekt*, No. 4. Warsaw, 1968, p. 18).

[31] In Böcklin's *Island of the Dead* the Surrealists—helped along by Chirico's Böcklin paraphrases such as *The Departure of the Knight Errant* (1923)—could find the common province of the subconscious: the rowboat in the foreground was for them a ferry to the island of mystery. There they met not only the sweet and spine-tingling secret of death; each one of them met himself on the world's stage on which (in Giacometti's words) the "totality of life" was playing to a full house. The Surrealists transformed Böcklin's island into a setting for their personal psychodramas.

The Swiss painter Walter Kurt Wiemken (1907–1940; he lived in Paris from 1927 on and knew Giacometti through their mutual acquaintance, the painter Kurt Seligmann) put a very tiny copy of the *Island of the Dead* as a "source reference" into one of his paintings, the rest of which consisted of variations on Böcklin's theme in a manner similar to Lurçat's series of landscapes. This painting is a good example of how the Surrealists saw in the island motif not only a place for self-realization but a metaphor for the world. (On Wiemken see Dorothea Christ, *Walter Kurt Wiem-*

ken. Lausanne: Rencontre, 1971. On the relationship of the Surrealists to Böcklin see Georg Schmidt, *Arnold Böcklin*. Basel: Hollein, 1951, pp. 29–30; Marcel Jean, *Histoire de la peinture surréaliste*. Paris: Seuil, 1959; William S. Rubin, *Dada and Surrealist Art*. New York: Abrams, 1968.)

[32] Although it does not belong to the composition proper, the complicated base of which Giacometti made two drawings (one formerly in the collection of Mrs. Pierre Matisse, New York, now lost, and the other in the Kupferstichkabinett, Basel) is not without iconographic significance. There is good reason for the observation that for his *Sea-Maid* (*L'Océanide*, 1932–33), Henri Laurens used a very similar pedestal consisting of a flat plate mounted on a thick segment of column (810); we might add why: Laurens's bronze is just as much a variation on a popular theme of bourgeois-kitsch salon painting as Giacometti's *Palace* is a variation of the *Island of the Dead*; for it is based on the painting *The Sea-Maids' Despair at the Foot of the Rock of Prometheus* (*Désolation des océanides au pied du roc de Prométhée*) by Henri Lehmann (1814–1882), once a public attraction at the former Luxembourg Museum. (This work was illustrated in the *Larousse du XXᵉ Siècle* as late as 1932. The article devoted to it noted that it was very widely distributed as a lithograph.) Both Laurens and Giacometti solved the problem of representing in sculpture how a painted theme appears suspended above the waves by using a flat plate mounted on a column; it might not be too farfetched to say that in both cases the pedestal is also a visualization of the force a figure needs to propel itself out of the water.

[33] About this time Giacometti modeled a mannequin's hand for the display window of Elsa Schiaparelli's boutique; the same or a similar hand still hung in his studio decades later (see Ernst Scheidegger's photograph, 714:130); it was a study for the hands of the *Invisible Object* figure. It was typical of the thirties that the Surrealists tried to bridge the gap between fine and applied art: first, in order to make a living during the sudden depression of the art market; secondly, to apply the theses of the Surrealist "revolution," one of which postulated the unity of the banal and the esoteric; and thirdly, to find new formal inspiration for their work. Show-window dummies were the great discovery of painters and photographers at the end of the twenties who saw in them symbols of the robot-like life of people in the big city. Later, the Surrealists used them to create homunculi for every erotic fancy. However, Giacometti's figures *Mannequin* and *Walking Woman* (both 1932), which took their form from stylistic necessity more than anything else, predated the Surrealist shows ("Street of Mannequins" at the International Surrealist Exhibition of 1938).

[34] Two elements in *Invisible Object* are rather difficult to interpret: the rectangular frame behind the figure, and the base, which is made up of several parts and looks rather like a squat stool. Andrew Causey (520:28) thought the "ladder-like chair" was a compositional idea of Lipchitz's. One might profitably speak of the aesthetic necessity of the frame in terms of "figure," "background," and "surrounding space," in other words in terms of the coming-into-being of the figure frontally against the depth of space behind it, much like the later paintings with their frames within the frame. All the elements of this composition which have yet to find their interpretation—the head and the way it overtops the frame behind it, the foreshortened chair seat and the plate covering the figure's shins—remind one strongly of the limestone statue of the Egyptian queen Nofrit on her throne (2800 B.C., Cairo Museum) as Giacometti studied it in *Plastik der Ägypter* (H. Fechheimer, Berlin 1920, Plates 18 and 19). These illustrations show it from the front and diagonally from the side. (On the basis of many of Giacometti's early drawings from Egyptian statues it is possible to determine from which reproductions he copied them.)

[35] Picasso, *Modèle et grande tête sculptée*. Etching from the *Suite Vollard* (Geiser Print Catalogue, No. G. 323; Bloch Catalogue, No. Bl. 170).—The caption *Pavilion by Night* (in the May issue of *Minotaure*. Paris, 1934, p. 42) is somewhat earlier as a title for *Cube* than the Lucerne title *Part of a Composition*. The pencil drawing *My Atelier* (1932; page 292, fig. 34) shows that a rhomboidal cage with enclosed figure was the first and basic form Giacometti's cube took. Thus what ended life as a head with etched self-portrait began as a container for a dreamlike action (a self-portrait in a cage of thoughts? as a dreamer?), similar to *The Palace at 4 A.M.* It is possible that this rhomboidal construction, which is otherwise undocumented, is the sculpture *Palace II*; earlier, *Cage* (1931) was published as *Palace III* (341; 363; 365).

The pedestal form of *Part of a Composition* reappears, interestingly enough, in those later works which treat the same theme using similar elements: *Seven Figures, One Head (The Forest)* and *Three Figures, One Head (City Square)*, both of 1950. In *The Cage* (1950–51) the base plate has been transformed into a tall stand.

The final, but never completed, conception of *Part of a Composition* can be seen in *Head on a Pedestal* of 1960, which, as an "artwork within the artwork," was to form a contrast to the *Standing Women* and *Walking Men* on Chase Manhattan Plaza—seen as a whole, this composition was more than ever a metaphor for the "totality of life" as Giacometti understood it.

[36] *Cahiers d'art*, 1933, Nos. 1/2: advertisement. The sculpture *Caress*—under the title *In Spite of the*

Hands—was the first Giacometti work to come under the auctioneer's gavel; it brought 2,100 francs on April 2, 1933, in the Hotel Drouot. (On June 20 of the same year Vicomte Charles de Noailles, true patron that he was, paid 6,000 francs for the Surrealist *Table* in plaster.) One gets an idea of the increasing difficulties of the avant-garde from the price another Giacometti brought at auction a few years later: the bronze *Cubist Composition* was sold for 230 francs in 1936 (403:235).

[37] Maurice Merleau-Ponty, *Phénoménologie de la Perception*. Paris: Gallimard, 1945. The chronology according to: Jean-Paul Sartre, *Situations IV*. Paris: Gallimard, 1964, p. 195.

[38] Art dealers' disinterest was limited to Giacometti's post-1935 work; in 1938, for instance, Peggy Guggenheim refused to exhibit his "little Greek heads which he carried in his pocket" in her new London gallery. Yet she expended no little effort in acquiring an earlier piece (155) and exhibited later Giacomettis in her New York gallery Art of This Century from 1942 to 1945, as did the gallery Pierre Matisse. The Paris galleries Jeanne Bucher and M. A. J. (Pierre Loeb) advertised "sculptures by Laurens, Lipchitz, Giacometti, Arp, Gonzalez, Calder, etc." until the Germans occupied France in the summer of 1940; these were necessarily post-Cubist and Surrealist compositions because Giacometti would not let the later things out of his sight, or because he often presented them to his contemporaries in a manner they could not understand. In 1939, for instance, when he was invited to participate in the exhibition *Zeichnen—Malen—Formen: Kunst der Gegenwart*, part of the Swiss Federal Exhibition in Zurich, he wanted to put one of his new tiny figures on a very large base made to his specifications. Aesthetically he was surely in the right, and perhaps his contribution would not have been refused if he had not set up the base in advance but had unveiled it together with the figure as an integral part of the composition. Significantly, an earlier work was chosen to replace the later one in this case, too—*Cube* of 1934—which the Swiss public could at least recognize as a stylized but nevertheless solid piece of rock (368). To date most of the surviving head and figure studies from the years 1936–45 are still in the Giacometti estate; very few are in private hands and none are in museum collections.

[39] Giacometti did not arrive at this conclusion completely unprepared. Nor was he the first to do so. Careful calculations have always been made when a monumental sculpture was to be erected; the Egyptian and Baroque periods provide us with good examples of this. Much more to the point, though, are the lectures held by the Swiss sculptor Carl Burckhardt when Giacometti was still at school. Speaking at the Rodin exhibition in Basel in 1918, he made use of the concepts *Nahform* (forms meant to be seen close up; for example Rodin's *Citizens of Calais*) and *Fernform* (forms meant to be seen from a distance; for example *The Thinker* and *Balzac*). See Carl Burckhardt, *Rodin und das plastische Problem*. Basel: Schwabe, 1921, pp. 41–47. This important source for Giacometti's aesthetics was discovered and quoted extensively by Carlo Huber (718:5–11).

Contrary to his sculpture, in his paintings and drawings Giacometti always related the apparent size of his subject to the width of his visual field. This is the basic reason underlying the anecdote about the pears which became "smaller and smaller" on his paper during a drawing lesson with his father. In many of his paintings, the black brushstrokes which form the inner frame serve to reduce the size of the canvas to the area of the visual field, namely, the central image and its immediate surroundings.

[40] Here, one involuntarily thinks of a spot in Balzac's novel *The Unknown Masterpiece* (1832), a book we will have cause to refer to again later in connection with Giacometti's difficulties in painting Isaku Yanaihara's portrait. In both cases, Balzac has his mad painter, Frenhofer, say things Giacometti could well have said:

The mission of art is not to copy nature but to express it! Otherwise a sculptor could just make plaster casts and be done with it. Just try it—make a casting of your mistress's hand and set it before you—you'll have a terrible cadaver with no resemblance to life at all ... only the artist's chisel can create movement and life. A hand is not just a thing hung on the body, it expresses a thought which has to be rendered. But your hand here reproduces, without your knowing it, the model you copied in your teacher's class.

[41] At this point it is easy to see the connection with theories of perception then current; Sartre's, for example (*Nausea*, 1938; *Being and Nothingness*, 1943), which sums up reality as its appearance *for someone*. But the thought had occurred to Giacometti long before, in 1921, at the deathbed of Van M., when he found a letter of Flaubert's quoted in Maupassant's *Note on Gustave Flaubert* (12) which strangely anticipated the insights he was to have later: "Did you ever believe in the existence of things? Isn't it more likely that everything is an illusion? The only true thing is our rapport with reality, that is, our perception of things." (Guy de Maupassant, "Étude sur Gustave Flaubert." In Flaubert, *Bouvard et Pécuchet*. Paris: Quantin, 1885. First reprinted in Flaubert, *Œuvres complètes*. Paris: Conard, 1930, vol. 29, p. 91.)

[42] Baroque theater—insofar as it, more than any other style, is the theater of appearances and presences—allows us to draw a clear analogy: What would the ghost of Hamlet's father be if it were to march across the stage in boots and spurs or even a shroud? A masquerade, but never a frightening apparition. And if, in the last act of *Don Giovanni* the statue of the Commendatore (an exact parallel to *Woman with the Chariot*!) were to be wheeled toward the banquet feast in any other way but frontally, straight on, then even timid Leporello would have to laugh at its ridiculousness; but frontally, even the skeptic falls under its spell.

[43] From 1947 on, Giacometti's striding figures were (with one exception) all masculine; the *Walking Man* theme (1947, 1949, 1960) had the rank of a monumental composition up until the time of the Chase Manhattan group. To interpret its content we must turn to the Surrealist manifesto of 1947, whose title page carried the sentence: "L'homme qui marche est une cause libre" (The walking man is a free agent; taken from the philosophy text by Arnauld and Nicole, *Logique du Port-Royal ou: Art de penser*. Paris, 1662). But the Surrealists had overprinted the words "L'homme qui marche" with the word "Le Surréalisme" in red (see Jean-Louis Bédouin, *Vingt ans de surréalisme, 1939–1959*. Paris: Denoel, 1961, p. 101), which may just have goaded Giacometti into using the original formulation to title his work.

[44] In the original of Parinaud's interview we read: "Those that are the least *realistic*," but Giacometti meant, of course, naturalistic (reproducing natural forms), not realistic (reproducing an experienced reality by transcending natural form).—Again, in Parinaud's text, Giacometti refers to the art of the "Chaldeans"; the works he is thinking of are generally referred to as "Sumerian" (at least in German and English). Giacometti speaks of "art chaldéen" in a text of 1957 (20) and an interview of 1961 (60), but of "art sumérien" in a conversation with Pierre Dumayet in 1963 (64).

[45] Actually there are very few "Etruscan" themes in Giacometti's work. Only one is worth mentioning, that inspired by the bronze liver the Etruscans used for cultic fortune-telling, with its projecting geometric shapes and engraved radia scales with characters (Etruscan Museum, Piacenza; 543:90; 572). It seems to have left its mark in *Model for a Square* (1932), *Fall of a Body Onto a Diagram* (1932; also called *Life Goes On*) and also in the time/space drawing in the text *The Dream, the Sphinx and the Death of T.* (12; 1946).

The Etruscan prejudice as part of the Giacometti legend goes back to the effect his personality had on the public when Michel Leiris and Jean Cocteau pushed the young sculptor from the Bergell into the bright lights of the Paris art world in 1929–30. His looks, his accent, and his friends' unclear ideas about the origin of the inhabitants of the Italian-speaking (not Romansh, as many thought) Bergell Valley in the Grisons fostered the rumor that he

was one of the last surviving members of some wonderfully preserved tribe; the next link in the chain of inference was when someone said he had "a head like an Etruscan statuette." (132) His way of pronouncing the "r" as something approaching "w," unlike a Frenchman or Italian but like the man from the Bergell he was, was interpreted in many interesting ways (as a speech impediment, for instance — 71:120) and was vaunted as a mixture of the peasant and the aristocrat in its possessor. "Seldom does an Italian from the seacoast have the rough timbre of the Italian-speaking Swiss, unless it is the result of alcohol. This vocal register was part of the fascination which Alberto Giacometti had on people." (Gian Paolo Tozzoli, *Gli Svizzeri visti da uno straniero.* Rome, 1966.)

[46] Goethe observed that "every person's power of fantasy [allows him] to imagine objects, when he wishes to find them significant, as higher than they are wide, which lends the image more character, seriousness, and dignity" (*Italienische Reise*, May 13, 1787); if there is such a psychological law, it certainly applies to Giacometti's monumental women. To take a very different report, that of a forty-three-year-old man who was enabled to see for the first time in his life by an eye operation: "The first thing I saw were eyes. This frightened me terribly at first, but then I realized I could see. They were the professor's eyes. Behind the professor *a shadow moved*. Its outlines *grew larger*, and suddenly a beautiful, *big* woman threw her arms around my neck: it was my wife, whom I had never seen in seventeen years of marriage." He goes on: "Up until then I had 'seen' only by touching things. But I couldn't judge proportions by measuring with my hands. I had always imagined cars as being very small oval or rectangular boxes. *Now they seemed gigantic to me*. At first I was very surprised that you can't see the roof of a house and the street at the same time, but that you have to *look up first* (one's ears pick up sounds from all directions simultaneously, of course) . . . *Everything is really enormous, especially high*." (From a newspaper report of March 23, 1969, on Antonio Dagati of Turin; emphasis added.) The moving shadows remind one of Giacometti's figure drawings of 1947–49—gray, smudged images as tall as the drawing paper, out of focus, schematic.

[47] But Giacometti said somewhat later that, in the last instance, art always comes out a second best to reality, of necessity (56). Yet he also knew that this was unimportant, that if art loses in the comparison, it is all to the good, for the superior richness of reality is revealed.

[48] "But," he added in parentheses, "that's not the only motive that compelled me to do this sculpture." (14) *Chariot* was made for the Paris City Council (Conseil Municipal de Paris), who com-

missioned a sculpture from him after the war (545); hence the idea of doing a monument on the Occupation played a role in the conception of this piece, too, as it had in *Study for a Monument* and *Night*. —It is hard to say how literally we can take Giacometti's story about a wheeled cart loaded with medicines (14) being the inspiration for *Chariot*; this may have been a bit of Surrealistic invention on his part. From the formal point of view the story is doubtful to say the least. The transformation of a low, four-wheeled cart with rows of bottles on it into an ancient-looking, high-wheeled chariot with a slender figure floating more than standing on it seems all the more unlikely for the fact that a more plausible source exists: the two-wheeled Theban battle chariot of the 18th Dynasty in the Egyptian Museum in Florence (page 295, fig. 56). The four-spoked, high wheels, the proportions, the slender rod over the axle, even the wooden blocks which fix it to the museum floor —everything is there and was still fresh in Giacometti's mind when he began work, "even though the theme was already part of the past for me" (he is referring to his trip to Italy in September, 1920). The question remains open as to why this thirty-year-old memory should force itself on him in 1950 to the extent that he found it impossible *not* to make *Chariot*; we can only suppose that his confrontation with Samuel Beckett and his novels had something to do with it. (Giacometti's connections with Beckett will be discussed in more detail below.)

[49] In 1950–51 Giacometti expanded this sculpture into a two-figure group which no longer exists today: *Pointing Man (bronze) and Standing Man (plaster)* (167: No. 28). We know nothing of the compositional idea that informed this group, but perhaps it was the same as in his painting *Men Bathing* (708:114), the bronze *Three Men Walking* (708:245), or the two isolated yet somehow related *Men Walking I and II* of the Chase Manhattan Plaza project.

[50] The formal history of *The Nose* includes not only the Polynesian rake in André Breton's collection which, when it was suspended from the point where handle met sheath, resembled nothing if not a tiny head with a long nose, but also the painted blow-weapon masks from New Britain (such as that in the Basel Ethnological Museum, Inventory No. V b 296; page 295, fig. 61).

[51] Giacometti wrote these two anecdotal interpretations in the fall of 1950 for the catalogue of his second exhibition at the Pierre Matisse Gallery in New York. He was still in the habit at this late date, of clothing his compositional ideas and technical problems with Surrealistic and basically superficial "crisis moments." The pieces *Me, Hurrying Down the Street in the Rain*, *The Dog*, and *The Cat*

(1950 and 1951) were also equipped with similar anecdotes, as if works like these needed any sort of extra justification; yet perhaps it is true after all that a piece like *The Dog* gains significance only when we know the story behind it (it is said to be a self-portrait in a moment of depression: 53; 723; 735).

We cannot know for certain what Giacometti intended with *Me, Hurrying Down the Street in the Rain* or his self-portrait as a dog. In the case of *The Cat*, at least the anecdote associated with it (which describes it as a representation of Diego's cat as it came to Giacometti's bedside every morning—723:21) suggests that it was meant to be seen from the front, as were most of his sculptures. And San Lazzaro's comment is interesting; Giacometti told him that the lack of volume in the cat's body symbolized its ability to walk between objects like a ray of light without touching them—a pertinent metaphor for the spirit of any living creature (207).

The brothel stories Giacometti told about the two compositions with four women in a row have successfully hindered anyone from uncovering their true sources. It was the Egyptian collections at Florence or Paris (more likely the one at Florence), which supplied him with the idea for *Chariot*, also done at this time (page 295, fig. 56). The glass showcases there, which are still very much the same as when Giacometti saw them first in 1920, hold large numbers of small bronze burial statuettes of gods and goddesses, mounted individually or severally on wooden bases and stood in rows. Here are the thread-thin figurines, the tiny heads, the hieratic statuettes with their stylized hair, all mounted on bases very similar to those Giacometti put to such good use to increase the effect of his tiny figures and heads. One meets Giacometti's walking figure *Me, Hurrying Down the Street in the Rain* among the Egyptians, too, but called *Ammon Walking* and displayed on a wooden board.

It would be possible to write a separate study concerning Giacometti's demands that his art should have the same effect as the great artworks in the museums. The arrangement of his bronzes resembles, more than anything else, that of a museum showcase—and here the museum should be understood as a substitute for a place of worship. Seen like this, only the frontal view (through the glass partition) would be possible—no getting close to the objects, no touching them, or walking around them.

Perhaps Giacometti's rather incomprehensible wish to put a golden patina on some of his figures might also be explained by the golden burial figures in the Egyptian collections; it was a stylistic means he associated with Egyptian art. But any discussion of this or other formal relationships Giacometti's work shared with Egyptian art should

always keep in mind the basic differences: with Giacometti, the real increase in value provided by the material—so important to the Egyptians—is missing; for them, the valuable material expressed their high respect for the dead and was an assurance of eternal life. Their artifacts were not made to be seen, but were hidden in graves; Giacometti's "phenomenological" sculpture is not complete without the observer. And he did not intend his sculptures as artifacts but as monuments—perhaps one can even say "cult images"—to be set up in the street, in public. Their size is the best indication of this. Giacometti was more challenged than inspired by the Egyptian collections he loved. He would have liked to have been able to speak ancient Egyptian, he said in 1933 (6); later, his sculpture spoke the language but filled it with modern content.

⁵² Using just these concepts of "in-depth focus" and "accommodation of the eyes," Heinz Keller made an excellent contribution to the art of looking at Giacometti sculpture (574), surely without prior knowledge of our earlier note on both Rembrandt's and Giacometti's use of "in-depth focus" in their work (563). Herbert Matter (728), Michael Speich (574), and Franco Cianetti (617) have made revealing photographs of Giacometti statues by varying the focus of their cameras; Giacometti is said to have been especially interested in Cianetti's "unsuccessful" (because out of focus) photographs (707:11).

⁵³ Here we shall condense the thoughts of Balzac's Frenhofer into a few excerpts from the novel and refer the reader for purposes of comparison to Giacometti's statements on Yanaihara in the "Documentary Biography" and especially to James Lord's descriptions of the sittings (723:26 etc.).
Yesterday evening I thought I was finished. I had found a way to reproduce on the flat canvas the relief and roundness of nature, but this morning, by daylight, I realized my error. The woman isn't alive . . . she is pasted on the canvas, you couldn't go around behind her, she's a lifeless silhouette, a cut-out image. One doesn't feel the air between the figure and the canvas; space and the feeling of distance are missing. Under this ivory skin there is no blood and there is no real life coursing in these veins. The contours are wrong, for they do not envelop the body and do not lead around the back. Anyway, there are no lines in nature, everything is volume—one would have to draw sculpturally, that is, detach the things from their surroundings. [It is a temptation to visualize Giacometti's drawings when reading these sentences of Balzac.] *. . . And now, look—with three or four brushstrokes and a blue-gray, mirror-smooth glaze one can start the air circulating around the head of this poor saint. And the line drawing won't stop at the contours now, for I'll put a nuance of warm, light halftones around the contour so that you won't be able to put your*

finger on the spot where the figure meets the background. [This holds literally for Giacometti's post-1954 portraits.] *But I'm not yet satisfied, I'm doubtful. Perhaps one should begin painting a face in the center with the clearest and closest parts and work out to the darker parts later. . .? I have been working on this picture for ten years now; but what are ten short years when one has joined battle with nature? Yet through my searching I've come to doubt the goal of my search. Oh! if one could only see the whole of divine nature, complete, just once . . .!*

Consciously or unconsciously, Giacometti lived out the "frenzy" of this artist legend. His life corresponded no less to that of the alchemist Claes in Balzac's *The Search for the Absolute* (1832), a title Sartre and his followers made the leitmotiv of their Giacometti exegeses (383; 617; 631).

⁵⁴ Here it becomes clear that the crises of the early thirties lay behind Sartre's interpretation—and behind his philosophy as a whole, for that matter. The roots of what is called "the Existentialist period," which is considered as connected with the Second World War and said to find expression in Giacometti's figures, lie in the common experiences of the then thirty- to forty-year-olds: Sartre, Giacometti, Camus, Céline, Henry Miller, and Beckett (to limit ourselves to the Paris scene). It is interesting to note here that Sartre begins the fictional diary which is the backbone of his novel *Nausea* (Paris, 1938) with an entry dated January, 1932, in which he records the complete and sudden change in all things perceived; the title *La Nausée* was suggested by the publisher, Gallimard; Sartre had called his manuscript *Mélancholie* (according to Simone de Beauvoir, *La Force de l'âge,* passim).

In cloudy memories of the splendour and misery of Montparnasse the Giacometti legend runs like this: "Giacometti: the last of the *Montparnassiens,* the last of the *maudits,* friend of poets and prostitutes . . ." (100) Baudelaire, Rimbaud, Van Gogh, Modigliani . . . such linear thinking is too easy, and thus widespread. Meret Oppenheim, the painter, visualized this chain of thought with her lifesize bronze *Alberto Giacometti's Ear,* a relic which dates from the years of active Surrealism, for it is based on a drawing she made in 1935. The obvious parallel is Van Gogh's ear, and one can assume that an artist like Meret Oppenheim meant the sur-real comparison literally.

The legendary comparison Giacometti-Modigliani came to life in 1941, the year Giacometti supposedly loaded all the sculptures in his atelier on a handcart and dumped them in the Seine (107)—just as Modigliani, in a destructive fury which came over him in Livorno in 1912, sunk a cartload of his sculptures in a pond. The latest legend (1970) brings Alberto's brother Diego into the game: in a feat rivaling the transference of miraculous deeds from the saints to the knights in the late Middle Ages, the brothers Giacometti have been

glorified as the latter-day Vincent and Theo van Gogh (140).

⁵⁵ We do not know the source of this statement. Thomas B. Hess and James Lord thought it so important that they emphasized it in their obituaries (156; 175).

⁵⁶ Eberhard Grisebach, *Maler des Expressionismus im Briefwechsel mit E. G.,* edited by Lothar Grisebach. Hamburg: Wegner, 1953. List paperback No. 343: *Von Munch bis Kirchner.* Munich: 1968, p. 130.

⁵⁷ The text *May, 1920* was published in January, 1953 (17), but idiosyncrasies of content and language date it at about the time of Giacometti's first letter to Pierre Matisse (13, late 1947). In it, he carries on the reminiscences he began in *The Dream, the Sphinx and the Death of T.* (12, late 1946), discusses themes mentioned in the Matisse letter and closes, as in the letter, with a sentence to the effect that everything has taken on a new aspect in the past few days, that something different is coming, but that he does not know exactly where he stands.

⁵⁸ Ferdinand Hodler described death in one of his notebooks of the time as "the permanence of immobility, the absolute immobility of speech, the permanence of absence." (C. A. Loosli, *Hodler.* Bern, 1924, IV, p. 223.) There is a painted parallel to Alberto's written report (12) in the work of his father—Giovanni Giacometti's self-portrait of 1899, which shows his head against a distant, snow-covered landscape with Segantini's funeral procession winding its way through it. Giovanni's head—very much in the foreground and very large—anticipates almost all the characteristics of his son's much later portraits: the severe frontality, the intense gaze, the question, implicit in the choice of subject, as to the meaning of life. Father and son never came closer than this in the basic content of their art.

⁵⁹ Guy de Maupassant, "Étude sur Gustave Flaubert." In Flaubert, *Bouvard et Pécuchet.* Paris: Quantin, 1885. First reprinted in Flaubert, *Œuvres complètes.* Paris: Conard, 1930, Vol. 29, p. 91. This quote, which so strangely corresponds to Giacometti's memory of his own experience, has been translated word for word with one exception: Maupassant wrote: "It is probable that the first blow *of epilepsy* imprinted melancholy and worry on the spirit of that robust fellow."

⁶⁰ Much later, however, Giacometti explained the personal consequences that resulted for him from Van M.'s death in terms of the chain of chance events which, he said, had deeply disturbed him (67 [1963]).

⁶¹ A sentence like: "Here I should add that the first thing I saw when I left the pharmacy, the

tube of Thiazyomide in my hand, and stepped out into the Avenue Junod—two steps away from my doctor's house—was the sign of a little café across the street, which read 'The Dream' [*Au Rêve*]"—such a sentence corresponds exactly with the theatrical quality of André Breton's anti-novel *Nadja* (Paris, 1928), in which, by the way, the lover of literary topography will find an illustration of the brothel-cum-hotel Le Sphinx (to which Giacometti's title alludes).

The doctrine of Surrealism attempted to sink new roots in postwar Paris. The catalogue of the *International Surrealist Exhibition* of 1947 (at the Galerie Maeght) named Giacometti as one of the perpetrators. Breton supposedly had insisted that his sculpture *Invisible Object* be included, but Giacometti refused to participate in any way (159;341). Even if by 1946 he had not yet overcome his Surrealistic literary style, the Surrealists' manifestations and, above all, their posing jarred on him at a time of intensive and serious work on pieces like *Head on a Stalk*. Later Giacometti condemned Surrealism in no uncertain terms, as did another visionary, Antonin Artaud, in the broadsides against the 1947 exhibition he sent to André Breton (*L'Éphémère*, No. 8, 1968, pp. 3-31). It was not until 1960, when Giacometti had found his own style and a well-earned, if belated, success and had shown *Invisible Object* in several retrospectives, that he allowed the piece to figure in an exhibition of (historical) Surrealism at the Galerie Charpentier.

[62] Beckett's stage directions sometimes evoke Baudelaire's poem, too; for example: "Very pompier trompe-l'œil backcloth to represent unbroken plain and sky receding to meet in far distance" (*Happy Days*, 1961).

The last line of Baudelaire's poem: "Le silence, l'espace affreux et captivant..." inspired not only Jacques Dupin's interpretation of 1954 (533), but also Palma Bucarelli's analysis of Giacometti's space-cages, which she published in 1961 under the title "Giacometti: o del Prigioniero" ("Giacometti, or: On the Prisoner"; 510); her association "space-cage with emaciated figures equals concentration camp with prisoners" is a hypothetical actualization of an aesthetic theme, at least as far as most of Giacometti's work of the kind goes. Yet it is not improbable—even though the artist himself answered direct questions on the subject with a wave of the hand or outright denials—that he was so shaken by photographs of the gas chambers and camps—for example, the photo of the naked Jewish woman being driven across the open space between the prisoners' barracks and the gas chambers—that he had to give vent to his feelings in his work: his *Woman in a Box Between Two Houses* (1950; page 296, fig. 76), with its two bronze cubes at either end flanking a central box of glass, evokes this

photograph most strongly. (The most impressive cast of this piece is in the Giacometti Foundation collection in Zurich; the female figure is the only part of the composition which is painted; she is naturalistic and pale, and seems terribly helpless and naked between the two blackish bronze bunkers. The version in the Ida Meyer-Chagall Collection in Basel transcends this naturalism with its golden-bronze figure and center section.) Perhaps sculptures like *Man Pointing* and *Head on a Stalk* (1947) or *Man Collapsing* (1950) were also influenced by the horrors of the war; perhaps the weathered, almost burnt-looking, mummified *Large Standing Figures* (1960; we are thinking of the painted versions at the Fondation Maeght, Saint-Paul-de-Vence) are mute witnesses to such visual impressions. Albert Camus, in his *Man in Revolt* of 1951, gave the best commentary on this aspect of art when he defined the sculptor's task as expressing through style "that which, in the body and visage of woman, survives every degradation."

[63] Giacometti's pathological vertigo may have been caused by his stomach problems (*vertigo a stomacho laeso* would be the medical diagnosis). In 1963 he underwent an operation for a chronic stomach ulcer. The different descriptions of the abyss feeling corroborate one another and add up to an existential experience in the deepest sense of the word. Giacometti apparently not only accepted his cancer in this sense but—if he had had the choice to make—would have wanted this disease (69;104).

[64] We know that Descartes dreamed about trees; such dreams, according to Freud, express the difficulty of understanding the universe (*The Interpretation of Dreams*. Leipzig and Vienna, 1900). Identifying with a tree is an expression of the wish to integrate oneself into the world—to be redeemed. Pascal described the man-nature polarity: "The greatness of man is great insofar as he knows he is miserable. A tree does not know it is miserable." (*Pensées*. Paris: Pléiade, 1950, p. 893).

[65] When one knows this excerpt, one is more critical upon a second reading of Sartre's interpretation of Giacometti's sculptures: "In space, says Giacometti, there is too much. This too much is purely and simply the coexistence of all individual particles in juxtaposition." (383) Here, Sartre brings Giacometti into his camp simply by putting words in his mouth. Sartre: "Every existence was confused, vaguely inquiet, with no sense of rapport with the others. Superfluity: that was the only rapport I could see between the trees, the fence, the gravel" (*Nausea*. Paris, 1938). And when Sartre writes in his essay on Giacometti's painting: "Giacometti thinks that the real is a purely positive thing; that there is something which exists and then it is gone; that a transition from being to

nothingness cannot be conceived of" (621), he is not quoting Giacometti but his own thoughts of 1938: "I could not put my finger on the flux of existence. Everything that exists comes from nowhere and goes nowhere." Giacometti's observations on the subject were much more concrete than this and questioned the artist's ability to capture reality whole: "Actually one only copies the vision of something which remains in one's mind after looking at it—the conscious image.... When I look at the glass on the table, its color, its form, its brightness, every time I look I grasp only a very tiny thing about it which is very difficult to analyze.... Every time I look, the glass seems to have re-formed and become a whole again; its reality becomes doubtful because its projection in my brain is doubtful, or at least partial. One sees it as if it were disappearing... and reappearing again... and disappearing... and reappearing... that means that it really and truly is always in a state between being and non-being. And that's what I'd like to copy." (61)

[66] It is extremely interesting to compare Giacometti's description of the hospital medicine cart he saw while recuperating from his foot injury: "I was really amazed at the medicine cart they wheeled clinking through the room" (14), with the words of Malone, lying strapped to his bed: "The door half opens, a hand puts a dish on the little table left there for that purpose.... When I want to eat I hook the table with my stick and draw it to me. It is on casters, it comes squeaking and lurching towards me" (Penguin ed., p. 12). The manuscript of *Malone Dies* had been finished for years when, in 1950, Giacometti wrote about *Chariot* in his report to Pierre Matisse.

[67] Olga Bernal, *Langage et fiction dans le roman de Beckett*. Paris: Gallimard, 1969.

[68] Hugh Kenner, *Samuel Beckett. A Critical Study*. London: Calder, 1962.

[69] By this time Giacometti had completely given up the kind of existential philosophizing which borrowed its most striking metaphors from the Paris school (Sartre, Camus, Fondane, Bataille on the one hand and Gabriel Marcel on the other). Beckett, in *The Unnamable*, made it quite clear that his view of the world touched deeper and more radical layers of human experience than Sartre's: "They must consider me sufficiently stupefied, with all their balls about being and existing.... Anything rather than these college quips... so as to exclaim, the sleight of hand accomplished, oh look, life again, life everywhere and always, the life that's on every tongue, the only possible!" (New York: Grove Press, 1958). Beckett's jibe was aimed at this sentence from Sartre's *Nausea*: "It was crawling with existences, existences which con-

tinually renewed themselves yet never came into being. . . . Existence everywhere, to infinity, too much, always and everywhere." Under the surface of many similar veiled references in his books, we see Beckett coming to terms with "them," the men who had turned the word "abyss" into a cheap formula and substituted it for a deep and real understanding of the meaning of existence.

To date, the best art-historical criticism of the Existentialist-literary interpretation of Giacometti's oeuvre (by Sartre, Palma Bucarelli, Jacques Dupin, and others) is that by Hilton Kramer in *Arts Magazine*, November, 1963 (577). Beckett apparently made no direct statements on Giacometti's work; his thoughts on the meaning of art and the function of the artist took the painter Bram van Velde as their example (*Cahiers d'art*, 1945/46; *Derrière Le Miroir*, Nos. 11/12, 1948; *Transition*, No. 5, 1949). It is not difficult to find many analogies to Giacometti's thinking in these articles, for the simple reason that Giacometti was very much affected by Beckett's words from the beginning.

[70] We can quote a third witness to the effect that, in Paris, the experience of distance, air, and atmosphere is apparently strongly associated with the color gray in all its variations; in 1956 Henry Miller reminisced about his years in Paris during the thirties: ". . . even the word gray . . . has little in common with that *gris* which, to the ears of a Frenchman, is capable of evoking a world of thought and feeling. . . . I mention it because Paris, as everyone knows, is pre-eminently a gray city. . . . In France the range of grays is seemingly infinite; here the very effect of gray is lost.—I was thinking of this immense world of gray which I knew in Paris. . . ." (*Quiet Days in Clichy*. New York: Grove Press, 1965, pp. 5–6.)

[71] We cannot put our finger on the exact place Beckett uses the metaphor of the blind man stretching his hand out in the night, but it shows the imagination of a true poet. The first line, which Giacometti repeats throughout his poem: "A blind man extends his hand in the void (in the blackness? in the night?)" reminds one of the spot in Céline's *Journey to the End of the Night* (Paris, 1932) where a man who does not yet realize he is blind stretches his hands out through an open window and asks if it is really dark, if it is nighttime.

[72] The side and top views Giacometti drew of this model are extremely accomplished and rank with compositions like *Model for a Square* (1932), *The City Square* (1948–49), and *The Forest* (1950). The model's cone-shaped feet came from *Cube* (1934) and its upright plates from *The Palace at 4 A.M.* (1932). The time/space disk's division into sectors reminds one of *Fall of a Body Onto a Diagram* (1932; page 293, fig. 42).

[73] Alain Robbe-Grillet on the time concept in the *nouveau roman* in the weekly *Arts-Lettres-Spectacles*, No. 890, October 10, 1962.—Claude Simon on one's knowledge of another person in *L'Express*, April 5, 1962.—A summary of the form and content of the *nouveau roman* in: Ludovic Janvier, *Une parole exigeante*. Paris: Minuit, 1967.

[74] Maurice Merleau-Ponty, "L'Œil et l'Esprit." In *Art de France*, No. 1. Paris, 1961, pp. 187–208; reprinted in: *Les Temps Modernes*, Nos. 184/185. Paris, 1961, pp. 193–227; our quotes: 213–14, 215. Book edition: Paris: Gallimard, 1964.

Merleau-Ponty's argumentation is not based on Giacometti's work but on the artist's second conversation with Georges Charbonnier (56). He quotes Giacometti's opinion that Cézanne searched his whole life long for a way to represent depth in space (56:176) and emphasizes that in his paintings Giacometti was looking for something that would help him understand the real world better (56:172). One star witness must be quoted here, for his words are a necessary addition to Merleau-Ponty's, Giacometti's, and my own; in his garden at Giverny, Claude Monet told Georges Clemenceau the following in the early 1920s:
While you search philosophically for the world as it is, I simply extend my efforts over the widest possible field of appearances, in close correlation with the unknown realities. When one is on the plane of corresponding appearances, one cannot be very far from reality, or at least from what we can know about it. I haven't done anything except observe what the universe has shown me, and then render it with my brush. But is that nothing? Your mistake is that you would like to reduce the world to your scale, whereas one's knowledge of self continually grows because one's knowledge of things also continually increases. (Georges Clemenceau, *Claude Monet*. Paris: Plon, 1928.)

[75] *Isab* derives from the word *Isba*, meaning Russian log house, a word which entered the Slavic and Romanic languages as a corruption of the German *Stube*.

[76] From a letter of Helene Spengler to Eberhard Grisebach, late December, 1920. In Eberhard Grisebach, *Maler des Expressionismus im Briefwechsel mit E. G.*, edited by Lothar Grisebach. Hamburg: Wegner, 1953. List paperback No. 343: *Von Munch bis Kirchner*. Munich: 1968, p. 130.

[77] On Sartre's preconceptions when describing Giacometti's sculptures as "shooting up," see especially his *L'Être et le Néant*. Paris: Gallimard, 1943, p. 327.

[78] Surrealism is the source of the paradoxical demand that an artist work with materials which deteriorate quickly. Here, Sartre is describing Giacometti in the same words André Breton used in the early thirties to describe Picasso's plaster sculptures (in *Minotaure*, No. 1. Paris, 1933, pp. 8–37).

[79] Dore Ashton, "L'École de Paris à New York." *XXe Siècle*, Vol. I, No. 3. Paris, April 15, 1959, p. 14.

[80] Thomas B. Hess, *Barnett Newman*. New York: Walker, 1969, p. 39.

[81] The national awards in the "small" Guggenheim contest are awarded by a jury of citizens of the country in question. Among the Swiss artists awarded honorable mentions the same year were the painters Richard Lohse, Max von Mühlenen, Pierre Terbois, and Varlin—hence Giacometti's prize was a relatively minor honor.

List of Illustrations

89 *Study with Four Heads in Profile from the Right.* 1938. Pencil, 11 × 8¼". Private collection, Paris.

90 *Carafes and Flowers.* 1938. Pen and ink, 10⅝ × 7½". Kunsthaus, Zurich. Giacometti Foundation.

91 *Drawing after an Egyptian Relief.* 1942. Pen and ink, 9½ × 7⅜". Collection Dr. Christoph Bernoulli, Basel.

92 *Street Scene with the Artist Drawing.* 1942. Pencil, 16 × 12¼". Private collection.

93 *The Sewing-Table.* 1941. Pencil, 16 × 12½". Galerie Claude Bernard, Paris.

94 *Portrait Head of Diego.* 1946. Pencil, 19⅝ × 12½". Galerie Claude Bernard, Paris.

95 *Female Nude.* 1946. Pencil, 20⅞ × 14⅛". Collection Sir Robert and Lady Sainsbury, London.

96 *Still Life with Apples.* 1946. Pencil, 14 × 13". Collection Allan Frumkin, New York.

97 *Hommage à Balzac.* 1946. Pencil, 18 × 12". Collection Sir Robert and Lady Sainsbury, London.

98 *Standing Female Nude.* 1946. Pencil, 19⅝ × 12⅝". Private collection, Paris.

99 *Figures.* 1947. Pencil, 19⅝ × 12½". Private collection, Paris.

100 *Jean-Paul Sartre.* 1946. Pencil, 11¾ × 8⅞". Collection James Lord, New York.

109 *Colonel Rol-Tanguy.* 1945–46. Bronze, height 10⅝" (including base).

110 *Sculptures in the Atelier.* From the years 1934–47.

111 *Standing Woman.* 1946–47. Plaster, height 3½" (including base). Private collection, Paris.

112 *Woman with the Chariot.* 1942–43. Bronze, height 65¾".

113 *Man Walking.* 1947. Bronze, height 66⅞".

114 *Head on a Stalk.* 1947. Painted plaster, height 24" (including base). Kunstmuseum, Basel. Giacometti Foundation.

115 *Head on a Stalk.* 1947. Painted plaster, height 24" (including base). Kunstmuseum, Basel. Giacometti Foundation.

116 *The Hand* (variation). 1947. Plaster, length 31⅛". Kunsthaus, Zurich. Giacometti Foundation.

117 *Man Pointing.* 1947. Bronze, height 69⅝".

118 *Large Standing Woman.* 1949. Bronze, height 65¾" (left).

118 *Standing Woman.* 1959. Bronze, height 23⅝" (right).

119 *Seven Women for Venice.* 1956. Bronze, heights from 43¼" to 52⅝".

120 *The Nose.* 1947. Metal and painted plaster, height 32½". Kunsthaus, Zurich. Giacometti Foundation.

121 *The Cat.* 1951. Plaster, 13 × 31⅞ × 11". Kunsthaus, Zurich. Giacometti Foundation

122 *The City Square.* 1948–49. Bronze, 24¾ × 17⅜ × 8¼".

123 *City Square (Three Figures, One Head).* 1950. Painted bronze, height 22". Kunsthaus, Zurich. Giacometti Foundation.

124 *The Forest (Seven Figures, One Head).* 1950. Painted bronze, height 22½". Kunsthaus, Zurich. Giacometti Foundation.

125 *The Glade (Nine Figures).* 1950. Bronze, height 22⅞.

126 *Three Men Walking.* 1949. Bronze, height 28⅜".

127 *Four Figures on a Pedestal.* 1950. Painted bronze, height 29⅞". Kunsthaus, Zurich. Giacometti Foundation.

128 *Four Women on a Base.* 1950. Painted bronze, height 63⅜". Kunstmuseum, Basel. Giacometti Foundation.

129 *The Cage (Woman and Head).* 1950. Painted bronze, height 69⅝". Kunsthaus, Zurich. Giacometti Foundation.

130 *Walking Quickly under the Rain.* 1949. Bronze, 17¾ × 30¼".

131 *Imprisoned Statuette.* 1950. Plaster, height 25⅝". Private collection, Paris.

132 *Chariot.* 1950. Bronze, height 56".

137 *Annette in the Atelier*, with *Chariot* and *Four Figures on a Pedestal.* 1950. Oil on canvas, 28¾ × 19⅝". Private collection, London (colorplate).

141 *Caroline II.* 1962. Oil on canvas, 39⅜ × 31⅞". Kunstmuseum, Basel (colorplate).

145 *My Mother.* 1937. Oil on canvas, 24 × 19⅝". Collection Mrs. Pierre Matisse, New York.

146 *The Table.* 1950. Oil on canvas, 13¼ × 18⅛". Kunstmuseum, Basel. Emanuel Hoffmann Foundation.

147 *Yellow Chair in the Atelier.* 1946. Oil on canvas, 17⅜ × 12⅝". Collection Herbert Lust, Chicago.

148 *Annette.* 1950. Oil on canvas, 28½ × 13½". Kunstmuseum, Basel. Emanuel Hoffmann Foundation.

149 *Tree Between Buildings (Rue Hippolyte-Maindron).* 1947. Oil on canvas, 24⅜ × 26⅜". Private collection.

150 *Standing Female Nude.* 1951. Oil on canvas, 24⅜ × 9". Private collection, London.

151 *My Mother in the Parlor.* 1950. Oil on canvas, 30 × 24". The Museum of Modern Art, New York.

152 *Three Plaster Heads in the Atelier.* 1947. Oil on canvas, 28¾ × 23½". Kunsthaus, Zurich. Giacometti Foundation.

153 *My Mother in the Bedroom.* 1951. Oil on canvas, 36¼ × 28¾". Collection Aimé Maeght, Paris.

154 *Small Figure.* 1953. Oil on canvas, 31⅞ × 25⅝". Galerie Beyeler, Basel.

155 *Still Life with Bottles.* 1954. Oil on canvas, 13 × 18¼". Galleria Galatea, Turin.

156 *Diego in the Atelier Reading a Newspaper.* 1955. Oil on canvas, 36¼ × 28". Kunstmuseum, Winterthur.

157 *Table in the Atelier with Bottles and Plaster Sculptures.* 1951. Oil on canvas, 31⅞ × 25⅝". Private collection, Riehen.

158 *Portrait of G. David Thompson.* 1957. Oil on canvas, 39⅜ × 28¾". Kunsthaus, Zurich. Giacometti Foundation.

159 *Figures (Annette once, Diego twice).* 1954. Oil on canvas, 31⅞ × 23⅝". Collection Louis Clayeux, Paris.

160 *The Street.* 1952. Oil on canvas, 28¾ × 21¼". Galerie Beyeler, Basel.

161 *The Garden in Stampa.* 1960. Oil on canvas, 21⅝ × 18⅛". Sidney Janis Gallery, New York.

162 *Portrait Bust of Diego.* 1957. Oil on canvas, 23⅝ × 28¾". Galleria Galatea, Turin.

163 *Gray Figure.* 1957. Oil on canvas, 25 × 21¼". Sidney Janis Gallery, New York.

164 *Half-Length Portrait of Annette Seated.* 1958. Oil on canvas, 30½ × 22⅞". Sidney Janis Gallery, New York.

165 *Portrait of Isaku Yanaihara.* 1958. Oil on canvas, 36¼ × 28¾". Galerie Claude Bernard, Paris.

166 *Portrait of Maurice Lefebvre-Foinet.* 1963. Oil on canvas, 31⅞ × 23⅝". Collection Maurice Lefebvre-Foinet, Paris.

167 *Head of a Woman.* 1964. Oil on canvas, 19⅝ × 15¾". Kunstmuseum, Basel. Giacometti Foundation.

168 *Caroline.* 1965. Oil on canvas, 51⅛ × 31⅞". Private collection, Paris.

173 *Large Standing Nude.* 1962. Oil on canvas, 69 × 27⅝". Galerie Beyeler, Basel (colorplate).

Documentary Illustrations, pages 289–296

1 Paul Cézanne. *Still Life with Apples.* 1895–98. Oil on canvas, 27×36½". The Museum of Modern Art, New York.

2 Giovanni Giacometti. *Vase and Fruit-Dish.* 1919. Oil on canvas, 26×29⅛". Private collection, Zurich.

3 Alberto Giacometti. *Plate with Apples.* 1920. Oil on cardboard, 16½×14". Private collection, Switzerland.

4 Ferdinand Hodler. *Sketch for "The Battle of Murten."* 1915. Pencil, gouache, and ink on paper, 8⅝×11¾". Private collection, Switzerland.

5 Alberto Giacometti. *Sketch for "The Stoning of Saint Stephen."* 1921. Oil, dimensions unknown. Private collection.

6 Auguste de Niederhäusern. *Bust of Giovann Giacometti.* 1905. Plaster, height 12¼". Kunsthaus, Chur.

7 Alberto Giacometti. *Bust of Brother Bruno.* 1917. Plaster, height 7½". Collection Bruno Giacometti, Zurich.

8 Cuno Amiet. *Bust of Alberto Giacometti.* 1920. Plaster, height 13⅜". Private collection, Switzerland.

9 Alberto Giacometti. *Bust of Diego Giacometti.* 1924–25. Painted plaster, dimensions unknown. Private collection.

10 Egyptian, 18th Dynasty. *Male Head.* c. 1400 B.C. Granite, height 8⅝". Archaeological Museum, Florence.

11 Alberto Giacometti. *Mother's Head.* About 1922. Plaster, dimensions unknown. Private collection.

12 Alberto Giacometti. *Mother's Head.* 1927. Plaster, height 13⅜". Private collection, Chiavenna, Italy.

13 Alberto Giacometti. *Flat Head (Josef Müller).* 1927. Plaster, height 13⅜". Private collection, Solothurn.

14 Alberto Giacometti. *Father's Head.* About 1927. Granite, height 11⅝". Private collection.

15 Alberto Giacometti. *Father's Head.* About 1927. Plaster, height 10⅝". Collection Bruno Giacometti, Zurich.

16 Alberto Giacometti. *Head of Bruno Giacometti.* About 1932. Plaster, height 12¼". Collection Bruno Giacometti, Zurich.

17 Alberto Giacometti. *Egyptian Woman (Portrait Bust of Isabelle II).* 1936. Bronze, height 12⅝".

18 Alberto Giacometti. *Woman.* About 1927. Plaster, dimensions unknown.

19 Alberto Giacometti. *Mother and Daughter.* 1933. Bronze, height 5⅞".

20 Alberto Giacometti. *Gravestone for Giovanni Giacometti.* 1934. Granite, height c. 24". Cemetery of San Giorgio di Borgonovo-Stampa.

21 Alberto Giacometti. *Vase or Lamp-Base.* Also known (wrongly) as "Sculpture." 1936. Plaster, height c. 20". Private collection.

22 Constantin Brancusi. *The Kiss.* 1908. Limestone, height 23". The Philadelphia Museum of Art. Louise and Walter Arensberg Collection.

23 Henri Laurens. *Crouching Woman.* 1922. Stone, height 20⅞". Private collection, Paris.

24 Jacques Lipchitz. *Musical Instruments.* 1925. Bronze, height 29".

25 Jacques Lipchitz. *Joie de Vivre.* 1927. Plaster, height 30¾". Collection of the artist.

26 New Guinea (northeast coast). *Dish with Human Head as Handle.* Wood, length 28¾". Galerie Beyeler, Basel.

27 Nigeria (Yoruba). *Male and Female Figure (Ibedji).* Wood, height 10⅝". Museum für Völkerkunde, Basel.

28 Lower Congo (Mayumbe). *Grave Marker of the West Bakongo (Basundi).* Painted wood, height 20⅛". Rietberg Museum, Zurich.

29 Mali (Bambara). *Tjiwara Dance Headdress.* Wood, height 23¼". Collection Eliot Elisofon, New York.

30 Solomon Islands (Bougainville). *Seated Statue of a Deceased Woman.* Painted wood, height 66⅞". Museum für Völkerkunde, Basel.

31 New Guinea (Middle Sepik). *Decoration for a House.* Wood, height 43¼". Collection Josef Müller, Solothurn.

32 Easter Islands. *Bird Figure.* Wood, length 6¾". From a photograph in the Museum für Völkerkunde, Berlin.

33 Alberto Giacometti. *Disagreeable Object.* 1931. Marble, length c. 20". Private collection.

34 Alberto Giacometti. *My Atelier.* 1932. Pencil, 11¾×18½". Kupferstichkabinett, Basel.

35 Alberto Giacometti. *Bed, Coat, and Sculptures in the Atelier.* 1932. Pencil, 12¼×16½". Kupferstichkabinett, Basel.

36 Alberto Giacometti. *The Hour of the Traces.* 1930–31. Wood, plaster, and metal. Size and present whereabouts unknown.

37 Alberto Giacometti. *Suspended Ball* (detail). See photo on page 57.

38 Pablo Picasso. *Project for a Monument.* 1928. Pen and ink, 11¾×8⅝". Private collection.

39 Brassaï. Photograph of Giacometti's atelier with the elements of *Model for a Square* (lifesize). 1932. See page 58.

40 Marcel Duchamp. *The Passage from Virgin to Bride.* 1912. Oil on canvas, 23½×21¼". The Museum of Modern Art, New York.

41 Alberto Giacometti. *Tormented Woman in Her Room at Night.* 1932. Plaster, destroyed, dimensions unknown.

42 Alberto Giacometti. *Life Goes On (Fall of a Body Onto a Diagram).* 1932. Plaster, destroyed, dimensions unknown.

43 Alberto Giacometti. *Project for a Passageway.* 1930–31. Plaster, length 49½". Kunsthaus, Zurich. Giacometti Foundation.

44 Henri Laurens. *Reclining Woman.* 1930. Terracotta, width 19¼". Musée National d'Art Moderne, Paris.

45 Alberto Giacometti. *Woman in the Form of a Spider.* 1932. Bronze, length c. 31".

46 Arnold Böcklin. *Island of the Dead.* 1880. Varnished tempera on canvas, 43¾×61". Öffentliche Kunstsammlung, Basel.

47 F.L. Popova. Model of the stage set for *The Wonderful Cuckold* by Crommelynck. Meyerhold Theater, Moscow, 1922.

48 Jean Lurçat. *Paysage.* 1929. Oil on canvas. Private collection.

49 Giovanni Giacometti. *The Stone Carriers of Promontogno.* 1896. Oil on canvas, 110¼×78¾". Kunstmuseum, Chur.

50 Paul Klee. *Pavilion with Flags.* 1927. Oil on wood, 15⅞×23⅝". Niedersächsisches Landesmuseum, Hanover. Städtische Galerie.

51 Alberto Giacometti. *The Palace at 4 A.M.* 1932. Model, plaster and wire, height c. 25¼". Present whereabouts unknown. See page 67.

52 Alberto Giacometti. Sketches on the reverse of the drawing *The Palace at 4 A.M.* 1932. Pencil, 8½×10⅝". Kupferstichkabinett, Basel.

53 Alberto Giacometti. *The Table.* 1933. Plaster, height 57½". Musée National d'Art Moderne, Paris.

54 Fernand Léger. *Woman at Table.* 1920. Watercolor, 12⅝×9⅞". Private collection, Germany.

55 René Magritte. *The Difficult Passage.* 1926. Oil on canvas, 31⅞ × 25⅝". Collection Madame Jean Krebs, Brussels.

56 Egyptian, 18th Dynasty. *Two-Wheeled Battle Chariot from a Grave in Thebes.* 1504–1450 B.C. Wood (reins modern). Archaeological Museum, Florence.

57 Alberto Giacometti. *The Chariot.* 1950. Painted bronze, height 56". Galerie Beyeler, Basel.

58 Etruscan (Vulci). *Incense Burner in the Form of a Boy on a Four-Wheeled Chariot.* Late 6th century B.C. Bronze, height 11¾". The Louvre, Paris.

59 Egyptian, Middle Kingdom. *The Woman Hennu from the Grave of the Fleet-Overseer Necht in Siut.* c. 1900 B.C. Wood, height, 26". Egyptian National Museum, Cairo.

60 Alberto Giacometti. *Woman in a Barque.* 1950–52. Bronze, height 15".

61 New Britain (Oceania). *Blowgun-Mask of the Baining.* Painted bamboo, 31½ × 48⅜". Museum für Völkerkunde, Basel.

62 Alberto Giacometti. *The Nose.* 1947. Metal and painted plaster, height 32¼". Kunsthaus, Zurich. Giacometti Foundation.

63 New Ireland (Oceania). *Prepared Human Skull.* Covered with wax, chalk, seashells, and painted. Museum für Völkerkunde, Basel.

64 Alberto Giacometti. *Head on a Stalk.* 1947. Painted plaster, height 24" (including base). Kunstmuseum, Basel. Giacometti Foundation.

65 Ivory Coast. *Idol Figure.* Clay, height 10¼". Museum für Völkerkunde, Basel.

66 Alberto Giacometti. *Male Busts (Diego).* 1965. Bronze, heights 21¼ and 18½".

67 Alberto Giacometti. *Tight-rope Walker.* 1943. Pencil, 14¾ × 11¼". Collection Caresse Crosby, U.S.A.

68 Alberto Giacometti. *Study for a Monument.* 1946. Plaster, height 11⅜". Destroyed.

69 Marc Vaux. Photograph of sculptures in Giacometti's atelier. 1946.

70 Alberto Giacometti. *Figure of a Woman in Process of Completion.* 1946. Plaster, height 43¼" (without base).

71 Alberto Giacometti. *Three Figures in the Street.* 1949. Oil on canvas, 22 × 10½". Collection Louis Clayeux, Paris.

72 Alberto Giacometti. *Standing Nude.* 1946. Pencil, 19⅝ × 12⅝".

73 Alberto Giacometti. *Standing Figure.* 1946. Pencil, 21¼ × 11⅜". Galerie Krugier, Geneva.

74 Alberto Giacometti. *Large Standing Woman.* 1947. Bronze, height 66⅛".

75 Alberto Giacometti. *Model of a Monument to a Famous Man.* 1953. Plaster and bronze, height 18⅛". Galerie Krugier, Geneva.

76 Alberto Giacometti. *Woman in a Box Between Two Houses.* 1950. Bronze, height 11¾".

77 Alberto Giacometti. *Man Before a Tree.* 1952. Colored pencil, 13¼ × 9". Private collection, Switzerland.

Systematic Bibliography

A. Texts by Alberto Giacometti (in Chronological Order)

1 "Objets mobiles et muets" [Seven sketches and the prose-poem "Toutes Choses"]. *Le Surréalisme au service de la révolution*, No. 3. Paris, Dec., 1931, pp. 18–19. English translation in the catalogue *Giacometti*. London: Arts Council Gallery, 1955, p. 7.

1a "Objets mobiles et muets" [New version as lithograph printed front and back, with abridged text]. *XXᵉ Siècle*, N. S. 3. Paris, June, 1952, pp. 68 ff. Reprinted in: Bibl. 543, pp. 312–13; Bibl. 727; the catalogue *Malende Dichter, dichtende Maler*. St. Gallen: Kunstmuseum, 1957, p. LXVII; *Bulletin of the Rhode Island School of Design*, LVI, No. 3, March, 1970, p. 26 (Catalogue *Giacometti, Dubuffet—Collection James Lord*); the catalogue *Alberto Giacometti: Dessins estampes, livres*. Geneva: Galerie Engelberts, 1970, p. 37.

2 "Poème en 7 espaces" [Text and typographical drawing]. *Le Surréalisme au service de la révolution*, No. 5. Paris, May, 1933, p. 15. Reprinted in: Bibl. 709, p. 110; Bibl. 712, p. 15; Bibl. 714, p. 12; *Signum*, II, No. 2. Copenhagen, 1962, p. 37. English translation by David Gascoyne, "Poem in Seven spaces." *Art in America*, vol. 54. New York, Jan., 1966, p. 87.

3 "Le Rideau brun" [Text and typographical drawing]. *Le Surréalisme au service de la révolution*, No. 5. Paris, May, 1933, p. 15. Reprinted in: Bibl. 709, p. 110; Bibl. 714, p. 12; *Signum*, II, No. 2. Copenhagen, 1962, p. 37.

4 "Charbon d'herbe." *Le Surréalisme au service de la révolution*, No. 5. Paris, May, 1933, p. 15. Reprinted in: Bibl. 709, p. 110; Bibl. 714, p. 14.

5 "Hier, Sables mouvants." *Le Surréalisme au service de la révolution*, No. 5. Paris, May, 1933, pp. 44–45. Reprinted in: Bibl. 712, p. 13; Bibl. 714, pp. 16–22. English translation in: Lucy R. Lippard, *Surrealism in Art*. New Jersey: Prentice-Hall, 1970; London: Prentice-Hall, 1971.

6 [Replies to the questionnaire:] "Recherches expérimentales sur la connaissance irrationnelle de l'objet: A. Boule de cristal des voyantes [Feb. 5, 1933]; B. Un morceau de velours rose [Feb. 11, 1933]; C. Sur les possibilités irrationnelles de pénétration et d'orientation dans un tableau: Giorgio de Chirico, 'L'Énigme d'une journée (Feb. 11, 1933]; D. Sur les possibilités irrationnelles de vie à une date quelconque [March 12, 1933]." *Le Surréalisme au service de la révolution*, No. 6. Paris, May, 1933, pp. 11–13, 17.

7 "Palais de 4 heures." *Minotaure*, Nos. 3/4. Paris, Dec., 1933, p. 46. Reprinted in Bibl. 733, p. 20. English translation, "1+1=3." *Trans/formation*, I, No. 3. New York, 1953, pp. 165–67. Also Lucy R. Lippard, *Surrealism in Art*. New Jersey: Prentice-Hall, 1970; London: Prentice-Hall, 1971; Bibl. 620, p. 195; Bibl. 731, p. 44.

8 [Reply to the questionnaire:] "Pouvez-vous dire quelle a été la rencontre capitale de votre vie? Jusqu'à quel point cette rencontre vous donne-t-elle l'impression du fortuit, du nécessaire?" *Minotaure*, Nos. 3/4. Paris, Dec., 1933, p. 109.

9 "Le Dialogue en 1934" [André Breton and Alberto Giacometti]. *Documents 34*, N. S. 1. Brussels, June, 1934, p. 25.

10 "Un sculpteur vu par un sculpteur" [Henri Laurens]. *Labyrinthe*, No. 4. Geneva, Jan. 15, 1945, p. 5. Reprinted in: *Verve*, VII, Nos. 27/28. Paris, Dec., 1952, p. 22; catalogue *Henri Laurens*. Amsterdam: Stedelijk Museum; Essen: Museum Folkwang; and Bremen: Kunsthalle, 1962; Bibl. 721, p. 12; catalogue *Henri Laurens*. Berlin: Haus am Waldsee, 1967; catalogue *Henri Laurens*. Le Havre, 1969.

11 "A propos de Jacques Callot." *Labyrinthe*, No. 7. Geneva, April 15, 1945, p. 3. Reprinted in Bibl. 709, pp. 115–17; *Neue Zürcher Zeitung*. 6 Feb., 1967.

12 "Le Rêve, le sphinx et la mort de T." [Text and four drawings]. *Labyrinthe*, Nos. 22/23. Geneva, Dec. 15, 1946, pp. 12–13. Reprinted in Bibl. 714, pp. 38–48.

13 "[Première] Lettre à Pierre Matisse" [Text with thirty-five sketches of the works]. In the catalogue *Alberto Giacometti*. New York: Pierre Matisse Gallery, 1948. Reprinted in: catalogue *André Masson, Alberto Giacometti*. Basel: Kunsthalle, 1950, pp. 18–20; Bibl. 714, pp. 24–31; Bibl. 715, pp. 8–15; Bibl. 726, pp. 16–23; Bibl. 731, pp. 15–29; catalogue *Alberto Giacometti, Zeichnungen*. Hanover: Kestner-Gesellschaft, 1966, p. 28; Bibl. 736, pp. 85–88. English translation by Lionel Abel in the catalogue *Alberto Giacometti*. New York: Pierre Matisse Gallery, 1948; *Tiger's Eye*, No. 4. New York, 1948: "The Ideals of Art. 14 Sculptors Write"; *Trans/formation*, I, No. 3. New York, 1953, pp. 165–67; Bibl. 731, pp. 14–28; Hershel B. Chipp, *Theories of Modern Art. A Source Book by Artists and Critics*. Los Angeles: University of California Press, 1968, and London: IBEG, 1969, pp. 598–601; Lucy R. Lippard, *Surrealism in Art*. New Jersey: Prentice-Hall, 1970, and London: Prentice-Hall, 1971.

13a "Tentative Catalog of the Early Works." In the catalogue *Alberto Giacometti*. New York: Pierre Matisse Gallery, 1948. Catalogue contains twenty-five sketches of the works with titles, dates, first owners. Reprinted in Bibl. 714, pp. 61–68, 75–77.

14 "[Deuxième] Lettre à Pierre Matisse" [Twelve sketches of works with accompanying texts]. In the catalogue *Alberto Giacometti*. New York: Pierre Matisse Gallery, 1950/51. Contains English translation by Lionel Abel. Reprinted in Bibl. 714, pp. 82, 123–24, 126; Bibl. 715, p. 72.

"L'Espace" [Questionnaire by Gualtieri di San Lazzaro, 1951]. See Bibl. 51.

15 "Un Aveugle avance la main dans la nuit." *XXᵉ Siècle*, N. S. 2. Paris, 1952, pp. 71–72. Reprinted in: catalogue *Alberto Giacometti*. London: Arts Council Gallery, 1955, p. 7; Bibl. 714, pp. 8, 10; catalogue *Alberto Giacometti*. Zurich: Kunsthaus, 1962, p. 13; Bibl. 709, pp. 112–13; Bibl. 712, p. 14.

16 "Gris, brun, noir . . ." [On Georges Braque]. *Derrière Le Miroir*, Nos. 48/49. Paris, June, 1952, pp. 2–3, 6–7. Reprinted in Bibl. 714, p. 120; Bibl. 709, pp. 118–20.

17 "Mai 1920 (Sur l'Italie)." *Verve*, VII, Nos. 27/28. Paris, Jan., 1953, pp. 33–34. Reprinted in the catalogue *Alberto Giacometti*. Zurich: Kunsthaus, 1962, pp. 11–12.

18 "Derain." *Derrière Le Miroir*, Nos. 94/95. Paris, Feb., 1957, pp. 7–8.

19 "Ma Réalité" [Reply to a questionnaire by Pierre Volboudt]. *XXᵉ Siècle*, N.S. 9. Paris, June, 1957, p. 35. Reprinted in: Bibl. 714, p. 6; catalogue *Alberto Giacometti*. Zurich: Kunsthaus, 1962, pp. 12–13; Bibl. 715, p. 18; Bibl. 711, p. 8. English translation by Lionel Abel in the catalogue *Alberto Giacometti*. New York: Pierre Matisse Gallery, 1961.

20 'La Voiture démystifiée" [On the Paris Automobile Salon, 1957]. *Arts—Lettres—Spectacles*, No. 639. Paris, Oct. 9, 1957, pp. 1, 4.

21 "My Artistic Intentions" [Reply to a questionnaire by Peter Selz]. *New Images of Man*. New York: Museum of Modern Art, 1959, p. 68.

22 "Lettre à Peter F. Althaus" [Excerpts]. *Du*, No. 205. Zurich, March, 1958, pp. 34, 36. Quoted in Bibl. 102.

23 "Gaston-Louis Roux" [Invitation card to the exhibition "Gaston-Louis Roux"]. Paris: Galerie des Cahiers d'art, May, 1962.

24 "31 Août 1963 (Braque vient de mourir)." *Derrière Le Miroir*, Nos. 144/46. Paris, 1964, p. 8.

25 "Notes sur les copies" [Texts of Oct. 4 and 18, and Nov. 30, 1965]. *L'Éphémère*, No. 1. Paris, 1966, pp. 104–8. Reprinted in Bibl. 703 (in French, English, German, Italian).

26 "Paris sans fin" [Texts of 1963/64 and fall, 1965]. *Paris sans fin, 150 lithographies originales*. Paris: Tériade, 1969.

27 "La Mort du professeur Jedlicka" [Text of Nov. 16, 1965, with a reproduction of a portrait drawing of 1953]. *Neue Zürcher Zeitung*. Nov. 21, 1965.

28 "Tout cela n'est pas grand'chose" (November, 1965). *L'Éphémère*, No. 1. Paris, 1966, p. 102. Reprinted in the catalogue *Aquarelle, Zeichnungen, Gouachen*. Basel: Galerie Beyeler, 1969, p. 5.

B. Alberto Giacometti, Conversations, 1950–1965 (in Chronological Order)

Peter Wyss. Radio interview, 1950. See Bibl. 823.

50 Georges Charbonnier, "Entretien avec Alberto Giacometti." Paris: RTF, March 3, 1951. Published as "[Premier] Entretien avec Alberto Giacometti." *Les Lettres nouvelles*, N.S. 6. Paris, April 8, 1959, pp. 20–27; Georges Charbonnier, *Le Monologue du peintre*. Paris: Juillard, 1959, pp. 159–70.

Georges Charbonnier. See also Bibl. 56, 514.

51 Gualtieri di San Lazzaro, "L'Espace" [Summary of a conversation with Alberto Giacometti, winter, 1961]. *XXᵉ Siècle*, N.S.2. Paris, 1952, p. 71. Reprinted in: Bibl. 711, p. 28; Bibl. 714, p. 8 (first part only); catalogue *Alberto Giacometti*. Zurich: Kunsthaus, 1962, p. 13.

Gualtieri di San Lazzaro. See also Bibl. 207.

52 Yvon Taillandier, "Samtal med Giacometti." *Konstrevy*, XXVIII, No. 6. Stockholm, 1952, pp. 262–67.

53 Gotthard Jedlicka, "Fragmente aus Tagebüchern" [Conversations with Giacometti of March 30, April 1, and April 3, 1953, and during 1958]. *Neue Zürcher Zeitung*. April 4, 1964. Reprinted in Bibl. 720, pp. 15–20.

Gotthard Jedlicka. See also Bibl. 69, 160, 161, 573, 719, 720.

54 Alexander Liberman, "Giacometti" [Visit in summer, 1954]. *Vogue*, No. 218. New York, Jan., 1955, pp. 146–51, 178–79. Reprinted in: Alexander Liberman, *The Artist in His Studio*. New York: Viking, 1960; London: Thames and Hudson, 1968, pp. 277–80, illus. 127–31.

Jean Genet, Conversations with Giacometti in 1954 and 1956. See Bibl. 713.

55 Alain Jouffroy, "Portrait d'un artiste: Giacometti." *Arts—Lettres—Spectacles*, No. 545. Paris, Dec., 1955, p. 9. Partially published in Pierre Cabanne, "La vraie sculpture n'est plus dans la rue." *Arts—Lettres—Spectacles*, No. 825. Paris, June 7, 1961.

56 Georges Charbonnier, "Le Monologue du peintre: Alberto Giacometti." Paris: RTF, April 16, 1957. Published as "[Deuxième] Entretien avec Alberto Giacometti." In Georges Charbonnier, *Le Monologue du peintre*. Paris: Juillard, 1959, pp. 171–83.

57 Alexander Watt, "Conversation with Giacometti." *Art in America*, No. 4. New York, 1960, pp. 100–102. Revised printing in Bibl. 649.

58 *Rinascità*. Rome, 1962. Conversation with Alberto Giacometti at the 1962 Venice Biennale. Published in: Mario de Micheli, "È morto lo scultore Alberto Giacometti." *L'Unità*. Rome, Jan. 13, 1966.

59 Pierre Mazars, "Giacometti." *Arts—Lettres—Spectacles*, No. 872. Paris, June 5, 1962.

60 Pierre Schneider, " 'Ma longue marche' par Alberto Giacometti." *L'Express*, No. 521. Paris, June 8, 1961, pp. 48–50.

Pierre Schneider. See also Bibl. 62.

61 André Parinaud, "Entretien avec Giacometti: 'Pourquoi je suis sculpteur.' " *Arts—Lettres—Spectacles*, No. 873. Paris, June 13, 1962, pp. 1, 5. Excerpts in: *Derrière Le Miroir*, Nos. 143/144. Paris, 1962; catalogue Alberto Giacometti. Zurich: Kunsthaus, 1962, pp. 14–15; Bibl. 711, 715.

62 Pierre Schneider, "Au Louvre avec Alberto Giacometti." *Preuves*, No. 139. Paris, Sept., 1962, pp. 23–31. English translation in: Pierre Schneider, *At the Louvre*. New York: Simon and Schuster, 1970.

63 Grazia Livi, "Interroghiamo gli artisti del nostro tempo: Che cosa ne pensano del mondo d'oggi? Giacometti." *Epoca*, No. 643. Milan, Jan. 20, 1963, pp. 58–61.

Jean-Marie Drôt. Television film with Giacometti. See Bibl. 803.

64 Pierre Dumayet, "La Difficulté de faire une tête: Giacometti." *Le Nouveau Candide*. Paris, June 6, 1963. Reprinted in Pierre Dumayet, *Vu et entendu*. Paris: Stock, 1964, pp. 37–46.

65 Jean-Luc Daval, "Fou de Réalité: Alberto Giacometti." *Journal de Genève*. June 8, 1963.

66 Marianne Adelmann, "Photo-finish" [Oct., 1963]. *The Studio*, No. 849. London, Jan., 1964, pp. 25–26.

Marianne Adelmann. See also Bibl. 734.

67 Jean Clay, "Alberto Giacometti: Le dialogue avec la mort d'un très grand sculpteur de notre temps." *Réalités*, No. 215. Paris, Dec., 1963, pp. 135–45. Reprinted in Jean Clay, *Visages de l'art moderne*. Paris–Lausanne: Rencontre, 1970.

68 Jean Clay, "Giacometti à l'Orangerie" [Includes notes on conversations in 1963 and 1965]. *Réalités*, No. 285. Paris, Oct., 1969, pp. 124–28.

69 Gotthard Jedlicka, "Begegnung mit Alberto Giacometti" [March 20, 1964]. *Neue Zürcher Zeitung*. Jan. 16, 1966.

70 Raoul-Jean Moulin, "Giacometti: 'Je travaille pour mieux voir'" [Conversations in April, 1964, March, 1965]. *Les Lettres françaises*, No. 1,115. Paris, Jan. 20, 1966, p. 17. Quotations in Bibl. 730.

Ludy Kessler. Television interview. See Bibl. 812.

71 Carlton Lake, "The Wisdom of Giacometti" [Sept., 1964]. *The Atlantic Monthly*. Boston, Sept., 1965, pp. 117–26.

72 J. P. Hodin, "Quand les artistes parlent du Sacré." *XXe Siècle*, N. S. 24. Paris, Dec., 1964, p. 28. English translation p. 144.

G. G. Tuor. Tape recording of an autobiographical conversation with Alberto Giacometti [Stampa, June 28, 1958]. See Bibl. 805.

David Sylvester. Radio interview [Sept., 1964]. See Bibl. 821. Compare also Bibl. 633–38, 737, 823.

James Lord, "A Giacometti Portrait" [Sept.–Oct., 1964]. See Bibl. 723. Compare also Bibl. 175, 585–87.

Jacques Dupin. Filmed conversation [1965]. See Bibl. 817. Compare also Bibl. 533, 708.

C. Biographical Testimonies and Poetic Interpretations

100 Adam, Henri-Georges. "Alberto Giacometti." *Les Lettres françaises*, No. 1,115. Paris, Jan. 20, 1966, p. 14.

101 Argan, Giulio Carlo. "Les Prix mis en question." *L'Arc*, V, No. 20. Aix-en-Provence, 1962, pp. 5–7.

102 Althaus, Peter F. "Zwei Generationen Giacometti." *Du*, No. 205. Zurich, March, 1958, pp. 32–39. Includes Bibl. 22, 145.

103 Aragon, Louis. "Alberto Giacometti est mort." *Les Lettres françaises*, No. 1,114. Paris, Jan. 13, 1966, p. 1.

104 Aragon, Louis. "Grandeur nature." *Les Lettres françaises*, No. 1,115. Paris, Jan. 20, 1966, pp. 16–17.

105 Auricoste, Emmanuel. "Alberto Giacometti." *Les Lettres françaises*, No. 1,115. Paris, Jan. 20, 1966, p. 23.

106 Baudouin, Pierre. "Alberto Giacometti." *Les Lettres françaises*, No. 1,115. Paris, Jan. 20, 1966, p. 15.

107 Beauvoir, Simone de. *La Force de l'âge*. Paris: Gallimard, 1960, pp. 499–503. English translation by P. Green, *The Prime of Life*. London: André Deutsch and Weidenfeld and Nicolson, 1963, and New York: Lancer Books, 1966.

108 Beauvoir, Simone de. *La Force des choses*. Paris: Gallimard, 1963, pp. 83, 85, 95, 99–100, 106, 108, 143 passim. English translation by Richard Howard, *Force of Circumstance*. New York: Putnam, and London: André Deutsch and Weidenfeld and Nicolson, 1965.

109 Bernoulli, Christoph. "Jugenderinnerungen an die Familie Giacometti." *Du*, No. 252. Zurich, Feb. 1962, pp. 16–22. Reprinted in the catalogue *Alberto Giacometti, Zeichnungen*. Hanover: Kestner-Gesellschaft, 1966, pp. 33–35.

110 Bernoulli, Christoph. "Alberto Giacometti. Ansprache zur Eröffnung der Giacometti-Ausstellung im Kunsthaus Zürich." *Neue Zürcher Zeitung*. Dec. 9, 1962.

111 Bernoulli, Christoph. "Alberto Giacometti. Die Person und das Werk." *National-Zeitung*. Basel, July 3, 1966.

112 Bonnefoy, Yves. "L'Étranger de Giacometti." *L'Éphémère*, No. 1. Paris, 1966, pp. 79–91.

113 Borgeaud, Georges. "Un Écorché vif du présent." *Les Nouvelles littéraires*. Paris, Oct. 23, 1969, p. 8.

114 Bouchet, André du. "Plus loin que le regard, une figure." *L'Éphémère*, No. 1. Paris, 1966, pp. 93–100.

115 Bouchet, André du. "... qui n'est pas tourné vers nous." *L'Éphémère*, No. 8, Paris, 1968, pp. 70–115. Reprinted in Bibl. 700.

Bouchet, André du. See also Bibl. 701.

116 Boudaille, Georges. "L'Interview impossible." *Les Lettres françaises*, No. 1,115. Paris, Jan. 20, 1966, p. 12.

117 Brassaï. "Ma Dernière Visite à Giacometti" [March 22, 1965]. *Le Figaro littéraire*. Paris, Jan. 20, 1966.

118 Breton, André. "L'Équation de l'objet." *Documents 34*, N. S. 1. Brussels, June, 1934, pp. 17–24. This forms part of Breton's later work, *L'Amour fou*. Paris: Gallimard, 1937, pp. 40–57. See also Bibl. 733, p. 34.

119 Breton, André. "Qu'est-ce que le Surréalisme?" *Documents 34*, N. S. 2. Brussels, Nov. 1934, p. 19.

120 Breton, André. "Dictionnaire abrégé du surréalisme." In the catalogue *Exhibition internationale du surréalisme*. Paris: Galerie Beaux-Arts, 1938, p. 13.

121 Breton, André. "Genèse et perspective artistique du surréalisme." *Labyrinthe*, No. 6. Geneva, March 15, 1945, pp. 4–5. Reprinted in Bibl. 122. English translation in the catalogue *Art of This Century*. New York: Peggy Guggenheim Gallery, 1942.

122 Breton, André. *Le Surréalisme et la peinture*. 2nd edition, New York and Paris: Brentano's, 1945, pp. 97–98. 3rd expanded and revised edition, Paris: Gallimard, 1965, pp. 72–73, 321, 351. English translation by Simon Watson Taylor, *Surrealism and Painting*. London, 1969.

123 Breton, André. *Entretiens avec André Parinaud* [Breton on Giacometti's postwar work]. Paris: Gallimard, 1952, pp. 161, 243.

Breton, André. See also Bibl. 9, 343.

124 Broesecke, Siegfried. "Alberto Giacometti." *Abendzeitung*. Munich, Jan. 15/16, 1966.

125 Campbell, Robin. "Alberto Giacometti. A Personal Reminiscence." *Studio International*, No. 2. London, 1966, p. 47.

126 Carluccio, Luigi. "Ricordi di Alberto Giacometti." *Arti*, No. 1. Milan, 1966, pp. 36–37.

Carluccio, Luigi. See also Bibl. 515, 516, 703.

127 Cassou, Jean. "Le Grand Prix national des arts pour Giacometti." *Gazette de Lausanne.* Jan. 15/16, 1966, p. 14.

Cassou, Jean. See also Bibl. 517–19.

128 Baldachini, Cesare [César]. "J'étais son voisin." *Gazette de Lausanne.* Jan. 15/16, 1966, p. 13.

129 Baldachini, Cesare [César]. "Alberto Giacometti." *Les Lettres françaises,* No. 1,115. Paris, Jan. 20, 1966, p. 14.

130 Char, René. "Alberto Giacometti." In: *Recherche de la base et du sommet suivi de pauvreté et privilège.* Paris: Gallimard, 1955, p. 142. Enlarged edition, Paris: Gallimard, 1965, pp. 65–66. English translation in: Peter Selz, *New Images of Man.* New York: Museum of Modern Art, 1959, pp. 74–75.

131 Char, René. "Célébrer Giacometti." In: *Retour-Amont.* Paris: GLM, 1966. Reprinted in Bibl. 711. English translation in: Peter Selz. *New Images of Man.* New York: Museum of Modern Art, 1958, pp. 74–75.

132 Cingria, Charles-Albert. "Falconetti sculpteur." *Aujourd'hui,* No. 6. Lausanne, Jan. 9, 1930, p. 5; No. 8, Jan. 23, 1930, p. 5. Partially reprinted in *Les Musées de Genève,* No. 65. Geneva, May, 1966, pp. 15–16.

133 Cocteau, Jean. *Opium.* Paris: Stock, 1930. Reprinted in Jean Cocteau. *Œuvres complètes,* vol. X. Lausanne: Marguerat, 1940, p. 140. English translation by Margaret Crosland and Sinclair Road, *Opium.* London: Owen, 1957, and New York: Grove Press, 1958.

134 Conil-Lacoste, Michel. "Giacometti l'été dernier." *Le Monde.* Paris, Jan. 28, 1966, p. 11.

135 Coumans, Willem K. "Alberto Giacometti" [poem]. *Kroniek van Kunst en Kultuur,* No. 2 Amsterdam, 1959, pp. 16–25.

136 Courthion, Pierre. "Alberto Giacometti." *Art-Documents,* Nos. 10/11. Geneva, July, 1951, p. 7. Reprinted in: Pierre Courthion, *L'Art indépendant.* Paris: Albin Michel, 1958, pp. 203–5.

137 Dali, Salvador. "Objets surréalistes: objets à fonctionnement symbolique" [etc.]. *Le Surréalisme au service de la révolution,* No. 3. Paris, Dec., 1931, pp. 16–17. Reprinted in *XXe Siècle,* N. S. 3. Paris, June, 1952, p. 69.

Dali, Salvador. See also Bibl. 314, 347.

138 Darle, Juliette. "Alberto Giacometti." *Les Lettres françaises,* No. 1,115. Paris, Jan. 20, 1966, p. 23.

139 Dorival, Bernard. "Alberto Giacometti." *Gazette de Lausanne,* Jan. 15/16, 1966, p. 15.

140 Dumayet, Pierre. "Les Giacometti." *Paris-Match,* No. 1,079. Jan. 10, 1970, pp. 39–45.

Dumayet, Pierre. See also Bibl. 64.

141 Ernst, Max. "Loplop introduit des membres du groupe des surréalistes." [Collage with a portrait photo of Giacometti, 1930.] Reproduced in the catalogue *Dada, Surrealism, and Their Heritage.* New York: Museum of Modern Art, 1968, p. 107.

142 Ernst, Max. Letter to Carola Giedion-Welcker about his work with Giacometti in Maloja in the summer of 1934. Published in Bibl. 543, p. 242 (with the date 1935).

143 Frasnay. *Peintres et sculpteurs: leur monde.* Paris: Draeger, 1969. Includes color photos of Giacometti's studio in February, 1966.

144 Gasser, Manuel. "Ich erinnere mich." *Die Weltwoche.* Zurich, Jan. 21, 1966, p. 23.

145 Giacometti, Giovanni. Excerpts from a letter to Bruno Giacometti about an exhibition, probably 1932. *Du,* No. 205. Zurich, March, 1958, p. 33. Included in Bibl. 102.

146 Giacometti, Guido. "Introduzione ad Alberto Giacometti." *Quaderni Grigionitaliani,* XXXVII. Poschiavo (Switzerland), April 2, 1968, pp. 143–49.

147 Giacometti, Luciano. "Ahnentafel der Familie Giacometti." *Quaderni Grigionitaliani,* XXI. Poschiavo (Switzerland), 1952, p. 299.

148 Giedion-Welcker, Carola. "Ein Gespräch in Maloja." *Du,* No. 252. Zurich, Feb. 1962, p. 28.

149 Giedion-Welcker, Carola. "Alberto Giacometti." *Neue Zürcher Zeitung.* Jan. 16, 1966.

150 Giedion-Welcker, Carola. "Das erahnte Ziel." *Die Weltwoche.* Zurich, Jan. 21, 1966, p. 23.

Giedion-Welcker, Carola. See also Bibl. 344, 363, 543–47.

151 Giedion, Sigfried. "Alberto Giacometti." *Neue Zürcher Zeitung.* Jan. 16, 1966.

Giedion, Sigfried. See also Bibl. 356.

152 Gilot, Françoise, and Lake, Carlton. *Life with Picasso.* New York: McGraw Hill, 1964, and London: Nelson, 1965.

153 Gimpel, René. *Journal d'un collectionneur-marchand de tableaux.* Paris: Calman-Lévy, 1963, p. 403. English translation by John Rosenberg, *Diary of an Art Dealer.* New York: Farrar, Straus and Giroux, and London: Hodder and Stoughton, 1966.

154 Giovanoli, Diego. "Discorso sulla tomba di Alberto Giacometti." *Quaderni Grigionitaliani.* Poschiavo (Switzerland), 1966, pp. 155–56.

155 Guggenheim, Peggy. *Out of This Century.* New York: Dial Press, 1946, p. 248. 2nd edition: *Confessions of an Art Addict.* New York: Macmillan, and London: André Deutsch, 1960, pp. 73–74, 105, 141.

156 Hess, Thomas B. "Alberto Giacometti." *Art News.* New York, March, 1966, p. 35.

Hess, Thomas B. See also Bibl. 387, 559–61.

157 Hugnet, Georges. *Petite Anthologie poétique du surréalisme.* Paris: Jeanne Bucher, 1934. Includes a photograph of Giacometti. Reprinted in Bibl. 360; 543, p. 264; 620, p. 435.

158 Jacometti, Nesto. "Il était une fois." *Die Weltwoche,* No. 1,680. Zurich, Jan. 21, 1966, p. 23.

159 Jean, Marcel. *Histoire de la peinture surréaliste.* Paris: Seuil, 1959, pp. 227–29. English translation by Simon Watson Taylor, *History of Surrealistic Painting.* New York: Grove Press, and London: Weidenfeld and Nicolson, 1960, pp. 226–29.

160 Jedlicka, Gotthard. "Alberto Giacomettis Bildniszeichnungen nach Henri Matisse." *Neue Zürcher Zeitung.* July 28, 1957. Reprinted in Bibl. 720, pp. 3–6.

161 Jedlicka, Gotthard. "Alberto Giacometti zum 60. Geburtstag." *Neue Zürcher Zeitung.* Oct. 10, 1961. Reprinted in Bibl. 720, pp. 10–14.

Jedlicka, Gotthard. See also Bibl. 53, 69, 573, 719, 720.

162 Kahnweiler, Daniel-Henry. "La Mort d'Alberto Giacometti." *Les Lettres françaises,* No. 1,115. Paris, Jan. 20, 1966.

163 Kornfeld, Eberhard W. "Letztes Erscheinen in der Öffentlichkeit." *Die Weltwoche,* No. 1,680. Zurich, Jan. 21, 1966, p. 24.

164 Larronde, Olivier. "Alberto Giacometti dégaîne." *Derrière Le Miroir,* No. 127. Paris, May, 1961, pp. 1–3. English translation in *Art and Literature,* No. 10. Paris and Lausanne, 1966, pp. 107–8.

165 Lassaigne, Jacques. "L'Enterrement à Stampa." *Les Lettres françaises,* No. 1,115. Paris, Jan. 20, 1966, p. 11.

166 Leiris, Michel. "L'Art de Giacometti." *Amis de l'art,* N. S. 1. Paris, 1950–51, p. 7.

167 Leiris, Michel. "Pierre pour un Alberto Giacometti." *Derrière Le Miroir,* Nos. 39/40. Paris, June, 1951. Reprinted in *Brisées.* Paris: Mercure de France, 1970, pp. 146–56. English trans-

lation by Douglas Cooper, "Thoughts Around Alberto Giacometti." *Horizon*, XIX, No. 114. New York, June, 1949, pp. 411–17.

168 Leiris, Michel. "Alberto Giacometti en timbre-poste ou en médaillon." *L'Arc*, V, No. 20. Aix-en-Provence, Oct. 1962, pp. 10–13. Reprinted in Bibl. 715, pp. 5–6; *Brisées*. Paris: Mercure de France, 1970, pp. 245–49. English translation in Bibl. 715, pp. 5–6.

169 Leiris, Michel. "Alberto Giacometti." *Les Lettres françaises*, No. 1,115. Paris, Jan. 20, 1966, p. 17.

170 Leiris, Michel. "Autres 'Pierres . . .'." *L'Éphémère*, No. 1. Paris, 1966, pp. 67–70. Concludes with the poem "Alberto"

Leiris, Michel. See also Bibl. 309.

171 Leymarie, Jean. "Alberto Giacometti." *Gazette de Lausanne*. Jan. 15/16, 1966, p. 13.

172 Leymarie, Jean. "La Justification de l'étrange aventure à laquelle je fais métier de m'intéresser." *Les Lettres françaises*, No. 1,115. Paris, Jan. 20, 1966, p. 13.

Leymarie, Jean. See also Bibl. 582, 722.

173 Limbour, Georges. "Un petit pas vers Giacometti." *France-Observateur*, No. 211. Paris, May 27, 1954.

Limbour, Georges. See also Bibl. 390.

174 Loetscher, Hugo. "Alberto Giacometti." *Die Weltwoche*, No. 1,680. Zurich, Jan. 21, 1966, p. 23.

175 Lord, James. "In memoriam Alberto Giacometti." *L'Œil*, No. 135. Paris, March, 1966, pp. 42–46, 67.

Lord, James. See also Bibl. 585–87, 723–25.

176 Mandriargues, André Pieyre de. "Alberto Giacometti." *Gazette de Lausanne*, Nos. 15/16. Jan. 1966, p. 14.

177 Marchiori. "De Venise." *Les Lettres françaises*, No. 1,115. Paris, Jan. 20, 1966, p. 13.

178 Marinotti, Paolo. "Giacometti: l'uomo senza terra." *Metro*, No. 7. Milan, 1962, pp. 62–67.

179 Markoff, Nicola G. "Alberto Giacometti und seine Krankheit." *Bündner Jahrbuch*. Chur, 1967, pp. 65–68. Offprint: Chur: Buchdruckerei Bischofsberger, 1967. 15 pages.

180 Masson, André. [On his work together with Giacometti in 1929.] Catalogue *André Masson*. Paris: Musée National d'Art Moderne, 1965. Reprinted in the catalogue *André Masson*. Musée de Lyon, 1967.

181 Masson, André. "Some Notes on the Unusual Georges Bataille." *Art and Literature*, No. 3. Paris and Lausanne, 1964, p. 107. Notes on the work he planned to do with Giacometti for the Surrealism exhibition at the Galerie Maeght, Paris, 1947.

182 Matisse, Pierre. "Alberto Giacometti." *Les Lettres françaises*, No. 1,115. Paris, Jan. 20, 1966, p. 12.

183 Matter, Mercedes. "Giacometti: In the Vicinity of the Impossible." *Art News*. New York, summer, 1965, pp. 27–29, 53–54.

184 Mauriac, François. "Alberto Giacometti." *Le Figaro*. Paris, Nov. 21, 1963. Reprinted in: François Mauriac, *Le Nouveau Bloc-Notes*. Paris: Flammarion, 1968.

185 Meisser, Leonhard. "Mit dem jungen Alberto Giacometti in Paris." *National-Zeitung*. Basel, Aug. 18, 1966. Reprinted in *Bündner Jahrbuch*. Chur, 1967, pp. 62–65.

186 Meyer, Franz. "Alberto Giacometti." *Neue Zürcher Zeitung*. Jan. 16, 1966.

Meyer, Franz. See also Bibl. 598, 599, 716, 729.

187 Mohler, Adolf. *Aus den Aufzeichnungen und Briefen eines Malers*. Zurich (private printing), 1965, pp. 22–24.

188 Moore, Henry. "Alberto Giacometti." *Les Lettres françaises*, No. 1,115. Paris, Jan. 20, 1966, p. 15.

Moore, Henry. See also Bibl. 602.

189 Mullin, Edwin. "The Artist in his Studio: Giacometti." *Weekend Telegraph*. London, July 9, 1965, pp. 22, 25.

Mullins, Edwin. See also Bibl. 603.

190 N.N. "La Fondation Alberto Giacometti et la Suisse française." *Neue Bündner Zeitung* (Chur), *Gazette de Lausanne, Journal de Genève, Tages-Anzeiger* (Zurich), *Corriere del Ticino* (Lugano), March 26/27, 1966.

191 N.N. "L'Enterrement d'Alberto Giacometti." *L'Illustré*. Zofingen (Switzerland), Jan., 1966. Account in photographs.

192 Netter, Maria. "Alberto Giacometti in der Kunsthalle Bern." *Die Weltwoche*, No. 1,181. Zurich, June 29, 1956, p. 15.

193 Osouf, Jean. "Alberto Giacometti." *Les Lettres françaises*, No. 1,115. Paris, Jan. 20, 1966, p. 23.

194 Passeron, René. *Histoire de la peinture surréaliste*. Paris: Libraire Générale, 1968, p. 85.

195 Paulhan, Jean. "Alberto Giacometti." *Gazette de Lausanne*. Jan. 15/16, 1966, p. 13.

196 Picon, Gaëtan. "Alberto Giacometti." *Gazette de Lausanne*. Jan. 15/16, 1966, p. 15.

197 Picon, Gaëtan. "Notes écrites après la mort de Giacometti." *L'Éphémère*, No. 1. Paris, 1966, pp. 71–77. Reprinted in: Gaëtan Picon. *Les Lignes de la main*. Paris: Gallimard, 1969, pp. 277–84.

198 Ponge, Francis. "Réflexions sur les statuettes, figures et peintures d'Alberto Giacometti." *Cahiers d'art*, XXVI. Paris, 1951, pp. 74–90. Reprinted in: Francis Ponge. *Le Grand Recueil*. Paris: Gallimard, 1961, pp. 70–75.

199 Ponge, Francis. "Joca Seria. Notes sur les sculptures d'Alberto Giacometti." *Médiations*, No. 7. Paris, 1964, pp. 5–47.

200 Prévert, Jacques. "Alberto Giacometti." *Les Lettres françaises*, No. 1,115. Paris, Jan. 20, 1966, p. 18. Compare Bibl. 711, p. 37 (postcard from Alberto Giacometti to Jacques Prévert, Samaden, July 15, 1930). Prévert used Giacometti's studio while Giacometti was undergoing an operation in the hospital at Samaden.

201 Ray, Man. *Selfportrait*. Boston: Little, Brown, London: André Deutsch, 1963.

202 Régnier, Gérard. "Une vision infernale." *Les Nouvelles littéraires*. Paris, Oct. 23, 1969, p. 19.

Régnier, Gérard. See also Bibl. 610–12.

203 Rotzler, Willy. "Alberto Giacometti." *Neue Zürcher Zeitung*. Jan. 16, 1966.

204 Rotzler, Willy. "Im Menschenwald." *Die Weltwoche*, No. 1,680. Zurich, Jan. 21, 1966, pp. 23–24.

Rotzler, Willy. See also Bibl. 616–18, 734.

205 Rougement, Denis de. "Alberto Giacometti." *Gazette de Lausanne*. Jan. 15/16, 1966, p. 13.

206 Sadoul, Georges. "Giaco." *Les Lettres françaises*, No. 1,115. Paris, Jan. 20, 1966, p. 18. Partial printing of a radio conversation on Giacometti (unavailable): "La Chaîne de l'amitié." *Europe*, No. 1. Paris, Feb. 23, 1962.

207 San Lazzaro, Gualtieri di. "Giacometti." *XXᵉ Siècle*, N. S. 28. Paris, 1966, p. 159.

San Lazzaro, Gualtieri di. See also Bibl. 51.

208 Sartre, Jean-Paul. *Les Mots*. Paris: Gallimard, 1964, p. 193. English translations by Bernard Frechtman, *Words*. New York: Braziller, 1964; and Irene Clephane, *Words*. London: Hamilton, 1964.

Sartre, Jean-Paul. See also Bibl. 383, 621.

209 Scheidegger, Ernst. "Die letzte Nacht in Paris." *Die Weltwoche*, No. 1,680. Zurich, Jan. 21, 1966, p. 23.

Scheidegger, Ernst. See also Bibl. 714.

210 Schifferli, Peter. "Bauernsohn und Eremit." *Die Weltwoche*, No. 1,680. Zurich, Jan. 21, 1966, p. 24.

211 Schumacher, Horst. "Auf den Spuren Giacomettis." *Die Tat*. Zurich, Nov. 8, 1969, p. 48.

212 Skira, Albert. "Giacometti: 'Copier pour mieux voir.'" *Labyrinthe*, No. 10. Geneva, July 15, 1945, p. 2.

213 Skira, Albert. "Alberto Giacometti in Genf 1942–1945." *Du*, No. 252. Zurich, Feb. 1962, p. 16.

214 Skira, Albert. "Giacometti à labyrinthe." *Les Lettres françaises*, No. 1,115. Paris, Jan. 20, 1966, pp. 11–12.

215 Soavi, Giorgio. "Il grande Alberto." *Panorama*, No. 28. Milan, Jan. 28, 1965, pp. 52–59. Reprinted in Bibl. 735, pp. 9–29.

216 Soavi, Giorgio. "Il Sogno di una testa." *Play-Men*, III, No. 1. Rome, Jan., 1969, pp. 149–55. Includes the transcript of the television interview with Ludy Kessler, 1964; compare Bibl. 812. Reprinted in Bibl. 735, 736.

217 Stahly, François. "Der Bildhauer Alberto Giacometti." *Werk*, XXXVII, No. 6. Winterthur (Switzerland), June, 1950, pp. 181–85.

Stahly, François, See also Bibl. 632.

218 Stampa, Renato. "Zaccharia, Giovanni, Augusto und Alberto Giacometti." *Terra Grischuna*, No. 4. Basel, 1961, pp. 293 ff.

219 Stampa, Renato. "Per il Centenaio della nascita di Giovanni Giacometti." *Quaderni Grigionitaliani*, XXXVII, No. 2. Poschiavo (Switzerland), 1968, pp. 4–47.

220 Stampa, Renato. "Reminiscenza." *Quaderni Grigionitaliani*, XXXV, No. 2. Poschiavo (Switzerland), 1966, pp. 82–86.

221 Stampa, Renato. "Commiato." *Quaderni Grigionitaliani*, XXXV, No. 2. Poschiavo (Switzerland), 1966, pp. 86–87, 206–8.

Stampa, Renato. See also Bibl. 820.

222 Stettler, Michael. "Giacometti: 'La vraie culture s'affirme par elle-même.'" *Gazette de Lausanne*. Jan. 15/16, 1966, p. 14.

223 Strambin. Three photographs of Giacometti's hotel room in Geneva. In *Labyrinthe*, No. 1. Geneva, Oct. 15, 1944, p. 3. Reprinted in Bibl. 721, p. 11.

224 Tardieu, Jean [Daniel Trevoux]. "Giacometti et la solitude." *XXᵉ Siècle*, N. S. 24, No. 18. Paris, Feb., 1962, pp. 13–19.

225 Taslitzky, Boris. "Alberto Giacometti." *Les Lettres françaises*, No. 1,115. Paris, Jan. 20, 1966, p. 12.

226 Waldbert, Patrick. "Alberto Giacometti, l'espace et l'angoisse." *Critique*, No. 141. Paris, April, 1959, pp. 328–40. Reprinted in: Patrick Waldbert, *Mains et merveilles*. Paris: Mercure de France, 1961, pp. 52–69.

227 Wehrli, René. "Alberto Giacometti." *Neue Zürcher Zeitung*. Jan. 16, 1966.

Wehrli, René. See also Bibl. 650–52.

228 Wescher, Herta. "Giacometti: a Profile." *Art Digest*, XXVIII, No. 5. New York, Dec., 1953, pp. 17, 28–29.

229 Wescher, Herta. "Alberto Giacometti als Nachbar." *Du*, No. 252. Zurich, Feb., 1962, pp. 14–15. Reprinted in the catalogue *Giacometti*. Basel: Kunsthalle, 1966.

230 Wilbur, Richard. "Alberto Giacometti." Poem in: Richard Wilbur, *Ceremony and Other Poems*. New York: Harcourt Brace, 1948, p. 51. Reprinted in *Tiger's Eye*, No. 7. New York, March, 1949, pp. 61–63.

231 Yanaihara, Isaku. "Pages de journal." *Derrière Le Miroir*, No. 127. Paris, May, 1961, pp. 18–26.

232 Yanaihara, Isaku. "Alberto Giacometti, A Diary." [Japanese.] *Dojidai*, No. 19. Tokyo, 1965, pp. 84–88.

Yanaihara, Isaku. See also Bibl. 728, 740.

233 Z'Graggen, Yvette. *L'Herbe d'octobre*. Geneva: Jeheber, 1950.

D. Documents on the Oeuvre. Critical Interpretations 1925–1950 (in Chronological Order)

300 *Le Salon des Tuileries*. Paris: Palais de Bois, 93 Av. de la Grande Armée, 1925. Exhibition catalogue.

301 *Almanacco dei Grigioni*. Chiavenna (Switzerland), 1926. Following p. 84: reprod. *Head (Diego) on a Low Pedestal*. 1925. Plaster.

302 Arnold M. Zendralli, "Cronaca d'arte 1925." *Almanacco dei Grigioni*. Chiavenna (Switzerland), 1926, pp. 108, 115.

303 *Le Salon des Tuileries*. Paris, 1926. Exhibition catalogue. Nos. 865, 866.

304 Tériade [Épherios], "Propos sur le Salon des Tuileries." *Cahiers d'art*. Paris, 1926, pp. 109–12. I have not yet been able to find the article in the Paris daily *L'Intransigeant* which Tériade is said to have written on the works Giacometti exhibited in the 1927 (?) Salon des Tuileries.

305 E. B. and T., "Ausstellung Giovanni [und Alberto] Giacometti. Galerie Aktuaryus Zürich, Oktober-November, 1927." *Neue Zürcher Zeitung*, Oct. 24, 1927 (Eduard Briner, "Die Eröffnungsfeier"); Nov. 23, 1927 (Paul Trog, commentary).

306 Hermann Ganz, "Ausstellung Giovanni [und Alberto] Giacometti in der Galerie Aktuaryus Zürich." *Kunst und Künstler*, XXVI. Berlin, 1928, p. 160.

307 "Artisti italiani di Parigi. Salon de l'Escalier, Parigi, febbraio, 1928." *Emporium*, XLVII. Bergamo (Italy), 1928, p. 254. Reprod. *Figura*. Plaster.

308 "Un Groupe d'Italiens à Paris." *Cahiers d'art*. Paris, 1929, p. 122. On the exhibition at the Galerie Zak, March–April, 1929.

309 Michel Leiris, "Alberto Giacometti." *Documents*. Paris, 1929, pp. 209–14. Contains a summary in English.

Michel Leiris. See also Bibl. 167–70.

310 Carl Einstein, "Exposition de sculpture moderne." *Documents*. Paris, 1929, p. 391. On the exhibition at the Galerie Georges Bernheim, Paris, 1929.

311 Christian Zervos, "Notes sur la sculpture contemporaine. A propos de la récente Exposition Internationale de Sculpture, Galerie Georges Bernheim, Paris." *Cahiers d'art*. Paris, 1929, pp. 465–73.

Christian Zervos. See also Bibl. 323, 335, 336, 366, 655.

312 Carl Einstein, *Die Kunst des 20. Jahrhunderts*. Berlin: Propyläen, 3rd printing, 1931, pp. 229, 628–32, 649.

313 Hans Hildebrandt. *Die Kunst des 19. und 20. Jahrhunderts*. Potsdam: Athenaion, 2nd printing, 1931.

314 Salvador Dali, "Objets surréalistes." *Le Surréalisme au service de la révolution*, No. 3. Paris, 1931, pp. 15–17. Includes reprod. *Objet à fonctionnement symbolique* [*Suspended Ball*]. 1930. Wood. Reprinted in *XXᵉ Siècle*, No. 3. Paris, 1952, p. 69.

Salvador Dali. See also Bibl. 347.

315 Marcel Zahar, "Où allons-nous?" *Formes*, No. 16. Paris, 1931, p. 107. On the exhibition at the Galerie Pierre Loeb, Paris, May–June,

1931. *Formes*, No. 25. Paris, 1932, p. 280. On the exhibition at the Galerie Colle, Paris, May 1932.

316 "Jeunes Artistes d'aujourd'hui." *Cahiers d'art*. Paris, 1931, p. 378. On the exhibition at the Galerie Georges Petit, Paris, November, 1931.

317 *Gaceta de arte*. Tenerife, 1932–1935. Reproductions. See also the catalogue *Exposition surréaliste*. Tenerife, May, 1935.

318 *Commune*. Paris, 1935, p. 1,135. Reprod. of the drawing *The Artist Greets the Progress of the Masses*. See B. Taslitzky in Bibl. 325.

319 *La Lutte*. Paris, 1932. Reprod. of political caricatures by "Ferrache" (Alberto Giacometti). See Aragon, Bibl. 104 (with reproductions), and Sadoul, Bibl. 206.

320 M. K. "Pariser Kunstchronik: Ausstellung 'Alberto Giacometti' in der Galerie Pierre Colle, Paris, 1932." *Neue Zürcher Zeitung*. May 15, 1932.

321 Georges Charensol, *Les Artistes suisses: Augusto Giacometti*. Paris: Quatre Chemins, 1932, vol. 1, p. 9.

322 Arnold M. Zendralli, "Alberto Giacometti a Parigi." *Quaderni Grigionitaliani*, No. 1. Poschiavo (Switzerland). 1931–32, pp. 51, 54.

323 Christian Zervos, "Quelques Notes sur les sculptures de Giacometti." *Cahiers d'art*. Paris, 1932, pp. 337–42. With seven photographs by Man Ray.

324 *Exposition surréaliste*. Paris: Galerie Pierre Colle, 1933. Exhibition catalogue.

324a "L'Exposition surréaliste à la Galerie Pierre Colle, Paris, 1933." *Cahiers d'art*, Nos. 5/6. Paris, 1933, p. 251.

325 *Le Surréalisme au service de la révolution*, No. 5. Paris, 1933, p. 41. Reprod. of the drawing *Meeting in a Corridor (Project for a Sculpture)*.

326 *Le Surréalisme au service de la révolution*, No. 6. Paris, 1933, plate 1. Reprod. *The Hour of the Traces*. Wood, plaster.

327 *Minotaure*, Nos. 3/4. Paris, 1933, p. 78. Reprod. *Dessin* [*Woman with Her Throat Cut*].

328 *Minotaure*, Nos. 3/4. Paris, 1933, p. 40. Reprod. *Figures* [*Three Steles on an Alp Above Maloja*]. Plaster. (Reprinted in *Du*, No. 252. Zurich, 1962, p. 28.) Page 46: reprod. *The Palace at 4 A.M.* and *Woman with Her Throat Cut*. Photographs by Brassaï.

329 Maurice Raynal, "Dieu—table—cuvette. Les ateliers de Brancusi, Despiau, Giacometti." *Minotaure*, Nos. 3/4. Paris, 1933, p. 47. Includes a photograph of the atelier showing *The Spoon Woman, Sculptures for a Square* (lifesize), *Woman with Her Throat Cut, Fall of a Body Onto a Diagram, Endangered Blossom*. All plaster.

330 Tériade [Épherios], "Aspects actuels de l'expression plastique." *Minotaure*, No. 5. Paris, 1934, p. 42. Reprod. *Head (Skull), Pavillon nocturne* [*Cube*]. Both plaster.

331 Anatole Jakovski, "Le Salon des Surindépendants 1933." *Cahiers d'art*. Paris, 1934, p. 264.

332 *Exposition Minotaure*. Brussels: Palais des Beaux-Arts, May–June, 1934. Exhibition catalogue.

333 *Pour Violette Nozière*. Brussels: Nicolas Flamel, 1934. One drawing in reproduction.

334 Max Ernst, "Was ist Surrealismus?" In the catalogue *Arp—Ernst—Giacometti—Gonzalez—Miró*. Zurich: Kunsthaus, October–November, 1934, p. 6.

Max Ernst. See also Bibl. 141, 142.

335 Christian Zervos, "Lettre recommandée au Kunsthaus." *Cahiers d'art*. Paris, 1934, p. 272. The story of the Zurich Surrealism Exhibition of 1934, which was originally conceived of as "Arp—Giacometti—Laurens—Lipchitz."

336 Christian Zervos, "Enquête sur l'importance de la révision des valeurs plastiques." *Cahiers d'art*. Paris, 1935, pp. 1–74. Reprod. *Faceted Head*. 1935. Plaster.

337 Anatole Jakovski, *24 Essais sur Arp ... Giacometti ... etc.* Paris: Orobitz, 1935. English translation: "Inscriptions under Pictures." *Axis*, No. 1. London, 1935, p. 17. The Catalan translation, in *D'Aci d'Alla*, No. 179, Barcelona, 1934, includes illustrations.

338 Paul Hilber. Giacometti bibliography in the catalogue *Thèse—antithèse—synthèse*. Lucerne, February–March, 1935, pp. 33–34. Reprod. *Partie d'une sculpture* [*Cube*]. Plaster.

339 "Thèse—antithèse—synthèse. Exposition au Kunstmuseum Lucerne." *Cahiers d'art*. Paris, 1934, p. 272.

340 Hans Erni, "Theses—Antitheses—Syntheses. Exhibition Kunstmuseum Lucerne." *Axis*, No. 2. London, 1935, pp. 27–28.

341 *Axis*, No. 1. London, 1935, p. 12. Reprod. *Palais de quatre heures III* [original title of *Cage*, 1931]. Wood.

342 *Axis*, No. 4. London, 1935, p. 8. Reprod. *Personnage* [*Woman, Plaque Sculpture*, about 1928]. Plaster.

343 André Breton, "Rêve-objet." *Cahiers d'art*. Paris, 1935, p. 125. See also André Breton, "Crise de l'objet." *Cahiers d'art*. Paris, 1936, pp. 21–26.

André Breton. See also Bibl. 118–23.

344 Carola Giedion-Welcker, "New Roads in Modern Sculpture." Translation by Eugene Jolas. *Transition*, No. 23. Paris, 1935, pp. 198–201.

Carola Giedion-Welcker. See also Bibl. 148–50, 363, 543–47.

345 James Thrall Soby, *After Picasso*. New York: Dodd, Mead and Co., 1935, pp. 98, 105–6. Illustrated.

346 David Gascoyne, *A Short Survey of Surrealism*. London: Cobden, Sanderson, 1935, pp. 64, 105, 108.

347 Salvador Dali, "Hommage à l'objet." *Cahiers d'art*. Paris, 1936, pp. 1–2, 53–56.

348 *Exposition surréaliste d'objets*. Paris: Galerie Charles Ratton, May, 1936. Exhibition catalogue.

349 "Exposition surréaliste d'objets." *Cahiers d'art*. Paris, 1936, p. 61. Reprod. *Trois Figures mobiles sur un plan* [*Man, Woman, Child*]. Wood and metal. 1931.

350 *Minotaure*, No. 8. Paris, 1936, p. 17. Reprod. *Cage*. Plaster.

351 *Transition*, No. 24. Paris, 1936. Reprod. *Composition 1932* [*Tormented Woman in Her Room at Night*]. Plaster.

352 *The Studio*. London, 1936, p. 75. Reprod. *The Palace at 4 A.M.* Plaster and wire.

353 Myfanwy Evans, "A Coming International Exhibition, Organized by Nicolette Gray. Oxford — Liverpool — London — Cambridge, February–June 1936." *Axis*, No. 4. London, 1935, p. 16; No. 5, 1936, p. 2; No. 6, 1936, p. 4: reprod. *Head (Skull)*. Plaster.

354 "International Surrealist Exhibition, New Burlington Galleries, London, June–July 1936." *Bulletin international du Surréalisme*, No. 4. London, 1936. Reprod. *The Spoon Woman*. Plaster. From a Gaumont-British film.

355 Herbert Read, *Surrealism*. London: Faber and Faber, 1936. Illustrated.

356 "Giedion—Bill—Le Corbusier." In the catalogue *Zeitprobleme in der Schweizer Malerei und Plastik*. Zurich: Kunsthaus, June-July, 1936, p. 25. Reprod. *Sculpture* [*Disagreeable Object*]. Marble. 1931.

357 Paul Éluard, "Un Soir courbé." (Poem and reprod. *Sculpture* [*Tormented Woman in Her Room at Night*]. Plaster.) *Konkretion*, No. 4. Copenhagen, 1936, pp. 174–75. (Special issue

for the exhibition "Kubismus, Surrealismus" in Copenhagen, Jan., 1935). The same illustration and *Model for a Square* appear in *Kunst og Kultur*, XVIII. Oslo, 1937, pp. 17 ff.

358 Julien Lévy, *Surrealism*. New York: Black Sun Press, 1936, pp. 21, 101, 142–43; illus. 14, 32, 33.

359 Alfred H. Barr jr. (ed.), *Fantastic Art, Dada, Surrealism*. New York: Museum of Modern Art, 1936/37, pp. 11, 47–50, 62–63, 172–73, 252; Cat. Nos. 377–79.

360 Georges Hugnet, "Dada and Surrealism." *The Bulletin of the Museum of Modern Art*, IV, Nos. 2/3, 1936, pp. 30–31. See also III, No. 5, 1936, pp. 1, 19 (reprod. *Tête-paysage* [*Landscape Head*] and *Tête* [*Head*]).

361 Jean de Bosschère, *Les Artistes à Paris, 1937*. Paris: Arts—Sciences—Lettres, 1937. Reprod. *Sculpture* [*Woman, Head, Tree*], plaster, following p. XL.

362 A. E. Gallatin, *Museum of Living Art. A. E. Gallatin Collection, New York University*. New York: Gallatin, 2nd printing, 1937; 3rd printing, 1940; illus. 34 (*Sculpture, 1927*, plaster).

363 Carola Giedion-Welcker, *Moderne Plastik*. Zurich: Girsberger, 1937, pp. 74–77, 79, 82, 154. English edition: *Modern Plastic Art*, ibid.

364 Martin, Nicholson, Gabo (ed.), *Circle-International Survey of Constructive Art*. London: Faber and Faber, 1937, illus. 17: *Untitled, 1936*, plaster; illus. 18: *Large Cube, 1933–34*, plaster.

365 *Werk*. Winterthur, 1938, p. 82. Reprod. *The Palace at 4 A.M. III* [*Cage, 1931*], 1934. Wood.

366 Christian Zervos, *Histoire de l'art contemporaine*. Paris: Édition Cahiers d'art, 1938, pp. 444–47. Illustrated.

367 Marcel Raval, "L'homme et son modèle." *Verve*, II, Nos. 5/6. Paris, 1939, pp. 125–28.

368 *Schweizerische Landesausstellung Zürich, Mai–Oktober, 1939*. Official catalogue of the exhibition "Zeichnen—Malen—Formen II: Kunst der Gegenwart." P. 28: reprod. *Cube*, plaster.

369 "Art représentatif de notre temps. En permanence sculptures de . . . Alberto Giacometti . . . Galerie MAJ (Pierre Loeb), Paris, janvier 1940." Advertisement in *Cahiers d'art*. Paris, 1939.

370 *Exposición internacional del Surrealismo*. Mexico City: Galerie de arte mexicana, Feb., 1940. Exhibition catalogue.

371 *Almanacco dei Grigioni*. Poschiavo, 1943, following p. 48: reprod. *Mother's Head*, about 1926. Plaster.

372 Eijler Bille, *Picasso, Surrealism, abstrakt Konst*. Copenhagen: Helios, 1945, pp. 176–84.

373 Maurice Nadeau, *Histoire du Surréalisme*. Paris: Seuil, 1945, p. 215. English translation by Richard Howard, *The History of Surrealism*. London: Cape, 1968.

374 *The Studio*. London, 1945. Illustrated.

375 *Art Digest*. New York, Feb. 15, 1945, p. 10.

376 *Art News*. New York, Feb. 15, 1945, p. 6.

377 *Exposition Alberto Giacometti: Dessins, peintures*. Paris: Galerie Pierre Loeb, 1946. List of the works.

378 "Alberto Giacometti, sculptures et dessins récents." *Cahiers d'art*. Paris, 1946, pp. 253–68.

379 Michel Florisoone, "La sculpture moderne et l'espace." *Amour de l'art*. Paris, 1947, pp. 219–24.

380 *Peintures et sculptures contemporaines*. Avignon: Palais des Papes, June–September, 1947. Exhibition catalogue.

381 Lassaigne, Cogniat, Zahar, *Panorama des arts 1948*. Paris: Somogy, 1948, p. 172. Commentary on the Giacometti exhibition at the Galerie des Arts in Paris, June, 1947.

382 Alberto Giacometti: *Exhibition of Sculptures, Paintings, Drawings*. New York: Pierre Matisse Gallery, January–February, 1948. Exhibition catalogue. Includes Bibl. 13, 13a, 383.

383 Jean-Paul Sartre, "La recherche de l'absolu." *Les Temps modernes*, III, No. 28. Paris, 1948, pp. 1, 153–63. Also in *Situations III*. Paris: Gallimard, 1949, pp. 289–305. English translation by Lionel Abel, "The Search for the Absolute," in Bibl. 382; also Frederick T. Davis, "The Search for the Absolute." *Harvard Art Review*, No. 1. Cambridge, Mass., 1966, pp. 28–30.

Jean-Paul Sartre. See also Bibl. 208, 621.

384 Robert M. Coates, "Giacometti Exhibition, Pierre Matisse Gallery, New York 1948." *The New Yorker*, XXIII, No. 50. New York, 1948, p. 42–43.

385 Clement Greenbaum, "Giacometti Exhibition, Pierre Matisse Gallery, New York 1948." *The Nation*, CLXVI. New York, 1948, pp. 163–64.

386 *Art News*. New York, Feb. 1, 1948, p. 31.

387 Thomas B. Hess, "Spotlight on Giacometti." *Art News*. New York, Feb. 12, 1948, p. 31.

Thomas B. Hess. See also Bibl. 156, 559–61.

388 *Art Digest*. New York, Feb. 1, 1948, p. 13.

389 *Arts and Architecture*, LXV, New York, June, 1948, p. 25.

390 Georges Limbour, "Giacometti." *Magazine of Art*, XLI, No. 7. New York, 1948, pp. 253–55.

Georges Limbour. See also Bibl. 173.

391 *Sculpteurs contemporains de l'École de Paris*. Bern: Kunsthalle, February–March, 1948. Exhibition catalogue. Foreword by Jean Cassou and Arnold Rüdlinger. Text reprinted in the catalogue *13 Beeldhouwers uit Parijs*. Amsterdam: Stedelijk Museum, 1948.

392 *Emporium*, CVII. Bergamo (Italy), 1948, p. 234.

393 Alfred H. Barr jr., *Painting and Sculpture in the Museum of Modern Art*. New York: Museum of Modern Art, 1948, pp. 294, 308.

394 *XXIV Biennale di Venezia*. Exhibition catalogue. Venice, 1948, p. 325.

395 *Art News*. New York, Jan. 1, 1949, p. 40.

396 [Waldemar George], "Exposition des sculptures en plein air—De Rodin à nos jours—Maison de la Pensée française, Paris." *Art et Industrie*, XVI. Paris, Oct., 1949, p. 21.

397 "Från några Paris atelijéer." *Prisma*, II. Stockholm, 1949, pp. 29–36.

398 *Life*. New York, June 20, 1949. Reproductions.

399 Arthur Drexler, "Giacometti. A Change of Space." *Interiors and Industrial Design*, CIX, No. 3. New York, 1949, pp. 102–7.

400 *Magazine of Art*, XLII. New York, Oct., 1949. Illus. p. 214.

401 *Illustrated London News*, CCXV. 1949, p. 755.

402 E. H. Ramsden, *Twentieth-Century Sculpture*. London: Pleiades, 1949, p. 40.

403 Jacques Busse, "Alberto Giacometti." In E. Bénézit, *Dictionnaire . . . des peintres, sculpteurs, etc.* New edition. Paris: Gründ, 1966, pp. 234–35 (text of 1949).

404 *Magazine of Art*, XLIII. New York, Feb., 1950, p. 53.

405 *Art News*. New York, May 1, 1950, p. 48.

406 *Emporium*, CXII. Bergamo (Italy), 1950, p. 91. See also the following numbers: 1951, pp. 36–37; 1954, pp. 169–70.

407 *The Museum of Modern Art Bulletin*, XVII Nos. 2/3. New York, 1950, p. 27.

408 René Chavence, "Échec et mat." *Art et Industrie*, No. 19. Paris, 1950, pp. 19–22. Illustrations of ceramic chessmen made by Giacometti for the decorator Jacques Adnet.

409 *André Masson, Alberto Giacometti*. Basel: Kunsthalle, May–June, 1950. Exhibition catalogue.

410 "Ausstellung 'Masson, Giacometti' in der Kunsthalle Basel." *Neue Zürcher Zeitung.* May 23, 1950.

411 Arnold M. Zendralli, "Alberto Giacometti a Basilea." *Quaderni Grigionitaliani*, No. 4. Poschiavo (Switzerland), 1950, pp. 310–11.

412 *Alberto Giacometti.* New York: Pierre Matisse Gallery, November, 1950–January, 1951. Exhibition catalogue. Includes Bibl. 14.

E. Critical Essays, 1951–1970. A Selection

Handbooks and monographs on twentieth-century sculpture and painting are not listed; reports on exhibitions, announcements of museum purchases, and obituaries have been listed only when their text or illustrations are of special interest.

500 Alvard, Julien. "Giacometti." *Cimaise,* No. 6. Paris, July/Aug., 1957, p. 32.

501 Ammann, Christoph. "Das Problem des Raumes im Werk Alberto Giacomettis." *Werk*, No. 6. Winterthur, 1966, pp. 237–40.

502 Ashton, Dore. "New Images of Man." *Art and Architecture*, No. 7. New York, 1958, pp. 10, 31.

503 Ashton, Dore. "L'École de Paris à New York." *XXᵉ Siècle*, éd. mensuelle, No. 3. Paris, 1959, p. 14.

504 Axelsson, Sun. "Giacometti och verkligheten." *Kunsten Idag.* Oslo, 1964, pp. 78–81, 106.

505 Barilli, Renato. "La prospettiva di Giacometti." *Letteratura*, Nos. 58/59. Rome, 1962, pp. 12–23.

506 Bianconi, Piero. "Fermatine nella XXXI Biennale Veneziana." *Cenobio.* Milan, 1962, pp. 474–82.

507 Boissonas, Édith. "A propos de Alberto Giacometti." *Nouvelle Revue française.* Paris, 1965, p. 1127–29.

508 Boustedt, Bo. "Quand Giacometti plaçait lui-même ses sculptures." *XXᵉ Siècle*, No. 33. Paris, 1969, pp. 21–36.

509 Brion, Marcel. *Art fantastique.* Paris: Albin Michel, 1961, pp. 94–100.

510 Bucarelli, Palma. "Giacometti: o del Prigioniero." *L'Europeo letteraria.* Rome, 1961, pp. 205–14. German, French, and English texts in *Cimaise*, No. 61. Paris, Sept., 1962, pp. 60–77. Amended reprint in Bibl. 702; and in the catalogue *Alberto Giacometti.* Rome: Villa Medici, 1970, pp. 13–19.

511 Bucarelli, Palma. "Alberto Giacometti." Catalogue *XXXI Biennale di Venezia.* Venice, 1962, p. 109.

512 Caflisch, Ulrich. "Alberto Giacometti. Abschied von einem grossen Künstler." *Bündner Jahrbuch.* Chur, 1967, pp. 59–62.

513 Chabrun, Jean-François. "Paris découvre Giacometti." *L'Express*, No. 311. Paris, 1967, pp. 22–23.

514 Charbonnier, Georges. "L'Espace et ses mirages." *Connaissance des arts*, No. 212. Paris, 1969, pp. 117–23.

Charbonnier, Georges. See also Bibl. 50, 56.

515 Carluccio, Luigi. "Alberto Giacometti." In the catalogue *Giacometti.* Turin: Galleria Galatea, 1961.

516 Carluccio, Luigi. "L'Amico di Giacometti. La collezione di Serafino Corbetta a Chiavenna." *Bolaffiarte*, No. 3. Turin, 1970, pp. 42–45.

Carluccio, Luigi. See also Bibl. 126, 703.

517 Cassou, Jean. "Les Espaces." *XXᵉ Siècle*, No. 2. Paris, 1952, pp. 11–12.

518 Cassou, Jean. *Le Dessin français au XXᵉ siècle.* Lausanne: Mermod, 1953, pp. 138–41, 178.

519 Cassou, Jean. "Variation du dessin." *Quadrum*, No. 10. Brussels, 1961, pp. 27–42.

Cassou, Jean. See also Bibl. 127.

520 Causey, Andrew. "Giacometti: Sculptor with a Tormented Soul." *The Illustrated London News.* Jan. 22, 1966, pp. 27–29.

521 Chevalier, Denys. "Nouvelles Conceptions de la sculpture." *Connaissance des arts*, No. 63. Paris, 1957, pp. 58–65.

522 Chevalier, Denys. "Alberto Giacometti ou l'intransigeance de l'absolu." *Vie des arts*, No. 47. Montreal, 1967, pp. 31–33.

523 Christ, Dorothea. "Alberto Giacomettis Gemälde 'Der Wegmacher' (1921)." *Der Schweizerische Beobachter*, No. 10, Basel, 1967. Title illus.

524 Christ, Dorothea. "Alberto Giacomettis Landschaftsbild 'Stampa' (1931)." *Der Schweizerische Beobachter*, No. 4. Basel, 1970. Title illus.

525 Clair, Jean. "Giacometti le sauveur." *La Nouvelle Revue française.* Paris, 1969, pp. 545–57.

526 Coulonges, Henri. "Giacometti vivant." In Bibl. 704.

527 Courtois, Michel. "La Figuration magique de Giacometti." *Art International.* Lugano, summer, 1962, pp. 38–45.

528 Curonici, Giuseppe. "Alberto Giacometti." *Cenobio*, XV. Milan, 1966, pp. 3–5.

529 Debrunner, Hugo, "Giacometti richtet seine Biennale-Ausstellung selber ein." *Die Tat.* Zurich, July 18, 1962.

530 Debrunner, Hugo. "Alberto Giacomettis Kunst. Ein Beitrag zum Mythos unserer Zeit." Lecture; summary in *Jahrbuch des psychologischen Clubs Zürich*. Private printing, 1962/63.

531 Debrunner, Hugo. "Giacometti und Hodler." *Die Tat.* Zurich, Feb. 5, 1965.

532 "Giacometti lithographe et eaux-fortiste." *Derrière Le Miroir* (hors série). Paris, 1956, pp. 17–21.

533 Dupin, Jacques. "Giacometti, sculpteur et peintre." *Cahiers d'art.* Paris, 1954, pp. 41–54.

Dupin, Jacques. See also Bibl. 708; compare also commentary and interview in Bibl. 817.

534 Duthuit, Georges. "Skulptur i Paris 1950 och tidigare." *Konstrevy*, No. 27. Stockholm, 1951, pp. 38–43.

535 Eager, Gerald. "The Missing and the Mutilated Eye in Contemporary Art." *Journal of Aesthetics and Art Criticism*, No. 1. Detroit, 1961, pp. 49–50.

536 Elsen, Albert E. *The Partial Figure in Modern Sculpture.* Baltimore Museum of Art, 1969, pp. 60–62.

537 France, José-Augusto. "Arp et Giacometti." *Quadrum*, No. 43. Brussels, 1966, pp. 35–39.

538 Frigerio, Simone. "Giacometti après Giacometti." *Aujourd'hui.* Paris, Feb., 1966, p. 72.

539 Gallego, J. "Dibujos de Giacometti." *Goya*, No. 91. Madrid, 1969, p. 35.

540 Gasser, H. U. "Der englische Maler Martin Frey." *Werk.* Winterthur, 1952, pp. 73–74. Discusses Giacometti's rank among artists in London.

541 George, L. "Giacometti and the Lonely World." *Art Digest.* New York, July, 1965, pp. 6–7. On the exhibition at the Guggenheim Museum, New York, 1955.

542 George, Waldemar. "Alberto Giacometti." *Art et Industrie*, No. 21. Paris, 1951, pp. 25–27.

543 Giedion-Welcker, Carola. *Plastik des 20. Jahrhunderts.* Stuttgart: Gerd Hatje, 1955, pp. 88–97, 242, 266, 269, 312–14. Expanded edition of Bibl. 363. English translation by Mary Hottinger, *Contemporary Sculpture.* New York: Wittenborn, and London: Faber and Faber, 1955; revised and expanded edition, 1961.

544 Giedion-Welcker, Carola. "Alberto Giacometti." *Werk*. Winterthur, 1956, pp. 151–52.

545 Giedion-Welcker, Carola. "Alberto Giacomettis Vision der Realität." *Werk*. Winterthur, 1959, pp. 205–12.

546 Giedion-Welcker, Carola. "Giacometti." *National-Zeitung*. Basel, May, 18, 1963.

547 Giedion-Welcker, Carola. "Alberto Giacometti." *Kunstwerk*, Nos. 1/2. Baden-Baden, 1966, pp. 4–12.

Giedion-Welcker, Carola. See also Bibl. 148–50, 344, 363.

548 Gindertael, R. V. "Alberto Giacometti. Une expérience figurée de la solitude." *Pour l'Art*, No. 75. Lausanne, 1960, pp. 25–27.

549 Goldwater, Robert. *Space and Dream*. New York: Walker, 1968, pp. 24–26. Book edition of the catalogue *Space and Dream*. New York: Knoedler Galleries, Dec., 1967.

550 Grand, Paul-Marie. "Today's Artists: Giacometti." *Portfolio and Art News Annual*, No. 3. New York, 1960, pp. 64–79, 138–40.

551 Grand, Paul-Marie. "Les Certitudes imprévues de Giacometti." *Le Monde*. Paris, Oct. 30, 1969, p. 17.

552 Grenier, Jean. "Giacometti." *Preuves*. Paris, July, 1961, pp. 66–68.

553 Gröger, Herbert. "A Great Swiss Sculptor: Alberto Giacometti." *Roopa-Lekka*, Nos. 1/2. New Delhi, 1965.

554 Guéguen, Pierre. "Giacometti." *Aujourd'hui*, Nos. 4/5. Boulogne, 1954, p. 62.

555 Gullon, Ricardo. "Visiones de Giacometti." *Quadernos hispano-americanos*, No. 95, Madrid, 1957, pp. 185–95.

556 Habasque, Guy. "Giacometti." In the catalogue *Minotaure*. Paris: Galerie L'Œil, 1962, Nos. 26–30.

557 Häsli, Richard. "Zum Projekt eines Alberto-Giacometti-Zentrums." *Neue Zürcher Zeitung*. Feb. 21, 1964.

558 Häsli, Richard. "Alberto Giacometti im Film." *Neue Zürcher Zeitung*. Jan. 26, 1966.

Häsli, Richard. See also Bibl. 732.

559 Hess, Thomas B. "Alberto Giacometti." *Art News*. New York, Jan., 1951, p. 44.

560 Hess, Thomas B. "Giacometti: The Uses of Adversity." *Art News*. New York, May, 1958, pp. 34–35, 67.

561 Hess, Thomas B. "The Cultural-Gap Blues." *Art News*. New York, Jan., 1959.

Hess, Thomas B. See also Bibl. 156, 387.

562 Hohl, Reinhold. "Zeichnungen von Alberto Giacometti." *National-Zeitung*. Basel, Aug. 19, 1959.

563 Hohl, Reinhold. "Alberto Giacometti im 'Du': Werkaufnahmen mit Tiefenunschärfe." *Neue Zürcher Zeitung*. Feb. 28, 1962.

564 Hohl, Reinhold. "Alberto Giacomettis Wirklichkeit." *National-Zeitung*. Basel, March 1, 1963.

565 Hohl, Reinhold. "Alberto Giacometti: Kunst als die Wissenschaft des Sehens." Yearbook *Die Ernte*. Basel, 1966, pp. 134–50.

566 Hohl, Reinhold. "Auge in Auge." *Neue Zürcher Zeitung*. Aug. 5, 1966.

567 Hohl, Reinhold. "Was jede Erniedrigung des Menschen überlebt." *Frankfurter Allgemeine Zeitung*. Nov. 22, 1969. On the Giacometti exhibition at the Orangerie, Paris.

567a Hohl, Reinhold. "Alberto Giacomettis Atelier im Jahr 1932." *Du*, No. 563. Zurich, May, 1971, pp. 352–65. On two recently discovered drawings.

568 Holz, Hans Heinz. "Gebärde der Bewegung." *National-Zeitung*. Basel, Jan. 16, 1966.

569 Hope, Henry R. "Alberto Giacometti." In *Encyclopedia of World Art*.

570 Huber, Carlo. "Alberto Giacometti: Vier Werke im Basler Kunstmuseum." *Geigy-Werkzeitung*, No. 6. Basel, 1962, pp. 25–29.

Huber, Carlo. See also Bibl. 718, 810.

571 Hüttinger, Eduard. "Zum Werk Alberto Giacomettis." In the catalogue *Giacometti*. Zurich: Kunsthaus, 1962, pp. 4–8.

572 Hüttinger, Eduard. "Aspekte der Kunst Alberto Giacomettis." *Neue Zürcher Zeitung*. Feb. 26, 1967. Reprinted in *Universitas*, No. 2. Stuttgart, 1968, pp. 169–84. Revised reprint in *Gedenkschrift Gotthard Jedlicka*. Zurich (in preparation).

573 Jedlicka, Gotthard. "Alberto Giacometti als Zeichner." *Neue Zürcher Zeitung*. Feb. 28, 1960. Reprinted in Bibl. 719.

Jedlicka, Gotthard. See also Bibl. 53, 69, 160, 161, 719, 720.

574 Keller, Heinz. "Über das Betrachten der Plastiken Alberto Giacomettis." *Werk*. Winterthur, 1963, pp. 161–64. Includes four photographs by Michael Speich, each with a different focus, of *Bust of Diego*, 1960, bronze.

575 *Konstrevy*. Stockholm, 1967, pp. 244–47: "Palatset klocken fyra på morgenen." Eight illustrations.

576 Kosice, Guyla. "Alberto Giacometti." *Konstrevy*. Stockholm, 1962, pp. 134–39.

577 Kramer, Hilton. "Reappraisals: Giacometti." *Arts Magazine*. New York, Nov. 1963, pp. 52–59.

578 Lanes, Gerold. "Alberto Giacometti." *Arts Yearbook*. New York, March, 1959, pp. 152–55.

579 Lange, Lothar. Catalogue: *Giacometti-Zeichnungen*. Berlin-Weissensee: Kunstkabinett, 1965.

580 Laude, Jean. "Le Combat solitaire d'Alberto Giacometti." *Critique*. Paris, 1963, pp. 1046–62.

581 Leclerq, Lena. "Jamais d'espaces imaginaires." *Derrière Le Miroir*, No. 127. Paris, 1961, pp. 6–16.

582 Leymarie, Jean. "Giacometti." In the catalogue *Giacometti*. Paris: Musée de l'Orangerie, 1969, pp. VII–XV. Reprinted as "L'Aventure singulière d'Alberto Giacometti." *Plaisir de France*, No. 371. Paris, 1969, pp. 10–17.

Leymarie, Jean. See also Bibl. 171, 172, 722.

583 *Life*. New York, April 23, 1968, p. 86: "A Mother for Giacometti." Comparison between photographs and paintings.

584 Lonzi, Carlo. "Mostre di Alberto Giacometti a Torino e a Milano." *L'Approdo letterario*, No. 16. Rome, 1961, pp. 174–75.

585 Lord, James. "Alberto Giacometti, sculpteur et peintre." *L'Œil*, No. 1. Paris, 1955, pp. 14–20.

585a Lord, James. "Biographical Notes on Alberto Giacometti." *Paris Review*, No. 18. Paris, 1958. Reprinted in *Bulletin of the Rhode Island School of Design*, LVI, No. 3, March, 1970, p. 27 (Catalogue *Giacometti, Dubuffet—Collection James Lord*).

586 Lord, James. "Alberto Giacometti and His Drawings." In the catalogue *Giacometti, Drawings*. New York: Pierre Matisse Gallery, 1964. Also includes a partial reprint from Bibl. 723.

587 Lord, James. "Alberto Giacometti and Balthus." In the catalogue *Giacometti and Balthus. Drawings*. New York: Albert Loeb and Kruger Gallery, 1966.

Lord, James. See also Bibl. 175, 723–25; and *La Parisienne*. Paris, June, 1954, pp. 713–14; *Arts*. New York, May 31, 1961, p. 2.

588 Lynton, Norbert. "Alberto Giacometti." *Art International*, No. 6. Lugano, 1965, pp. 50–51.

589 Lynton, Norbert. "Giacometti." *The Guardian*. London, July 17, 1965.

590 Maldiney. "La Fondation Marguerite et Aimé Maeght." *Derrière Le Miroir*, No. 148. Paris, 1964, pp. 35–41, 43.

591 Martini, Alberto. "Alberto Giacometti: La poesia delle apparenze." *Arte antica e moderna*, No. 29. Bologna, 1965, pp. 25–38.

592 Martini, Alberto. "Solitude des hommes et des choses dans la profondeur de l'espace." In Bibl. 704.

593 Mastai, M. L. D. "Giacometti Studies." *The Connoisseur*, No. 4. London, 1965, p. 279.

594 Merleau-Ponty, Maurice. "L'Œil et l'esprit." *Art de France*, No. 1. Paris, 1961, pp. 187–208. Reprinted in *Les Temps modernes*, Nos. 184/85. Paris, 1961, pp. 193–227; *L'Œil et l'esprit*. Paris: Gallimard, 1964 (on Giacometti: pp. 24, 64).

595 Melville, R. "Giacometti. Retrospective Exhibition at the Tate Gallery." *Architectural Review*. London, Oct., 1965, pp. 283–85.

596 Metken, Günter. "Alberto Giacometti." *Kunstwerk*, Nos. 5/6. Baden-Baden, 1970.

Metken, Günter. See also Bibl. 814.

597 Metzger, Othmar. "Zur surrealistischen Plastik 'Femme couchée qui rêve' von Alberto Giacometti." *Bulletin der Museen von Köln*, No. 3. Cologne, 1966, pp. 455–56.

598 Meyer, Franz. Catalogue *Giacometti*. Bern: Kunsthalle, 1956.

599 Meyer, Franz. Catalogue *Giacometti*. Basel: Kunsthalle, 1966.

Meyer, Franz. See also Bibl. 186, 716, 729.

600 Meyer, Peter. *Testfall des Kunstbetriebes. Grundsätzliches anlässlich der Zürcher Giacometti-Diskussion*. Zurich: Artemis, 1966.

601 Monnier, Jacques. "Giacometti. A propos d'une sculpture." *Pour l'Art*, Nos. 50/51. Lausanne, 1956, pp. 13–14. On *Three Men Walking I*.

602 Moore, Henry. "On Giacometti." In: John and Vera Fussell, "Conversations with Henry Moore." *The Sunday Times*. London, Dec. 17 and 24, 1961. Reprinted in: Philip James (ed.), *Henry Moore on Sculpture*. London: Macdonald, 1966, and New York: Viking, 1967, pp. 201–203. For Henry Moore on Giacometti see also *L'Œil*, No. 155. Paris, 1967. Also the quotations in Donald Hall, *Henry Moore*. New York: Harper and Row, and London: Gollancz, 1966, pp. 87 and 96; John Russell, *Henry Moore*. New York: Putnam, and London: Allen Lane, 1968, p. 44.

Henry Moore. See also Bibl. 188.

603 Mullins, Edwin. "Exact Distortions." *Weekend Telegraph*, No. 42. London, 1965, pp. 22–23, 25.

Mullins, Edwin. See also Bibl. 189.

604 Negri, Mario. "Frammenti per un Alberto Giacometti." *Domus*, No. 320. Milan, 1956, pp. 40–48.

605 Negri, Mario. "Alberto Giacometti." *Domus*, No. 439. Milan, 1966, pp. 32–36.

606 Negri, Mario. "L'Art de Giacometti." In Bibl. 705.

607 Padrta, Jiri. ["Space in Giacometti's Work" —in Czech]. *Vytv. Umeni*, XIII. Prague, 1963, pp. 157–65.

608 Pleynet, Marcelin. "Écriture d'Alberto Giacometti." *Tel Quel*, No. 14. Paris, 1963, pp. 58–60.

609 Ragon, Michel. "Alberto Giacometti. Peintre et sculpteur." *Jardin des arts*, No. 158. Paris, 1968, pp. 2–9.

610 Régnier, Gérard. "Biographie comparative et bibliographie d'Alberto Giacometti." In the catalogue *Alberto Giacometti*. Paris: Musée de l'Orangerie, 1969, pp. XVII–XIX, 165–68.

611 Régnier, Gérard. "L'Exposition Alberto Giacometti au Musée de l'Orangerie." *Revue du Louvre*, Nos. 4/5. Paris, 1969, pp. 287–94.

612 Régnier, Gérard. "L'Exposition Giacometti au Musée des Tuileries, Paris." *Revue de l'art*, No. 8. Paris, 1970, pp. 79–80.

Régnier, Gérard. See also Bibl. 202.

613 Restany, Pierre. "Giacometti." *Cimaise*, No. 54 Paris, 1961, p. 97.

614 Roberts, K. "Alberto Giacometti. Exhibition at the Tate Gallery." *Burlington Magazine*. London, 1965, p. 441.

615 Robertson, Bryan. "Alberto Giacometti: The Triumph of Time." *The Spectator*, No. 7,153. London, 1965, pp. 150–51.

616 Rotzler, Willy. "Die Alberto-Giacometti-Stiftung als Modellfall der Kunstpflege." *Neue Zürcher Zeitung*. Jan. 22, 1965.

617 Rotzler, Willy. "Alberto Giacometti—Suchen nach dem Absoluten." *Kunstnachrichten*, No. 7. Lucerne, 1965.

618 Rotzler, Willy. "Alberto Giacometti. Sein Werk im Spiegel der Schweizerischen Giacometti-Stiftung." *Die Weltwoche*, No. 1,629. Zurich, 1965, p. 23.

Rotzler, Willy. See also Bibl. 203, 204, 734.

619 Russoli, Franco. "Artista alla Biennale: Alberto Giacometti." *Communità*, No. 42. Milan, 1965, pp. 74–77.

620 Rubin, William S. *Dada and Surrealist Art*. New York: Harry N. Abrams, 1968; and London: Thames and Hudson, 1970; pp. 249–55, 264, 283. Revised reprint in the catalogue *Dada, Surrealism and Their Heritage*. New York: Museum of Modern Art, 1968, pp. 114–19.

621 Sartre, Jean-Paul: "Les Peintures de Giacometti." *Derrière Le Miroir*, No. 65. Paris, 1954. Reprinted in *Les Temps modernes*. Paris, 1954, pp. 2220–32; and *Situations IV*. Paris: Gallimard, 1964, pp. 347–63. English translations by: Lionel Abel, "Giacometti in Search of Space." *Art News*, No. 5. New York, 1955, pp. 26–29, 63–65; Warren Ramsey, "The Painting of Giacometti." *Art and Artist*. Berkeley and Los Angeles: University of California Press, 1956, pp. 179–94; Benita Eisle in: Jean-Paul Sartre, *Situations*. New York: Braziller, 1965.

Sartre, Jean-Paul. See also Bibl. 208, 383.

622 Schmied, Wieland. "Notizen zu Alberto Giacometti." In the catalogue *Giacometti, Zeichnungen*. Hanover: Kestner-Gesellschaft, 1966, pp. 5–10.

623 *Schweizer Künstler-Lexikon des 20. Jahrhunderts*. Ed. by Eduard Plüss. Frauenfeld: Huber, 1963, pp. 349–51: "Alberto Giacometti."

624 Selz, Peter. *New Images of Man*. New York: Museum of Modern Art, 1959, pp. 68–75. Includes Bibl. 21.

625 Selz, Peter. "Introductory Note." In the catalogue *Alberto Giacometti*. New York: Museum of Modern Art, 1965, pp. 8–11.

626 Seuphor, Michel. "Le Vide actif." *XXᵉ Siècle*, No. 2. Paris, 1952, p. 86.

627 Seuphor, Michel. "Giacometti à la Galerie Maeght." *Preuves*, No. 41. Paris, 1954, pp. 79–80.

628 Seuphor, Michel. "Giacometti and Sartre." *Art Digest*, No. 1. New York, 1954, p. 14.

629 Smithson, R. "Quasi-Infinities and the Waning of Space." *Arts*. New York, Nov., 1966, p. 30.

630 Solier, René de. "Giacometti." *Les Cahiers de la Pléiade*, No. 12. Paris, 1951, pp. 44–47.

631 Spies, Werner. "Suche nach dem Absoluten." *Frankfurter Allgemeine Zeitung*. Aug. 26, 1965.

632 Stahly, François. "Die junge französische Plastik." *Werk*. Winterthur, 1952, pp. 369–76.

Stahly, François. See also Bibl. 217.

633 Sylvester, David. "Festival Sculpture." *Studio*. London, 1951, pp. 72–77.

634 Sylvester, David. "Perpetuating the Transient." In the catalogue *Giacometti*. London: Arts Council Gallery, 1955.

635 Sylvester, David. "Post Picasso Paris." *The New Statesman and Nation*. London, 1957, p. 838.

636 Sylvester, David. "Biographical Notes." In the catalogue *Giacometti*. London: Tate Gallery, 1965.

637 Sylvester, David. "The Residue of a Vision." In the catalogue *Giacometti*. London: Tate Gallery, 1965.

638 Sylvester, David. "Giacometti: An Inability to Tinker." *Sunday Times*. London, July, 1965, pp. 19–25. Includes a partial reprint of Bibl. 819.

Sylvester, David. See also Bibl. 737, 821, 822.

639 Terrasse, Antoine. "L'Angoisse de voir." In Bibl. 705.

640 *The Times*. London, April 18, 1963: "Alberto Giacometti."

641 *The Times*. London, Jan. 13, 1966: "Sculptor Who Achieved Expression Through Skeletal Forms." Discusses Giacometti's influence on the "Monument to the unknown political prisoner" theme.

642 Tummers, Nico. "Alberto Giacometti." *Kroniek van Kunst en Kultuur*, No. 2. Amsterdam, 1959, pp. 16–25.

643 Vad, Poul. "Giacometti." *Signum*, No. 2. Copenhagen, 1962, pp. 28–36. Reprinted in Bibl. 726, pp. 8, 10.

644 Vallentin, Antonina. "Alberto Giacometti. Exposition Galerie Maeght, Paris 1951." *Les Temps modernes*. Paris, Sept., 1951.

645 Veronese, Giulia. "Alberto Giacometti." *Emporium*, No. 679. Bergamo (Italy), 1951, pp. 36–37.

646 Waddington, C. H. *Behind Appearance*. Edinburgh: University Press, 1969, pp. 228–34.

647 Waldberg, Patrick. "Alberto Giacometti. Un genio fantasmagico." *Arti*, No. 12. Milan, 1963, pp. 5–6.

648 Waldberg, Patrick. "La Ville rêvée et la ville vécue." *XXᵉ Siècle*, No. 28. Paris, 1966, p. 56.

649 Watt, Alexander. "Alberto Giacometti: Pursuit of the Unapproachable." *The Studio*, No. 849. London, 1964, pp. 20–27. Revised reprint of Bibl. 57.

650 Wehrli, René. *Giacometti*. Zurich: Kunsthaus, 1962, p. 3. Catalogue.

651 Wehrli, René. "Alberto Giacometti." *Werk*, No. 2. Winterthur, 1962, pp. 80–81.

652 Wehrli, René. "Für eine Alberto-Giacometti-Stiftung." *Neue Zürcher Zeitung*. Jan. 11, 1965; Jan. 27, 1965.

Wehrli, René. See also Bibl. 227.

653 Whittet, Q. S. "Giacometti. Paintings and Drawings in the Exhibition at the Tate Gallery." *The Studio*. London, 1965, pp. 130–31.

654 Zala, Romerio. "Parliamo di Alberto Giacometti." *Quaderni Grigionitaliani*, XXVII. Poschiavo (Switzerland), 1956/57, pp. 15–25.

655 Zervos, Christian. "La Situation faite au dessin dans l'art contemporain." *Cahiers d'art*. Paris, 1953, pp. 161–311.

Zervos, Christian. See also Bibl. 311, 323, 335, 336, 366.

F. Monographs and Collections of Texts (Publications, Special Issues of Magazines, Detailed Exhibition Catalogues)

700 Bouchet, André du. *Giacometti, Dessins*. Paris: Galerie Claude Bernard, 1968. 84 pp., 42 illus. Includes text of Bibl. 115.

701 Bouchet, André du. *Alberto Giacometti, Dessins 1914–1965*. Paris: Maeght, 1969. 128 pp., 114 illus. Includes the text "Sur le foyer des dessins d'Alberto Giacometti" of 1965.

702 Bucarelli, Palma. *Giacometti*. Rome: Editalia, 1962. 192 pp., 114 illus. Text, in Italian, French, and English, includes text of Bibl. 510, slightly altered.

703 Carluccio, Luigi. *Alberto Giacometti. Le copie del passato*. Turin: Botero, 1968. 330 pp., 144 illus. Includes Giacometti's text from Bibl. 25. English translation by Barbara Luigia La Penta, *A Sketchbook of Interpretative Drawings*. New York: Harry N. Abrams, 1968.

Carluccio, Luigi. See also Bibl. 126, 515, 516.

704 *Chefs-d'œuvre de l'art: Grands Peintres, No. 55. Giacometti peintures*. Milan: Fabbri, and Paris: Hachette, 1967. 8 pp., 15 color illus. Includes: N. N., "Un Visionnaire international"; Alberto Martini, "Solitude des hommes et des choses dans la profondeur de l'espace"; Henri Coulonges, "Giacometti vivant."

705 *Chefs-d'œuvre de l'art: Grands Peintres, No. 131. Giacometti sculptures*. Milan: Fabbri, and Paris: Hachette, 1969. 8 pp., 17 color illus. Includes: Mario Negri, "Biographie" and "L'Art de Giacometti"; Antoine Terrasse, "L'Angoisse de voir."

706 *Dojidai* [Contemporaries], No. 19. Tokyo, 1965, pp. 1–100: "Hommage à Alberto Giacometti." Includes, in Japanese, Bibl. 12, 24, 130, 148, 167, 713, and the following Japanese contributions: Eiji Usami, "Twilight in Giacometti's Work," pp. 10–23; Shuzo Takiguchi, "An Invisible Meeting," pp. 23–26; Jun Miyakawa, "Mirror," pp. 50–55; Toyoichiro Miyoshi, "Notes on Giacometti," pp. 67–69; Norio Awazu, "An Approach to Giacometti," pp. 69–72; Sakon So, "The Dramatic in Giacometti's Oeuvre," pp. 72–81; Yoshio Dohi, "Alberto Giacometti and Switzerland," pp. 89–93; Jiro Koyamada and Noritsugu Horiuchi, "A Conversation on Giacometti," pp. 94–99; Isaku Yanaihara, "Alberto Giacometti, A Diary," pp. 84–100; "Chronology of Giacometti's Life," p. 100.

707 *Du*, No. 252. Zurich, Feb., 1962, pp. 2–46. In addition to Bibl. 109, 148, 213, 229, 231, it includes two texts by M[anuel G[asser]: "Zu diesem Heft" [pp. 2, 40; Giacometti on the unfocused photographs]; and "Giacometti und die Wirklichkeit," pp. 45–46; also photographs by Franco Cianetti, eight of them color plates, and three photographs of *Portrait d'Annette* [in fact *Caroline*], 1961, oil, taken with different focusings.

708 Dupin, Jacques. *Alberto Giacometti*. Paris: Maeght, 1962. 316 pp., 236 illus. English translation by John Ashbery, *Alberto Giacometti*. Paris: Maeght, 1962.

Dupin, Jacques. See also Bibl. 533, 817.

709 Engelberts, Edwin. Catalogue *Alberto Giacometti: Dessins, estampes, livres illustrés, sculpture*. Geneva: Galerie Engelberts, March–April, 1967. 106 pp., 185 illus. Includes a scheme for an oeuvre catalogue of the drawings and prints. Enlarged edition with new material added: Geneva: Engelberts, 1970. 116 pp., 178 illus.

710 *L'Éphémère*, No. 1. Paris, 1966, pp. 67–112. Includes Bibl. 28, 112, 114, 170, 197.

711 Filippini, Felice. *Fare il ritratto di Alberto Giacometti*. Locarno: Galleria Marino, 1966. 48 pp.,

17 illus. (of Filippini's paintings). Reprinted in *Quaderni Grigionitaliani*, XXXVI. Poschiavo (Switzerland), 1967, pp. 1–36. 15 illus.

712 *Gazette de Lausanne*. Jan. 15/16, 1966, pp. 13–15: "Hommage à Giacometti." Includes, in addition to Bibl. 127, 128, 139, 171, 176, 186, 196, 205, 222, articles by Franck Jotterand and André Küenzi.

713 Genet, Jean. *L'Atelier d'Alberto Giacometti*. Décine: Barbezat, 1958. Published in part in *Derrière Le Miroir*, No. 98. Paris, 1957. Again in: Jean Genet, *Les Bonnes. L'Atelier de Giacometti*. Décine: Barbezat, 1959. New edition with photographs by Ernst Scheidegger issued by the same publishers in 1963; 54 pp. 33 illus.

714 *Alberto Giacometti: Schriften, Zeichnungen*. Ed. Ernst Scheidegger. Zurich: Arche, 1958, 132 pp., 80 illus. Includes, in addition to Bibl. 2–5, 12–16, 19, 51, photographs and the text: Ernst Scheidegger, "Zu den Fotos," pp. 79–81.

715 *Alberto Giacometti*. Basel: Galerie Beyeler, 1964. 132 pp., 102 illus. German, French, and English editions. Book edition of the catalogue: *Giacometti*. Basel: Galerie Beyeler, 1963. Includes quotes from Bibl. 61, and material reprinted from Bibl. 13, 168. New edition, 1971.

716 *Alberto-Giacometti-Stiftung* [For a Swiss Giacometti-Foundation. Booklet by the launching committee]. Zurich: Kunsthaus, Sekretariat der Giacometti-Stiftung, 1964. 24 pp. Includes addresses by Gotthard Jedlicka and Franz Meyer, and selections from the Swiss press of Feb. 21–28, 1964.

717 *Alberto-Giacometti-Stiftung*. Catalogue compiled by Bettina von Meyenburg-Campbell and Dagmar Hnìkova. Zurich: Kunstgesellschaft, 1971, 245 pp.

718 Huber, Carlo. *Alberto Giacometti*. Zurich: Ex Libris, and Lausanne: Rencontre, 1970. 128 pp., 46 illus.

Huber, Carlo. See also Bibl. 570, 810.

719 Jedlicka, Gotthard. *Alberto Giacometti als Zeichner*. Olten: Bücherfreunde, 1960. 17 pp., 1 illus. Includes text from Bibl. 573.

720 Jedlicka, Gotthard. *Einige Aufsätze zu Alberto Giacometti*. Zurich: Kunsthaus, Sekretariat der Giacometti-Stiftung, n. d. [1965]. 26 pp. Includes Bibl. 53, 160, 161, 573, 719.

721 *Les Lettres françaises*, No. 1,115. Paris, Jan. 20, 1966: "Hommages après la mort d'Alberto Giacometti." Includes Bibl. 100, 104–6, 116, 129, 138, 162, 165, 172, 177, 182, 188, 193, 200, 206, 214, 223, 225.

722 Leymarie, Jean. *Quarantacinque Disegni di Alberto Giacometti*. Ed. Lamberto Vitali. Turin: Einaudi, 1963, 16 pp. With text and 45 facsimile reproductions in a cassette.

Leymarie, Jean. See also Bibl. 171, 172, 582.

723 Lord, James. *A Giacometti Portrait*. New York: Doubleday, 1965. 68 pp., 5 pp. of illus.

724 Lord, James. *Alberto Giacometti, Drawings*. New York: Graphic Society, and London: Thames and Hudson, 1971. 256 pp., 120 illus.

725 Lord, James. Alberto Giacometti. *A Biography*. In preparation.

Lord, James. See also Bibl. 175, 585–87.

726 *Louisiana Revy*, VI. Humlebaek, Sept. 1, 1965, pp. 1–40. (Compare catalogue *Giacometti*. Louisiana Museum, Humlebaek, 1965.) Includes Bibl. 4, 5, 13, 17, 19, 61, 168, 636, 638, 643, 713 (all in Danish), and also: Knud W. Jensen, "Giacometti—udstillingen på Louisiana," p. 9; Albert Mertz, "Hilsen til Alberto Giacometti," p. 36; Uffe Harder, "Fondation Maeght i Saint-Paul-de-Vence," p. 39.

727 Lust, Herbert C. *Alberto Giacometti. The Complete Graphics and Fifteen Drawings*. New York: Tudor, 1970. 224 pp., 368 illus. List of works published in the catalogue *Alberto Giacometti. The Complete Graphics*. Milwaukee Art Center, 1970.

728 Matter, Herbert. *Alberto Giacometti. A Photographic Essay*. Text by Isaku Yanaihara (translated from Bibl. 740), biography by Mercedes Matter. Basel: Druck- und Verlagsanstalt. In preparation. Partially published (from an exhibition of photographs) as "Giacometti by Giacometti and Giacometti by Herbert Matter." *Art News*. New York, Jan., 1962, pp. 41–57.

729 Meyer, Franz. *Alberto Giacometti. Eine Kunst existentieller Wirklichkeit*. Frauenfeld-Stuttgart: Huber, 1968. 260 pp., 34 illus.

Meyer, Franz. See also Bibl. 186, 598, 599, 716.

730 Moulin, Raoul. *Giacometti. Sculpture*. Petite Encyclopédie de l'art, 62. Paris: Hazan, 1964. 12 pp., 24 illus. Includes quotes from Bibl. 70. English translation by Bettina Wadia, London: Methuen, 1964.

731 Museum of Modern Art, New York. Catalogue *Alberto Giacometti*. Exhibitions 1965–66 in New York, Chicago (Art Institute), Los Angeles (County Museum of Art), San Francisco (Museum of Art). 120 pp., 100 illus. and plates. Includes Bibl. 7, 13, 625, 808.

732 *Neue Zürcher Zeitung*. Articles on Alberto Giacometti:

a) Documentation on the Alberto Giacometti Foundation: Jan. 21, 1964; Dec. 21, 1964; Jan. 5, 1965; Jan. 6, 1965; Jan. 14, 1965; Jan. 15, 1965; Jan. 21, 1965; Jan. 22, 1965; Jan. 26, 1965; Jan. 27, 1965; Feb. 4, 1965; March 26, 1965; March 30, 1965; Nov. 12, 1965.

b) "Zeugnis und Dank" [On Giacometti's death]. Jan. 22, 1966. Includes Bibl. 149, 151, 186, 203, 227.

c) "In memoriam Alberto Giacometti." Jan. 22, 1966. Text by Richard Häsli. 12 photographs by Ernst Scheidegger.

733 Orangerie des Tuileries, Paris. Catalogue *Alberto Giacometti*. Exhibition of Oct. 24, 1969–Jan. 12, 1970. 170 pp., 157 illus. Includes Bibl. 7, 118, 582, 610.

734 Rotzler, Willy, and Adelmann, Marianne. *Alberto Giacometti*. Orbis Pictus, 55. Bern: Hallwag, 1970. 48 pp., 19 color illus.

Rotzler, Willy. See also Bibl. 203, 204, 616–18, For Marianne Adelmann, see also Bibl. 66.

735 Soavi, Giorgio. *Il mio Giacometti*. Milan: Scheiwiller, 1966. 72 pp., 6 illus. Partially reprinted in Bibl. 215, 216; reprinted in Bibl. 736.

736 Soavi, Giorgio. *Protagonisti. Giacometti, Sutherland, De Chirico*. Milan: Longanesi, 1969, pp. 15–96. Text of Bibl. 735 with a postscript of Dec., 1968. Photographs of the studio and works, by the author.

Soavi, Giorgio. See also Bibl. 818.

737 Sylvester, David. *Alberto Giacometti*. London: Weidenfeld and Nicolson. In preparation. Partially published in Bibl. 634, 635, 637, 638.

Sylvester, David. See also Bibl. 633, 636, 819, 820.

738 Tate Gallery, London. Catalogue *Alberto Giacometti: Sculpture, Paintings, Drawings*. Published by The Arts Council of Great Britain for the exhibition of July 17–Aug. 30, 1965. 100 pp., 75 plates, 11 illus. Includes Bibl. 636, 637.

739 *Die Weltwoche*, No. 1,680. Zurich, 1966, pp. 23–24: "Zum Tode Alberto Giacomettis." Includes Bibl. 144, 150, 163, 174, 204, 209, 210.

740 Yanaihara, Isaku. *Alberto Giacometti* [Japanese]. Tokyo: Misusu, 1958. 106 pp., 57 illus.

Yanaihara, Isaku. See also Bibl. 231, 232, 706, 728.

G. Unpublished Sources (Manuscripts, Mimeographed Texts, Tape Recordings, and Films)

800 Bechtler, Hans C. "Das Werden der Alberto-Giacometti-Stiftung." Address held upon the presentation of Basel's contribution to the Foundation. Kunstmuseum, Basel, Oct. 21, 1967. Mimeographed manuscript.

801 Block, Susi Regina. "The Early Works of Alberto Giacometti: The Development of the Tableau Object." Master's thesis, New York University, Feb., 1963. 94 pp., illus. Manuscript copy in the Reference Library, Museum of Modern Art, New York. Photocopy in the library of the Kunstmuseum, Basel.

802 Columbia University, Center for Mass Communication. *Alberto Giacometti.* Color film, 16 mm, 12 min. New York: Columbia University Press, 1966.

803 Drôt, Jean-Marie. *Alberto Giacometti.* Television film, 35 mm, 46 min. Paris: ORTF, Nov. 19, 1963. (Series "Les Heures chaudes de Montparnasse," IX.) Revised version: Paris: ORTF, 1966.

804 Giacometti, Alberto. Letters to his godfather Cuno Amiet, 1906–20, 1933–58. Cuno-Amiet-Archiv, Oschwand, Switzerland (Frau Lydia Thalmann-Amiet).

805 Alberto Giacometti. *Autobiographical Conversation* [in Italian]. Stampa, June 28, 1958. Tape recording by G. G. Tuor, c. 15 minutes. Alberto-Giacometti-Archiv. Società Culturale Bergell, Stampa (Diego Giovanoli).

806 Giacometti, Alberto. Twenty-eight-page manuscript on his accident in 1938. To have been published in *Les Temps modernes.* According to Gotthard Jedlicka in Bibl. 69.

807 Giacometti-Stampa, Giovanni and Annetta. Letters to Cuno Amiet, 1901–59. Cuno-Amiet-Archiv, Oschwand, Switzerland (Frau Lydia Thalmann-Amiet).

Giacometti, Giovanni. See also Bibl. 146.

808 Forslund, Inga. "Alberto Giacometti. A Comprehensive Bibliography." Xeroxed. Reference Library, Museum of Modern Art, New York. Partially printed in the catalogue *Giacometti.* New York: Museum of Modern Art, 1965.

809 Gröger, Herbert. "Ein grosser Schweizer Bildhauer: Alberto Giacometti." Mimeographed. Pro Helvetia, Zurich, 1964, 4 pp. For English translation see Bibl. 553.

810 Huber, Carlo. "Alberto Giacometti: Palais de quatre heures du matin." Manuscript. Annual report of the Öffentliche Kunstsammlung, Basel. In preparation.

Huber, Carlo. See also Bibl. 570, 718.

811 Institute of Contemporary Arts. "Points of View on Alberto Giacometti." Discussion meeting. London University, 1953. Not in print.

812 Kessler, Ludy. "Alberto Giacometti." Television interview in Stampa, summer, 1964. Lugano: Televisione della Svizzera Italiana. Partially published in Bibl. 216, pp. 153–54; Bibl. 736; 818.

813 Maurizio, Remo. *Memories of Alberto Giacometti* [in Italian]. Lugano: Radio della Svizzera Italiana, Jan. 23, 1971. Tape recording, c. 15 minutes. Alberto-Giacometti-Archiv. Società Culturale Bergell, Stampa (Diego Giovanoli).

814 Metken, Günter. "Im Atelier Giacometti." Radio programm. Saarbrücken: Saarländischer Rundfunk, II. Programm, July 7, 1968.

Metken, Günter. See also Bibl. 596.

815 Museum of Modern Art, New York. *Alberto Giacometti.* Color film, 16 mm, 12 min. New York: Museum of Modern Art, 1965.

816 Picon, Gaëtan. "Allocution sur la tombe d'Alberto Giacometti." Borgonovo-Stampa, Jan. 15, 1966. Not in print.

817 Scheidegger, Ernst; Münger, Peter; Dupin Jacques. *Alberto Giacometti.* Color film, 16 and 35 mm, 29 min. Zurich: Scheidegger- u. Rialto-Verleih, 1966.

818 Soavi, Giorgio. *Il Sogno di una testa. Ritratto di Alberto Giacometti.* Black and white film, 16 mm. Lugano: Televisione Svizzera Italiana, 1969. Includes interviews with Diego Giacometti, Jean Leymarie, Franco Russoli, Louis Clayeux, Pierre Matisse, Jacques Dupin, Serafino Corbetta. Alberto-Giacometti-Archiv. Società Culturale Bergell, Stampa (Diego Giovanoli).

Soavi, Giorgio. See also Bibl. 215, 216, 735, 736.

819 Stravinsky, Igor. *This Was My Life.* Television film. New York: NBC, 1957. Includes about ten minutes unedited archive film of a portrait sitting in the south of France.

820 Stampa, Renato. *Radio Conversation about the Artist Family Giacometti* [in Italian]. Lugano: Radio della Svizzera Italiana, Jan. 23, 1971. Tape recording, c. 40 minutes.

821 Sylvester, David. Interview with Alberto Giacometti, Sept., 1964. London: BBC Third Programme. Partially published in Bibl. 638.

822 Sylvester, David. "No More Play. Giacometti and Surrealism." Lecture at the Institute of Fine Arts, New York University, March 3, 1967.

Sylvester, David. See also Bibl. 633–38, 737.

823 Wyss, Peter. Interview with Alberto Giacometti, May, 1950. Basel: Schweizer Radio. Tape recording, c. 7 minutes.

824 From conversations with and letters to the author. We are grateful to the people who have provided this previously unpublished information, and have chosen to leave them unnamed rather than abuse the trust they showed us in private conversation. We take full responsibility for publication of excerpts from this material.

Index

Photo Credits

Marianne Adelmann, Florence 295 (66)
Alinari, Florence 289 (10), 295 (56)
Raymond Asseo, Geneva 109, 180, 265, 296 (73)

Galerie Claude Bernard, Paris 44, 93, 94, 165
Galerie Beyeler, Basel 16, 28, 43, 51, 64 (top), 113, 154, 158, 160, 173, 234, 237, 295 (57)
Paul Bijtebier, Brussels 294 (55)
Kurt Blum, Bern 64 (bottom)
Bo Boustedt, Kungälv, Sweden 70 (right), 132, 266, 267
Brassaï, Paris 293 (39)

Alfred Carlebach, London 88, 149
Geoffrey Clements, New York 163, 164

Walter Dräyer, Zurich 13, 18, 19, 26, 46, 47, 52, 90, 114, 116, 119, 123, 127, 128, 253, 257, 261, 290 (19), 295 (58, 62), 296 (76)

Egyptian National Museum, Cairo 295 (59)
Atelier Eidenbenz, Basel 15, 37, 195, 289, (7), 290 (13, 15, 16), 296 (75)
Eliot Elisofon, New York 291 (29)

Galleria Galatea, Turin 155, 162, 223, 235
Claude Gaspari, Paris 87, 153
Gimpel & Hanover Galerie, Zurich 295 (60)
The Solomon R. Guggenheim Museum, New York 66

Ernst Hahn, Zurich 291 (28)
Peter Heman, Basel 36, 117
Reinhold Hohl, Basel 290 (20)

Sidney Janis Gallery, New York 163, 164

Galerie Louise Leiris, Paris 291 (23), 293 (44)

Galerie Maeght, Paris 150, 242, 244, 256
Marlborough Galleries, London 291 (24)
Pierre Matisse Gallery, New York 145, 296 (67)
Herbert Matter, New York 258, 260
Federico Arborio Mella, Milan 57
Milwaukee Art Center, Milwaukee, Wis. 147
Moderna Museet, Stockholm 56
Peter Moeschlin, Basel 224
Moeschlin & Baur, Basel 291 (31)
Musée d'Art et d'Histoire, Geneva 289 (4)
The Museum of Modern Art, New York (Soichi Sunami) 67, 122, 151, 233, 289 (1), 293 (40)
Museum für Völkerkunde – Schweizerisches Museum für Volkskunde, Basel 291 (27, 30), 295 (61, 63, 65)
Museum für Völkerkunde, Berlin 291 (32)

Niedersächsisches Landesmuseum, Hanover 294 (50)

Öffentliche Kunstsammlung, Basel 17, 65, 86, 141, 146, 148, 167, 183, 292 (34, 35), 294 (46, 52), 295 (64), 296 (74)

Philadelphia Museum of Art, Philadelphia, Pa. (A. J. Wyatt) 41, 290 (22)
Eric Pollitzer, Garden City Park, New York 161, 241, 262–264

Galerie Dr. Raeber, Basel 240
Man Ray, Paris 293 (41, 42), 294 (51)
Claire Roessiger, Basel 157

Ernst Scheidegger, Zurich 33–35, 40, 49, 50, 53, 59, 60, 68, 71, 72, 74 (bottom left and right), 75, 76, 110, 111, 115, 118 (right), 120, 121, 124–126, 129–131, 152, 193, 194, 196–204, 254, 255, 259, 289 (5), 290 (12, 14), 293 (43), 294 (53)
Schweizerisches Institut für Kunstwissenschaft, Zurich 92, 289 (2), 294 (49)
Service de Documentation Photographique de la Réunion des Musées Nationaux, Paris 62, 96
Soprintendenza alle Gallerie Roma II, Galleria Nazionale d'Arte Moderna, Arte Contemporanea, Rome 25, 69, 112, 159, 296 (71)
Michael Speich, Winterthur 156, 290 (17)
Hans Steiner, Basel 23, 137, 289 (3), 291 (26), 294 (54), 296 (77)
Stickelmann, Bremen 222

Tate Gallery, London 118 (left), 168

Vasari, Rome 85
Marc Vaux, Paris 38, 39, 48, 54, 55, 58, 63, 73, 74 (top left and right), 291 (33), 293 (45), 296 (69)
Vonow, Chur 289 (6)

John Webb, London 70 (left), 100, 216
Étienne Bertrand Weill, Courbevoie, France 45
Sabine Weiss, Paris 217, 220, 268–272
Dieter Widmer, Basel 61, 91
Albert Winkler, Bern 42, 236

The publishers acknowledge gratefully the kind permission to reproduce illustrations from the following publications:

Almanacco dei Grigioni, Poschiavo 289 (9), 290 (11)
Cahiers d'Art, Paris 89, 98, 291 (25), 293 (38, 41, 42), 294 (47, 48, 51), 296 (68, 70, 72)
Derrière Le Miroir, Paris 218–219, 238–239
Emporium, Bergamo 290 (18)
Carl von Mandach, *Cuno Amiet*. Bern, Verlag Stämpfli 289 (8)
Martin-Nicholson-Gabo, *Circle*. London, Faber, 1936, 290 (21)
Le Surréalisme au Service de la Révolution, Paris, 1933, 293 (36)

Lamberto Vitali, *Quarantacinque Disegni di Alberto Giacometti*. Turin, Giulio Einaudi Editore, 1963, 95, 99, 184, 214, 215, 221

Reproduction authorized for:

p. 289, ill. 4; p. 294, ill. 50 – Copyright by Cosmopress, Geneva
p. 290, ill. 22; p. 291, ill. 23; p. 293, ills. 40 and 44; p. 294, ill. 55 – Copyright by ADAGP, Paris, and Cosmopress, Geneva
p. 293, ill. 38, p. 294, ill. 54 – Copyright by SPADEM, Paris, and Cosmopress, Geneva

ACKNOWLEDGMENTS

We are particularly grateful to the following for their advice and assistance: Annette Giacometti, Paris; Diego Giacometti, Paris; Bruno and Odette Giacometti, Zurich; James Lord, New York.

We should also like to thank the following for their help and the loan of photographs:

Marianne Adelmann, Florence; Marguerite Arp-Hagenbach, Clamart–Locarno; Dr. Christoph Bernoulli, Basel; Ernst Beyeler, Basel; Dr. Wibke von Bonin, Cologne; Michael Brenson, Paris–Baltimore; Gordon Bunshaft, New York; Dr. Palma Bucarelli, Rome; Pierre Cailler, Lausanne; Jacques Dupin, Paris; Hugo Debrunner, Bieberstein; Marie-Suzanne Feigel, Basel; Inga Forslund, New York; Dr. Carola Giedion-Welcker, Zurich; Wilder Green, New York; Dr. Lothar Grisebach, Hilchenbach; Henriette Grindat, Lausanne; Herbert Gröger, Zollikon; Dr. R. von Hirsch, Basel; Dr. Carlo Huber, Bern; Nesto Jacometti, Locarno; Fritz Imhof and the Völkerkundemuseum, Basel; Eberhard Kornfeld, Bern; Dr. Elisabeth Koehler, Zurich; Dr. Dieter Koepplin, Basel; André Küenzi, Lausanne; Meret LaRoche-Oppenheim, Bern; Herbert Lust, Chicago; Maurice Lefebvre-Foinet, Paris; Hans von Matt, Stans; Ida Meyer-Chagall, Basel; Dr. Franz Meyer, Basel; Josef Müller, Solothurn; Man Ray, Paris; Mme. Rhodia Dufet-Bourdelle, Paris; Dr. med. Rieder-Stampa, Uster; Gaston-Louis Roux, Paris; Frau Dr. Maja Sacher, Pratteln; Ernst Scheidegger, Zurich; Werner Spies, Paris; Professor Dr. Renato Stampa, Chur; Hans Stocker, Basel; Dr. Robert Stoll, Basel; Lydia Thalmann-Amiet, Oschwand; Hilda Trog, Zurich; Contessa Madina Visconti, Rome; Jeanne Welti-Nigg, Zurich; Irène Zurkinden, Basel.